The Sculptural Imagination

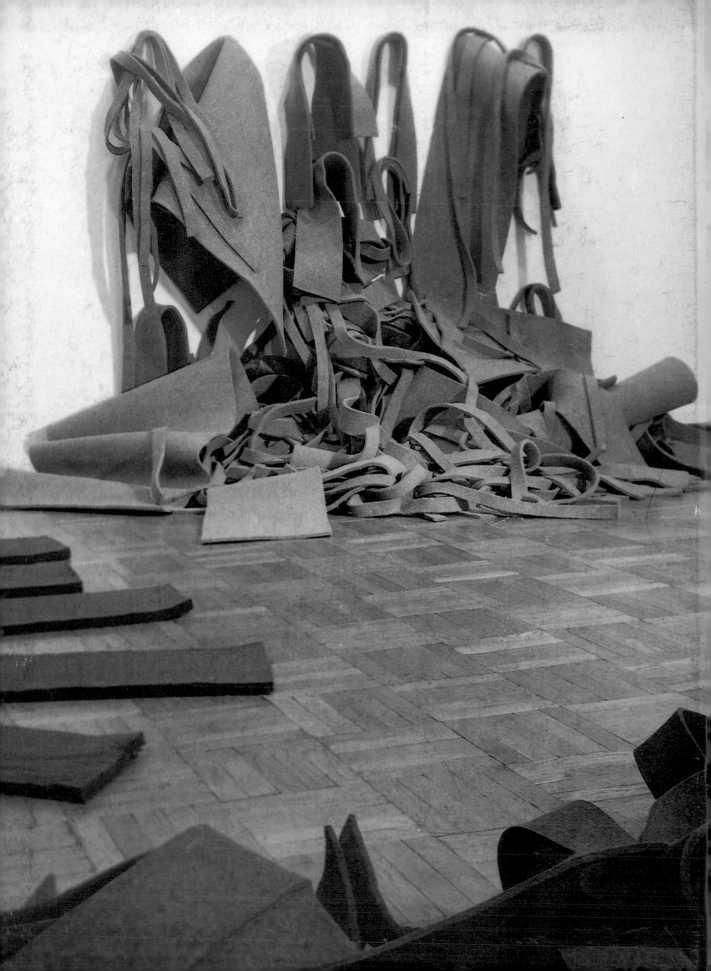

The Sculptural Imagination

Figurative, Modernist, Minimalist

Alex Potts

Yale University Press

New Haven and London

Designed by Gillian Malpass

Printed in Singapore

Library of Congress Cataloging-in-Publication Data

Potts, Alex.
 The sculptural imagination : figurative, modernist, minimalist / Alex Potts.
 p. cm.
 Includes index.
 ISBN 978-0-300-08801-4 (cloth : alk. paper)
 1. Sculpture – Appreciation. I. Title.
 NB1142.5 .P68 2000
 730'.1'1 – dc21 00-042879

A catalogue record for this book is available from
The British Library

Frontispiece Robert Morris, *Untitled* (detail), 1967,
as installed in the Leo Castelli Galley, New York, in 1968,
felt, variable dimensions, collection of the artist

Contents

Acknowledgements

The origins of this book are found in a period I spent teaching fine-art students at Camberwell School of Art in the 1980s. My early thinking on modern sculpture owes a lot to discussions with colleagues and students there, particularly Tony Carter, Wendy Smith and Conal Shields. This community was unfortunately dispersed when Camberwell fell victim to the wave of Thatcherite rationalisation of art-college education in London in the late 1980s.

I am grateful to Caroline Arscott and David Solkin for prompting me to focus in a concerted way on the viewing of sculpture by asking me to give a paper at the session they organised on 'The Viewer in the Frame' at the Association of Art Historians' annual conference in 1991. An invitation the next year to deliver a series of research seminars at the Department of History of Art, University of California, Berkeley, on 'Male Phantasy and Modern Sculpture' gave me an opportunity to lay the foundations of a book, helped by feedback from, among others, Michael Baxandall, Tim Clark and Anne Wagner. The project was consolidated by an invitation from Lisa Tickner and Jon Bird to contribute to a set of art-history publications they were editing. I wish to thank Lisa Tickner for her generous input into the book at that stage, even if its expanding scope and deferred deadlines meant that it had to find another home.

Numerous colleagues, students and friends have played a part in the genesis and working out of the ideas presented here, including Dawn Ades, Graham Andrews, Caroline Arscott, Stephen Bann, David Batchelor, Roger Cook, Tom Crow, Penelope Curtis, Whitney Davis, Martina Droth, Steve Edwards, Tamar Garb, Adrian Forty, Michael Fried, Christopher Green, Andrew Hemingway, Anthony Hughes, David Hulks, Lewis Johnson, Sharon Kivland, Eva Lajer-Burcharth, Simon Lee, Sue Malvern, Tim Martin, Stanley Mitchell, Mignon Nixon, Fred Orton, Brendan Prendeville, Adrian Rifkin, Alison Sleeman, Jon Thompson, Kim Tong and Anthony Vidler. I owe a particular debt to Anne Wagner, with whose work on sculpture I have had many productive encounters over the years, and to Malcolm Baker, whose generously shared and creative thinking about the viewing, making and display of sculptural objects has been a constant source of stimulus and encouragement. Last, but certainly not least, there has been Michael Podro's increasingly timely insistence that looking closely and thinking carefully lie at the very core of any worthwhile engagement with works of art.

To Briony Fer I owe a lot for her valuable commentary on the final manuscript, as well as for the more intangible effects her own work has had on my analysis. I am also much indebted to Tim Clark for his full, carefully considered responses to the text which helped me to sharpen the formulation of a number of crucial passages. Finally, there is a very special debt I owe to Susan Siegfried. Discussions with her played a formative role

throughout my working on this project, generating fresh ideas and greater clarity of critical perspective.

The British Academy and the Henry Moore Foundation generously agreed to fund part of the illustration costs: without their support it would not have been possible to offer anything like the same range and quality of plates. I should like to thank also Goldsmiths College and the University of Reading for granting me periods of study leave, and the Center for Advanced Studies in the Visual Arts, National Gallery of Art, Washington, for help when I was Visiting Scholar there. I am indebted to Clare Robertson at Reading for making it possible for me to complete the final editing of the book to schedule. It has been a genuine pleasure to work with Gillian Malpass at Yale University Press. I am grateful for the care she took designing the book and seeing through its publication, and for her generous responses while I was in the final stages of working on the text.

Lastly I want to thank Rachel and Joanna for putting up with my absorption in this project over the past couple of years.

Preface

Sculpture is a category so obvious that it is usually taken for granted, and at the same time a little awkward, partly because it disrupts the pervasive logic of the two-dimensional image in modern culture. What has defined sculpture is not so much a set of self-contained rules or principles, but its status as something different from painting. The purpose of this book is to explore this otherness of sculpture, focusing on the distinctive practices of viewing and modes of display it invites, as well as those ideologically charged problems that keep recurring in modern discussions of sculptural aesthetics.

For one thing, a free-standing sculpture tends to activate a more directly physical and bodily engaged response from the viewer than a painting. Rather than facing the viewer as a surface hung flat against the wall, it intrudes on the surrounding space, and has to be walked round rather than just looked at. Sculpture also tends to heighten the tensions between an individual, private mode of viewing art, and the public staging of this viewing in a gallery space. At the same time, the insistently literal nature of sculpture will often add a further edge to modern anxieties about works of art being no more than mere objects or commodities.

When, during the Renaissance, a systematic theory of the visual arts began to be formulated, sculpture was both related to painting as an art based on *disegno* or drawing, and distinguished from it because of its different materials and processes of fabrication. A *paragone* debate developed over whether sculpture or painting was the superior art, which considered the relative difficulty and nobility of the artistries involved.[1] My analysis begins in the late eighteenth century when a new differentiation between sculpture and painting began to assert itself, one that shifted the focus of attention from the artist's process of conception and making to the aesthetic experience of the viewer.

Once the sculptural in art was conceived to be systematically distinct from the painterly, and this continued to be the case until quite recently, sculpture tended to be regarded by the artistic public as somewhat marginal. Painting was usually assumed to be the leading art, with sculpture being thought of as a more limited, more literal and more primitive art by comparison. I shall confront this traditional valuation, but not by seeking to reverse it and claim special privileges for the sculptural over the painterly. The awkwardness of sculpture is a significant feature of the modern visual imagination, and its more substantial ramifications extend well beyond the limits of sculptural aesthetics.[2] I am keen here to counter a ghettoising of what are still often seen to be specialist sculptural concerns. Equally, my analysis is framed by recent developments that have thrown into question post-Enlightenment conceptions of sculpture as categorically distinct from painting. In this new context, sculpture, or three-dimensional work, has become a capacious category that includes installations, environments, staged video displays and assemblages of objects, and now enjoys just as high a profile in exhibitions of contemporary art as painting or other strictly two-dimensional work.

This book is based on a close reading of a number of key texts on sculpture that illuminate the shifts in conceptions of sculpture and sculptural viewing over the past two hundred years,[3] beginning with Herder's ground-breaking analysis in the late eighteenth century of how apprehending a three-dimensional sculpture differs from viewing a two-dimensional painting. At the same time, it examines work by a few selected artists who have functioned as models in these theoretical reconceptualisings of sculpture, such as Canova, Rodin, Brancusi, David Smith, Donald Judd, Eva Hesse and Louise Bourgeois. The texts I have found most fruitful are generally not the standard discussions of sculptural aesthetics, where the significance of sculpture is assumed to be self-evident. Rather, I have been drawn to more polemical and densely argued writings where sculpture emerges as in some way problematic yet also strangely compelling. It is often the case that the most vivid insights into an aesthetic or artistic phenomenon come by way of critique. But more is at issue here. The point is that the writers who have been most illuminating about sculpture are sensitive to the way it disrupts painterly modes of viewing and sometimes subverts the clear-cut apprehension of plastic shape captured in two-dimensional representations. The most telling responses to Neo-Classical sculpture were those that criticised its vivid surface effects and intricacies of form for throwing into disarray the viewer's desire for a stable definition of plastic shape like that projected in the drawn image of a figure. Later, in the nineteenth century, Baudelaire's and Walter Pater's analyses of the limits of sculpture, and of the structural difficulties it created for a viewer attuned to the conventions of painterly representation, stand out as among the most eloquent and suggestive accounts of conceptions of sculpture at the time. A particularly telling indication of how free-standing sculpture was not easily accommodated within the painting-based formal paradigms dominating discussion of art at the end of the nineteenth century comes in a curious, seemingly anti-sculptural polemic by the artist Adolf von Hildebrand, *The Problem of Form in Figurative Art* published in German in 1893. His argument that sculpture needed to be endowed with the two-dimensional frontality of relief was in part prompted by his particularly keen awareness of the kinaesthetic effects that came into play when viewing a work in the round.

Rilke in his essays on Rodin published in 1903 and 1907 and Carl Einstein in his book on African sculpture published in 1915, by voicing their anxieties over whether sculpture could ever be presented in an imaginatively convincing way in a modern context, each in their different ways brought into focus those factors that made viewing a free-standing work of sculpture both so perplexing and fascinating for the visual imagination of the period. Equally, one of the most suggestive analyses of sculpture from the inter-war and immediate post-war years was elaborated by a critic, Adrian Stokes, who remained resolutely committed to the formalist view that sculpture operated primarily as visually activated surface. Finally, it was Michael Fried's apparently rearguard critique of Minimalist sculpture as threatening the very foundations of high modernist art that offered the most resonant analysis of what was at stake in the move to installation and viewer-orientated forms of three-dimensional art in the post-war period – a shift which in the end blurred the distinctions between the sculptural and the painterly that until then had made sculpture seem a little intractable.

In the second half of this book, there is a shift of gear as I explore the reshaping and restaging of sculpture in Minimalist and post-Minimalist work by turning to the writ-

ings of practising sculptors. A number of the artists involved, including Robert Morris, Donald Judd, Eva Hesse, Carl Andre and Louise Bourgeois, were driven to reflect intensively on their practice. They developed easily the most incisive commentary made at the time on the larger resonances of their work. In their cases, the articulation of an acute critical awareness combined in a peculiarly productive way with a strongly driven, non-verbal, often non-imagistic practice. It is through them we can best track the restructuring of sculpture as something activated in the phenomenal encounter between viewer and work, and see how that perennially awkward and fascinating entity, the sculptural object, was both negated and restaged. We no longer necessarily view all three-dimensional art through a Minimalist or post-Minimalist lens; but an adequate explanation of what sustains our engagement with work that is in any way sculptural still has to take account of the continuing affective and conceptual power of Minimalism's pared down and emphatically materialist refashioning of sculptural objects and practices of viewing.

Minimalism, and concerns about the sculptural object and the phenomenology of sculptural viewing that it brought into focus, thus loom large in my analysis. This is partly because the advent of Minimalism so evidently disrupted previous modernist paradigms, and had the effect of foregrounding sculptural or three-dimensional work as central to the debate about what a modern art might be. This shift into three dimensions was not limited to, and certainly not exclusively initiated in, the New York art world. Even so, the distinctive conditions prevailing there were such that the new situation of the sculptural object was debated with particular intensity and clarity. New York in the post-war period functioned a little like Paris in the late nineteenth and early twentieth centuries as the arena for an unusually intellectually self-conscious and ideologically charged debate about developments in contemporary art. At the same time, one needs to bear in mind that these developments were fostered as much, and often more inventively, by European as by American patronage.[4]

The sharp definition of the Minimalists' interventions, as well as of other self-consciously avant-garde initiatives in the 1960s, owed much to specific political and cultural circumstances that momentarily gave the ambition to refashion the art object a particular urgency. If the American artists involved did not usually envisage their work as making overt political statements, as did some Europeans such as Joseph Beuys,[5] their conception of art had an oppositional thrust that was just as bound up with a larger politicising of culture, evident in the new political movements of the period and in the eruptions of disquiet over the flagrant consumerism of post-war, American-style capitalism.

At that time, a radical rethinking of the sculptural object rather than of painting seemed to offer the most fruitful avenue for questioning received aesthetic paradigms. While any real political urgency attaching to such a revolutionising of sculpture was soon dissipated, changes in conceptions of sculpture have continued since then to register with peculiar vividness, if indirectly, the pressures of larger social forces. Over the past two or three decades, for example, there has been a quite spectacular regendering of sculpture and of scholarly studies of sculpture. Nowadays, not only are many if not most of the more significant artists working in three dimensions female, but the general character of ambitious sculpture no longer has the masculine resonances it retained as

late as the 1960s when making a serious piece of sculpture was still generally considered man's work.

My preoccupation with the particular breakdown of modern conceptions of the sculptural brought to a head by Minimalism also has its contingent aspect, bound up as it is with the formation of my own particular interest in modern sculpture. My earliest serious engagement with contemporary sculpture came in London in the late 1960s and early 1970s, at a time when my own research was concerned with Neo-Classicism and Neo-Classical aesthetics. In Britain Henry Moore was being dethroned, even as his large, late bronze sculptures were being installed everywhere in urban and rural landscapes. The works being featured as up to date and modern were the heavy-metal, modernist constructions of Caro and artists associated with him. While such work intrigued me, I had a growing awareness that something else more in tune with the temper of the times was emerging, and that this was actively at odds with the still somewhat stolid and self-importantly purist conceptions of sculpture prevailing in the new British school promoted at the time. I remember being struck by the anti-sculptural sculpture of artists like Barry Flanagan and Gilbert and George. But what in the end really set me going, quite late in the day, was the major exhibition of Carl Andre's work at the Whitechapel Gallery, London, in 1978. This was sculpture that in its insistent materiality seemed eminently sculptural, but at the same time set up powerful interactions with the viewer that made it impossible to apprehend as a traditional sculptural object.

This encounter helped to crystallise a shift in my understanding of what a modern sculpture might be, which was also taking off from my reading on the subject. Until then I had had to make do with the discussions of sculptural form and space in standard modernist accounts by writers such as Albert Elsen and Herbert Read which I found confusing and somewhat unconvincing.[6] William Tucker's *The Language of Modern Sculpture*, published in 1974, at least went some way towards describing the intricacies of looking closely at the sculpture that I felt particularly drawn to such as Brancusi's. This book, however, was still weighed down by a cult of the sculptural to which I could not fully subscribe. By contrast, the intellectual sharpness and deconstructive thrust of Rosalind Krauss's *Passages in Modern Sculpture*, when it came out in 1977,[7] seemed something of a revelation. Her analysis successfully undermined the increasingly threadbare assumptions on which recent understandings of the sculptural had been based, and gave real urgency to the problematics of looking at twentieth-century sculpture.

Subsequently, my own thinking about sculpture has alternately been stimulated and partly thrown into disarray by an ongoing internal debate with the paradigms set out in Krauss's book, paradigms that seemed intensely seductive and yet somewhat at odds with persistent features of my own take on sculptural aesthetics. The powerful effects of her book I think had a lot to do with the rigour and intellectual subtlety, and sense of engagement, with which it faced up to the unconscious dependence of modern conceptions of the sculptural on painterly paradigms. No one has worked through more persuasively than Krauss the dematerialising implications of a high modernist formalism for an understanding of modern sculpture – in her case subtly inflected by semiotic and phenomenological theory.

My preoccupation with sculptural aesthetics has also derived from an interest in the self-consciousness of viewing elicited by early Neo-Classical sculpture such as Canova's,

to which the seminal work on Canova's studio practice by Hugh Honour first alerted me.[8] A particularly crucial stimulus, however, came from Michael Baxandall's analysis of a rather different sculptural tradition in his *The Limewood Sculptors of Renaissance Germany* published in 1980. His way of dealing with the materiality of sculpture, and the conditions of its display, has major implications for any phenomenology of sculptural viewing. He shows, for example, how one needs to take account of the optical effects generated by the play of light on a sculpture's surfaces as much as its apparently more substantive qualities as an object.[9] Modern conventions of display often work against these important subtleties of visual effect. Sculpture is generally not seen to good advantage in a space sealed off from natural illumination and thrown into sharp relief by spotlights that blank out any but the crudest gradations of light and shadow.[10]

One of the great strengths of Baxandall's book is the way it insists on an intense close viewing of sculpture, while making clear that anything we say about such viewing is dependent upon linguistic constructs and cultural convention — both ours and those current in the milieu for which the work was created. If we wish to explore a particular sculptural aesthetic, we do not just go straight to the sculpture concerned. We need to engage with the verbal paradigms and cultural praxes which we surmise would have framed the viewing of the work for its original audience, and also those possibly rather different paradigms and praxes within which our own viewing of the sculpture is embedded.

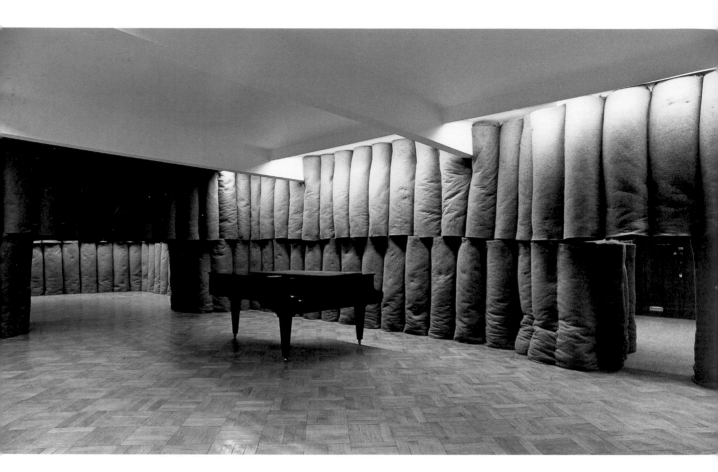

1 Joseph Beuys, *Plight*, 1958–85, felt, piano, thermometer, as installed at the Anthony d'Offay Gallery, London, 1985, now in the Centre Georges Pompidou, Paris

Introduction

The Sculptural Imagination and the Viewing of Sculpture

Some time in the late 1950s or early 1960s, in the heyday of high modernist formalism, the painter Ad Reinhardt came up with a statement that enjoyed a remarkable resonance because it was so in tune with long-standing attitudes to sculpture: 'A definition of sculpture: something you bump into when you back up to look at a painting.'[1] In more traditional gallery installations, the sculptures often do feel a little out of place, either unframed and somewhat awkward intrusions on the viewer's space or decorative adjuncts to the display of paintings (fig. 2). As objects, they may seem not to invite the same level of imaginatively engaged viewing that paintings elicit through their clearly defined status as depictions or representations.

Ad Reinhardt's dictum points to something very real about public attitudes to viewing sculpture, exposing a pervasive modern unease about the staging of sculptures as objects of display in galleries and museums. This framing of the sculptural, though, needs to be set against a very different but equally significant and in its own way equally modern perspective on sculpture. It comes into play when a viewer encountering a work of sculpture does become absorbed in looking at it. At the moment when Reinhardt made his uncompromisingly negative statement, the American sculptor David Smith offered an equally telling commentary on what happens as we are drawn into a sculpture's ambit and become actively involved in the 'adventure' of viewing it (fig. 78): 'My position for vision in my works aims to be in it . . . It is an adventure viewed.'[2]

Engaging with a sculpture for what it is, a physical thing intervening in our space, is in the end what has to cheat the tendency to see it as inertly object-like.[3] When a sculpture displayed in a gallery does somehow seem compelling, our attention is sustained by an intensified visual and kinaesthetic engagement with it which is continually changing and shifting register. This is what makes its fixed shape and substance seem to come alive. Caught up in what Smith called 'an adventure viewed', the work momentarily becomes a little strange and elusive as well as being insistently present, unlike the objects we encounter more casually in the course of our everyday lives.

* * *

What I am envisaging here as a distinctively modern sculptural imaginary began to define itself as a result of developments in the eighteenth-century art world, among the most important of which were the emergence of public exhibitions and, towards the end of the century, the establishment of public art galleries. These formed a context where works of art were presented to be viewed as relatively autonomous entities within a public space.

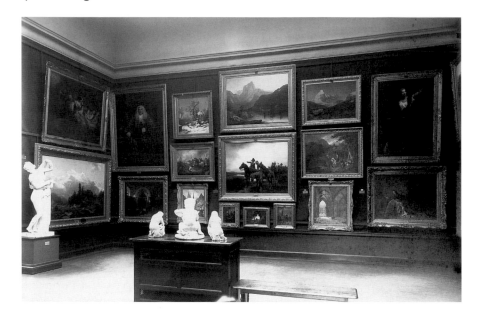

2 Gallery in the Hanover
Landesmuseum in the early
1920s

The custom-designed sculpture gallery, where sculptures featured as self-sufficient objects, and not just as adjuncts to an architectural setting, was largely a creation of the period – one key example being the remodelling of the display of antique sculpture in and around the Vatican Belvedere in the 1770s to create the Museo Pio-Clementino.[4] In such a context, a sculpture was defined as a generically different kind of art work from a painting, while being granted a status as an autonomous entity like an easel painting, even though it would in practice often be installed more decoratively, and might be partly integrated into the museum's interior architecture.

Here I am concerned primarily with sculpture designed to be viewed in an interior space. Outdoor sculpture, that functions as landmark or monument, or part of an architectural ensemble, raises a rather different set of problems, as does work such as Robert Smithson's with its interplay between interior and exterior sites.[5] At the same time, indoor sculpture still has to be seen as existing in a dialectical relationship with the more public and monumentalising values that come into play with large-scale outdoor work.

Also important in creating a context for a distinctively modern sculptural imaginary was an aesthetic theory being developed in the eighteenth century that engaged in a systematic enquiry into the differences and affinities between various forms of art. Lessing set the ball rolling with the famous distinction he made between visual art and literature in his celebrated essay *Laocoon* published in 1766.[6] The idea that the formal organisation of a work of art had a basis in the distinctive mode of apprehension it elicited was later developed to define a systematic distinction within visual art between sculpture and painting – first by Herder in an essay entitled *Sculpture* published in 1778 and later, most influentially, in Hegel's *Aesthetics*.[7]

In this differentiation from painting, sculpture acquired a strangely ambiguous and problematic status. Sculpture, designated as the art centrally concerned with form, was in theory primary, but in practice it acquired a status below painting, not only because

painting had more formal means at its disposal – light, colour and atmosphere, for example – but also because painting seemed better able to capture transitory appearances, while sculpture was seen to be limited to the rendering of fixed shapes. Painting's ostensiveness seemed more modern, more subjective in a way, more akin to inner perceptual and imaginative experience. The problematic status of sculpture in the nineteenth century was nicely summed up in Walter Pater's influential study *The Renaissance*, published in 1873. On the one hand, he wrote, sculpture, as epitomised by ancient Greek statuary, 'records the first naive, unperplexed recognition of man by himself'.[8] On the other, it can only work for a modern viewer if it somehow overcomes its 'tendency' 'to a hard realism . . . Against this tendency to hard presentment of mere form trying vainly to compete with the reality of nature itself, all noble sculpture constantly struggles.'[9]

The paradoxical imperative for sculpture to dematerialise the literalising of shape that distinguished it from painting became if anything more insistent later on, in the period of early modernism – a moment when painting took over as the principal arena for avant-garde innovation, and sculpture, at least as mainstream practice, rather than as informal object-making, played a secondary role.[10] It has only been in the past few decades, starting with tendencies such as Minimalism, Arte Povera and Neo-Dada in the 1960s, that three-dimensional art has come to occupy a central position in the visual imaginary of the modern art world. Earlier in the twentieth century, the spatially more inventive sculptural experiments functioned less as phenomena in their own right than as ideas for architecture. The artists involved in such work, however, most notably the Russian Constructivists, did pioneer some novel installation-orientated forms of display. Tatlin's exhibition of his *Model of the Monument to the Third International* (fig. 54) in 1920,[11] for example, has come to be seen in retrospect as a major sculptural work in its own right, even if this goes somewhat against the grain of its original conception.

The once problematic status of sculpture as an art that has systematically to be distinguished from painting is no longer a major issue in contemporary art circles. This change has gone hand in hand with the dissolution of modernist notions of sculpture as an embodiment of plastic form, and with a new emphasis on installation and display and viewer response. In 1978, Rosalind Krauss came up with a classic formulation of this change as 'sculpture in the expanded field'[12] – a sculpture no longer circumscribed by a monumentalising or classicising ideal, or by a modernist cult of the self-contained art object. Sculpture was now seen to deal in spaces and environments and assemblages of objects. It had in a way become painting that had moved out into three dimensions, with the frame extended to encompass the viewer (fig. 1).

In the 1970s, when this reconfiguring of the sculptural was still relatively recent, it made sense to celebrate it as a radical clearing away of the dead weight of worn-out aesthetic categories, and an opening up of new possibilities. There was something quite exciting about the shift from the object-focused conception of sculpture that had dominated until then, and about the new expanded notion of viewing that resulted – no longer just a disembodied gazing, but a process involving the viewer spatially and kinaesthetically and intellectually, as well as visually. From a present-day perspective, however, the situation looks rather different.[13] Installation has become naturalised, as has a self-conscious contextualising of art work, while post-modern fashion has largely rendered

redundant the categorical distinctions between different forms of art that previously made sculpture seem problematic. In the present context, then, a continuing celebration of the move beyond the confines of the traditional sculptural object is hardly more than a conventionalised promotion of current practice. The freeing up of the boundaries between different media, and the supposedly critically aware liberation from traditional norms this produces, has effectively become just one further wonder of the triumph of late capitalism.[14] My misgivings on this score are not only the obvious political ones, nor are they entirely explained by my antipathy to modern versions of a blandly progressivist liberal view of history and a mindless welcoming of ever expanding possibilities. Something more precise is also at issue.

The self-conscious departure from normative conceptions of sculpture initiated by the Minimalists in the 1960s derived much of its energy from the continuing fascination exerted by the insistent materiality of their work (figs 118, 148). There still existed a tension between the idea of a new, more open intervention in three-dimensional space and the awareness of a work's resistant object-likeness. A compelling feature of three-dimensional art at the time was that it did not disclose itself to the viewer with quite the same ease as painting or image-based work – its inert thingness, its impinging on the viewer's space, still getting in the way of normative patterns of visual consumption. Nowadays, sculpture no longer seems weighed down by the austere heaviness of monumental form or by the literal inertness of solidly embodied shape, but assimilates itself often quite self-consciously to popular forms of visual spectacle, whether displays of commodities in shops, fashionable minimalist interiors or pop video scenarios. The troublesome facticity of the sculptural object has largely disappeared from view, and in the process lost much of its potential for portentous inertness, as well as its intermittent resistance to image-based consumerism.

* * *

From the Neo-Classical figure sculptures of the late Enlightenment and early nineteenth century through to the installation-conscious work of recent decades, there have undeniably been some radical changes in what counts as sculpture. At issue are not just differences in the formal structuring of sculptural objects. Equally, if not more important, are the different ways in which work has been staged, and the different modes of viewing it has invited. To clarify this, I shall posit a crudely schematic history of changing formations of modern sculpture, moving from the classical figure to the autonomous modernist object and then on to Minimalist and post-Minimalist things and spatial arenas and markings of place.

This schema, I hasten to add, is not designed to offer a complete mapping of tendencies in modern sculpture. Many of these will emerge later in my detailed discussion of those moments in modern sculptural theory and practice that I have singled out for attention. It is a schema with a distinctive agenda, and is designed to highlight aspects of modern engagements with the sculptural that have to do with the physical, sensual and affective dimensions of the encounter between viewer and work. A different schema would be appropriate were I wishing, for example, to focus on the anti-form and conceptual

imperatives that have been associated with Duchamp's distaste for sensory immediacy. It is not that I wish to deny the strategic significance of various late avant-garde attempts to suppress visual and affective resonances in an effort to combat a conservative privileging of the visual and tactile wholeness of the art object, though I would argue strongly against the idea that such suppression is still a necessary precondition for art with an oppositional political edge. Rather, I am making a case for a critical rethinking of sculptural norms that engages seriously with the more vividly embodied physical and perceptual responses activated by viewing three-dimensional work. Not only are such levels of response integral to any apprehension of an art object, however anti-aestheticising it might be bringing into play issues that cannot be dealt with adequately at a purely conceptual or ideological level; the more phenomenological dimensions of a viewer's interaction with a work of sculpture particularly need to be addressed in the present context because they have not been accorded anything like the same critical attention as the viewing of painting.[15] Conceptually based redefinitions of the art object have tended to dominate in most of the more critically and intellectually engaged studies of three-dimensional work over the past couple of decades.[16]

The point of departure for the tripartite schema I propose is the classicising representation of a self-contained, beautiful human body. In the late eighteenth and through most of the nineteenth century, free-standing indoor sculpture usually took the form of an ideal nude or lightly clad figure modelled on antique Graeco-Roman prototypes. The *Venus Italica* completed by Canova just after 1800 (fig. 22) serves as a good example because it has now become something of an unacknowledged popular icon. Wherever you find crude, small-scale replicas of classicising sculpture for sale, in gift shops or garden centres, more often than not the Venus is not an antique Greek or Roman one but Canova's *Venus Italica*.

The sculpture presents itself as autonomous at several levels – firstly, formally, as a finely configured shape, and secondly, representationally, as an image of a body and self in perfect harmony with one another. What animates the sculpture, however, is the way in which it slightly disrupts the ideal of a self-sufficient and fully realised wholeness that theoretically was the aim of this kind of work. Its mode of address is a little ambiguous, the pose both confidently at ease and cautiously guarded. The figure is not quite self-sufficient and set apart in its own world, but aware of being constituted in someone else's gaze.

In histories of modern art, it has long been standard practice to single out Rodin's sculpture as making a definitive break with the classical ideal and opening the way to a radically different, modern conception of sculpture.[17] A traditional sculptural wholeness is supposedly disrupted by the fragmenting of the body in his late partial figures, and by the prominent residues these display of the process of fabrication – making them almost more like objects than representations of a figure. Such claims, however, require considerable qualification. For one thing, the fragmentary status of the figures is bound up with a conception of sculpture latent in an earlier sculptural imaginary. It had been customary for some time to display recently excavated Greek sculpture, however incomplete, in unrestored fragmentary form. What makes the status of Rodin's late sculpture particularly paradoxical in any mapping between classical figure and modernist object, however, is the way the object-likeness actually functions to make some of the figurative

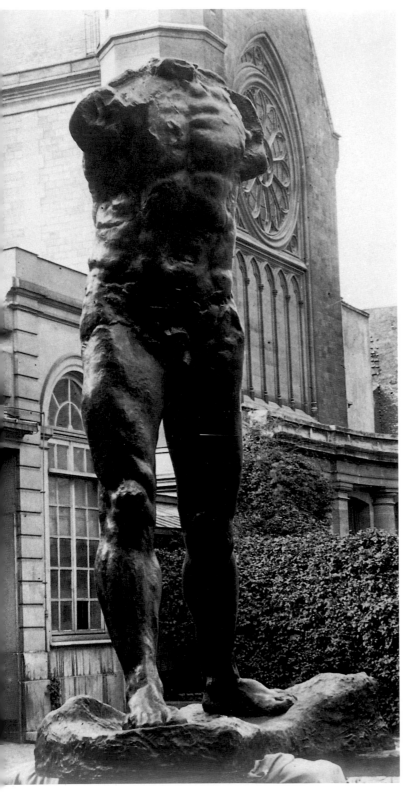

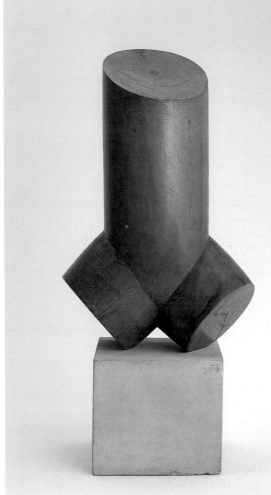

4 Constantin Brancusi, *Torso of a Young Man*, c. 1916, maple, 48.3 × 31.5 × 18.5 cm, on limestone block, height 21.5 cm, Philadelphia Museum of Art: The Louise and Walter Arensberg Collection

3 (*left*) Auguste Rodin, *Striding Man* (bronze, from 1907 plaster model, 214 × 70.5 × 154 cm) temporarily displayed in the courtyard of the Hôtel de Biron, Rodin's residence in Paris, photographed by Druet

elements more vividly alive.[18] Few traditional whole figures convey the dynamic of walking with the immediacy of Rodin's headless and armless *Striding Man* (fig. 3).

The work of a slightly later modernist artist such as Brancusi certainly makes even Rodin's more incomplete renderings of the human body look unequivocally figurative. His *Torso of a Young Man* (fig. 4) is clearly much more of an object than any Rodin sculpture. It is, in a way, a found object, fashioned in its earliest wooden version by adapting the given form of a branched trunk. Its scale, very much smaller than life size, reduces any semblance of figurative presence. It is also presented as an object and set on a custom-designed pedestal. These pedestals, however, play an intriguingly ambiguous role. While they underline the autonomy of the object displayed by isolating it from its surroundings, they also partially undo this autonomy by virtue of the sculptural interest they excite in their own right (fig. 68).[19]

5 Carl Andre, *Lever*, as installed at the 'Primary Structures' exhibition in the Jewish Museum, New York, in 1966, 137 firebricks each 6.4 × 11.4 × 20.3 cm, overall 11.4 × 20.3 × 885 cm, National Gallery of Canada, Ottawa

What is most significant about the shift in the later conception of sculpture that came to a head in the 1960s and early 1970s is not so much the radically abstract reconstitution of the object, but the undoing of the expectation that the object should command attention through the internal integrity of its form (fig. 5). When Donald Judd called the new three-dimensional works specific objects, what he had in mind was their specificity as physical entities rather than as formal constructs, things having a specific scale, made of specific materials, and having a specific placement in their immediate environment. An open array of galvanised metal boxes set along a line marked out by a separate blue bar too thin substantially to structure the arrangement, which was devised by Judd in 1966, became one work when resting on the floor and quite another raised up and cantilevered off the wall (fig. 121).

When other Minimalist artists of Judd's generation came to describe the kind of art work they were producing, they would often avoid the word 'object' altogether because of the associations it had with the idea of a closed, self-contained construct. The new

sculptures were variously represented as things or places or sites. This compulsion to get away from the structuring imperatives of the word 'object' is nicely articulated in an interview Carl Andre gave in 1970 where he proposed the designation 'place' to describe his work.[20]

Andre's metal floor pieces (figs 132, 134) almost force the viewer to envisage them as subverting the visual logic of a traditional sculpted motif. Looking straight ahead, there is nothing much to see. Yet the work impacts dramatically on the space where it is placed. This undoing of sculpture as plastic shape took a number of forms at the time, as in the dangling rope and string pieces Eva Hesse produced towards the end of her career in 1969–70 (figs 149, 150). Situation in both cases is crucial. Andre's work hugs the floor, it is visibly grounded, by contrast with most sculpture where little is made of how it rests on the ground. With Hesse, the situation is reversed. The specificity of the work comes from its being suspended, and thus negating the standard notion of a sculpture as a self-supporting construct. In both cases, there is a teasing ambiguity between a sense of insideness and outsideness that the closed solid shape of most traditional sculptural objects largely precludes.

A shift occurs, then, whereby the structuring of a work is partly defined through the viewer's physical encounter with it, and can no longer be located entirely in its form. A psychic dynamic is activated by its physically intruding on or reshaping the viewer's sense of ambient space, and from the vague feelings of contact the viewer has with the shaping and texturing of the stuff from which it is made – hard, dense and sharply defined with Andre, or more indeterminate and flexible, yet stringily fibrous and knotty, with Hesse. The impact made by these works also depends importantly on optical effects of a kind that traditional theories of the sculptural dismissed as secondary. The reflective sheen that catches the eye as one looks closely at Andre's metal floor pieces, for example, momentarily almost de-solidifies them, transforming them into shimmering planes of light floating just above the matt, inert floor on which they rest (figs 133, 136). Light gives the work lift-off, just as the fibrous opacity of the latex-covered free-floating rope core in the Hesse gives it a certain weight and density.

Traditionally, sculpture has been envisaged as the visual art that gives substance to forms that can only be depicted in painting. This effect would if anything seem to be enhanced in Minimalist and post-Minimalist work, as such sculpture gives literal three-dimensional substance not only to plastic shapes but also to spaces and environments (fig. 99). But does this materialising of form and space mean that one's viewing of sculpture is somehow more stably anchored than one's viewing of images or paintings? I would claim not. If, with painting, instability is created by the ostensiveness of the spatial fields and shapes its flat surfaces evoke, with sculpture we are made more aware of instabilities inherent in our perceptual encounter with the work itself as object or environmental configuration.

The sustained viewing of a free-standing sculpture not only dissipates the fixed image we might have of it because of the different aspects it presents from different angles. There are also other, more radical instabilities that come into play as we come close to it. Our sense of the work as a whole shape literally gets displaced by the spectacle of continually shifting partial aspects it presents. This destabilising effect is particularly insistent in the case of a sculpture because of the distinctive kinds of visual and spatial

awareness that now come into operation. Not only does what we see change more rapidly with the slightest shifts of the eye, but stereoscopic vision begins to kick in, so that the shaping of surface in depth is felt much more strongly. The parts we are looking at now seem to impinge more dramatically on their ambient space. They also almost float free. There is no single clearly defined plane in which they are arrayed, as in a painting, and we no longer see them as anchored in their surrounding environment as we did in the more distant overviews we had of the work. The impact made by a recent work by Tony Cragg, for example, is almost entirely lost if we simply stand back from it and take it in as a whole motif, which at first can seem a little banal or arbitrarily abundant, and fail to open our viewing to the striking flows and hiatuses and shifting modulations of surface that come into play as we get close (figs 6, 7).

Far from the close viewing of a sculpture giving a solid grounding to our perception of its shape, then, the effect is to activate changing sensations of surface and texture and depth that give us a quite different, more indeterminate sense of what the work is. The disparity between close and far views could be seen as the sculptural equivalent of the disjunction between the different apprehensions to be had in looking closely at a painting as the visual sensations generated by the marks and colours on its surface separate out from the image or visual configuration into which these coalesce when we take in the whole work at a glance.

Last, but not least, the kinaesthetic viewing activated by three-dimensional work brings with it a heightened sense of temporality. An important feature of the close looking elicited by any work of art compared with everyday image recognition is the way we linger and become so conscious of viewing as a process unfolding over time. The ritualised viewing of a painting or sculpture, exemplified in the 'look and tell' routines of gallery guides, takes the form of peering intently first at this and then at that feature of it. Our sense of the work as a whole is partly defined through the ever changing and variously focused partial views we have of it, and can never entirely be condensed in a single stable image. With painting, awareness of this is more easily occluded because we can shift attention from detail to detail without having to change position. By contrast, taking in a sculpture is manifestly not just a matter of looking and scanning but also, as Serra emphasised, of taking time to walk round it too (figs 8, 9).[21] Michael Fried, in his critique of Minimalism in his 1967 essay 'Art and Objecthood', evoked this insistently temporal dimension of viewing sculpture when he expressed his unease over being drawn by his encounter with Minimalist objects into a sense of 'endlessness, being able to go on and on, and even having to go on and on . . . of time passing and to come, simultaneously approaching and receding.'[22]

A consciousness of the temporality of viewing, previously registered mostly indirectly by analysing the time-bound processes of making a work of art, was given a particular impetus in the 1950s and 1960s through the expansion of avant-garde practice into performance work[23] and work that itself visibly changed over time – whether because it was kinetic or because it was made to retain marks of short-term wear and tear. Minimalist sculpture played a key role in this development in that it brought such temporal awareness into a sphere traditionally seen as operating outside or transcending time, namely the viewing of a static object or configuration. A significant interplay thus took place between the heightened awareness of temporality created by performance work and

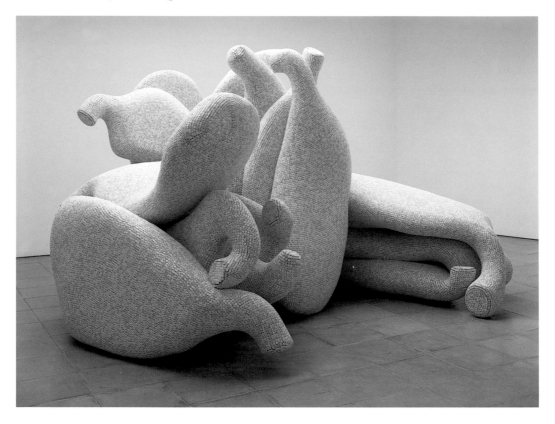

6 Tony Cragg, *Secretions*, 1998, thermo plastic and fibreglass, five parts, 248 × 335 × 295 cm, Courtesy Lisson Gallery, London

a new interest in the temporal dimension of viewing art objects. Several prominent artists of the period, such as Morris, Beuys and Oldenburg, developed their practice by moving between performance and sculpture. Fried rightly identified temporality as a key issue in the Minimalists' performative or theatrical staging of sculptural objects.

The highly schematic history of sculpture that I have just adumbrated might suggest that there was a progressive shift from the sculptural figure, representing an idealised human body as a whole, beautiful form, to the sculptural object, offering a single isolated shape characterised by its integrity of form, to work defined more as an arena of encounter with the viewer. It would seem that in this last phase the viewing of three-dimensional work finally came into its own, liberated from norms more appropriate to viewing paintings or two-dimensional images. However, the recent focus on installation and experiencing work in its three-dimensionality has not superseded what might be seen as traditional sculptural figuration or object-making. Essentially abstract Minimalist or post-Minimalist concerns now often come most vividly to the fore in work that offers the viewer a recognisable figure or naturalistic motif. Charles Ray's manikins, for example, depend for their effect on a response attuned both to their physical scale and presence as objects and to the kind of figure they so graphically represent. What makes Ray's *Boy* (fig. 10) particularly striking is the awkward disproportion between its adult size

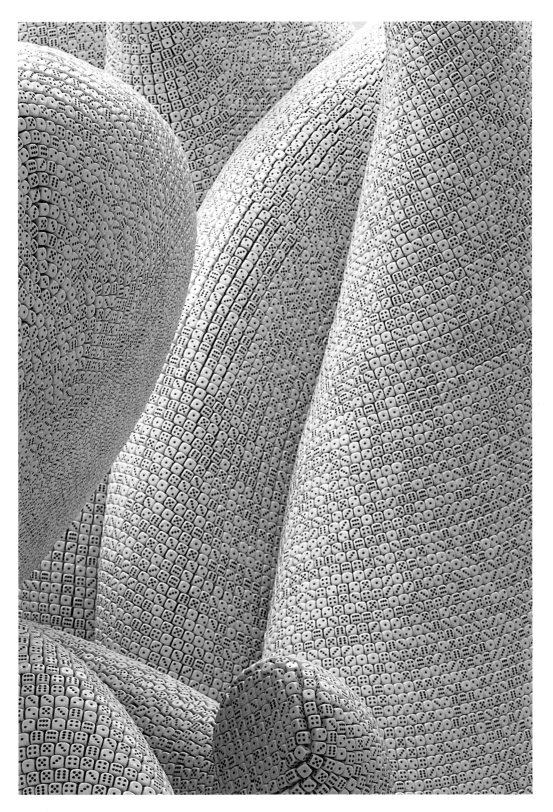

7 Tony Cragg, *Secretions*, detail

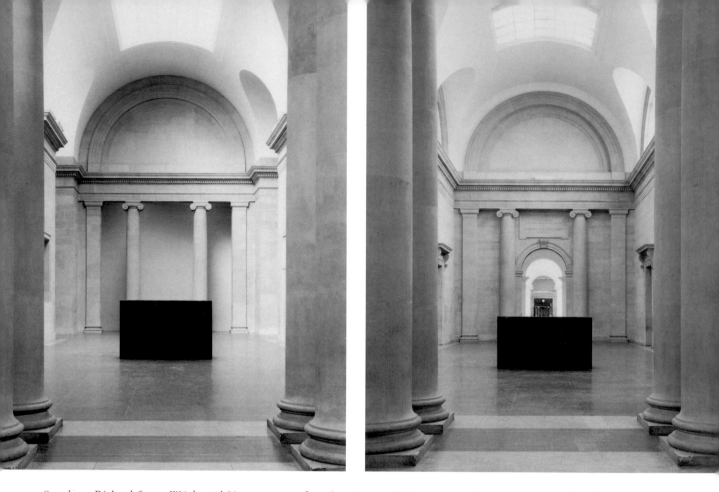

8 and 9 Richard Serra, *Weight and Measure*, 1992, forged steel, two blocks, one 173 × 275 × 104 cm, the other 152 × 275 × 104 cm, installed at the Tate Gallery, London, in 1993, (*above left*) view towards the far end of the sculpture gallery, and (*above right*) view towards the entrance of the sculpture gallery

and its boyish shape. As one approaches, the enlarged yet blandly accurate body and children's shoes and pinafore outfit begin to look a little monstrous.

A simple historical progression from figure to object to arena of encounter also becomes significantly complicated if we look backwards historically. Now we are attuned to envisaging a sculpture as something existing in our space that activates a potentially endless flow of shifting apperceptions, it is apparent that earlier figurative or object sculpture often presented itself to be viewed in such a way. Krauss's *Passages in Modern Sculpture*, published in 1977, the classic formulation of the new post-Minimalist phenomenological sculptural aesthetic, revisited Rodin's and Brancusi's objects to show how they came alive for a present-day sensibility because they were not envisaged solely as autonomous plastic forms, but brought into play other more contingent dimensions of viewing.

This opening up of our understanding of earlier sculpture can however be taken much further than Krauss herself would allow. Canova's sculpture the *Three Graces* (figs 11, 12) is featured by her as an exemplar of the stable wholeness demanded by traditional conceptions of sculpture. But it only remains so if one looks no further than the photograph showing the front of the group seen head on. Approaching it, and looking closely at the details, it is difficult not to be carried away by a spectacle of vividly felt

shapes and surfaces quite disconnected from the clearly configured form the sculpture presents from a distance. One's attention is seized by the touch of a hand on a cheek, the inclination of two heads in gentle contact with one another, the ripple of drapery brushing against an area of smooth flesh, and above all by the unendingly varied modulations of contour and surface. This decentring, this proliferation of viewing, is accentuated thematically by the cross-cut of exchanged glances between the three figures.

It may be a long way from Canova's sculpture to a Robert Morris felt piece from the late 1960s (fig. 13). My contention, however, is that Morris's sculpture, which is literally a play of surface almost entirely disconnected from any supporting structure, dramatises something that goes on in certain moments of the close viewing of a work such as Canova's *Three Graces*.[24] And the Morris felt is not entirely formless either. It involves a particular kind of shaping, with the malleable array suspended from three clusters of nails set in the wall, tumbling down to accumulate on the floor. There is a weight and measure to it, a weight and measure that one simultaneously knows, feels and sees. It is perhaps no less a whole thing than the Canova, where the apparent tightness of linear composition and the figurative motif disguise a certain cavalier disregard for integrated plastic form. The elusive and provisional sense of wholeness one has in the presence of the Canova can never be pinned down — it too hovers forever on the margins of one's immediate awareness.

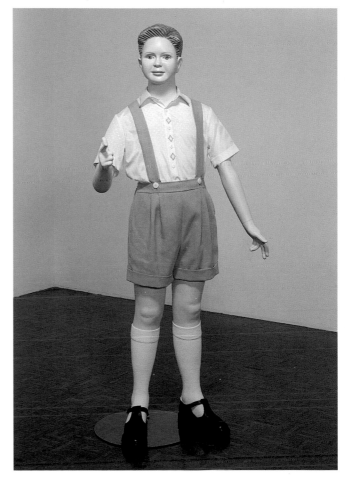

10 Charles Ray, *Boy*, 1992, painted fibreglass, steel, fabric, 181.6 × 68.6 × 86.4 cm, Whitney Museum of American Art, New York, Purchase with funds from Jeffrey Deitch, Bernardo Nadal-Ginard, and Penny and Mike Winton

* * *

If a consideration of sculptural viewing can begin to blur neatly defined distinctions between Neo-Classical figurative sculpture and late twentieth-century three-dimensional work, significant historical differences nevertheless still assert themselves. These differences have largely to do with changing notions of the kind of sculptural object that could seriously sustain a viewer's attention and present itself as having an autonomous value when displayed as a free-standing entity in a gallery. During the late eighteenth and

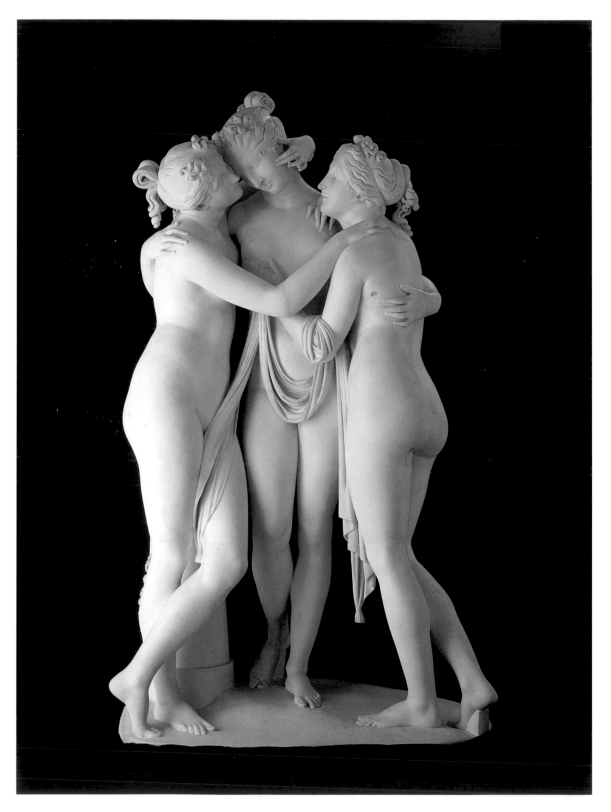

11 Antonio Canova, *The Three Graces*, 1815–17, marble, 173 × 97.2 × 75 cm, National Gallery of Scotland, Edinburgh, and Victoria and Albert Museum, London

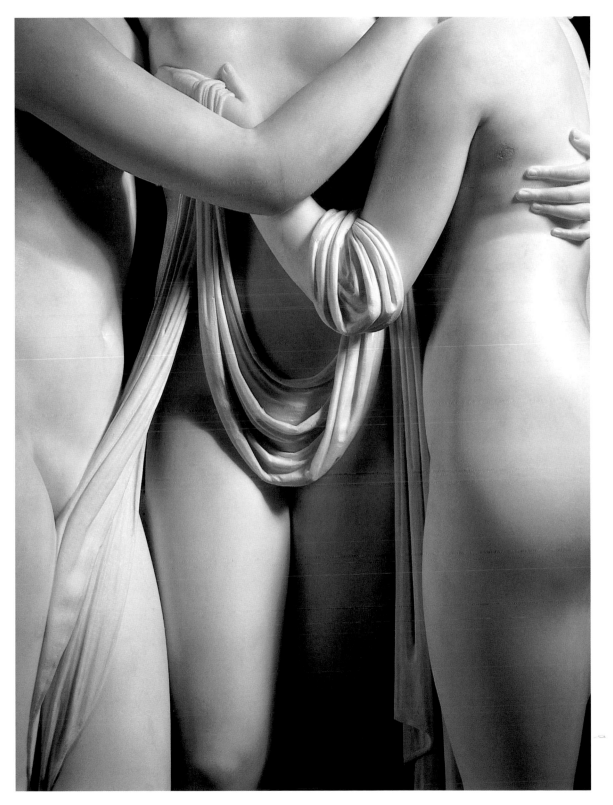

12 Antonio Canova, *The Three Graces*, detail

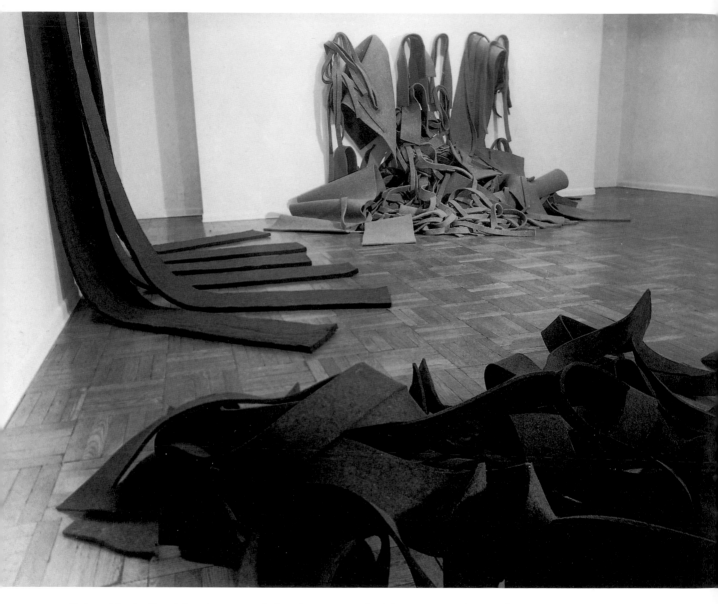

13 Robert Morris, *Untitled*, 1967, as installed in the Leo Castelli Gallery, New York, in 1968, felt, variable dimensions, collection the artist

much of the nineteenth centuries, the assumption was that such an object needed to take the form of a beautiful, finely shaped nude or lightly clad figure. The identity of such an object as a self-sufficient thing was underpinned by its symbolic significance as the representation of a human subjectivity at one with itself. This underpinning was precarious in that most ideal figures in nineteenth-century sculpture were endowed with an obvious erotic charge (fig. 14), so the figure engaged the viewer not just as the image of an ideal self but also – and perhaps primarily – as something one might desire. In a way, this

precariousness made the empty fiction of pure autonomy capable of exciting a viewer's interest.[25]

Looking back on this paradigm from a present-day perspective, the question then becomes why it ceased to be viable. How was it that in avant-garde circles of the early twentieth century the assumption developed that a sense of convincing autonomy could only be recovered by making a sculpture object-like rather than figure-like? Within the terms of an early modernist aesthetic, the answer would be that the autonomy of a sculpture was compromised if it projected the semblance of being what it itself patently was not. A sculptural object could only devalue its integrity by masquerading as a living human subjectivity. This imperative was so powerful that Rilke, when seeking to represent Rodin's work as radically modern in his famous essay of 1907, envisaged his sculptures as things rather than figures.

Now that the anti-representational imperatives of modernist theory no longer have the same purchase, other issues seem to be more crucial. We might argue that the classicising figure ceased to be a viable model for any even remotely critically aware sculptural practice because it presented itself so blatantly as a reassuringly consumable commodity. It had become the reification of a fixed subjective ideal, rather than a stimulus to think subjectivity anew. If it was to sustain an imaginative resonance, a sculptural object had in some way to resist being projected as a familiar and gratifying image of the self.

Except in the case of the odd defiantly

14 James Pradier, *Nyssia*, 1848, marble, height 176 cm, Musée Fabre, Montpellier

non-sculptural and anti-aesthetic experimental work by Dada or Surrealist artists such as Duchamp, however, or the more political antiart interventions of the Russian Constructivists, the general assumption continued to be that a compelling work of sculpture was possessed of an autonomy, echoing the viewer's own, that was somehow inherent in its qualities as an object. In this way, the more idealist modernist conceptions of sculptural art, which began to establish themselves as normative from the 1920s onwards, were able to perpetuate the assumption that the viewing subject generated out of her or

his contemplation of a sculptural object a sense of subjective wholeness that could be located, if not in some figurative image the object represented, then at least in its inner formal structure.

The dissolution of traditional ideas of sculptural embodiment went a stage further with the reconceptualising of the three-dimensional art object that got under way in the 1960s. A Minimalist object in particular no longer presented a dense enough internal structuring to be seen as a formal correlative of a figure, let alone as embodying a human subjectivity. Increasingly, there has been a move away from the format where a single autonomous object centred the viewer's contemplation. A work would often be dispersed into an array of objects (fig. 161) or become an arena or environment (fig. 162), providing a context within which a subjective awareness was activated that could not be associated with any substantively defined motif or shape.

At issue in this development is not so much some intangible decentring of subjectivity as such, but rather the tendency to a perpetual unfixing of images representing any ideal or collectively shared subjectivity within modern culture. In the circumstances of contemporary capitalism's unrelenting dissolution and remaking of those cultural norms that momentarily mediate between the individual's self-awareness and a sense of the larger social and economic realities within which this self-awareness is constituted, the compelling art work will no longer be one that purports to embody some stable essence of individual subjectivity. If a work gives rise to a vivid subjective awareness, this awareness cannot seem to be encapsulated in some potentially inert and fixed objective thing. It has to emerge from within the contingencies of the viewer's encounter with a work. Where three-dimensional art of the past few decades differs most noticeably from modernist sculpture is the way the staging focuses the viewer's attention on this contingency and unfixing.

One significant factor at work in these changes from what, crudely speaking, we could call a figurative condition of sculpture to an object-based one to a situational post-Minimalist one, concerns specific changes in the conditions of staging and viewing sculpture. To modern eyes, the display of large-scale sculpture in nineteenth-century exhibitions and museums often seems to emphasise the public-parade dimensions of visiting galleries and viewing art (fig. 15). The sculptures appear to be installed so as to create an overall richness of spectacle that still has affinities with the decorative arrangement of sculpture within grand architectural schemes or in formal gardens. To put this another way, sculpture as an art form was still envisaged as in some way a public fixture. There was one-to-one communion with a work, but it took place in a public arena, and the vivid representation of a human figure was almost a necessary precondition for a statue to stand out from other decorative objects and architectural features in its immediate environment.

In the early twentieth century, particularly in avant-garde circles, a deep antipathy emerged to this public-display dimension to sculpture. Innovative work tended to be small in scale and adapted to an intimate viewing space. The artist's studio came to be imagined as an ideal context, one where a private communion with the work could take place in an environment shaped by the artist's concerns, and uncontaminated by the demands of public consumption.[26] Brancusi himself staged such a viewing of his sculpture when he conducted visitors on tours of his Paris studio, and circulated photographs

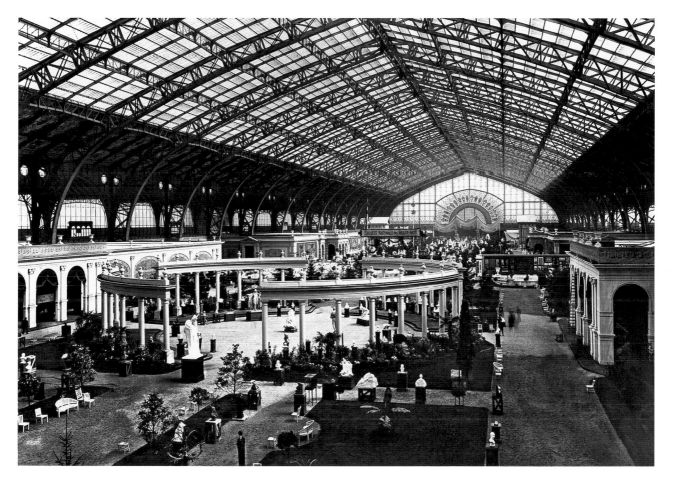

15 Sculpture Garden at the Salon of the Société Nationale des Beaux-Arts in Paris in 1898 with Rodin's *Balzac* and *Kiss*

of his work displayed in this informal environment (fig. 71). Moreover, many exhibitions of modern art at the time, with small-scale objects and paintings in relatively intimate spaces, have affinities with private domestic interiors (fig. 16).

Nowadays, significant sculptural work is usually much more extensive and presented in more generous spaces, a tendency that got underway in the immediate post-war period when modernist artists began to produce work on a figure-like scale, and the so-called white cube gallery space was being introduced.[27] A sparer mode of installation has now become so much the norm that earlier displays of work in public galleries usually seem terribly cluttered (fig. 17). In the relatively generously arranged exhibition spaces available to the Minimalists, a work was able to invite a more focused viewing than an everyday object without having to offer a striking or structurally complex form. The viewer was also made more aware of the nature of her or his interaction with the work (fig. 102). Nowadays, even a traditional-seeming sculpture (fig. 164) will often be staged so as visibly to confront the viewer, and force her or him to attend to a dynamic of encounter that is now too vivid to ignore.

16 Installation of Brancusi's work at
the Sculptor's Gallery, New York, with
Three Penguins and *Maiastra*, 1922

17 (*below*) Sculpture Gallery of the
Musée du Luxembourg, Paris, c. 1900

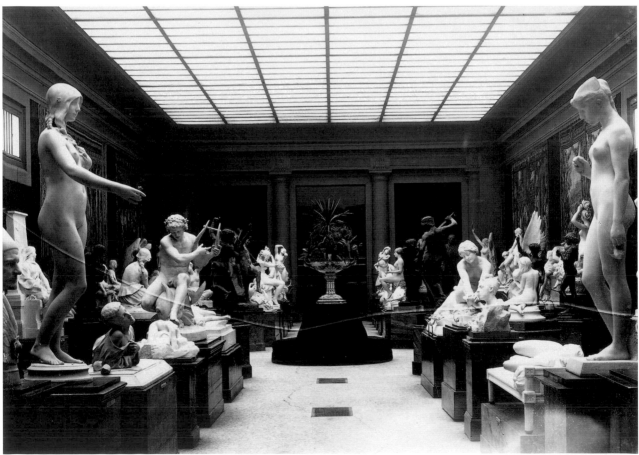

The viewing of art, whether in a tradi-
tional gallery or in an intimate modernist
interior or in a present-day art space, is both
a private and a public affair. Even if the ideal
model of viewing is a close one-to-one com-
munion between viewer and work, the arena
is still public, as is the sense of occasion that
makes a viewer come to see the work on
display. The practices of viewing art in a
gallery are curiously situated between the
more private praxis of reading and the more
public praxis of attending the performance
of a play or a piece of music or the showing
of a film. In a gallery, one is not alone with
a work as with a book in a domestic envi-
ronment, or even in a library. But neither do
viewers line up in front of works of art as
they do in front of a performance to enjoy a
properly collective experience – except on
guided tours. This tension and symbiosis
between private and public modes of con-
sumption, however, does change character
with the different contexts of viewing that
public galleries have provided since their
inception in the late eighteenth century.

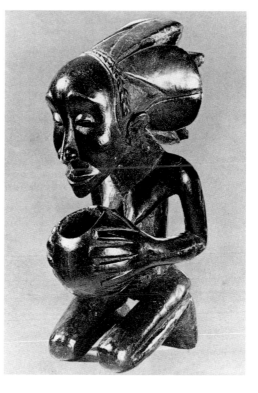

18 Illustration of a Baluba sculpture from Zaire
in André Malraux, *Les Voix du Silence* (1951)

In the relatively recent shift away from an
intimate display of small objects, the sense of there being a clear divide between an
authentic, intensely private communion with the sculptural object and an inevitably
compromised public staging of it has to a large degree broken down. There is no longer
the same aura attaching to the idea of a sculpture whose uncompromising autonomy would
preclude considerations of display. Of course, the latter involved a particular understand-
ing of how a sculptural object should be presented in public so as to foster the illusion of
a close, unmediated encounter between viewer and work. We see this very clearly in the
way sculpture was packaged for public consumption in the illustrations in art books such
as André Malraux's *The Voices of Silence* of 1951 (fig. 18), where it loomed on the page as
a closely cropped, apparently isolated image.[28] Now that this ideal of an unmediated
private communion with the art object is widely, if passively, recognised as itself an
ideological construct and simply taken to be an established mode of visual display and
consumption, it has ceased to have much real resonance for practising artists.

The breakdown of this paradigm, and the shift to a freer interplay between a one-to-
one communion with a work and its installation in a public arena, needs to be related to
larger changes that have been taking place in contemporary culture, evident not only in
the art world but also in the world of politics and in those many other arenas of
collective experience that are now filtered through the media. With television in par-
ticular, people are engaged in modes of visual consumption that take place in a private,

domestic space while being plugged into a public distribution network. Significant events and personalities are thus processed in such a way that they are amenable to private consumption, while intimate individual confessions are staged for collective viewing. In the case of iconic figures such as stars of the entertainment world and also politicians, and even famous personalities from the past, their public profiles are increasingly being defined in terms of supposed revelations about their private lives. The proprieties regarding public access to prominent individuals' more private concerns are constantly being contested and re-negotiated, particularly in the Anglo-Saxon world where the constraints of privacy laws are either absent or ill-defined.

The change to a more evidently public staging of the individual encounter with a work of sculpture, which in some ways represents a return to the conditions of display in late nineteenth-century exhibitions, no more resolves an inherent tension between private consumption and the public arena in which this takes place than the earlier modernist paradigm did by seeming to enclose authentic work within a private world.[29] Much of the more ambitious work by later twentieth-century artists is such that it can only exist when it is staged publicly and accommodated to public modes of viewing and consumption.[30] But these conditions can potentially distract, and at times even discomfit, the viewer. This is not what either artist or viewer necessarily want. As Bruce Nauman put it when commenting on his corridor pieces (fig. 162), which both enclose the viewer in an isolated space and dramatise her or his exposure to others in the gallery:

> I was thinking a lot about the connection between public and private experiences. I think it came from working in the studio. You work alone in the studio, and the work goes out into a public situation. How do people deal with that? . . . you tend to try an experience with art, but protect yourself in some way. You have to learn to shut yourself away from the rest of the public. So in those corridor pieces which were about the connection between public and private experience, the video helps the private part even though it's a public situation. The way you watch television is a private kind of experience. But it's beginning to break down in those sports events where you now have a large screen.[31]

The more public and installation-orientated notion of sculpture, paradoxically, has had the effect of focusing attention on the distinctive nature of a viewer's individual perceptual encounter with a work. But only apparently paradoxically. For this development has not redefined sculpture as a public art so much as produced a different public ritualising of individualised viewing and of the artist's individualised intervention in the gallery space.[32] The result has been to shift the prevailing conception of three-dimensional art so that it is no longer focused on isolated plastic form, on what traditionally has been thought of as the essentially sculptural. Superficially, this might look like a dematerialising of sculpture. But I would claim that it represents, rather, a different form of its materialisation, where conditions of viewing and display play a more significant role. What the viewer sees as being there may not be a clearly delimited object or image, but it is there nonetheless, both fixed fact and contingent phenomenon.

In the final analysis, most Minimalist and post-Minimalist work is still poised on a fault line between an installation-orientated conception of art and a continuing concern

with sculpture as some kind of object; just as the modernist work that continues to command attention straddles the fault line from the other direction. A Brancusi sculpture can be viewed as an autonomous plastic form, but the shifting aspects it presents as one responds to its carefully contrived staging are integral to its effect and definition as a work of art. By drawing attention to the historical longevity of this double take, I wish to highlight how, throughout various shifts in the modern sculptural imaginary, the instability of a viewer's encounter with a three-dimensional work has been integral to any affective and conceptual power it might have, as well as to any resistance it might offer to being consumed as mere commodity. Yet such instability, that at times has reached the point where the material integrity of the sculptural object almost becomes irrelevant, is so much in evidence now because it conforms to the disintegrating drive of an increasingly pervasive and unrestricted process of commodification, consumption and capital accumulation. In its constant erosion of any fixed mediations between the individual and the public arena, this capitalist dynamic lays bare the tension within modern practices of beholding art between an individual's close, one might almost say private, one-to-one engagement with a work and the staging of this viewing in a public space such as an art gallery. Sculpture has long been a focus for anxieties generated by this tension because of its mythic status as an art of stable embodiment and because of the gap between its public and monumentalising functions and its role as the paradigmatic autonomous object of aesthetic contemplation.

1 Classical Figures

A new understanding of the distinction between painting and sculpture began to emerge in the second half of the eighteenth century. The real issue here is not the distinction as such. Sculpture had always been thought of as different, if only because its execution required different skills, it was made of different materials and existed as solid thing rather than painted surface. In art theory, where painting and sculpture were seen to be grounded in a common mastery of drawing or *dessin* or *disegno*, the distinctiveness of sculpture began to matter in more radical ways once it was thought that sculpture might require a different approach to the design of form.

A Sculptural Aesthetic

Most standard treatises of the time, such as Dandré-Bardon's *Essay on Sculpture*, published in 1765,[1] show little sign of such a new conception of sculpture, but it already plays a significant, if tentative, role in the French sculptor Falconet's influential *Reflections on Sculpture*, delivered as a discourse to the French Academy in 1760, and later incorporated in the *Encyclopédie* as the article on sculpture.[2] Falconet was worried by a common perception that sculpture was at a certain disadvantage compared with painting, being unable to exploit colouristic and complex compositional effects, and thus being necessarily more limited in its means. Such assumptions about the limits within which sculpture had to operate were common currency at the time.[3] What is interesting is the particular way Falconet tried to turn them to positive advantage. Although sculpture included fewer parts of artistic practice than painting, he argued, 'those which it proposes for itself, and which are common to the two arts, are the most difficult to represent, namely expression, the science of contours, and the difficult art of draping and of distinguishing between different kinds drapery [*étoffes*]'.[4]

He then went on to make his most important point. Because sculpture had fewer means to arouse the viewer's interest, and was unable to create some of the striking visual effects found in painting, the sculptor had to seize the viewer's attention through his mastery of those means he did have at his disposal. Above all, drawing, the basic design of form, had to be more perfect and exact: 'As sculpture requires the most rigid exactitude, in it carelessness in the drawing will be much less bearable than with painting'.[5] In theory at least, then, sculpture was to be valued for being a formally more austere and demanding, if somewhat less immediately appealing, art than painting.

In this treatise Falconet no more than other mainstream commentators on sculpture at the time had anything to say about a work of sculpture's distinctive identity as an object existing in space, viewed from a multiplicity of positions, though he briefly com-

mented on the need for the sculptor to take account of the light and shade produced by ambient light.[6] It was only in a later treatise, discussing the merits and faults of the Roman equestrian statue of Marcus Aurelius, that he made an issue of how it is imperative for a sculpture's form to be more correct than a painting's to allow for the changing effects of light and variations in viewing position.[7]

Falconet was no purist and was also a practising sculptor. His sculptural aesthetic negotiated interestingly between an insistence on formal restraint and simplicity, and a recognition that in practice sculpture often had to utilise effects that in theory might seem to be painterly aberrations in order to captivate the viewer. According to him, present-day sculpture should not be excluded from drawing on the compositional virtuosity, the elaborate arrangement of drapery and the vividly realist rendering of the surface of the flesh absent in ancient sculpture, but often found in modern art, particularly painting.[8] If sculpture was of its nature more classical and austere than painting, it should still be allowed to exploit a certain painterly richness of effect. Other theorists, by contrast, took a more puritanical line, pursuing the consequences of Falconet's idea that sculpture required a more rigorous conception of form than painting without regard to the actual resources of sculpture as a concrete practice.

One of the more rigorous of these hard-line theorists was the painter Joshua Reynolds, who devoted the tenth of his discourses delivered to the Royal Academy in London in 1780 to sculpture. In his view, sculpture differed from painting because it existed as an abstract ideal of formal purity. In developing this perspective, he adumbrated a conception of sculpture that was both rooted in prevailing attitudes of the period and had a number of striking affinities with later, modern ideas on the subject. For a start, he insisted more categorically than Falconet ever did on the limits within which sculpture had to remain as compared with painting.[9] The difference is most marked in his discussion of how expressive effects needed to be more restrained in sculpture than in painting. When Falconet made the point that a sculptor had to be careful not to sacrifice the precision of form underlying his art to the expression of feeling, he began by emphasising that feeling was the soul of sculpture, and that 'expressing the forms of bodies without joining feeling to them was only to go half way to fulfilling the object' of sculpture.[10] Reynolds, by contrast, firmly laid down the principle that the 'undetermined effects of the Art' of sculpture were such that it was barred from rendering the refinements of expression and character of which painting was capable.

What Reynolds had particularly in mind was facial expression. In his view, the relatively blank faces on antique sculptures were exemplary. Any expressivity needed to be conveyed through the overall attitude and form of a figure, and thus could only be defined 'in a very general manner'. Reynolds went on to make the preceptive point, which almost seems to have been taken to heart by late nineteenth-century sculptors such as Rodin and Degas, that as regards expression, 'the Sculptor's art is not unlike that of Dancing, where the attention of the spectator is principally engaged by the attitude and action of the performer; and it is there he must look for whatever expression that art is capable of exhibiting'.[11]

What is the logic of Reynolds's extreme insistence that sculpture of its very nature must eschew all the more subtle and elaborate picturesque and expressive effects that enliven painting? It is as if sculpture functioned for him as a theoretical model for the

pursuit of the exact and beautiful rendering of the human form that he saw as under-pinning a painter's training, but not necessarily his practice. Sculpture for him was a model and a pedagogical prop, rather than a modern art that needed to appeal to and seduce its audience. Insomuch as he had any concrete examples of sculpture in mind, these were classical antique works. As a painter, he could easily afford to take this position, the more so as sculptors did not play a central role in the Royal Academy, any more than did a training specifically directed to sculptural practice. At the same time he gave voice to a new perception of sculpture gaining ascendancy at the time, and did so in a way that exhibited a remarkable degree of theoretical rigour. No one, except perhaps Herder, who was arguing from the position of a philosopher and writer rather than a practitioner, offered such a systematic account of the formal differences between sculpture and painting.

Reynolds explained how,

> though Painting and Sculpture are, like many other arts, governed by the same general principles, yet in detail, or what may be called the by-laws of each art, there seems to be no longer any connection between them. The different materials upon which these two arts exert their powers must infallibly create a proportional difference in their practice.[12]

Reynolds gave voice here to a distinctively modern ambivalence of attitude to sculpture, namely that sculpture was at one and the same time a very limited art but also intriguingly distinct from painting by virtue of the restricted and seemingly uncontaminated aesthetic arena in which it operated. Its peculiar simplicity and austerity made it both empty and strangely significant, conventionalised yet free of artifice and arid academicism. As Reynolds put it, 'Sculpture is formal, regular, and austere; disdains all familiar objects, as incompatible with its dignity; and is an enemy to every species of affectation, or appearance of academical art . . .' and 'The grave and austere character of Sculpture requires the utmost degree of formality in composition; picturesque contrasts have no place; every thing is carefully weighted and measured.'[13]

There is some evidence that Reynolds did think about the distinctive impact made by the works of sculpture most admired at the time, particularly those antique sculptures such as the *Belvedere Torso* (fig. 19), which, because of their fragmentary state, could not be seen to command a viewer's attention by virtue of a drama they evoked or through the expressive character of the figure they represented. Such sculptures affected the viewer, according to Reynolds, precisely because their abstract form and relative emptiness somehow managed to seduce one. At least, this is one construction to be placed on the point he made about how, with sculpture,

> we are sure from experience, that the beauty of form alone, without the assistance of any other quality, makes of itself a great work, and justly claims our esteem and admiration . . . what artist ever looked at the Torso [this defaced and shattered fragment, as Reynolds calls it] without feeling a warmth of enthusiasm, as from the highest efforts of poetry? From whence does this proceed? What is there in this fragment that produces this effect, but the perfection of this science of abstract form?

To a present-day audience, schooled to thinking of fragments such as the *Belvedere Torso*

19 *Belvedere Torso*, first century
BC, marble, height 159 cm, Vatican
Museum, Rome

in relation to Rodin's late work (fig. 3), the answer might have more to do with the powerful suggestions of vigour and vitality created by the firmly modelled surfaces, rather than abstract purity of form. Yet there could be a shared recognition that there is something about the directness and intensity with which this work affects a viewer that sets it apart from most classical sculpture, and that this something is not be explained by the pose or character of the figure represented by it. Reynolds was perhaps also suggesting an interesting point about its literal identity as a shaped piece of marble, as distinct from the illusion it gave of living flesh, when he related his 'feeling a warmth of enthusiasm' in its presence to an intense awareness of 'the perfection of this science of abstract form'.[14]

Diderot put a similar case for the austere simplicity of sculpture as compared with painting, though a little more vividly than Reynolds's at times pedantically measured pronouncements. He was also more interested in sculpture as concrete phenomenon than Reynolds. Among other things he was a close friend of Falconet's, and his understanding of sculpture would in part have been shaped by familiarity with a practising sculptor's concerns. In his 1765 *Salon*, when discussing the need for artists to balance the study of nature with that of the antique, he was driven to speculate why sculptors were more attentive to the pure simple forms of the classical antique than painters. There was the

obvious point that sculptors had far more precedents to work from – sculpture of the finest quality had survived from antiquity, while painting had not. But more significant, in his view, was the fact that sculpture of its very nature was at further remove from nature and as a consequence had to focus more on the formal beauty of a figure than on expressive feeling. This meant that sculpture was less immediately accessible to the non-expert than painting. Most people would prefer a sculpture like the famous *Dying Gladiator*, or *Dying Gaul* as it is now called, because it represented strong emotions, to a more austere work like the *Borghese Gladiator*, where the simple action gave one little else to consider than the fine rendering of form. Sculptors such as Falconet and Pigalle, by contrast, those who really knew about the art of sculpture, preferred the simpler *Gladiator*, 'a grand figure, single and all white; it is so simple'.[15]

This was not just a chance observation. In an essay he had written on the French sculptor Bouchardon two years before, Diderot made the point that sculpture was not an appropriate medium for rendering refined and delicate ideas. In sculpture, he claimed, 'it is imperative that the thought be simple, noble, strong and grand.' Considered from this point of view, a fine sculpture in the round would be less immediately appealing than a painting, yet in a way superior to it. The very greatest classical sculptures had a status in the modern world like the classic texts of Homer and Virgil – exemplary, yet unfortunately largely ignored.[16] Diderot's views struck a strong chord and continued to resonate for some time afterwards. A discussion of modern British sculpture published as late as 1901, for example, still cited Diderot's view on this 'chaste, grave, and severe art'.[17]

* * *

We move into rather different territory with Herder's much more ambitious and wide-ranging essay *Sculpture. Some observations on form and shape from Pygmalion's creative dream*, published in 1778, but mostly written rather earlier in 1768–70, that is, almost contemporaneously with Falconet's and Diderot's commentaries. Herder's starting point was very different because he came from outside the art world, and in particular the metropolitan Parisian art world of Diderot and Falconet. Herder was clearly aware of Falconet's treatise, and it was without doubt one of his points of reference.[18] What prompted his enquiry was a philosophical concern with the aesthetics of the fine arts and with post-Lockean theories of sense experience. The systematic analysis Lessing developed of the distinctive domains and respective limits of the visual arts and of literature in his essay *Laocoon*, published in 1766, gave Herder a cue for thinking in similar terms about the categorical distinction that might be drawn between the two main forms of figurative visual art, painting and sculpture. What particularly excited Herder was his realisation that the distinction could be grounded in a more basic distinction between touch and sight. The sculptural and the painterly thus came to represent for him the different apprehensions to be derived from feeling one's way around things and looking at them. His in a way was the first modern phenomenology of the sculptural – and remains today one of the most intriguing and suggestive. But it was conceived above all as part of a larger exploration of the basic operations of the human mind and their grounding in sense experience.[19] His predecessors were Diderot of the *Letter on the Blind* (1749) and George

Berkeley of an *Essay towards a New Theory of Vision* (1709), and ultimately of course the key Enlightenment thinkers on sensation, Locke and Condillac. At the same time, his essay retains its greatest interest today as an intensive and suggestive speculation on how a close viewing of sculpture makes us aware of our basic physical engagement with things in the world in ways that the viewing of painting does not.

Herder tackles the distinction between painting and sculpture at two levels, firstly by thinking in general terms about the different ways in which things are structured for us when we apprehend them using sight or touch, and secondly, more specifically, by addressing the question of how viewing a work of sculpture differs from looking at a painting. To an extent, he does concede that the distinction is not entirely clear-cut. He recognises that, as we look and feel our way round in the world, we rarely experience touching and seeing separately. Seeing things, he points out on several occasions, carries an implicit felt sense of their shape and disposition deriving from our tactile contact with the world. He also openly acknowledges that the apprehension of sculpture is not a lit-erally tactile experience, but a looking that then assimilates itself to the dynamic of a tactile exploration.[20] This said, he usually assumes that a simple categorical distinction can be made between a purely painterly, autonomously visual looking, divorced from any tactile experience, and a tactile sculptural apprehension in which one's looking does not merely echo, but limits itself to, a purely felt engagement with things that sculpture's literal three-dimensionality invites. Such a distinction has its value as a heuristic model, and certainly is illuminating about the different modes of viewing invited by a painting and a free-standing sculpture. But used as the basis for explaining the distinctive formal configurations of sculpture, it gets Herder into difficulties, leading him to represent sculpture as an art having to operate in isolation from the pleasures, and complexities, of visual appearances.

If sculpture is grounded in touch, according to Herder, and painting in sight, the distinctive effects and particular domains of these arts are to be explained with reference to the different perceptions of things we have through these two basic senses. Touch slowly reveals the real shape and the disposition of things in depth, sight makes one instantaneously aware of them as a flat array of motifs set out side by side. Touch, by giving us a sense of the essential form of things, gives us truth, sight presents us with appearances, with things seen at a distance, as in fiction or in a dream. The novelty of Herder's analysis is to envisage the distinction between the sculptural and the painterly in these larger terms, sculpture becoming for him the art of deeply felt naked truth, painting the art of semblance and appearance.[21] In art theory of the period, the qualities that he envisages as distinctively tactile or sculptural would be associated with drawing or design, while those he considers painterly would be thought of as having to do with chiaroscuro and colour effects. Theoretically, his analysis gives sculpture a new priority. It is not just the art where drawing is more important or more fully exposed but is the art that embodies one's basic sense of the shape of things.

One of the more suggestive consequences he draws from his analysis is a point about how painterly looking and sculptural touching define the disposition of the various aspects of what one apprehends very differently. With seeing, things exist simul-taneously, 'side by side' (*nebeneinander*), with touch they exist 'within one another' (*ineinander*).[22] Herder is implying, very succinctly, something that was to become a central

preoccupation of later phenomenological theories of perception, namely that it is through tactile or kinaesthetic apprehension that we have the most immediate sense of things as existing in an environment surrounded by other things, and of our own existence as bodies immersed within, rather than looking out onto, the physical world.

Herder makes his most suggestive points about sculpture as a particular form of art when he comes to discuss in detail how sculpture demands a different kind of viewing from painting. He explains how we cannot properly see a sculpture for what it is unless we bring to bear in our viewing a felt sense of form. The passage is worth quoting because it offers one of the most vivid evocations of a sculptural viewing anywhere in Western writing about art. Herder begins:

> Let a being who is all eye, indeed an Argus with a hundred eyes, look at a statue from every side – is it not a being that has a hand and at one time touched and at the very least could touch itself: a bird's eye . . . will only have a bird's eye view of this thing. Through sight, we do not apprehend space, corner, disposition, roundness as such, in their corporeal truth, not to mention the essence of this art [of sculpture], beautiful form, beautiful build, that are not a play of proportional symmetry, of light and shadow, but the presentation of tangible truth [*dargestellte, tastbare Wahrheit*]. The beautiful line that here forever alters its course, is never rudely interrupted, never softened untowardly, rolls over the body with splendour and beauty, never at rest, and ever poised to continue fashioning the mould and fullness and soft blown enrapturing corporeality of the body, that knows nothing of flatness, or angles or corners. This line cannot become a plane visible to sight, a picture or an engraving, for it then loses all that is proper to it. Vision destroys the beautiful statue rather than creating it . . . It is impossible then that vision can be the mother of sculpture.

Then he goes on to explain what happens when a viewer truly apprehends this sculptural line, and becomes immersed in a felt engagement with the work:

> Look at this art lover, sunk deep in his unsteady circling of the statue. What does he not do to turn his seeing into feeling, to look as if he were feeling in the dark? He glides around, seeks repose but finds none, has no single viewpoint, as with a painting, because a thousand do not suffice him, because as soon as a viewpoint takes root, the living spectacle and the beautiful round form are dismembered and become a miserable polygon. Thus he glides around – his eye becomes a hand, the beam of light a finger, or rather his soul has a much finer finger than hand and beam of light to apprehend within himself the image that emerged from the creator's art and soul. The soul has it! the illusion is complete: it lives, and the soul feels that it lives.[23]

For Herder, two aspects of sculptural viewing are particularly salient. Firstly, it is a close viewing. This may in practice be had at a certain distance, but involves focusing on various aspects of the sculpture as if one were drawing near it to touch it. Secondly, it is a viewing that is forever on the move, that does not seize on the statue as a fixed form but senses its wholeness as it glides over its surfaces. The time-bound nature of this mode of viewing, its slow probing of form, is something that Herder draws out on a number of occasions, most intriguingly when he is speculating on the origins of ancient

Greek sculpture in the massive cult images displayed in the darkness of an inner sanctuary. He points out how the slow process of feeling one's way around and slowly apprehending these seemingly endless forms in the darkness or semi-darkness would have given them a grandeur that one would never feel when looking at a painted figure, as the latter would be bounded by a frame and could be taken in at a glance. When we apprehend something by slowly feeling it, Herder explains, it strikes us as being larger than when we simply look at it:

> The hand never touches the whole, can never apprehend a form all at once, except for the perfectly enclosed form of the sphere . . . with articulated forms, and above all in feeling a human body, and even with the tiniest crucifix, the hand's touching is never completed, never comes to an end, it is always in a certain sense endless.[24]

Because Herder conceives of sculptural viewing as very different from the simultaneity of painterly viewing – the *coup d'oeil* that takes in the basic parameters of something all at once – a sculptural shape could never for him be assimilated to a single fixed image. It involves a different kind of awareness of a thing that emerges and is given fullness in time. His understanding of the sense of a whole conveyed by sculpture is an ambiguous one. In no way is it to be equated with the clearly defined and contoured shape that plays such an important role in late Enlightenment theorising about art.[25] If anything, this sculptural wholeness is for him the opposite of a clear rational delineation; it is a 'unity', as he describes it, characterised by 'indefiniteness' (*Unbezeichnung*), something in excess of what one can grasp at any given moment.[26] But it is also for him bound up with Enlightenment understandings of truth, being a wholeness that is more solidly grounded than the wholeness of an image, and purged of the fantasies and delusions of mere visual appearances. Like Berkeley, Herder believes that the sense of touch gives us a true, direct sense of the shape and disposition of things in depth, which we can only infer from sight. If for Herder sculptural viewing provides the basis for a firmly anchored sense of things, however, it is also a probing around in the dark, unfixed and changing, its origins submerged in the obscure superstitions of early humankind. This complexity is edited out when he gets down to applying his theory to provide a rationale for the dominant classical sculptural aesthetic of the period.

Herder in the end takes a quite conventional view of the ideal sculptural object. The essence of sculpture for him is realised in the naked forms of the beautiful, finely shaped physique in classical Greek art. He also shares the views of the more formalist classicists of his time about the strict limits to be placed on sculpture by comparison with painting, which he argues for afresh on the basis that sculpture should concern itself exclusively with a felt sense of form, as distinct from the complexities of visual appearances. Thus sculpture has to eschew elaborate composition and painterly grouping – 'in it unity is all and all is unity'. It is an art of centring attention on a single form that a felt exploration can easily probe, in contrast with painting, the art designed to create an elaborate visual array spread out before one.[27] Colour and colouristic effect are excluded because they are not apparent to touch,[28] and any elaborate drapery which might obscure the simple forms of the nude should be avoided.[29] Herder effectively argues for a strict adherence to the conventions of classical antique statuary. The distinctive features of modern sculpture, the elaborations that endowed modern sculpture with its own visual interest

– which were central to the astounding vitality of contemporary sculptural work by artists such as Roubiliac and which Falconet defended – were at best peripheral to, at worst a travesty of the essence of sculptural form.

With the limited direct experience of sculpture that he had, Herder focused exclusively on what he took to be the canonical works of antique sculpture. His analysis of these was not based on first-hand contact with the ancient sculpture then available, but on the modern copies of famous antiques that had been commissioned for Versailles, and on which he took notes during a trip to France in 1769.[30] He did eventually get to Rome in 1788, but this was well after the publication of his treatise on sculpture. At least one can say that he was much more concerned than Lessing with the specificity of sculpture as a concrete art form. Lessing's treatise on the boundary between the visual and literary arts, based on the different treatment of the Laocoon myth in ancient writing and in the famous sculptural group in Rome (fig. 20), was written using an engraving and memories of seeing a cast of the statue in Mannheim. He had in fact taken Winckelmann to task for arguing that a systematic study of classical antiquities needed to be based on first-hand experience of the works concerned.[31]

What imposed the most severe constraints on Herder's conceptions of sculpture was his belief that sculpture, unlike painting, was able to convey a simple feeling for the unadorned body, largely unmediated by art or the play of appearances, and should concern itself exclusively with the task of rendering this human essence.[32] He insisted more than many of his strictly classicising contemporaries that sculpture had reached its apogee with the ancient Greeks, believing that they had been able to realise sculpture in its fullness and perfection because they were directly in touch with the natural naked beauty of the body, and had a more unclouded apprehension of basic human nature than subsequent civilisations. All those distinctive apprehensions and understandings of things particular to the modern world lay, in Herder's scheme of things, in the domain of painting rather than sculpture. He summed up as follows:

> The forms of sculpture are as uniform and eternal as simple, pure human nature [revealed in its greatest purity and fullness to the ancient Greeks]; the forms of painting, that are a register of time [*die eine Tafel der Zeit sind*], vary with history, peoples and times.[33]

Sculpture for Herder was both a much more basic and more innocent art than painting, and touch less subject to a corrupting lust and sensuality than seeing. True sculpture offered up the image of humanity in paradise, before the fall. Painting, the more sophisticated and modern art, was quite different. Rather than giving one the simple objective physical reality of a body, it offered a subjective view of it that could too easily be imbued with feelings of lust and desire. 'Description, fantasy, representation', as Herder put it, 'open up to fantasy a wide field and lure it into its colourful, dusky gardens of voluptuousness.'[34] In other words, sculpture rendered a pleasure of engaging with a body purged of or, as Herder would think of it, prior to sensuality. Herder's innocent sculptural touching was still gendered. He identified a purified desire of one sex for the other, what he called '*Geschlechtsgefühl*', as one of the primary, natural human feelings. This activated and gave warmth to a person's response to the body of someone of the other sex.[35] The implication, which Herder only partly spelt out, was that a man would respond

20 *Laocoon*, first century AD, prior to modern restoration of right arm, marble, height 242 cm (including base), Vatican Museum, Rome

with greater sensitivity to a sculptural representation of a female figure, a woman to that of a male figure. Talking as a man, Herder's analysis effectively gave precedence to the female body as a sculptural motif. This involved a very un-Greek gendering of viewing, as well as an unconscious reaffirmation of the preference shown for the female over the male nude in the artistic culture of the time.

Even taking his theory on his own terms, Herder confined sculpture within very narrow limits in comparison with painting. While he envisaged painting as having to embrace a sculptural, tactile apprehension of form, he took a much stricter line on sculpture. Sculpture, as the more autonomous and purer art, could only successfully render a human figure if its appearance were divested of all painterly effect, while painting, precisely because of its lack of self-sufficiency, was able legitimately, if inadequately, to draw on the resources of the sculptural. Thus Herder insisted that properly seeing a line delineated on a flat plane always brought into play a sculptural sense of line in the round. Commenting on Hogarth's theory of the line of beauty, he wrote:

> all outlines and lines in painting derive from bodies and living life, and . . . if this art only gives the appearance of these in flattened figures, this is only the case, because it can render no more. Its sense and medium, sight and light, militate against any more being given; it struggles with both as best it can, however, in order to raise the figure from its ground and give the fantasy free reign, not so it sees more, but so it enjoys, touches, feels. As a result, no lines of beauty and grace are self-sufficient, rather they derive from, and seek to return to, living bodies.[36]

Sculpture, by contrast, was envisaged by Herder as limited to a felt sense of plastic form, unable to strive beyond this and to activate those optical effects constituting the fabric of visual experience that he confined to the domain of painting. This led Herder to the extreme conclusion that while a painter needed to anchor an apprehension of visual appearances in the tactile experience of shape, a full sculptural mastery of form could in theory be achieved without reference to vision. Indeed, a blind person, he suggested, might be better able to create a fine sculptural shape than someone who was able to see.[37] He saw no need to take account of the fact that subtleties of visual effect play an integral role in the apprehension of sculptural form. In straining his theory to the limits so as to isolate an entirely separate sphere of substantive, felt form for sculpture, he ended up with a strangely dematerialised view of it, one that excluded important dimensions of its materiality as physical phenomenon. This is a move repeatedly re-enacted in later sculptural aesthetics. The more the specificity of sculpture as a non-painterly phenomenon was insisted upon, the emptier, the more disembodied the sphere of the sculptural often became.

* * *

In representing the experience of viewing a figurative statue as entirely equivalent to feeling a living body, Herder occluded another important aspect of sculpture – the disparity between the living being it evokes and its literal identity as a thing made of hard stone or bronze or plaster. He effectively ignored the Pygmalion problem, namely the potential for frustration resulting from the fact that, however convincingly a sculpture might conjure up a warm living body, it remains a cold, inert object. This discrepancy between image and object was seen as a problem posed by sculpture even in antiquity, and it has shadowed most modern discussions of sculpture. Discussions of painting may linger on the trickery and hollowness of illusion, but are not obsessed to the same degree

by the regret that the pleasure of seeing a living presence evoked by a work is frustrated by the inanimate object-like quality of the work of art itself.[38]

Sculpture highlights the Pygmalion problem in two ways, firstly because a sculpted figure exists in real space and thus gives one a more immediate physical sense of a human presence, and secondly because the image of the represented figure is identical to the inanimate mass of the sculpture, so the disparity between the illusion of living flesh and the reality of the inert material is more acute than in painting. By ignoring the object-like aspect of the work of sculpture, Herder left out of account one of the more important factors animating the viewing of figurative work: how the viewer, both frustrated and intrigued by the discrepancy between a suggested live body and the dead medium in which it is realised, is motivated to look harder and focus intently on those features of the work, some of them painterly, that momentarily make the fixed shape seem moving and alive.[39]

Rousseau, in a short libretto he wrote in 1762 called *Pygmalion, a lyric scene* (published some nine years later), gives an intriguing psychic twist to the story by presenting the sculptor's ardent fantasy as blatantly narcissistic. In Rousseau's telling, Pygmalion wishes his marble figure of the beautiful nymph Galatea to come alive so that he could truly love and admire her, but is worried that he would as a result lose one crucial aspect of the fantasy he was currently nurturing. As a living being, she would be separate from him, rather than an emanation of himself in the way that she was as his artistic creation. In the end, however, the dilemma is resolved. When Galatea does comes alive, she steps off the pedestal, touches her now warm flesh and exclaims 'Me'. The sculptor repeats excitedly after her 'Me'. Then she touches one of the inanimate marble statues in the sculptor's studio and exclaims 'This is no longer me'. Finally, she turns to the sculptor, and he seizes her warm hand and places it on his heart. She then utters with a sigh 'Ah! still me', at which point the artist is transported in an orgy of excitement.[40]

Perhaps inadvertently, Rousseau makes an important point here about the narcissism inherent in one's seeing a figurative sculpture as alive in some way. Insomuch as a sculpture succeeds in evoking something living, this happens by way of an enhanced sense of one's own physical presence facing the sculpture.[41] Its momentary resonance is partly an effect of an internalised feeling of being there provoked by its intrusion on one's space. There is simultaneously a narcissistic identification with the imagined figure and a separation and distancing, because the sculpture in the end remains other, not least because it is fixed and inert. This ambiguity can be pleasurable, but it can also be frustratingly elusive and dissatisfying, a point we shall encounter again when we look at Rilke's little parable about dolls and things.

One particularly fully argued and richly invested restatement of the Pygmalion syndrome comes in a treatise on desire by the Dutch philosopher and physiologist Hemsterhuis, published in 1770 at about the time when Herder was writing his essay on sculpture. Hemsterhuis's central point is an almost proto-Freudian one that the main driving force behind human thought and activity is sexual desire, the effects of which are counterbalanced by inertia, which functions in his theory a little like the death drive. It is important to bear in mind, though, that this quasi-libidinal force is characterised by Hemsterhuis as a specifically Platonic desire for union with the other.[42] According to Hemsterhuis, this drive to union is in the end always frustrated, but there are

circumstances which can sustain the illusion that the other is seamlessly integrated with one, namely those of friendship and love. Even with these the illusion inevitably comes to an end, and we then experience a feeling of revulsion. In viewing a sculpture, this dynamic is played out with particular rudeness because the initial illusion is so patently unsustainable:

> When I contemplate some beautiful thing, a beautiful statue, I am in truth only seeking to unite my being, my essence, with this heterogenous being; but after much contemplation I become disgusted with the statue, and this disgust arises uniquely from the tacit reflection I engage in about the impossibility of a perfect union.[43]

His *Letter on Sculpture* published the year before in 1769 is somewhat like Herder's treatise in that its main purpose is not artistic but to analyse the sensory and psychic processes that come into play when apprehending a sculpture. It is more by the way that he gives an account of the rationale governing classical sculptural aesthetics, whose paradigmatic status he simply takes for granted. His point of departure is a general theory which he feels explains what makes a work of art striking or pleasing to us, namely that we take particular pleasure in depictions of figures that 'convey to us the greatest possible number of ideas in the least possible space of time'. This can occur in two ways, either because there is a refinement and simplicity of contour that enable us to take in the form of the figure quickly, or because a skilful use of expressive effect conveys to us succinctly a range of different feelings or passions. These two dimensions to our apprehension of a figure, however, are to some extent in conflict with one another, for 'every passion expressed in some figure or other is going to diminish a little that fine and flowing quality of contour, that makes it so easy for our eyes to survey it.'[44]

Hemsterhuis's perspective is rather like Lessing's in that he believes that all the visual arts, including painting and sculpture, are less effective in conveying passions and feelings and states of mind than poetry. Thus, the visual arts need to focus on perfection and beauty of contour, rather than on expression. It is in this way that they can surpass nature, for in nature

> it would be a very singular accident that so placed a certain number of parts together that there resulted this optimum that I desire, and which is analogous, not to the essence of things, but to the rapport that there is between things and the construction of our organs [of perception].[45]

As sculpture was seen at the time to be an art of form rather than expression, giving prominence to the bounding contour defining the shape of a figure, there are purely theoretical reasons for Hemsterhuis's focus on sculpture. However, when discussing why the imperatives of finely formed shape are more important for sculpture than for painting, he does occasionally show an interest in the actual material make-up of the sculptural object in a way Herder never does. Because of the distinctive hardness of the materials of sculpture, and of the difficulty of working with them, Hemsterhuis argues, sculpture, in contrast with painting, 'is limited naturally to the representation of a simple figure or a composition of a few simplified figures'. He goes on to point out how this imperative is accentuated by the distinctive way in which a sculpture is viewed. Because

a sculpture has to be seen from all sides, excellence and simplicity of contour are particularly important. Added to this is the fact that there is far less scope in sculpture than in painting to deploy those expressive effects that immediately convey a pleasurable complexity of feeling and sensation to the viewer.[46]

For all his interest in the basic drives that animate viewing, Hemsterhuis too arrives at a highly abstract and formalised view of sculpture. In his view, what matters above all in sculpture, and what gives pleasure when looking at it, is the immediate and unobstructed apprehension of its overall shape, made possible by the fine and fluent quality of the bounding contour. This leads him to reassert the very strictest principles of classical aesthetics, excluding from sculpture all the expressive subtleties, the richness and complexity of composition and the dramatic subject matter that were seen at the time to constitute much of the interest of painting. Also, like Herder, he sees sculpture as having reached its apogee in the ancient Greek world, and as being at odds with the spirit of modern times.[47] There are only a few comments that betray an awareness of the practical concessions which might be made so that a work of sculpture could engage a modern viewer's interest. At one point, for example, he observes that a more complex painterly grouping is allowable in sculpture designed for niches, where it will be seen head-on, like a painting or bas-relief.[48]

Hemsterhuis's larger interest in how we apprehend things makes him articulate with unusual clarity one widely held assumption about processes of viewing sculpture that serves to bring into focus the originality of Herder's ideas on the subject. Hemsterhuis envisages the apprehension of a sculpture as being in essence the relatively distant view one has when one sees its overall shape, and when in effect it is configured like an image. It is on these grounds that he sees a more painterly complexity and expressivity as possibly legitimate in small sculptures that one examines at close range, like paintings.[49] Herder takes almost the opposite position. He sees a distinctively sculptural mode of viewing coming into play in the close, almost felt, exploration of a sculpture's surfaces. It is then that it comes alive. This coming alive results not, as in the Pygmalion story, because one's desire for the real body represented in the sculpture fires the illusion of lifelikeness to the point that it momentarily seems real, but because the sculpture is caught up in the ever shifting, living dynamic of one's perceptual exploration of it. Herder, however, does not give thought to those qualities of a sculpture that distinguish it from other objects and invite, indeed compel, one to engage in the close, activated viewing that he describes so vividly, beyond the illusionistic representation of bodily form. To get at such more pragmatic understandings of sculpture in the period, we need to turn from sculptural theory to sculptural practice. I have singled out Canova for these purposes because many contemporaries saw his work as reincarnating a classical sculptural ideal. At the same time, some of the more pure-minded were troubled about qualities in it that they felt to be inherently unsculptural and anti-classical, but that were essential for making the simple wholeness of sculptural form to which they were committed come alive for the modern viewer.

* * *

Surface Values: Canova

Trying to make sense of Canova's Neo-Classical sculpture, and how it relates to new understandings of the sculptural that developed in the late Enlightenment, is important not just as an historical exercise. It has implications for any larger history of modern sculpture, particularly for present-day assumptions about the radical nature of modernist and post-modernist deconstructions of sculpture as a monumental, classicising art. Canova's work is undoubtedly classical in character, but what we mean by this needs to be questioned. As we have seen, it is not at all self-evident that his *Three Graces* (figs 11, 12), for example, is to be seen primarily as a plastic shape disclosing a clear inner unity and coherence to the eye of a disinterested viewer, and thus as constituting a polar opposite to the play of surface in the more decentred forms of twentieth-century work.

Classicism has long functioned in modern discussions of the visual arts to signify the mythic configuration of some stable other to a modern, complex, potentially destabilising art. My claim here is that Canova's work, while playing to classicising understandings of sculpture, engages a viewer's interest partly by undoing them. Indeed, a number of his contemporaries found a close viewing of his work subverted the sense of a secure subjective wholeness they had come to expect from the contemplation of sculptural form.

As we have seen from the commentary on sculpture produced by writers as diverse as Herder, Diderot and Hemsterhuis, at the time when Canova was launching his career, the paradigmatic form envisaged as an object of aesthetic contemplation was antique Graeco-Roman sculpture of a nude or semi-nude figure. Throughout the eighteenth century, the most famous of these antiques (figs 19–21) functioned as touchstones for thinking about sculptural form, and most could be seen by interested art lovers and artists on their Italian tour in princely or aristocratic galleries in Rome and Florence, even if many of these collections were not yet quite public museums in the modern sense.[50]

While Renaissance, Baroque and Rococo sculptors produced independent sculptures to be displayed indoors in a gallery like the most famous Graeco-Roman antiques – most notably Bernini with his sculptures for the Borghese Gallery in Rome – it would be fair to say that the focus of their practice necessarily lay elsewhere, in sculpture designed to fit a larger architectural or decorative schema. So the emphasis on the antique in theoretical discussions of sculpture in the late Enlightenment was not simply a classicising prejudice. It was grounded in the day-to-day realities of how sculpture was being displayed and seen. Most of the large-scale statues presented to be viewed as autonomous works were antique rather than modern – though many of these were so heavily restored that they could almost count as modern creations.[51]

This situation began to shift towards the very end of the eighteenth century, and the artist more closely associated with this shift than any other was Canova. While he continued to produce hybrid architectural and sculptural works, such as funerary monuments, he also developed a new kind of practice centred on the production of independent, free-standing ideal figures after he established himself in Rome in the 1780s. That these works were so evidently classicising and often presented as variations on some well-known

antique figure was not just a matter of classicising taste but also of the context in which such work was viewed. Some of Canova's most prestigious commissions came from collectors who actually displayed his works as part of their collection of antique sculptures.[52] This is not to deny a specifically modern taste for Canova's work, and the existence of patrons, like Sommariva, who would display it in elaborately designed, fashionably 'moderne' Neo-Classical settings.[53]

The shift towards the production of work designed to be looked at closely as a self-contained art object[54] was not in the long term, however, an entirely liberating development. Certainly, in the late Enlightenment and early nineteenth century, sculpture attracted an unusually high level of interest, and sculptors were impelled to try out new forms of work, almost all destined for private, and sometimes custom-built, settings. The innovative impulse did not last long, however: the new public conditions of display in museums and exhibitions and the new conditions of the art market in the end put sculpture at something of a disadvantage compared with painting. As time went on, a growing anxiety was voiced by critics and theorists that sculpture was inherently problematic in a modern-day context, and that it was constrained by classicising imperatives that made it less immediately appealing than the more modern art of painting. It is true that sculpture on anything like an ambitious scale could hardly emulate the status of the easel painting as a portable and marketable commodity.

Canova, coming at the beginning of this change, was able to work inventively both with and against the abstract classical ideal that came to weigh so heavily in nineteenth-century conceptions of sculpture. His work without doubt is possessed of a vividness and complexity that matches the finer creations of earlier sculptors such as Bernini. Before going on to explore the mixed reception his work was accorded, and the dismay of some of the more classicising theorists who were disturbed by its wayward transgressions against their purist conception of sculptural form, I wish to say a little about an issue that came increasingly to make free-standing sculpture seem problematic by comparison with easel painting – the question of how to produce a sculpture that would set in train a viewing which undid the literal fixity and inertness of shape resulting from its being a solid thing rather than a painterly depiction.

There are two features of Canova's work that deserve mention in this respect. One concerns the staging, or the situating and pose of the figure, and one the treatment of surface. In each case the activation of sculptural form is pushed to lengths that in the end displeased many of Canova's more purist contemporaries, testifying to a consciousness on Canova's part that in the current circumstances a sculpture would seem dead and inert unless extreme measures were taken to enliven the viewer's engagement with it. He had to develop, within the confines of the new classicising aesthetic, means that would emulate the obvious – and for the period eye, far too obvious – painterly and expressive devices used by Baroque and Rococo sculptors to animate their work. In both the staging of his figures and in the way they encourage a close viewing of their subtly animated surfaces, there is an intriguing double-take between an invitation to the calm, disinterested contemplation that classicising aesthetics took as the norm for sculptural viewing and a blatant theatricality and erotically charged sensuality.

The distinctive forms of staging exploited by Canova could not exactly be characterised as what we today call installation. Although a number of his works were placed in

21 *Venus de' Medici*, first century BC, marble, height 153 cm, Uffizi, Florence

elaborate, custom-built settings, and though he sometimes made unusual provision for devices that would allow a sculpture to be rotated on its base, the general format of presentation he favoured was fairly standard. His free-standing sculptures were designed to be seen raised up three feet or so above ground level on quite a substantial, often elaborately decorated, pedestal, which would supplement the relatively modest marble stand incorporated in the statue.[55] Displayed in this way, the sculpture simultaneously occupied the same space as the viewer and was also set a little apart. Such a mode of installation, framing and giving a certain basic inflection to the viewer's interaction with a statue, remained the norm for the display of gallery sculpture well into the twentieth century. What was particularly distinctive in Canova's case was the intricately contrived stance of his figures, and the way their address or self-presentation made them relate to a viewer in complex ways.

The antique Graeco-Roman statuary which stood as the norm for sculpture at the time was seen to differ from Baroque sculpture because of its untheatricality.[56] It seemed to abjure any obvious rhetoric of address to the viewer. To take one example – possibly the single most famous classical female nude at the time – the *Venus de' Medici* (fig. 21) has a clear frontal pose, defining the direction from which it is to be viewed. Yet its look and gesture do not address themselves outwards. The gathering of the hands over the breast, the 'pudica' pose, while ostensibly being a gesture of self-protection, is too indeterminate to articulate at all expressively a withdrawal from the gaze of a possible intruder. This unresponsiveness and independence of any implied outside presence, the poised balance between an inward and outward directedness, is echoed in the turn of the head and in the body's overall stance.

By contrast, in Canova's *Venus Italica* (fig. 22) there is a precision to the look, to the inward clasping of the hands, and to the bend of the body, that conveys a lively sense of the figure responding to a disturbance that has just caught its attention.[57] In other ways too the pose has a definition absent in the antique Venus. The figure is clearly pausing in the midst of striding forwards, caught in an instant of frozen attentiveness. This self-presentation has a certain theatricality, but the theatricality is ambiguous in that the

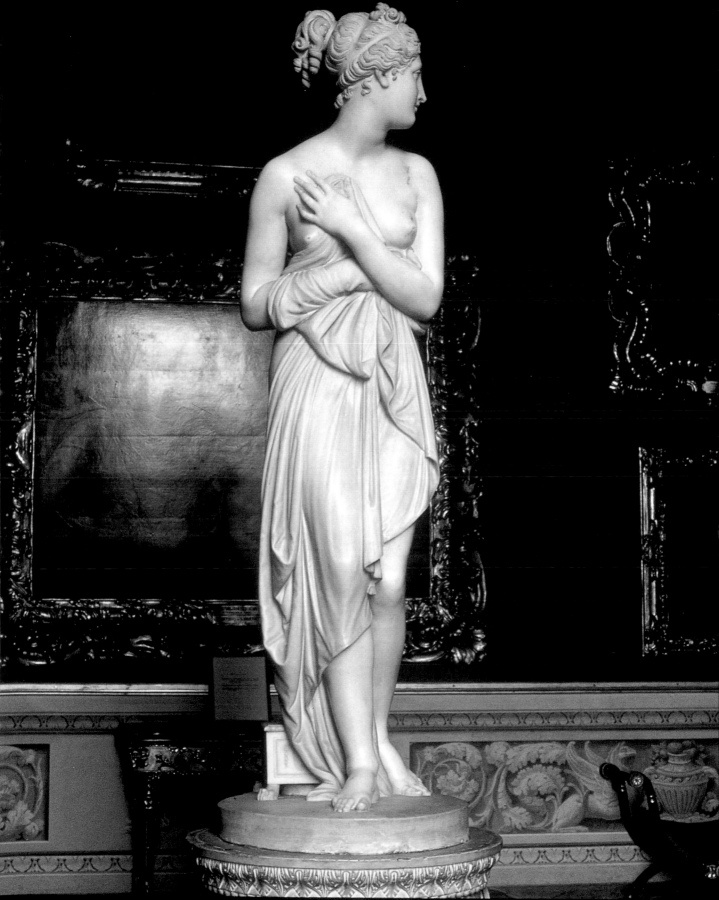

viewer is subtly prevented from seeing the figure as staged for him or her. Its look is directed at right angles to the forward-facing movement of its body, so any implied positioning in relation to it is relentlessly split. Moreover, because it is displayed on a pedestal, its head raised well above eye level, it can never connect with the viewer's gaze. Denied a stable positioning, the viewer is driven to circulate round the statue, forever slightly frustrated in the search for some single stable image in which the figure fully discloses itself.

The unusual refinement and subtlety in the shaping of surface, quite unlike that in any Graeco-Roman sculpture, also functions to activate an unstable and dynamic, rather than a fixed contemplative, viewing. Looking closely at the statue, as one patently is invited to do, is to become engrossed by the vividly sensual impact of the texturing and modulation of individual surfaces, and the contrasts between them – say between the subtly varied smoothness of the flesh and the sharply incised hair, or the gentler undulations of the slightly roughened drapery where the scratch marks left by the rasp are not rubbed away. Even within the exposed areas of the body, there are striking variations between surfaces that are almost devoid of incident, such as the expanse of chest between the shoulders, and intricately shaped features like the face and hands.

The close viewing that the statue invites need not be literally close, but can involve a drifting focus of attention on different areas. It animates what might otherwise seem a static shape by distracting from the overall image that the statue presents, and drawing one into a free-floating engagement with its variegated surfaces and vividly shaped parts. This would have been accentuated at the time by the common practice of inspecting such statues by candlelight and torchlight. Then the illuminated details and surfaces would cease to be anchored within a larger form – the form traced in the outline images found in most prints after Canova's work published in the early nineteenth century.[58]

* * *

The focus on surface was integral to Canova's studio practice. He organised a division of labour whereby the rough shaping of the marble from a full-size plaster model would be done with mechanical aids by assistants, ensuring that his involvement with the carving was concentrated on the final rendering of surface. He executed the last details of the marble carving in much the same way that a painter would carry out the finishing touches on a large work produced with the help of assistants, but more systematically. Judging from contemporary records, analysed by Hugh Honour in his seminal work on the artist,[59] the subtleties of the surface in Canova's statues were largely if not entirely by his own hand, except for decorative accessories such as caskets or flowers, which would be done by specialists, and the mechanical polishing and cleaning that gave the marble a final added lustre.

Leopoldo Cicognara, a close contemporary of Canova and his principal biographer, emphasised that the sculptor's new practice of employing assistants to 'reduce the block [of marble] to the last stratum of the superfices' using a full-scale model in no way meant that the marble was simply a mechanical repetition of the model. The sculptor himself, Cicognara explained,

always applied himself to putting the final touches to his works, giving to his marble a softness and delicacy of contour, a minute accuracy of expression, for which we look in vain in the work of others. Indeed, the great superiority of Canova is more particularly seen in the last fine touches of art . . . the last minute and finishing touches are those which require the highest powers of the artist . . . [60]

Contemporary commentaries on Canova's work often drew attention to the virtuoso refinement of the carving, whether they took a positive or negative view of this animation of plastic form. It was largely among later anti-classical writers that the misapprehension arose that Neo-Classical sculptors such as Canova confined their intervention to the clay model and left the execution of the marble to assistants using a pointing machine. Critics of the time, by contrast, often drew attention to the vivid sensuality of the surfaces and the virtuoso execution that seemed to overcome any sense of laboriously carved stone, as in this comment by Cicognara. He was praising one of the sculptor's more graceful male figures that represented not just a desiring but thoroughly desirable, naked adolescent Paris, clasping the prize apple teasingly just above the exposed divide of his buttocks:

All the senses are delighted in a way that is easier to experience than describe. . . . the chisel is the last tool that comes to mind, for if statues could be made by caressing marble rather than by roughly carving and chipping, I would say that this statue has been formed by wearing down the surrounding marble by dint of kisses and caresses. [61]

Canova's preoccupation with enlivening the surface extended to the disputed practice of treating the flesh areas with wash to give them a slightly yellowish, more flesh-like tint. Melchior Missirini, Canova's secretary, described an incident that shows that the sculptor was perfectly well aware of the quasi-painterliness of the effects he was creating. After applying a tint of *acqua di rosa* to a finished figure, Canova apparently commented on the effect this produced as follows:

See how it is more beautiful and more brilliant. Well now I shall make use of the rasp in such a way that I shall manage to achieve without colour the very effect of colour and make it [the statue] more beautiful and more brilliant than it is as you see it now, even though afterwards it will be white. After speaking thus, he returned to work on it carefully with his tools and suffused it with that inspiration which is felt in the heart, and caressed it to such an extent that with his rasp he made a painting of it, to the point that through his rasp work it acquired the splendour and greater lifelikeness that it first had with the aid of that gentle rose tint. [62]

This unreservedly positive response to the surface effects in Canova's sculpture was shared even by that doyen of high Neo-Classicism, Quatremère de Quincy. [63] But the younger generation of classically minded critics were more dubious, and often went so far as to argue that these seductions were antithetical to the austere essence of sculpture. When Canova was introduced to the post-Revolutionary French artistic public with a display of several major sculptures commissioned by French patrons at the 1808 Paris Salon, Landon, one of the more ubiquitous figures of the art publishing world in Napoleonic France, warned young sculptors not to be taken in by the superficial appeal of Canova's

23 Antonio Canova,
Hebe, 1816–17, marble
and gilded bronze,
height 166 cm,
Pinacoteca Comunale,
Forli

work, stressing that it had not 'seduced those people of severe taste' like himself. What he and several other French critics particularly objected to was the colouristic effect of the fine finish of the marble, as well as the literal polychromy, both the tinting with wash to enhance the differences of texture between flesh and drapery and the use of metal accessories, as in the *Hebe* (fig. 23).[64]

When Canova made a later appearance at the 1812 Salon, Landon took a more positive view, but he still voiced a certain unease. Canova's works, as he put it, with their 'gracious' facility and distinctive 'seductiveness' of style, 'do not tend to return sculpture to its primitive simplicity and grandeur'. At the same time he did admit that the 'delicate sensations and softness and seductiveness' represented a 'new departure', and that these refinements enabled one to turn a blind eye to the deviations from strict sculptural form and 'should disarm the most severe censor'. This view of Canova became very much the norm in the nineteenth century.[65]

* * *

Such misgivings expressed about Canova can show more sensitivity to the distinctive qualities of his work than the often rather indiscriminate celebrations of it as a return to the classical simplicity of ancient sculpture – a point which will become clearer when we turn to the severest, and yet in many ways most illuminating and thoroughgoing, analysis of Canova's sculpture in the period by the German critic Carl Ludwig Fernow. But first it is important to address the ideological and sexual anxieties fuelling the widespread unease being expressed that Canova cultivated a feminised grace and seductiveness at the expense of a true male austerity and simplicity of plastic form.

As we shall see, some of this talk articulated a concern that the unstable viewing which his work incited and its surface sensuality worked against the clearly defined, stable sense of wholeness that his critics expected of a classical sculpture. This wholeness mattered because what was at issue was not only artistic form but also the subjective self-awareness being activated. The unease also had more particular inflections, however. Firstly there was a concern that Canova was corruptly feminising sculpture through the refinements and sensual appeal he cultivated in his work, and secondly a dismay over those disturbingly violent images of masculinity he did create, most notably the over life-size male figures conceived in the mid-1790s, of which the eleven-foot sculpture of *Hercules and Lichas* (figs 24, 25) is perhaps the best known.

Canova's statue represents the power of a male figure not as heroic but as brute and blind physical force that is out of control. The raw violence makes the drama in the antique statue *Laocoon* (fig. 20) seem quite composed in comparison, as if that does really embody the 'noble simplicity and still grandeur' Winckelmann saw in it.[66] Hercules is shown at the moment just before his death, when the robe poisoned by the centaur Nessus' blood sent to him by his deserted wife, Dejanira, is eating into his flesh, and the unbearable pain is driving him mad. He has just caught sight of Lichas, the hapless bearer of the source of his torment, seizes hold of him in a blind fury, twirls him round his head and, according to the story told in Ovid, hurls him far out to sea and with such force that Lichas' body turns to stone.

This eruption of uncontrollable, yet momentarily intensely focused, physical violence follows a strong current in Greek and Roman mythology and writing, one that fascinated a number of Renaissance and Baroque artists such as Rubens, but was largely omitted from the Neo-Classical image of antiquity that prevailed in Enlightenment and in most Romantic attitudes to antique art (though we do see some echoes of it in painting, by artists such as Girodet and Fuseli). *Hercules and Lichas* presents the figure of an ancient hero devoid of suggestions of ethical depth – though we need to be aware that a contemporary Neo-Classical sensibility could rescue something of the conventional image of heroic composure even from this work. Countess Albrizzi, for example, was struck by the way that Hercules' distorted features, in comparison with Lichas's expression of sheer terror, 'preserve that dignity of aspect which the great masters have always observed, even in depicting the severest bodily or mental suffering'.[67]

The subject was not one plucked out of thin air. Stories about Hercules seized by destructive convulsions of madness were something of a preoccupation of Canova's. In the late 1790s, when he was working on the full-scale model of *Hercules and Lichas*, he sketched a small group of Hercules slaughtering his wife and children in another fit visited on him by the goddess Hera.[68] But, more importantly, Hercules had become

24 Antonio Canova, *Hercules and Lichas*, 1795–1815, marble, height 335 cm, Galleria Nazionale d'Arte Moderna, Rome

a potent political image at the time. Traditionally deployed as a figure of the all-powerful monarch, Hercules had recently acquired a new significance as the image of the people in French Revolutionary iconography.[69] This political impetus necessarily worked in complex ways in Canova's case since he was hardly sympathetic to the cause of the

25 Antonio Canova, *Hercules and Lichas*, side view

French Revolution. He had been deeply disturbed, both personally and financially, by the effects of the French invasion of Italy in 1796–7, one result of which was the termination of his contract with the Neapolitan nobleman who had commissioned *Hercules and Lichas*.[70]

Clear evidence shows, however, that Canova, when seeking to find a new destination for the statue – possibly the most potent and sublime image of Hercules to be produced in the period – was far from being blind to its political resonances. These seem to have come into focus for him as a result of the responses of some French soldiers of the invading army when they saw the full-size model in his studio in Rome. Canova suggested in a letter that the sculpture, a massive and costly work for which he had already acquired the marble, but which no longer had a buyer, might be used for the monument proposed by the city of Verona to celebrate one of the few Austrian victories over the French that took place in April 1799. He saw fit to strengthen his case by referring to the French soldiers' reading of the statue as the symbol of the people triumphing over tyranny. The twists and turns of Canova's propositioning are fascinating, and symptomatic of the way in which counter-revolutionary politics so often fed directly on the intensified political awareness generated by the French Revolutionaries. Canova's letter to Count Roberti, who was acting as intermediary between Canova and the Italian authorities interested in erecting a monument to Francis I, reads as follows:

> You already know that at Rome I was working on a group representing 'The Maddened Hercules who cast Lichas into the Sea' . . . I do not know whether I have ever told you the little story of some Frenchmen concerning the sculpture. These [men] said that such a work would have to be set up in Paris, that the 'Hercules' would have been the 'French Hercules', who throws monarchy to the wind. You know very well whether I would ever have adhered to such an idea for all the money in the world. But now could not this 'Hercules' perhaps be the inverse of the Frenchmen's proposition? Could not Lichas be licentious liberty?

The idea as relayed by Roberti apparently met with the approval of the Verona council, possibly eager to establish their loyalist credentials with the Austrians, but the Austrian court, on receipt of the proposal, decided that erecting a monument of this kind in such a moment of extreme political instability was not appropriate. The commission was cancelled, ostensibly on the grounds that an elaborate monument would represent an excessive drain on the city of Verona's resources, at a time when it was struggling to recover from the effects of the recent military campaign.[71] The political trajectory of this statue is telling – initiated under the *ancien régime* with a commission from an Italian aristocrat connected to the Bourbon court in Naples, it enjoyed a brief career as a political symbol during the Revolutionary and Napoleonic wars and was finally acquired in the early years of the Restoration by the Roman banker Giovanni Torlonia, who installed it as a prize item of his private collection in a specially designed gallery in his palazzo in Rome.

How does it work as a sculpture? Unlike Canova's better-known female figures, it presents the viewer with a single, clearly defined shape when seen in profile from what is obviously the principal viewpoint. Was it the case, perhaps, that a sublime, virile figure, in contrast to a female figure, had to assert its solidity and integrity by offering up a more powerfully configured plastic image? But what then motivated the critic Fernow to write of it in 1806, just at the moment when the marble had been completed: 'The group, as group, presents no pleasing image; it does not offer up a satisfying overview from any standpoint'? Clearly, the psychic and ideological tenor of the work disturbed Fernow in ways he could not quite articulate. At the same time, when he highlighted

the failure of the statue to disclose itself properly from any one position, he was describing accurately what happened when a viewer moved from the distant side view (fig. 24) – the main profile view the statue would have offered someone approaching the rotunda where Torlonia later installed it – and came in closer to get a better look at the details: there the viewer would find that he or she was forced to move round it to see these properly, a viewing this later installation also allowed for by creating a space around the statue.[72]

Seen close to, the pose does become significantly less stable than it seems from the clear image presented at a distance. Hercules is gripping Lichas to swing him round his head, not to fling him directly forwards onto the ground. While the bulk of Hercules' body is caught up in an emphatic sidewards movement, the action of his arms and the bent curve of Lichas's body define an arched motion which cuts across this axis (fig. 25). Not only is there a tension between the sidewards lunge that dominates the main profile view and the spiralling action of throwing. The movement suggested by the legs creates yet another axis skewed at a slight diagonal from the main sideways thrust. The result is to break up the clear bas-relief shape one sees from a distance. This is a device commonly exploited in modern sculpture to give a clear accent at the same time as an activating instability to one's viewing of a statue. The much more self-consciously formal work of David Smith, for example, sets up a similar tension between the flattened profile shape cut into space that one sees from afar and the complex internal accents that come into view and prise this shape open as one gets closer and moves round it.[73]

A vivid rendering of surface also comes into play at close quarters, in this case not the gentle modulations found in the *Venus Italica* (fig. 22), but a muscular heaving and swelling. Various features stand out, such as the twisting, deeply modelled curve of Lichas's back, the elastic flexing of the musculature in Hercules' forward-thrust left thigh, the soft swelling of the flesh on his chest where it is compressed by the powerfully raised arm, the firm and finely formed shaping of Lichas's buttocks, each exerting a libidinally charged fascination that can become detached from the impression made by the main action. This experience of the statue's more vivid tactile qualities is accented by some rough edges, the indentations where the poisoned drapery stretches across and eats into Hercules' flesh and creates slight coruscations in the smooth swelling of the muscles, as well as the clutching and grasping and tearing action of the figures' hands, the very antithesis of the gently flowing touching enacted by Canova's female figures. The violence of the overall action, then, is echoed in tactile rips and tears that interrupt and punctuate one's viewing of what at one moment looks like a throbbing expanse of elastic flesh, at another like a heavy rigid pile crashing into one's space.

* * *

For all the disruptions that heroic figures such as *Hercules and Lichas* create, they always present a clearly articulated profile shape on which the viewer can anchor his or her response. The most insistent dispersal of that formal and subjective wholeness then identified with classical sculpture is to be found in a few particularly intricate and complexly modulated female figures, such as the *Hebe* (fig. 23), whose polychromy and novel refinements of surface caused a stir at the 1808 French Salon,[74] and the *Three Graces* (figs 11,

12), but particularly the latter. There, the flowing interlacing of the figures almost defies any impulse a viewer might have to hold on to a sense of clearly configured wholeness. The three figures may be posed so that their torsos open out in one direction, as if to disclose themselves to a calmly stable viewing. The complex intertwining of the legs, and the self-engrossed coupling of glances and gestures, however, actively frustrate this. The suggestion of exclusion introduces a note of self-consciousness, casting the viewer as something of a voyeur. Alternatively, if the dispersed flux of tactile looking the sculpture invites seems perfectly suited to a flagrantly fetishistic viewing of the figures' naked body parts, this too is thrown into disarray by the very profusion of shapes, mingling with and playing off one another.[75]

Like the *Hebe*, the *Three Graces* are on a relatively small scale, the figures slightly less than life-size – just over five feet tall rather than the usual five and a half feet of his other female figures. Seen from a distance, these statues can at moments seem like exquisitely wrought luxury objects, a suggestion particularly strong in the case of the *Three Graces* because of the ornamental composition.[76] The group might almost be an oversize porcelain figurine or the enlarged model for the top of some ornate vessel. This introduces an instability in one's sense of scale – the group can expand, if one moves close, and invade one's whole field of vision with its sensuous modulations and then, as one steps back, contract to being a smallish object easily taken in at a glance, yet slipping from one's grasp. The sculpture seems to be flirting with the fatality that a finely made modern sculpture can so easily be viewed as the exquisite decorative object which at one level it literally is, even if it would be a perversely limited mode of viewing that remained fixed at this level. There is then some logic to critiques of the sculptural refinements of Canova's work as too obviously courting the merely sensory allure of the luxury commodity.

The *Three Graces* postdates the most substantial of such critiques of Canova, the book published by Carl Ludwig Fernow *On the Sculptor Canova and his Works* in 1806. The sculpture that elicited from Fernow his fullest analysis of Canova's undoing of plastic form was the relatively early and somewhat uncharacteristic group *Cupid and Psyche*, finished in 1793 (figs 26, 27). Here we have a complex intertwining of figures that refuses even the provisional stability of outline that the principal view of a statue such as the *Three Graces* offers. Fernow objected to the work on the grounds that:

> one can never arrive at a satisfying view of the work, from whichever side one looks at the group. One has to leap around it, looking at it now from above, now from below, getting lost in the individual partial views, without ever getting an impression of the whole. The viewer is spared something of this trouble because the group can be turned round on its base [there are handles in the marble block for this purpose], but one still seeks in vain for a view from which both figures' faces can be seen simultaneously and where the expression of tenderness will converge. Above all this tower the wings of Cupid, spreading out over the loosely arrayed group that further confuses the eye with the several gaps and openings it offers to the view . . .[77]

Fernow is noticing a distinctive feature of the work. While the figures seem about to embrace, their engagement with one another is a little disconnected. They do not quite look into one another's eyes – certainly Cupid fails to meet Psyche's gaze. The embrace itself is an elusive touching and slipping consistent with the moment in the story of Psyche when she is being revived from a fatal swooning after opening Persephone's jar.

Fernow felt cheated because he was denied a principal viewpoint from which the essence of the gesturing between the two figures could be consolidated in a single clear, graphic image.

A waxy softness of form also bothered him, which reminded him of Bernini's *Apollo and Daphne*. The Bernini group is certainly a comparable display of virtuoso carving which stretches the possibilities of marble sculpture to the limits. Fernow not only objected to what he saw as the excessive refinements of finish, which he felt drew too much attention to themselves, but also took extreme exception to Canova's application of a light yellowish wash and the resulting softening and enlivening of surface. 'This coating', he wrote, 'is designed not so much for purposes of beauty as to lure the art lover's lustful eye, that feels the more drawn to the work and flattered by it, the softer and mellower the material, and the more melting and pale, or if one can put it thus, the more formless the form appears.'[78] For Fernow, the problem was that the sensations generated by looking at the work made him lose any grip he had on the sculpture's shape.

He also had an intriguing response to a very different, more virile statue, which attracted much attention just when his study of Canova came out in 1806, the figure of *Perseus Triumphant* (figs 28, 29). Originally commissioned by a member of the French government in Italy, it was finally acquired by the Pope to compensate for the gap left after the *Apollo Belvedere* was ceded to the French under the Treaty of Tolentino.[79] The first work Canova exhibited after the French occupying force left Rome, it played an important role in securing Canova's international reputation as the leading sculptor of his time. Fernow, however, felt that its success was due to a lack of public discrimination as regards sculpture. In his view, it was a travesty of the antique masterpiece, the *Apollo Belvedere*, with which it was so explicitly inviting comparison. Canova's re-articulation of the pose, which Fernow found unsettling, is elaborate. In place of the antique figure's indefinite gliding, this figure is drawing its striding motion to a halt. Rather as in the *Hercules*, what seems at first sight a clear sideways thrust, parallel with the plane defined by the outward face of its torso, is complicated by divergent accents that break open the apparently flat, clearly bounded shape once one gets close (fig. 29). There is the slightly diagonal movement of the legs, emphasised by the flow of the drapery, as well as the barely perceptible skewed positioning of the two arms.

The root of the problem with the statue, in Fernow's view, its real offence against a true 'plastic sense', lay in its lack 'of unity and definite character'. It presented itself in such a way that, 'as an ingenious connoisseur so aptly put it, one thinks one has seen not one but several statues when one leaves off looking at it [*wenn man ihn verlässt*]'. For him it only had a pleasing effect once one stopped looking at it as a whole and focused on the incredibly finely rendered parts:

> This magical charm of the perfect finish of the dazzlingly pure material is what above all enchants all art lovers, and the eye is still glued to the beautiful surfaces when the higher sense finds itself already disappointed in its expectation of a pure artistic enjoyment.[80]

There is indeed a strong effect of dispersal enhanced by the unusually open spread of the pose, and by the emphatic crossing of gazes. Contemporaries noticed that the head of Medusa became an important focus of interest in its own right,[81] as if possessed of an intensity and beauty which it took all of Perseus's body to balance. Perseus's sword

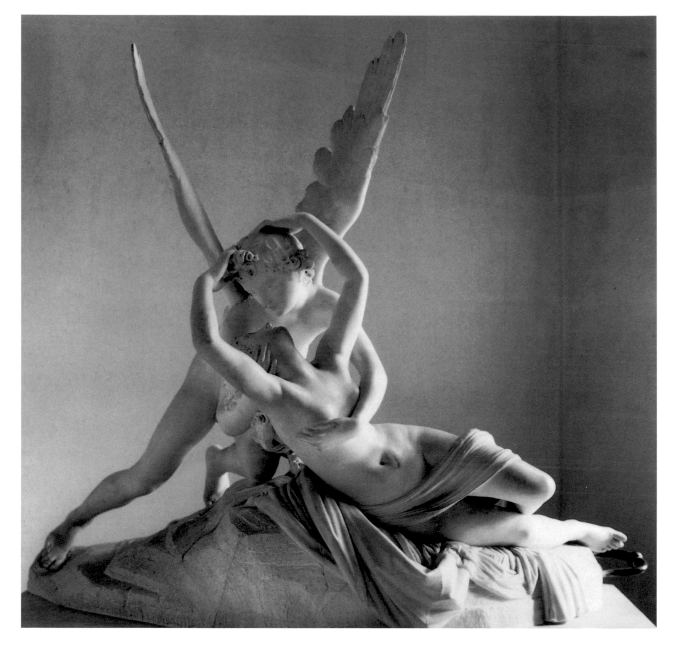

26 Antonio Canova, *Cupid and Psyche*, 1787–93, marble, height 155 cm, width 168 cm, Louvre, Paris

provides another separate point of emphasis, its sharp cutting edge contrasting with the softened expanse of his torso, which in turn has it own psychic charge. The uncompact pose provides a kind of open frame within which these disparate visual and psychic accents play off one other.

In this case, the figure's self-presentation is unusually and flagrantly theatrical. It seems to be putting its finely formed body and its trophy on show – but not quite, for while

27 Antonio Canova, *Cupid and Psyche*, detail

its torso opens out to disclose itself to a viewer placed directly before it, the head looks sharply away, directed towards the other object of one's gaze, the head of Medusa, which if we really caught its eye would turn us to stone. In this way, our looking is simultaneously enticed and deflected, as it is also by the blank wall of soft flesh Perseus's torso presents to us.

<p style="text-align:center">* * *</p>

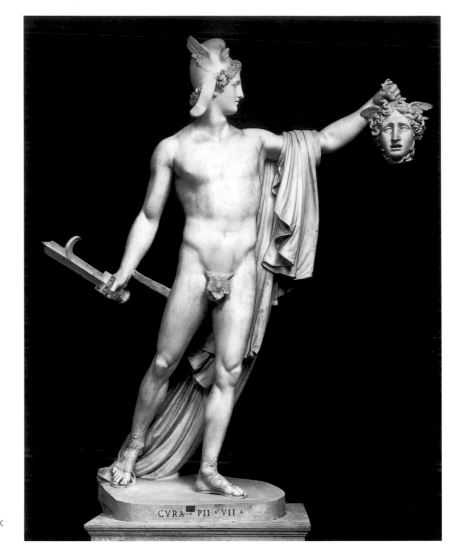

28 Antonio Canova, *Perseus*,
1797–1801, marble, 235 × 190 ×
110 cm, Vatican Museum, Rome

There is nothing of this psychic or visual complexity in the statue by Thorwaldsen that
Fernow holds up as a model of 'true plastic sense', a figure of a striding Jason. The com-
parison was topical because Thorwaldsen had just launched himself into the international
art world in Rome by exhibiting a plaster model of *Jason*.[82] However, the somewhat undis-
tinguished *Jason* largely functioned for Fernow as a foil to Canova's work. What emerges
most clearly from his discussion is the fascination Canova's sculpture exerted for him,
commanding his attention yet subverting what he felt sculpture should be.

Canova's sculpture disturbed him because it made the viewer acutely aware of the
impact it had as sensual phenomenon – both through its physical qualities as marble
object and through the physicality of the naked human presence it evoked. For Fernow,
the essence of a sculpture could in theory be judged from the plaster model and the
internal formal values this embodied, while the sensory effects arising from the render-
ing of its marble surfaces and from its siting in relation to the viewer were marginal.

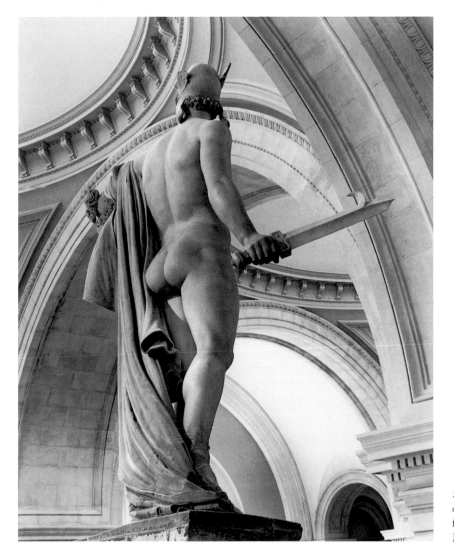

29 Antonio Canova, *Perseus*, detail, from the version dating from 1804–6 in the Metropolitan Museum of Art, New York

Only with work on a very large scale, which might have to be raised up particularly high, does 'the placing [*das Örtliche*] come into consideration', as he put it. He sums up:

> Whether the thought, composition and style of a work, whether the character and expression of a figure are good or bad, must already be capable of being judged on the basis of the finished model and [appreciated] in whatever place the sculpture can be viewed, because those features are not dependent upon characteristics of material or place.[83]

Antique sculpture could function for him, and for other classicising critics, as the model of ideal plastic form because it presented itself as something that seemed to exist independently of the contingencies of one's viewing of it, its significance supposedly fixed by tradition, and by the ideal imperatives of the now lost culture that produced it. The crucial point about the great works of classical antiquity was that they had

not been created to be consumed by a modern art lover. They thus seemed to escape the condition of the modern luxury art object, which had to claim a space for itself and actively seduce the viewer. They could be seen to have a definitive autonomy because their original coming into being was not conditioned by the potentially corrupting demands of the modern art world, even if it was the latter that had singled them out and staged them as things to be contemplated with special attentiveness, prized as models of an ideal art and as images of an ideally composed and perfectly embodied self.[84] This staging itself had a long history, going back in a way to Roman and late Hellenistic times when famous Greek statues began to be taken from their ritual setting and re-presented as prize objects.

What Fernow, like later generations of more or less rigorous aficionados of an ideal classical sculpture, failed to address at all searchingly was why the mode of physical embodiment figured in antique Graeco-Roman statues should be so fascinating. It was simply taken for granted. What fascination a sculpted nude might exert emerges in critiques of forms of sculpture that seemed to disturb or negate this ideal, such as Fernow's analysis of Canova, or the widespread purist misgivings about the more powerfully affecting work of earlier modern sculptors such as Bernini and Michelangelo. The investment in the classical ideal largely defined itself by default, in response to modern practices of sculptural viewing and modern anxieties concerning the status of the art object. Classical statuary seemed so exciting because of the way the purified ideal it intimated emerged from within the disturbances and anxieties that viewing sculpture in the modern world activated.

Such motifs as the icy stare of the beautiful head of Medusa, held aloft by Canova's *Perseus*, or more purely sculptural features, such as the seductive dissolution of plastic form produced by the vivid modulations and sensual fleshiness of Canova's sculpted surfaces, or the intriguing instabilities created by the multiple axes of address of his statues, and their refusal to disclose themselves fully from any one viewpoint, these are the materials on which Fernow's deep investment in a classical ideal feeds, and which animate his viewing of the antique by way of some perversely insistent displacement. For the real threat to his sculptural ideal was the threat of its becoming disembodied emptiness. It was by being embedded in the complexities of a modern sculptural viewing that his purified viewing of ideal sculptural form came alive, complexities to which Canova's intriguing yet questionable sculptural objects appealed so flagrantly.

This brings me back to Thorwaldsen who, like Canova, catered to the international sculpture market in Rome and who came to represent for many in the nineteenth century a less self-consciously staged, less superficially alluring, less *moderne* and more truly plastic form of sculpture than Canova. Put this way, Thorwaldsen emerges as the boring normative other to Canova, a sculptor of inert plasticity, of suppressed and faux-naif eroticism. But this does not quite do justice to the ways in which he too played to a modern sculptural sensibility. In a sense, he was just as unclassical as Canova. His work, like Canova's, testifies to the need for a modern sculpture to stage itself and actively engage the viewer's attention.

If we look closely at a work like the very popular *Shepherd Boy* (fig. 30), the model for which was completed in 1817,[85] we become aware of a certain self-consciousness in the posing of the figure as autonomous and self-absorbed. While Canova's figures

teasingly present themselves to a viewer, affirming their physical and erotic presence, Thorwaldsen's are insistently withdrawn and absorbed in their own world. They exist in the affective atmosphere of an inwardly sunk, distracted gaze. Theirs is a sentimental autonomy, not the autonomy of an unproblematic 'thereness'. In the *Shepherd Boy*, the delicately curved torso seems to be devoid of self-sustaining impulse, the limbs are limp, in a kind of peaceful arrest that nothing for the moment is going to disturb. As object, the sculpture is somewhat delicate and fragile, and it does not hold itself up very well if one looks to it for a solidly configured structure in the round.

The slightly schematic finish may be a little a-sensual, but the smoothness and stoniness are not just a negation of Canova's enlivening of surface. They create their own distinctive effect, inviting an uninflected viewing that would be disturbed by any too vivid detailing. There is an apparent clarity to the smoothness, but also a certain blurred indeterminacy that keeps its charm provided one does not probe too insistently – that is, provided one remains absorbed in a vaguely unfocused looking, a little like that which the figure's own gaze and light touching of itself enact.

Whereas Canova's figures are presented in such a way that a viewer becomes conscious of their sensual presence, and often also con-

30 Bertel Thorwaldsen, *Shepherd Boy*, 1822–5, marble (from plaster model executed in 1817), height 148 cm, Thorwaldsen Museum, Copenhagen

scious that they seem aware of being looked at and admired, Thorwaldsen's are staged so as to block any such explicit awareness. His work encourages the viewer to disavow the pleasures he or she takes in looking intently at a beautifully formed, and partly available, naked body. With both sculptors, there is a kind of dissolution of one's sense of the sculpture as an articulated whole, in Canova's case through the intensity and multiplicity of sensuous engagement his work invites, in Thorwaldsen's through a kind of distracted fascination, a strange, erotically suffused unfocusing. For this to engage the viewer, though, some hints of disturbance are still necessary.

In the case of the *Shepherd Boy*, the animal attentiveness of the dog offers some intimation of the suppressed charge that might animate one's viewing. But it is in another equally popular work conceived at about the same time that this possibility of disturbance is more pointedly thematised, the Jupiter and Ganymede group (fig. 31). Here again

31 Bertel Thorwaldsen, *Ganymede with Eagle*, 1817, marble, height 93.3, width 118.3 cm, Thorwaldsen Museum, Copenhagen

the figure of Ganymede is delicate, dreamy, self-engrossed, narcissistically withdrawing into itself, rather than presenting itself to the viewer and the eager eagle. In stark contrast to it, the heavily feathered, sharp-beaked bird looks intently into the bowl, but even more intently beyond the bowl at Ganymede's beautifully formed body, in particular at his genitals, which we are blocked from seeing.

In a moment there will be a violent explosion of sexual energy, that will assault the seemingly innocent figure, poised there as the passive object of we do not know how many admiring gazes. Or is the situation going to resolve itself in this way? Might we not be caught up in a closed round of viewing from which no one, not Ganymede or the eagle or ourselves, can be extricated? This is a sculpture, after all, it does not move. More-over, if we think of the classical story, this could be Ganymede calmly offering Zeus a draught of nectar in Olympus after he has been transported there, playing his role as cup-

bearer to and favourite of the gods. This makes the stony delicacy of his sculpted form entirely appropriate, as well as the perfectly poised and very slightly tense interplay of looking and being looked at that the sculptural group enacts. Thorwaldsen as sculptor half knew what he was doing, was at some level aware of the complex impulses that viewing such a sculpture activated, of how it needed not only to evoke but also to frustrate fantasies of classical wholeness and ideal plasticity if it was to sustain a viewer's interest. This is another way of saying that he was a modern sculptor, that he no more than Canova worked outside the tensions generated by modern practices of sculptural viewing and the shifting and at times destabilising subjective awareness and desiring these involved. His work, being less self conscious in conception than Canova's, however, was more likely to hold a viewer in thrall to its superficial appeal as finely made precious object or erotically charged image. Canova played more freely and intriguingly with the disturbances and fascinations of a distinctively modern engagement with sculpture that was beginning to define itself in the aftermath of the French Revolution.

32 Auguste Rodin, *Iris, Messenger of the Gods* (1890–1, bronze, 95 × 87 × 40 cm) with the *Gates of Hell* in the background, photographed in Rodin's studio by Druet

The late nineteenth and very early years of the twentieth century marked a moment of intensive yet ambiguous re-engagement with the sculptural. A crucial element in this enlivening of discussion around sculpture was a shift away from the assumption that free-standing work was of necessity classical. Sculpture, sidelined in earlier debates about art and modernity, or at best standing as the model for an ideal that modern painting was defining itself against, now became embroiled in speculation about a modern visual imagination. The sculpture of Rodin played a key role in this development, particularly in the years around 1900 when he began exhibiting fragmentary large-scale figures that seemed to challenge inherited notions of classical wholeness, and set up a more immediate and open encounter between viewer and work. The two essays by the poet Rilke published in 1903 and 1907 are the most intensely wrought and dense of these speculations about the modernity of Rodin's work. They are so by virtue of engaging with what was distinctively sculptural about it, rather than simply seeing his figures' fluidity of form, or their representation of restless movement, as vaguely expressive of a modern spirit.

The sense that a new sculpture was emerging which spoke more eloquently to a modern imagination than the classicising figures dominant in previous free-standing gallery work did not bring an end to certain deeply ingrained attitudes that sculpture was of its very nature not so in tune with a modern sensibility as painting or music or poetry. Rodin himself would sometimes be drawn into reiterating the view that ancient Greek culture had been the natural cradle of sculpture and had created works of unsurpassable beauty. 'There was', as Gsell quoted him saying, 'a perfect harmony between thought and matter animated by thought. The modern spirit, to the contrary, disrupts and shatters all the forms in which it is incarnated.'[1]

A perception that sculpture was inherently problematic by comparison with painting received a new impetus from the formalist theory of the visual arts emerging at the very moment of this renovation of interest in the sculptural. The ramifications of this development will be explored in the next chapter, where we shall be considering the formation of a modernist sculptural aesthetic that in the first instance defined itself in opposition to the kind of modern sculpture associated with Rodin. Within this modernist or proto-modernist framing, the essence of sculpture came to be located in its rendering of plastic form. Just as the sculptural embodiment of the classical ideal was in many instances a painterly fantasy, so too the sculptural realisation of pure plastic form as imagined in early formalist theory was largely structured by a painterly aesthetic, as we can see in the German sculptor Adolf von Hildebrand's influential treatise *The Problem of Form in Figurative Art*, published in 1893. The problems Hildebrand faced as a practising sculptor negotiating this situation, at some level seeking to legitimise sculpture by assimilating

it to the formal logic of the latest painting-based aesthetic, and at another vividly aware of those aspects of the viewing of sculpture that disrupted a purely painterly apprehension of artistic form, makes his analysis particularly fascinating and significant.

Sculpture and Modernity

We now need to consider for a moment the perceptions of the situation of sculpture prevalent in the mid- to late nineteenth century against which, and also partly out of which, the new engagement with the sculpture of artists such as Rodin developed. To this end I shall be focusing on two particularly eloquent discussions of sculpture. Firstly, there is Baudelaire's direct confrontation with the problem of sculpture in his essay 'Why sculpture is boring', from his review of the 1846 Salon. Secondly, there is Walter Pater's slightly later, more theoretical and cultural, historical analysis of the situation of sculpture in his book *The Renaissance: Studies in Art and Poetry*, published in 1873. Pater offers one of the most intriguing formulations of a paradox lodged in conceptions of sculpture at the time, asking how an art form seemingly inherently at odds with a contemporary sensibility might nevertheless affect and fascinate a modern viewer.

That sculpture did not come over as effectively in the modern museum or art exhibition as painting had become something of a cliché by the mid-nineteenth century, summed up nicely in the Daumier caricature, 'Sad countenance of sculpture in the midst of painting' ('Triste contenance de la Sculpture placée au milieu de la Peinture'; fig. 33). Sculpture was usually displayed separately from painting in the lower, darker areas of a gallery or museum, as at the Paris Salon or the Royal Academy summer exhibition. Comments were often made about how the art-going public tended to ignore the display of sculpture in favour of the more exciting, and excitingly installed, paintings in the airier galleries above.[2] A reviewer of the 1844 Royal Academy exhibition commented:

> All those who have visited the . . . Exhibition may not be acquainted with the den in which British Sculpture is confined, for the chamber being on the ground-floor, it is often overlooked by persons who are unconscious of its existence; others postpone their visit until the upper-floor rooms have been examined, and then find themselves too much fatigued to enter another apartment. Our sculpture, therefore, is likely to continue, as it has long been, a thing of nought in public estimation.[3]

Baudelaire's comments on sculpture in his review of the 1846 Salon come almost as an afterthought to his discussion of painting. He begins by making the point that the literalness which distinguishes sculpture from painting makes it a more basic and archaic form of art. A sculpture, he explains, is a palpable thing that even the most untutored can seize upon and marvel at. Painting, by contrast, is possessed of a 'singular mystery that cannot be touched with the fingers'.[4] This means that a work of sculpture disrupts the more sophisticated viewing habits that painting demands and therefore frustrates the visitor to a gallery who is attuned to seeing a work of visual art as the imaginative projection of the artist's vision of things:

> Sculpture has several drawbacks that are a necessary consequence of its means. Brutal and positive like nature, it is at the same time vague and eludes one's grasp, because

SALON DE 1857 . 5

Triste contenance de la Sculpture placée au milieu de la Peinture .

33 Honoré Daumier, *Salon of 1857*, 'Sad countenance of sculpture in the midst of painting', 1857, lithograph

it presents too many faces at once. It is in vain that the sculptor strives to put himself at the service of a unique point of view; the spectator, who revolves around the figure, can choose a hundred different points of view, except the right one, and it often happens, which is humiliating for the artist, that a chance illumination, an effect of lamplight, reveals a beauty which was not the one he had thought of. A painting is only what he wants it to be; there is no way of looking at it other than in its own light. Painting has only one point of view; it is exclusive and despotic: and so the expression a painter can command is much stronger.'

For Baudelaire, a free-standing sculpture is problematic not only because it elicits a less focused, less imaginative mode of viewing than a painting, opening itself up much more than a painting to the physical contingencies of its conditions of display. It also suffers because it too easily becomes indistinguishable from a luxury object. In earlier societies, sculpture had a setting and ritual significance that made it appear to be something special. Nowadays, displayed as an object in a gallery, it is denuded of that imaginative resonance. It can only distinguish itself by a trivialising perfection of execution that makes it approach the condition of the primitive fetish but without the magic – only the fake allure of the modern commodity.

To become obsessed with fabricating physical objects in the way the modern sculptor has to, 'industriously to carve portable figures' as Baudelaire put it, is to return sculpture to its original barbaric destiny, before it was elevated into grand architectural or painterly ensembles, such as the medieval cathedral or the Baroque garden:

> As soon as sculpture consents to being seen from close to, there are no minutiae and puerilities which the sculptor won't hazard, that surpass victoriously any ritual pipe or fetish. . . . [Modern sculptors would] voluntarily transform the tombs of Saint-Denis into cigar boxes or cashmere shawls, and all the Florentine bronzes into two-penny pieces.[6]

Such unease over the status of the sculptural object in the modern world, no longer anchored in religious belief and ritual, and now merely an object to be looked at, goes back at least to the moment when public museums of sculpture were being formed at the beginning of the nineteenth century. The German archaeologist Carl August Böttiger, writing in an essay on antique sculpture published in 1814, traced the origins of the degraded function of classical sculpture as objects displayed in a museum to the excavations carried out by Leo X in Rome:

> So begins the last period of old art works, when they were simply brought together and taken into custody to be put on display . . . And that is their third and lowest function, of which the great creators of these works of art and even their imitators, and the imitators of these imitators, would never have conceived.[7]

Baudelaire is very much of his time, however, in linking this unease so directly to the commodity status of the art work.

If, in Baudelaire's terms, the context provided by the modern gallery space makes sculpture a trivial caricature of the primitive fetish, then what are the possibilities, if any, for sculpture to acquire an imaginative charge for the modern viewer? This could happen, he suggests, only when the setting of a sculpture allows one to imagine that its literal identity as object is dissolved in its surrounding environment. Sculpture can properly function only as a complementary art, presented as an element within an architectural ensemble, or displayed surrounded by fountains and hedges in a garden setting. In this way it is effectively transformed into a motif within a picturesque scene. Some thirteen years later, in his review of the Salon of 1859, when he tried to conjure up a vision of the potentially 'divine role of sculpture' in the modern world, he envisaged an urban *flaneur* encountering a monument and momentarily seeing it as a strange apparition floating in the sky above the mêlée of the city. Such a sculpture acquires significance, not as an autonomous work of art, but as a found object animated by the fleeting drama of an encounter with it in some particularly evocative context.

It is as a primitive art, however, that the idea of sculpture has the most intense resonance for Baudelaire – as that 'singular art which buries itself in the shadows of time, and which already in primitive ages produced work that astonishes the civilised mind.' Archaic sculpture achieved a kind of transcendence through its magical negation of the inherent limitations of sculpture as material object. 'As a consequence of the barbaric conditions in which sculpture is trapped', Baudelaire explains, 'it requires, at the same time as a very perfect execution, a very elevated spirituality'. But the imaginative

force that transformed the primitive fetish is lacking in the case of modern sculpture. Nowadays we have only the numbing spectacle of the 'monotonous whiteness of all these large dolls' (figs 14, 17). If we consider how truly difficult it is for sculpture to achieve the 'austere enchantment' that brings it alive, Baudelaire continues, 'we will hardly be surprised by the fatigue and discouragement that often seizes our mind as we wander though the galleries of modern sculpture, where the divine goal is almost always misunderstood, and where the pretty, the minute, the flattering are substituted for the grand'.[8] Sculpture for Baudelaire highlights a tension inherent in the status of the art object in the modern world between the ideal of a true work of art whose imaginative power would seize us the moment we set eyes on it and its trivialised existence as mere item of display or commodity.

* * *

Walter Pater offers a very differently framed discussion of sculpture in two essays in *The Renaissance*.[9] His point of departure is a Hegelian theory of the nature and status of the different arts, elaborated in a chapter on Winckelmann, where sculpture is defined as in essence a classical art that was the characteristic product of ancient Greek culture. Then, in a short essay on Luca della Robbia, he considers how modern sculpture, in particular the sculpture of Michelangelo, was able to negotiate the distinctive limits within which it had to operate. In the latter essay, even the supposed self-contained embodiment achieved by classical Greek sculpture is problematised, with Pater asking how a modern sensibility can see in antique sculpture something more than a lifeless fixing of the human figure in inert and solid form.

In his broadly Hegelian analysis of the ancient Greek sculptural ideal, he argues for the prevailing view that the perfect sculptural embodiment of the human form is a distinctive achievement of ancient Greek culture, the product of a particular moment in the history of human consciousness when the highest aspirations could still find a fully satisfying correlative in the physical image of a beautifully formed body.[10] 'The art of sculpture', as Pater puts it, 'records the first naive, unperplexed recognition of man by himself' (fig. 34).[11] In making the point that the classical sculpture of the ancients was bound up with a naive self-awareness no longer possible in the modern world, Pater is not saying anything particularly unusual or remarkable. But he pushes this analysis further, not just making the point that the more dematerialised arts of painting, music and poetry are better adapted to giving artistic form to a modern self-awareness than sculpture, but going on to ask how, as concrete works of art rather than as ciphers of some lost sense of harmony with the physical world, classical Greek sculptures could strike a modern viewer as compelling.

He starts by setting out the disadvantages peculiar to sculpture. For all its literal concreteness, he claims, sculpture cannot render as convincingly as poetry and painting what for the modern mind counts as human presence:

at first sight sculpture, with its solidity of form, seems a thing more real and full than the faint, abstract world of poetry and painting. Still the fact is the reverse. Discourse and actions show man as he is, more directly than the play of muscles and the

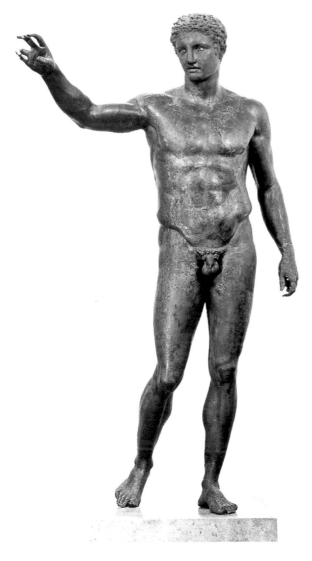

34 *Antikythera Youth*, c. 340 BC, bronze, height 194 cm,
National Archaeological Museum, Athens

moulding of the flesh; and over these poetry has command. Painting, by the flushing of colour in the face and dilation of light in the eye – music, by its subtle range of tones – can refine more delicately upon a single moment of passion, unravelling its subtlest threads.

But why should sculpture thus limit itself to pure form?[12]

The next few pages of Pater's sometimes tortuous discussion present an answer that is much more elusive than the declarative posing of the question suggests. For the most part, his comments about the Greek sculptural ideal, its 'colourless, unclassified purity of life', its being 'the highest expression of the indifference which lies beyond all that is relative or partial',[13] are restatements of the standard idea that classical sculpture represents the human figure purged of the contingencies and particularities of a real body, though he gives it a distinctively negative cast. The figure represented is a figure devoid of passion and character, isolated from any milieu or atmosphere of the kind rendered so effectively in modern poetry and painting, and divested of the perturbations and excitement of sex, even if still in some way sensual. The immediate affective appeal of the physical wellbeing and serenity of mind these works flawlessly embody is an enigma shadowed by emptiness: 'Here there is a moral sexlessness, a kind of ineffectual wholeness of nature, yet with a true beauty and significance of its own.'[14]

For a discussion that engages more with the physical, sculptural qualities of the Greek ideal, we need to turn to other parts of his book. Firstly, there is the famous passage in the conclusion, where Pater represents the modern sense of self as being in perpetual flux, constituted by 'the passage and dissolution of impressions, images, sensations'. In this context, the sharply delineated form of Greek sculpture is far from being a stable essence: 'that clear, perpetual outline of face and limb is but an image of ours . . . is but the concurrence, renewed from moment to moment, of forces parting sooner or later on their ways'.[15] The pure, almost empty forms of Greek statuary take on substance and vitality for the modern imagination, then, not as fixed entities, not as stable embodiments of an ideal self, but as evanescent figures momentarily taking shape in the perpetual flow of

things.[16] Or, to put it a little differently, the classical statue's sharply defined poise acquires intensity only when it is caught up in the unstable dynamic of our modern viewing, in the 'delicate and elusive' 'transition from curve to curve' traced by our look as it glances over the statue's surfaces.[17]

A more fully argued analysis of the problematics of sculptural form is developed by Pater when he considers how Renaissance sculptors were able to exploit a medium that in theory appeared to offer such limited scope for achieving animation, and which did not seem to speak to a modern, or post-classical, sense of self and view of the world. When sculptors like Luca della Robbia and Michelangelo sought in their different ways to 'meet and overcome the special limitations of sculpture', they were facing

> that limitation [which] results from the material, and other necessary conditions, of all sculptured work, and consists in the tendency of such work to a hard realism, a one-sided presentment of mere form, that solid material frame which only motion can relieve, a thing of heavy shadows, and an individuality of expression pushed to caricature. Against this tendency to the hard presentment of mere form vainly trying to compete with the reality of nature itself, all noble sculpture constantly struggles; each great system of sculpture resisting it in its own way, etherealising, spiritualising, relieving, its stiffness, and death. . . . To get not colour, but the equivalent of colour; to secure the expression and the play of life; to expand the too firmly fixed individuality of pure, unrelieved, uncoloured form.[18]

Before considering Pater's conception of the different solutions to the problem of sculpture – the abstract ideality of form of the classical antique, the low-relief system of the fifteenth-century Italian artists and the system of 'incompleteness' developed by Michelangelo – there are other issues raised here that bear dwelling on for a moment. Pater moves beyond a conventional privileging of the painterly by insisting on certain particularities of sculpture, and asking in precise terms what it is about the sculptural fixing of form that constitutes its distinctive limitation. He makes explicit how the very essence of sculpture as commonly understood in eighteenth and nineteenth-century aesthetic theory becomes its most insistent shortcoming, nicely encapsulated in his phrase 'a one-sided presentment of mere form'. Sculpture not only threatens ideal form with a deadening inertness but has an even more destructive hardening effect on realistic detail and individuality of expression. Painting gives visual animation to form through colour and light effects, and through an ostensive rendering of three-dimensional shape, which allow scope for suggestions of movement denied to sculpture. The issue, then, is to identify a sculptural equivalent to these enlivening effects of painterly depiction.

How in Pater's view did Greek sculpture relieve 'the hardness and unspirituality of pure form'? It was through a process of almost paradoxical self-negation. Greek sculpture presented such vivid images of the human figure by purging them of all individuality and of all suggestions of the impermanent and contingent. Ancient Greek sculptures were 'like some subtle extract or essence, or almost like pure thoughts or ideas: hence the breadth of humanity in them.'[19] Pater here abruptly exposes a central paradox lodged in post-Renaissance conceptions of classical form and, more particularly, in the academic classicism shaping attitudes to sculpture in the nineteenth century. The ideal classical figure has to be both vividly immediate as a quasi-human presence, and abstract and

ideal. Pater fleshes out this paradox by indicating how a sculptural figure can captivate the viewer only as something more than an inert and coarsening congealing of living form by not being too literally real. The vitality and the erotically charged fluidity of a human figure cannot be given sculptural shape unless the solid definition of form is dematerialised in some way. While bearing in mind that Pater is concerned with figurative representations, we can recognise in this analysis certain important affinities with the dematerialising imperatives of later modernist theories of the sculptural.

Such ideas are given a more specific and suggestive inflection when Pater goes on to discuss Renaissance sculpture, and spells out in concrete terms how sculptural form, when it comes alive, is not to be identified with the literal shape of the work, but is partly an imagined projection. The sculptural 'system' he sees operating in early Renaissance stone and terracotta work extends the shaping of form in relief sculpture to the rendering of fully three-dimensional effigies, with the literal three-dimensional shape being flattened to suggest a depth that is more ample than the actual depth. In this way the sculpture takes on some of the ostensiveness of a painting. Such a formalising of shape, commonly used by figurative sculptors such as Canova to create an enlivening tension in the viewer's apprehension of a work, was also to be deployed to create a certain dematerialising ambiguity in modernist sculpture such as David Smith's.[20] This low-relief system, as Pater conceives it, not only effects a flattening but also makes the most of the variations of light and shade created by ambient lighting falling on a sculpture's surfaces. An excessively static and solid definition of form, the 'heaviness' and 'emphasis' produced by 'strongly-opposed light and shade', can be avoided by utilising 'the last refinements of shadow', that may be 'almost invisible except in a strong light', to suggest a slight animation and evoke a passing flicker of expression.[21]

It is in his characterisation of the sculptural system he identifies with Michelangelo that Pater offers his fullest discussion of the material particularities of sculpture. He envisages Michelangelo as a characteristically modern artist, reworking the sculptural figurations of the ancients so as to give expression to a modern sense of 'inwardness' and 'individuality and intensity of expression' that could not be encompassed within the antique 'system of abstraction' and pure sense of 'outward life'. But endowing sculpture with a modern expressivity and realism was a difficult matter. It was imperative to avoid the 'too heavy realism, that tendency to harden into caricature which the representation of feeling in sculpture is apt to display.' This Michelangelo did by 'leaving nearly all his sculpture in a puzzling sort of incompleteness, which suggests rather than realises actual form'. The state in which much of his work emerged 'so rough-hewn here, so delicately finished there', in effect constituted a 'perfect finish'. It was his 'equivalent of colour in sculpture', his way of 'communicating to it breath, pulsation, the effect of life'. 'In this way he combines the utmost passion and intensity with the sense of a yielding and flexible life.'[22]

This characterisation could almost be transposed to Rodin's later work – not to the unfinished marbles, with their self-conscious, almost decorative contrasting of rough and smooth textures, but to the later modelled works cast in plaster and bronze, where surfaces suggestive of living flesh are punctuated by the vivid impress of raw or roughly worked clay. The issue here is not just a standard late nineteenth-century privileging of the imaginative resonances of sketch-like or unfinished work. Pater is pointing to a dis-

tinctive tension in Michelangelo's sculpture between areas delicately delineating some aspect of human form and areas of more roughly hewn stone that insistently retain their stoniness. The effect of vitality is then created by making the viewer intently aware of a conjuncture between the actual stony inertness of the sculpture and the evocations of softly modulated flesh.[23]

In Pater's view, then, what makes Michelangelo's sculpture so compelling is the way that the quality of the stone itself, instead of submerging the suggestions of living form in inert materiality, becomes integral to its vital animation. There is of course the problem as to how intentional an effect this was in Michelangelo's case, a problem of which Pater was fully aware.[24] But regardless of the historical judgement one would wish to make about the role played by intentionality or contingency in the different degrees of finish in Michelangelo's sculptures, Pater's analysis needs to be seen as a particularly telling account of the fascination exerted by such unfinish for late nineteenth-century viewers. Pater was giving voice to an appreciation forming at the time for the aesthetic value of incomplete sculptures – and this included not only work by Michelangelo but also unrestored antique sculpture.[25] That a preoccupation with effects of sculptural unfinish was

35 Michelangelo, *Day*, from the tomb of Giuliano de' Medici, c. 1530, marble, length 185 cm, San Lorenzo, Florence

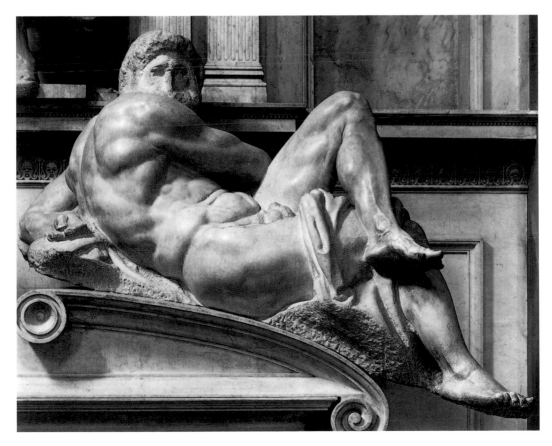

widespread at the time is indicated by Nathaniel Hawthorne's inclusion of a relatively complex dialogue on the subject in his novel *The Marble Faun*, published in 1860, where he specifically cites the 'rough mass of the head of Brutus, by Michel Angelo'.[26]

Pater's analysis of Michelangelo's sculpture culminates in a suggestive passage on the life and death drama played out in his allegories of the times of day (fig. 35) in the Medici Chapel in Florence. In singling out these four figures from the schema in which they are set, Pater is being true to the impact they make when one visits the chapel. Balanced, almost suspended, on the sloping tops of the two sarcophagi in the middle of opposite walls of the chapel, and protruding outwards rather than framed and partially enveloped by a recess – like the much less intensely wrought images of the deceased Medici above them – they are incontrovertibly the most powerful sculptural presences in the space. It is almost as if the whole chapel functions as an arena for them.

In Pater's account, their significance as allegorical figures, forming part of a commemoration of the dead, is played out in their physical sculptural qualities. Their distinctive intensity is generated by the interplay they set up between a sense of hard, inanimate stone and an equally insistent, yet elusive, suggestion of a 'breath of life', partly produced by the passing effects of light and shadow animating the sculptures' surfaces. This is the sculptural correlative of their significance as representations of human bodies that are simultaneously palpable things and elusive, immaterial impulses, tomb figures suspended in a state between inertness and animation, between a drifting into death and an uncertain coming to life. Pater describes how, looking closely at these sculptures, they take shape before one's eyes as a

> dumb inquiry over the relapse after death into the formlessness which preceded life, the change, the revolt from that change, then the correcting, hallowing, consoling rush of pity; at last far off, thin and vague, yet not more vague than the most definite thoughts men have had through three centuries on a matter that has been so near their hearts, the new body – a passing light, a mere intangible, external effect, over those too rigid, or too formless faces.[27]

Pater's distinctive position on the dematerialising logic of a sculpture as it vividly seizes the imagination is imbued with more than a touch of aestheticist idealism and of a symbolist penchant for dream-like states of mind. At the same time, he ponders more fully than almost any of his contemporaries how an intensive engagement with an inanimate sculptural object can make it almost come alive, and how this in turn might echo an enigmatic, and at times disturbing, sense one has of one's own physical existence as solid and substantive, yet also impalpable and dematerialised, presence.

* * *

We come to a very different perception of the significance sculpture might have for a modern sensibility when we move forward to the turn of the century, and consider the new conceptions of a distinctively modern sculpture that Rodin's later work brought into focus.[28] By this point, something little short of a major shift in normative views of sculpture had taken place. When Baudelaire was writing, modern sculpture was still largely felt to be classical, and Rome remained the most important centre for the international

market in sculpture. Indeed, most free-standing gallery sculpture continued to be broadly speaking Neo-Classical in conception. In the later decades of the nineteenth century, by contrast, there developed a growing sense that contemporary sculptors were fashioning a new kind of distinctively modern work. This perception went hand in hand with the idea that sculpture was becoming more accessible, with some critics even taking the view that sculpture was attracting more attention than painting.[29] That modern sculpture was gaining a noticeably higher profile by the 1860s and 1870s can be explained partly by a tremendous upsurge of commissions for public monuments which continued well into the early years of the twentieth century. This stimulated experiments with new sculptural forms that would speak more directly to a modern sensibility, and also provided a financial basis for sculptors wanting to pursue independent experiment. The publicity surrounding such controversial works as Rodin's *Balzac*, Carpeaux's *Dance* and Alfred Gilbert's *Eros* did much to make sculpture a prominent feature of contemporary culture.[30] The display of sculpture also became more spectacular, a development particularly evident in the Paris Salon where the new, more open glass-house-like exhibition spaces encouraged elaborate stagings of work akin to the formal gardens of the Baroque period (fig. 15).[31]

Also important in shifting perceptions of sculpture was the sense that the new sculpture did not stand in such stark contrast to the fluidity and poetic resonance of painting. Modelling was increasingly preferred, which meant in practice that greater importance was accorded work in bronze because it reproduced more directly than carving in marble the forms of the artist's plaster-cast clay model. In fact, much work continued to be executed in marble, and the earlier classical paradigm of sculpture as simplified plastic form continued to hold considerable sway. It is still the case, though, that by contrast with the situation in the early and mid-nineteenth century, when leading sculptors such as Thorwaldsen (figs 30, 31), Gibson and Pradier (fig. 14) worked primarily in marble, towards the end of the century the pre-eminent modern sculptors, such as Alfred Gilbert in Britain, Rodin in France, Meunier in Belgium or Saint-Gaudens in the United States, were mostly disseminating their work in the form of bronze casts.[32] This meant that even work in marble would often be prized for fluidity and liveliness of modelling rather than clarity and classical perfection.

The celebration of a new, truly modern sculpture, however, did not lay to rest earlier ambiguities of attitude, as is evident in one of the more ambitious publications tracing the recent history of sculpture in Britain, M. H. Spielman's *British Sculpture and Sculptors of To-Day*, published in 1901. Spielman begins with a flourish, singling out the work of Alfred Gilbert (fig. 36), Hamo Thornycroft and Thomas Brock as evidence that

> Since the year 1875 or thereabouts a radical change has come over British sculpture – a change so revolutionary that it has given a new direction to the aims and ambitions of the artist and raised the British school to a height unhoped for, or at least wholly unexpected, thirty years ago.[33]

The original impetus for this change, in Spielman's view, came from France, transmitted by the sculptor Jules Dalou who moved to Britain and exerted considerable influence as a teacher. The work of Carpeaux in particular was an important initial inspiration: he was an artist who 'infused flesh and blood and joyous life into his marble', and

who stood in the same relation to his classical predecessors as Delacroix had to David and 'the cold professors of the formal school'.[34]

But Spielman also offers some significant qualifications to this upbeat picture. In the end he feels the need to insist that sculpture cannot just emulate painting and make itself equally immediate, modern and vital. Sculpture, in his view, is still not really popular with the general public, who find it easier to come to terms with painting, where colour 'flattered' the senses, rather than with sculpture, the art of 'form'. Spielman repeats the standard point about how sculpture is of its very nature a more austere, limited art than painting, not only deprived of 'the atmosphere and tone which are the delight of painting', but also necessarily more restricted in its expressive effects and subject matter, having to confine itself to simply posed nudes or lightly clad figures. Like Baudelaire, he believes that sculpture needs to be informed by the highest ideal to compensate for the limiting effects of its literal materiality. Such misgivings, which take one a considerable way from his initial celebration of a new flesh and blood vitality in modern sculpture, come to a head in the following passage, which is particularly interesting because it is so open about the fact that for much of the artistic public, sculpture still did not have the same immediate appeal as painting. People tend to be more form-blind than colour-blind, Spielman explains, so

> Sculpture . . . is unquestionably more difficult to comprehend . . . while a painting is frankly illusive, a statue *appears* to the unthinking to be imitative. Yet it is nothing of the sort . . . it is at once ideal and positive; it must conform to the highest requirements, with the poorest means.[35]

It is in responses to Rodin, particularly those from the very early years of the twentieth century, that more thoroughgoing cases are made for a modern sculpture. Two stand out for their ambition in trying to define what it might be which a modern sensibility finds so resonant in Rodin's work. Rilke's famous essays on Rodin are easily the most complex and fully articulated analysis, and continued to reverberate in twentieth-century discussions of sculpture, even after a purist modernist reaction set in against what for a time were seen to be the somewhat unsculptural, painterly and naturalistic qualities of Rodin's art. The sociologist Georg Simmel's almost exactly contemporary analysis does not engage so closely with the distinctive qualities of Rodin's work, but does seek to offer a larger cultural explanation of its modernity and its departure from classicising conceptions of sculptural form.

The very title of Simmel's first essay on Rodin published in 1902 sets out the issue in no uncertain terms, 'Rodin's sculpture and the contemporary spirit' (*Geistesrichtung der Gegenwart*). Rodin is chosen as the artist who has managed to give convincing form to a distinctively modern sense of self and of the world by revolutionising an art whose literal materiality seemed to be particularly resistant to the subjectivising cast of the modern spirit. In Simmel's diagnosis of the modern condition, there is an irreducible split between subjective individualism and submission to some external, objective law. Art has the function of fulfilling the longing for a fusion of the two, offering an instance where a law-like necessity does not oppose but is at one with the free projection of individual impulse. In art, this apparent fusion is achieved by a synthesis between two aspects of physical appearances that are starkly at odds with one another in the modern world,

36 Alfred Gilbert, *Comedy and Tragedy: 'Sic Vita'*, 1891–2, bronze, height 66 cm, Art Gallery of Ontario, Toronto: Purchase, Dr. S. I. Streight Endowment, 1971

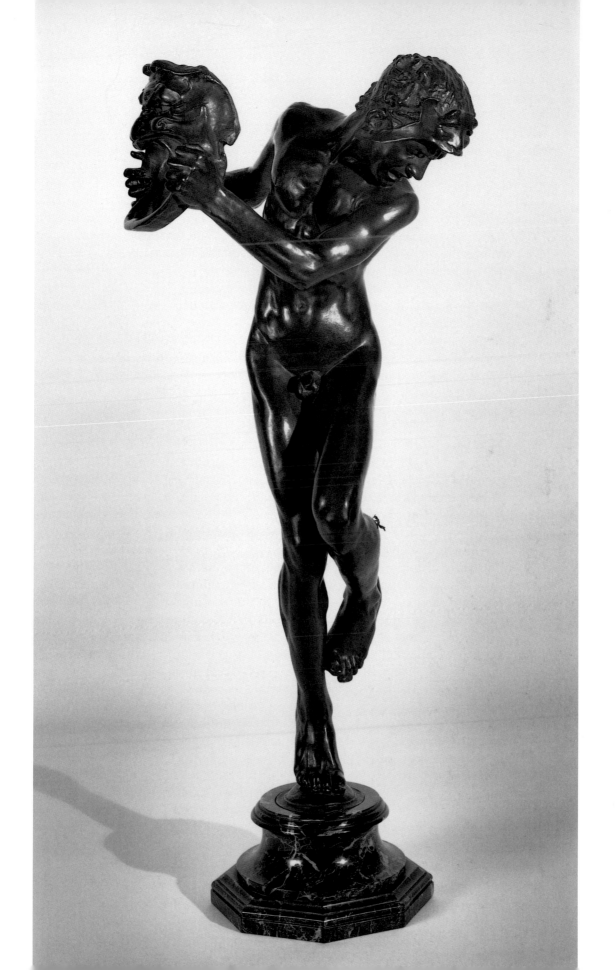

the image as material thing, as purely sensual, objective phenomenon, and the image as symbol and expression of the soul. The modern work of art achieves this synthesis by intensifying the disparity, by making the split in modern existence unavoidably evident.[36]

According to Simmel, Rodin's art works so convincingly in this respect because it gives phenomenal form to the promptings of the inner self, while at the same time the organisation of mass and the play of line are so self-sufficiently satisfying that they justify themselves as pure sensory appearance without reference to any spiritual content.[37] This echoes a splitting in the period's accepted understanding of sculpture as an art simultaneously very material and intensely ideal or spiritual. But, in Simmel's view, it also relates specifically to a distinctive feature of Rodin's work, its state of unfinish. The unfinish, as he sees it, operates in two ways, firstly by accentuating the tension between the inert mass of sculptural material and the animated form created by the artist, and secondly by giving the viewer scope to fill out the partly defined external forms with his or her inner subjective promptings. Rodin's sculpture thus activates an inner sense of being more intensely than the 'fully rounded totality' of classical sculpture.[38] The result is quite different from the sculptural unfinish of Michelangelo's work. With Michelangelo, the figure struggling out of the stone creates a tragic expressive effect. With Rodin, by contrast, the unfinish is a self-consciously deployed artistic device whose effect is one of refinement. When Simmel goes on to elaborate the significance of Rodin's unfinish and talks about its apparent negation of the completion and wholeness of classical form, it is clear that what most fascinates him is the way that the physical shape and substance of the work seem to have become secondary to its evocative effect. The material specificity of Rodin's works as sculpture is not in the end of much concern to Simmel.

This is made explicit in an essay on the third dimension dating from 1906, where he argues that the depth and tactility evoked by a sculpture is experienced in essentially the same way as in a painting. In both cases, the viewer is inferring from a two-dimensional visual impression a depth and speciality which is not directly visible to the eye. Starting from the incontrovertible point that apprehending a sculpture, no less than apprehending a painting, is a matter of looking, not literally touching, he then goes on to assume, unlike Baudelaire but like so many modern writers on the visual arts, that there is in essence no real distinction between viewing a sculpture and a painting. The kinaesthetic dimension that disturbs a painterly viewing is not an issue for Simmel, though it is, as we shall see, for his formalist contemporary Hildebrand.[39] The increasing insistence on medium specificity in art theory of the period is thus complemented by a rather more pervasive compulsion to view all art in terms of two-dimensional images.

Simmel's later discussion of Rodin's sculpture, published in 1911, takes Rodin as the exemplary modern artist whose work not only mirrors the modern condition but is also in its very substance permeated by this condition. Contrasting him with another modern sculptor, Constantin Meunier, who discovered in the worker's body a new subject matter worthy of the highest art, but no new form, he sees Rodin as discovering 'a style with which to express the attitude of the modern soul towards life'.[40] But Simmel's engagement with the sculptural aspect of Rodin's work still occurs at quite an abstract level, based on the Hegelian idea that art plays out the underlying dialectic in a culture between inner subjective spirit and outer objective substance and bodily existence. Obviously, the distinctive materiality of Rodin's sculpture plays a role in Simmel's analysis. Rodin's

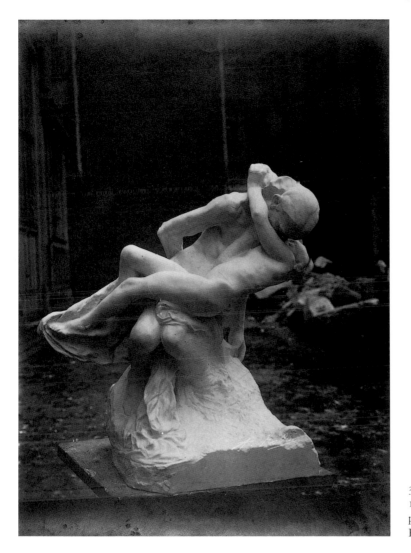

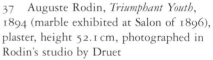

37 Auguste Rodin, *Triumphant Youth*, 1894 (marble exhibited at Salon of 1896), plaster, height 52.1 cm, photographed in Rodin's studio by Druet

work, however, dramatises the condition of modernity for him less for its own qualities than because the art of sculpture Rodin revolutionised had previously been 'the specifically unmodern art', antithetical to 'the feeling for life of modern-day man.'[41]

Two aspects of Rodin's work on which Simmel dwells were becoming paradigmatic in celebrations of his modernity, the unclassical sense of movement and the apparently unsculptural dissolution of fixed substance in a fluidity of form redolent of an inner psychological apprehension of things. He comments perceptively on how Rodin's figures often seem to be in mid-movement, breaking out from the confines of the plastic structure still insistently there in Michelangelo's work where a momentarily frozen pose has to suggest indirectly the movement of some anticipated or past action. In this context we might be reminded of the forward striding of Rodin's *Striding Man* (fig. 3) or the flow of movement in some of the smaller informal groups (fig. 37). Rodin, he explains,

through a new suppleness in the joints, a new vitality and vibration inherent in the surfaces, through a new way he makes one feel two bodies coming into contact with one another or the inner contact of a body with itself, through a new use of light, through a new way of making surfaces collide with and oppose or flow into one another . . . has brought a new dimension of movement to the figure, which makes more completely visible than had been possible before the inner vitality of the whole man.[42]

If Simmel on occasion, as here, can be very eloquent on the effects created by Rodin's work, for the most part he does not move beyond a conventional focus on the expressive gesturing and pose of the figures. When he goes on to explain further how in a truly modern visual art, movement would permeate the very substance of the apparently static configuring of form, he finds in van Gogh's painting of landscape a fuller realisation of this than Rodin's sculpture:

Seen externally, there is in most of his landscapes and still lifes a neutral objectivity [*Zuständlichkeit*], not as in Rodin, a ceaseless coming hither and going thither; and yet they are redolent of a stormy unrest that surpasses even Rodin's, an unrest whose source in the calm being there of its subject is one of the uncanniest of artistic syntheses.[43]

Similarly, when he defines more precisely what he means by Rodin's sculpture embodying a distinctively modern psychological sense of becoming that dissolves fixity and boundedness, he holds up as paradigmatic a non-sculptural art whose fluidity of means makes it more appropriate to embodying this aspect of the modern spirit, namely music. As he explains,

the essence of the modern is psychologism, that experience and understanding of the world in terms of the reactions of our inner self . . . an inner world, in which fixed content has been dissolved in the fluid element of the soul, from which all substance has been purged, and whose forms are only forms of movement. Hence music, the most agitated of art, is the truly modern art.[44]

When, after celebrating the musical or Wagnerian embodiment of modernity, Simmel returns to sum up the essence of Rodin's conception of sculpture, he makes an interesting point about how expression, normally confined to the face, has been diffused over the entire body. The faces are relatively impassive, and what counts is the 'self bending and self stretching of the body . . . the shuddering and trembling that ripple over the whole surface, the convulsions that transfer themselves from the soul's centre and emerge in the bending or jerking of these bodies, in their being crushed or in their impulse to fly'.[45] It is as if he were looking to Rodin's *Gates of Hell* (fig. 32) to represent the essence of the sculptor's achievement, seeing this vast unarchitectonic relief as a pictorial epic, out of which from time to time odd writhing figures, odd convulsed embraces and gestures of unrequited longing would emerge as motifs for independent sculptures.

What happened, though, when torsos and figures were torn from this context, and enlarged and transformed into free-standing sculptures, when they ceased to be motifs in a cosmic drama and became isolated objects displayed in the empty space of the studio or gallery? How then did they acquire a vitality that prevented them from being seen merely as closed, inert embodiments of plastic form? For an account of this we need to

turn to Rilke, who brings us back to some of the issues concerning sculptural viewing raised in Herder's essay, and who also returns us to questions about the uneasy status of modern sculpture as an isolated object of display which preoccupied Baudelaire.

Rodin, Rilke and Sculptural Things

Rilke's first essay on Rodin was published in 1903, a monograph he had been commissioned to write by a German professor of art history and editor, Richard Muther. It begins with a discussion of the situation of modern sculpture that brings together some of the key concerns voiced by earlier writers. Sculpture, he explains, not being an art of 'deception', of 'beautiful and accomplished illusion' like painting, but instead satisfying a longing for 'the true and the simple', offers solid embodiment in the face of life's intangible uncertainties, and is an art whose greatest moments lie in the past. He points to the cathedral sculpture of the Middle Ages, the classic work of ancient Greece and Rome, as well as to the sculpture of more distant antiquity. The last moment of 'great plastic art' had been the Renaissance, so 'what now?' Rilke asks. 'Had not a time come again that felt the urge for this form of expression, for this powerful and forcible construction of what was unutterable, chaotic and mysterious?' Could not sculpture be summoned to follow where the other arts had gone before, and embody our modern condition, even as it 'hesitated in fear of its great past?' This, as he conceives it, is the task that fell to Rodin.[46]

Two features of this scene-setting distinguish Rilke's analysis as being attuned to the concrete situation of sculpture at the time, as befits someone whose contact with Rodin extended to acting as his private secretary for several months.[47] First, there is the elaborate way in which Rilke unveils his drama. If, like most of his contemporaries, he assumes that the basic language of sculpture is the language of the body, the body he sees Rodin rendering is not the classical body admired in Greek art. Since antiquity, he explains, the body has been covered by layer upon layer upon of clothing, and 'under the protection of these encrustations the developing soul had transformed it . . . It had become quite other.'

> If one uncovered this body, it would probably display a thousand expressions for everything nameless and new that had come into existence in the meanwhile, and for those archaic secrets emerging from the unconscious that raised their bleary-eyed faces above the rush of blood like strange river gods. And this body could not be less beautiful than the body of antiquity, it must be of greater beauty still . . . painting dreamed of this body, it embellished it with light and penetrated it with twilight, surrounded it with every delicacy and every enchantment . . . but the art of sculpture, to which [this body] belonged, did not as yet know it.[48]

How did Rodin come to know this body and render it? It was by devoting himself to studying surfaces, not just as they were felt, but as they were made visible in the

> endlessly many encounters of light with things. It became apparent that every one of these encounters was different and every one remarkable. At this place [the light and the thing it touched] seemed to welcome each other, at that to greet one another

hesitatingly, and at a third to pass one another by as strangers; and there were such places without end . . . There was no emptiness.[49]

This engagement with the surfaces of things, and the dynamic of looking it entails, are features of Rodin's sculpture about which Rilke has a lot to say, and we shall be turning to this later on. But first we need to consider a second issue Rilke addresses when he introduces Rodin's work, the problematic situation of the sculptural object in modern times, and the consequences to be drawn from the absence of public arenas conducive to the close and imaginatively charged viewing his sculpture demanded. We can detect in Rilke's comments on the subject echoes of Baudelaire and countless other writers on sculpture in the nineteenth century, as well as premonitions of later disquisitions on the autonomy and sitelessness of the modern sculptural object. Rilke is surmising how Rodin, at the very beginning of his career, when he was working on some architectural sculpture in Brussels,

> must have felt that there were no buildings any more that gathered works of sculpture around themselves, as the cathedrals had done, those great magnets of the plastic art of a past time. The work of sculpture was on its own, just as the painting was, the easel painting, but it had no need even of a wall as this did. It did not even need a roof. It was a thing that could exist on its own, and it was only right entirely to give it the character of a thing that one could move around and view from all sides. And yet somehow it must distinguish itself from other things, those ordinary things that anyone could grab just like that. It must somehow be made untouchable, sacrosanct, be isolated from accident and time . . .[50]

As a poet, Rilke was fascinated by the idea of the art work as autonomous object. A sculpture, because it literally was an object, both brought this issue into focus and made it deeply problematic. Sculpture appealed to Rilke because it was the very embodiment of the work of art as a solidly grounded, primordial thing. Yet he was acutely aware that a sculpture did not possess such an aura through the mere fact of being a material object. In the absence of a sacred, ritually validated setting, such as a Greek temple or medieval cathedral, it could only become a special kind of thing if its mere objectness were somehow transformed by the imaginative projection that the viewer conjured out of her or his close encounter with it.

When, in the later essay on Rodin, which he originally conceived as a lecture, Rilke begins by evoking the significance of Rodin's work, he does not talk about its artistic qualities. Rather, he invites his audience to conjure up memories of objects to which they had been particularly attached in their childhood. He does not even ask them to reach back into the historical past to come up with the image of a truly resonant sculptural object, but wants them to delve into the distant recesses of their own memories and uncover the residual traces of odd objects, mostly insignificant in themselves, that had formed an intimate part of their world as very young children.[51] It seems then that, for Rilke, the true significance of Rodin's work would not become apparent were one simply to think of it as sculpture in a museum or in some other public setting such as the façade of the Brussels Bourse on which Rodin briefly worked.

He is trying to plunge his audience into an imaginary space where things are not defined by their functional or aesthetic significance, a scene of childhood fantasy where

the boundaries between inner and outer world are not yet sharply drawn, and where those objects felt to carry a charge are still envisaged as extensions of the inner self. Psycho-analysts would call these transitional objects, objects which a child would seize upon, whether it was a doll or some piece of cloth, and endow with personality and presence. Through these objects the child would be able to play out and explore its relation with the outside world, still dimly existing on the fringes of its consciousness.

Rilke rounds out this evocation of childhood things by prompting his audience to imagine another, equally primordial relation to objects, namely how early peoples would have been taken aback to discover that some artefact they had made, once it ceased to be part of their frantic everyday activity, suddenly acquired the enduring quality of a thing that had always been there. Now detached from them, though once part of their immediate experience, this mysterious thing could function as an embodiment of all that they found puzzling and frightening in the world around them.[52]

Is this world into which Rilke is inviting his audience, this vision of 'the great calmness of things that have no urge', as he puts it, a world of pure imaginative aura and depth?[53] The ordinariness of the objects he evokes, the block of wood a child plays with and takes to be an 'animal, and tree and king and child', or the basic tools and utensils that early peoples fashioned, introduces a note of the concrete and everyday. It is the combination of richly resonant fantasy with a feeling for the commonplace that makes Rilke such an astute commentator on the sculptural imagination of his time. This bringing down to earth of the evocative memories of childhood playthings is taken even further in a fascinating essay he published in 1914 on dolls, which he was prompted to write by the wax dolls created by a female acquaintance of his, Lotte Pritzel.

The essay on dolls could almost be read as a parable of sculpture gone wrong. The doll is the childhood object that fails us, cast aside for inviting and then cheating the illusion that things in the world are there to respond to our inner impulses. Directly recalling his earlier hymn to things, Rilke writes:

> If we were to bring to mind, in thinking of our childhood, the intimate, the touching, the deserted, thoughtful aspect of things . . . [and] . . . at the same time find one of these dolls, pulling it out from a pile of more responsive things – it would almost anger us with its frightful obese forgetfulness, the hatred, which undoubtedly has always been a part of our relationship to it unconsciously, would break out, it would lie before us unmasked as the horrible foreign body on which we had wasted our purest ardour.[54]

The doll angers because, after offering itself to us as another being that can respond to us without reserve, it will at some moment stand revealed as the 'motionless mannequin' it really is, 'silent . . . because it was made of useless and entirely irresponsible material.'[55]

Other more ordinary objects that we endow with an imaginative charge, such as the insignificant block of wood Rilke invoked in his earlier hymn to things, are more our own creations. Their personification is not given to us ready-made as is that of the doll. And they can more easily be incorporated into our everyday world because they become worn and patinated through use. Moreover, they can be released and returned to the outside world without our doing violence to them. Not so the immaculately formed doll,

with its unchanging waxen face and perfect clothes, that, even when it is no longer warmed by the outpourings of our imagination, still insinuates itself as a presence until we literally destroy it. Dolls cannot fade away gracefully.[56] To continue Rilke's parable, something similar might be said about a too perfectly finished, and immaculately real, classicising sculpture to which we found ourselves drawn momentarily. When the Pygmalion fantasy, the suggestion that the sculpture is a living presence echoing our inner desires, subsides, the sculpture will continue to insist that it be taken for real, even as its cool indifference openly cheats us. Maybe the evident materiality of Rodin's sculptures distinguished them in Rilke's eyes from the 'monotonous whiteness of all those great dolls' (fig. 17) so disliked by Baudelaire,[57] and also made them more akin to the simple block of wood of childhood memory than to those actual dolls that had 'confronted [him] and almost overwhelmed [him] by their waxen nature'.

*　　*　　*

This still begs the question of what happens when we encounter Rodin's sculptures,[58] and what might prompt an apprehension of them as resonant things rather than as mere objects. Clearly for Rilke, the standard context in which sculptures were displayed presented a problem in this respect. The conclusion to his later essay on Rodin, mirroring the hymn to things that starts it off, contains a passage describing how there is no place in the modern world where the sculptures Rodin produced can find a home and be guaranteed a sympathetic viewing. This is not just some vague point about the sitelessness of the modern work of art, or the disparity between the permanence of sculpture and the restless dynamic of a modern society, where 'all that is solid melts into air'. It involves a more concrete awareness of the problems faced by modern sculptors situating their work in the public sphere. Rilke makes much of the fact that Rodin often encountered difficulties with his public commissions. He describes how the *Burghers of Calais* were not installed in the way Rodin had intended, how the base of the monument to Claude Lorraine in Nancy had to be modified in response to criticism in ways he subsequently regretted, how the famous *Balzac* was rejected by the society that commissioned it after the plaster model was shown at the 1898 Salon and how a plaster of the *Thinker*, provisionally installed before the Pantheon in 1905, was hacked to pieces by a member of the public. Rilke then goes on to dramatise an ideal encounter with Rodin's work as taking place in his studio (figs 40, 42), where it exists in an atmosphere intimately connected with the artist and his conceptions, and is not exiled to the hostile or indifferent world outside. Here it can be seen for what it truly is, not at the Salon, nor in those few public places where his work had found a permanent, if usually an unsatisfactory, siting.

Such a studio contextualising of the viewing of sculpture had been instituted by earlier, Neo-Classical artists such as Canova and Thorwaldsen working for an international market in Rome. They installed elaborate displays of their plaster models and work in progress in their studios, which functioned a little like private museums where the artistic public and prospective patrons could come to see their sculpture.[59] Equally, the studio display became crucial for the presentation of sculpture in the twentieth century. With artists such as Brancusi, the studio was in effect the privileged site for seeing his work (figs 66, 71), either by visiting it or by way of photographs showing work

displayed in this informal, yet highly controlled environment. David Smith went to similar lengths to stage his sculpture in a sympathetic semi-private environment, in his case outside, set against trees, grass and sky and inundated by natural light (figs 79, 85) in the grounds surrounding his studio at Bolton Landing.

It is not just Rodin's own work, according to Rilke, that comes into its own in the sympathetic environment of his home and studio. The same is true of the artefacts he acquired and displayed in a pavilion in the garden of his residence in Meudon. 'These objects', Rilke writes, tacitly contrasting their situation with the usual one of art objects in the modern world, whether in private collections or museums,

> are surrounded by care and held in honour, but no one expects of them that they should have to give out agreeableness or sentiment. It is almost as if one had never experienced the individual impact of art works of very different times and places in such a strong, undiminished way, as here, where they do not look pretentious as they would in a collection, and also are not forced to contribute with the power of their beauty to a general feeling of pleasure that takes no real account of them.[60]

The crux in his commentary on the situating of Rodin's sculptures comes as he surveys the vast array of work accumulated in the studio, including clay and plaster models and 'finished works . . . shimmering stones' and 'bronzes'. He thinks of how Rodin, with his seemingly unquenchable creative energy, would go on to produce yet more studios full of work in years to come (he was wrong, incidentally, for 1907 marked the end of Rodin's last major burst of creative activity). His eye alights on the looming figure of *Balzac*, the model for a monument given a public showing at the Salon of 1898 (fig. 38) but then refused a public home and taken back to Rodin's Meudon residence – there later to be photographed in the protected environment of Rodin's garden and relaunched in the public sphere as an isolated image starkly silhouetted against a dusky sky (fig. 39). Rilke conjures up an image of the statue returned to the studio, rising above Rodin's other creations, as 'the one who came back, the rejected one, standing there arrogantly, as if he never wanted to go out again.'[61]

This, Rilke concludes, is the tragic situation of Rodin's sculptures, a situation that also bears testimony to the greatness of his project. 'These things can go nowhere. Who would dare to take them home with him?' he concludes. But though there was no place for these things, they 'could not wait, they had to be made. [Rodin] had long foreseen their homelessness. To him there only remained the choice, either to smother them inside himself, or to win them a place in the sky that surrounds the mountains.'[62] According to one strand of Rilke's narrative, the homelessness of Rodin's works, the absence of a permanent public setting for them akin to the medieval cathedral and their vulnerability to rejection and despoliation once they left the protected environment of his studio all testified to the superhuman creative power of the artist who produced things regardless of his awareness that they might never be accommodated and might even be destroyed.

In addition to this somewhat conventional fantasy of boundless creativity – Rilke identifying with an artist who represented the antithesis of his own spare, spasmodic, nervous creativity as a lyric poet – there is a more intriguing, distinctively modern, sculptural fantasy at work here, one enacted in the photographs of the statue of Balzac and which continued apace in the later staging and imaging of modern sculpture. Sculptors, such

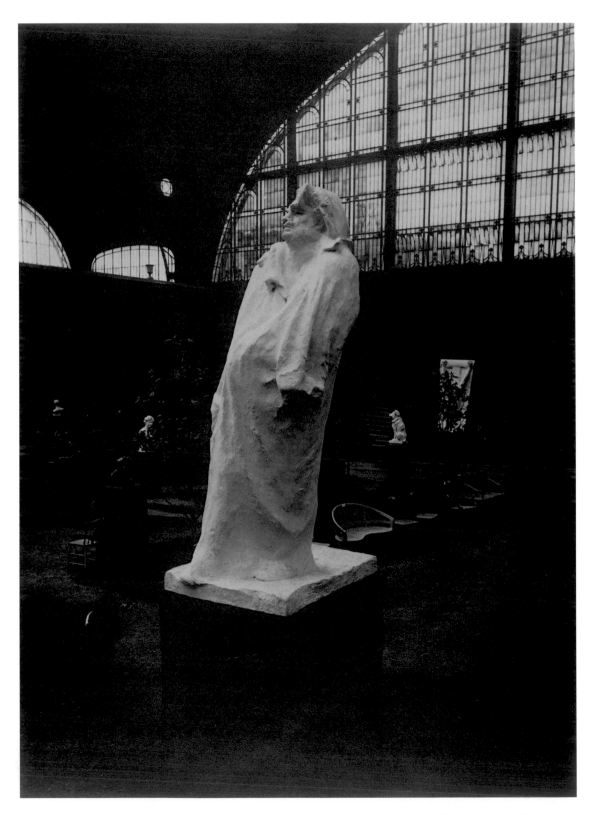

38 August Rodin, *The Monument to Balzac*, plaster, 300 × 120 × 120 cm, displayed at the Salon of 1898 and photographed by Druet

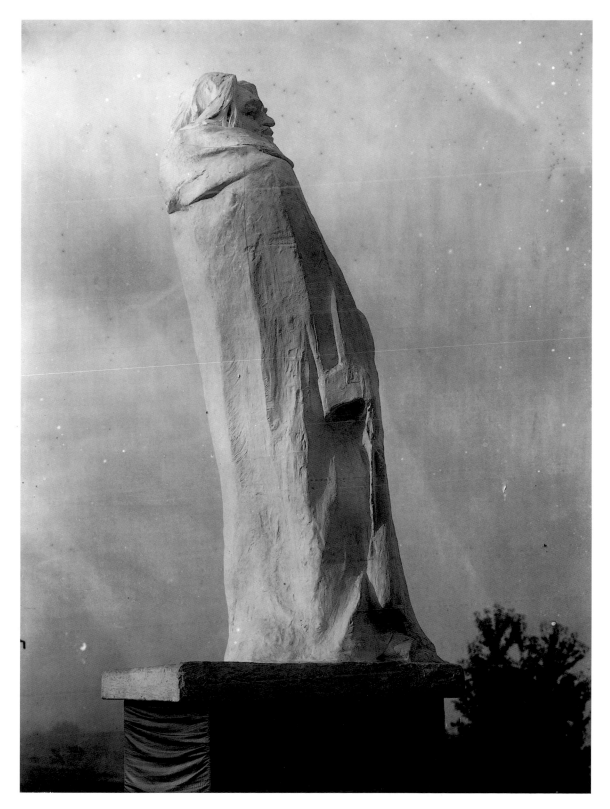

39 Auguste Rodin, *The Monument to Balzac* (1898, plaster) temporarily displayed in Rodin's garden at Meudon and photographed by Bulloz in 1908

as David Smith (fig. 83), and Henry Moore for that matter too, created dramatic displays of their work as looming presences in an empty landscape projected against the sky. And later, land artists such as Robert Smithson usually sited their work in some wide open, abandoned or natural environment, photographing it so that it would either reflect, like Smithson's *Spiral Jetty* in the waters of the Great Salt Lake, or be framed by an open expanse of sky.[63]

Another, very modernist, sculptural fantasy is played out by Rilke's dystopic projection of sculptural things in his essay on the dumbly insistent presence of dolls. These things, once the spell of illusion is broken, he explains, remain entrapped in their inert facticity, until they begin to excite our imagination by prompting us to think of them consumed, dematerialised in a puff of smoke. As objects to be destroyed, they are things that suddenly excite us because we can imagine them vaporising into dust, almost like certain Surrealist objects.[64] As Rilke puts it:

> Sexless as the dolls of childhood were, they find no way to perish in their state of ever deferred desire, which has no inflow or outflow. It is as if they were pining away for a beautiful flame, into which to throw themselves like moths (and then the passing smell of their burning would inundate us with boundless, hitherto unknown emotions). As one reflects in this way, and looks up, one stands, almost deeply moved, before their waxen being.[65]

There is a further more conventional aspect to Rilke's meditation on the homelessness of Rodin's sculptures – one could say sitelessness, but this introduces a self-consciously modernist note not quite appropriate to Rodin, let alone to Rilke's discussion of him. Like Simmel, Rilke identifies an inherent contradiction between the objective and permanent, antique, thing-like quality of sculpture and the inward-looking, subjective, 'fluid', 'ever vague and self-transforming, ever becoming' nature of a modern sensibility. But he takes this idea further than Simmel, suggesting that sculpture such as Rodin's must exist for us more as an image we carry within ourselves than as a thing permanently planted in the landscapes of our everyday life. Such sculpture, when it evokes in us the sense of a something primordial and permanent, exists mostly as such in memory, in fantasy, a fantasy stirred by the very impossibility of imagining any actual sculpture permanently planted as auratic presence in the fabric of our life. Rodin's sculptures, standing there 'in space', 'abandoned', 'no longer to be held in check by any building', 'what are they to us', Rilke asks? 'Imagine a mountain', he continues,

> rising up within an encampment of nomads. They would leave it behind and move on for the sake of their herds.
> And we are a wandering people, all of us; not on account of the fact that none of us has a home, where we stay and which we care for, but because we no longer have a common home. Because we also forever have to carry around our greatness with us, rather than setting it down from time to time, where a greatness stands.[66]

In the past, people were similarly 'always on the move and full of change', but they also had certain special places, such as the cathedrals of the Middle Ages, where their shared intimations of some larger 'greatness' they felt within themselves could be embodied. Rodin, according to Rilke, not only acutely felt the absence of such arenas where sculp-

ture such as his could find a permanent home, but also talked with nostalgia about the houses and parks of the eighteenth century where sculpture had still in some way been able to function as 'the visage of the inner world of its time'. Prompted by these regrets, Rodin apparently looked out at the view he could see from his garden at Meudon and commented, as if giving up on the prospects for sculpture in the modern world, 'Voilà tous les styles futurs'.

Rilke also took the view that landscape was the visual art of the future, able to offer the most resonant embodiment of human self-awareness in conditions of modernity. Cézanne, in the end, was for him the more truly modern artist than Rodin. Rodin had somehow succeeded against the odds, producing a sculpture which, by virtue of being so out of place and uncompromisingly homeless in the modern world, was also magnificently, tragically modern. At the same time, the imperatives of modernity were such that visual figurations of the body were ceasing to be the most telling and authentic embodiment of human subjectivity. Art was having to come to terms with the changed realities of a self existing in a world unsustained by common feeling with other living presences, and isolated among things that did not respond to human needs and desires. The underlying reality of subjective awareness in modern times was inhuman, as Rilke made vividly explicit in an essay on landscape – the modern self was 'no longer the social entity, moving with poise amongst its like', as in antiquity, but a presence 'placed amongst things like a thing, infinitely alone'. Existence was no longer embodied in figures and objects but resided in the depths where things were immersed.[67]

The language here is certainly reminiscent of later Heideggerian, and also ultra-conservative, meditations on being and homelessness and on the impossibility of collectivity in the modern world, and is tinged with a slightly easy fin-de-siècle melancholy. Even so Rilke does give voice to a certain no-nonsense, materialist sense of the condition of things in the modern world, which echoes important features of the sociological diagnoses of modernity developed by contemporary writers like Simmel and Lukács. The images these writers offer of the distinctive structuring of the social and material world within modern capitalist society, highlighting the unstable conflation of insistent reification and insistent dematerialisation, in turn echo, as we have seen, key aspects of the sculptural imaginary of their time.

Where does Rilke's general analysis of the situation of sculpture leave the viewing and presentation of actual works by Rodin? One place is as the images we see in those darkening photographs Rodin had made of sculpture in his studio (fig. 40). With these, a sculpture is presented both as material object, its hard metallic or plaster or stone surfaces here and there visibly reflecting the light, and as shadowy presence immersed in an enveloping atmosphere, floating in its own world against the dimly glimpsed backdrop of the debris in the studio. It becomes a thing silhouetted against its surroundings and also a presence looming within the inner landscapes of fantasy. Rodin's sculptures could escape the limiting condition of the sculptural object in the modern world in other ways too – as those small-scale groups of twisting figures, looking like passing fragments of some vaster human drama momentarily attracting our attention. I am thinking not just of the *Gates of Hell* (fig. 32), that unwieldy, terminally incomplete conglomeration of swirling bodies, but also of those improvised, fragmentary groupings of figures he created, which seem as if captured in the fading spasm of a gesture, and ripped from a larger

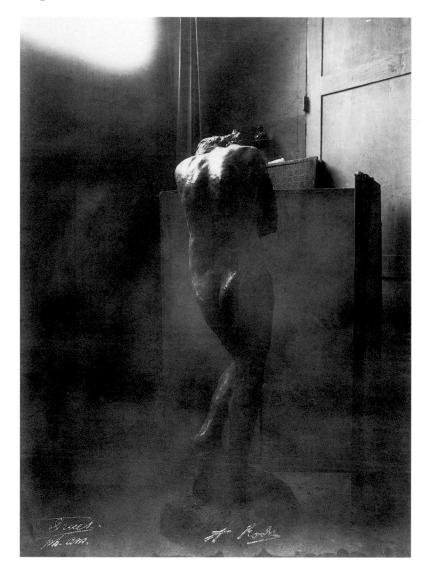

40 Auguste Rodin,
Eve, 1881, bronze,
173.5 × 59.9 ×
64.5 cm, photographed
in Rodin's studio by
Druet

context (fig. 37). Such works are devised to be seen as siteless, close to, rather like sketches, and they gave the symbolist imaginary of Rodin's time all it wanted in the way of expressively tragic drama, couplings charged with alienation and frustration, or unconsummated lunges after an ever fleeting figure of desire.

Much of Rodin's work, though, does not accommodate itself so readily to a fin-de-siècle imaginary nor to the provisional form of the sketched composition that is its characteristic visual medium, but takes shape as isolated, firmly delimited, substantial objects, planting themselves before the viewer. Such work has to be staged, and we have already seen that one way in which this could be done was through studio photographs. Some sense of this staging is also implicit in the imagery of Rilke's intriguing evocations of the homeless condition of modern sculpture. He is suggesting, in the conclusion to his second Rodin essay which I quoted, where he talks about the essen-

41 Rachel Whiteread, *Water Tower*, 1999, resin and steel, West Broadway and Grand, New York

tially nomadic conditions of existence in the modern world, that a sculptural object can be projected as imaginatively resonant in two ways: either as a presence that is felt to be so close that we feel it almost as an extension of our inner world, or as something set in a sphere quite apart from the immediate environment we inhabit, seeming almost to hover against a distant horizon, like a mountain peak. This dichotomy continues to resonate in present-day conceptions of sculpture, with some artists like Whiteread negotiating striking shifts of register between work that evokes immediate, intimate bodily contact (fig. 154) and work installed far out of reach, silhouetted against the sky (fig. 41).

This is the point to consider Rilke's account of what actually happened when Rodin's sculptures were staged in public spaces outside the studio. He describes in some detail Rodin's frustrations over the placing of the *Burghers of Calais*. Rodin, he explains,

envisaged setting the group in the market place at Calais, on the very spot where the actual event he represented supposedly took place, 'raised by a low step only a little above the everyday', and thus set almost directly on a level with the viewer. When the idea of a low pedestal was rejected on the grounds that it was contrary to custom, Rodin put forward a radical alternative. A narrow, two-storey-high tower, its cross section the same dimensions as the base of the statue, should be built close by the sea and the group installed on top of it, held aloft 'in the loneliness of the wind and the sky'.[68] Neither of these ideal sitings, the latter anticipating Brancusi's musings about an enlarged *Bird in Space* (fig. 72) hovering in the sky, was realised.[69]

When Rodin had the group photographed after he had finished the full-size plaster model, he raised it up on a low pedestal – more accurately a trestle – that was significantly lower than the standard three to four-foot high gallery pedestal, just as he did the single figure of *Eustache de St Pierre* when he exhibited it at the Salon.[70] This gives one some indication of what Rilke might have meant by Rodin's scheme to display the work on a low step. Rodin, it seems, was still concerned to set the group in a space slightly apart, stretching the standard display of sculpture to its limits so that the work would almost seem to loom directly before the viewer while still not quite literally entering the viewer's space at her or his own level.[71] It was an issue for any actual sculpture, as Rilke remarked in some notes he made in 1900, that there must be something about it that distinguished it from 'objects of daily use'. Otherwise it would become no more than a mere 'paperweight', however large it might be. The point was not simply that a sculpture needed to be raised up on a pedestal but that it needed to define the space it occupied as something special.[72]

* * *

While Rilke's way of talking about the autonomy and the resonantly thing-like quality of a truly significant sculpture might make it seem to us as if he were simply asking for a little old-fashioned aura, he does envisage this autonomy as having to be enacted through the stance of the figure and its situating of itself in its environment. He makes the point, for example, that a sculpture should never look the viewer directly in the eye, but must seem self-absorbed.[73] Autonomy cannot be taken for granted. It has to be dramatised as a concentrated inward-lookingness, as he explains in an astounding passage on Rodin's *Meditation* (fig. 42):

> Never has a human body been so collected in on itself, been so made to bend to [the promptings of] its own spirit and so held aloft again by the elastic power of its blood. And as the neck raises itself up just that bit from the steep sideways sinking of the body and stretches and suspends the listening head above the distant rush of life, this is so insistently and grandly felt, that one is unable to recall a more stirring and intense inwardly absorbed gesture.[74]

Of all the figures by Rodin that are presented as gathered in on themselves – and this is far from being the only mode of self-presentation in his large-scale sculptures – the *Meditation* is most strikingly so because the inward-directedness has no apparent expressive logic, compared say to the *Thinker* sunk in thought (fig. 47), or *Eve* (fig. 40) shying away

42 Auguste Rodin, *Meditation*
(1885 or 1896–7), plaster, small-scale
prototype of the life-size version
dating from 1896–7, photographed in
Rodin's studio by Freuler

in guilt from the gaze of a disapproving god. *Meditation* does not withdraw, but only
turns in on itself, an effect accentuated by the curious way in which it neither quite stands
up on its own account nor leans or rests on a support, as it did originally when incorpo-
rated as an accessory figure in the monument to Victor Hugo. It seems to be suspended
in the air, a little like the earlier *Age of Bronze* (fig. 45), which also, though less dramati-
cally, is held in a pose that no actual body could sustain. This male figure was originally
designed to support itself by leaning slightly on a vertical spear held by the bent left
arm. With this prop removed, it tips forward a little precariously, and seems suspended
between a rising and a collapsing, an ambiguity registered in the two titles Rodin gave
it, first *The Vanquished One*, then *The Age of Bronze* with its connotations of 'primitive
man's' awakening to a new understanding.[75]

With the *Meditation*, where the destabilising is more radical, the unusually forceful suggestion of a powerfully bent torso's holding itself there in space is partly made possible by the removal of the arms and protruding knees from the initial version of the statue. These anatomical features rationalised the positioning of the figure as a momentary phase in a movement of twisting and turning, to much less compelling effect. The final work's apparent incompleteness, by focusing attention on the thrust of the torso and making the overall shape more compact, also creates a more convincing effect of wholeness. As Rilke notes, the literal fragmentation of the body, far from threatening the sculpture's integrity, makes it all the more insistent. It is almost as if the presence of arms in a figure like the *Meditation* would be 'a superfluity, a bit of decoration', while now one stands 'before something whole, perfectly complete, which allows no addition'.[76]

The effect of self-sufficiency in the inwardly absorbed figure of *Meditation* is not simply created by the shape of the sculpture, its enclosing contour, or the internal composition of its parts. It is activated by the way the sculpture faces the viewer and projects itself into space. Rodin seems to have been getting at a sense of this when he expressed his misgivings about the way the *Kiss* struck him when he saw it beside his *Balzac*. It seemed as if it 'fell before the other'. Its 'interlacing' or composition was fine, but it appeared lacking precisely because it presented a 'subject complete in itself and artificially isolated from the world which surrounds it.'[77] The conventionally integrated composition failed to convey, indeed got in the way of conveying, the striking effect of wholeness projected by the starkly simplified figure of *Balzac*.

The *Balzac* (fig. 39) has an obvious outward address, it faces up and out to the world. In its different more subtle way, the *Meditation* also plants itself before one, the torso's elastic power giving a striking upward thrust to its inward bending. If the *Thinker* (fig. 47) too gathers its body inwards, it also pushes itself forwards, tensely poised rather than just sitting there. Rodin's single figures are almost always posed so as to impinge actively in some way on the space around them. There may be a driving forward thrust, as with the *Striding Man* (fig. 3), or a dramatic rising up, as with the *Iris* (fig. 32), or a push and pull between a looming forward and a tilting back, as with the *Cybele* (fig. 43). In each case, however, the figure projects itself in such a way as to seem utterly oblivious of any viewer, even a potential one. We are here in a very different world from that of Canova and his contemporaries. The 'facingness' of a Rodin statue is constituted through the blind address of the body, rather than the directedness of a look, a look which in his case has often been excised.[78]

The *Iris* (fig. 32) presents a particularly dramatic case of a torso confronting one, the vividly landscaped expanse of its front surface almost functioning as a mute, de-anthropomorphised face. In this case, the dynamic stance is created by its placing, for it was made by setting upright a female figure originally lying prone on its back. In the latter position, the conception of the figure is close to that in the many pornographic drawings Rodin did of recumbent female models viewed down their open thighs. His approach in these is little short of rape by gaze and pencil – the pose is yielding, but as if yielding to coercion, with the legs almost forcibly spread out to expose the genitals. Raised up to face the viewer, the stance of the figure changes dramatically from passive to active. It seems to leap upwards, vigorously planting itself in the space before one.

With its strong build and confidently flexing limbs, it is now almost the antithesis of the traditional female nude – even for example Rodin's *Eve* (fig. 40). But if its gender momentarily seems redundant, it is not entirely so. There is still a trace of the figure's origins, its being exposed to a kind of violation, particularly when impaled on a 'stalk of iron',[79] as a visitor described it in Rodin's studio.

A different dynamic instability, one that is more grounded, is effected by the seemingly straightforward pose of the similarly headless, and equally imposing, figure of *Cybele* (figs 43, 44). In contrast to the seated *Thinker*, this figure opens itself out to the space before it. Yet the powerfully raised frontality is somewhat skewed. The broad shoulders are not set directly over where the buttocks rest on their support, but a little behind. The backwards tilt, accentuated by the action of the hand curling up and in towards the left shoulder, creates a certain inner tension. Facing the figure, it is as if the broad expanse of the strongly modelled torso is an imposing wall, or cliff, which leans back slightly, but then reveals itself as a little unstable and unbalanced as one moves to the side. From here one sees that the pivotal part of the torso connecting the broad and heavy chest and shoulders to the powerful, firmly anchored hips below is quite narrowly tapered and that the stomach muscles there are tensed and straining.

More so than with the *Iris*, this work reconfigures a conventional gendering of body shape in sculpture. It is as vividly and powerfully muscled, and as confidently poised, as any male torso. It suggests a slightly tensed strength, suffused with a certain ease and grace, that could be seen as a modern equivalent of Michelangelo's famed, very masculine, 'sweetness and strength'.[80] When Rodin first exhibited this enlarged fragment from the *Gates of Hell* as an independent piece at the 1905 Salon, he seemed to want to keep its gendering at bay by naming it simply 'une figure'. By the time it was exhibited in London in 1914, however, it had acquired the name *Cybele*, a reference to the ancient Greek-Asiatic goddess of nature, which has since stuck. This of course puts the figure back into the realm of gendered archetypes, associating it with an image of primeval femininity and fertility that enjoyed a vogue among mythographers of the ancient world in the early half of the twentieth century. But the name also has its more disconcerting connotations. Cybele, in a fit of jealousy, drove her son mad so he castrated himself, and the priests who officiated at her cult in Rome, the Galli, were castrati

* * *

As important as stance for activating the viewer's response to Rodin's sculpture is the rendering of surface. That Rodin thought the surfaces to be important in the viewer's encounter with a work is evident from even the most atmospheric photographs he had done of his sculptures (figs 39, 40).[81] There are always passages where light condenses on the impenetrable metallic sheen of bronze, or the powdery opacity of plaster, or the very slightly translucent glaze of polished marble. The light glancing on a resistant surface gives definition to the sculpture's occupancy of space – not as inert lump but as actively defined volume. Particularly as one becomes aware of the subtle effects of light suffusing it, the surface takes on a certain flow and flexibility. The irregular texturing, above all in the later work, adds a further dimension to this interplay between hard

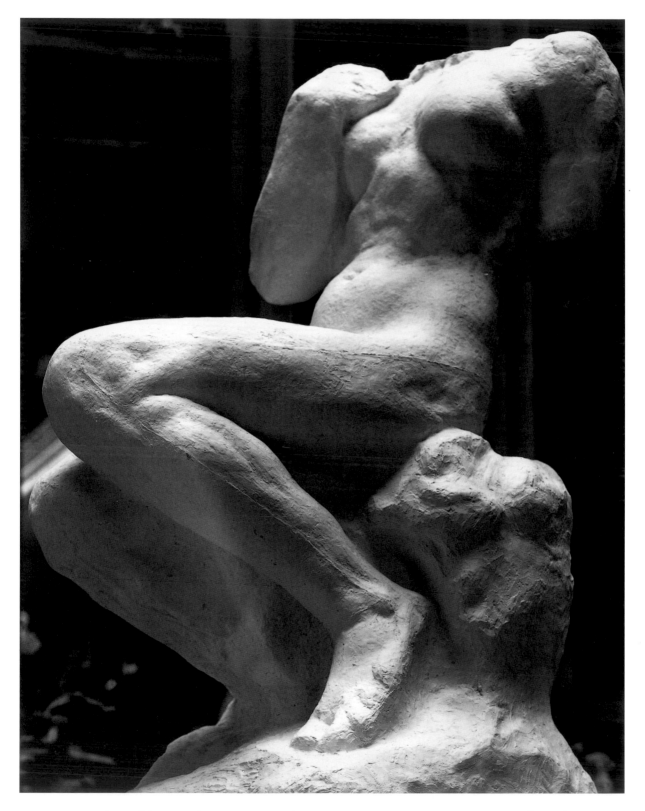

43 Auguste Rodin, *Cybele* or *Seated Woman*, plaster, 162 × 132 × 84 cm, photographed at the Salon of 1905 by Bulloz

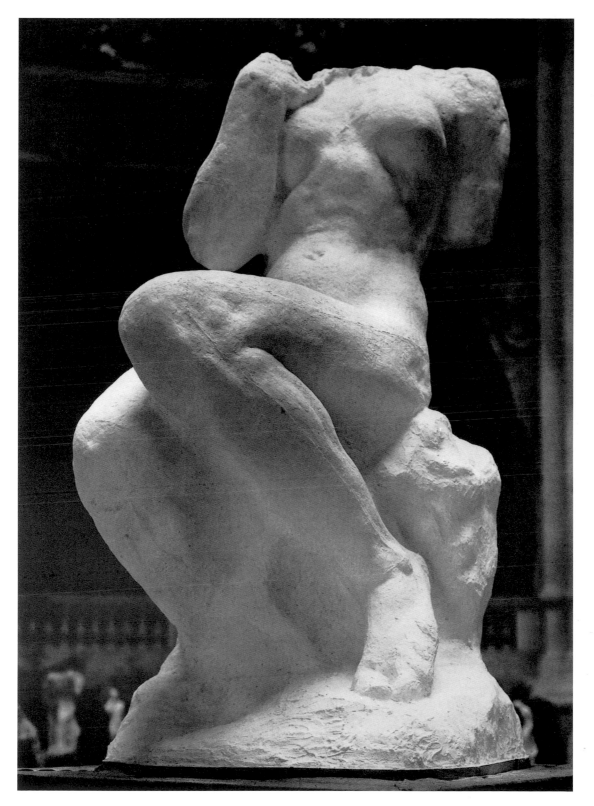

44 Auguste Rodin, *Cybele* or *Seated Woman*, 1889, plaster, Musée Rodin, Paris, photographed by Bulloz

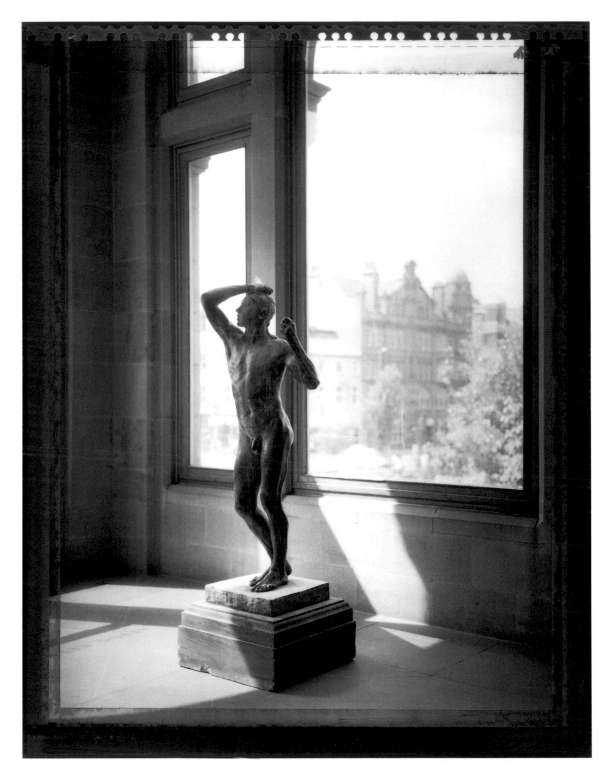

45 Auguste Rodin, *The Age of Bronze*, 1875–6, bronze, 181 × 54 × 64 cm, Leeds City Art Gallery, photographed by David Ward

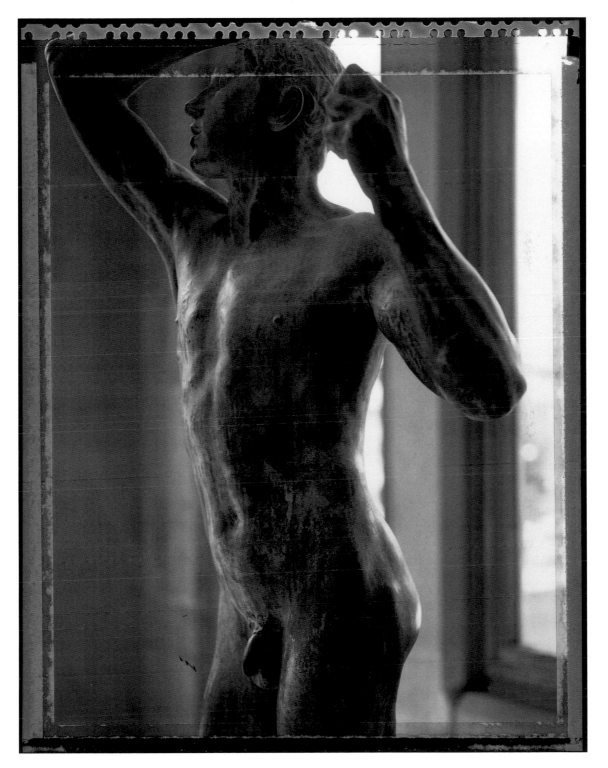

46 Auguste Rodin, *The Age of Bronze*, detail, photographed by David Ward

impenetrable material and almost yielding flow. The surface is roughened and coarsened by lumps and cracks and incisions, arbitrary coruscations and delvings left by the working process, but it is also modulated by swells and gentle indentations that are every bit as subtle as the surface effects on a sculpture by Canova or Bernini or Michelangelo.

These effects are most vivid in the plasters and bronzes, media that directly transfer the subtleties and the crudities of the clay model which was the basis of Rodin's working process. Plaster's chalky dryness gives the shaping of surface a particular clarity because of the way it shows up the least effects of shadowing, sometimes lost in the dark reflective sheen of patinated bronze. The slight roughness of texture, enlivened by raking light, can evoke the subtle imperfection, and hence also flexibility, of skin on a body. Bronze creates more of a flow. The sheen and flicker of light and pools of shadow make the precise form of the surfaces just a little ambiguous, at times almost giving the illusion that they are flexing slightly. In the later work, the strongly marked bumps and incisions picked up by the bronze casts from the clay and plaster models interrupt the flow of surface, giving it a particularly animated irregularity that relates to a sense of living flesh. Marble usually does not do the job – the slight translucence tends to give a hard, regular smoothness to the surface that is at odds with Rodin's modelling.

Most importantly, however, a finished marble is a hand-made rather than purely mechanical replica of the plaster model, and inevitably dulls the irregularities of surface that Rodin and his assistants created in the primary processes of modelling in clay and then replicating and enlarging the clay models through moulding and casting.[82] With bronzes and plasters, all the way through, from modelling the figures in clay to replicating them in plaster, to fragmenting and recombining and enlarging the plaster models, and to the final casting in plaster and transfer into bronze, traces of previous accidents of working are replicated and overlaid by further traces of process. Carving in marble breaks this chain, obliterating many of the accidental residues of the previous stages and introducing the bland inaccuracies and dulling refinement of a routinely hand-crafted process of copying. The irregular modulations of surface in the full-scale plaster model are either smoothed over or refashioned as ornamental embellishments by the assistants delegated to carry out the carving. The purely mechanical aspect of making a replica of a sculpture in marble using a pointing machine only guides the larger rendering of shape and, by contrast with the process of casting, does not pick up the seemingly insignificant variegations and markings of surface which were in fact the essence of Rodin's 'finish'.

Rilke's most suggestive commentary on Rodin's rendering of surface makes a dramatic entry just after his famous evocation of things in his second essay on the sculptor. After running through the vast array of emotionally charged drama in Rodin's sculpture, he draws up short, saying:

> but suddenly they all vanish, like a contracting glow of light – and one sees the basic reason why. One sees men and women, men and women, over and over again men and women. And the longer one looks at it, the more this content simplifies itself, and one sees: things.[83]

How does the spectacle of these supplicating or self-absorbed figures recede as one looks intently at them (figs 45, 46) and what is it one begins to see instead? According to

Rilke, one becomes absorbed by that 'awareness of surface through which the entire world offers itself up to this art' of sculpture. The eye gliding over the surfaces of the sculpture senses something of the living pulse of the outer surface of a body, where inner sensation and flexing of muscle comes into contact with the shape of things outside. In the light of this, the logic of a much quoted comment by Rodin becomes a little clearer: 'When all is said and done . . . you should not attribute much importance to the theme you interpret. No doubt they have their value and help to charm the public, but the main concern of the artist should be to fashion living musculatures.'[84]

The close apprehension of surface, Rilke suggests, is the ground of one's sense of what the sculpture is, just as it is the ground of the artist's process of creating it. Like Herder, Rilke envisages a world of sculptural sensation, unanchored from the more familiar world of clearly defined images with their designated place and significance. To enter fully into the sculptural modelling of surface is to immerse oneself in a blind groping. The modeller proceeds 'so unselectively on face and hand and body that nothing designatable was there any more, that one was only forming without knowing exactly what was coming into being, like the worm that makes its way in the dark from place to place.'[85]

For the viewer, however, the modelled surface needs to come alive and seem to move, not through actually touching it, but through looking closely at it. Movement and animation, for Rilke as for Simmel, is a key feature of Rodin's work. Rilke, though, sees nothing inherently novel about Rodin's animation of gesture and bodily movement. What for him is quite new is

> the kind of movement that the light is compelled to make as a result of the unusual formation of these surfaces, the inclines of which are modified so frequently that the light flows slowly here and falls precipitously there, at one point appearing shallow and at another deep, at one gleaming at another dull . . . this acquisition and appropriation of light as a consequence of an absolutely clearly defined surface was recognized by Rodin to be an essential characteristic of plastic things.[86]

Such a 'reclamation [*Gewinnung*] of light', Rilke goes on to remind us, is of the essence of sculpture, and had also been achieved in its different way in antique and Gothic work. Rodin's innovation is to have found a new – quite modern – solution to this age old plastic problem.

One further aspect of Rodin's sculpture relating to his mastery of surface that Rilke singles out for comment is 'the acquisition of space'. He himself admits that it is hard to say precisely what he means by this. He begins by talking about a 'secret geometry of space', of which Rodin had caught a glimpse, making the sculptor aware 'that the contours of a thing must order themselves into several planes inclining towards one another, so that the thing would really be taken up by the space [around it], and so to speak recognised by space as cosmically self-sufficient.'[87] Such a projection of the sculptural object, its surfaces seeming to break out beyond their literal boundaries and penetrate and be absorbed into the space around them, became a staple of modernist sculptural aesthetics. It was one pervasive way of talking about Constructivist sculptures and architectonic designs, such as Gabo's (fig. 52), where planes were juxtaposed in open abstract configurations. But this is not quite what Rilke has in mind here. His idea of 'acquisition of space' is more embodied and refers to the way a sculptural figure seems to occupy

and impinge upon the space around it and not just to a formal play of planes and sur-
faces. Rodin's *Age of Bronze*, for example, he seen as drawn inwards and suspended in the
enclosing space of its own interiority, while the *Balzac* (fig. 39), by contrast, appears
to thrust itself out into and take over the whole arena it surveys. Even to our eyes, the
Striding Man (fig. 3) can seem to achieve a kind of lift off, as Rilke suggests, through the
stark shaping of its relentless – almost inhuman – forward pacing. The twist and stretch
of its legs and tilted torso create a play of movement and planes that almost seems to
float free and reverberate out into the space it traverses.

* * *

In suggesting that a sculpture by Rodin can sometimes seem to open out and penetrate
the space around it, Rilke is making a further point. When we look very closely,
the lively flow of surface can seem to develop an energy of its own and float free of the
sculpture envisaged as a whole, bounded object (figs 45, 46). This brings me to an
issue which I have been identifying as a central feature of sculptural viewing, namely the
interplay between a relatively stable apprehension of the overall shape of a work and an
unfixed close viewing of the modulations of form and play of light on the surface. With
Rodin's sculpture the disparity between these different modalities of viewing can be
particularly insistent, partly because the vigorous modelling means that the almost
autonomous play of surface begins to impinge on one's awareness even as one surveys the
whole shape. The disparity becomes particularly striking in the large-scale single-figure
sculptures such as the *Thinker* (figs 47, 48) where there is an intricate structuring of
gesture and pose. From afar, the figure seems to gather itself inwards in a tensed attitude
of strained self-absorption that almost excludes the viewer. Close to, however, the effect
is quite different. The statue opens up, and one's sense of the heavy clenched pose is dis-
solved in the vividly sensuous and gently powerful flex and flow of muscles.

We have seen how the disparity between a distant overview of a sculpture's shape and
a close view of its surfaces played a key role in Canova's work. In Rodin's case the dis-
parity is played out in a different register. Indeed, the difference is such that a different
structuring of sculptural viewing is involved. In the first place, the disparity is much
more insistent, particularly in later work such as the enlarged *Thinker* and the partial
figures of the *Striding Man* and *Cybele* (figs 3, 43, 44), where so much is happening
on the surface. The modelling creates such an immediately absorbing spectacle that
from the outset one cannot but recognise it as having a force of its own. With Canova's
sculpture (figs 11, 12), the surface animation only makes itself apparent once one
looks closely. It is then one discovers that the work comes alive in subtle ways which
are slightly disguised by the apparent integration and smoothness of form it initially
presents.

Another, more significant, distinction relates to the fact that the surfaces of Canova's
marbles are more insistently surface-like in ways that have not just to do with their being
smoother and more regular. They strike one as being without apparent depth, or sug-
gesting only the slightest hint of depth. Looking closely at a Canova sculpture, one
glances over the surface, following the ever-changing curves and contours on a 'wanton
chase'. Viewing a Rodin, something different happens. At times one's looking becomes

48 Auguste Rodin, *Thinker*, detail

47 (*left*) Auguste Rodin, *Thinker*, 1904,
bronze, 182 × 108 × 141 cm, Musée Rodin,
Paris

almost engulfed in the swellings and lumps, an effect accentuated in the case of versions
in bronze where the alternations between glint and darkness can make it almost impos-
sible to envisage the surface as a clearly defined form.

Until now I have said little about one prominent feature of Rilke's discussion of Rodin's
sculpture, namely his comments about the sense of depth they convey and the almost
deathly calm associated with this. The matter of depth is not just some Romantic idea
of aura. Rilke begins his hymn to things by evoking 'the stillness that surrounds things'
when 'all movement subsides, becomes contour, and past and future close in on one
another and something enduring emerges: space, the great calmness of things that have
no urge'.[88] This, he implies, is how we see Rodin's sculptures when we cease to envisage
them as actors caught up in a drama, and find that the represented movement of
the figures is absorbed by a 'circulation' of movement in the surfaces that has a certain

undisturbed 'calm' and 'stability'.[89] Rilke does have a point here, and the paradox he describes is very real. To be immersed in a close viewing of these sculptural modulations of surface is not just to be swimming in an unstable flux of sensation. It is also momentarily to sink into an almost inhuman calm – a still state of absorption at odds with the restless animation of the anxieties and drives rendered by the drama depicted in much of Rodin's work. Rilke's poetry is permeated by such fantasies that follow the logic of the death drive's compulsion to quell the excitations of the living organism and return it to the state of 'inanimate things'.[90] These fantasies, though, are not ones of absolute death-like calm but of an indeterminate state suspended between life and death, dramatised in the myth of Orpheus and Eurydice that so fascinated Rilke.

There is a final point arising out of Rilke's suggestive analysis of Rodin's sculpture that deserves mention. While he stresses the materiality and objective integrity of Rodin's sculptures, he also keeps returning to the way they seem so close and immediate, the sensations of surface they elicit at times almost engulfing one. The interaction between viewer and work he is talking about seems more akin to the relatively unmediated, open encounter invited by later Minimalist and post-Minimalist work than to the poised interplay between viewer and isolated, autonomous object favoured by the modernist artists who were Rodin's immediate successors. This has a bearing on Rodin's ambiguous positioning in narratives of the history of modern art. The point is not only that his sculpture appealed both to a very period-bound taste for Wagnerian depth and symbolist excess, as well as to a more modern-seeming formalist sensibility. At issue is something more integral to the impact made by his sculpture, the tension between its invitation to a close and immediate, quasi-tactile engagement and the distancing effect of its evident materiality and traces of fabrication. For the modernists, Rodin's work often seemed unmodern, not just because it was so insistently figurative – after all, a lot of modernist sculpture is itself figurative (fig. 64) – but also because its address to the viewer got in the way of sustaining a stable sense of it as a separate, self-contained object (fig. 43).[91]

There is an intriguing parallel to be drawn in this respect between the status of Rodin within modern sculpture and that of Monet in modern painting, which makes it logical to think of them sharing an exhibition space as they did for the 1889 International Exhibition in Paris.[92] Both exploited a similar rhetoric of immediacy at the same time as exposing the stuff from which their art was fabricated. Both suffered a temporary eclipse after enjoying a huge reputation as great modern masters at the turn of the century and both underwent a revival among those of avant-gardist persuasion in the period after the Second World War, when a new emphasis was placed on the direct physical and perceptual encounter between viewer and work. And in both cases their work has an intriguingly split status as innovatively modern on the one hand and as middle-brow kitsch on the other. For a long time, the taste for Rodin's work has hardly been an exclusive one. Bronze replicas of his more famous works people art galleries and sculpture gardens the world over and his Paris residence, the Hôtel de Biron, is a popular site of pilgrimage for budding art lovers. Like much Impressionist and Post-Impressionist painting, his sculptures obviously fulfil the needs of some common, if deep-seated bourgeois, desire for immediately accessible, resonant images that will embody the most intimate and ineffable inner experiences, and do so much more effectively than any subsequent modern

sculpture. It is a fantasy already played out in all its vulgarity in Rilke's two essays on Rodin, just as these same essays' complex wrestling with the significance of a modern sculpture has made them a crucial point of reference for generations of self-consciously modern, or avant-gardist, sculptors and critics. With Rodin it is not a matter of avant-garde or kitsch, but avant-garde and kitsch.

Judging from the record of his conversations with the American writer Paul Gsell published in 1911, Rodin in old age seems to have been complicit in most aspects of the packaging of his work that guaranteed its long-standing popularity. At the same time, he did balk at some points, most significantly, I feel, when Gsell was expatiating to him about how, in his sculpture, he had explored 'the mysterious and vast domain of the individual psyche' and 'the most profound, the most secret emotions of the soul', and in doing so had been party to the 'powerful wave of individualism that passes over the old society and will help to modify it little by little . . . [and will overcome] 'the social inequalities that enslave people, the poor to the rich, the woman to the man, the weak to the strong.' Rodin did not quite wish to be party to this rosy vision of the triumphal progress of bourgeois individualism and freedom-promoting capitalism. He wanted to locate the integrity of his project elsewhere. 'It is true, nevertheless', he interjected, 'that I have tried to be useful by formulating, as carefully as I could, my vision of beings and of things.'[93]

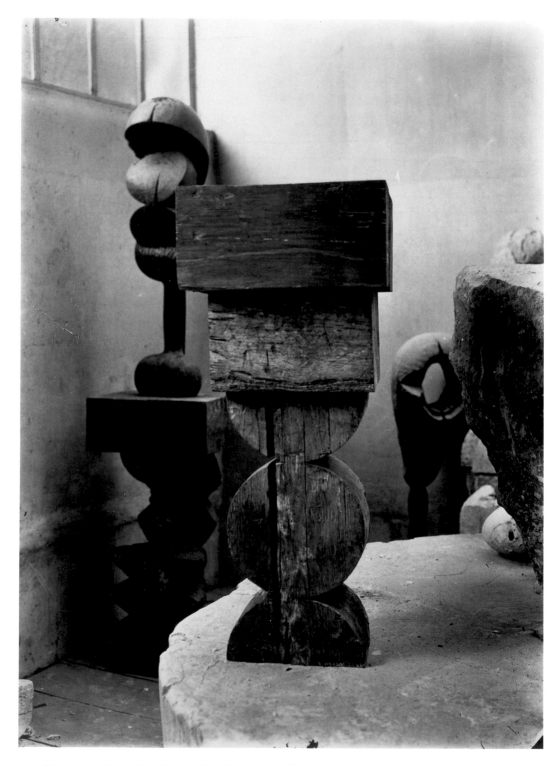

49 Constantin Brancusi, *Adam and Eve*, photographed by the artist, 1922, Musée National d'Art Moderne, Paris

3 Modernist Objects and Plastic Form

Modernist sculpture, which could roughly be defined chronologically as work produced after Rodin and before the shake-up of sculptural practice in the 1960s and early 1970s, had in its own time, and continues to have, an oddly uncertain status. There is no denying the pervasiveness of the modernist desire to create a new kind of object that would offer a radical alternative to the classicising and monumentalising tendencies of traditional sculpture, and would parallel the rethinking of picturing and pictorial representation that occurred in the period. But the idea of a modern sculpture as a significant historical development gathered momentum relatively late, in the 1930s, coming to a head with the spate of publications in the 1950s and 1960s specifically dedicated to the subject.[1] Even in the heyday of this idea of a modern sculptural tradition, however, histories of modern art still tended to present sculpture as a minor adjunct to the master narrative of modern painting.

When the pioneers of modern sculpture moved from informal studio works to a more sustained mainstream sculptural practice, the development was a decidedly ambivalent one. Think of those ever larger, ever more arbitrary bronze lumps by Lipchitz, Laurens, Archipenko, Zadkine and Miró, compared with their early small-scale experiments in non-traditional, often lightweight materials. While the later, more categorically sculptural, pieces enjoyed a certain authority as classics of modern sculpture, they never really caught the attention of a larger artistic public. The sculptural productions of the new generation that came to prominence in the forties and fifties did not fare much better, whether one thinks of the open, spindly or tortured cast bronze or welded metal constructions of Reg Butler, Germaine Richier, Lynn Chadwick or Theodore Roszak, or the more puristically sculptural work of Isamu Noguchi.[2] The designer mobiles of Calder and the elaborately dysfunctional machinery of Tinguely might momentarily have broken through the sculpture boredom barrier, but they hardly add up to a new vision of sculpture.

In this company, the now generally unfashionable work of Henry Moore looks pretty good, even the later pieces. It is thus hardly surprising that his work provided a target for the new sculptors or anti-sculptors of the 1960s. It was a target that a significant portion of the artistic public at least took note of and even cared for in some way, particularly as Moore's reputation was bolstered by his considerable talents as a draughtsman. Some of the drawings he created genuinely captured people's imagination and have survived subsequent changes of fashion rather better than his sculptural work. In his sculpture, he was mostly at pains to put traditional sculptural values back into modern sculpture, rather than make new kinds of modernist objects, which may in part account for the fact that he, as opposed say to his erstwhile colleague Barbara Hepworth, was regarded for a time by mainstream opinion as the leading exponent of a modern sculptural tradition.

The exceptions to this broad-brush picture are what will concern me in this chapter and the next. In a way, my aim is to clarify what it is that makes certain objects stand out from the usually less then remarkable hubbub of modernist sculptural production. Why should Brancusi or Giacometti or David Smith have continued to excite a lively interest beyond their own generation? What makes their work such singular exceptions to the 'why sculpture is boring' syndrome that Baudelaire identified as the fate of sculpture in the nineteenth century, and that continued to colour many viewers' experience of the bronze casts of modernist shapes which were supposedly radical alternatives to the 'great white dolls' of earlier classicism?

Modernism and the Situation of Sculpture

The odd situation of early modernist sculpture in a present-day context came home to me very vividly a few years ago, when I was looking at the extensive collection of such work in the gallery circling the interior courtyard of the Hirshhorn Museum in Washington. This sculpture hall functioned as a circulation area connecting the more conventional galleries displaying the collection's finest examples of twentieth-century art, mostly paintings, with a few sculptures of exceptional interest, such as Louise Bourgeois's lumberingly eloquent and disturbing painted wood construction, *The Blind Leading the Blind*,[3] and Barbara Hepworth's seemingly simple, curiously scooped out, wooden object *Pendour* (fig. 75).

I remember sinking into a state of vaguely irritated boredom as I scanned the various lumps and tangles of metal and bits of stone sitting on pedestals or in display cases. Indifferent paintings at least do not take up so much space, they sit back on the wall, waiting to be looked at. Why all this stuff? It was as if most of the artists had fiddled away industriously to give solid form to some possibly intriguing looking plastic shape but had failed to take into account what the resulting object would look like as sculpture. How would it project itself when set in a public display space and hold the attention of a viewer drifting round a gallery? The cubistic forms, the vaguely primitivising shapes might have been fine in impromptu sketches, or enlivened by indeterminacy of depth and activated surface in a painting, but congealed into lumps of matter they too readily went dead. But odd things did stand out, and why?

It was above all a small work by Brancusi that struck me, the simple head shape of a *Sleeping Muse* dating from 1909–10, partly because of its economy of form and the absence of arbitrary bulges and protrusions, but more because of the way it was poised – it seemed self-contained, yet its presence impinged subtly on the surface where it rested. This work played out a creative tension between the idea of autonomy and the need for such autonomy to be activated in the work's placing and implied address to the viewer. An isolated, small-scale sculptural object is all too likely to strike one as mere thing or failed ornamental object unless it is staged so as to prompt one to think otherwise of it.

Many of the items that now are seen to be among the more significant sculptural works of early modernism would not at the time have been envisaged as sculpture, often even by their makers (fig. 59). Moreover, many modernist sculptures that have come to feature in histories of modern art were produced by painters such as Picasso (fig. 50) and Matisse,

50 Pablo Picasso, *Guitar*, 1912, construction of sheet metal and wire, 77.5 × 35 × 19.3 cm, The Museum of Modern Art, New York. Gift of the artist

not self-professed sculptors.[4] Such objects were mostly conceived as informal experiments in switching between painted form and sculpted object. What happens when a depicted shape is made into a real thing? It was the informality of these experiments that was one of their main strengths. It enabled them to be true to the deconstructive and demateri-alising imperatives of a modernist aesthetic, and to avoid having to engage with the expectations raised by full-blown sculpture.

This brings me to a crucial feature of the modernist engagement with sculpture, the dominant role played by painting in the remaking of the vocabulary of visual art at the time. Undeniably, many modernists were intrigued by the idea of moving out from paint-ing into three dimensions, from representation or depiction into real space, as it were. It is important, however, to distinguish between an actual shift from painting to work in three dimensions and a fascination with imagining depicted forms taking shape in three dimensions, something that relates less to sculpture than to the preoccupation with rep-resented depth central to modern Western painting. We shall see in the next section

of this chapter, where I discuss sculptural theory in the period, how many modernist conceptions of plastic form were basically painterly in this way.

Boccioni's 'Technical Manifesto of Futurist Sculpture', first published in 1912, is a good case in point. The vision of a new sculpture is a direct extension of Boccioni's rethinking of space and form and of the principle of the 'interpenetration of surfaces' in his 'Technical Manifesto of Futurist Painting' published two years before.[5] Sculpture became an ideal site for imagining a Futurist revolution, not because of its specific resources as an art form, but because sculpture was such a *retardataire*, classicising art, completely out of tune with the demands of the modern age and thus in need of a total blowing apart. As Boccioni put it,

> It is almost inexplicable that generations of sculptors continue to construct puppets without asking why all these sculpture galleries [*salons de sculpture*] have become reservoirs of boredom and nausea, and the inauguration of monuments in public squares occasions of unbridled hilarity. That is hardly true in painting which, with its slow but continual renovations, brutally condemns the plagiarised and sterile work of all the sculptors of our time.[6]

The new sculpture, according to Boccioni, is no longer to be sculpture in any recognisable sense, for it will utterly have to negate conventional sculptural qualities. It will effect 'the complete abolition of finished line and the closed statue.' 'Open up the figure like a window', he writes, 'and let us enclose within it the milieu in which it exists.'[7] The only way that a true sculptural revolution can be achieved is by creating a 'sculpture of milieu or ambience, because it is only thus that plastic form will be able to develop itself by extending itself into space so as to model it . . . futurist sculpture will at last be able to model in clay the atmosphere which surrounds things.'[8]

Boccioni might seem to be promoting the novel idea of an environmental rather than object-based sculpture. But what is being proposed is an equivalent to the kind of modelling of space realised in Cubist and Futurist painting, where forms demarcating things are opened up and merge into the depiction of the space surrounding them. Boccioni has little specific to say about how this pictorial interplay between representations of things and spaces could be transferred to sculpture. When at one point he refers to 'transparent planes of glass or celluloid, wires, interior and exterior electric lights' that 'will be able to indicate the planes, the tendencies, the tones and the half-tones of a new reality', this puts one more in mind of the Constructivists' architectonic structuring of planes and volumes than his own traditional use of clay or plaster to define and bind together sculptural shapes.[9]

In the end, the 'modelling of atmosphere' he has in mind comes down to modelling forms in relief that one can read pictorially as non-literal suggestions of depth, space or fragments of solid shape, as if the forms of a Futurist painting were being congealed in clay. The problem, though, is that the boundaries of these forms are impermeable and substantive and can never be broken down to the point where the distinction between substance and space becomes as ambiguous as in painting. This difficulty Boccioni addressed in a very ad hoc manner in his own sculpture by making the shapes he modelled depart in strikingly irregular ways from the shapes being depicted. For all his theoretical radicalness, his own sculpture never quite broke out of the limits of the sculptural

51 Umberto Boccioni, *Unique Forms of Continuity in Space*, 1913, bronze, 114 × 84 × 37 cm, Tate Gallery, London

lump. Several of his sculptures, nevertheless, do have their own strangely lumbering appeal, suggesting a foiled dynamism caught up in a heavy, awkward yet exuberant disarray (fig. 51), their ingenious titles, such as *Unique Forms of Continuity in Space*, giving them an unexpected conceptualist twist.

* * *

The early modernist fascination with realising in real space what could only be depicted or suggested in painting was played out more in architecture than in sculpture. Boccioni suggested as much at one point in his manifesto when he described the new Futurist sculpture as 'architectonic, not only from the point of view of the construction of masses, but also because the sculptural block will contain the architectonic elements of the sculptural milieu in which [we] as subjects live.'[10] It was in the conceptions of architecture emerging at the time that the modernist imperative to define three-dimensional form in

52 Naum Gabo, *Column*, 1923, glass
(original glass now replaced by
perspex), metal and wood,
height 104 cm, Solomon R.
Guggenheim Museum, New York

terms of space, volume and surface rather than solid mass and shape was most fully played out. Many of the more radically abstract sculptural-looking objects produced in the period, those which definitively broke with suggestions of figuration and went for non-objectivity as consistently as the painting of Malevich and Mondrian, were conceived as architectonic experiments.[11] It was only much later that sculpture as a practice expanded from the making of plastic or constructed shapes, or of models of architectural ideas, to the literal configuring of environments.

In the projects of the early Russian Constructivists, the emphasis is on a projected reshaping of the real three-dimensional world beyond the confines of the gallery. By contrast, a lot of later Constructivist work, conceived self-consciously as sculpture rather than as models for rethinking the spaces and structures we inhabit, exists in a kind of limbo.[12] The work of artists like Gabo (fig. 52) and Pevsner, both of whom left Communist Russia to pursue careers as fine artists rather than artist-engineers, often suffers from a category uncertainty, felt particularly now that our expectations have ceased

to be informed by residues of the semi-utopian architectonic imaginings of the early modernists. These Constructivist sculptures seem to offer generalised evocations of larger architectonic structures, but in the end they have to be taken simply for what they are, relatively self-contained objects displayed in a gallery, and as such they can often look a bit empty or shoddy. Gabo's most interesting later work, the curvilinear, finely striated, slightly organic-looking and eroticised constructions of transparent perspex, present themselves more straightforwardly, and effectively, as things intervening in a gallery space.[13]

Several of the models produced by the Russian Constructivists in the wake of the Bolshevik Revolution have now become icons of early modernist sculpture. This status is very much deserved but also needs to be questioned a little, not only because many were genuinely provisional experiments, but also because they were pointedly conceived as refusing the status of aestheticised sculptural object. Even so, they were objects and they were put on display, often in novel and imaginative ways that questioned the formal constitution of sculpture as plastic shape much more radically than anything the Italian Futurists produced.

53 Alexander Rodchenko, *Oval Hanging Construction No. 12*, c. 1920, from the series 'Light Reflective Surfaces', plywood open construction partially painted with aluminium paint, and wire, 61 × 83.7 × 47 cm, The Museum of Modern Art, New York. Acquisition made possible through the extraordinary efforts of George and Zinaida Costakis, and through the Nate B. and Frances Spingold, Matthew H. and Erna Futter, and Enid A. Haupt funds

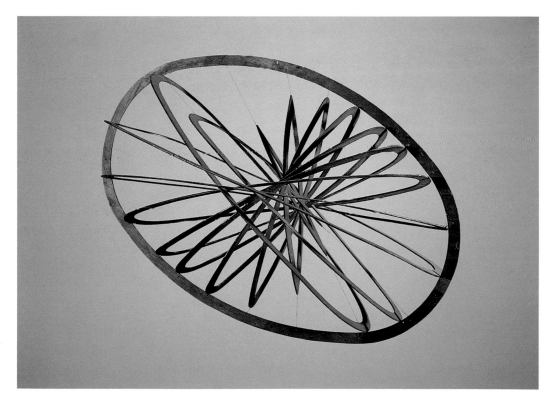

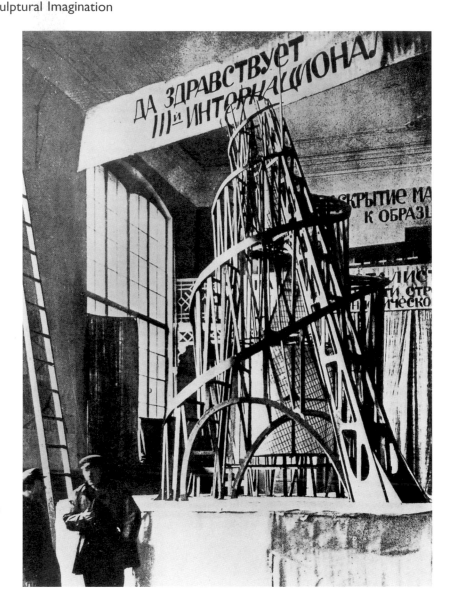

54 Vladimir Tatlin, *Model of the Monument to the Third International*, exhibited in the Studio of Materials, Volume and Construction in the Mosaics Studio of the former Academy of Arts, Petrograd (St Petersburg), November 1920, photograph from N. Punin, *The Monument to the Third International* (1920)

A light wooden, metal-painted geometric construction by Rodchenko dating from about 1920 (fig. 53), for example, is remarkable, not so much because its form anticipates that of later sculptural work – it is after all devised as a laboratory experiment in the possibilities of 'light reflective surfaces' – but because of the way it is presented. Suspended well above the viewer's line of sight, it presents itself as an intriguingly anti-sculptural thing, which dispenses with base and support and offers itself as a leap into the void. It is not just a defiantly non-figurative construct, it also rebels against the constraints imposed on traditional sculptural and architectonic structures by gravity. It is set in space in such a way that as one comes close and looks up at it, it momentarily appears to float free of the confining walls and floors of the interior environment where it is placed.

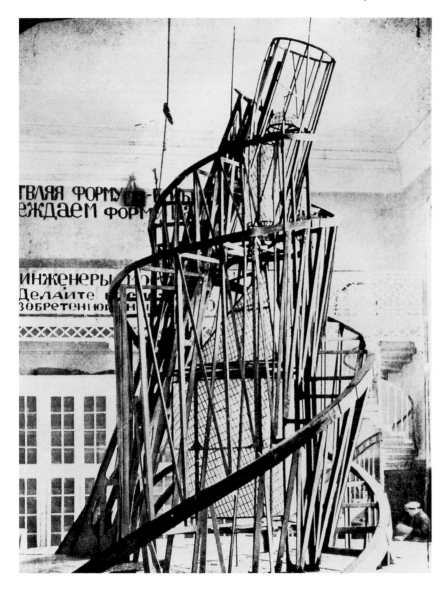

55 Vladimir Tatlin, *Model of the Monument to the Third International*, photograph from N. Punin, *The Monument to the Third International* (1920)

The model that most vividly stages the larger aspirations of early modernist Constructivism, Tatlin's *Model for a Monument to the Third International* (figs 54, 55), curiously became one of the most compelling sculptural creations of the period, even while rebelling in its very conception against the category of sculptural object. More so than Rodchenko's work, the model as first displayed in 1920 was elaborate enough to command attention as a structure in its own right. At the same time, it was integral to its conception that the viewer imagine it as a huge building looming over the cityscape. Its unrealisability, its extravagant impracticality as the plan for a real piece of engineering, particularly in the straightened circumstances of the new Bolshevik regime faced with technological collapse and civil war, was part of its point, part of its utopian impulse to break out into the realm of a totally new order of things.[14]

It was designed as a model for a building considerably higher than anything erected so far, a mobile building, one turned inside out, with no solid core and only a supporting frame, its functioning interiors suspended in space, almost defying gravity. At the same time, the actual look and feel of the model as a carpentered structure do count for a lot, indeed are integral to its truth value as the idea for an almost impossibly ambitious monument and building. The structure is futuristic in form and also wonderfully old-fashioned, the supporting struts of wood aligned less with the engineer's geometric precision than with the handcrafter's more ad hoc, but equally hard-headed and pragmatic, adjustments done by hand and eye. Its look and feel project simultaneously the idea of a radically new future in the making and a lumbering metal structure from the late Victorian railway age, of a new airborne architecture and a big dipper in a fairground.

The model works as a construct in its own right in other ways too. Looking at the carefully staged grainy photographs of the model in its exhibition space, one is struck, not only by the dynamic power and intriguing, almost excessive complexity of the open structure, but also by its carefully contrived conception and installation as a work in three dimensions. It is designed to make a dramatic impact on a viewer as a largish presence in the room where it is placed on its own, seemingly quite centrally, surrounded by words on banners hung from the ceiling or pinned to the walls clarifying its significance ('engineers and bridge-builders, make calculations for an invented new form'), and raised on a platform to loom slightly over one, but not to dominate overbearingly. It is envisaged as a structure existing in space, not just as an image or shape to be looked at. Thus it literally incorporates space in a dramatic way that few modernist sculptures actually do, with the strutted outer frame wrapped in a spiral round the cube, pyramid, cylinder and hemisphere suspended within – each of these translucent so that their outer faces become delicate skins enclosing yet further, this time partially impenetrable, interior volumes.

The way the structure sits there also introduces a dynamic instability that the plastic shapes of so much Futurist and other modernist sculpture seem to strive for but lack. Looking at the photograph which shows it from the side where one can most clearly see the largest diagonal strut going from the ground to the top (fig. 54), the effect is of a slightly tilting upwards thrust – emphatic, if a little precarious. From other angles, the effect can shift dramatically. Looking at it from a position where the supporting strut is partly hidden, and one's view is dominated by the two spirals curling upwards (fig. 55), these no longer appear in strict geometric alignment with one another but seem to be pulling together and pushing apart a little waywardly. The spirals summarily come to an end before the very top, exposing a sloping cylinder whose tilt adds to the general sense of dynamic instability. The effect is of a structure simultaneously rising upwards and collapsing in on itself. It both defies and partly succumbs to the insistent force of gravity, as if the airborne possibilities, the upwards surge, of this new open architectonics can only seem real if actively resisting the drag of material weight and mass. Few modern three-dimensional structures rebel so vigorously against the fatality of a fixed, static object.

The *Monument* may be an unusually open structure but its interiors are still literally inaccessible. One can see inside it, but can only imagine oneself being inside, even though

56 Vladimir Tatlin, *Letatlin*, with Tatlin in piloting position, c. 1932

the outer frame is permeable and the interior space opens directly into the space one shares with it. The idea of a work one might enter into is taken a stage further in Tatlin's last major project, the model for a one-person self-propelled gliding and flying machine based on studies of bird flight and bird anatomy (fig. 56). In this case, the prospective user would be enclosed inside the structure, and Tatlin had himself photographed stretched out inside its light outer frame. Again we have a materially embodied model for thinking beyond what seem to be the limits of the materially possible – technologically, it was not feasible for a machine powered by human muscle alone to take off in flight like a bird, though some compromise, a form of enhanced hang-gliding, was not out of the question.

This project, even less than the *Monument*, is not to be envisaged as an object or sculpture one simply looks at, and is striking for the way it seeks to materialise two key fantasies surrounding the idea of a new anti-sculptural sculpture in the period. Tatlin's commitment to a political and aesthetic materialism no doubt played a role in his taking things further than most of his contemporaries, and conceiving his models of a new kind of object as substantive entities existing in a real rather than merely projected space. Firstly, there is the idea of abolishing the distinction between viewer and work and creating something that would literally envelop one. Secondly, there is the fantasy of an object released from the constraints of gravity, which no longer sits on a pedestal or on the ground but exists freely in space. Brancusi's *Bird in Space* (fig. 72), almost directly contemporary with Tatlin's *Letatlin*, plays out this fantasy in a more purely sculptural register with an object that simultaneously denies and then reinstates its anchoring support.

For all the overt refusal of the status of sculptural object implicit in its original presentation, Russian Constructivist work engages the viewer in ways that are particularly

important for understanding the larger situation of sculpture in the modernist imaginary. It is work that exists as a model, prompting the viewer to imagine new kinds of structure in the real world outside the gallery, and also as an object situated in a particular environment of display, which engages the viewer directly at a physical level. The more compelling modernist objects with a model-like status, which openly invite the imaginative projections common in modernist rethinkings of the object, are those where the viewer's fantasy plays off against her or his encounter with the work as thing, and where the staging is part of its conception rather than a passive effect of the practical necessity of presenting it to be viewed. Duchamp is a key figure here because his ready-mades give that interplay a self-consciously dead-end twist.

The ultra-ordinariness of a Duchamp ready-made, such as the *Bottle Rack* (figs 57, 58), does not just pose a conceptual conundrum by presenting itself as a work of art, eliciting notions of aesthetic value while asserting its utter aesthetic valuelessness. In this respect it is unlike a found object that is supposed at the very least to be the relic of a charged encounter. The double bind also extends to one's engagement with it as an object that is staged to be viewed. A viewer of the kind to whom Boccioni's 'Technical Manifesto of Futurist Sculpture' was appealing, schooled to see a sculpture not so much for what it literally was but as a three-dimensional realisation of a painterly projection of shape, space and volume, would have this fantasy emphatically blocked by the *Bottle Rack* as soon as recognition of the object hit home. The force of this blocking may be mitigated in a present-day context because the object in question is a little exotic and no longer part of everyday life in our throwaway society. But leaving this aside, the point is that for the blocking to come into operation something in the encounter with the object needs to stimulate the viewer's projective fantasy — and this is where one begins to wonder whether the viewer is being invited to encounter Duchamp's ready-mades as objects displayed in a gallery or whether the encounter is not being staged more effectively in other ways.

57 Marcel Duchamp, *Bottle Rack*, displayed at the Tate Gallery, London, in 1966

In practice, the ready-mades are mostly widely known through the carefully contrived photographs of them that Duchamp circulated. This is not only true of the famous Stieglitz photograph of the *Fountain* (fig. 59), published after the work was censored from the Independents show in New York in 1917. There are several well-known photographs by Man Ray of other ready-mades, such as the *Bottle Rack*, taken in Duchamp's studio or flat. These were then treated and cropped by Duchamp and included in the Green Box (fig. 58) as authenticated representations. In viewing such photographs, the double bind between an imaginative projection of the work as a

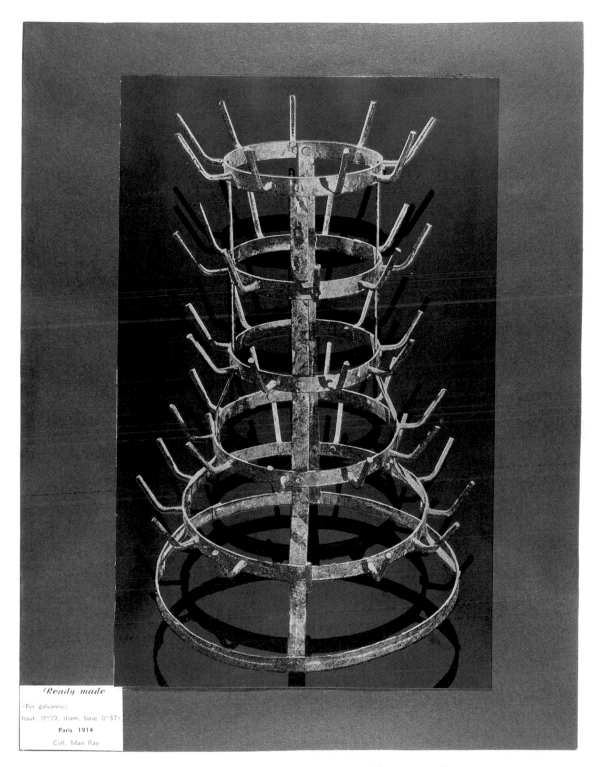

Ready made

(Fer galvanisé;

haut. 0ᵐ59, diam. base 0ᵐ37)

Paris 1914

Coll. Man Ray

58 Marcel Duchamp, *Bottle Rack* (1914, height 64 cm) from the *Boîte en Valise*, photograph by Man Ray treated by Duchamp, Philadephia Museum of Art, The Louise and Walter Arensberg Collection

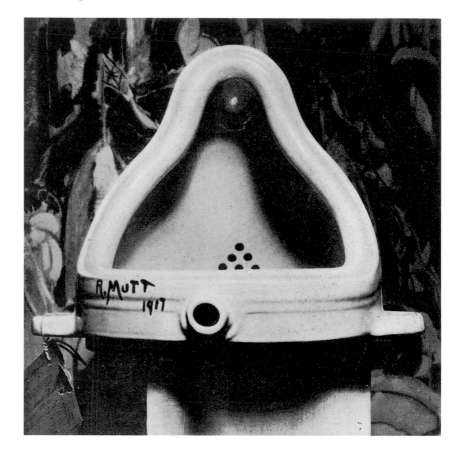

59 Marcel Duchamp, *Fountain*
(porcelain, height 60 cm),
photographed by Alfred Stieglitz
and published in *The Blind Man*,
No. 2, 1917

resonant form or shape, and the blocking of that through one's awareness of what it actually is, really comes into its own. The photograph cuts the object out of its context and not only defamiliarises it by isolating it as a thing to be viewed but also gives it a certain aura, partly through the calculated cropping and shading and simplifying that makes the shape stand out. This effect then comes into conflict with the equally immediate sense one has of the cheap ordinariness of the thing posed in the photograph.

In a gallery, the actual insignificance of the work as object, essential to its conception, can dominate too much, often highlighted by its arty presentation on a pedestal under focused spotlights (fig. 57). The proportions and substance of a *Bottle Rack* are actually fairly mean and flimsy, whereas the photograph sets up a kind of tease – almost tricking one into seeing it as an intriguing form. It might be argued that the ordinary object as presented in a gallery, rather than in a photographic image, creates a telling aesthetic blank spot in an arena devoted to aestheticised display. But even this only works if the ordinariness of the object is in some way striking. Nowadays, too, an everyday object displayed as a work of art is unlikely to make one think of the unconditional blankness of the non-aesthetic because the artistic gesture involved has itself become so ordinary.

There are other ways too in which the ready-mades as displayed in a gallery suffer in comparison with their photographic presentation. The photographs convey the sense of an immediate, no-nonsense one-to-one encounter with the object, unencumbered by the

sanitising panoply of museum display, whether pedestal or showcase. The *Bottle Rack* should just seem to be sitting on the floor, impertinently and purposelessly. Interestingly, the original Man Ray photograph shows it on a lowly home-made pedestal, excised by Duchamp, which infuses it with just a touch of the stolid and distancing self-importance of the sculptural object. It should also look like something one could pick up and put elsewhere, or shove a few empty bottles onto. One needs to imagine engaging with it at several different levels, as an object to be moved and handled and not only looked at, and one is hardly incited to do this when viewing it as an *objet d'art* in a gallery. Similarly, the *Fountain* (fig. 59) is an object to be pissed into and which, when installed as a working urinal, will flush itself out with water. Tipped onto its side, with the empty socket that would take the pipe feeding it with water facing outwards, there is, for a man at least, one further and extremely uncomfortable mode of engagement being suggested, one that is enhanced by imagining the protruding hole placed at crotch level. Truly a blind encounter this one, but one perhaps we do not want to get too stuck into.

<p style="text-align:center">* * *</p>

The issue of the viewer's mode of encounter with a work brings me to a rather later moment in twentieth-century modernism, when the encounter with the object became a concern in its own right. I say encounter with an object, rather than a sculptural object, because Surrealist theories of the object were categorically anti-formal and purposefully blind to questions about the staging and viewing of sculpture. The Surrealist conception of the object was elaborated most fully by André Breton in his essays on the situation and crisis of the object dating from 1935–6 and in his novella *Mad Love*, published in 1934, where he developed the idea of the found object.[15] His theorising, while ostensibly concerned with objects that were in no way to be seen as art objects or sculptures in a conventional sense, was clearly intended as an intervention in debates about modern art, paralleling the 'Surrealist Exhibition of Objects' he helped organise in Paris in 1936. This exhibition, incidentally, included Duchamp's *Bottle Rack* and other odd modern works, along with examples of what was then seen as tribal or primitive art, crowded together in glass display cases.[16]

Breton's discussion focuses on the idea of an object, whether the latter is fabricated or chanced upon, whether it exists in three dimensions or is depicted in a painting, that momentarily seems to be an emanation or concretisation of one's inner fantasy, the external object seeming to fuse with the image in the mind.[17] While at one level this echoes certain late Romantic understandings of the aesthetic object, it is also quite contemporary in that Breton draws on recent psychoanalytic theory, and introduces a note of contingency and arbitrariness to the constitution of the object in question. As Breton sees it, it is not something lodged in the object that produces the experience. The experience is generated in the chance encounter between the viewer and an object he or she suddenly seizes upon, which seems to respond to some inner drive and involuntarily triggers a psychically charged response. The object in question is conceived rather as Freud conceived the object of an instinct,

> the thing in regard to which or through which the instinct is able to achieve its aim. It is what is most variable about an instinct and is not originally connected with it,

but becomes assigned to it only in consequence of being peculiarly fitted to make the satisfaction possible.[18]

The essential contingency of a psychically charged encounter between viewer and object, stressed by Breton, is an important feature of any viewer's response to a work of art which tends to be ignored in most art theory. However, Breton's analysis evades a crucial dimension of this encounter when the object concerned is not a found one, but one staged to be viewed and to elicit a response. The viewing involved then is always a little focused and self-conscious, with the viewer becoming aware of disparities between what the object is as artefact and physical phenomenon and the inner fantasies it might momentarily stir. The moment of immediacy beloved of Breton, when inner impulse and external object seem to be one, cannot be sustained under these circumstances. Moreover, while it is easy enough to imagine coming across an object in the way Breton envisaged in the course of cruising round an exhibition or museum, or leafing abstractedly through a set of photographic illustrations, this is not the case as soon as Breton's idea of an 'authentic Surrealist object' is introduced.[19] When an object is singled out that is supposed to spark a charged unconscious response, this gets in the way of the free-wheeling spontaneity of encounter that is the precondition of such unconscious interplay between self and object. A Surrealist object, presented to the viewer as giving concrete shape to her or his inner fantasies, is a bit of a contradiction in terms, which may in part be why it is also quite an interesting idea.

Breton neither invented the idea of the Surrealist object nor the notion of a contingent, psychically charged encounter, but he did play a leading role in propagating a new fascination with three-dimensional objects that might escape traditional definitions of the sculptural, a 'type of little non-sculptural construction', as he put it.[20] Experiment with Surrealist objects goes back at least to the late 1920s. By 1932, Salvador Dalí had already published his influential essay 'The Object Revealed in Surrealist Experiment', which Breton cited extensively. I want, though, to focus on a lesser-known piece of writing, a critical essay on Giacometti's objects published by the Surrealist writer Michel Leiris in *Documents* in 1929, because it exposes so well some of the ambivalences that haunt the Surrealists' attitude to sculpture.[21] While Leiris refers to Giacometti's objects as 'sculpture', he also stresses that they are not dead like most sculpture, and begins his discussion saying: 'Don't expect that I shall actually talk about *sculpture*. I prefer to DIGRESS; because these beautiful objects that I have been able to look at and feel activate in me so many memories'.

Leiris makes it clear that he is fascinated by Giacometti's work because it had an unexpected effect on him at odds with the state of boredom in which he usually found himself in the presence of works of art. His encounter with it provoked one of those rare moments of genuine crisis 'where what is outside us seems brusquely to respond to the summons that we issue to it from within ourselves, where the external world opens itself up so that a sudden communication establishes itself between it and our heart.' The events that usually spark such a crisis, Leiris explains, are 'futile in appearance, denuded of symbolic value and if one so wishes, *gratuitous*.' We come back here to an issue we noted in connection with Breton: how does one have a gratuitous encounter with an object that is presented as being something special?

Coming across Giacometti's work when he visited the artist's studio, Leiris is suggesting, was something of a discovery, and as such had a certain element of chance about it. It appears too that the work struck him as lacking in the formality and aesthetic pretension of conventional sculpture and as being intimate enough in conception to answer to his fantasy in ways that most art did not. Indeed, the works in question were quite small studio experiments, almost sculptural sketches, which still mostly existed in plaster and were not yet fully packaged as *objets d'art*.[22] Their apparent informality also struck Leiris as answering to another anti-sculptural fantasy, that of an object concretised in hard matter that could nevertheless be imagined as dissolving itself in the fluid medium of air or water. Leiris's essay finishes with him musing about how the stuff from which the sculptures were formed – mostly plaster – could be metamorphosed into dust, then into salt, a salt that in turn dissolves and becomes the salt water of the sea, or the salty liquid of human sweat and tears and then, in a nice return to the gritty, the salt of cracking joints. Moreover, these objects seemed to him not just things to be looked at, or even touched and mused over, but things one might literally engorge. 'Here at last', he concludes, 'are dishes in stone, food of marvellously living bronze, and capable for a long time of arousing and reviving our great hunger.'

The Surrealists raised one crucial point about the nature of a viewer's interaction with a three-dimensional object that was consistently bracketed in contemporary formalist aesthetics, namely that what one feels when looking at an object can resonate with a non-visual physical contact with it. Dalí talked about objects that would not just operate symbolically, but would 'fulfil the necessity of being open to action by our own hand', or where 'it does not seem enough to devour [them] with our eyes, and our anxiety to join actively and effectively in their existence brings us to want to eat them.'[23] This invitation to imagine a multiplicity of sensuous contacts with a thing is certainly crucial to that most widely known Surrealist object, Meret Oppenheim's *Déjeuner en Fourrure* (fig. 60). It provokes a curious mixture of fascination and disgust by prompting one to think of drinking out of the fur-covered cup, and of the sensation of furry hair coming into contact with one's tongue and lips, perhaps sodden with warm liquid, all the while thinking of the origins of the actual fur as the hair and skin covering a once living body.

Giacometti's *Suspended Ball* (fig. 61), a work he produced a year or two after the more conventional sculptural objects admired by Leiris, has also become a Surrealist icon and also, if less immediately and directly than Oppenheim's *Déjeuner*, prompts the viewer to imagine physically intervening in it. But the more highly charged interactions in this case are played out within the work. When one imagines setting the ball swinging to and fro, the most powerful effect is the teasing interplay this would activate between the sharp incising object and the apparently softly rounded ball, with the one seeming almost sadistically to cut into the other, but then perhaps not actually quite making contact with it either. This effect has none of the open informality of contact invited by some of Giacometti's single small objects, which just lie there ready to be picked up, like the phallic *Disagreeable Object* with flesh-lacerating points affixed to its tip – 'objects . . . without value, to be thrown away', as Giacometti put it.[24] *Suspended Ball* is carefully composed and framed – almost like a picture in three dimensions. When Giacometti later made the point that with this kind of work he had 'a tendency to become absorbed only in the construction of the objects themselves', he may have been referring to the

60 Meret Oppenheim, *Objet: Déjeuner en Fourrure*, 1936, fur-covered cup, saucer and spoon, height 7, diameter 24 cm, Museum of Modern Art, New York, photographed by Man Ray

potential trap of formalist fiddling to which these more elaborately contrived objects could lead.[25]

* * *

In a self-conscious shift away from his Surrealist object making of the 1920s and 1930s, Giacometti relaunched his career immediately after the Second World War with a series of free-standing figures. His much quoted letter to the New York based dealer Pierre Matisse, which introduced the catalogue of his exhibition held there in 1947, offers an elaborate rationale for this change. He obviously wanted to ensure that the new departure was not seen as a conservative return to figuration but as a formally self-conscious restructuring of his practice.[26] The change has been discussed very thoroughly, but there are some points that I need to draw out for my argument about changing conceptions of modern sculpture. I want to focus on how Giacometti's later figures (fig. 62) are calcu-

latedly designed to set up very different kinds of interactions with the viewer than his earlier objects.

It is this aspect of Giacometti's later work that struck a strong chord with Minimalist artists such as Serra and Judd. Judd singled out Giacometti as one of the few exceptions to the general tendency of modern sculptors to focus on the solid and monolithic, making space 'primarily negative' or 'pictorial or 'inherent in the representation'. With Giacometti, he argued, there began to be a sense of the work as activating and articulating space. His 'standing figures . . . are the apple core of their spatial apple' – though he added the qualification that even so, Giacometti stopped short of a full advance into a spatial, proto-Minimalist sculpture. 'The apple core', as he put it, 'is not the center of an expanded shape but is the residue of a solid.'[27]

Giacometti remained a committed modernist, above all committed to the modernist refusal of mass and monumentality. 'Figures were never for me a compact mass but like a transparent construction', he wrote.[28] If one cannot literally see through his later figures, one can easily see past them. They are far from being impenetrable things blocking one's space, and in so much as they are felt to have presence, it is not by virtue of their mass or substance. I recall an installation in the central sculpture gallery of the Tate Gallery when a Giacometti figure was placed in the company of a number of post-war bronze figures by Henry Moore. It was striking how the relatively diminutive Giacometti marked a place in the gallery and asserted itself much more insistently than the Moores, which seemed somewhat lumpish and inert in comparison. What I have to say here is partly addressed to thinking how and why this might be the case.

In a way conventional vertical sculptures, Giacometti's figures are as such comparable to the work David Smith was producing (fig. 80) when he departed from the more horizontal object-like format of his earlier sculpture. The idea of an expansive horizontal intervention in space – work that was 'open and extended' as Judd later put it – did not really enter into sculptural practice until the 1960s, first with Caro's free range, sprawling constructions and then with Minimalist work and the informal floor installations of process art. When Giacometti was reconfiguring his sculpture in the 1940s, the alternatives were roughly speaking between an all-round, small-scale, relatively contained

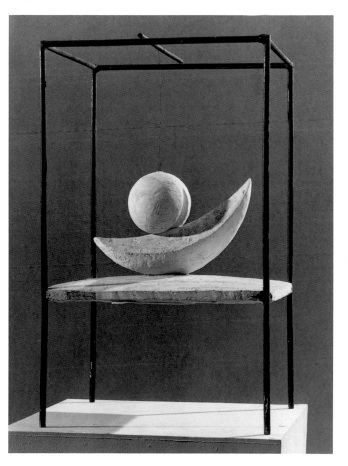

61 Alberto Giacometti, *Suspended Ball*, 1930–1, iron and plaster, height 60 cm, Alberto Giacometti Foundation, Kunsthaus, Zurich

object-like work, whose presence did not directly compete with the viewer's, and work that was figure-like in scale and format, mostly upright, but sometimes reclining or sitting. It is clear that Giacometti wanted to move away from an object format and create work that planted itself directly in the viewer's space and that faced one, rather than being something one came across. Hence his much quoted comment about his main rival: 'Brancusi makes objects and only objects.'[29]

Far from being the reductively simple things they initially seem, Giacometti's figures – particularly the standing female ones (figs 62, 63), as distinct from the less consistently poised striding or pointing men – set up complex interactions, insistent and at the same time elusive, with the viewer who approaches them. The figures face in one direction, almost looking as if standing to attention. For all its emphasis, though, their facing out is not given a very settled, substantive form. This is not only because the figures are thin, upright struts, with little in the way of modelled shape to define the front of a body, but also because the head is usually squeezed flat and so when looking at it frontally, the face reduces to a thin point. The axis of address only becomes fully visible when one is displaced to the side and sees a profile jutting out at right angles from the very slightly flattened front of the torso. There is then a tension between the all-round quality of the tapering shape seen as a whole and its subtle, yet insistent, articulation as a figure facing in one direction. A further tension makes itself felt in the figures' vertical thrust, produced by the disparity between the attenuated thinness of the overall form and the thickening lump of substance at the feet. The figure is planted firmly, almost sunk into the ground, and yet also seems to soar upwards, defying mass and the pull of gravity.

Much has been made both by Giacometti and his critics of the way the thinness of these figures creates ambiguities in one's sense of their placing and scale.[30] On the one hand, their narrowness and the diminutive proportions of the heads, confounding the dominant presence of the head in one's everyday perceptions of a human figure, make them keep their distance, however close one gets. On the other, even the smaller figures have a vertical reach that creates the effect of a presence looming directly before one, an effect enhanced by the absence of horizontal articulations that usually help to fix the scale and locate the distance of things one sees.

In addition to this instability of general address, there is a further equally striking instability, which is not so often commented upon, and that only becomes apparent if one moves in very close. From most standpoints, one sees a simple upright shape, with slight smudges adhering to the geometric core – Barnett Newman appropriately thought of it as spittle (fig. 62).[31] But the sketchy, almost repulsively bitty irregularities of the modelling look radically different when one comes close. Then a vibrantly modelled surface comes into view, leading the eye up and down the figure in a continuous, restless flow of movement (fig. 63). The effect is quite different from that in Rodin's work. The modelled surface is too narrow to engulf one, and there are no undulations and bends to tip one's orientation, so everything remains strictly up and down. The main difference, though, is the radical disparity between the vivid substance of the modelling when viewed close up and the thin, astringent silhouette of the whole figure seen from a distance.

As one looks closely, specific shapes also begin to make themselves felt, scratches or cuts marking an eye, a split separating the legs, and incisions and lumps suggesting the

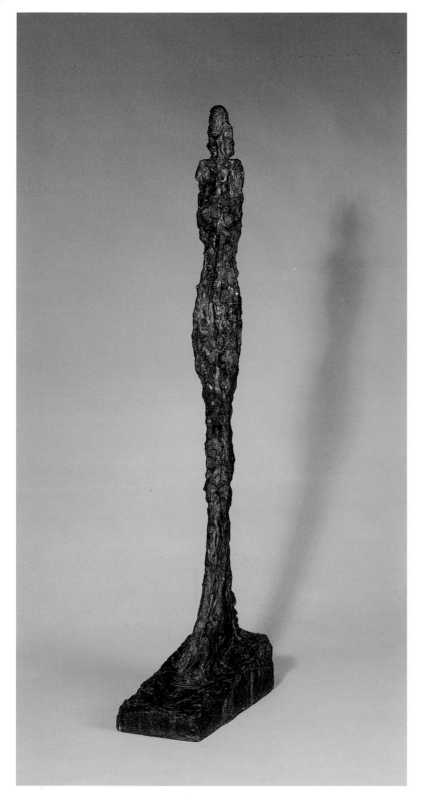

63 (*above*) Alberto Giacometti, *Venice Woman IX*, detail

62 Alberto Giacometti, *Venice Woman IX*, one of a series created for the Venice Biennale in 1956, bronze, 113 × 16.5 × 34.5 cm, Tate Gallery, London

rounding of different parts of the abdomen. While they may now and again loom large, these features never stabilise themselves. They are suggested by irregularities of modelling that appear to be generated almost contingently in rapid, even movements of the hands, touching and cutting. Just as for the viewer, distinct body shapes come into focus from time to time only to disappear again, so too they seem to have been fashioned in a process of shaping and unshaping. The one clear anchoring in all this is the vertical armature, itself no more than an empty cipher, a spare marker of presence, whose rigid uprightness never quite dissolves in the play of surface that flows along and around it.

One of the most telling responses to these figures in Giacometti's lifetime comes in an essay Jean-Paul Sartre published in 1948.[32] Much of what Sartre writes might seem a little dated now, part of the Existentialist Giacometti myth that so resonated among intellectuals in the 1940s and 1950s. Also, as with so many other commentators on Giacometti, there is a slightly discomfiting slippage between his evident fascination with the scarcely indicated sex of the female figures and his conception of them as embodiments of some basic human essence. Still, Sartre often describes the hold these sculptures had over him in ways that remain evocative today. One comment provides a fitting note on which to end this encounter with Giacometti, suggesting as it does something of the larger content that gave the artist's formal innovations a resonance that has outlived several subsequent changes of artistic and philosophical fashion. Sartre is trying to explain the nature of

> the kind of Copernican revolution that Giacometti tried to introduce into sculpture. Before him people thought they were sculpting *being*, and this absolute collapsed into an infinity of appearances. He chose to sculpt situated appearance, and it became apparent that by way of this one attained the absolute.[33]

Sartre has in mind here the bare suggestion of some unconditional self-posting, pared down to almost nothing and yet somehow sustained within the disparate appearances that constitute our situation in the world.

The Problem of Sculptural Form

Before moving on to consider Brancusi's project as a maker of objects, we need to consider how sculpture was being conceived within the new formalist theory, largely of German origin, that played such an important role in modernist conceptions of visual art. As we have seen, sculpture in the period was often thought of as simply embodying in three dimensions a plastic form depicted in painting. At the same time, it was a vehicle for certain persistent fantasies surrounding the modernist art object. Sculpture provided a peculiarly concrete instance of the autonomy of the art work, of plastic form really made into objective self-sufficient thing.[34] Equally, and almost contradicting this, the modernist fascination with the idea of dematerialising solidity and mass in pure form and space and volume was played out in projections of a radically new conception of sculpture. In practice, of course, the evident materiality of actual sculpture could make the fantasy difficult to sustain, just as it threatened to reduce autonomy to commonplace fact.

If one is to understand the theoretical paradigms shaping attitudes to sculpture in the early twentieth century, a good place to start is Adolf Hildebrand's *The Problem of Form in Figurative Art*, first published in German in 1893. This text became a key reference for early formalist accounts of sculpture. Hildebrand's analysis is particularly relevant for my purposes because he was a sculptor and he developed an aesthetic that took account of the distinctive ways in which a sculpture would be viewed. Thus, while he proposed a painterly model of formal coherence, he also drew attention to perceptual effects that come into play when looking at a free-standing sculpture, which were ignored by many later writers who criticised him for his painterly bias.[35]

The notion of plastic form as it was deployed by Hildebrand and other contemporary German theorists of artistic style, such as Alois Riegl, was not a sculptural term. It designated the densely textured, opaque two-dimensional shape that distinguished itself from the relative emptiness of the visual field surrounding it when the perceptual apparatus differentiated figure from ground. The plastic form of an object was that view of it which presented its overall shape with greatest clarity. Egyptian relief sculpture was seen as a characteristic instance of a plastic art, where objects stood out as separate, palpable and clearly delimited shapes laid out in a plane oriented perpendicular to the line of sight. Representing the world in these terms defined a haptic, that is, a tactile, way of seeing, as distinguished from a painterly one in which such stable forms were dissolved in effects of colour and tone.[36] Hildebrand's thesis was that the variable forms presented by sculpture in the round had to be overcome by defining a principal viewpoint from which the sculpture became manifest as clearly delimited form. Only this guaranteed that the sculpture would be seen as a satisfying whole, allowing the viewer a contemplative calm that would be disturbed by having to move round it and observe its shape from different viewpoints.

Hildebrand's analysis invoked a model of seeing pervasive at the time, which continued to inform the formal analysis of art for most of the twentieth century. 'Vision', as he understood it, 'is in its very nature two dimensional', and vision in depth is a second-order inference made on the basis of the stream of two-dimensional images that we immediately see as we move around in a three-dimensional world. In the terms established by this model, the priority of the two-dimensional image relies not only on the two-dimensional character of the raw data recorded on the retina, but also on the structuring forms through which the mind creates a stable representation of the world from the flux of immediate visual and kinaesthetic sensation. For Hildebrand, as for subsequent generations of formalist theorists, the processes whereby we create an intelligible spatial mapping of the world involve two-dimensional representations that provide maximal information about three-dimensional shape and space. Writing when he did, Hildebrand simply took for granted that 'the unitary plane picture' defines how we apprehend things visually, even though this assumption was not necessarily born out by the recent scientific theories of visual apperception on which he and other modern writers on art and visual aesthetics drew.[37]

What we seem to have with Hildebrand is a purely optical conception of sculpture, in which the point of reference for the artist working in the round, and for the viewer, is the relief image a work presents from its principal viewpoint. The other partial views, comparable to the 'complex of innumerable kinaesthetic ideas' one has when

looking at things in the real world, should not, according to Hildebrand, separate out as significant in themselves, but be subordinated to this 'simple visual impression stimulating a strong idea of depth, which the resting eye is able to take in, without kinaesthetic sensations, or movements producing such.'[38] The very explicitness with which this model accommodates the viewing of sculpture to the literally framed apprehension of a painting or a relief serves to highlight a number of important points. Hildebrand's theoretical stance forced him to tackle an issue usually evaded by theorists of the time, who insisted on a straightforward distinction between the tactile nature of sculpture and the visual character of painting. Such a distinction, based on differences between touch and sight, could never be as clear-cut as it might seem at first, given that sculpture, no less than painting, needs to be viewed. A more important complicating of the distinction, though, on which Hildebrand insisted, arises from the interplay between the visual and the tactile or kinaesthetic which is internal to processes of seeing. He argued that we never see things in purely visual terms, in isolation from the awareness of their three-dimensional shape and spatial positioning that we unconsciously infer from our looking. There can be no purely visual looking. We are always apprehending things in space in a way that encompasses both seeing and coming into contact with them. Thus we could not 'regard the sculptor's art as appealing exclusively to the tactual-kinaesthetic sense of the aesthetic percipient . . . [and] the painter's art, on the other hand, as appealing exclusively to the visual sense quite apart from all experience of form.'[39]

The main force of his polemic was directed against contemporary conceptions of painting as an art of pure visual sensation which, for example, informed certain apologias for Impressionist work. Hildebrand was allying himself with theorists of a classicising bent who stressed the significance of tactile or plastic values in painting, even if he himself did not make much use of these actual terms.[40] He was unusual, though, in thinking about the implications of this stress on tactile values for sculpture. Tactile values, his analysis made clear, are essentially painterly in nature, and concern the vivid sense of three-dimensional shape and depth suggested by certain two-dimensional forms. In his scheme of things, then, sculpture in the round does not simply embody tactile values. It can only create an aesthetically resonant apprehension of depth by defining a principal viewpoint from which it offers a clear and satisfying two-dimensional plastic form. Hildebrand, unlike many later theorists of the sculptural, here at least explicitly recognised how much his own viewing of sculpture was inflected by expectations and habits derived from the viewing of painting.

He also provided an unusually full analysis of the distinctive kinaesthetic effects produced by viewing sculpture in the round. Normally, commentary on this was limited to the fairly obvious point that a sculpture changes appearance as one moves round it and sees it from different viewpoints. Hildebrand went a stage further, drawing attention to the radically different kinds of visual apprehension that come into play as one shifts from a relatively distant viewpoint to a near one. He pointed out how, close up, perceptions of depth become much more vivid as the effects of stereoscopic vision start making themselves felt. The visual sensations registered by the eyes also change much more rapidly with their slightest movement, while the eyes themselves have to make continual adjustments in order to maintain accommodation and convergence. Accommodation refers to the adaptations made by the lens in the eye to keep an object in focus, and convergence

to the different angling of the eyes that is required when they are trained on an object that is close by.[41] Hildebrand was well aware of the power of these kinaesthetic sensations, and how they could become more vivid than the image-like apprehension of the sculpture as a whole plastic shape seen from a distance.

It was Hildebrand's acute awareness of these kinaesthetic effects of viewing a sculpture in the round that made him so insistent that apprehension of a sculpture needed to be anchored in a single relatively stable shape. The sculptor's problem, as he saw it, was to ensure the dominance of the 'pictorial clearness' of form to be had from the principal viewpoint. This meant that the forms of a work needed to be chosen with a view to how they would look at a distance, from the principal vantage point, bearing in mind that 'it does not follow that forms which are expressive when perceived stereoscopically, or separately at close range, should continue to be so when presented in the visual projection'.[42] The particular consequences that Hildebrand drew from his analysis bracketed out the more vivid disparities between different views of a work in favour of a classical unity, repose and visual clarity. Even so, he unwittingly provided a basis for defining the distinctive kinaesthetic effects exploited in sculpture such as Rodin's, the very work he was implicitly arguing against, and which captivated the imaginary of the contemporary art world in ways that his own elegant and undeniably highly accomplished productions as a sculptor singularly did not.

One of his most prescriptive passages is instructive for it brings to a head the tension, productive at times, stultifying at others, between his acute sensitivity to kinaesthetic effects and his commitment to a classical model of formal coherence. He is discussing how a sculpture needs to present itself from its principal viewpoint as if it and its immediately surrounding space are enclosed within a rectilinear frame, with the sculpture disclosing itself as a compact shape organised in receding planes like a relief:

> Whenever this is not the case, the unitary pictorial effect of the figure is lost. A tendency is then felt to clarify what we cannot perceive from our present point of view, by a change of position. Thus we are driven all around the figure without ever being able to grasp it once in its entirety. Not a hairbreadth's advance has been made through representing the object in a work of art: it might as well have been left a piece of Nature. The purpose of sculpture is not to put the spectator in a haphazard and troubled state regarding the three dimensional or cubic aspect of things, leaving him to do the best he may in forming his visual ideas. The real aim is to give him instantly a perfectly clear visual idea and thus remove the disturbing problem of cubic form.[43]

This discussion points forward to aspects of later modernist analysis, and also backwards, to the sorts of unease nineteenth-century critics such as Baudelaire expressed about free-standing sculpture. Like Baudelaire, Hildebrand envisaged the autonomous sculpture as an inherently problematic departure from earlier sculpture that had an architectural anchoring. His anxieties, though, were expressed in much more formal terms. An architectural framing, as he saw it, was important because it situated a sculpture and structured the viewer's perceptual encounter with it. When sculpture was located in an architectural context, 'the plastic representation remains enclosed in a simple, comprehensible total form – a fact which insures to the eye unity and repose'. As a result of

modern sculpture having 'emancipated itself from the architectural bond', and freed itself from the 'necessity of a regular and compact total form', 'there arose a new problem'.[44]

Hildebrand's solution to this problem, which involved articulating a principal axis of address from which the sculpture would present a clearly defined shape, does not simply testify to the pervasiveness of an essentially pictorial understanding of sculpture. His analysis has a richer purchase than this because it highlights a general problem, which so much modern theorising of the sculptural failed to acknowledge, that a sculpture constitutes itself as a thing to be viewed by way of some kind of framing or staging of its situation in relation to the viewer.[45] Viewing a sculpture is never a purely open encounter between a free-standing object and free-wheeling viewer. Free-standing is in fact a misnomer. The very existence of a sculpture as a work deliberately constituted to be looked at depends upon a tension between the in theory open-ended, ever-changing views it offers and some sense one has of it as a definite thing impinging on one's awareness.

* * *

Soon, Hildebrand's conception of sculpture came in for a considerable amount of criticism from formalist writers who saw it as imposing an excessively pictorial model on sculpture. But this does not mean that the modified conceptions of the sculptural being proposed were any less in thrall to a pictorial understanding of sculpture as plastic shape than Hildebrand's. A good case in point is the sharp critique of Hildebrand's supposed suppression of the experience of shape in the round, or of cubic depth as it was referred to at the time,[46] launched by the early theorist of Cubism, the dealer Daniel-Henri Kahnweiler. He was particularly intrigued by the idea of sculpture as some radical other to painting, some absolutely autonomous *Gestalt* that escaped the framing structurings of pictorial representation.

In his essay 'The Essence of Sculpture', published in 1919, Kahnweiler not only took Hildebrand sternly to task for his painterly notion that a free-standing sculpture should be structured formally like a bas-relief. He also argued forcefully against the idea that sculpture distinguishes itself from painting because, as three-dimensional object, it is viewed differently and brings into play kinaesthetic apprehensions that are excluded from painting. As a champion of Cubism, Kahnweiler not only wanted to think of modern painting as being capable of encompassing the multiple sculptural apprehensions of an object seen from different positions.[47] He also wanted to shift the discussion away from questions about modes of viewing and focus instead on the absence of a figure/ground relation in sculpture.

The representation of an object in a painting, as he explained, inevitably includes something of its context, whereas a sculptural representation has to limit itself to 'the object pure and simple, detached from everything surrounding it'. This means that in a painting an object always exists within a separate field bounded by the frame, while with a sculpture the situation is quite different. The object exists in the real space within which it happens to be shown and there is no fictive space around it to delimit it from other real objects. It is in effect 'one object among others'.[48] According to Kahnweiler, the only thing that can set a sculptural representation off from other ordinary objects that happen to enter one's visual field is a satisfying regularity of form, a regularity that needs to stand

out regardless of the context in which the work is shown. A true sculpture thus is an object possessed of an autonomy and inner formal logic that are manifest independently of the context in which the object is seen:

> It knows how to live in any kind of milieu, always sovereign, because the forms it presents are not fortuitous. They are those primary forms themselves that condition all our experience of space.[49]

But here we hit a problem common to much modernist theory of visual abstraction. How can the visible form of an art object embody structures that underpin our perception of space and shape when such structures are the non-empirical categories that enable us to apprehend the particular forms of the object in the first place? Kahnweiler's true sculpture seems to be an ideal, mental object that needs no actual material context to come into being. This impression is certainly confirmed by the conclusion to his essay where he engages in a wholesale critique of the painterliness of all existing Western sculpture, from the Middle Ages through Michelangelo to Rodin and Rosso. Every sculpture he passes in review is condemned as impure and contaminated by suggestions of fictive pictorial space.[50] This of course may be the real condition of any actual sculpture.

* * *

A rather more suggestive critique of the image-based formalism that dominated sculptural aesthetics in the early twentieth century is to be found in Carl Einstein's pioneering essay on African sculpture published in 1915. This offers by far the most concerted attempt in the period to adumbrate a sculptural aesthetic that would do justice to the 'cubic' quality of free-standing sculpture. Einstein was more actively antagonistic than Kahnweiler to the view of sculpture adumbrated by Hildebrand and to what he saw as its essentially pictorial frame of reference. What was needed, he felt, was a conception of sculptural form that properly privileged 'the immediate expression of the third dimension'.[51] But what precisely did this mean? A little like Kahnweiler, he was obliged to define this 'cubic' sense of shape in largely negative terms. A true sculpture, in his view, should be entirely free of the pictorial devices that structure two-dimensional representation and of any consideration of context. Its staging, or a sense of it being placed somewhere to be viewed, represented a concession to a painterly, subjectivist conception of things that belied the simple, real objectivity of true sculpture.[52]

Traditional African sculpture suited this paradigm perfectly because it was made as a sacred object, and so would seem to require no audience to endow it with significance. It could be seen to exist in its own right independently of any human response. In Einstein's view, 'the European work of art has precisely become the metaphor of effect, which incites the spectator to an indolent liberty. The negro art work is categorical and is in possession of an essential existence which excludes all qualification.'[53] African sculpture was effectively seen by him as the very embodiment of the modernist fantasy of an absolutely autonomous art object existing only in and for itself. His analysis is particularly significant for projecting this fantasy onto work that at the time seemed more immediate and vital than the classical works of ancient Greek sculpture that previously

had stood as models of such autonomy and wholeness, and as the other to modern art's subjectivism and perspectivism and theatrical seeking after effect.

Einstein's attempt to define the essence of the authentically sculptural led him to exclude on principle any consideration of how sculpture might be viewed, whether as an item of ritual use in its culture of origin or as an object in a modern gallery or museum. For him, the true apprehension of sculpture was a static, timeless experience that abolished any suggestion of the process of viewing. The three-dimensional shape, the volume as he called it, should come over as 'immediate and instantaneous form'.[54] The key term in his sculptural aesthetic was volume, a form transparently manifest to the inner and outer eye in all the fullness of its three-dimensionality. In practice, of course, this volume had to be apprehended as an image, with the full-frontal view presenting a single, clear shape that had no spatial ambiguities.

Einstein did not just want to abolish the material contingencies of viewing a sculpture that might interrupt an apprehension of its perfect wholeness. He also wanted to do away with any sense of mass and substance. Mass implied a materiality that would block the apparent transparency of a volume instantaneously revealing itself to the mind's eye. He was not here wishing away the literal opacity of African sculpture, but claiming that the shape was defined with such categorical simplicity that the viewer could see it in its full three-dimensionality at a glance. In wanting to locate the aesthetic impact of sculpture in an apprehension of volume that rendered redundant solidity and mass, he was very much in tune with the dematerialising tendencies of contemporary avant-garde sensibility.

The implications of these ideas on sculpture were never developed by Einstein himself in his subsequent writing on modern art. In the wide-ranging survey *The Art of the Twentieth Century* which came out in 1926, he was at a bit of a loss to reconcile the actual work of modern sculptors with what he took to be the most vital currents in contemporary art, currents he identified above all with Cubist painting. His discussion of sculpture was very brief and tacked on at the end, almost as an afterthought. Like many modernist critics of the period, he singled out Maillol as the foremost practitioner of a truly sculptural art in an age dominated by a painterliness epitomised in his view by the public liking for the baroque, non-sculptural effects of Rodin's work. Maillol (fig. 64), he claimed, 'fixed the tactile essential volume, the volume which was effective as cubic form. He bound it together so that from as many viewpoints as possible, the viewer was faced with a clarified cubic form.'[55] But with a caveat. Maillol's commitment to a true plasticity in harmony with early Greek and Egyptian conceptions of sculpture – which now seems little more than bland middle-brow wholesomeness – meant that his art was probably not adapted to giving form to present-day concerns. We had to question 'whether we can seek our satisfaction in this calm balance, whether this doesn't bind and limit us too much historically.'[56]

To suggest that sculpture was in some way antithetical to a modern European sensibility and located in the past – whether ancient Greece or the culturally more distant traditional societies of Africa – was something of a cliché. Equally conventional was Einstein's claim that the twentieth century was essentially a century of painting, and that only painting could point the way to a truly modern sculpture that had not yet come into being, one that would renounce solid configurations of three-

dimensional form for a play of volume and space. He did mention in passing that there were signs of a new beginning – sculpture in which depth was no longer tactile but constituted optically, as in Cubist painting[57] – but this fell far short of the idea of a distinctive sculptural form he had conjured up so evocatively in his earlier essay on African sculpture.

More significant than these half hearted attempts to identify what a modern sculpture might be are certain larger implications of Einstein's essay on African sculpture. These are worth considering for a moment, not because of any direct influence Einstein might have had, but because they involve a radical reconceptualising of the sculptural object to which he gave particularly vivid and uncompromising expression. Such a rethinking of sculpture not only played an important role in the period when he was writing but also had significant long-term repercussions. By locating the essence of a sculpture in volume rather than solid shape, Einstein took the important step of defining sculpture in terms of occupancy of space rather than the shaping of solid material by carving or modelling. The term volume also suggested that a sculpture might

64 Aristide Maillol, *Night*, 1909, bronze, height 95 cm, Kunstmuseum, Winterthur

project an interior space, activating a sense of something felt from the inside as well as the outside. While Einstein's insistence on instantaneous apprehension clearly relates to a conception of art as immediately manifest optical shape that was very much of its time, his emphasis on grasping the work as an unconditional whole, rather than as a contrived arrangement of parts, re-emerged in the 1960s, if in rather different form, among sculptors and critics who unlike him set great store by the materiality of the sculptural object. Finally, his polemic had the somewhat paradoxical effect of making the contingencies of a viewer's encounter with a sculpture a significant issue. The interaction between viewer and object, and the staging of the object, were brought into focus by the very force and consistency of such attempts as his to imagine a sculpture where these considerations would somehow become irrelevant.

* * *

Sculpture as Object: Brancusi

Brancusi has enjoyed an unusual reputation as a pioneer of modern sculpture, his work celebrated for its reconfiguring of the sculptural object by writers of widely different aesthetic persuasions. This is evident if one simply looks at the two basic texts in English on modern sculpture published in the 1970s. In William Tucker's *The Language of Sculpture* Brancusi is presented as the exemplary creator of a perfectly self-contained modernist object, and associated by implication with the heavy metal, self-consciously formalist work of artists like Caro. In Rosalind Krauss's *Passages in Modern Sculpture*, by contrast, he is seen to prefigure the post-Minimalist shift from such an obsession with the inner formal logic of the object to a concern with its surface qualities and its staging.[58] Similarly, in the period leading up to the Second World War, his work had featured as the embodiment of apparently contradictory imperatives, when he, rather than any of the neo-Cubists or the Constructivists, was singled out as pointing the way to a truly modern conception of sculpture. His work struck a strong chord not only with those of a modernist or formalist persuasion but also with the Surrealists. Breton simply echoed the prevailing orthodoxy when he said 'it was Brancusi who gave sculpture the original impulse in the new direction'.[59] The Dadaist, and fellow Rumanian, Tristan Tzara regarded Brancusi highly, as did Duchamp, who played an active role helping to instal several major Brancusi exhibitions in the United States in the 1920s and 30s and who also collected his work, being among the first to appreciate that it would make a sound financial investment.[60]

Brancusi was usually celebrated for his supposed pursuit of an utterly simplified sculptural ideal. Carola Giedion-Welcker, the author of an influential history of modern sculpture published in 1937, stressed Brancusi's commitment to 'restore the sovereign clarity of simplicity' and purify sculpture 'of all associative corruption', characterising him as an artist who 'lives in a world of forms as simply and intimately as St. Francis of Assisi dwelt among the birds.' The naive purism, however, was somewhat complicated by her also highlighting elements of humour, which she compared to James Joyce's, observing that Brancusi's work 'starts from the incoherence of the subconscious'.[61]

Among earlier writers on modern sculpture, Carl Einstein was something of an exception in his dismissive attitude to Brancusi. In his view, Brancusi had taken the simplification of form too far, so his work lacked the activation of volumetric form Einstein had found so compelling in African sculpture. Artistic form, in his view, could only come alive by evoking the shaping of the human figure, and he found Brancusi's purist abstraction ultimately sterile.[62] Part of the problem was Einstein's preference for the internal juxtapositions of shape and volume found in Cubist-inspired work which Brancusi increasingly expunged from his sculpture. In my discussion, I shall be focusing on those features of Brancusi's oeuvre that suggest a concern with the placement of the object and its interaction with the viewer, showing how these features, to which critics such as Einstein remained relatively blind, impinged on the modernist cult of the autonomous object.

Brancusi's project manifests an awareness on his part that the autonomy of a sculpture needed to be activated in some way, particularly when the work was small in scale, as were his and most other early modernist objects. This is apparent from the care he took

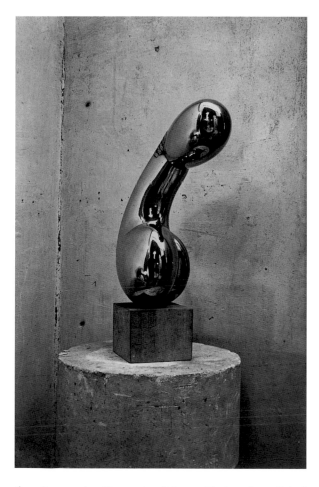

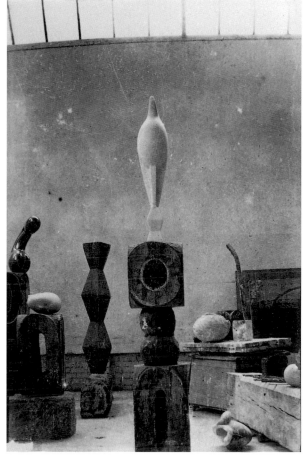

65 Constantin Brancusi, *Princess X* (1916, polished bronze, height 57.4 cm), photographed by the artist c. 1916 –20, Musée National d'Art Moderne, Paris

66 Brancusi's studio with *Princess X*, *Prometheus*, *Endless Column* and *Maiastra*, photographed by the artist c. 1917, Musée National d'Art Moderne, Paris

with the bases which he used to control the context of display of his work and from the way he went about photographing sculpture in his studio. These photographs set up an interplay between close views of works, where they are presented as single isolated shapes (fig. 65), and shots showing them amid the clutter of other work in the studio (fig. 66), clutter being the operative word because the atmospheric informality of Brancusi's staging of his work in his studio is so different from the clean clinical look of a gallery display.[63] In these shots, the sculptures are presented as if one were coming across them almost accidentally while scanning the studio environment.

Two points need to be drawn out here. Firstly, a trajectory of viewing sculpture is suggested by the photographs that moves from a distracted awareness of the sculpture as one presence among many, to an absorbed contemplation of it in partial isolation from its surroundings. Secondly, even the close-up photographs of individual works, which might seem to conform to a more conventional imaging of sculpture as self-contained

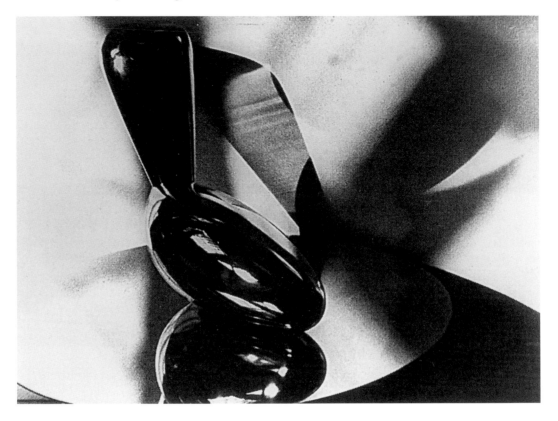

67 Brancusi's *Leda* on a rotating base (1926, polished bronze, height 54 cm, Musée National d'Art
Moderne, Paris), still from a film taken by the artist c. 1934

object, draw attention to contingent surface and light effects produced by the work's
staging (fig. 65). One extreme case relates to Brancusi's experimental installation of a
bronze *Leda* on a rotating base driven by a motor, a moving spectacle that became a
feature of conducted tours of his studio. He filmed the display using one of the earliest
available ciné cameras,[64] setting up the lighting so that in some stills (fig. 67) the sculp-
ture's form is almost completely dissolved by the surface dazzle and play of shadow.
However, the status of the object as a relatively autonomous focus of interest does
not disappear. While Brancusi's photographic presentations often suggest a decentred,
destabilising mode of viewing, in which one object might even substitute
for another on the array of bases in his studio (fig. 71), it also takes for granted a
fixation on individual objects' shapes.

* * *

To highlight an awareness of the contingencies of viewing a work resulting from its
staging in a particular environment clearly involves projecting back onto Brancusi certain
more recent concerns that he himself did not articulate in his much quoted comments
on sculptural aesthetics.[65] But it is not without its foundations in contemporary dis-

cussions of his sculpture. This is clear from the most important early apologia for Brancusi's work, the essay published by Ezra Pound in 1921. What fascinated Pound about Brancusi's sculpture was that it seemed to realise his own ideal of a perfectly formed, self-contained art work, the visual concreteness being very much in tune with his imagist aesthetic. At the same time, Pound's account contains some suggestive reflections on how the work comes alive through the contingencies of a viewer's interaction with it.

For Pound, the core of Brancusi's achievement, an objectively realised 'ideal of form' pared down to essentials, was represented most clearly by his egg shapes or ovoids, works such as *The Beginning of the World* (fig. 69).[66] Yet he was aware that such shapes might easily seem merely banal geometric forms. As pure image, or 'in the photos', as he said, 'the egg comes to nothing'. In his view what stopped the simplifying of form from becoming merely empty was the process of its creation, 'the maddeningly difficult . . . exploration toward getting all the forms into one form . . . Starting with an ideal of form one arrives at a mathematical exactitude of proportion, but not by mathematics.'[67] The apparent simplicity of shape, then, had been achieved by hard-won effort and was not the straightforward realisation of a predetermined geometric form. But how did this become apparent when a viewer looked at the work? How could one tell a hard-won ovoid from a mechanically produced one? This question acquired practical urgency a few years later when US customs classified Brancusi's *Bird in Space* (fig. 72) as a manufactured object and insisted on charging the duty which was waived in the case of works of art, until their ruling was successfully challenged in court.[68]

Pound made the point that the sculpture needed to come alive in the dynamic of the viewer's momentary responses to it. As he explained, 'every one of the thousand angles of approach to a statue ought to be interesting, it ought to have a life . . . of its own', it has to 'catch the eye'. 'It is . . . conceivably more difficult', he concluded, 'to give . . . formal-satisfaction by a single mass, or let us say to sustain the formal-interest by a single mass, than to excite transient visual interests by more monumental and melodramatic combinations.'[69]

The complex twists and turns that occur as he grappled with the question of how the object's potentially banal simplicity of form might be overcome by the 'transient visual interests' it excited are very telling:

> In the case of the ovoid, I take it Brancusi is meditating upon pure form free from all terrestrial gravitation; form free in its own life as the form of the analytic geometers; and the measure of his success in this experiment (unfinished and probably unfinishable) is that from some angles at least the ovid does come to life and appear ready to levitate. (Or this is perhaps merely a fortuitous anecdote, like any other expression.)[70]

If the sculpture did not 'appear ready to levitate', it would be unremarkable, and yet this effect is 'perhaps merely a fortuitous anecdote' produced in a momentary, accidental encounter. What we today might see as activating this 'levitation' is not so much the fashioning of the egg itself as the optical interplay between egg and supporting disc, and the apparently precarious balancing of its refined ovoid on a firmly grounded base.

There then comes a point where Pound drew back and felt he had to resist the threat to the autonomy of the object posed by 'transient visual interests'. He was uneasy about Brancusi's exploiting the dazzle of polished bronze, which he saw as exerting a hypnotic

68 Constantin Brancusi, *Endless Column* in Edward Steichen's garden at Voulangis,?1926, oak, originally c. 720cm high, now in two fragments in the Musée National d'Art Moderne, Paris

effect, a trivialising unconscious fixation, in contrast to the 'consciousness of formal perfection' attained by work in marble. Even with marble, 'the contemplation of form or of formal-beauty leading into the infinite must be disassociated from the dazzle of crystal'.[71] At the same time he also acknowledged that things were not so straightforward, and that the dazzle which seemed to undo the abstract perfection of form could not be disassociated from what it was that made a sculpture come alive for a viewer. When he insisted on the 'divergence' between the contemplation of 'formal-beauty' and 'dazzle', he also noted that 'there is a sort of relation'. And what brought him to the problem of dazzle? An association between the ovoid seeming to levitate and the momentary visual seduction of surface features like the shine of bronze, or what he called 'crystal-gazing'.

Pound thus tracked a sequence of shifting apprehensions in which the sculpture became more than a merely 'abstract ovoid'. Firstly, there was the 'fortuitous anecdote' of its appearing 'ready to levitate', then 'crystal-gazing', akin to 'self-hypnosis by means of highly polished brass surfaces', and finally 'an excitement of the "sub-conscious" or unconscious (whatever the devil they may be)'. Pound both recognised and then sought to suppress the momentary, involuntary responses that the physical presence of the sculpture provoked. He was compelled, if very uneasily, to register how these physical accidents of viewing, which could momentarily disturb one's sense of the work as a clearly shaped object, helped to give it an enlivening immediacy.

If immediate context and shifting interactions with the viewer are crucial in Brancusi's work to an extent that modernist critics such as Pound at times found almost discomfiting, his work is still very different in conception from later, explicitly situational sculpture of the kind developed by Minimalist or post-Minimalist sculptors. The relation between viewer and object is different with Brancusi, partly because of its smaller scale, so the domain in which the work exists is not experienced as a direct analogue of the space occupied by the viewer's body. The work is also envisaged much more as a contained object than as a presence shaping its surrounding environment. Moreover, it has to be presented as an object that is held up to be viewed, resting on a pedestal rather than being placed directly on the floor or suspended from the ceiling. The one real exception to this is the *Endless Column* (fig. 68), a twenty-three-and-a-half foot high version of

69 Constantin Brancusi, *Beginning of the World*, 1924, polished bronze, 19 × 28.5 × 17.5 cm, on polished steel disc and oak base, height 74 cm, Musée National d'Art Moderne, Paris

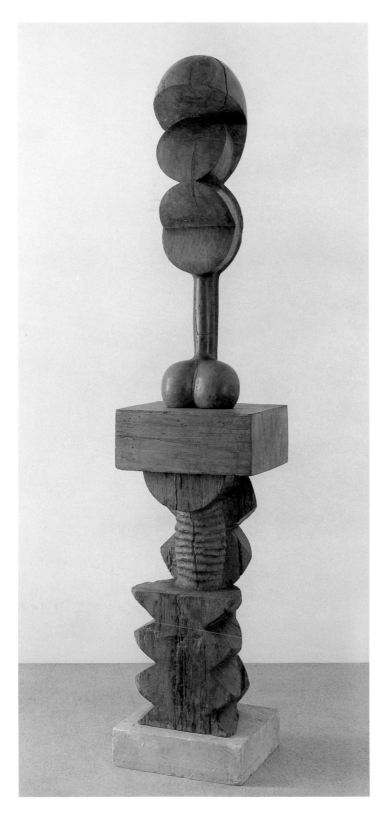

70b Constantin Brancusi, *Adam and Eve*, photographed by the artist, 1922, Musée National d'Art Moderne, Paris

70a (*left*) Constantin Brancusi, *Adam and Eve*, 1921, *Eve* (above) oak, *Adam* (below) chestnut, 227 × 48.2 × 44 cm, on limestone block, height 13.5 cm, Solomon R. Guggenheim Museum, New York

which was installed in the mid-1920s in Steichen's garden in Paris so that it rose directly out of the ground. It is hardly surprising that this and later versions of the work particularly intrigued artists of the Minimalist generation, as did the bases that were often felt to have a raw immediacy lacking in the more refined, object-like things they were supporting.[72]

Of course, it can be argued that in Brancusi's case the sculpture is the whole entity comprising the object and its pedestal. But the segmented juxtaposition of elements gets in the way of any compulsion to envisage the ensemble as a single presence facing one, even when it is on a directly human scale. In the *Adam and Eve* (figs 70a, 70b), an erect columnar figure rising to a height that more or less echoes the viewer's, the cut into horizontal sections deconstructs any sense one might have of it as a physical analogue of one's own presence. It is evidently not one thing but two distinct things piled one on top of the other, a heavy chunky Adam thing down below, and a lighter, smoother, elegantly erect Eve thing up above, each set on its own separate block-shaped base.

Juxtapositions of this kind operate in most of Brancusi's placements of work on pedestals, indeed are integral to the instabilities of staging and viewing that give Brancusi's apparently simple objects their complex dynamic. Few of the sculptures just sit there. They partly define themselves with reference to their immediate support. The simpler egg-like or head shapes are usually balanced on the flat, fairly broad expanse of a disk or cylinder (fig. 69), while the more biomorphic ones such as *Princess X* and the *Torso of a Young Man* (figs 65, 4) are set on smallish stone cubes whose chunky geometric form contrasts with the rounded more body-like shape above. The narrow, vertical *Birds in Space* (fig. 72) not only taper down to a narrow footing but are perched precariously on a thin element connecting them to a more substantial support, the latter acting as a solid ground from which they rise up and are also slightly displaced. Sculptures such as the early *Kiss*, a block that simply sits squarely on its support, are a rarity in Brancusi's work.

The *Adam and Eve*, despite the break in the middle, is solidly grounded, but the tendency to inert stolidity is counteracted by the sharply defined address to the viewer. The work faces emphatically in one direction (figs 70a, 70b). Usually, the address is more ambiguous. Indeed, with the abstract egg-like shapes that fascinated Pound (fig. 69) there is a systematic denial of frontality, the work being all-round like the perfectly round disc on which it rests – though because it is an irregular oval, more pointed at one end than the other, its aspect shifts continually, slightly expanding and contracting, as one moves round it. With works like *Mlle Pogany* (fig. 71) and *Princess X* (figs 66, 65), from certain directions the sculpture can look as if it might be facing outwards, an effect emphasised in the case of *Princess X* by a disconcerting suggestion of probing. But this implied address proves elusive. As one changes position, there also emerges a different sense of the work as a thing or figure collapsing inwards and turning away.

Even the *Bird in Space*, which from the side seems to be launching itself in a direction defined by the outward curve of the body (fig. 72), does not set up a stable directional axis. The subtle variations in the slender rounded shape as one moves round it make it difficult to isolate any one view as the definitive profile shape. Seen head-on the work becomes very narrow (fig. 73), a little like the later Giacometti figures (fig. 62), but it lacks a definite profile to anchor this elusive frontality. If one continues circulating round

71 Brancusi's studio with two versions of *Mademoiselle Pogany II* (marble, 1919, height 44.2 cm, and polished bronze), photographed by the artist, 1920, Musée National d'Art Moderne, Paris

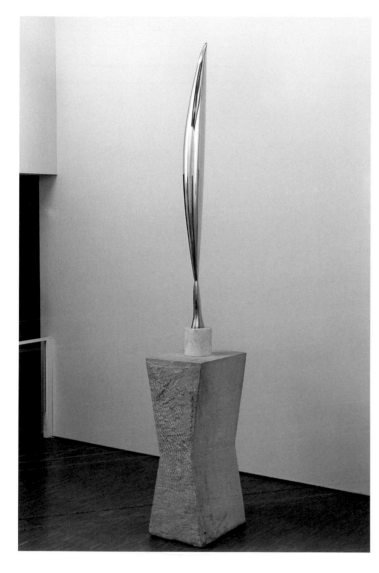

73 Constantin Brancusi, *Bird in Space* (polished bronze, 1927, height 184 cm, National Gallery of Art, Washington), photographed by the artist c. 1927–30, Musée National d'Art Moderne, Paris

72 (*left*) Constantin Brancusi, *Bird in Space*, 1941?, polished bronze, height 193.6 cm, on two-part base of white marble and limestone, height 136 cm, Musée National d'Art Moderne, Paris

the work to try to get a firmer grip on its pose and shape, this only creates more ambiguity, as the barely perceptible variations of aspect alternately suggest that it is launching itself outwards or pulling back.

In his lifetime, Brancusi was usually seen as doing what any nicely behaved modernist purist ought to do, which was to pare down the irregularities of observed form in the interests of creating a new purity and stability of shape. The successive versions of *Mlle Pogany* seem like a textbook demonstration of such a process of abstraction, as more and more of the irregularities in this image of a figure holding its head in its hand are smoothed away and the shape becomes cleaner and more clear-cut.[73] And yet the geometric simplicity of the final version (fig. 71) only makes more evident its irreducibility to any simple, stably poised form. The asymmetries of the awkward pose, far from being wiped out, become more obvious — just as in paring down the *Maiastra*

(fig. 66) to create the *Bird in Space* (fig. 72), Brancusi created a simpler but less stable form, one that refused to assimilate itself to the perfect symmetry of a slender column or cylinder to which it seemed to aspire, while losing the original motif's clearly defined profile and front.

<p style="text-align:center">* * *</p>

The apparent purifying of shape in Brancusi's work often brings into focus some impurity that is psychic as well as formal. The reductive simplicity of the *Torso of A Young Man* (fig. 4), for example, which makes the sculpture look a little like the sawn-off junction of three pieces of piping, at first seems to excise all trace of sex. The crotch area is wiped clean to become the pure geometric intersection of two smaller cylinders branching out from a larger one. At the same time, this makes one more aware of what is missing than would a fig leaf, or traces of mutilation on a more figurative work, particularly when one's sense of the clean precision of the castration flips into a recognition of the whole shape as a substitute penis and testicles. The staging of the object and the evocative power and simplicity of shape work together to prompt these sudden reversals between reductive purism and sexual provocation.

Provocations elicited entirely by the image suggested tended to dominate early responses to Brancusi's work. One of the slightly earlier, more naturalistic versions of *Mlle Pogany* became a star item at the New York Armory Show in 1913, picked out by critics as exemplifying the weird and unnatural distortions that modern art imposed on things. Did anyone actually look like this, they asked?[74] Such work created a disturbance in people's psyche, partly because its impact as object was so fine-tuned, but mostly because it offered a strikingly strange image. This aspect of Brancusi's work, which again became an issue with the furore over the penis-like shape of *Princess X*, prefigured certain Surrealist preoccupations. If the strangeness of these images no longer makes a sensational impact, the psychic provocation is still there. The purist Brancusi, the master of form, the precursor of Minimalism, the father of Judd's optically activated geometric forms, now exists alongside the psychoanalytic Brancusi,[75] the ambivalent magician of sexually evocative body parts and precursor of artists like Louise Bourgeois (fig. 157).

What particularly concerns me here is an oscillation in the response invited by a Brancusi sculpture between seeing it as a highly formalised art object and as an object of fantasy. The oscillation is remarkable because of the absence of features in the work that might mediate between these split perceptions. With more densely articulated figurative work, including Rodin's, we can usually move without abrupt transition between seeing the work as shape and surface and adopting a different perspective in which these amalgamate to form the image of a figure or a body part. In looking at a starkly simple motif such as *Princess X* (fig. 65), however, there is a characteristically modern disjunction between seeing it as a female bust or a penis and then as an immaculately made, slightly awkward modernist object. There are no mediating articulations of form within the work that would allow one to move smoothly between these disparate apperceptions.

The poet William Carlos Williams brings this out nicely in a short essay on Brancusi which, though published quite late, in 1955, was based on contacts with the sculptor

going back to the 1920s.[76] Williams did not shape his responses to Brancusi's sculptures into a coherent narrative, but instead gives us a series of jottings, a kaleidoscope of sensations and projections. *Princess X*, which he called 'the most spectacular of Brancusi's creations', elicited from him an intriguing hodge-podge of sexualised male fantasies and modernist reflection on essential form. Williams was not the first to see in this work an image of femininity that metamorphosed itself into the shape of a penis. The story goes that Matisse was particularly upset when he found his delectation of the object's female form interrupted by a disconcerting substitution, the softly smooth object of desire stiffening into the organ of his own desiring.[77]

Williams begins abruptly with the 'flagrant implication: it resembles the human phallus.' This is qualified by an assertion of the work's formal refinement, which then gives way to a tangle of fantasy in which precious object and gratifying spectacle of erotic beauty merge into one another:

> It is a figure of the head and upper breast of a woman . . . It immediately attracts, as the contours inevitably suggest the phallus and testicles of a man. The mind jumps from that to the conclusion of the woman's interest in all men whom she governs and impresses with her charms.

He then turns from the purely imagistic connotations to its aesthetic interest as a work of art. He envisages the shifting psychological suggestions of immaculately confident narcissism alternating with insouciant exhibitionism as echoing an interplay in the conception of the work between a self-enclosed autonomy and an easy, open mode of address to the viewer:

> As always with Brancusi, the sculptor's sole interest has been to portray the plastic interest of his subject for him, and in this he has succeeded brilliantly. It had to be done in polished metal to show the sophisticated character of the subject. It had to be done with the daring that disdained to hide with aristocratic candor a contempt for hiding anything from the view of the world. It would be the nature of his subject to be indifferent to what was thought of her. So the artist, as in the case of Goya in his *Maja Desnuda*, had nothing to conceal and did not.

The interplay between reticence and openness is envisioned as integral to Brancusi's conception of the sculpture as a work of art, and not just through the psychological projection of it as the figure of a woman. It might be blatant but, in so much as 'in all the arts, reticence is a virtue, the subject is covered in the obscurity of the art itself'.[78] In addition to picking up on Brancusi's overtly sexualised conception of the sculpture as an erotically charged female form presenting itself to be viewed, Williams here is registering an attentiveness to the rhetorical subtleties of interaction between the sculptural object and the viewer. Elsewhere he offers a more explicit commentary on Brancusi's staging of his work. When talking about the formal purism of his sculpture, saying that 'there was . . . with Brancusi the constant pull towards the centre, to simplify, to eliminate the inessential, to purify, a scientific impulse to get at the very gist of the matter', he immediately goes on to comment on the significance of the bases: 'His pedestals separate him from a hostile world, isolating his subject from the inessential, keeping it "sterile" in the surgical sense, making it something to be considered separately.'[79]

The point Williams is making is quite a complex one. It is not just that the pedestal functions like a frame, marking a boundary between the work and its surroundings so that we respond to it as art. The pedestal literally sets the sculpture apart, away from the living mess of the everyday, and does so at a cost. Poised as resplendent object deserving a special kind of attention, but purified of distracting imperfection, it is also distanced and untouchable – 'sterilised', as Williams put it. Situated in this way, *Princess X* seems both resplendently alluring and a little empty, evacuated of charge.

The impurity that interests me here, inherent in the demotic tenor of Williams's reading of Brancusi's *Princess X*, comes over so vividly partly because it emerges out of his fixation on a potentially sterile ideal of formal autonomy and purity. Williams's commentary extends from psychically charged responses, which as it were envelop the art object in the viewer's desires and anxieties, to a recognition of the work for what it is – a deliberately staged art object, with all the formal artifice and potential banality this entails. Works such as *Princess X* and *Adam and Eve* seem designed to evoke crude and basic fantasies about body parts and to invite the viewer to enter a world where subjectivity is blindly fixated on the destabilising stirrings of sexual desiring. But any first-hand response to these works is going to involve moments of withdrawal from psychic fantasy, moments where the sculptural object ceases to approximate itself to the psychoanalytic object – moments when it looks inert and its immaculate artifice may even approximate to that of an oversize, Art Deco curio. David Smith made a good comment on this knife-edge instability: 'It's strange how vulgar curios are and how undefinable is that narrow margin between the total vulgarity of curios and the vulgarity in a creative work of art.'[80]

Brancusi's contemporaries were captivated by what they saw as the uncompromisingly simple formal purism of his work, and the stray aphorisms that visitors to his studio managed to elicit from the none too loquacious and eloquent sculptor tended to play up to this perception. If the sculptures were simply to be seen as pure forms, however, they would hardly continue to elicit much interest today. Even so, the purism is not just some negligible period dross, the effect of a discredited myth of autonomous plastic form. It is, on the contrary, crucial to the evocative effect of the impurities that appealed to the other, Surrealist or Dadaist, aspect of the early modernist imaginary. The purism, even in its tendency to dry pedantry or vulgar banality, brings the impurity into focus, gives an activating edge to the viewer's shifting and necessarily unstable response to the work. One writer particularly drawn to the apparent formal simplicity of Brancusi's sculpture effectively said as much. Giedion-Welcker commented how 'all these primal forms reduced to the last degree of simplicity manifest, in an elementary language, an introvert, inchoate dream existence.'[81] With Brancusi, such impure and formless psychic resonances are sparked by the crudely, and also elegantly, simple appearance his work presents as it first seizes one's attention.

4 Modernist Sculpture

The systematic characterisation of a distinctively modern tradition in sculpture first properly established itself in the art world in the 1930s. I say systematic with certain qualifications, because what counted as modern often involved what we might now see as contradictory tendencies. On one hand, the modern was thought to involve a focus on simplified compact plastic mass, for which the work of Maillol (fig. 64) was the most prominent model. On the other, it was conceived as a negation of monolithic mass, with the formal autonomy of the figure being replaced by the pared down simplicity of objects such as Brancusi's, or by a more radically dematerialising articulation of space that eschewed solid sculptural form, as in Constructivist work.[1]

The Idea of a Modern Sculpture

The attempt to define a distinctively modern or modernist sculpture achieved its classic formulation in a book by Carola Giedion-Welcker published in German in 1937 and immediately translated into English. What Giedion-Welcker mapped out as the more vital tendencies in modern sculpture is not very different from what one finds in present-day surveys of earlier twentieth-century three-dimensional work. At the same time, the different titles under which Giedion-Welcker's book came out testify to its attempts to encompass an almost unmanageable diversity of impulses. The first German edition was called *Moderne Plastik: Elemente der Wirklichkeit, Masse und Auflockerung*. In the English version, *Modern Plastic Art: Elements of Reality, Volume and Disintegration, Auflockerung*, a word that suggests a combination of breaking or loosening up and opening out, became 'disintegration', which is not inaccurate but puts a very partial gloss on its connotations, and 'mass' was replaced by 'volume'. When the book was reissued with substantial additions in 1954, it was renamed *Contemporary Sculpture: An Evolution in Volume and Space*. The implication was that a high modernist optical resolution had been achieved which, if belied by the ambivalences of the original introduction, where 'Mass' and 'Reality' were still an important presence, was in line with the rather academic and dully formalist account of 'The Situation Today' written for the new edition.

This academicising of the modern manifests itself in the later edition by Giedion-Welcker's giving less overall emphasis to the radically deconstructive and futuristic, scientific ideas of a dissolution of traditional sculptural form that had originally captivated her and that had derived to a considerable degree from her close involvement with the rethinking of mass, form and space in modernist architecture.[2] The tendency is evident in her welcoming a recent return to solidity and plasticity by artists such as Henry Moore, in line with most of the new books on modern sculpture which began pouring

out in the 1950s and early 1960s. Not much of the work promoted by this post-war discovery of a modern sculptural sensibility has stood the test of time. One is inclined to agree with Clement Greenberg's prognosis that the promise of a new sculpture that seemed to offer itself in the late 1940s and early 1950s did not in the end amount to much.[3]

One very considerable exception, the work of David Smith, will be the subject of a separate analysis in the second half of this chapter. First, however, I want to round out this discussion of modernist theories of sculpture by focusing on two key writers, fairly briefly on Herbert Read, whose *The Art of Sculpture* published in 1956 is a classic statement of mainstream post-war ideas on modern sculptural aesthetics, and at rather great length on Adrian Stokes, a more maverick writer for whom sculptural concerns played a central but also rather complex role. Stokes, by riding with the painterly priorities of his time, and envisioning sculpture in terms of an activation of surface, rather than trying to imagine a true sculpture that would be categorically distinct from painting, offers some particularly telling insights into conceptions of the sculptural in the period.

I shall be dealing with Herbert Read's *Art of Sculpture* rather than the book he published in 1964 called *A Concise History of Modern Sculpture* because the latter is, as the title, implies a survey rather than an analysis. That *Art of Sculpture* is conceived as an intervention in debates about modern sculptural aesthetics is evident, not only in the dedication to Gabo, Hepworth and Moore, but also in the whole tenor of the preface. Read's point of departure is the idea that sculpture can now be looked at anew because it has finally become a truly autonomous art, progressively liberated since the late nineteenth century from the contextual constraints imposed by its traditional architectural and monumental functions. As he puts it,

> the full consciousness of the need for such liberation came only with Rodin. Since Rodin's time, there has arisen what is virtually a new art – a concept of a piece of sculpture as three-dimensional mass occupying space and only to be apprehended by senses that are alive to its volume and ponderability, as well as to its visual appearance.

He goes on to quote a comment by Henry Moore that functions as a talismanic encapsulation of that new 'awareness of the essential nature of sculpture'. A sculptor, in Moore's words,

> must strive continually to think of, and use, form in all its spatial completeness. He gets the solid shape, as it were, inside his head – he thinks of it, whatever its size, as if he were holding it completely enclosed in the hollow of his hand. He mentally visualizes a complex form *from all around itself*; he knows while he looks at one side what the other side is like; he identifies himself with its centre of gravity, its mass, its weight; he realizes its volume, as the space that the shape displaces in air.[4]

Such a notion of the essentially sculptural, widespread in the period – indeed one finds it already adumbrated much earlier in comments by Matisse[5] – envisages a viewer engaging with a sculpture as a hand-held shape in the round, whose whole tactile form is somehow immediately manifest, however one looks at it. Scale and situation are irrel-

evant, as are any visual effects created by light falling on the sculpture's surfaces. Sculpture, according to Read, is an exclusively 'plastic art that gives preference to tactile sensations as against visual sensations'. Hildebrand receives some criticism for failing to recognise that 'the sensibility required for [the sculptor's] effort of realization had nothing in common with visual perception, i.e., with the visual impression of a three-dimensional form in a two-dimensional plane.'[6]

Sculpture where light effects play a significant role, or which is conceived as a 'coherence of surfaces rather than as a realization of mass', is in Read's view essentially illusionistic and painterly rather than sculptural. On these grounds, Maillol and Arp provide a purer realisation of sculptural form than Rodin.[7] Moreover, where a sculpture offers a spectacle of differing aspects from different angles, rather than being a shape that appears to be more or less the same from different points of view, it is playing up to a perspectival or essentially painterly and also theatrical mode of viewing. In Read's words, 'the object faces an audience, and as on a piece of scenery on stage what is *not* seen need not correspond with what is seen.'[8]

Read also picks out with varying degrees of fascination and unease a number of radical departures from this true sculptural privileging of ponderable plastic shape. These include the exploitation of light effects to dissolve the sense of solid form and create a 'sculpture of volume in outline', as well as the literal dynamic instability of the new mobile sculpture. Such initiatives are significant to him in so much as they are expressive of the distinctive 'spiritual conflicts of the modern age'. But the dematerialisation, the dissolution of sculpture's 'tactile compactness', he feels, also represents a tendency to a 'negative sculpture' whose upshot is a return to the impure painterliness of Baroque art.[9]

In the post-war period, there was a growing fascination with the possibilities of a new technologically orientated art that would deal in energy, light, space and movement, rather than in solid structure or stable mass, and that would render the traditional sculptural object redundant. This techno-utopianism reached something of a climax in an intriguingly eccentric analysis of the condition of modern sculpture, *Beyond Modern Sculpture: The Effects of Science and Technology on the Sculpture of this Century*, published by the American critic and sculptor Jack Burnham in 1968. Burnham points the way to a new cyborg art of the future, in which the limits of even the most futuristic-looking machine sculptures would be transcended by the real animation and autonomy of intelligent, self-activating robots. While Read and Burnham clearly represent two different tendencies appropriate to their different periods of formation, it is worth thinking of this unlikely pair together for a moment in that they share a fascination with sculpture as concretised fantasy.

In both cases, there is a play upon the immediacy that a sculptural object seems to promise by virtue of being an actual physical presence, seemingly rendering redundant the formal conventions through which paintings evoke images of things. Yet this immediacy only works insomuch as the sculpture itself is conceived as image, its literal identity as object and the context where it might be displayed dissolved in some modernist variant of Pygmalion's dream, whether this be a staid vision of primordial rock-like shapes growing out of the landscape or a more modern filmic one of a robotic techno-future. In making this unlikely juxtaposition between Read's lumbering plastic forms and Burnham's sci-fi automata, I was also intrigued by the possibility of evoking two very

different variants of a modernist sculptural nightmare, with Moore's wombless, faceless megalithic mothers stirring into life and confronting the relentless drive of some terminator cyborgs.

<p style="text-align:center">* * *</p>

Adrian Stokes returns us to more carefully worked out ways of thinking about the sculptural object as physical and visual phenomenon which nevertheless remain equally distant from today's conceptions of three-dimensional art. Stokes is best known for the distinction he made between a carving and a modelling approach to sculpture in a book on fifteenth-century Italian Renaissance architectural sculpture, *Stones of Rimini*, published in 1934. This distinction is clearly embedded in a very period-bound obsession with truth to materials, while the focus on traditional processes of making sculpture also appears to be at odds with the more radical rethinkings of sculpture taking place at the time. However, if Stokes at first seems worlds away from a strict Greenbergian modernism where 'the distinction between carving and modelling becomes irrelevant' and 'a work . . . is not so much sculpted as constructed, built, assembled, arranged,'[10] we shall find that this is not really the case.

Like any theorist who has thought at all closely about the formal and aesthetic distinctions implicit in different processes of making, Stokes envisages the processes involved less in literal terms than as models for conceptualising the different kinds of relation that come into play when a subject, whether maker or viewer, engages closely with the objective form and substance of an art work. In his earlier theorising, the emphasis tends to be on the artist fabricating and creating a work, and his discussion of artistic creation at this point is inflected by some curiously sexualised and male-orientated fantasies about engendering and giving birth. However, he does not just focus on the activity of making. After introducing the basic distinction between carving and modelling,[11] he goes on to develop a full analysis of the different ways in which shape is suggested to a viewer by carved or modelled work, regardless of whether the work involved is literally carved or not.[12]

Stokes privileges carving over modelling because in carved work, the given material qualities, the hardness and resistance to shaping, as well as visual effects of texture and illumination over which the artist does not have full control, are integral to the impact it makes. By contrast with modelled work, it is not only the shape the artist creates that matters but also more contingent factors, such as the way that light diffuses over the surface to give it a vibrant luminosity.[13] He is interested in sculpture more as an activation of surface than as a moulding of form and thinks it misleading to define sculpture as a plastic art. Arguing that 'a basic distinction be made between what is carving conception, and what is plastic or modelling conception, even though some traces of both conceptions are to be found in all sculpture whether it be carved or modelled', he adds emphatically, if a little preciously: 'In view of the Germans and their horrid noun *Plastik*, one cannot emphasize too strongly that sculptural values are not synonymous with plastic values.'[14]

He goes further than this, arguing to a point that almost seems anti-sculptural that the carved conception is not to be associated with sculpture in the round so much as with

relief work implanted in solid masonry walls. The emphasis on relief is, as one might expect from the polemic quoted above, very different from Hildebrand's, in that he is not concerned with the clear definition of plastic shape. The modelled shape in the round to which he opposes his idea of carved relief is above all the small, potentially hand-held object, a pure shape that has no architectonic anchoring and over which viewer and artist in effect have complete control. For Stokes, who is very much in tune with the early modernist preference for architecture as the leading three-dimensional art, sculpture, as an art that involves the activation of surface, is not to be seen as an autonomous realisation of plastic form. Rather it is situated on the boundary between painting and architecture. In his view, 'All developed sculpture has been founded on an association, at least, with architecture',[15] so carved sculpture is not characteristically some autonomous isolated shape:

> The carved stone that you take in your hand, that you turn over to examine every liveliness, has a created entirety which in the last resort I would rather associate with modelling. For the essence of stone is its power to symbolize objectivity. It should stand, be more or less immovable: and what better occasion for vital objectivity than when carving gives expression to masonry itself, when relief shows the surface of the stone alive?[16]

In an article published in 1933, just before his *Stones of Rimini*, Stokes argued that Henry Moore's work, like that of a number of other modern artists who were turning to carving in stone, was primarily informed by a 'plastic aim'. Moore's was a modelling conception. He and his contemporaries 'have sought to make of the block something as simple and integral as a lump of clay',[17] with one major exception, Barbara Hepworth. As he explained in a separate critical analysis of her work published in the same year,

> A glance at [her] carvings shows that their unstressed rounded shapes magnify the equality of radiance so typical of stone: once again we are ready to believe that from the stone's suffused or equal or slightly luminous light, all successful sculpture in whatever material has borrowed a vital steadiness, a solid and vital repose.[18]

What value is there in this distinction, beyond its being a corrective to the usual tendency to lump Hepworth's and Moore's early stone carvings together? Stokes is pointing to something more significant than the simple fact that a number of Moore's works he saw, such as a figure cast in lead and some sculptures in concrete, had literally been modelled.[19] His analysis highlights a difference in Moore's and Hepworth's conception of sculptural form that became even more marked later on (figs 74, 75). Stokes was struck by how Hepworth's rounded shapes were not only less arbitrary than Moore's but gave greater emphasis to the activation of surface. Their convexity and hardness, enlivened by the play of light, were integral to their conception. In some of Hepworth's earlier work (fig. 77), incised lines function to heighten the sense of the surfaces' smoothed roundness.[20] When we look at a work by Moore (fig. 74), even an early directly carved one, the texture and colour of the stone or wood may be quite striking, but the bulges and undulations of surface make most sense if viewed, less on their own account, than as part of the overall plastic shape, animated by internal stresses and strains that the figurative or biomorphic form suggests.

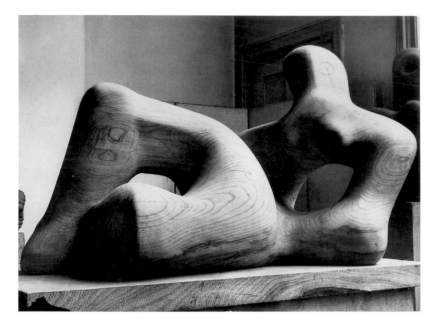

74 Henry Moore, *Reclining Figure*, 1936, elmwood, length 106.5 cm, Wakefield
City Art Gallery

75 Barbara Hepworth, *Pendour*, 1947–8, photographed at St Ives, wood, white and light blue paint, width
71 cm, Hirshhorn Museum and Sculpture Garden, Smithsonian Institution, Washington, D.C.

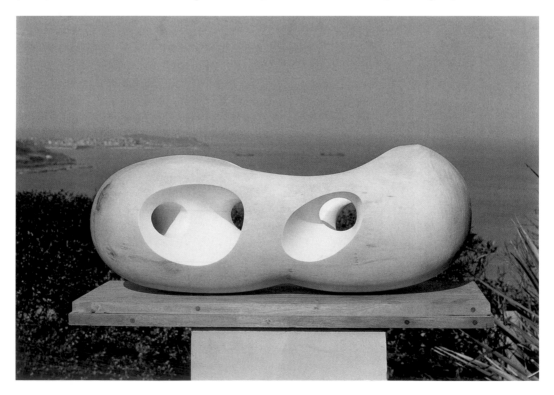

Stokes's analysis might be summed up by saying that Hepworth was a modernist object maker, attentive to the given or found qualities of her materials, and Moore a modern figure modeller. Put this way, though, features of their different approach are made apparent that could not be encompassed by Stoke's conception of sculpture as carved or modelled surface. Moore's works, for all their appearance of object-like three-dimensionality, actually conform, if in a rather unstructured way, to Hildebrand's imperative that a sculpture in the round should be clearly manifest as plastic shape when viewed from head on. Indeed, the basic form of Moore's figures, including their cavities and holes, is usually clearly apparent from the main viewpoint. With Hepworth's sculptures, the situation is very different. They are not so much plastic shapes as objects that take on a very different character when seen from various angles.

From one side (fig. 75), Hepworth's modestly sized wooden *Pendour*, for example, looks like a fairly solid object resting flat on its side, with two rounded cavities scooped into it that run through to what seem to be equivalent cuts made into the other side. From this opposite side (fig. 76), however, more and also larger cavities come into view, and a hollowing out effect takes precedence over a sense of rounded solidity. The difference between the two views is emphasised by the slightly different coloration of the hollows, light blue on one side and white on the other, with both contrasting with the darker, outer form of the work. Moreover, because the cavities are cut out sharply with no transitional modelling, the interruptions created by those on the far side breaking into the

76 Barbara Hepworth, *Pendour*

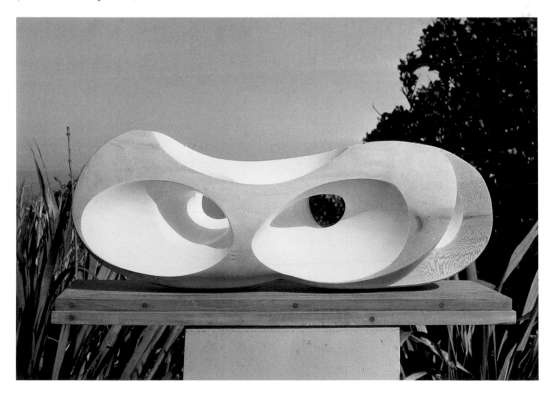

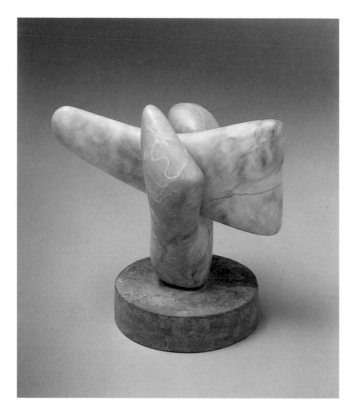

77 Barbara Hepworth, *Two Forms*,
1933, pink alabaster on limestone
base, height 30.5 cm, private
collection, on loan to the Tate
Gallery, London

simply rounded overall form of the sculpture cannot be inferred from slight irregular-
ities in the shaping of the sculpture's outer surfaces on the near side.

With Moore, by contrast (fig. 74), the overall relation between the outer shape and
the hollows gouged into it can usually be apprehended from the principal viewpoint, and
there are few unexpected shifts in one's perception of the work as one changes position.
It is as if what animates one's viewing of a sculpture by Moore is primarily some sug-
gestion of movement represented by the pose or overall shape. In the case of the Hep-
worth, the animation is much more kinaesthetic, and located in the continually shifting
apprehensions of the work to be had as one circulates round it and hollows and cuts come
in and out of view. In those of Hepworth's sculptures where two or more separate forms
are juxtaposed, a similar animated instability is created by the shifting sense of the rela-
tion between them as they are viewed from different angles. At one point they will almost
fuse together, then at another split apart again.

What is perhaps Hepworth's most Surrealist and psychically loaded work, *Two Forms*
(fig. 77), dating from the time of Stokes's commentary, consists of a flattish rounded stone
thrust into the cleft of a forked one, in a configuration that shares some of the intima-
tions of sexualised violence found in Giacometti's *Suspended Ball* (fig. 61). With the Hep-
worth, though, the dynamic tension between the two elements is suggested less by their
internal composition than by the noticeable way the relation between them changes once
one circulates round the work. Looking from the side, with the upper shape in profile,
the flattened form seems to be held tightly in the grip of the lower one. When one moves

round ninety degrees, however, so the thin end of this upper shape points directly at one, gaps appear between it and the cleft into which it is inserted. It now seems to rest in place, tilting gently to one side, and there is a sense of release. But then, moving on, the gap closes and the outer forked form again tightens its grip. This shifting sense of tightening and releasing does as much to sustain the work's psychic charge as the vivid image of two awkwardly and suggestively juxtaposed forms it presents as one first comes across it.

At this point, we need to return to Stokes's distinction between carving and modelling to remind ourselves how much this was embedded in the painterly imperatives of his early modernist aesthetic, and so would not be attuned to those aspects of Hepworth's object-based conception of sculpture I have highlighted here. Far from presenting the viewer with a shifting array of appearances, carved sculpture for Stokes elicits a sustained stability of apprehension. Many of the theorists we have been looking at in this chapter shared such a view of sculpture. Even so, Stokes's distinctive concern with the shaping of surface gives his analysis a different inflection. If we look at his ideas on the different temporal rhythms of apprehending carved or modelled forms, we shall find that his understanding of viewing a carved form does not entail an outright denial of temporality, as is the case with most theorists who insist that the form or volume of a sculpture disclose itself instantaneously. As Stokes explains,

> The mind that is intent on plasticity often expresses in sculpture the sense of rhythm, the mental pulse. Plastic objects, though they are objects, often betray a tempo. Carving conception, on the other hand, causes its object, the solid bit of space, to be more spatial still. Temporal significance, instead of being incorporated in space, is here turned into space and thus is shown in immediate form, deprived of rhythm.[21]

Stokes is thinking here of the temporal rhythm of viewing not work in the round but work set out on a flat plane, whether the shaped surface of a relief or the marked and pigmented surface of a painting. With carved work, there is a sense of all-overness as one scans it, an absence of emphatic masses and gaps or of larger accents. A dense array of interlocking facets of more or less equal value modulate the whole area one sees. The vividly temporal rhythm of viewing which modelled work invites, as one shifts between full plastic figures and neutral ground, is evened out with carved work. In spite of this, apprehending a carved work has a temporal quality, involving an intense steadiness of looking, that is more like the experience of listening to a succession of sustained chords than the uneven dynamic pulse of a melody.

For Stokes, a carved surface could be exemplified as well by a painting by Piero della Francesca or Cézanne as by a Renaissance relief sculpture.[22] Indeed, he concludes his discussion of carving and modelling in *Stones of Rimini* by indicating that it is in modern painting that he sees a 'future . . . for carving, or for the full spatial conception . . . the strength of such modern painting as is truly contemporary is founded upon a reaction from modelling values in favour of carving values'.[23] For Stokes, as for most of his contemporaries and immediate predecessors, modern painting is where the action really is, while sculpture furnishes images that clarify and render concrete the ideas he has about painting. At least he is very explicit about this, as Greenberg was to be later, and also about the kinds of viewing invited by work arrayed on a flat surface.

* * *

After the series of articles he published in 1933, which included the commentary on Moore and Hepworth discussed above, Stokes engaged in very little sustained criticism of work by contemporary artists. However, after the war, he did write a number of extended essays where he developed a general analysis of the condition of contemporary art.[24] It is in a discussion of collage in the essay *Reflections on the Nude* published in 1967 that he reformulated his duality between carving and modelling in a way that is particularly suggestive for understanding attitudes to sculpture in the immediate post-war period. I want to dwell on this discussion for a moment, partly to highlight the larger importance of Cubist collage for mid-century conceptions of sculpture. Stokes, rather like Greenberg, envisaged modernist sculpture in terms of collage rather than a privileging of the object.[25]

Collage for Stokes was the characteristic manifestation of carving values in modern art now that the integrative capacities exemplified by Renaissance relief carving were no longer viable. To be credible, the actuality and objective givenness that modern art dealt in had to be insistently literal and to comprise the stuff of modern life. The objectivity of the found fragments in collage offered, in Stokes's view, a modern equivalent of the givenness of the stone block from which earlier artists had fashioned their carved work. 'A substance to be carved', he explained, 'unlike the moulded clay, is a potential ready-made, an object fit to be contemplated in isolation, to some degree an *objet trouvé*, an over-riding sense of whose actuality usually persists whatever the sculptor does with it.'

Collage, in his view, was not to be seen as a purely painterly device. Not only had it given rise to painting that 'combines with sculpture', but it also now informed the work of many 'pure sculptors', notably David Smith's (figs 79, 80). His 'generous steel constructions', as Stokes put it, and 'abraded piled cubes provide a countenance for steel and for welded construction, but not at all an expressionist countenance for robots . . . Out of fire and shrill piercing, out of sharp usage, an anatomy has been forged of great breadth for metal.'[26] If some of us might balk at Stokes's suggestion that Smith's forging and welding of metal was closely related to 'the anthropomorphic carving of stone', we should have to credit Stokes with seeing that in Smith's work – rather as in Tatlin's constructions – the modernity of the materials and the conception combine with a dogged refusal of any easy modernist rhetoric of machine-age power and mechanical efficiency. Smith called his works monsters, and their combination of delicacy and a lumbering clumsiness perhaps has a certain affinity with the impressively awkward constructions fashioned by Tatlin.

The most significant shift in Stokes's later understanding of sculpture was the broadening of his ideas on carving and modelling so as to take in the psychodynamics of the viewer's engagement with the object or work. He now defined a carved work as one that a viewer experienced as having a wholeness independent of his or her fantasies and inner impulses, in contrast to modelled work where these seemed to take over and shape the object. Stokes was explicitly referring here to the distinction between part- and whole-object relations in Kleinian psychoanalytic theory. In this theory of the object as human presence, part-object perceptions characterise the very young infant's relations with the external world when it makes no clear distinction between its inner impulses and things

outside, and envisages these things as looming fragmentary presences redolent of its own desires or anxieties. Whole-object perceptions, in comparison, are more mature ones, where the object is acknowledged as separate and possessed of a certain autonomy, and is no longer subsumed within whatever inner impulse or fantasy it might elicit.[27]

Like so many theorists of modernity in the period, Stokes envisaged the modern subject as regressing to hypnotic and anxiety-laden part-object projections of things, stimulated by the overload of fragmented and disjointed sensations coming from the modern environment.[28] Carving, with its emphasis on the integrity and givenness of materials, offered a model for a way of engaging with the external world that resisted 'the incantatory power of modelling' and the modern 'systematic rationalization of omnipotence'. In a world where the almost infinite shaping and transforming power of modern science and manufacture made the given substance of objects seem immaterial, this resistance had to be taken to extremes, to a cult of the found object and a 'code of aesthetic reverence for the mere presence of things'.[29]

In Stokes's view, the more extreme reductive or minimalising tendencies in contemporary art were a necessary response to the disintegrative conditions of modernity. He even noted how earlier modernist attempts to forge a figurative motif that, however reduced, however fragmented, could still stand as the cipher of an autonomous human presence, no longer seemed to work. While Giacometti's figures (fig. 62) had provided some kind of 'symbolic whole-object briefly encountered', he wrote,

> much visual art today has abandoned this direct search for an unconquerable quiddity of the self, an occupation of Romantic thinking right through to the Existentialist version of the present time, in favour of the sifting for the parallel term, for the unconquerable natural or manufactured object, the ordinary objects of the outside world stripped or cleaned of our easier modes of appropriation by projection and of their subservience from the imaginative point of view to facile emotions and memories.[30]

The condition of contemporary art, as he saw it, was a complex one, for alongside 'some humility before objects, some idolatry of the actual, an old omnipotence may be exploiting a manic and predominately dismissive rule.' This meant that an extreme modelling dissolution of resistant materiality in work based on 'chance effects' or 'artistic happenings' constituted the other side of a modern imaginary that embraced an equally extreme carving tendency to 'the stubborn, unidealized affirmation' of the 'is-ness' of actual things. There was an inherent instability in a modern engagement with objects. With the 'imaginative permissiveness that extends to objects an opaque identity that has eluded our possessiveness', he wrote, 'objects have become mysterious; we are sometimes unable to establish a progressive visual system from part- to whole-objects.' This was a social condition, as 'not only the urban environment but even technological exploration projected on to paper tends to blur divergence between' these alternatives.[31]

In drawing attention to this tendency to unanchored oscillation between an engulfing appropriation of objects as fantoms of an inner world and a sense of their obstinately given, alien otherness, Stokes was not only adding a psychoanalytic twist to a long-standing diagnosis of the conditions of modernity, which goes back to the sociological analysis of writers such as Simmel at the turn of the century. He was also identifying something more specific to the artistic culture of his time. As we shall see, such patterns

of psychic instablity were a distinctive feature of the more highly charged reponses to Minimalist sculpture in the period.

* * *

I want to conclude by returning to Stokes's conception of sculpture as an art positioned between painting and architecture. Stokes's ideas on sculpture stand out from most theorising on the subject in the period because he did not invoke some abstract ideal of fully embodied sculptural plasticity to hide the gap in modernist conceptions of sculpture. We have seen how his sculptural aesthetic is in many ways embedded in a painterly framework. Here I shall consider how he addressed certain important issues relating to sculpture through an analysis of architecture in his oddly compelling, partly autobiographical meditation on the affective power of the physical environment, *The Smooth and the Rough*, a book he published in 1951 but conceived during and in the aftermath of the Second World War. It is in these speculations on the psychic resonances carried by even the simplest and most abstract architectural form that he developed his most sustained analysis of how the configuring of space and surface in a three-dimensional object or structure might affect a viewer.

It is Stokes's contention that architectural forms, 'however forcible the effect of mass, whatever the stimulus of the plastic nerve', 'resolve themselves, more especially for their inhabitants, into surfaces that are pierced by apertures with entry to a womb-like cave.' In his view, one's apprehension of any piece of architecture is structured by the distinction between the slightly rough resistant face of the wall and the yielding smoothness of the openings cut into it. This not only defines the sense of depth and enclosure fundamental to architecture as three-dimensional structure but also the psychic dynamic in any response to architectural form. In his view, all the dualities of architectural aesthetics devolve from this basic dichotomy between smooth and rough:

> Such effects as volume and scale, each providing a separate sensation, are finally themselves the qualities of that smooth–rough distinction which we observe plainly in the simple Mediterranean house; best known, perhaps, in the process of being built, before glass has tamed yawning apertures of velvet-smooth blackness which confer an ordered sense of voluminous depth, smoother than the plastered walls whose bottom courses are sometimes left bare, displaying the close packing of stones that were blasted from the rock upon the site.[32]

This distinction between smooth and rough operates in Stokes's analysis at two levels. There is the more radical, almost minimalist one adumbrated in the quotation above, where the emphasis is on the bare contrast between the rougher resistant outer surface of a wall and the smooth opening into an interior. The distinction between rough and smooth is in this case an unmediated cut between exteriority and interiority – as in the pierced walls of modernist buildings or the uncompromisingly sharp transition between outer surface and inner space in later Minimalist work such as Judd's. But the rough–smooth dichotomy also operates at a more conventional level in Stokes's analysis when he comes to discuss the distinctly unmodern modulations of surface in Renaissance architecture. In this context, he emphasises the subtle transitions within the solid sur-

faces of the wall between the smoothness of the undecorated areas and the roughness of the mouldings and other architectural motifs in relief, transitions that moderate the abrupt cut between wall and aperture.

In both instances, Stokes keeps to a surface model of aesthetically compelling form, with a sense of depth being produced in the shift of register between a more resistant rough area and a more yielding smooth one. A new element, absent in his earlier discussion of relief sculpture, is the interplay between exterior face and interior opening or volume that he associates with the transitions between rough and smooth. He interprets the psychic logic of this interplay in complex, one might almost say convoluted, Kleinian terms. The building becomes a fantasmic image of the body of the mother, both desired as a source of solace and nourishment and torn open in aggressive spasms of greed and frustration, but then restored to a resonant totality. Within this schema, the mouldings and the modulations of surface in Renaissance architecture function to repair the violent cuts made by the gaping apertures penetrating to the interior.

I am not convinced that the analysis quite works even on its own terms. But there are features of it that make sense even if one is not totally committed to his version of Kleinian object relations theory. Here Stokes is suggesting, in a distinctively modernist way, how feelings of depth and interiority are activated through what can literally be seen on the surface of things. This brings me back to the modern sculptor whom Stokes had earlier singled out as best realising a carved conception of sculptural form, Barbara Hepworth. I want to consider briefly how Stokes's ideas might illuminate a distinctive interplay between exteriority and interiority in her sculpture that differs from most other attempts made at the time to open up the sculptural block and penetrate it with space. We have seen how with Moore (fig. 74), for example, the modelling is such that there is a smooth transition from the exposed outer face of the block to the indentations or holes. The hollowed out sculpture remains a solid shape, if made more complex, and all the surfaces still register as the exterior of a suggested body part or limb. With Hepworth (figs 75, 76), the effect is very different because of the sharp cuts between the smooth, slightly convex outer surfaces and the concave hollowed out inner ones. The cavities seem to penetrate into the interior of the block and expose its inside. Someone coming to her sculpture charged by Stokesian fantasies of maternal bodies might well see 'surfaces that are pierced by apertures with entry to a womb-like cave,' though I feel that 'womb-like' is not quite appropriate to Hepworth's cool and spare, yet resonant, evocations of interiority.

A rather different understanding of this aspect of Hepworth's work is to be found in the unexpected tribute to her in Burnham's *Beyond Modern Sculpture*:

Barbara Hepworth has mentioned the intense feeling of achievement that came with carving a hole directly *through* a sculpture . . . Not intending to create a negative silhouette, she rather intended in making these penetrations to make an *inside* to her carvings. Often she seductively emphasized this *insideness* with the use of brilliant yellow and white paint. The viewer is very much lured by the inviting brightness of these lightened spaces. One is reminded of Gaston Bachelard's essay, 'The Dialectics of Outside and Inside' . . . where he writes of the 'interior immensity' and spatial dizziness that can result even from small spaces that lend themselves to sudden accessibility.[33]

If Hepworth herself talked about how 'the colour in the concavities plunged me into the depth of water, caves, or shadows deeper than the carved concavities themselves', Burnham is still right to draw attention to the 'inviting brightness' or 'lightened spaces' of her hollowed out interiors, to the suggestions of lightness and openness, very different from the 'velvet smooth blackness' of Stokes's evocations of womb-like interiority. But Stokes's dark shadows and Hepworth's depths are there too in these whitewashed hollows.

It is almost as if Hepworth wanted to give the interiority of the shadowed hollows of her sculpture a dynamic instability by artificially lightening them with paint. There is a potentially disquieting effect of dilation as the hollows suggest both closing in and opening up, or a 'spatial dizziness' as Burnham described it. This echoes a further dilation between feeling distanced from the smallish bounded object and feeling drawn in close, almost as if entering its interiors. Hepworth once commented on this shifting relation between self and object in which work such as *Pendour* had involved her: 'From the sculptor's point of view, one can either be the spectator of the object or the object itself . . . I was the figure in the landscape and every sculpture contained . . . the ever-changing forms and contours embodying my own response to a given position in a landscape.'[34] In saying this, she was not inviting one, as Moore often did, to view her sculpture as if it were a feature in some natural landscape. She was talking about the unstable self-situating that resulted from being caught up in a close encounter with the sculpture and momentarily being denied a stable external point of reference. While at one moment the work would seem like a thing set in an environment of some kind, at another, when seen closely, it effectively became an environment one inhabited.

Once drawn into what Hepworth described as 'the encircling interplay and dance . . . between the object and human sensibility', the sculpture ceased to be an isolated, bounded shape, and opened inwards. Perhaps, thinking of Stokes, we could say that it momentarily became more like architecture than sculpture, though the architecture involved would have to be one of constantly shifting articulations of shape and of unexpected transitions between inside and outside. The dilating effect, alternating between a closed object and a more open environment, could be just another modernist flight of fancy, were it not produced in the process of viewing the hollow scoop and solid swell of surface and subtly awkward poise of this deceptively simple sculpture.

Sculpture as Collage, as Monster: David Smith

In the immediate post-war period, the modern alternative to traditional figurative sculpture was increasingly envisaged as a kind of collage in three dimensions. The work involved took the form of open structures of welded metal parts. It was generally seen as having been pioneered by Gonzalez (figs 81, 82) and then brought into the mainstream of sculptural practice with the larger figure-size work of artists of David Smith's generation, and finally given new currency by Caro and other sculptors of the 1960s. From the outset, David Smith was seen as the single most important early proponent of this new

sculpture, rather as Brancusi had been for the earlier shift to small-scale, pared down object-like work. Such a historical framing of Smith's project, though, needs to be qualified on two counts. Firstly, if one single image of modern sculpture circulated among the broader artistic public in the 1950s and 1960s, this would probably have been a reclining figure by Henry Moore, even though Smith's work was generally considered by committed modernists to involve a more radical rethinking of sculptural form.[35] Furthermore, from a present-day perspective, Smith's sculpture seems less the prototype for a major new trend than something of an exception. The subtleties of its staging, the complexities of viewing it elicits and its larger resonances and exceptionally broad reach now make it seem very different from the post-war sculptural drawing in space with which it was once identified.

Such ambiguities in Smith's positioning within the post-war modernist sculpture are brought out nicely in Clement Greenberg's analysis of his work. At first, when Smith began to emerge as an important figure in the modern art world after the war – though never so dramatically or with so much international publicity as his American painter contemporaries such as Pollock and De Kooning and Rothko – Greenberg presented him as playing a key role in a larger transformation of modern sculptural practice, moving it away from the traditional monolith to a 'new linear pictorial sculpture' that derived its inspiration from Cubist painting and collage.[36] Soon, however, Greenberg retreated from this situating of Smith's project. When in 1956 he came to write his most extensive essay on the sculptor, which he reprinted in slightly revised form in *Art and Culture*, his hopes for a larger sculptural revolution taking off from the principles of 'cubist collage and bas relief' had 'faded'. He was of the view that painting, far from ever being surpassed or at least equalled by a new sculpture, 'continues to hold the field, by virtue of its greater breadth of statement as well as by its greater energy.' So where did that leave Smith?

In contrast with his American and European contemporaries, who made of the new welded steel assemblage inspired by Gonzalez little more than a 'superior kind of garden statuary' or 'a new, oversized kind of *objet d'art*', Smith alone, Greenberg felt, stood out for the 'copiousness of his gift, the scale and generosity of his powers of conception and execution.' The formal and technical innovations that previously had seemed to offer a basis for a new, truly modernist sculptural practice now appeared less significant.[37] Smith remained remarkable for Greenberg not as the force behind a radical reconfiguring of modern sculpture, in the way say that Pollock was seen to be for modern painting. Rather he became an exception who somehow managed to fashion from the unpromising art of sculpture an unusually sustained and intriguing practice. Indeed, those moments when Greenberg continued to represent Smith's work in systematically formal terms lack the urgency of his attempts to grapple with qualities that lie beyond the reach of his favoured formal paradigms, as in the following comment on Smith's inventiveness, from an essay written shortly before the sculptor's death:

> I can see that Smith's felicities are won from a wealth of content, of things to say; and this is the hardest, and most lasting, way in which they can be won. The burden of content is what keeps an artist going, and the wonderful thing about Smith is the way that the burden seems to grow with his years instead of shrinking.[38]

Smith himself had a clear sense of his own project that he took considerable pains to articulate. Like the later generation of American artists which included Judd, Smithson and Morris, he speculated at length on the issues he felt his work was addressing in a series of eloquently formulated essays and statements. Of his direct contemporaries, he came closest in this respect to the painter Barnett Newman. Rather than letting drop isolated aphorisms about his art, like Brancusi or Rodin, for example, which would then be packaged by a sympathetic writer, he constituted himself as a critic who had a clear understanding of the larger intellectual and critical parameters of his practice. The text of his talk at the symposium 'The New Sculpture' sponsored by the Museum of Modern Art in New York in 1952 is easily as incisively argued an analysis of the situation of contemporary sculpture as the now classic essay 'The New Sculpture' that Greenberg featured in his book *Art and Culture*.[39]

* * *

Smith's sense of his own project grew out of a pretty clear awareness of the shifting social and political circumstances of artistic practice in pre- and post-war America. Early on, in response to the often highly politicised debate in the late 1930s about the relative merits of abstraction and realism for a radical artistic practice, Smith developed his own, ideologically resonant, defence of abstraction. His statement 'On Abstract Art', delivered at the United American Artists forum in New York early in 1940, argued forcefully for a non-mystical, materialist understanding of abstract art. At this point, his aesthetic commitments were shaped by an overt anti-capitalism with a definite Marxist edge. The stand he took at the time against American entry into the Second World War bears witness to his positioning on the radical left; he was indeed for a time a member of the American Communist Party. While he argued for the radical potential of abstract art as against a more populist realism, he could still exhibit a series called *Medals for Dishonour* in 1940 whose figurative imagery projected an explicitly anti-imperialist and anti-capitalist message.[40]

Like many of his American avant-garde contemporaries who became politicised in the 1930s, he ceased to take such an overtly socialist or Marxist stance as the climate in the US shifted to the right in the lead-up to the Cold War. Smith, however, never actively renounced his previous Communist sympathies and maintained an emphatic, if very personal, loyalty to what he saw as the basic values of the labour movement. Unlike most of his peers, he did not undergo a conversion to a classless, American-style, liberal humanism, and did not buy into fashionable theories about the essentially alienated condition of the modern intellectual and artist.[41] He certainly felt increasingly at odds with cultural and political life as it was shaping up in post-war America. He also found that his sense of solidarity with the position of the working man was becoming an increasingly individual matter, which tended to underline his sense of cultural isolation. If, like many committed modernists at the time, he began to take the view that in these circumstances, maintaining a sense of integrity increasingly required a retreat into the self, he could still write in a note made in 1948 that:

> by choice I identify myself with working men and still belong to Local 2054 United Steelworkers of America. I belong by craft — yet the subject of aesthetics introduces a

breach. I suppose because I believe in the future, [in] a working man's society, and in that society I hope to find a place. In this society I find little place of identify[ing] myself economically.[42]

To the end of his career, he continued to maintain that the public initiatives of Roosevelt's Works Progress Administration had been hugely important for artists of his generation. In an interview he gave in 1964, for example, he recalled how he and his fellow artist had then felt

> for the first time, collectively, we belonged somewhere. It gave us unity, it gave us friendship, and it gave us a collective defensiveness . . . In a sense we belonged to society at large. It was the first time we ever belonged or had recognition from our own government that we existed.[43]

At the same time, he was hard-headedly aware that the situation since then had radically altered. This was not just because the incipient collectivism of government policy under the Roosevelt administration had come to an abrupt end. It was also because the circumstances within which modernist artists like himself were working were such that there was no longer any broader sense of public purpose with which they could realistically identify.[44] Smith registered the shift very clearly in his changing assessment of the prospects for a modern public sculpture, which back in the thirties and early forties he had believed could combine with architecture as part of a progressive modernising project.

In the essay he wrote for a proposed Federal Art Project publication called 'Modern Art and Society' in 1940, he took the view, widely shared by radical modernists in the inter-war years, that the recent revolution in art was giving rise to a new synthesis of sculpture and architecture that would eventually have a truly public, democratic function. In seeing sculpture's destiny as a public art anchored in an architectural context he was, as we have seen, also echoing a long-standing view that sculpture was somewhat at odds with the modern conception of the art work as autonomous, siteless entity on the model of an easel painting. As he put it,

> The present function of sculpture in our democratic society relies primarily on its relation to architecture . . . The secondary use may be designated as free-creative. Here the sculpture is conceived independently, for purely aesthetic or fetish reasons. Creative sculpture has always had a definite relation to the architecture of its period . . .

He also put a clear political gloss on what he described as the 'typical bourgeois attitude' of opposition to modern sculpture, emphasising that 'the reactionaries', or more specifically the 'Babbit reactionaries', who 'object to modern sculpture and modern architecture . . . do not always object on aesthetic grounds alone, but because they object to government power generation and conservation, housing, educational and civic building.'[45]

The diagnosis he offered in a lecture delivered in 1957 on 'The Artist and the Architect' was radically different. By then he had come to the conclusion that the modernist programme for an integration of art and architecture in a new public role had proved to be a 'myth', a quite unsustainable 'marvel of idealism'. On one hand, he felt, this hope of union was at odds with the radically different priorities of sculpture and

architecture, which had been thrown into sharper relief since the emergence of the modern art movement in the late nineteenth century. On the other, and more importantly, it went against the grain of the essentially individualistic condition of art practice in contemporary society.

Smith concluded with a perspicacious assessment of why the current fashion for embellishing architectural projects with assorted modern sculptures was such an unsatisfactory and empty compromise. Contemporary understandings of what constituted an authentic art work required a different model of how architecture and sculpture might interact with one another, one that took on board their competing claims and recognised the force of the individualism guiding modern art practice:

> There is no ideal union of art and architecture when art is needed simply to fill a hole or enliven a dead wall. Good architecture does not need art if the architect himself doesn't see it in his conception . . . Good sculpture . . . is based upon a different aesthetic structure. Until the architect . . . accepts it on its own terms, seeks it as one contemporary autonomy meeting another in a relationship of aesthetic strength and excellence, art and architecture will remain the strangers they have been for at least the last hundred years.[46]

What in particular did Smith have in mind when he insisted that sculpture is 'based upon a different aesthetic structure' from architecture? His key point was that modern sculpture had nothing to do with the complex collective imperatives in which architecture as a functional art was necessarily involved. In Smith's view, the disparity between sculpture and architecture had become even sharper in recent years with the emphasis on the individual act of making in sculpture such as his, which involved direct working with welded and forged metal, as distinct from indirect casting. For Smith, contemporary sculpture now operated in effect like easel painting as a fully autonomous art, and not as some kind of shaping, or model for shaping, the 'man-made' environment.[47]

Abandoning his earlier hopes that a socialist society was in the making where the sculptor could collaborate with the architect in creating a new, truly public environment, Smith was forced to conclude that the only viable destiny for a modern sculpture was as an individual creation that would address the viewer on a one-to-one basis, and would thus have to be siteless or homeless. Smith took a consistent stand on this issue, refusing to satisfy the increasing demand for corporate or municipal sculpture, which left him with little alternative but to show his work in a conventional gallery setting. The one major exception was the temporary display he arranged in a Roman amphitheatre at Spoleto of work he had been making at a disused factory at Voltri near Genoa on the invitation of the Italian government in 1962.[48]

Like Brancusi and Rodin before him, however, he went to some pains to create a sympathetic context for his sculpture in an environment over which he did have control. As he had no plaster models he could retain like Rodin, he kept back an unusually high proportion of his finished output which he displayed, not in the more usual indoor studio setting, but in an outdoor one that was radically different from the spaces where he habitually showed his work. In the grounds surrounding his studio at Bolton Landing in the Adirondack Mountains in upstate New York, he created a kind of sculpture garden. This display was not public except in the very limited sense that favoured critics and

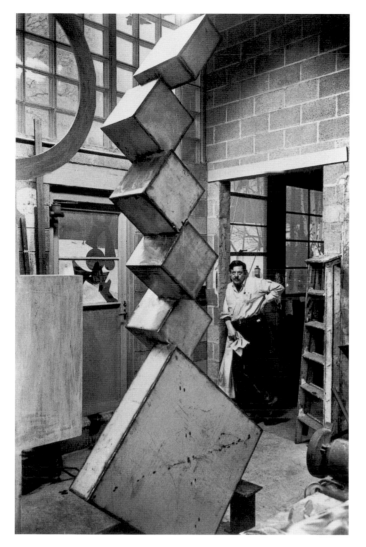

78 David Smith, *Cubi I*, 1963, partially completed, photographed in Smith's studio at Bolton Landing by Dan Budnik

friends could visit it. Smith, however, ensured that images of it entered the public domain by carefully photographing his work in this context (fig. 90) and, at the very end of his career, having chosen photographers such as Ugo Mulas and David Budnik to do the same (fig. 85).[49]

There is then a radical ambiguity as to how Smith conceived the context in which his sculpture should ideally be seen, which is reflected in comments he made on the subject. On the one hand, he would argue against outdoor public or architectural sculpture in terms that seem to privilege a neutral, gallery-like, indoor setting (fig. 78):

Most of my sculpture is personal, needs response in close proximity and the human ratio. The demand that sculpture be outdoors is historic or royal and has nothing to do with the contemporary concept. It needn't be outside any more than painting. Outdoors and far away it makes less demands on the viewer.[50]

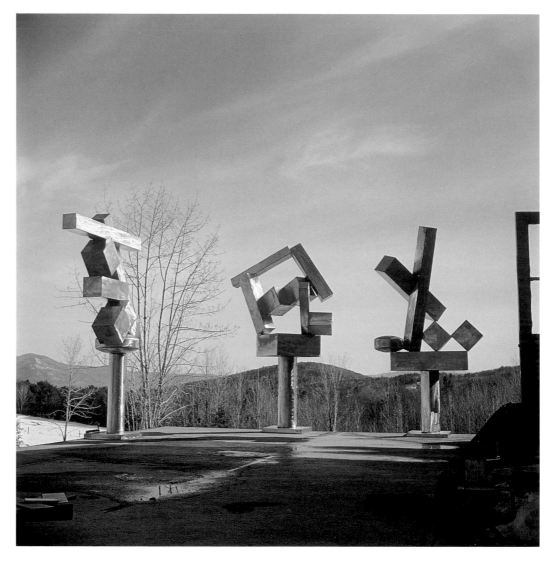

79　David Smith, *Cubi XVIII*, 1964 (Museum of Fine Arts, Boston), *Cubi XVII*, 1963 (Dallas Museum of Fine Arts) and *Cubi XIX*, 1964 (Tate Gallery, London), all burnished stainless steel, photographed by the artist at Bolton Landing

On the other, when talking about the reflective qualities of the burnished steel in his new *Cubi* series (figs 79, 89), he would say:

> I like outdoor sculpture and the most practical thing for outdoor sculpture is stainless steel, and I made them and I polished them in such a way that on a dull day, they take on the dull blue, or the color of the sky in the late afternoon sun, the glow, golden like the rays, the colors of nature. And in a particular sense, I have used atmosphere in a reflective way on surfaces . . . They are designed for outdoors . . . they are not designed for modern buildings.[51]

How was Smith imagining his work on this occasion? It was not as marker in a landscape, like later land artists, though his photographic staging of it has some affinities with theirs. Should we perhaps be thinking of Rilke's image of Rodin's work projected 'in the sky that surrounds the mountains'? Or would it be more appropriate to think of contemporary parallels, such as Henry Moore's use of photography to stage his work in natural landscape settings? The differences in the latter case are as illuminating as the similarities. Smith did not present his sculptures so that they seemed to blend in with their natural setting, as Moore did, but so they stood out sharply from it. Their communion with their setting was by way of shared light and colour effects. They were not made to look like natural things. Frank O'Hara emphasised this point when recalling his impressions of the display of work at Bolton Landing:

> The contrast between the sculptures and this rural scene is striking: to see a cow or a pony in the same perspective as one of the *Ziggurats* [fig. 87], with the trees and mountains behind, is to find nature soft and art harsh; nature looks intimate, vulnerable, the sculpture powerful, indomitable . . . Earlier works, mounted on pedestals or stones about the terrace and garden, seem to partake of the physical atmosphere [fig. 82], but the recent works [fig. 79] assert an authoritative presence over the panorama of mountains, divorced from nature by the insistence of their individual personalities, by the originality of their scale and the exclusion of specific references to natural forms.[52]

* * *

O'Hara's comment highlights the significant point that Smith's sculptures, the later ones in particular, confront the viewer as looming, inhuman presences (figs 78, 80). The issue of how his work presents itself to be viewed is crucial, being something to which Smith himself drew attention in his essay on the new sculpture from which I quoted in the Introduction:

> My position for vision in my works aims to be in it, and not a scientific physical viewing it as subject. I wish to comment in the travel. It is an adventure viewed. I do not enter its order as lover, brother or associate, I seem to view it equally from the travelling height of a plane two miles up, or from my mountain workshop viewing a cloud-like procession.[53]

It is obvious that the mode of viewing Smith has in mind is not the traditional one in which a viewing subject looks at an object from a distance. He favours a viewing where one's positioning in relation to the work is unstable, and one feels both inside and outside it, both close and distant. Even the distant view alternates between seeming to look down onto something grounded and up at something skied. It is not surprising that Smith lighted on Julio Gonzalez's comments about how 'Only a cathedral-spire can show as a point in the sky where our soul is suspended. It is these points in the infinite that are precursors of the new art: *To draw in space*.'[54] Yet there is also something in what Gonzalez says that betrays an important difference between his and Smith's conception of sculpture.

80 David Smith, *Sentinel I*, 1956,
steel, 227.5 × 57.5 × 43 cm,
National Gallery of Art,
Washington, D.C., photographed by
the artist at Bolton Landing

Gonzalez's words are an eloquent expression of the early modernist tendency to project small-scale sculptural objects as imagined architectonic constructs. It also makes some sense to think of his sculpture as drawing in space (fig. 81). But this is not so evidently the case with Smith. For one thing, Smith's sculptures do not have the same intimacy of scale and delicacy of construction that give Gonzalez's sculptures their drawing-like quality.[55] There is a further fact that militates against such a view of Smith's work, particularly later on when he departed from his more open constructions (fig. 83) and created work that was no longer supported object-like on a pedestal but planted directly on the ground (fig. 87). The invitation to project such work as a drawing in space is partly blocked by its insistent presence as a thing directly impinging on the viewer's space. Smith's fascination with this kind of confrontation with the viewer is shown in a photograph he took of himself sizing up, a little apprehensively, or maybe suspiciously, the first of his *Cubi* that he had just assembled in his workshop (fig. 78).

82 Julio Gonzalez, *Head called 'The Tunnel'*, c. 1932–3, iron, 46.7 × 21.8 × 30.9 cm, Tate Gallery, London

81 (*left*) Julio Gonzalez, *Large Maternity*, c. 1934, iron, 130.5 × 41 × 23.5 cm, Tate Gallery, London

There is no definitive break in Smith's work between an earlier phase, inviting a more projective, modernist mode of viewing, and a later one, where a more literal, proto-Minimalist viewing is elicited. Even with an apparently drawing-like work such as *Australia,* there is a striking interplay between seeing the work as an open expansive form projected in space (fig. 83) and becoming aware of its actual size and the material density of its structural elements, as well as of the insistent deviations from perfect flatness (fig. 84). In the case of later work, such as *Wagon II* (fig. 90), there is an analogous double-take between a relatively contextless projection of the work as a looming form dominating one's visual field and a more literal apprehension of it as the awkward, heavy, human-scaled thing it actually is. It can expand to acquire a certain grandeur or contract down, even to the point of seeming to be an overblown children's toy. In one of Ugo Mulas's photographs of two *Wagons* in a field at Bolton Landing (fig. 85), these almost look like toy dogs on wheels trailing behind one another.

83 David Smith, *Australia*, 1951, painted steel, 202 × 274 × 41 cm, The Museum of Modern Art, New York, photographed by the artist at Bolton Landing

The ambiguous switching between dematerialised expansion and weighed-down contraction plays off against a further oscillation between seeing the sculpture as a flat pattern projected against a distant background and as a fully three-dimensional thing. The flatness marks another clear departure from Gonzalez, and is taken to a point where suggestions of interiority, of line and surface encompassing an inside space, are largely blocked. Smith's sculptures not only present themselves much more as flat shapes than Gonzalez's (figs 80, 81), but even in their details eschew the suggestions of enclosed volume that Gonzalez exploited to great effect (fig. 82). The flatness, though, does not mean that the sculpture is reduced to being like a painting or two-dimensional image. The flat profile or face of a work serves to articulate its positioning as a free-standing entity, giving it an axis of address that intensifies the viewer's sense of it impinging on the space in which it is planted. *Zig II* (fig. 87) emphatically faces the viewer head-on, while *Sentinel I* and *Volton XV* (fig. 86) turn themselves equally sharply in profile, at right

84 David Smith, *Australia*, photographed by the artist

85 (*below*) Sculpture by David Smith at Bolton Landing, photographed by Ugo Mulas in 1965

angles to the main axis of viewing, exposing a spindly yet sharp phallic protrusion thrusting from their middrift.

The clear profile or frontal image provides an anchoring that is reminiscent of Hildebrand's prescriptions for free-standing sculpture. Yet it is effected in an oddly perverse way that tends to undo the stability that Hildebrand was seeking. The principal view usually presents a fairly close-knit, firmly constructed shape (fig. 87). However, as one moves round to the side, the shape begins to fall apart, opening out precariously as the curved sheets and flat facets and struts of steel begin to separate out (fig. 88), just propping one another up rather than fusing together. Architectonic works, like *Cubi XXIV* (fig. 89), may often appear to be firmly articulated post-and-beam, gate-like structures from the front, but from the side it becomes apparent that the vertical and horizontal struts are displaced in a structurally unsound way from their supports, and that the whole thing would tumble down were it not welded together. Without the integrated formal structuring of the principal view, this instability of effect would not be so forceful and one would not be so aware of the sculpture as a somewhat awkward, precarious yet also substantial thing.

The pictorial flatness that Smith often plays with has, paradoxically, another intensely sculptural effect. With a work such as *Australia* (fig. 83), for example, the tension between the unusually flat overall shape and the way individual elements visibly intrude into three

86 David Smith, *Volton XV*, 1963, steel, height 190.5, depth 24 cm, Museum Ludwig, Cologne, photographed by the artist at Bolton Landing

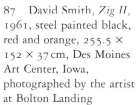

87　David Smith, *Zig II*,
1961, steel painted black,
red and orange, 255.5 ×
152 × 37 cm, Des Moines
Art Center, Iowa,
photographed by the artist
at Bolton Landing

88　David Smith, *Zig II*,
photographed by the artist

89 David Smith, *Cubi XXIV (Gate I)*, 1964, burnished stainless steel, 291 × 214 × 72.5 cm, Museum of Art, Carnegie Institute, Pittsburgh, photographed by the artist at Bolton Landing

dimensions as one shifts to look at the work end on (fig. 84), in the end makes one all the more conscious of it as a construct of a certain substance and thickness balancing precariously in space. Smith, in an interview he gave in 1965, argued against the way

> some critics [to] refer to certain pieces of my sculpture as 'two-dimensional'. Others call it 'line drawing'. I do not admit to this, either conceptually or physically. It may be true in part, but only as one attribute of many . . . I make no apology for my end-views . . . If a sculpture could be a line drawing, then speculate that a line drawing removed from its paper bond and viewed from the side would be a beautiful thing, one which I would delight in seeing in the work of other artists [56]

In his later work, the flatness may often be less marked but is never abolished, and there is almost always a clear directional axis, with a more expansive, formally integrated profile view defining itself at right angles to a narrower, more disarticulated edge-on one. The teasing interplay this sets up is nicely suggested in a widely circulated photograph of three late *Cubi* displayed at Bolton Landing (fig. 79). The left-hand one presents, slightly obliquely, a rather awkward tipping edge view, while in the other two, the tumbling array of cuboid forms opens out and fuses together to form a more firmly defined, flat profile. The directionality is sometimes given a further emphasis by making the main profile suggest a thrust to one side. With works such as *Wagon II* and *Sentinel I* (figs 90, 80), this takes an almost comically literal turn, as the whole structure rests on wheels set to run in the direction of the sideways movement.

The interplay between a firming up of shape and a collapse into formal disarticulation is not only played out when moving round a work. It also comes into operation when shifting along a principal axis between distant and close views. Close-up, the emphatic flatness momentarily stabilising the overview almost literally disassembles itself, as the variegated bends and tilts and curves and inclined facets makes themselves felt. One becomes very aware of the discrete nature of the component parts, of their edges and welded joins, and the differences of colour cease to fuse together in a flat pattern. A sense of formal structure gives way to a fascination with the intriguing textures and shapes, whether these are smoothly forged or slightly rough raw metal (fig. 90), or shimmering planes of shiny, lightly abraded stainless steel (fig. 79). Close to (fig. 91), the surface texturing of the metal rods can acquire a slight suppleness reminiscent of living members. The variegated undulations of surface that come into view suggest an inner flexing power, with the bent sections seeming to have the element they enclose tightly in their grip, and the welding and forging (fig. 80) at times evoking a tough yet flexible connectiveness akin to cartilage. Moving between distant and close views, however, produces another somewhat different effect. Coming in close does not, as is more usual, simply make for an increased sense of instability by unanchoring one's sense of the overall shape in a play of surface. In contrast with the somewhat precarious structure of the work as a whole, individual pieces and joins can begin to stand out as having a striking simplicity and firmness of shape. For a moment, it is almost as if the more immediate suggestions of solidity and stability are to be found in the parts. In a discussion of Smith's late *Voltri-Bolton* or *Volton* series – the works Smith made in his studio from the metal parts acquired during his spell at the factory in Voltri in Italy (fig. 86) – Clement Greenberg commented on this effect, noticing how hardly a piece

90 David Smith, *Wagon II*, 1964, steel, 273 × 282.5 × 112cm, Tate Gallery, London, photographed by the artist at Bolton Landing

makes the impression of geometrical regularity as a whole. If there is geometry here, it is geometry that writhes and squirms. Only when we inspect parts or details do we notice how simplified and trued and faired everything – or almost everything – is. The relatively simple and forthright has been put together to form unities that are complex and polymorphous.[57]

In a work such *Wagon II* (figs 90, 91), there is a forthright strength and solidity and firmness in the fashioning and joining of parts, but overall, once the whole structure comes into view, the thing can look a little awkward and ludicrous, almost collapsed. As Smith himself described it, 'It's a kind of iron chariot on four wheels, with open linear elements. Each section of drawing is totally unrelated, and they don't fall together. They just sit there, broken.'[58]

91 David Smith, *Wagon II*, detail

* * *

Greenberg often talked in characteristically modernist terms about the imperative to view Smith's works structurally and diagrammatically, not as substantive monoliths. But it would be a mistake to infer from this that he simply envisaged Smith's sculptures as dematerialised formal constructs. As we have seen, he himself drew attention to the physically substantive tension between the irregularities and instabilities of the overall shape and the 'trued and faired planes and lines' of the individual parts. Contrary to the drift of his later pronouncements on sculpture, what particularly fascinated him about Smith's work were the structural awkwardnesses, the way that wherever there was 'cursive grace', for example, there was also 'vestigial rawness'. He even on occasion suggested that such tensions might echo certain basic physical tensions felt within one's own body.

Remarking on the figure-like format of many of Smith's late works, he commented how 'It was the soar of the human figure that held him, the uncompromising thrust it makes, the fight it carries on with the force of gravity'.[59]

It is important not to proceed from this to an easy anthropomorphising of Smith's sculptures. To do so would only devalue the ambiguous hold they have on us as incongruous yet compelling ciphers of subjectivity. When Smith talked about the 'adventure viewed' into which his sculpture drew one, he insisted: 'I do not enter its order as lover, brother or associate'. The sculpture is not to be seen as a quasi-human with which one could commune or identify. Its sharp-edged metallic impersonality defies such empathy. Yet its presence still carries certain suggestions of enigmatic subjectivity. Such ambiguities are apparent in Smith's own commentary when he feels compelled to envisage his works as gendered presences and yet refuses any fixed associations between them and the male or female body.

Talking of his *Wagons* in a speech he gave in 1960, for example, he suddenly switches from describing them as 'big constructions which have wheels' to pre-empting any suggestion that as sculptures they might be seen as embodying a beauty traditionally associated with the female figure. There is in his denial of the associations with the female body he himself brings into the picture an unreflective misogyny that often surfaces in his writing. But also implicit in the intriguing incoherence, edginess and truculence is a compulsion that has a bearing on the undefinable 'wealth of content' Greenberg saw in Smith's work:

> I don't feel at all like the age of graces. I like girls, but I don't feel like using that feminine grace in concepts . . . I don't think this is the age of grace. I don't know whether my monsters on wheels will become graces to other people and I don't know or not whether they will be rationalized as being a need or statement of time. They are non-rational, but they filled a need within me.[60]

In conversation with Frank O'Hara, the slippage from thing or construct to gendered body turns, as one might expect, to boys. In this context, Smith is forced to go for the relatively safe option of imagining his sculptures as female presences. Whatever they are, these 'monsters', which might even become 'graces', carry a psycho-sexual charge whose definition is as unstable as it is insistent:

> O'HARA: You must feel that there are all these strange objects around you, in your whole studio or outside.
> SMITH: Well, they're all girl sculptures. Oh, they're all girls.
> O'HARA: Yeh, they're all female sculptures.
> SMITH: I don't make boy sculptures. They become kind of personages, and sometimes they play out to me that I should have been better or bigger . . .[61]

The charge that activates our viewing of Smith's work is not just psycho-sexual but political and ideological too. Smith's intensely ambivalent refusal of grace, of female beauty, of boyish beauty, has its political edge. Work that has a powerful impact in some way puts him in mind of beauty and grace, but in order to retain some measure of integrity, the suggestions of gratification and warm identification have to be shot through with monstrousness, awkwardness or 'vulgarity', as Smith puts it. This split condition is

the political reality of art and of the desires it elicits in an at times viciously anti-collective world.[62] Smith's comments, in all their wayward contrariness and eloquence, get at certain basic complexities in a peculiarly suggestive way:

> The term 'vulgar' is a quality, the extreme to which I want to project form, and it may be society's vulgarity, but it is my beauty. The celebrations, the poetic statement in the form of cloud-longing is always menaced by brutality. The cloud-fearing of spectres has always the note of hope, and within the vulgarity of form an upturn of beauty.

The art of sculpture, as taken passionately seriously by Smith, allows no resolution, no finality. Even at its very best, it is sustained by conflicting spasms of crude wish-fulfilment and destructive violence. There is no moving beyond this condition. In Smith's words, 'the point of departure will start at departure. The metaphor will be the metaphor of a metaphor, and then totally oppose it.'[63] This incessant stirring up and cancelling out of conflicting aspirations and meanings is quite unlike any post-modern play of signification.

For all its singular, emphatic presence, Smith's sculpture ends up blocking the articulation of the larger significance it momentarily seems to have. His is not a sculptural project that seeks to create 'monuments of its own magnificence', to borrow a phrase from Yeats.[64] The eloquence of his work resides rather in some awkward conflation of precariousness and power. His strangely compelling constructions, with their ludicrous clumsiness and odd hints of violence as well as their intermittent suggestions of calm and vivid refinement, seem strongly poised and yet also on the verge of disarticulation and collapse.

5 Minimalism and High Modernism

In the 1950s and 1960s, the norms previously governing mainstream sculptural practice were being thrown into question by a number of different initiatives, whether Pop, Conceptualist, Minimalist, Arte Povera, Neo-Dada, or performance orientated.[1] I shall be focusing here on Minimalist work, and the critical context framing it, because it was out of this that by far the most intensive and sustained engagement with earlier understandings of sculpture emerged. Minimalist objects may not necessarily have produced more resonant or complex bodily responses than other forms of three-dimensional art, but they did more to provoke critical opinion into taking these levels of response into account. The distinctive combination of a substantive and complex occupancy of space with spare, non-imagistic shapes put the viewer in a position where a sense of the work as physical presence, which prompted a variety of shifting apperceptions, was made to seem just as important as any form or image it presented.

Literalism and Objecthood

The analysis of Minimalism that most fully encapsulated the issues involved in this larger rethinking of three-dimensional art, and also brought out most clearly what distinguished the preoccupations implicit in Minimalist and other related work from previous conceptions of a modernist sculpture, was the essay 'Art and Objecthood' published by Michael Fried in *Artforum* in 1967. This intense yet complex polemic against Minimalism made explicit in ways that no other commentary did at the time two key factors, the new anti-modernist focus on the art work as literal object and the new theatricalising emphasis on the staging of work and the viewer's bodily encounter with it.

In the longer term, the more important issue for a reconceptualising of sculpture was the latter point, what Fried called theatricality. He was not so much claiming that the Minimalists were indulging in easy theatrical effect all presentation and no substance – though there was something of this in his critique. Rather he was responding to a larger shift in the artistic culture of the period, from the making and inner formal constitution of the art work to viewer response and processes of consumption. For him the term theatricality also highlighted a feature of the modern viewer's encounter with art that had been an issue ever since public exhibitions were instituted in the eighteenth century, the question of how a work presented itself when displayed in a public arena.[2] At the same time, he was responding specifically to recent installations of work in white cube or warehouse-type galleries, where it was displayed without the mediation of frame or pedestal, and impinged on the viewer in a directly physical way.

What featured most prominently in earlier debate about the new Minimalist objects was their literalism.[3] They provoked particular anxiety because they seemed to have taken the reduction of form to the point of visual, conceptual and expressive nullity. By presenting themselves as no more than physical objects that were simply there, they appeared to threaten the complexity that had given abstract art its self-defining autonomy. To draw out the broader implications of these anxieties, I shall be looking at Adorno's writing on aesthetics because it offers a particularly deeply invested, and politically self-aware, understanding of those developments in art of the period that were challenging the modernist insistence on autonomy.

While I shall be treating Fried's 'Art and Objecthood' as symptomatic of larger shifts in late twentieth-century understandings of sculpture or three-dimensional art, it is important to bear in mind the local art politics that played a role in shaping his arguments. The immediate provocation for his polemic was that Minimalists such as Judd and Morris seemed to have hijacked the principles of his and Greenberg's conception of a modernist art, and reconfigured them in such a way as to threaten the status of the high modernist abstract painting to which both were committed at the time.[4] It was a local battle, albeit one waged with no less motivation and intensity for that, over the soul of the avant-garde in the New York art world. Was high modernist painting finished, and had, as the Minimalists seemed to claim, the critical paring down of painting's means reached the point of no return, where flat surface was all there was and a painting became no more than a mere object? Was the logical step now to move out into three dimensions and abandon the worn-out formal problematics of painting? Ironically, this move was to an extent prefigured by Greenberg himself in an early essay on 'the new sculpture' which he published in 1949, to which I shall return.

The issue of literalism was one whose significance reached well beyond the confines of the debates around modernism and Minimalism in the New York art world. Literalism had become an issue in avant-grade initiatives in a wide range of artistic activity, from Robbe-Grillet's 'nouveau roman' to John Cage's musical compositional techniques, the new dance of Merce Cunningham and Yvonne Rainer, and the privileging of everyday objects in movements such as Pop, European 'Art of the Real' and Arte Povera. Fried was attacking a literalist tendency whose pervasiveness impelled him to mount an elaborate apologia for the modernist commitment to the formal autonomy of the work of art that now seemed under threat.

Fried's analysis needs to be understood in the context of the particular high modernist engagement with the sculptural out of which he came — which in effect means the notion of a modern sculpture as developed by Greenberg. I say engagement with the sculptural, but it was an engagement largely played out within a painterly understanding of the formal logic of art. While Greenberg did write eloquently and incisively on certain aspects of modernist sculpture, particularly, as we have seen, David Smith's, a close engagement with painting functioned as the engine of his aesthetic commitments throughout his career as a critic. Greenberg, more unequivocally than anyone else at the time, gave voice to a long-standing formalist unease, and fascination, with sculpture as involving real depth and space and shortcircuiting the ostensible projection of depth in painting.[5]

Given the logic of Greenberg's analysis, it is to be expected that he felt impelled to offer a systematic theory of what he thought the formal imperatives of a truly modernist sculpture might be. This he did most thoroughly, but also somewhat ambiguously, in an essay called 'The New Sculpture' published in 1949. Here he almost prefigured the Minimalist idea of a move out from painting into three dimensions by suggesting that a new, non-monolithic sculpture might now take over as the leading modernist art. This momentary enthusiasm for the idea of a modern sculpture, though, soon foundered and was expunged from the later, radically revised, version of the essay he wrote in 1958.[6]

In the earlier essay, he was of the view that a new arena might open up for sculpture because of painting's now limited potential for fulfilling the imperatives of 'that sense of concretely felt, irreducible experience in which our sensibility finds its fundamental certainty'.[7] Previously sculpture had been handicapped by being 'too *literal* a medium' because it was 'at a lesser remove than any of the other arts from that which it imitated'.[8] But, Greenberg speculated, the situation may have changed:

> Sculpture has always been able to create objects that seem to have a denser, more literal reality than those created by painting; this, which used to be its handicap, now constitutes its greater appeal to our newfangled, positivist sensibility, and this also gives it greater licence. It is now free to invent an infinity of new objects and dispose of a potential wealth of forms with which our taste cannot quarrel in principle, since they will all have their self-evident reality.

At the same time Greenberg had second thoughts, as if he were all too aware that such an attempt to re-enact the Russian Constructivists' project of creating 'a palpable new world' was not going to work when replayed as farce in contemporary capitalist America. Above all, he was conscious that the painterly imperatives of the art world he inhabited created a situation where such down to earth sculptural objects would probably not be seen to lift themselves up from the level of the commonplace. As he put it, 'for most of us, raised as we are to look only at a painting, a piece of sculpture fades too quickly into an indifferent background as a matter-of-fact ornamental object'.[9] Sculpture, he seemed to be saying, could not escape the fatal trivialisation of the fabricated object in contemporary culture, which painting's ostensiveness as framed representation helped to keep at one remove. Moreover, when he came to consider concrete examples of modern sculpture, it was clear that a viable work of sculpture in his view needed to undermine those very properties that seemed to set previous sculpture most clearly apart from painting, namely any suggestions of massiveness or being too evidently thing-like. This put the monoliths of traditional sculpture completely out of court and favoured work that could be seen as a kind of weightless drawing in three dimensions, a three-dimensional equivalent of Cubist collage. So the insistent materiality of sculpture as object again became inherently problematic.

The later version of the essay tried to resolve the ambiguity by assimilating sculpture to the optical formalism of high modernist painting. It is important to stress here that Greenberg's revisionism, his turning away from some positivist utopia of 'real' sculptural objects, was motivated more by his general disappointment with the quality of work generated by the post-war sculpture boom than by the arrival on the scene of work that

seemed to take his erstwhile literalism and positivism too much at face value. The late 1950s were the years when a new literalist sensibility in the New York art world began to form, but this development had not yet reached the point where Greenberg could have seen it as a challenge, in the way that he did the assorted Pop, Neo-Dada and Minimalist initiatives of the 1960s.

Greenberg's unease over these later tendencies in three-dimensional art was spelled out explicitly in an essay titled 'Recentness of Sculpture', which he contributed to the catalogue of an exhibition called 'American Sculpture of the Sixties', held in Los Angeles in 1967. There he criticised Minimalist work for taking the cultivation of an inert non-art look so far that the objects concerned did not stand out as art any more and could only be projected as art conceptually. This dovetails with Fried's critique of the 'literalism' of Minimalist work, just as Greenberg's distaste for the affective power of Minimalism's simple large forms is in tune with Fried's negative response to the strong sensations of presence these provoked in him. 'What puzzles me', Greenberg wrote, 'is how sheer size can produce an effect so soft and ingratiating, and at the same time so superfluous'.[10] The problem was that Minimalist work operated only at a sensuous 'phenomenal' level and could achieve a strong effect without involving the viewer in any 'aesthetic or artistic' response.

What, if anything, then could Greenberg offer by way of a positive definition of the possibilities open to a high modernist sculpture when, in his 1958 revision of 'The New Sculpture', he abandoned his own earlier fascination with the idea of an art of sculpture anchored in its materiality as object? Far from envisaging the literalness of sculpture as the source of a potential advantage over painting, he now saw modern sculpture as handicapped by what seemed an insistent pressure to compensate with artiness for a 'fear lest the work of art not display its identity as art sufficiently and be confused with either a utilitarian or a purely arbitrary object'.[11] He went on to propose a conception of sculpture that, like the best modernist painting would preclude confusion between its immediacy of aesthetic affect and the affectivity of things and presences in the real world.

In his words, the defining imperative of such a new sculpture would be to render 'substance entirely optical, and form, whether pictorial, sculptural or architectural, as an integral part of ambient space . . . Instead of the illusion of things, we are now offered the illusion of modalities: namely, that matter is incorporeal, weightless and exists only optically like a mirage.'[12] This vision of a new sculpture did not quite jive with his enthusiasm for David Smith's work, for all his attempt in a late essay dating from 1964 to accommodate the latter to the imperative 'to concentrate attention on the structural and general as against the material and specific, on the diagrammatic as against the substantial.'[13] The embodiment of a new optical sculpture had to await Michael Fried's discovery of Caro as the artist who had finally achieved a thoroughgoing revolutionising of sculptural form in line with high modernist norms.

Even such a claim, however, was not without its ambiguities, which emerged more clearly in Fried's analysis of Caro than in Greenberg's rather lacklustre statement of the case for Caro in an essay dating from 1965.[14] Fried represented Caro in his essay 'Art and Objecthood' as the artist who had achieved the equivalent in sculpture of the optical ostensiveness of modernist painting, but he was not in the end able to stand by this claim. In a slightly later essay, 'Shape as Form', which achieved a wide circulation when reprinted

in Henry Geldzahler's catalogue *New York Painting and Sculpture: 1940–1970*, the pressure to assert the primacy of abstract painting as the locus of any truly compelling modern art became paramount. A coda on Caro made it clear that Caro's work, simply by virtue of being sculptural, could never quite fulfil the demanding formal requirements exemplified in the finest painting of the time. With sculpture, even sculpture as intensely optical as Caro's, the literal three-dimensionality and substance of its constitutive elements meant that it fell short of the most compelling configuring of visual form.

Fried's commitment to the primacy of the painterly emerges very clearly when he goes on to detail the inherent limitations of sculpture. Firstly, he claims, the real depth of sculpture precludes that free symbiosis between flat optical shape and suggested three-dimensional form made possible in painting. Secondly, painting can define weightless configurations that sculpture can only emulate inadequately because it is bound by the need to give these real support. And finally, while painting presents one with a surface that is fully visible, a sculpture's surfaces are going to be occluded to some extent as one looks at the work from any one point of view, with the result that the literal identity of its surfaces intrudes on any ostensible optical surface effect they might suggest.[15] Evidently, the fantasy of a purely optical sculpture, which intermittently fascinated both Fried and Greenberg, could not quite be realised in any actual sculpture because the distinctive nature of viewing and encountering a sculpture as three-dimensional thing gets in the way.

Yet Caro's sculpture was still central for Fried. Looking back on his early career as a critic of contemporary art in the 1960s some thirty years after the event, he described his first experience of Caro's work in the artist's studio in London as absolutely formative and still very vivid for him.[16] Caro did enjoy a huge reputation in the 1960s and early 1970s, and not just among Greenbergian modernists, for supposedly having achieved a major breakthrough. His open, radically abstract, pedastel-less metal structures were seen to establish a new syntax for a modernist sculpture freed of the vestiges of figuration and monumentality that still clung to much so-called modern sculpture in the post-war period. In the long term, however, if a normative vocabulary of abstract sculptural form did establish itself, it was not Caro's loosely composed, low slung drawing in three dimensions so much as the tighter box and grid format of the Minimalists that Fried found so inimical. That for a time Caro seemed central to any serious thinking about sculpture might seem a little puzzling in retrospect, particularly in the light of Caro's later practice. One would be hard put to imagine the radical impact of his early moves into a wholly abstract and openly arrayed syntax on the basis of his lumbering and emptily formalist work of recent years, particularly as much of it displays the vague figurative reference and sense of monumentality that his earlier work seemed set to purge from modern sculpture.

While Fried's critical response to Caro's early work assimilates it to painterly paradigms, it also points to certain specifically sculptural qualities. It does so, however, paradoxically, by always in the end insisting that Caro's achievement was to have realised a formal analogue to the high modernist painting of the time through overcoming the inherent literalness of sculpture. Even so, on several occasions, as in his discussion of *Prairie* (fig. 92) published in 1967, the year of 'Art and Objecthood', he writes at length about how a viewer is invited to respond to such work at two different levels, both as

92 Anthony Caro, *Prairie*, 1967, steel painted matt yellow, 96 × 582 × 320 cm, private collection, on long-term loan to the National Gallery of Art, Washington, D.C.

ostensibly weightless configuration suspended in space and as engineered construction of heavy, clumsy, steel girders and I- and T-beams. If in the final analysis he insists that the syntactical relation between elements takes precedence over any sense of their substance or mass, such a sublation gains in intensity from the obdurate weightiness that it momentarily seems to be overcome.[17]

Equally, there are some intriguing passages in his criticism of Caro where he suggests that the interest of the work lies in its conveying the sense of a whole configuration in the face of a powerful disparity in one's partial apprehension of its form and structure from different viewpoints. Some of the larger more open sculpture, he notes, 'conspicuously resists being seen in its entirety from any given position'. The implication is that a sculpture such as *Prairie* is so compelling because it highlights a structural tension that simultaneously needs to be acknowledged and somehow overcome. The overcoming is achieved on his reckoning because Caro's work is so configured that one sees enough of the syntactical logic from most points of view, even when significant features are temporarily occluded, to be able to have its totality vividly present in one's mind.[18] At the same time, his insistence on a galvanising sense of integrated form betrays a certain unease that there is a powerful disintegrative logic at work too.[19]

Fried is also sensitive to the way in which the open structure, the partial undoing of a sense of bounded plastic shape, which is often asserted by individual sections thrusting or dangling out from the central arena of the work, disrupts a conventional viewing

of Caro's sculpture as a bounded structure. But if the sculpture can seem to intrude in a slightly destabilising way on the ambient space, Fried is right in his insistence that the kinaesthetic effect of Caro's sculpture, 'experiences such as entering, going through, being enclosed, looking out from within', are kept at one remove and are more virtual than literal, as one always remains a little back from the sculpture. They suggest themselves without inviting such a close viewing that one's grip on the overall syntax of the work is completely lost.[20]

At the same time, Caro himself insisted that he would often work on a sculpture in a confined space where he was prevented from backing far enough way from it to take it in as a whole. He would put himself in a situation where 'compositional decisions' and 'balance and that sort of thing' were made irrelevant.[21] Caro here is making a fairly conventional modernist point about excluding the possibility of deliberate compositional adjustments so as to create a space for innovation, where a new compelling and uncontrived sense of order or totality would emerge almost spontaneously. But there is also the implication that the viewer is not to take as primary a sense of the overall configuration from a distance, and should rather get close enough for a clearly articulated sense of the relation between part and whole to be momentarily suspended. In an early commentary on Caro published in 1965, Fried too seems to be making this point. He takes off from Caro's comments on the close positioning of the artist making the work, and intriguingly turns them round so as to suggest a new take on the dynamic instabilities of a viewer's experience:

> We step back, see how it looks, worry about its appearance – above all we put it at arm's length: *this* is what composing, seeing it in compositional terms, means. We distance it. And our inclination to do this amounts in effect to a desire to escape the work, to break its grip on us, to destroy the intimacy it threatens to create, to pull out. And one doesn't step back or pull out just a little, or more or less (the relevant comparison is with human relationships here). One is either in or out: and if one steps back, whatever the grip of the things was or may have been is broken or forestalled, and whatever the relationship was or may have been is ended or aborted. There is even a sense in which it is only then that one begins to see: that one becomes a spectator. But of course the object (or person) now being seen for the first time is no longer the same.[22]

Here Fried gives, perhaps unwittingly, expression to the psychic tension involved as one moves between viewing the sculpture from a distance, where it sets itself apart and crystallises as an integrated form, and viewing it close to, as it were within the sculpture's open yet resistant clutches – where one's sense of its shape dissolves in the spectacle of suspended and supporting elements, of intensified points of juncture and tension, of things thrusting outward and pushing one away or opening and drawing one in. Caro's sculpture could be said to suggest – and no doubt this is one reason why it was so fruitful as a point of departure for many of the newer generation of anti-formalists – a partial subversion of the standard idealist paradigm of viewing a sculpture as fixed form or essence set in a sphere apart.

It is undeniable that Caro's best sculpture keeps driving one to view it in different ways, close to and further away, from above and to one side, none of which quite offers

a sense of wholeness, but produces instead a somewhat baffling concatenation of different, unresolved and unstable apprehensions of what the work is. *Prairie*, for example, might be envisaged as a flattened horizontal yellow expanse, but the consistency of such a perception is frustrated by the impossibility of positioning oneself so as to be able to survey the whole work from above. Standing back to view it in its entirety, one sees it more and more in profile, as a structure raised from the ground. The cutting upward thrust of the vertical metal plate set a little to one side from the main body of the work also throws into disarray any settled sense of horizontality.

Soon one realises that a multiple game of imbalance is being played out, endowed with a tongue-in-cheek conceptual twist by the title *Prairie*. The four long horizontal poles, that more than anything else give an empatic accent to the horizontality of the work, could easily be viewed as toppled vertical elements, as cut stalks of wheat say, a suggestion amplified by the implied ground defined by the crenellated horizontal metal sheet set a little below and at right angles to the open horizontal plane of the poles. The symbiosis between 'ground' and 'stalk' is further activated by the way the four grooves or furrows in the 'ground' sheet literally parallel, but at cross purposes, the four poles or 'stalks' suspended above. This formal and conceptual play is denied any stable point of reference, however, because of the almost perversely precarious and structurally ambiguous supporting structure of obliquely tilted metal sheets, whose complexity plays havoc with any sense one might have of some clear layering in horizontal planes or some neatly articulated tension between horizontal and vertical. What is striking is the sheer power of Fried's formalistic gaze that can momentarily transfigure these insistently awkward, sharp-edged, sparely austere structures into almost weightless and substanceless articulations of pure syntax.

*　　*　　*

As we have seen, Fried's attack on literalism in 'Art and Objecthood' was sparked by local art political imperatives. In making the collapse of any distinction between the art object as physical phenomenon and a non-physical formal logic an issue, he was hoping to drive a wedge between the high modernist art he most admired and those new tendencies within the New York art world that looked most likely to threaten it. He focused on Minimalism because it could so easily be seen as a logical progression from Greenberg's rigorous modernist insistence on the exclusion of illusion, reference or expression and on the reductive paring down of each art form to its formal essentials. The new literalism which Fried attacked seemed to take to ludicrous extremes a possibility of reducing painting to its barest conditions as object that Greenberg himself had briefly toyed with in an aside in his essay 'After Abstract Expressionism', and which Fried quoted at the beginning of 'Art and Objecthood': 'a stretched or tacked-up canvas already exists as a picture – though not necessarily as a *successful* one.'[23] Fried's strategy was to highlight the absurdity of such a radical reductiveness, not just for painting, but also for three-dimensional art where there seemed superficially to be more scope for manoeuvre within an aesthetic of literalism.

The leitmotif of Fried's argument, repeated on several occasions in 'Art and Objecthood', was that modernist painting 'has reached a point historically where it has come

to find it imperative that it defeat or suspend its own objecthood'.[24] At one level, this imperative was a way of formulating what he took to be the general condition of the modern art work. It only becomes art, whether it is a made object or a found one, if something about it prompts the viewer to move beyond mere recognition of it as physical thing and look for something in it that is not literally there. Fried's point was that a situation of crisis had been reached on this issue. The very identity of painting as an art was being threatened by the contemporary tendency to envisage the work of art as mere object. Progressive and compelling painting could not evade this condition but had to confront and overcome it.

While the issue of literalism, then, was tied up with the specific situation of painting in New York in the late 1950s and earlier 1960s, and with the specific terms of the Greenbergian formalism that had become the dominant framework for reflecting critically on this painting, Fried's polemic against literalism also addressed something relevant to the larger condition of post-war art. Fried felt the need to reassert the autonomy of the art work, an idea that lay at the heart of so much anti-representational practice in twentieth-century artistic culture. Minimalist literalism, 'what you see is what you see',[25] seemed to throw into question the assumption that any worthwhile art work embodied a formal logic that endowed it with a wholeness distinct from the passive wholeness it had as mere object, an assumption that Dadaist and other radical avant-garde gestures had for some time been questioning from the periphery, but that now seemed to be threatened from within mainstream modernism.

Significantly, Greenbergian formalism had already thrown into question the standard models in terms of which the autonomy of the work of art, particularly of a painting, had traditionally been asserted. In recent colour field painting, the figure–ground relation had been almost entirely effaced, and with it the conception of a painting as a composition of distinct elements arrayed within a painterly field. Autonomy could no longer be located formally in a compositional structure. We have seen how even an artist working with such relatively complex configurations as Caro wished to refuse the traditional idea of composition as an overall integrative schema immediately apparent to the eye. It is significant that Fried insisted on the distinction between the novel structure of Caro's work – which he saw as being achieved by 'naked juxtaposition of the I-beams, girders, cylinders, lengths of piping, sheet metal and grill which it comprises', a pure 'mutual inflection of one part by another' – and the more traditional-seeming structure of David Smith's superficially similar metal sculptures, where, as Fried saw it, the constituent elements were integrated or composed into a 'compound object'.[26]

Fried, seeking to rescue for the colour field painting he most admired an internal structuring that would still endow it with formal autonomy, identified a formal logic that did not rely on the figure–ground distinction. He brought the literal support of the painting into the equation, so formal structure was no longer played out at a purely representational level. Recent modernist painting, as he saw it, was posited on a tension between the literal shape of the support and the depicted shape marked out on the canvas. The tension operated between different levels of visual apprehension and qualitatively different conceptions of visible shape, that is, between the work of art as literal thing and the work of art as disembodied or depicted form. If this formal logic made sense only within the context of the new focus on the act of beholding that had been almost entirely

absent from earlier modernist theory, it still located the structural tension within the art work itself, defining it in relation to an ideal beholding that was independent of the material conditions of any actual viewing, particularly if these involved the shifting viewpoints integral to apprehending a sculpture in the round.

This redefinition of the structure that gives the art work a compelling autonomy is intriguingly ambiguous. It both is and is not a tension, as is evident in the verbal slippages in Fried's insistence that it is 'imperative that [modernist painting] defeat or suspend its own objecthood'. Defeat implies abolishing or transcending, perhaps a Hegelian sublation, a moving on to a higher level which encompasses both terms of the contradiction between art work as art and as mere object. But suspend is a different matter, suggesting a momentary escape from an endemic tension that inevitably will return at some point, and is always at the very least latent. Fried as polemicist, when he was championing early Stella and Caro as opposing the literalist sensibility epitomised by Minimalism, tends to represent these artists as achieving a transcendant abolition of this basic tension, but when he does so, he veers towards a conventional conception of formal resolution that does not quite do justice to his own more astute observations on their work. Caro's sculpture seems least compelling when projected by Fried as elevated to a state of weightlessness where it 'exists only optically like a mirage', fulfilling Greenberg's criteria for a new modernist sculpture.[27]

Until the point when he gave up art criticism around 1970, Fried's increasing insistence that the art he most admired had managed to transcend rather than momentarily suspend objecthood threatened to blight this art with something of the very emptiness of which he accused the Minimalists, whom he saw as evading the endemic tensions between art and objecthood by collapsing their work into the purely literal. If the shape is located in the depicted shape, which has absorbed within itself as pure formal illusion any concrete sense of literal shape, we have a reverse mirroring of that Minimalist condition where 'the shape *is* the object'.[28] In the end, neither monism can be upheld whenever a work draws the viewer into a sustained process of looking. If even the simplest work holds one's attention, precisely what one is seeing can never be fully defined in terms of its literal properties and configuration as object, any more than it can in terms of a formal structure or field that it evokes.

The point is, what keeps one looking? Fried might have answered that it is the expectation of a transcendant experience. A literalist, on the other hand, might stress the elusiveness of the fascination exerted by a particularly compelling work, as well as the contingencies and instabilities of the viewing it elicits. Such viewing would be impelled as much by intermittent feelings of lack and frustration as by a sense of presentness and immediacy. Fried has much to say about what keeps one looking in this way in the absence of a guarantee of some final moment of illumination. If such illumination were an inevitable effect of engaging closely with an art work that possessed the appropriate formal qualities, looking at it would be a merely contingent preliminary. The fact that he does not assume this to be the case is what makes him such a good critic.

* * *

Theatricality

What was Fried really trying to convey when he used the term theatricality to define the relation between beholder and work that disturbed him in Minimalist and other anti-modernist artistic tendencies of the 1960s? The term was not one that had any particular currency in art critical circles at the time, but he obviously meant to convey something more precise than a simple striving after theatrical effect. His particular understanding of the term derives from Stanley Cavell's anti-Brechtian discussion of the difference between good and bad theatre, between real theatre as it were and the constant threat of theatricality.[29] Theatre, according to Cavell, works compellingly when we feel ourselves to be in immediate contact with the scene being enacted before us and at the same time situated physically in a sphere apart, and thus undisturbed by the compulsion to respond to the actors as we would were we to feel we existed in the same space as them. Theatricality intervenes in this experience when we have the sense that the actors might recognise our being present, and so the question arises for us as to whether the scene taking place is real or illusory. Of course, it is clear that the play acting is indeed illusory, partly because we are too aware that the actors are really actors. We would not shout out to someone on stage to warn them that they were being stalked or were about to be murdered, say, though as children many of us might have enjoyed doing this at a pantomime. We are thus obliged to theatricalise the scene, to 'convert the other [the actor] into a character and make the world a stage for him.'[30]

The fall into theatricality thus involves a dual effect. Firstly the theatrical scene or art object intrudes on us in such a way as to make us acutely aware of its physical presence in our space, as something that we potentially might have to acknowledge or take responsibility for. It puts us in a position where we seem to be called upon to respond. Then comes the second stage, as the too insistent presence of scene or object compels us to represent it to ourselves as illusion, as mere piece of theatre. If the work strikes us as too corporeally real, then in the end we come to see it as hollow illusion, and it loses its immediacy. Film precludes this problematic because the scene projected on the screen is pure image and could never be a presence impinging physically on the space we inhabit. Here we have a pervasive modernist anxiety that the autonomy or integrity of the work of art will be compromised, along with the viewer's critical autonomy, if the work impinges too directly at a physical level on her or his awareness.

If we bring this back to sculpture, it is as if Fried were arguing for conditions of viewing where a sculpture, no longer categorically staged in a sphere apart by being set on a pedestal, would still keep its distance from us once it came down onto the floor. But where and how to draw the line between sculpture and viewer? Any work of sculpture we approach will impinge on our sense of ambient space, at the same time that our response to it will be formalised to the extent that we do not feel impelled to take account of this intrusion as we would that of some object in an everyday situation that we felt was literally getting in our way. Fried's point is that certain Minimalist sculptures project a presence that momentarily feels oppressive, while the subsequent realisation that this is mere illusion annoys us and makes the intrusive effect seem hollowly theatrical. In the end, however, what matters is whether, after the immediate intersubjective drama subsides, something continues to fascinate us about the work that may even involve an

awareness of the incongruity of our initial response, the latter persisting as a residual background effect while we attend to the work more closely. The apparent threat posed by an invasive steel wall by Serra (fig. 100) cutting into our space may remain as an intriguing [irritant, or stimulus,] in our more detached and contemplative engagement with the work as this theatrical effect wears off.

[Fried's obsession with theatricality betrays an acute awareness of how the illusion created by an art object, the sense that something more is there than the literal facts of its existence, is constantly in danger of collapse, particularly with sculpture.] The work becomes mere theatre – theatricality intrudes – once a viewer becomes uneasy in the awareness that he or she has been taken in by such an illusion after it ceases to be convincing. To sustain itself as something worth attending to, the modern work of art needs in some way to internalise this threat of theatricality, presenting itself incontrovertibly both as real object and as momentary illusion, rather than as mere object or mere illusion – like the actor who manages to come over to an audience as a real person successfully playing the part of a fictive character.

In Fried's seemingly straightforward attack on theatrical illusion, and his call for a non-theatrical art, there is an implicit recognition that the theatrical implosion of the art work is the very condition of its existence in the modern world. Thus he makes the point that the 'antitheatrical' impulse, which needs continually to work against the contingencies of this condition, 'emerges as a structure of intention on the part of painters [and one could also say sculptors} and as a structure of demand, expectation, and reception on the part of critics and audiences, not as a formal or expressive quality inhering or failing to inhere, timelessly and changelessly, in individual works', and that 'the viewer's conviction in a work's seriousness . . . is never for a moment, or is only for a moment, safe from the possibility of doubt . . . conviction – grace – must be secured again and again, as though continuously, by the work itself but also, in the act of experiencing, by the viewer, by us.'[31] This is a fairly voluntarist way of putting a point formulated in more systematic, political terms by a Marxist thinker whose aesthetic theory we shall be considering in the next section, Theodor Adorno, and whose severe consciousness of the limits and constraints under which modern art operates is at odds with [Fried's often unapologetic bourgeois individualism.]

Even so, if we look to Fried's much quoted clarion call for an anti-theatrical conception of art in the conclusion to 'Art and Objecthood', some telling ambiguities do emerge. While he ends emphatically, declaring that 'I want to claim that it is by virtue of their presentness and instantaneousness that modernist painting and sculpture defeat theatre . . . We are all literalists most or all of our lives. Presentness is grace',[32] he also underlines 'the utter pervasiveness – the virtual universality – of the sensibility or mode of being which I have characterised as corrupted or perverted by theatre'. This alerts us to the ambiguous play upon 'most or all'. The hell of literalism and theatricality may easily be all-pervasive, may indeed be the sustaining substance of the grace Fried glimpses from time to time.

* * *

Fried stands out among early commentators who sought to define the unease aroused by Minimalism by focusing, not on the reductive, potentially dehumanised and industrial matter-of-fact character of Minimalist objects, but on the destabilising psychodynamic produced by the new physical relation set up between beholder and work. His point was that the object confronted the viewing subject, encroaching on his or her space, unlike modernist work that allowed the viewer to enjoy an immediate visual experience while physically, and psychically, maintaining a critical distance. For Fried, the almost tangible directness of encounter with a Minimalist work could momentarily provoke the disquieting feeling that one was coming across another human presence:

> the beholder knows himself to stand in an indeterminate, open-ended – and unexacting – relation *as subject* to the impassive object on the wall or floor. In fact, being distanced by such objects is not, I suggest, entirely unlike being distanced, or crowded, by the silent presence of another *person* the experience of coming upon literalist objects unexpectedly – for example in somewhat darkened rooms – can be strongly, if momentarily disquieting in just this way . . .
>
>
>
> once [the beholder] is in the room the work refuses, obstinately, to let him alone – which is to say, it refuses to stop confronting him, distancing him, isolating him.[33]

But these objects are evidently not human presences, and it is their staging that affects us in such a way that we momentarily envisage them as no longer being the 'obdurate solid masses' they actually are. The more lasting impact they make is as a result one of alienation – they come over as 'hollow'.[34]

Something more significant is involved here than a standard modernist distaste for work that smacks of a return to the anthropomorphic presences of traditional figurative sculpture. The sense of disquiet articulated by Fried runs much deeper than this. Nor is the crucial issue the fact that the works themselves were particularly large or dominating or massive in comparison with earlier sculptural objects. Only a few Minimalist works of the 1960s are physically more imposing than earlier large-scale indoor sculpture or present a particularly heavy, closed and solid shape. Indeed, almost all the more significant Minimalist work eschews monumental solidity. Judd's box structures are usually open, and even if not, are devised in such a way as to indicate that they are made of thin sheets of material and are not solid or massive, though some early photographs do tend to dramatise them as such (figs 109, 110). Morris's constructions in light-weight plywood are inert rather than imposing (fig. 102), while Andre's metal floor pieces (fig. 132) deny the viewer the spectacle of something large and imposing facing him or her. If some of Andre's and Morris's very earliest installations did indeed take over the spaces where they were exhibited – Andre's styrofoam *Compound* in the Tibor de Nagy Gallery in New York in 1965,[35] for example, or Morris's famous Green Gallery installation of 1964 (fig. 103) – these are very much the exception. The one real exception is Tony Smith's six-foot-square steel cube *Die* (fig. 93), which curiously has come to stand as the paradigmatic Minimalist object, both among those who feel uneasy about such work and those who seek to dramatise its existential or psychic resonances.[36] In many ways, this work is more akin to the heavy, large-scale, metal late modernist sculpture of the 1960s than it is to the new Minimalist art.

93 Tony Smith, *Die*, 1962, steel, 183 × 183 × 183 cm, 2nd of edition of 3, Paula Cooper Gallery, New York

Fried later summed up his case against Minimalist theatricality as follows:

My critique of the literalist address to the viewer's body was not that bodiliness as such had no place in art but rather that literalism theatricalised the body, put it endlessly on stage, made it uncanny or opaque to itself, hollowed it out, deadened its expressiveness, denied its finitude and in a sense its humaneness, and so on. There is, I might add, something vaguely monstrous about the body in literalism.[37]

What most aroused the extreme disquiet expressed in Fried's response to Minimalist work was that the uncompromisingly simple forms and stark staging seemed to dissolve the

94 Richard Serra, *Tilted Arc*,
1981, steel, 366 × 3658 ×
6.5 cm, Federal Plaza, New
York (destroyed)

95 (*below*) Richard Serra, *Tilted
Arc*, photograph by Susan
Swider

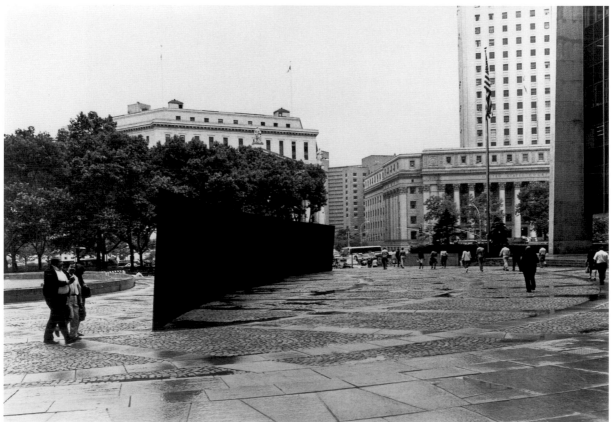

framing of aesthetic experience to which he was accustomed. The work did not just impinge uncomfortably on his visual and spatial awareness but got at his psyche too. His unease combined an acute sense of alienation from the work with a disquieting sense of being engulfed by it, as if the mediations normally framing interactions with the world of objects were momentarily suspended, and there was a regression to an infantile universe peopled by enigmatically dominating and sexualised presences. A Minimalist work could serve as a dumping ground for free-floating, potentially sexualised anxieties and disquiet of this kind because it staged such a direct physical encounter between the viewing self and the obdurate otherness of the object, and seemed to lack internal articulations that might keep at one remove the irrational, highly charged responses such encounters could provoke.

In thus stressing the disturbing psychodynamic that could inflect a viewer's interaction with Minimalist work, Fried certainly put his finger on something. He expressed a disquiet mostly only latent in other more conceptual or formalist discussions of Mini-

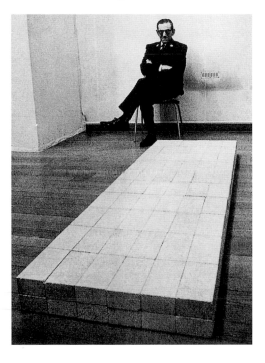

96 Carl Andre, *Equivalent VIII*, 1969, displayed at the Tate Gallery in 1976, remake of destroyed version dating from 1966, 120 firebricks, 2 high, 6 header, 10 stretcher, each brick 6.4 × 11.4 × 22.9, overall 12.7 × 68.6 × 229 cm

malism at the time, and also prefigured some of the more intensive anti-modernist or post-modernist critiques of Minimalist work that erupted subsequently. I am thinking for example of the unusual intensity of the outrage occasioned by Richard Serra's now dismantled *Tilted Arc* after it was installed on a plaza in New York in 1981 (figs 94, 95), and the attack on the incipient violence and dominating aggression of Minimalist work published by Anna Chave in *Arts Magazine* in 1990, an article that struck a strong chord in the psychoanalytic and viewer-response orientated art world of the time.

The disproportionate controversy that broke out when in 1976 public attention was drawn to the Tate Gallery's purchase of Carl Andre's brick *Equivalent VIII* (fig. 96) is rather different, more in the nature of standard anti-modernist outrage at a work being endowed with so much value by the art establishment when it seemed to be just a pile of old bricks.[38] The motivating mind-set was not entirely dissimilar from that behind Ruskin's diatribe against Whistler's *Nocturnes* as a pot of paint flung in the public's face. In the case of Andre's bricks, however, something about the presence of the work, and the psychodynamics of viewing which it elicited, must have played a role, if a subservient one, in stoking the antagonism. The controversy would hardly have taken off in the same way if the sculpture had been more conceptual, or physically less substantively present to the viewer. It is not that such Minimalist work necessarily provokes unease and hostility, but

rather that its insistent blankness, and its lack of identifiable formal structure, seem to invite more extreme and at times paranoid reactions than overtly ideologically or psychically loaded pieces of art. On the face of it, Kiefer's paintings would seem to confront the viewer as far more explicitly macho and dominating than a Morris box or Serra sheet of metal, and yet the latter seem to have been more intrusively disruptive of many viewers' sense of what should be going on when they communed with a work of art.

The controversial affect of Minimalist work has now petered out, inevitably, as its interventions in the public spaces for viewing art come to seem less and less striking and novel. Controversy now gravitates round work that offers readily recognisable images of the body which certain people find sensational or offensive, not round work that seems formally to negate or frustrate accepted conceptions of what a work of art should be. But even if Minimalist work could not sustain a position in the imaginary of the modern art world as a paradigm of the alienating or disquieting modern art object, even if it now merges into high modernist abstraction as representative of a phase of particularly insistent formal purism, and as a result will often tend to elicit indifference rather unease from the casual visitor to a museum of modern art, its becoming acceptable or normalised also bears testimony to a larger shift of sensibility. The intensity of Fried's response seems curious now because the unframing that disturbed him is no longer an issue for viewers habituated to being incorporated within the spaces defined by three-dimensional work.

The body of the viewer has now been brought into the formal equation, with the framing of the art work seen as embracing not only the viewed objects but also the whole viewing arena, including the viewer. This is not necessarily to be equated with a move to work that abolishes the object in favour of viewer response. Bruce Nauman, for example, has been insistent that his 'interactive' works, such as the corridors with monitors that present one with unexpected views of one's progress through them (fig. 162), are not designed to give the viewer control over her or his experience. On the contrary, the work confines the viewer's body within a strictly structured situation. My point is that shifting practices of beholding mean that it is no longer possible to experience as unmediated the direct physical encounter between viewer and work that unhinged earlier reactions to Minimalism.

Fried himself launched a direct attack on Minimalist or literalist work because 'it is concerned with the actual circumstances in which the beholder encounters the work.' The problem was, as he saw it, that 'the experience of literalist art is of an object *in a situation – one which, virtually by definition, includes the beholder.*'[59] This critique, however, far from making the cancelling of any awareness of the arena of encounter between viewer and work seem an attractive alternative, functioned to draw attention to some of the intriguing ways in which three-dimensional art could impinge on a viewer's sense of ambient space. He was both anxious about yet fascinated by the affective power of work that had a strong impact on a viewer's sense of occupancy of space, and he also highlighted how any talk about such affective power inevitably brought into play a vocabulary of intersubjectivity in which the work became a quasi-human presence. In the case of Minimalist sculpture, he invoked a very specific kind of intersubjective drama, as if the presence that impinged were always going to crowd out and confront one. Caro's work, by contrast, had a very different effect as far as he was concerned. It could seem to embrace one because this embrace was posited without the intrusion of any too physical a suggestion of bodily presence.

The question of whether a work like Judd's *Untitled 1968* (fig. 101) intrudes more or less aggressively on one's space as a viewer than Caro's *Prairie* (fig. 92) is really a matter of individual sensibility and psychic susceptibility. I personally find the metal prongs and sharp-edged surfaces of the Caro insistently hard and unyielding, a little awkward and distancing, and the simple clarity of volume and surface modulated by the subtle play of shadow and colour in the Judd invitingly sensuous. But the crucial point is that Fried drew attention to the affective, psychic dynamic of the interaction between viewer and work, unlike most writers on modern or modernist art at the time, who treated such interaction, if they treated it at all, in purely formal terms as the articulation of space, placement and scale. Such affect is inherently unstable and can take many forms: it can involve a sense of expansiveness, or of being closed in, of opening out, or of being blocked, of feeling enclosed and enveloped, or of being pushed away and intruded upon. Merleau-Ponty summed this up nicely when he talked about the basic interactions between self and world as promiscuity and encroachment.[40] Between Fried and Minimalist objects, however, there was not much promiscuity, unless of course one wishes to interpret the intensity of his response as a defence against what he felt to be some apparently heavy-handed and intrusive nightmare of indiscriminate soliciting.

* * *

One further significant aspect of the interaction between viewer and object brought into focus by Fried's analysis of the theatricality of Minimalism, and which traditional painting-based norms of beholding tended to exclude, was the time-bound nature of a viewer's apprehension of a work. There is a relatively straightforward temporal dimension to viewing any free-standing three-dimensional work because of the time it takes to move round it and take in its different aspects. Fried recognised the significance of this, even in the expressly anti-theatrical account he gave of viewing his favoured works by Caro. However, his claim was that one's sense of the duration of viewing in this case is secondary and is in the end eclipsed by an instantaneous apprehension of the work in its totality:

> It is as though one's experience of [the best modernist painting and sculpture] *has* no duration – not because one *in fact* experiences a picture . . . or a sculpture . . . in no time at all, but because *at every moment the work itself is wholly manifest* (this is true of sculpture despite the obvious fact that, being three-dimensional, it can be seen from an infinite number of points of view . . .) It is this continuous and entire presentness . . . that one experiences as a kind of *instantaneousness*: as though if only one were infinitely more acute, a single infinitely brief instant would be long enough to see everything, to experience the work in all its depth and fullness . . .

Taken as a qualititative distinction between a debased literal 'concept of interest' involving 'temporality in the form of continuing attention directed at the object', and a transcendant sense of 'conviction' that takes one out of the literal flow of time and offers an experience of 'grace' or 'presentness' as distinct from mere 'presence',[41] the claim begins to look a little like a rearguard, if sophisticated, defence of a high mode of beholding which tendencies in the art world of the 1960s were definitively undermining.[42] However, the excessive insistence and convolution of Fried's prose indicate that the qualitative

distinction he is trying to make is not clear-cut, is indeed precarious. As a result, his apparently negative characterisation of the distinctive sense of temporality involved in viewing Minimalist work provides some particularly sharp insights into that work:

> Like Judd's Specific Objects [fig. 110] and Morris's gestalts [fig. 102] or unitary forms, Smith's cube [Tony Smith; fig. 93] is *always* of further interest; one never feels that one has come to the end of it; it is inexhaustible, however, not because of any fullness – *that* is the inexhaustibility of art – but because there is nothing there to exhaust. It is endless in the way a road might be: if it were circular, for example.

And he concludes:

> Here finally I want to emphasize something that may already have become clear: the experience in question *persists in time*, and the presentment of endlessness which, I have been claiming, is central to literalist art and theory is essentially a present-ment of endless, or indefinite, *duration* . . . The literalist preoccupation with . . . the duration of experience . . . addresses a sense of temporality, of time both passing and to come, *simultaneously approaching and receding*, as if apprehended in an infinite perspective . . .'[43]

Fried seems to be claiming that Minimalist work confines the viewer within a literal experience of the passage of time in which any larger sense of past and future is evacu-ated, and everything just exists in the narrow dimension of the immediate present. That is to take his analysis at face value, as re-articulating his unease about an aesthetic experi-ence that engulfs the viewer, for a time at least, in immediate physical affect – when the experience of the work as it were mesmerizes one. His polemic could easily be countered by pointing out that when viewing an art work, one is never entirely engulfed in this way, and that a reflective awareness can split one off from this immediacy of experience at any time. In Fried's own description, the supposed total immersion in the flow of sensation is interrupted by a moment of withdrawal, of slight revulsion, and hence of self-awareness or self-displacement.

What is most suggestive about Fried's analysis is that it indicates how different kinds of work can invite different temporal inflections of the experience of viewing. What is the Minimalist viewing experience as he describes it? It is one in which there is no clear-cut climactic moment. No even provisionally privileged viewpoint is being offered where one might linger to stabilise one's feeling for the overall logic of the work, and no par-ticular view singles itself out as making this logic clearly manifest. One goes on looking, not to discover hidden depths, but because one finds it strangely compelling to be caught up in an experience where there is always 'something simultaneously approaching and receding'. The experience is potentially endless, both because there is no logical moment of cut-off and because one becomes acutely aware that this is the case and starts think-ing about the source of the indeterminate compulsion to continue looking intently at a work whose apparent formal or imagistic features seem so limited.

At issue here is also the rhythmic inflection, or lack of it, in the kind of viewing invited by Minimalist work. When Fried describes the sense of 'duration' involved as 'something endless the way a road might be: if it were circular, for example', he is drawing atten-tion to a sense of looping central to the conception of Minimalist sculpture. Any viewing of a three-dimensional work involves some form of repetitive looping – as one moves

right round a work back to the position where one was first standing, or moves in closer and gets absorbed by various local effects of surface shaping and texture and shadowing and then steps back again. The rhythm of such viewing has something of the sense of passing through repeated circuits, which may be more or less regular, more or less expansive, more or less open or closed. A Minimalist work tends to foreground the sense of looping because there are not many variegated incidents in the circuits one traverses, and because the work's relatively simple spatial configuration invites a similarly simple structuring of one's pattern of viewing.

Looping is explicitly a feature of the Minimalist music of composers such as Steve Reich. The musical parallel is worth considering because it highlights how even the most basic looping patterns are to be distinguished from mere repetition. In Minimalist music the sequences of notes and rhythms are very similar but not exactly the same, shifting through barely perceptible variations that bring certain patterns in and out of phase with one another. When one moves in several circuits round a sculpture, not only is each circuit actually a little different but also it is never experienced in quite the same way each time round. Looping draws one in by its mesmeric repetitive patternings, yet also makes one acutely aware that time moves on and that one never comes back again to exactly where one was before. Of course, looping can become boring but, equally, so can the experience of a piece of music or sculpture that is filled with an arbitrarily rich variety of incident, and ends up sounding or looking monotonous because no significant patterns stand out in the ever changing flow of sound or visual sensation.

A basic sense of looping, of a potentially endlessly repeated, slightly variegated, circuiting is perhaps even more central to the temporal dimension of apprehending a work of art than it is to the experience of listening to music. Most work which draws the viewer into its spatial ambit, and in effect makes the viewer into a performer, such as Nauman's *Going Around the Corner* (fig. 162), is structured to engage her or him in a limited repetetive sequence of bodily activities and experiences. Strict looping, by contrast, is only one among several different kinds of temporal patterning in music, if often exploited by the early Minimalists, and in much recent pop music. While recapitulation is an essential musical device, just as are the mesmeric effects of insistently repeated patternings and rhythms, any near-repetitions or loopings are usually embedded in more complex overall structures.

A simple looping, however, is in effect built into the presentation of art works in a gallery, including recent time-based works. The latter have to be designed so they are not unique performances that one watches through from a clearly delimited beginning to definite end – like the videos about an artist that so often accompany exhibitions nowadays – but present a sequence that one can connect with and disconnect from at will. Video pieces installed in a gallery are usually based on a fairly short circuit of viewing, mostly not more than ten to fifteen minutes, and are devised so one can enter and begin to engage with them at any point in the circuit, a factor that favours a short-looped structuring of repeated, slightly shifting, sequences of images within the larger circuit, rather than a more complex narrative pattern where any local incident only makes sense in relation to the structuring of what has gone on for some time before.

There is another equally fundamental factor involved in this sense of returning or looping which distinguishes visual art from film or music. The conditions of display are such that a work of visual art always strikes one as fixed in some way. Whether it is an

object or thing, an image, or an arena of viewing, most of its basic parameters do not change. Much of the temporal dynamic of the work arises from one's own moving round, scanning, shifting the focus of one's attention from this aspect or bit of the work to another, or entering or leaving the visual and spatial field where the work begins to assert itself. If one watches a video under normal viewing conditions, one is not particularly aware of the static placing and framing of the moving image in the monitor, whereas this does come to the fore when one comes across a video work in a gallery (fig. 163).

Fried's response to Minimalist work highlights a more pervasive and deeply rooted feature of the temporality of viewing in recent art than looping strictly speaking – a tension between the momentary nature of suddenly becoming aware of and struck by a work, and a sense of potentially interminable duration as one stays with it and lingers over it. Time-based works often exploit this double aspect by spacing the repeated events the work enacts so that one spends most of one's time waiting for the short event to occur again. The video installation by Gillian Wearing *Sixty Minutes*, first shown in 1998, exploited this dramatically. It took an hour before the stiffly posed people dressed as police officers, arranged in rows as in a formal group photograph, slightly fidgeting and shifting, were finally shown breaking down, as if they could not keep up their act of staying still any longer. Rebecca Horn gives this stasis in movement an intriguing psychic dimension in her simpler mobile sculptures, such as the *Kiss of the Rhino* (fig. 97). This work too keeps the viewer in a state of expectant frustration, hanging on as the two arms of the work very slowly come together, and waiting for the moment when the rhinoceros horns get close enough, though never touching, to allow a small electric spark to pass between them. After this brief emission, the arms start moving apart again, leaving one spending most of the time looking and waiting for this event to recur. The temporal experience of the work is divided between a rushing ahead, anticipating the less than consummated and almost instantaneous moment of climax, and a feeling of being locked into the inexorably slow flow of the cycle of movement acted out by the piece. The more one focuses on the actual passage of time – on 'duration' as Fried would put it – the more one anticipates a climactic moment of instantaneous apprehension which one can never hold onto.

The contrast Fried made between the viewing of Minimalist work and the ostensibly structurally more complex modernist work of Caro raises an important point about a general differentiation inflecting the viewing of modern sculpture. Viewing a modernist work (fig. 92) as Fried envisaged it, one would imagine that the essence of what one sees is some fully present structure or configuration – as if out of the variegated and ever shifting partial views, there emerges the instantaneous vision of a configuration that exists in a sphere apart from, while underpinning, the drawn out process of viewing the work's various aspects. By contrast, in the case of a Minimalist work by an artist such as Judd (fig. 101), Fried argued that one's sense of the work is located firmly in the potentially endlessly looping experience of viewing it. It exists as something simultaneously emerging and sliding from view in the pattern of changing partial aspects it presents, and the awareness one has of it as some whole thing never seems to condense, even momentarily, into an articulable form or structure.

Some brief indication was given by Fried himself that a musical analogy might be appropriate to illuminating these differing temporal modalities of viewing contemporary sculpture. Caught up in looking at one of Caro's finer works, he once wrote, one becomes

97 Rebecca Horn, *Kiss of the Rhinoceros*, 1989, steel, aluminium and motor, height 250 (closed), width 500 (open), depth 28 cm, private collection

aware of 'relations whose presentness to the senses is not that of an object or image. . . . One might say that . . . the visual initiative his pieces call for is more like *listening to* than *looking at*.'[44] To which one could add that looking closely at a work by Caro might be a little like listening to a piece of music by Eliott Carter (though I feel this would be flattering to Caro), while attending carefully to a sculpture by Judd would have affinities with being at a performance of an early piece by Philip Glass (though this would be flattering to Glass).

Aesthetic Theory

Fried's polemic against Minimalist tendencies that seemed to question the autonomy of the work of art could easily be represented as a rearguard defence of an increasingly outmoded modernist aesthetic. As we have seen, however, the situation is nothing like so simple. Fried himself recognised the limits of standard formalist understandings of a work of art's integrity or autonomy, and offered an alternative conception whereby the grounding structure of a work would not be some ideal configuration or *Gestalt* that integrated disparate parts into an ideal whole, but rather was some momentary overcoming or suspension of a structural tension endemic to the work of art in the modern world. The formal dichotomies out of which a work of art's autonomy was forged, in his view, needed to encompass the very features that threatened to deny it this autonomy – on one hand, the literalist danger that it might remain for the viewer no more than a mere physical

object, and on the other a theatricalising tendency to reach out to the viewer, and thus possibly strike her or him as lacking in real substance or integrity because obviously designed to have an immediate effect.

This kind of dialectical thinking has certain affinities with the aesthetic theory of a writer with whom Fried would not normally be associated, but who has had an enormous impact on the politically more self-aware critical writing on art of the past few decades. I am thinking of Adorno, whose last major work, his posthumous *Aesthetic Theory*, was being written in the late 1960s contemporaneously with Fried's discussion of art and objecthood. While Adorno was of a very different generation and intellectual formation from Fried, a modernist of the pre-war period, part of the impetus behind his book was to make sense of certain avant-gardist tendencies that had emerged in the 1950s and 60s which conflicted with his austerely modernist aesthetic commitments. This affinity is in part worth pursuing because of the disparate nature of the intellectual traditions from which the two writers came. It highlights how some of the larger issues at stake in Fried's polemic have ramifications that go well beyond the confines of the post-war American art world. Insomuch as Fried did involve himself in the dialectics of Marxist theory, incidentally, it was not those of Adorno or even Benjamin but of Lukács, whose *History and Class Consciousness* he cited as a formative intellectual influence on his early criticism, along with the writing of Merleau-Ponty.[45]

Fried's central claim concerning 'modernist painting's self-imposed imperative that it defeat or suspend its own objecthood'[46] echoes something of those moments in Adorno's analysis where he discusses the thing-like dimension of art's existence in the modern world:

> The perennial revolt of art against art has its basis in fact. Just as it is essential for art works to be things, so it is equally essential for them to negate their thing-like nature, and [*damit*] in this way art turns against art. The completely objectified art work would solidify into mere thing, while one that withheld itself from objectification would relapse [*regredierte*] into helpless subjective impulse and sink in the empirical world.[47]

The negative polarities Adorno identifies here, the art work as 'mere thing', and the dissolution of the integrity of the work in mere 'subjective impulse', have clear parallels in Fried's analysis of literalism or mere objecthood on the one hand and theatricality on the other. There are real differences, of course, in that thing-likeness for Adorno, and the related notion of reification, is a complex concept that should not be elided with the idea of an art work being reduced to mere physical thing or object. At the same time, real similarities are to be found in the anxieties that Adorno and Fried voice regarding the condition of the art work in the contemporary world, and in their misgivings about recent attempts in avant-gardist art to move beyond or abolish the complex dialectics inherent in their modernist aesthetic – even as one has to acknowledge that Adorno's analysis was much more explicitly political, and more grounded in the structural concerns of modern critical and aesthetic theory, than Fried's, and that Fried's was more finely tuned to the particular imperatives of post-war visual art.

What we have in both Fried's and Adorno's case is a complex recasting of the modernist commitment to the idea that the art work has a structure that endows it with

autonomy and that this structure internalises larger tensions that the modern art work cannot escape. The compelling work of art is one that does not seek to evade such constitutive tensions. On Fried's understanding, it overcomes and sustains itself at some level in the face of these tensions, while with Adorno, the dialectic involved is much more negative. Rather than momentarily suspending or overcoming its thing-likeness, the work of art succeeds by negating the negativity of its debased but unavoidable thing-like condition, the result of this double negation being at best some precariously fragmented but somehow compelling destructuring.

Adorno and Fried share the assumption that any artistic structuring has in some way to be embodied or deposited in the work. Both are also deeply suspicious of work that plunges the viewer or listener into an immediately affective and physically engulfing response, momentarily obliterating that separation between apprehending subject and apprehended object that makes it possible for the viewer, or listener in Adorno's case, to appreciate its organising structure. At the same time, they are both attuned to thinking of the art work as phenomenon in ways that earlier modernists were not, and both have illuminating things to say about the processes whereby a work and its defining structure become manifest to a viewer or listener. Both, then, register that larger post-war shift from an exclusive concern with the work itself and its creation by the artist.

* * *

In drawing on Adorno's *Aesthetic Theory* to clarify the ramifications of certain key issues raised by Fried,[48] it may seem that I am moving the centre of gravity of my analysis away from the specifics of sculptural aesthetics. Sculpture as such is hardly mentioned by Adorno, and the visual arts as a whole do not play a major role in his discussion of modern art. Certain terms he repeatedly uses have a suggestive visual inflection, such as *Dinghaftigikeit* or 'thing-likeness' and *Anschaulichkeit*, often translated as 'visuality', though in German its resonances are more general and do not necessarily refer to visibility but to anything of a sensory nature that is immediately intuitable or perceptible without conceptual mediation. If Adorno's use of such terms often makes his comments, such as the one quoted above, seem particularly suggestive for thinking about visual art, it is undeniable that the art that most deeply concerned him was music. But this, paradoxical as it may seem, serves my current purposes rather well, in that the focus on music brings to the fore the time-bound, dynamic aspect of the apprehension of a work of art.

This is not to deny the significant distinctions that have to be made between a viewer's looking at a work of sculpture and a listener's attending to a piece of music. The temporal pattern of viewing of a free-standing sculpture is to a large degree impelled by the inner dynamic of one's response, and is much more open, and in no way so closely articulated or controlled as the process of listening to a piece of music. But there are still points of affinity. A free-floating attentiveness is always an important dimension of listening to music, with some features standing out and remaining in one's mind, others sinking away almost as they emerge. When one listens, one's temporal experience is not glued to the literal flow of musical sound. Equally, when viewing a sculpture, the sense one has of it as a whole is not a static image, but something that

emerges within, and is defined by, the temporal flow of the various aspects that momentarily seize one's attention, rather as one's sense of a piece of music as a totality emerges from the changing stream of variously structured sounds that capture the attention as the piece unfolds.

Adorno is very insistent that the defining logic of a piece of music can in no way be mapped out in terms of some determinate structure, partly because this logic exists at a different level from any immediately apprehensible shape or form,[49] and partly because it only emerges within the temporal flow of one's apprehending the work. Any art work, then, whether musical or visual or literary, is not to be conceived as a mere thing fixed in space and time, but as 'a phenomenon, something which appears'. At the same time this phenomenality is not just 'blind appearance.'[50] The dynamic of apprehending a work of art has a conceptual as well a sensory dimension, with the conceptual apprehension in Adorno's view being more vividly intense than the flow of immediate sensory appearance that it both emerges out of and interrupts.[51]

The temporal apprehension of a work as 'appearance', then, is not a surrender to the flux of sensation, in music say to the immediately apprehensible rhythmic inflections and shaping and tonalities of sound, and in sculpture, to the different images and sensations of space and surface. What becomes manifest as one attends to the work's sensory appearances is a non-sensory or non-material dimension to its formation, a dimension that Adorno calls intellectuality or spirituality (*Geistigkeit*).[52] When a work comes alive for a viewer or listener, the sensory or psychic immediacy of the experience is less significant than the non-sensory structure that is shaping this experience and that bears the weight of the ideologically loaded contradictions defining the work of art as aesthetic phenomenon in modern culture. Or, as he puts it, 'To say that the apprehension of art work is adequate only if alive is not just to say something about the relation between viewer and viewed, about psychological cathexis as the condition of aesthetic perception. Aesthetic apprehension takes on life by way of the object in that moment when a work of art comes alive under its gaze.'[53]

For Adorno the Marxist, the structural tensions in which the art work is embedded have to do first and foremost with larger processes of reification operating in modern culture, processes that are played out in the objectification inherent in the constitution of a work of art as phenomenon. At issue is not the literal identity of the work of art as a physical object, but the objectifying process whereby it 'appears' or comes into being, both at the level of being created and being apprehended:

> What it is that appears in works of art cannot be separated from their the process of appearing, but it is also not identical with the latter. It is the nonfactual in the facticity of their appearing, its spirit. This spirit makes works of art, which are things among things, into something other than the mere things. It is nevertheless only as things that they can come into being, the latter occurring, not through their being localised in space and time, but through the immanent process of reification whereby they become equivalent to themselves.[54]

In any art work, something is objectified – the process of objectification is what enables it to come into being. But as a result of this objectification, of this emergence of the work of art as a definable object, it becomes a potential object of consumption, and this obscures and even gives the lie to the very process whereby it actually came into being. The larger

logic of reification at work in modern society thus makes any artistic objectification acutely problematic:

> Only an obdurately philistine credulity could fail to recognise the complicity of artistic reification with social reification, and thereby with its untruth, its fetishising of what is inherently a process, a relation between moments. The work is process and instant in one. Its objectification, the condition of its aesthetic autonomy, is also a petrification. The more the social labour inserted into the art work becomes objectified and comprehensively organised, the more audibly the work becomes an empty rattle and alien to itself.[55]

There is one particularly fruitful ambiguity in Adorno's analysis that I want to highlight here. While the coming into being of the art work as he envisages it clearly refers to the process of its production (not just the artist's activity of making but the whole process of constituting it as commodity), he at the same conceives the art work as an entity that circulates in society as something to be apprehended, and thus also has in mind the modality of its appearing to a beholder. His approach marks a noticeable shift from a traditional Marxist focus on production to an orientation that also concerns itself with consumption. Certainly, compared with most modernists, he was not fixated on process as something exclusively enacted in the artist's creating of a work – indeed, he was sharply critical of such a perspective: 'That there is a false confusion of the work of art with its genesis, as if how it comes into being provides a general key to what it is, testifies to how alien from art the critical analysis of art [*Kunstwissenschaften*] now is; for works of art are true to their law of formation in so much as they consume the traces of their genesis.'[56]

The interplay between a concern with the formation of the art work itself and its formation as phenomenon appearing to a viewer or listener, recalls something we have seen at work in Fried. At one level, Adorno, a little like Fried, is a good modernist who is extremely critical of avant-gardist attempts to evade the problematic condition of the art work through seeking to abolish any objective fixing of form that might get in the way of a viewer's or audience's fluidity of response, as say in free improvisation. But if he seems set against tendencies that privilege viewer response over the integrity of the art work, he is also acutely aware of the impetus behind them. No one could be more eloquent than he is on the alienating effects of the reification that inevitably sets in as soon as a work does acquire objectifying substance.[57]

Insomuch as a work of art has a certain integrity, and it must have this in his view, such integrity or autonomy is not to be defined as a formal structure embodied in its physical make-up. On the contrary, it arises out of the work's confronting and seeking to negate its inevitable tendency to reification. Adorno is undoubtedly more categorical than Fried in getting away from earlier modernist conceptions of the work of art as possessed of a higher structural logic that in some way overcomes the contingent and disparate materiality of its constituent elements. For him the art work grants no sustained moments of grace – at best only intermittent intimations of some alternative to the dislocated, fragmented and tension-ridden reality that gives rise to it, and in which the beholder too is embedded.[58] The structural or configurational nature of the art work, if it is to be compelling, has to be at odds with the conventional notions of order, wholeness and synthesis that allow the viewer the illusion that a transcendant totality can be achieved. Unity can only be sustained in so far as it negates itself:

No work of art is possessed of unconditional unity, though every work must mislead one into thinking it is. As a result it is in conflict with itself. Aesthetic unity, confronted by an antagonistic reality against which it sets itself, is inherently a semblance.[59]

Adorno was following in a well established modernist tradition when he insisted as he did on the disjunction between whole and part, but he was also being very much of the moment. In the 1960s art world, compositional devices for achieving synthesis came under particularly sustained attack for being empty and inauthentic. The Minimalists, for example, were arguing that the compositional format of earlier abstract art effected a false rationalising synthesis of whole and part that was no longer credible. Adorno made a similar point when he argued that even the Constructivist refusal of traditional compositional synthesis did not go far enough in recognising an inherent disparity that now existed between the formal order and the material particularity of the constituent elements of a work. Rather than imposing on these an abstract totality with which they were visibly at odds, it was necessary to get away from any appearance of subordinating them to 'aesthetic regularity' (*ästhetische Gesetzmässigkeit*):

> With the default of any higher jurisdiction, the contesting claims of whole and part have been referred back to a lower court, to the play of impulses that emanate from detail, the situation in this respect being in conformity with a prevailing nominalism of outlook. The only art imaginable is one which is not usurped by the claims of a pre-given over-arching order.[60]

His analysis picks up on the preoccupations of the time in other ways too. He was perhaps the theorist *par excellence* of the negative dialectics inherent in certain critically engaged forms of modernism that gained ascendancy in the immediate post-war period. In retrospect, this can at times seems to result in a certain formalising of an aesthetics of dissonance. The compelling art work, as he conceives it, is one structured so that the dispersed moments of sensuous particularity necessarily appear unassimilable to, or at odds with, one another. There needs to be a pervasive fragmentation and disjunction, a consistent decomposition of any suggestion of wholeness, or of gratifying sensory fullness, as in Beckett's work, which Adorno considered paradigmatic. As he put it, 'Art can only assimilate the world of objects as "membra disjecta" [scattered parts]; and only a dismantled object world is commensurate with art's law of form.'[61]

* * *

What gives one most pause in reading Adorno now are some of the particular consequences he draws from these imperatives, consequences such as the one that Schoenberg's twelve-tone music, with its consistent negation of conventional rhythmic and melodic effect, and the insistently fragmenting logic of its structures, is of its very nature more compelling than Stravinsky's work, and that the more immediately accessible shaping and affect of the latter's music make it inherently debased, like jazz. The issue here is not Adorno's individual critical judgement, the fact that he responds to Schoenberg and finds Stravinksy irritating, but rather the terms in which this judgement is couched. He almost makes it seem that the negational logic of Schoenberg's music would guarantee it a certain integrity,

while the more immediately accessible structuring of Stravinsky's work, including the supposed retreats into a self-conscious classicism, are necessarily symptomatic of an easy capitulation to consumerism.

The distinctive and historically specific cast of Adorno's aesthetic imperatives is particularly apparent in his commitment to a critique of anything in a work of art that might suggest a gratifying, sensuous richness and harmony and thereby seem to deny the unspeakable horrors contaminating a culture that had given rise to fascism. Within post-Romantic, modern culture, he argued, specifically invoking Hegel's theory of art, 'anything pleasurable to the senses, and beyond that any allure emanating from the materials, has been relegated to the pre-artistic'.[62] A notion of art that in any way privileged sensuous pleasure was in his view necessarily regressive and childish, and when coupled with the bourgeois notion that the pleasure to be had from art somehow raised one up into a higher realm of experience, became the ultimate philistine notion.[63]

Adorno's continuing stress in his later writing on the need to deny or certainly keep

98 Jeff Koons, *Stacked*, 1988, polychromed wood, 155 × 127 67 cm, edition of 3 plus artist's proof

at bay the spell of sensuous or psychic fascination betrays an anxiety a little similar to Fried's about being engulfed in an immediate physical and affective response to a work – as if succumbing to the irrational charge of a rhythmic or melodic pulse, or of some looming visual presence, put one in the grip of impulses that would blot out one's critical self-awareness. What seems to be precluded by Adorno is a response in which such moments of fixation, or of surrender to the flow of immediate sensation, might merge into or even stimulate a complexly distanced or even alienated response. To take an example that would certainly have disgusted Adorno: suppose one momentarily did succumb to Jeff Koons's injunction to surrender to the mind-numbing appeal of a work like *Stacked* (fig. 98). This could result in a moment of withdrawal, in which the confused intermingling of pleasure and faint displeasure at the work and at oneself for being drawn into its ambit had some oddly intractable ramifications that could not be rationalised as ironic distancing from the dumb gratification the work seemed to flaunt.

If one looks closely at Adorno, however, he provides no basis for the view which gained currency in the wake of [1960s and 1970s conceptualist experiments that a systematic denial of the sensuous aspect of art could offer an escape from aesthetic reification.] That view would not only go against his understanding of reification, but is also at odds with his repeated insistence that modern art is posited on a complex dialectic between anti-sensuousness and some residue of sensuous density. 'Art will no more survive without

recollection of a moment [of imprinting itself on the sensuous]', he wrote, 'than if it yields to the sensuous without the mediation of form [*ausserhalb ihrer Gestalt*].'[64] He was adamant that a critically engaged art and apprehension of art could not be achieved by excluding illusion and sensuous immediacy, that bundle of pre-rational engagements between viewer or listener and art work he called mimesis: 'The experience of art cannot be totally separated from being moved, from the moment of enchantment any more than from the moment of uplift; otherwise it would be submerged in indifference.'[65] If the throb of jazz rhythms repelled Adorno because of its vivid tug of sensation, just as the intense physical and psychic resonance of Minimalist work disquieted Fried, there was in Adorno's theory no *a priori* exclusion of such moments of sensuous vividness and intensity of affect, provided they did not completely take over the response to a work.

I shall finish with an intriguing commentary by Adorno on the limits and the illusions of an aesthetics of physical matter-of-factness, of *Sachlichkeit*, because this brings me back to Fried's critique of Minimalist literalism that began this chapter. *Sachlichkeit* for Adorno represented the idea that a systematic exclusion of all illusory aspects of aesthetic experience would somehow take one beyond the compromises inherent in the aesthetic.[66] Adorno mainly had in mind here 1930s German *Neue-Sachlichkeit* (New Objectivity), but he was also thinking of tendencies in contemporary art, and in particular of work that rejected everything except the most basic 'canvas and mere sound material' – the latter referring to Stockhausen's and Cage's musical experiments.[67] His verdict on this tendency intriguingly converges with Fried's commentary on Minimalism. He argued that a literalist rejection of any formal organisation, and of any semblance of illusion, resulted in a situation where the art work had to rely on a false theatricality to make an impact:

> Nothing can guarantee in advance that the work of art, once its immanent movement has blown apart any overarching form, will in the end reconstitute itself, that its *membra disjecta* will somehow come together. This has led to artificial procedures being instituted back stage – the theatrical term is quite appropriate – whereby individual elements are deliberately prefabricated in advance so they will effect that transition to a totality that otherwise would be denied by the absolute contingency of the successive details resulting from the liquidation of any informing sense of order.[68]

Like Fried, Adorno was expressing his anxiety about artistic interventions that claimed to abolish the complex dialectics of art articulated in the more demanding forms of modernism, and that sought to do away with the residual integrity or autonomy still enacted in the most pared down modernist work. Both were highly critical of art that seemed to refuse a recognisable integrity of form, replacing this as they saw it with a staged and hollow illusion of wholeness. In making such a case, both were in their different ways motivated by a sensibility deeply suspicious of work that seemed to be constituted through its physical staging and the viewer's or listener's physical interaction with it. At the same time, both brought such considerations into the arena of critical debate because they envisaged the art work as a phenomenon emerging in the beholder's or listener's apprehension of it, and did so with a feeling for the subtle inflections of response involved often lacking in the generalised abstractions of viewer and reader response theory.

6 The Phenomenological Turn

If there was one word which dominated discussion of new departures in three-dimensional art in the 1960s, it was the object. What kind of an object could still count as art? Or, more radically, how might work be produced that escaped the closures of conventional conceptions of the object? Minimalism, along with the Neo-Dada and conceptual tendencies of sixties art, brought these issues to a head, Minimalism perhaps most dramatically because the work involved so evidently had object-like qualities. That these were the issues to worry about philosophically emerges with symptomatic clarity in Richard Wollheim's eponymous 'Minimal Art' essay of 1965.[1] Retrospectively, partly because of the influential account of Minimalism given by Rosalind Krauss in her *Passages in Modern Sculpture* published in 1977, the significance of Minimalism has come to be seen in a somewhat different light. The potentially sculptural concerns Krauss raises, relating to processes of viewing and to the situation created when the viewer enters the space occupied by the work, feature rarely in the earlier critiques of and apologias for Minimalist work. You get a good sense of this glancing through Battcock's anthology *Minimal Art* published in 1968. Only two texts stand out for making such issues central, Fried's 'Art and Objecthood' of 1967 and Robert Morris's 'Notes on Sculpture' of 1966, to which in a way Fried's analysis is a riposte.

Sculpture and Phenomenological Theory

In introducing Merleau-Ponty into this discussion of new understandings of sculpture which emerged in the 1960s, I am following two different logics that may at times be slightly at odds with one another. Firstly, and foremost, his analysis of vision as a part of the self's interaction with the world, as a mode of being, rather than simply an instrument of visual mapping and categorising and control, provides a fruitful framework for making sense of the new sculptural imaginary associated with Minimalism. Equally, it is clear that his approach had a historical significance. It struck quite a strong chord in the Anglo-American art world, though it appears not to be the case that the artists I shall be singling out for attention, namely Judd, Morris, Andre, Hesse and Serra, read his work at all closely when it first became available in English, however striking the affinities between his concerns and theirs might now seem. Moreover, the interest in phenomenology was not confined to Merleau-Ponty. The more technical philosophical writings of Husserl, the 'father' of modern phenomenology, particularly his *The Phenomenology of Internal Time-Consciousness* (translated in 1964), also enjoyed a cult status in the English-speaking art world.

Among those interested in art, Merleau-Ponty's most widely known piece of writing was his book *The Phenomenology of Perception*, published in French in 1945 and translated in 1962 – though few, I imagine, ever read the 456 closely printed pages in their entirety. There were also several shorter essays specifically concerned with the visual arts, all available in English translation by 1964, the short essay 'Cézanne's Doubt', first published in 1948, and two more extended works, 'Indirect Language and the Voices of Silence' which first appeared in 1952 and was incorporated in the volume *Signs* and *Eye and Mind*, first published in 1960 and made available in English in the posthumous collection of essays entitled *The Primacy of Perception*.[2] Here, as in the case of the impact later made by French structuralist and post-structuralist thinking in the Anglo-Saxon world, we see a considerable time-lag occurring. Not only had Merleau-Ponty died before his writings on art and visual perception properly came to the attention of English-speaking readers but his *Phenomenology of Perception* had been written almost two decades before its full impact began to be felt.

The affinities between Merleau-Ponty's writing and the concerns of the 1960s art world are quite complex. He offered a new way of thinking about viewing and visual perception that represented a radical alternative to the norms of conventional formal analysis. Viewing was envisaged by him, not as the self-contained activity of a disembodied eye, but as embedded within the body and inextricably bound up with a broader situating of the body within the physical environment. As such his ideas had close affinities with a rethinking of the sculptural object as an intervention in the spatial arena shared with the viewer rather than as isolated, self-contained shape. But what art did Merleau-Ponty himself write about? Not sculpture certainly. Modern art for him was above all mainstream early modernist European painting, the art of Matisse, of Klee, of Robert Delaunay and above all of Cézanne. As Krauss, who did more than anyone to associate his writing with the new sculptural priorities of the 1960s, pointed out in an essay on Serra she wrote for a French audience in 1983, the take-up of his phenomenology in the European art world was associated with tendencies that were radically at odds with the Minimalist, and categorically abstract, imperatives that preoccupied her.[3]

His writing interested a number of critics who envisaged modern art as still centrally engaged with issues of representation, and who were particularly fascinated with the recent figurative work of artists such as Giacometti. David Sylvester's analysis of Giacometti's sculpture, some of which goes back to the 1950s, is often couched in phenomenological and existential language, and specifically refers to Merleau-Ponty in an illuminating analysis of the complex impact made by Giacometti's figures as human presences simultaneously mirroring and distancing themselves from the viewer. Sylvester was interested in how such sculpture embodied a stance echoed in the viewer's sense of his or her own body as she/he faced up to it, and yet at the same time presented itself as strangely other and distant.[4]

This double-sided appropriation of Merleau-Ponty is played out in the opposed positions of the two American critics who most fully acknowledged the importance of Merleau-Ponty for their early writing on sculpture, namely Krauss and Fried. Fried's engagement with French phenomenology was rather like Sylvester's. Merleau-Ponty offered him a way of talking about how sculpture such as Caro's might configure a bodily stance or physical mode of being in the world that would be echoed in the viewer's

response to it. Among American writers on contemporary art Fried was very quick to appreciate the value of Merleau-Ponty's ideas, and he already cited him in an essay on Caro dating from 1963.[5] His subsequent writing on the sculptor's work is peppered with comments about 'the ambition to make sculpture out of primordial involvement with being in the world', and about how 'the three-dimensionality of sculpture corresponds to the phenomenological framework in which we exist, move, perceive, experience, and communicate with others', which have a strong whiff of Merleau-Ponty about them.[6] Fried's retrospective comments on his career as an art critic underlined the significance of Merleau-Ponty for helping him to articulate his response to Caro's work when he first came across it in the early 1960s. He had been struck by how it evoked 'a wide range of bodily feeling and movement' even though it was entirely abstract and

> in no way depicted the human figure. In this connection I appealed to the writings of the French existential phenomenologist Merleau-Ponty . . . [It was] Not that Merleau-Ponty was required to alert me to the bodily aspect of Caro's art, or art in general . . . But Merleau-Ponty provided philosophical sanction for taking those feelings seriously and trying to discover where they led.[7]

Merleau-Ponty was already featuring prominently in Krauss's early essay on Donald Judd dating from 1966. This must count as one of the first and also more sophisticated appeals to Merleau-Ponty's ideas to make sense of the new relation between viewer and object interpolated by Minimalist work. It comes well before her better-known invocations to Merleau-Ponty in her now classic critique of Fried's anti-theatrical stance in *Passages in Modern Sculpture*.[8] For Krauss, writing on Judd in 1966, the key issue was already different from that highlighted in Fried's analysis of Caro. What concerned her were not the bodily sensations and gestures immediately suggested by the internal syntactical structure of the sculpture but rather the bodily sensations produced in the viewer by the disparate apperceptions she or he had of the sculpture's configuration as seen from different standpoints. Though at this stage still identifying herself with Fried's and Greenberg's modernism, she was already introducing, by way of a quote from Merleau-Ponty, a key point of difference which she later represented setting her apart from Greenbergian formalism. What she saw as being given to the viewer in the experience of the sculptural works she admired was not some immanent sense of centred structure or form that transcended all one's partial views but 'the infinite sum of an indefinite series of perspectival views in each of which the object is given but in none of which it is given exhaustively'.[9]

When in *Passages in Modern Sculpture* she defined her conception of a contemporary sculptural sensibility in antithesis to Fried's in 'Art and Objecthood' and recast literalism and theatricality as positive values, the polemical edge derived in part from her insistence on a thoroughgoing decentring and splitting both of the viewing subject and viewed object, and her Morris-like antipathy to any notion of the work of art as an autonomous whole.[10] This new positioning annulled a residual allegiance in her early essay on Judd to the idea that the viewer would in the end experience sculptural objects 'as meaningful, whole presences' by attending closely to the disconnected partial views that literally presented themselves to the eye, an allegiance which might be seen as truer to the integrative logic and to the sense of connectedness and wholeness implicit in much

of Merleau-Ponty's writing. At the same time, Krauss's subsequent commitment to a radical decentring has affinities with certain tendencies in Merleau-Ponty that came to the fore in his later thinking, though the systematic nature of her post-structuralist refusal of any suggestion of presence, or of any sense of a whole thing presenting itself to one's view, however contingently and provisionally, is still at odds with the general tenor of Merleau-Ponty's project.

* * *

Soon after the flurry of translations into English in the mid-1960s, rounded out with the posthumous publication in English of the incomplete *The Visible and the Invisible* in 1968, Merleau-Ponty's work began to sink from public view. Phenomenology was displaced by structuralism, then post-structuralism, and the imperatives of the newly popular linguistic and semiotic models made a focus on perceptual processes seem old-fashionedly humanistic. By the end of the 1960s, artists or art critics looking to ground their analysis philosophically, and seeking alternatives to traditional rationalist or positivist models, tended to turn to Wittgenstein rather than to the French existentialists or phenomenologists. With his insistence on the centrality of an understanding of language to a conceptually informed critical analysis, Wittgenstein became the thinking artist's and critic's philosopher.[11]

I have certain misgivings about reintroducing the old antithesis between phenomenology and structuralism, particularly when a close look at the situation makes it apparent that on many issues the two blur into one another. Merleau-Ponty, after all, welcomed Lévi-Strauss's structuralist approach as showing a way beyond the traditional 'correlation of subject and object' that had dominated modern philosophy.[12] His intensive speculations on language in the later phases of his career were based on Saussure, though it was with *parole*, that is utterance or speech act, rather than with language, the structural preconditions of utterance, that he was mainly concerned.[13] Even so, the divisions that opened up between structuralist or post-structuralist priorities and earlier phenomenological analysis were very real and were reinforced, one might almost say overdetermined, by factors specific to the art world which made a phenomenological understanding of the viewer's engagement with a work of art seem increasingly irrelevant. Anti-formalism, and the reaction against high modernism's purist opticality and focus on the autonomy of the art object, produced a mind-set that was deeply suspicious of any privileging of a visual, or even physical, dimension to responses to work of art. Such responses began to seem ideologically suspect, too bound up with an easy bourgeois and sexist delectation of the sensually resplendent art object.

Insomuch as modernist formalism was updated, it was not by giving it a phenomenological grounding in the bodily dimensions of viewing, as Fried and early on Krauss sought to do, but by thinking of formal structures as echoing certain underlying patterns of articulation that governed linguistic sign systems. Moreover, Merleau-Ponty's own writings on art could easily be associated with an unfashionable preference for picture making and painterly depiction that came to seem increasingly irrelevant to an art world that set such store by non-traditional forms of practice. However, the very overdetermination of the reaction against phenomenology might be part of the reason that it has a

certain purchase again today – as a cogently thought through alternative to the paradigms supplanting it which tended to exclude any close consideration of the visual and perceptual dimensions to the engagement with works of art. Not that anyone particularly wants a return to hushed talk about the primordial immediacy of the visual that made hard-headed linguistic analysis once seem so attractive, and that is, as we shall see, also at odds with Merleau-Ponty's own complex understanding of the relative status of the verbal and visual.

There is another more straightforwardly political factor that needs to be brought out here if we are to understand the collapse of interest in Merleau-Ponty's phenomenology in the post-1960s art world, signalled in Robert Morris's acid comments I have quoted about the apolitical and bankrupt humanism implicit in a phenomenological style of thinking and its privileging of such things as the 'presence' of the work of art.[14] Indeed, coming unprepared to the poised, magisterially reasoned and confidently centred style of Merleau-Ponty's argument, a present-day reader could easily misinterpret it as signalling an apolitical, high liberal humanism. Merleau-Ponty's style is less mandarin and technical than that of later French theorists such as Derrida and Foucault, but it lacks the latter's seemingly tough-minded oppositional rhetoric. However, if he did not give his philosophical analysis the edge of political drama that later came to seem imperative for signalling a writer's oppositional credentials, he was much more actively politically involved, indeed anti-capitalist, than the structuralist and post-structuralist thinkers who supplanted him as proponents of a more radical-seeming style of thinking in the Anglo-American academic world.

Merleau-Ponty was as much a political commentator, and a very shrewd and hard-headed one at that, as a philosopher and phenomenologist. Moreover, the ideological underpinning of his major study, *The Phenomenology of Perception*, was very far from being liberal humanist. The book was largely conceived as grounding the Hegelian Marxism to which he was deeply committed at the time. In it he sought to establish the fundamentals of philosophical thought in material practices, envisaging consciousness as embedded in the physical interaction of an embodied self with the world it inhabited.[15] He saw this analysis as illuminating the nature of political and above all revolutionary praxis, as well as everyday perceptual praxis, as sections of the last chapter of the *Phenomenology* make very explicit.[16]

In fact, the take-up of Merleau-Ponty's thinking in the art world has tended to launder out the political dimension integral to it. Ironically, while this laundering probably contributed to the demise of his reputation in the politically conscious art world of the 1970s, earlier, in the shadow of the Cold War, it probably functioned to make him more acceptable to a left-liberal intelligentsia that would not have warmed to his early political reputation in the English-speaking world as something of a hard-line Communist Marxist – though he was never actually a member of the French Communist Party.[17] His *Humanism and Terror: Essays on the Communist Problem* published in French in 1947 initially caused quite a stir because of its attempt to try to understand the deformed revolutionary logic at work in the confessions of prominent Bolsheviks in the Stalin show trials. This was seen by many on the left as outright Stalinism. At the same time, his indictments of the imperialist violence latent in the anti-Communism espoused by the United States government would not have endeared him to many American

intellectuals, even those of a radical persuasion. So, at one end of his career he had a problematic reputation as a dogmatic Bolshevik Communist, itself as a much a misreading of his position as the later apolitical reading of him.[18]

By the time of his early and unexpected death in 1961, Merleau-Ponty's public political stance had shifted somewhat: if anything he had emerged as something of a liberal. In his dispute with Sartre in the 1950s, he voiced a deep personal mistrust of what he saw as revolutionary voluntarism – what used to be called ultra-leftism – and, if not strictly speaking anti-Communist, became much more sharply critical of the Stalinisation stifling the Soviet Union and the Eastern European People's Republics than he was of anything in Western capitalism and liberal democracy. Even so, Sartre's tribute to him published in the journal *Les Temps Modernes* in 1961 is written as from one comrade to another. Here I feel Sartre caught something essential about the ethical and political impetus of Merleau-Ponty's work:

> Cutting through the ties that bind us to our contemporaries, the bourgeoisie shuts us up in the cocoon of private life and defines us with slashes of the knife as individuals . . . as molecules without history who drag themselves from one instant to the other. Through Merleau, we rediscover ourselves as singular through the contingency of our anchorage in nature and in history, that is through that adventure in time in which we are [situated] at the heart of the human adventure.[19]

In *Signs*, the book of essays he published just before his death, Merleau-Ponty continued to display his scorn for those erstwhile left intellectuals who had turned their backs on the Marxism that once had informed their thinking and their politics. If for him Marxism had lost its immediate links with a credible revolutionary politics, it still remained for him an indispensable way of thinking about and understanding the world. Marx, as he put it, had become a classic and his ideas remained deeply engrained in the fabric of contemporary culture.[20] He also refused the radical intellectual's safe haven of knowing pessimistic negation. Despite coming to the conclusion that the impetus for revolutionary change which he once hoped would gather force in the wake of the struggle against fascism had completely collapsed, and had indeed been betrayed, he still insisted that one should not get locked into such a bleak and also historically contingent perspective on things:

> What we call disorder and ruin, others, younger than us, experience as natural, and perhaps they will have the ingenuity to dominate it precisely because they are no longer seeking their points of reference where we took ours. In the din of demolition, many a morose passion, many a hypocrisy and madness, many a false dilemma are disappearing too. Who would have hoped this ten years ago? Perhaps we are at one of those moments when history passes on. We are deafened by the events in France [the Algerian crisis] or the noisy episodes of diplomacy [the Cold War]. But beneath all the noise, there is emerging a silence, an awaiting. Why should this not be a hope?[21]

The political movements of the 1960s in a way bore this out.

An important impetus behind Merleau-Ponty's exploration of the intersubjective awareness constituted in immediate physical interactions between an embodied self and the world around it was the desire to establish a materialist basis for such a hope. He

argued throughout his career that the relation between self and other was not nec-
essarily a Hobbesian relation of confrontation and conflict, which we might be led to
believe it was from the alienating, individualist constitution of social relations in modern
capitalist society, or from the oppressive regimes of social control in the so-called Com-
munist states. He was at pains to establish that an element of symbiosis, of free give and
take, was inherent in the basic processes whereby a human subject made its way in the
world. And this is where he perhaps differs most sharply, not from Barthes, but from the
French post-Marxist intellectuals who have dominated so much subsequent cultural
theory, and for whom, as for Sartre (with whom Merleau-Ponty was engaged in an
ongoing debate), the basic relation of self and other and self and world was a drama of
confrontation imbued with paranoid-schizoid impulses. When considering the kinds
of interaction played out between viewing subject and viewed object in recent three-
dimensional art, we shall find that these different politically loaded understandings of
intersubjective relations are pretty important; they may indeed be the nub of the issue.

Perception and Presence

Neither of the major publications where Merleau-Ponty analysed the complexities of
viewing and visual awareness, whether his *Phenomenology of Perception* or his later *The Visible
and Invisible*, dealt directly with art or visual aesthetics. In these, he was concerned above
all to explore the ramifications of everyday visual apprehension, rather than the more
self-conscious and deliberately framed processes of viewing elicited by works of art. His
primary ambition as a philosopher was to move beyond the dichotomy, deeply lodged in
modern thought, between an empiricist or positivist conception of things as objectively
given entities prevailing in modern science, and a traditional philosophical location of
truth in the operations of mind and reflexive thought. By taking as the basis of his enquiry
an exploration of how self-awareness and awareness of things were generated in interac-
tions between a physical self and the material world of which it was part, he was in
a way seeking to turn philosophy on its head, a little as Marx had done. His larger
concerns were ones that have preoccupied a number of major thinkers, not just in the
twentieth century, and I am not trying here to make some special case for him as
a critical thinker. But I would claim that his analysis is particularly pertinent for
thinking about the distinctive modes of viewing invited by art. He presented issues
of critical self-awareness in unusually concrete visual terms, and his doing so was
partly shaped by an interest in painting that I shall be addressing in the next section.[22]

If one takes a route through the early *Phenomenology of Perception* to the incomplete and
posthumously published *The Visible and the Invisible* – a long route if we follow it closely
and a difficult one at times where many retracings have to be made – and then goes on
to tackle his essays on art, a perspective on the viewing of things in space and time opens
out that suggestively breaks the bounds of the conventional pictorial imaginary in which
Merleau-Ponty might seem to be lodged if one looked at his writings on art in isolation.
His analysis has a particular bearing on sculpture because viewing sculpture is more
akin to everyday processes of viewing objects in the world than is viewing painting.
Merleau-Ponty effects a reconceptualising of viewing at a philosophical level that is a

very real equivalent of what went on in the reconfiguring of sculpture in the decade or so after his death.

In his *Phenomenology of Perception* Merleau-Ponty highlights several issues that pertain to a sculptural mode of viewing. For one thing, he is adamant that we cannot understand the complex sense we have of what we see in the environment round us by isolating some purely optical level of sensory awareness.[23] Seeing integrates within itself the kinaesthetic and tactile dimensions of experience. When we look at things, we are situated in their space and move around among them, and our seeing them needs to convey an immediate sense of them as things to be touched and acted upon or physically responded to.

He later made an illuminating point about the misleading tendency in conventional formal analysis of art to talk about the tactility conveyed in paintings as a distinct sensation produced by an experience that is essentially optical in nature:

> When, in connection with Italian painting, the young Berenson talked about the evocation of tactile values, he could not have been more wrong; painting does not evoke anything, and notably not the tactile, it does something quite different, almost the reverse; it gives visible existence to what everyday vision believes to be invisible, it makes it so that we do not need a 'muscular sense' in order to have the voluminosity of the world.[24]

His critique of purely optical models of viewing was partly impelled by the need he felt to counter a misleadingly objectifying understanding of perception in modern thought based on traditional models of seeing, where things perceived were clearly visible entities set out before the viewer rather than phenomena taking shape within his or her perceptual field. Indeed, to think momentarily of a purely tactile engagement with things could help to illuminate aspects of perception occluded by a conventional focus on seeing:

> In visual experience, which pushes objectification further than does tactile experience, we can, at least at first sight, flatter ourselves that we constitute the world, because it presents us with a spectacle spread out before us at a distance, and gives us the illusion of being immediately present everywhere and being situated nowhere. Tactile experience, on the other hand, adheres to the surface of our body; we cannot deploy it before us, and it never quite becomes an object. Correspondingly, as the subject of touch, I cannot flatter myself that I am everywhere and [situated] nowhere: I cannot forget in this case that it is through [the medium of] my body that I go out into world, and that tactile experience comes into existence 'ahead' of me, and is not centred inside me.[25]

Merleau-Ponty's writing on perception came at a moment when new developments in the psychology of perception were putting integrationist and contextualist models on the agenda, and when conventional pictorial or retinal models were increasingly being thrown into question. What later came to be called ecological approaches were beginning to gain ground. In these, tactile and kinaesthetic and optical apperceptions were treated as part of an organism's larger interaction with its environment, and not as distinct systems.[26] In other words, Merleau-Ponty was writing at a time when a major rethinking of perceptual process was taking place, and he was an acutely intelligent and perceptive witness

to all this. Gombrich, writing a decade or so later, also found it was a good moment to be thinking about the new models being developed by scientists and psychologists. If his positivist approach was very different from Merleau Ponty's, his *Art and Illusion* equally challenged conventional understandings of the naive eye, as well as formalist models of art that separated a purely optical level of apperception from processes of mapping and making physical contact with the world.

The modern scientific study of visual perceptual has developed dramatically since Merleau-Ponty first formulated his theories, largely because of the stimulus provided by computerised simulation in developing new models of how perception might operate. In his own time, Merleau Ponty was very much up to date with such scientific developments. At the end of his career he developed a keen interest in cybernetics and information theory,[27] and even took some nice swipes at the fashionable appropriation of the new behaviourist 'gradient' models that were later to be deployed with more scien tific rigour in the ecological theories of perception which J. J. Gibson was formulating.[28] This is as one would expect of someone who insisted that thinking needed to operate at the interface between the physical and the mental, and who devoted considerable energy to challenging the intellectualism and idealism of the neo-Kantian thinking dominant in traditional philosophy and cultural theory, as well as the subjectivism of the new existentialism of Sartre. His critique was directed as much at the mentally constituted objects of philosophical idealism as it was at the self-evident physical facts of scientific positivism.

While his outlook was shaped by his readings in *Gestalt* psychology, a school of thinking which has now largely been supplanted, he stands apart from contemporary writers on art who like him took an interest in *Gestalt* psychology, such as Arnheim. His was a sophisticated understanding of the notion of *Gestalt*, and he refused the popular derivations of *Gestalt* theory that gained a hold in thinking about modern abstract art and that envisaged the configurational underpinning of perception as reducible to geometric patternings of the visual field. He was resolutely anti-formalist in this superficial sense, realising that if one was going to talk about the deep structures that made perception possible, such as dimensionality, these were of their very nature invisible and could not be represented diagrammatically.[29]

<p style="text-align:center">* * *</p>

Merleau-Ponty offers some of his fullest and most suggestive insights into viewing in the *Phenomenology of Perception* when he analyses the spaciality and temporality inherent in seeing and discusses the inadequacy of traditional image models for dealing with these dimensions of visual experience. A persistent theme in his discussions of perceptual awareness is that the space we actually see is not an abstract Cartesian space within which we map out the positioning of things, as if we were a disembodied eye overseeing them. Rather, he insists, the space we see is a realm in which we ourselves, as viewers, are situated, not something we look out at or into. We see things from within our own horizon of viewing. Depth, he also maintains, is a dimension of the world around us which we see as directly as any other aspect of it. We do not infer it indirectly from a more primary flat patterning of our field of vision.[30] As we have seen, this runs counter

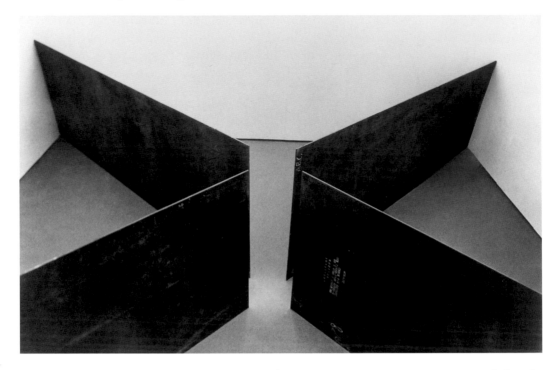

99 Richard Serra, *Circuit*, 1972, hot rolled steel, four plates, each 244 × 732 × 2.5 cm, installed at the Kassel Documenta in 1972

to the model of depth perception implicit in much modern formal analysis of art such as Hildebrand's.

Rather than relying exclusively on the idea of figure–ground to describe the way phenomena stand out in our immediate field of awareness as we focus attention on them, he also invokes the idea of point-horizon given currency in Edmund Husserl's much more technically philosophical phenomenological analysis, to which Merleau-Ponty was deeply indebted.[31] The point-horizon model has certain features that suit Merleau-Ponty's purposes rather well. The word horizon emphasises the idea that the perceptual field within which things come into focus is not an objective ground but the very condition of our seeing anything. It registers the situatedness of our act of perception. Point-horizon also suggests that whatever comes to our attention is not necessarily a substantive entity, as the word figure implies. It represents one's seeing something as a process of focusing on a point or nucleus that makes what is situated there stand out from what lies around it and is less clearly present to us, while figure–ground could in theory refer to a visible phenomenon being differentiated from its surroundings in a more objectivising way.[32]

Merleau-Ponty's reflexive conception of a point-horizon model of viewing is particularly suggestive for thinking about the spatial dimensions of viewing sculpture. A horizon is something that completely surrounds us, defining not only the spatial arena we can survey but also the ambient space we inhabit at a particular moment and within which we move. According to this model, our viewing operates projectively by setting the thing

on which we focus our attention within its own horizon or ambient space, with the result that we also see ourselves as positioned within the horizons of the things we catch sight of. Such a point-horizon conception seems almost tailor-made for thinking about the viewing elicited by the more spatial sculpture to come out of the late 1960s and early 1970s, particularly Richard Serra's. This is most obvious in the case of environmental work such as Serra's *Spin-Out* (fig. 106), where the work literally enacts a point-horizon configuration. When we see it from a distance, we project ourselves as being at its centre in the empty space in the middle of the small valley, and then, as we move in and put ourselves in this situation, our horizon and the work's become concentric. But the model also has a bearing on how we view an indoor piece such as *Circuit* (figs 99, 100) which dramatically reshapes the gallery space where it is set. If we were to enter the gallery, we would become intensely aware that both our visual horizon and our sense of ambient

100 Richard Serra, *Circuit*, detail, from the version created for the Museum of Modern Art, New York, in 1986 (plates 305 high and 5 cm thick), The Museum of Modern Art, New York. Enid A. Haupt and S. I. Newhouse, Jr. Funds

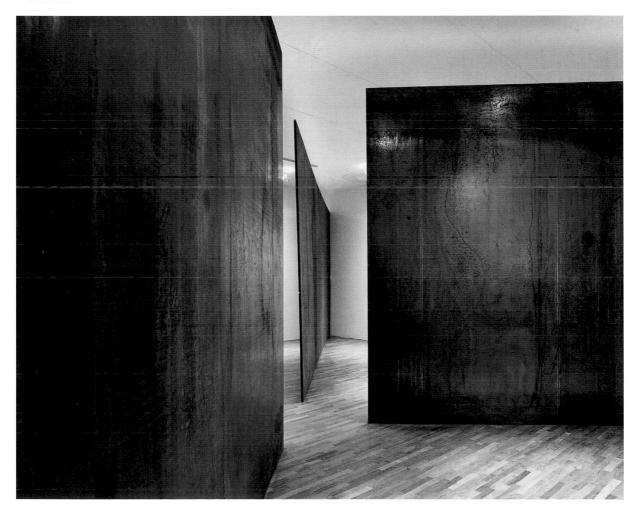

space are being restricted and reconfigured in ways we actively have to negotiate. The experience is quite different from a normal sense of being enclosed within a room like a gallery which is so generically familiar that we are hardly aware of its shaping the space around us.

How such sculpture works also has to do with a certain distancing and temporal displacement. At issue is a visual awareness of our situation, not just the immediate sensation of being blocked or crowded out. We do not have to be right inside the gallery with the sculpture to see what it is about, and even when we are there, we can detach and momentarily think about the effect it is having, almost, but not quite, as if we were projecting ourselves inside it. Engaging with the sculpture at the very basic level of immersing ourselves in our motor responses and negotiating the restrictions it imposes on our movements is also complicated by a distancing inherent in the process of viewing it. As we wander round and look at Serra's *Circuit*, we are prospectively imagining what it would be like to move into the spaces we see opening ahead of us, and towards which as a result we direct our steps. On immediately entering the room where the sculpture is placed, we would almost automatically be drawn to the very middle, and the experience we get there would be inflected by what we previously imagined we might see or feel, and by anticipations of what it would be like to move away again to another spot. In Merleau-Ponty's scheme of things, this temporal layering of response, this dimension of non-immediacy in our immediate viewing of what lies before us, is integral to the process of seeing.

Temporality is absolutely central to Merleau-Ponty's understanding of visual apperception. He envisages perceptual awareness as located in an ever shifting present, but at the same time made possible because what we presently perceive develops out of what we have perceived in the immediate past, and also anticipates what we are about to perceive in the immediate future. What we see then is simultaneously fashioned from and dispersed by the duration of our awareness – or as he put it, 'the living present is torn between a past which it takes up and a future which it projects'.[33] Viewing always involves a dimension of temporal awareness and as such cannot be immediately present to itself – anything we become aware of has already slipped into the past, at the same time that this awareness is anchored in the immediate present.[34] What makes his discussion so suggestive is that he manages to give the complexities of Husserl's and Heidegger's insistence on the temporality inherent in self-awareness a new concreteness and immediacy through his sharp focus on processes of viewing.

This is a good point to return to the perennial sculptural problem of partial views, which I want to consider in relation to the phenomenological chestnut of how it is that we apprehend a whole cube for what it is when we only see a series of partial views. Merleau-Ponty insists that the whole thing we apprehend is not just the sum total of the immediately seen partial views we have of it. It is no more the cumulative effect of a stream of disconnected visual sensations dispersed over time than it is some ideal totality we adumbrate in our mind as we synthesise the partial views into some imagined overview in which all key aspects of the thing we are looking at are transparently manifest. Merleau-Ponty is arguing that the thing we apprehend is felt to be present within the restricted horizon of our immediately present apperception of it because the latter includes recollections of what became manifest in previous views, and anticipations

of what will become manifest if we shift our horizon or focus of attention. It is the thing as it exists and makes itself felt within the temporal flow of our continually shifting and synthesising visual apprehensions of it. This makes the idea, central to a traditional aesthetics of pure plastic form, that we apprehend a thing in its totality as a fully defined plastic shape an existential non-starter:

> How can any thing ever really and truly *present itself* to us, since its synthesis is never a completed process, and since at any moment it is possible I might see it break down and fall to the status of mere illusion? Yet there *is* something and not nothing . . . Even if in the last resort I have no absolute knowledge of this stone [we could think of this as a sculpture], and even if my knowledge regarding it takes me step by step along an infinite road and cannot ever be complete, the fact remains that the perceived stone is there, that I recognize it, that I have named it and that we agree on a certain number of statements about it. Thus it seems that we are led to a contradiction: the belief in the thing and the world can only mean presuming a completed synthesis – and yet this completion is rendered impossible by the very nature of the perspectives which have to be inter-related, since each one of them defers beyond its horizons to other perspectives . . . The contradiction ceases or rather it generalises itself, it connects with the previous conditions of our experience and coincides with the very possibility of living and thinking, if we operate in time, and succeed in understanding time as the measure of being.[35]

Looking at a sculpture could be thought of as a distinctive kind of experience that makes us more acutely aware of the temporality lodged in our awareness of things than an everyday looking at objects. We linger on our looking, noticing the different aspects the work presents and the unstable, shifting sense we have of its immediate appearance rather than merely taking note of it and registering its appropriateness as an object of use or pleasure. We would go crazy if we opened up our everyday apprehension of things in this way. Yet if for practical purposes we assume that we live in an objective world, dealing with the things we encounter as objects with definite functional properties, that is not the whole story. In the physical world we see and inhabit, however closely we look, the things around us never quite become determinate objects whose attributes are exhaustively fixed. Both their existence and our apprehension of them are subject to the passage of time. It is Merleau-Ponty's point that our never attaining to a fully objective view of things cannot just be attributed to the limiting horizons of our partial views – there is no bedrock of things in themselves that evade our view in this way. Rather, it is the case that

> There is nothing to be seen beyond our horizons but other landscapes and still other horizons, and nothing inside the thing but other smaller things. The ideal of objective thought is both based upon and ruined by temporality. The world, in the full sense of the world, is not an object, for though it has an envelope of objective and determinate attributes, it has also fissures and gaps into which subjectivities slip and lodge themselves, or rather they are those subjectivities themselves.[36]

The things around us and our bodies cannot be fully encapsulated in our awareness of them as objects – that perhaps is the ethos of some of the more interesting currents in

the art world of the 1960s, just as it is of Merleau-Ponty's thinking about how we apprehend things. If, according to him, a presence impinging on our awareness strikes us as being a whole thing, its wholeness cannot be located in a formal or structural essence that it somehow embodies objectively. Rather, it is a crude fact of its existing, and subject to the vagaries and contingencies of such existential facts. Its existence as thing resides in its convincingly presenting itself to us as being there at the present moment, as having been there for a time, and as continuing to so for a time too.

A further aspect of Merleau-Ponty's analysis that is particularly suggestive for a rethinking of sculptural viewing is his insistence on the constitutive role played in perception by the viewer's awareness of his or her own viewing body – his or her own body image in other words. For him, seeing something also involves sensing our own body as a thing situated in the world, along with the things we embrace in our view. When he envisages a body image playing a role in our viewing of things, then, he does so in terms that are radically at odds with traditional anthropomorphic models. Such models envisage apperception as a process in which inanimate things that capture our attention are humanised by our imagining them to be like living bodies. Their shape and presence are projected as being akin to those of a human figure.[37] The body image Merleau-Ponty talks about, in contrast, is the internalised sense we have of our own body as we apprehend things in the world around us. We can be made acutely aware of this body image when we look closely at objects such as sculptures because they impinge so insistently on the ambient space in which our body is situated.

If this body image is immediately lodged in our visual awareness, however, it is not transparently present to us.[38] It cannot be seen directly as a visible object nor indirectly as some image in which the body's features are mapped out. There is no image or intellectual model that could define this interiorised sense we have of our perceiving body because we can never actually see ourselves seeing.[39] When we see other bodies, we can only see them from the outside as bounded entities located in one place. We cannot see the internalised body image that consists both of a sense of the body as object and of a visual awareness opening out onto the world. The body we inhabit, the body that is looking at and in contact with the world, is not in its essence a mass of solid stuff. It is also a field of awareness and sphere of possible action that extends well beyond the limits of the body as bounded object:

> The body on its own, the body at rest is merely an obscure mass. We only perceive it as a precise and identifiable being when it propels itself towards something, that is in so much as it projects itself intentionally towards the outside world, and one only becomes aware of it in the corner of one's eye and at the margin of one's consciousness, the centre of which is occupied by things and the world.[40]

Some of Merleau-Ponty's most eloquent and suggestive descriptions of our interiorised physical sense of visual and tactile contact with the world comes in his late *The Visible and the Invisible*. A good example is his discussion of the elusiveness of trying to feel ourselves feeling when we hold one of our hands as it touches something. Here he contrasts the relatively weightless and fluid interior sense we have of our hand moving around and touching things, with the inert massiveness it seems to have as a thing we feel from the outside. He compares this with the disparity between our interiorised sense of freely

looking about and our sense of the eye as an organ implanted in our body and impelled in its weightless scanning by the action of our muscles:

> Between the massive sentiment I have of the sack where I am enclosed, and the control of the outside that my one hand exercises over the other, there is as much difference as between the movements of my eyes and the changes these produce in the visible.[41]

Such a duality between a confined, grounded massiveness and a fluid openness that characterises the interiorised body image we have of ourselves extends to how we apprehend the world around us, for in the process of seeing, the external fabric of the things we see is at one with the internal fabric of our seeing them:

> My flesh [that is the fabric of what I see] and that of the world [that is the world incarnated in my seeing of it] consists then of clear zones, of openings round which revolve opaque zones. The first [order] visibility, that of the sensory '*quale*' [namely the most basic, seemingly irreducible visual sensations] and of things, does not proceed without a second [order] visibility, that of lines of force and dimensions, the massive flesh without a subtle flesh, the momentary body without a glorious body.[42]

Such a duality could well describe what happens when we are drawn into looking at a work of sculpture, and it ceases to strike us as simply a closed, inert, substantive object and opens up in some way, coming to life as a phenomenon that constitutes itself in the dynamic of our apprehending it.

* * *

The marked shift that occurred in Merleau-Ponty's thinking towards the end of his career was largely prompted by his wanting to get beyond the reliance on ideas of subjectivity and individual consciousness still operating in his earlier writing.[43] In this respect, his later project echoes that of several other major twentieth-century thinkers such as Heidegger, by whom he was very much influenced, who were seeking to make a definitive break with the dominant model of subject and object in Western thought. Merleau-Ponty wanted to avoid positing any duality between the object as a pre-given entity, a basic building block of the world as we know and think it, and the subject as the self-constituting agent of consciousness and thought. The philosophical significance of this move to a mind-set more akin to later post-structuralist thinking is less relevant to my purposes, however, than the different model of viewing to which it gave rise. When Merleau-Ponty recast his previous ideas on the perceptual interactions between an embodied self and the physical world in which it was embedded, he came to envisage seeing as a process completely immersed in the physical fabric of what is seen.

In *The Visible and the Invisible*, seeing, conceived as a process prior to any definition of a viewing subject and a viewed object, is not located in a consciousness, but in a gap that opens up in the inert, given positivity of things. To the extent that the notion of a perceiving subject still persists, it is imagined, not as a definable entity, but as 'a "lake of non-being", a certain nothingness engulfed in a local and temporal *aperture* – as seeing and feeling in fact, and not as the thinking of seeing and feeling'.[44] At this point Merleau-Ponty is seeking to define a texture of visibility rather than an individual

subject's act of seeing. In making this shift, however, he is not abandoning his previous preoccupation with processes of apperception so much as defining these in different, and at times very evocative, terms.[45]

His earlier model of visual apperception as developed in the *Phenomenology of Perception* offers a particularly rich account of the embodied subject situating itself within the spatial arena it immediately inhabits. Here, a viewer's kinaesthetic interactions with things are to the fore. There is an emphasis on articulations of space and shape, and on the processes whereby the positioning of things seen and of the person seeing come to be defined within the latter's ever shifting horizons of viewing. In the model of visual apperception proposed in *The Visible and the Invisible*, by contrast, suggestions of placing and shaping no longer feature because Merleau-Ponty wanted to get away from any implication that the viewing subject and the viewed object exist as distinct entities. We now have the sense of a self immersed within the physical fabric of its apperceptions, its surfaces of sensory contact with things never fixed or clearly situated. When things manifest themselves within this texture of visibility, they are more like psychoanalytic objects than material objects as conventionally conceived. They are presences felt within one's apperception and fantasy more than things one comes across. This distinction between Merleau-Ponty's earlier and later thinking has certain analogies with one operating in modern sculptural sensibility between a mode of viewing focused on definitions of space and shape and position, and a more unanchored viewing where one's attention is absorbed by surfaces and substances.

Once spaciality and situation cease to be central as they were with his earlier deployment of a point-horizon model in *Phenomenology of Perception*, we find that the figure–ground model actually suits his new purposes better. The figure–ground distinction, though, is not conceived in terms of a substantive, clearly bounded motif set off against neutral background, but of a basic differentiation opening up within one's field of vision as something defines itself as being there.[46] Seeing is now conceived as a symbiosis, not between someone seeing and something seen, but between an inside and an outside, the boundaries of which are constantly shifting. In the process of seeing, what is outside enters inside, and what is inside projects itself to the outside, with inside and outside at any instant split apart at their point of contact. It is by virtue of straddling this constitutive gap or split between inside and outside that seeing ceases to be locked blindly within itself and can open onto the world. On this model, visual apperception is envisaged in terms of fluctuating surfaces of contact and separation. The dynamic is one of enveloping and being enveloped, and of encroaching and being encroached upon, not of looking and being looked at.[47]

The *Phenomenology of Perception* posits a mode of viewing which is suggestively in tune with that elicited by work such as Richard Serra's (fig. 100). Moving to *The Visible and the Invisible*, a world without definable objects and spatial arenas, and of unstable interfaces and reversals between inside and outside, we come closer to the kind of viewing invited by work such as Eva Hesse's (fig. 149). Merleau-Ponty's later thinking also brings to the fore the affective dimensions of viewing in a way that prefigures the concerns of some of the more interesting artists working in three dimensions in the past couple of decades such as Bourgeois (fig. 161) and Nauman (fig. 163). His later conception of viewing is less cognitive in emphasis, and has an obvious psychic resonance. The basic

interaction with and awareness of things constituted by viewing now becomes an 'encroachment of everything on everything, a universal promiscuity of being'.[48] However, if Merleau-Ponty's later analysis immerses seeing in psychological affect, he does not simply psychologise visual awareness. When he describes the constitution of the self in its most basic interchange with the world as displaced or split, as posited on a gap or emptiness, he is insistent that we envisage this as a fundamental condition of existence, not as some tragic or despairing inner feeling – nor as an existential drama of the kind projected by Sartre with his conception of the self as nothingness.[49] The split condition of the self is not the split self as pathological self, it is not experienced as a state of mind. It is what conditions any state of mind. While 'the aesthetic world [the world of sense experience, the world of visibility and tactility] is to be described as . . . a space of incompatibilities, of rupture, of dehiscence, and not as a space of immanent objectivity', 'the divergence [écart] which in a first approximation establishes sense [or significance] is not a negativity which I affect, a lack which I constitute as a lack . . . it is a *natural* negativity, instituted at the outset, always already there.'[50] This makes Merleau-Ponty much closer to Lacan than to those popularising theorists of the divided self or the anxious self at the time he was writing.[51]

It can sometimes seem, however, that Merleau-Ponty, particularly in his earlier writing, tends, like the good philosopher he was, to represent seeing and sensory apperception as a first order engagement with things that takes place prior to any motivation by drives and appetites, as if the self begins its negotiation with the world by situating itself and knowing its surroundings. But if one takes his writing as a whole and reads the earlier analysis of perception attentively enough, it is clear that he never bracketed out the dimension of desire. Freud and sexuality are there from the start, albeit initially as one rather short chapter in the *Phenomenology of Perception*.[52]

Moreover, by holding onto the cognitive dimension of viewing, in the end he offered a fuller and more compelling model for thinking about the viewing elicited by works of art than he would have had he simply grounded this viewing in the psychic, in the dimension of affect. A psychologising of viewer response can easily lead to a crude anthropomorphising of the interchange between self and art object as straightforward intersubjective drama without enquiring into how the encounter with an inert material object might impel one to make such projections in the first place. The processes whereby a work impinges on our awareness as a sensory phenomenon will be crucial for the kind, extent and duration of the psychic resonances it provokes, even while this psychic dimension is already there in the very first flash of awareness we have of it as a significant presence. For Merleau-Ponty, the cognitive is neither engulfed in the psychic and the affective nor prior to it. They are both fundamental to our being alive:

> One no longer has to ask why we have *affects* in addition to the 'representative sensations' because the representative sensation . . . is affect, is the body's presence to the world and the world's presence to the body . . . Reason also exists with*in* this horizon – promiscuity with Being and with the world.[53]

* * *

Merleau-Ponty and the Viewing of Art

Given that, at the time when Merleau-Ponty was writing, painting very much took precedence over sculpture as a model for speculating about processes of viewing, it is hardly surprising that his discussions of visual art focused almost exclusively on painting.[54] Cézanne, the artist whose work was seen at the time as the paradigm of modern conceptions of vision and visual representation, played a key role for him.[55] It was primarily through thinking intensively how painting such as Cézanne's might activate an existential self-awareness that was neither naively empirical nor trapped within established categories of critical thought, that Merleau-Ponty was able to develop a perspective that was later seen to have suggestive implications for reconceptualising the viewing of sculpture.

However, there is still a formidable gap to be negotiated between Merleau-Ponty's understanding of visual art and the mind-set of the artists and theorists who later took up or at least echoed significant aspects of his rethinking when they developed a more phenomenological perspective on sculpture. Merleau-Ponty's actual discussion of the visual arts has a decidedly ambiguous and conflicted status in this context. Logically, what he said about art should form the culmination of a discussion of the implications of his thinking for a later twentieth-century sculptural imagination. But this is clearly not the case. Merleau-Ponty was a philosopher, not an art critic or an artist, and for him the visual arts served less as an object of concern in their own right than as models that might help to illuminate his general speculations on the embeddedness of vision in the physical, material world.

It is then only to be expected that his views on the visual arts derived from conventional modern understandings of art, particularly painting, current when he was writing – the very conceptions against which later artists and critics reacted in developing a phenomenological perspective on viewing sculpture. Only in his very late essay *Eye and Mind* published just before his death in 1960 did something really exciting begin to happen in his thinking about art. At this point we see emerging a new sense of the viewer's experience of a work of art that begins to match the richness of insight into visual apperception which we find in his other writing. His reconceptualising of viewing adumbrated in his posthumous *The Visible and the Invisible* now interacted fruitfully with his thinking about the qualities that intrigued him in modern painting. My discussion here, however, will have to operate by way of a detour, through the more conventional and less immediately suggestive aspects of Merleau-Ponty's earlier writing about art. But this indirect path will lead us eventually to a more grounded understanding of the larger implications for the visual arts of the ideas he elaborated, first in the *Phenomenology of Perception* and then in *The Visible and the Invisible*. The detour is necessary if only to situate Merleau-Ponty's thinking on art historically and to appreciate the extent to which later critics and artists who found in his writings a fruitful echo of their own concerns had to engage in a highly selective reading, one that effectively turned a blind eye to most of his direct pronouncements on art.

At the same time, as a writer who thought carefully about the empirical implications of his ideas on visual perception, Merleau-Ponty exposed in an illuminating way the inner logic and limits of a pervasive model of painterly depiction that his more general think-

ing about viewing would later encourage others to abandon. In his earlier discussions of the visual arts he also registered a growing unease over prevailing conceptions of the art object as something engaging the viewer at a purely visual, non-cognitive level. As we shall see, far from privileging visual art as embodying a more basic and immediate, pre-linguistic engagement with things than language, he actually came to the conclusion that visual artefacts were inherently limited by comparison with texts or linguistic utter-ances, until he came to write his very late *Eye and Mind*. What happened at this point was that he began to take account of the phenomenological complexities of the viewer's encounter with the work of art as itself a material thing in the world and not just as the trace or representation of the artist's perception of something he or she had seen.

The short essay 'Cézanne's Doubt', first published in 1948, was probably the most widely read of Merleau-Ponty's writings on art, particularly in the Anglo-Saxon world. It is, however, much less dense and less closely involved with the problematics of viewing and visual depiction that fascinated him than his more wide-ranging 'Indirect Language and the Voices of Silence', first published in 1952 and made available in English in 1964. Apart from his late *Eye and Mind*, this is his most fully articulated piece of writing on the visual arts. It was conceived as a response to Malraux's book *The Imaginary Museum*, published in 1947 and then reissued in revised form as part of *The Voices of Silence* in 1951. Malraux's discussion of the modern visual imaginary, and the particular form of communion with the art of the past projected within its museological frame of reference, had a pervasive impact at the time.[56]

Merleau-Ponty particularly objected to Malraux's idea that modern art had become entirely subjective, and that the modern experience of art was a purely individual one which was severed from any engagement with the world at large.[57] Even so, while arguing against Malraux's rather standard subjectivist understanding of modern art, he still envis-aged painting as depiction in a fairly narrow sense, focusing on the activity of the artist painting and perceiving things rather than the viewer's perceptual activity coming to terms with this depiction. A painting, as Merleau-Ponty understood it at this point, func-tioned to record the painter's perceptual response to the motif represented, while its literal aspect was of no particular interest in its own right. The marks on the canvas effectively made transparently visible to the viewer the painter's way of seeing things.[58]

Two key aspects of standard conceptions of painting current at the time play a role in Merleau-Ponty's distinctive fascination with painting. Firstly, he was drawn to the idea that a painting was the product of a largely unmediated symbiosis between self and world and as a result could be seen directly to embody the processes of visual apprehension analysed in his *Phenomenology of Perception*. Equally, current conceptions of painterly depic-tion intrigued him because they highlighted the active expressive response on the part of the artist to his or her perception of things as well as the recording of these percep-tions. Painting envisaged thus as expressive gesture became an embryonic form of the more richly expressive positing articulated in speech.

Such ideas concerning painting and visual art preoccupied many critics, theorists and artists at the time. No one has made more of the complexities of trying to render in art a perceptual engagement with things than Giacometti did in the 1940s and 50s. His struggles with trying to depict exactly what he saw, dramatised in statements he made and interviews he gave later, became the bread and butter of talk about modern art in

the period. As we have seen, he also engaged interestingly with the rather different problems of viewing and situating sculpture in the round, in a way that marks him out from many of his sculptor contemporaries. But as a paradigmatic figure in the modern art world of the time, what mattered above all was his obsessive reworking of an artistic problem most people envisaged in terms of life drawing and painterly depiction, and not in sculptural terms. Indeed it was as a painter, rather than as a sculptor, that Merleau-Ponty himself found Giacometti most intriguing.[59]

Merleau-Ponty's interest in the painter's expressive gesture puts one in mind of some of the more intense contemporary responses to the Abstract Expressionist painting of De Kooning and Pollock in the 1940s and '50s, neither of whose work Merleau-Ponty seems to have known, and to neither of whom, judging from his off-hand anti-American comments,[60] he would probably have responded positively. But a Merleau-Ponty-like idea that gestural painting embodied the bare outlines of an expressive enunciatory act became a key paradigm in early discussion of Abstract Expressionist painting, before the Greenbergian, and later the literalist and Minimalist, focus on formal and material properties took over.

If Merleau-Ponty's notion of painting as depiction was a conventional one, it is worth lingering on for a moment because he made so explicit its inner workings, while elsewhere proposing a larger understanding of visual apperception that was later taken up to throw this very model into question. In particular, he clarified what was at work in the assumption that the viewer's experience of a painting directly mirrored the painter's process of making the work as he or she viewed and responded to the depicted motif. As he put it, a painting invited the viewer 'to re-enact the gesture through which [the painting] was created, so that, dispensing with intermediaries, having no guide other than the invented line, this almost incorporeal trace, he or she rejoins the silent world of the painter, from now on proffered to him and made accessible.'[61]

The key passage on this subject in 'Indirect Language and the Voices of Silence' begins by describing in a suggestive way the complex nature of what happens when we look at and constitute an object in our field of vision. It then goes on to spell out how the process of painting as an activity which is simultaneously perceptual and gestural replays these complexities and puts them on view:

> I should see nothing clearly, there would be no object for me, if I did not direct my eyes in such a way as to make possible the seeing of the single object. And it is not the mind which relays [something] to the body and anticipates what we are going to see. No, it is my acts of looking themselves, it is their synergy, their exploration, their prospection, which bring into focus the object in its immanence, and our corrections [of our initial perceptions] would never be rapid and precise enough if they had to base themselves on an actual calculation of effects. One has to acknowledge then that under the designation of look, of hand and in general of body, there is a system of systems dedicated to the inspection of a world, capable of traversing distances, of penetrating future perception, of articulating within the inconceivable flatness of being, hollows and reliefs, distances and divergences, a sense or meaning . . . The artist's movement tracing his arabesque in infinite matter amplifies, but also continues, the simple marvel of self-directed movement or of gestures of grasping. In the gesture of designation, not only does the body itself project out into a world, the schema of which

it carries within itself: it possesses this world at a distance more than being possessed by it. All the more reason then that the gesture of expression [the painter's marking the canvas], which undertakes to draw or designate itself and to make externally apparent what it has caught sight of, will recuperate the world.[62]

At issue here is a particular conception of viewing painting that invokes a somewhat period-bound understanding of how a work of art is created. It is only in the case of certain more gestural painting and drawing that one can credibly imagine a process of making where such a close, partly unconscious coordination is sustained between an apperception and a direct response to this in the shaping action of the hand. Even in such instances, there is inevitably going to be some moment of distancing when seeing or visualising and the gesture of marking or fabricating separate out from one another.

To conceive artistic making as a perfect symbiosis of eye, mind and hand clearly works to the disadvantage of sculpture where the sheer weight and substance of the stuff from which the work is made, the evident resistance to spontaneous handling, force one to imagine a gap intruding between inner visual awareness and the act of fabrication carried out in response to this. A graphic instance is provided by the photographs taken of Henry Moore in the 1950s carving directly into a huge lump of wood. The gesture of carving with the tiny chisel seems so incommensurate with the actual task of shaping the large block that the photograph inevitably becomes the artificial staging of an idea of making. The machine tools, the multitude of assistants, lurk in the background, only just out of view.

Merleau-Ponty's symbiotic view of the process of artistic fabrication made good sense in relation to the priorities of the modern art world of the time. Painters like Picasso and Pollock, for example, were filmed in the act of generating a drawn line on a piece of glass. Painterly, gestural painting, and the sketchiness of an informal drawing, were assumed to be infused with the artist's creative impulse in ways that more consciously elaborated works were not. By contrast, one could say that in recent art, particularly three-dimensional work, a key source of interest is an often strikingly anti-symbiotic split between the artist's conceiving and visualising a work and the process of realising and fabricating it. There is a no-nonsense clarity to the correlation between the mental conception and physical substance of Judd's metal and perspex sculptures, with their clean thin edges and joins and their sharply articulated alternations of translucent and slightly reflective surfaces (fig. 101). At the same time, any trace of gestural symbiosis between seeing and making is programmatically excluded by the artist's subcontracting the process of manufacture.

This thinking of visual art as embodying an intuitive and culturally unmediated interplay between seeing and making was probably a factor in giving the more popular and romanticised versions of phenomenological analysis a bad name. Merleau-Ponty might also seem unduly wedded to a long-standing modernist assumption which was soon to come under intensive attack, the idea that art is in its essence purely visual and should exist outside or beyond the realm of language. This is what Merleau-Ponty might seem to be asserting when he made comments like: 'the world of the painter is a visible world, nothing but the visible.'[63] However, he was no uncritical big-eye man or the apologist for a pre-linguistic immersion in some primordial sea of Being.

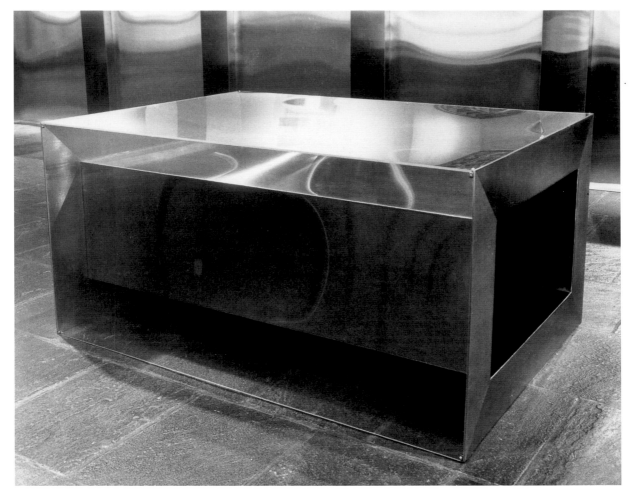

101 Donald Judd, *Untitled 1968*, installed in the Leo Castelli Gallery, New York, amber plexiglass top and sides, stainless steel ends and centre, 83.8 × 172.7 × 122 cm, Whitney Museum of American Art, New York

* * *

Let us begin by looking at the follow-up to his comment about the painter's world being 'nothing but the visible'. This is a world, he adds, that is 'almost mad, because it is only complete insomuch as it is partial. Painting awakens, takes to its very limit, a delirium which is vision itself, because seeing is *having at a distance*, and because painting extends this bizarre possession to all aspects of being that are obliged in some fashion to make themselves visible so as to enter within it.'[64] There is a similarly Lacanian tinge to a comment he makes elsewhere when he tries to imagine what a pre-linguistic, purely visual interchange with another viewing subject would be. He comes to the conclusion that it too would be a kind of madness, with the two subjects suspended in a free-floating and unresolvable mutual fascination. Only the mediation of language, by creating the possibility of intersubjective exchange, would be able to break the spell of this

strange visual fixation.[65] Painting thus cannot be either conceived or viewed in purely visual terms – it must exist in some way at the edge of this madness, of this inarticulacy of pure looking.

It is a central feature of Merleau-Ponty's thinking, particularly his late thinking, that there is both a differentiation and incipient positing producing a splitting of awareness within looking itself, even if they cannot be lodged in a coded structure and manipulated like the differentiations and positings played out in the medium of language. This is not the place to enter into the technicalities of Merleau-Ponty's theory of language, to which much of his later thinking was devoted. What I want to point to is the way he poses the perennial question about the disparity between art or visual experience and language in such a way that precludes easy resolution.[66] He does not allow one the comfort of imagining that there is some pre-linguistic foundation to the operations of language, that there is somehow a real and immediate awareness of things that language then artificially codifies, nor does he offer one the reverse comfort, the hypostasising of language as the arena within which all awareness and thinking are articulated.

Like Lacan, who was not only a friend but an intellectual colleague,[67] he was too much of a realist to abandon the notion that the world as defined in language and thought is implanted in – and, in Lacan's case, subject to radical perturbations from – some substratum of material existence that can never be encompassed in linguistic terms. Something of the tenor of Merleau-Ponty's thinking on the subject emerges in a passage where he explicitly refers to Lacan's famous dictum that the unconscious is structured as a language:

> language is not a mask over being in general, but, if one knows how to regain possession of it with all its roots and all its foliage, it is the most valid witness of this being; it does not interrupt an immediacy which would be perfect without it, and even vision, even thought are, as someone said, 'structured like a language' [here he cites Lacan], are *articulation* 'avant la lettre' . . .[68]

His understanding that the awareness articulated in language can never be entirely differentiated from the 'inarticulate' awareness that emerges in vision, highlights the recalcitrant thingness, the dimension of opacity in each – thereby reversing the usual appeal to sight as the sense whose operations come closest to the clarity of conscious thought. Indeed, as we have seen, he increasingly rejected a conception of thinking in which things could be constituted as clearly defined objects fully manifest to the thinking mind, and instead saw thinking as grounded in a more rudimentary positing of things being there and emerging in one's field of awareness.[69] He increasingly insisted that the apparently purest operations of thought, the consciousness lodged in the intricacies of language, could never be thought of as existing in a semi-autonomous realm apart from the materiality of our everyday physical exchanges with the world.

If there is one thing that interesting visual art consistently does, particularly sculpture, it is to plant one in a region where one can no longer maintain a categorical distinction between mind and matter, between the representational flexibility of language and the stuff of material world. Merleau-Ponty's complex muddying of the usually clear-cut separation between a linguistic realm of thought and a visual realm of perceptual awareness does some considerable justice to this.

The essay 'Indirect Language and the Voices of Silence' tackles this problem of art and language from a rather different, more conventional perspective. Here Merleau-Ponty asserts a standard distinction between the immediacy and atemporality of visual artefacts and the complex mediations and temporal nature of texts and linguistic utterances. Far from privileging a primordial level of mute and pre-lingustic apprehension, he argues here for the superiority of language as a way of understanding even the most basic aspects of our situation as beings in a physical world. Language, he explains, actively forms our cognitive self-awarness in a way that pure seeing never can. 'The whole of painting', as he puts it, 'presents itself like an aborted effort to say something which always remains to be said.' Only in the open-ended temporality of language is the configuring of meaning possible. A linguistic utterance, by contrast with the singularity and discrete finality of a work of visual art, is an active process of continually re-using and transforming previous utterances. It is possessed of an inherent historicity that visual art cuts short by fixing an image that is always fully present to the viewer.[70] All this comes to a head in the following passage:

> That immediate access to something lasting which painting claims for itself, it pays for this curiously by being subject, much more than writing, to the movement of time . . . To the extent that it renounces the hypocritical eternity of art, that it bravely confronts time, that it makes time evident rather than evoking it vaguely, literature emerges victorious and endows time with a significance. The statues of Olympia, which do so much to draw us to Greece, nevertheless nourish, in the state in which they have come down to us – whitened, broken, detached from the whole work – a fraudulent myth of Greece. They cannot resist time as a manuscript does, even when it is incomplete, torn, almost illegible. Heraclitus' [fragmentary] text throws out illumination as no statue broken into pieces can, because significance is deposited otherwise, is concentrated otherwise in it than it is in these, and because nothing is equal to the ductility of the word. In the end language says [something], and the voices of painting are the voices of silence.[71]

For Merleau-Ponty, a work of art, while inevitably deteriorating over time like all physical things, is not able to internalise the temporality to which it is subject as language can. In making this point, Merleau-Ponty is subscribing to the traditional view that a work of art is in essence an isolated, static thing that manifests itself to a viewer instantaneously, and exists in a gallery or museum as something forever fixed and immediately present until it is literally destroyed. According to him, the seemingly privileged status of the readily apprehensible image offered by the visual artefact, far from giving us immediate access to the culture and fabric of experience that produced the work, effaces what was once most significant about it, namely the living process whereby it came into being.

In the process of discussing Malraux's idea of a museum without walls, Merleau-Ponty voiced a long-standing suspicion of museums and museum display as reifying and momentalising the works they contained. He argued that the museum context dispelled any evocativeness these works might have as traces of a lived engagement with things, and made them into dead relics and precious objects with no real affective or cognitive value. To this unease about the museum or gallery as a site for displaying and encoun-

tering art, isolated from our more everyday engagement with things, he added a political edge that subsequently played an increasingly prominent role in avant-garde attitudes to the art object. Take this passage:

> We go [to museums] with a reverence which is not completely genuine. The museum makes us feel as if we are burglars. The idea comes to us from time to time that all the same these works were not made to *finish up* within these morose walls, for the pleasure of Sunday promenaders or Monday intellectuals. We are well aware that there is a loss and that the contemplative atmosphere of the necropolis is not the true milieu of art, that so many pleasures and pains, so many angers, so much work, were not *destined* to reflect one day the sad light of the museum . . . The museum adds a false prestige to the true value of works by detaching them from the accidents of the milieu in which they were born . . .[72]

What form might a truer, alternative mode of viewing take? It might be the viewing of art works in the informal context of the artist's studio, or perhaps communing in private with reproductions in books, as Malraux envisaged. But this still leaves out of account, except as a purely negative constraint that gets in the way of a properly empathetic communion with the art work, the mediations that shape a viewer's response to a work when it is encountered in some kind of public or semi-public gallery setting. This, for better or for worse, is the arena in which most modern works of art have to be staged to be viewed. But there is also something more deep-rooted that Merleau-Ponty's analysis evades.

The mediations involved in making a work of art available to its public inevitably affect in some way any seemingly private one-to-one communion with it. The compelling work is not one that seeks against the odds to transcend the material conditions of its existence as an object of display, as it were so absorbing that one becomes oblivious of the context of viewing. Rather it is, as Adorno would have seen it, a work that takes the reifying tendencies endemic to art in the modern world and makes them internal to the work and the responses it activates. If we have museums without walls, it is because the museum's ambience permeates almost any encounter with an art work, even to the point of helping to activate the momentary thrill felt when a work seems to break outside its sphere of influence.

* * *

The late essay *Eye and Mind* focuses almost exclusively on painting, but offers a far richer account than Merleau-Ponty's earlier writings of the process of viewing a work of art. The painting itself as physical phenomenon, not only its genesis, is drawn into a temporal process by his now considering the viewer's activity of apprehending it. In this context he is particularly concerned to tease out the ways in which the modern painting he most admires makes present a distinctive kind of visibility, even when it is no longer representational but 'autofigurative' or abstract. He now takes account of how painting has as much to do with viewing paintings as with viewing some aspect of the visible world, and how the genesis even of more traditional representational work involves a symbiosis between the two.[73]

Most strikingly new are the insights he offers into the ambiguities of depth and the modulations of visibility produced by colour in painting when discussing how these apparently insubstantial effects can create substantive presence. Take for example this passage on how Cézanne's paintings involve the viewer in 'the experience of the reversibility of dimensions, of a global "locality" where everything *exists* at one and the same time, from which height, breadth and distance are abstracted, the experience of a voluminosity which one expresses in a word by saying that a thing is there.'[74] Or consider his comments on how the 'dimension of colour' in painting creates 'from within itself identities, differences, a texture, a materiality, a something . . .'[75] This evocation of an enveloping voluminosity and texture of visibility, poised between the emergence of definite shapes and spaces and their dissolution, has suggestive implications for thinking about viewing three-dimensional work as well as painting.

Merleau-Ponty's intensive interrogation of painting can be related to the viewing of sculpture because he is so insistent that the modalities of viewing elicited by painting bring into play kinaesthetic as well as optical interactions between one's body and the world in which it is implanted. Viewing cannot be understood as an operation of pure eye and pure mind, he keeps explaining, but involves the whole 'body in operation', not a static contemplative body but a body

> which is not a segment of space, a bundle of [separate] functions, but which is an intertwining of vision and movement . . . This extraordinary [mutual] encroachment [of self and world], about which one does not think enough, forbids one to conceive of vision as an operation of thought which draws up before the mind a picture or a representation of the world, a world of immanence and ideality.[76]

The most richly evocative of Merleau-Ponty's discussions of painting comes in a passage where he points out how in drawing, the most basic act of mark-making transforms one's sense of the surface where it is placed, dissolving its substance and opacity and opening it out as an emptiness in which a new visibility emerges, a pictorial space modulated by the dynamic of the line:

> Figurative or not, the line in any case is no longer an imitation of a thing or itself a thing. It is a certain disequilibrium contrived in the indifference of the white paper, it is a kind of hole drilled into the in-itself, a certain constitutive emptiness . . . The line is not, as in classical geometry, some entity that appears against the emptiness of a background: as in modern geometries, it is restriction, segregation, modulation of a pre-established spaciality.[77]

This echoes a comment of his in *The Visible and the Invisible* about how seeing is constituted through an opening momentarily occurring in the inert positivity of things. Seeing, as he puts it there, is formed in '"a lake of non-being", a certain emptiness'.[78] A drawing or painting is no longer simply envisaged at this point as a frozen trace that functions to make the artist's process of perceiving immediately manifest to the eye of the viewer. It is rather something which draws the viewer into an intensified awareness of how he or she sees things. Painting, as an art that of its very nature radically shifts one's perception of the surface on which it is laid out, momentarily annihilating one's apprehension of this surface as a clearly defined object, is now seen by Merleau-Ponty as enacting a further

de-objectivising in its depiction of things. Thus he writes on the logic of Cézanne's painting and of Cubist work:

> External form, the envelope [of things], is secondary, derived, it is not what makes a thing take form. One has to break this shell of space, smash the fruit dish – and paint what in its place?[79]

The 'what' cannot be pure form, but is rather the sense of depth and colour from which such form emerges.

This brings me to the crucial point: what in sculpture might be the equivalent of the disequilibrium, the emptiness momentarily opening up in the inert positivity of things that the viewing of a painting effects by dissolving the actual surface in a spatial field where lines and colours are loosened from their support? Merleau-Ponty himself says almost nothing on the subject,[80] but his analysis proved to be suggestive for subsequent generations of readers trying to develop some alternative to conventional understandings of sculpture. One might say that he offered a provocation to rethink sculpture so that the visualising involved would be as complex and vital as painting was for him. If this entails approaching sculpture by way of a close engagement with painting, this is the way sculpture has often been reconceptualised.

The crucial issue is not to find some direct equivalent in sculpture to the dissolution of surface produced by a drawn line. The drawing in space envisaged by certain modernist theorists hardly works in this way because the constructed line of a sculpture literally exists in empty space. A more cogent parallel would to be think of the ways in which looking intently at a sculpture can induce a sense of its surfaces and spatial configurations losing their inert positivity and becoming slightly unfixed. We need to consider in general terms how a sculpture, as a three-dimensional thing that does not have built into it painting's constitutive tension between actual surface and depicted field, might prompt a viewer into seeing in it something other than mere inert shape or structure.

Precisely by focusing our attention on the actual material and visual properties of its surfaces and its literal occupancy of space as distinct from what it might represent as image, a sculpture often does activate a mode of viewing that puts into abeyance a straightforward recognition of it as the inert object or array of objects it literally is. We could follow Merleau-Ponty's lead, and think how a 'constitutive emptiness', a 'certain disequilibrium' opens up in one's apprehension of it, so that it acquires something of the instability of an actively projected rather than a merely fixed and given presence, drawing one out of oneself and into the arena it seems to activate. Such a way of looking at a sculpture would make one more acutely aware that 'Vision', as Merleau-Ponty put it, involves a continual shifting of perspective, a moving out towards what one sees and then back again, as 'the means given to me to be absent from myself, to participate from within in that fission of Being, only at the end point [*terme*] of which I close back in on myself.'[81] This in a way is what the more committed artists working in three dimensions in the next decade or so did, artists such as Andre who envisioned a sculptural 'thing' as 'a hole in a thing it is not',[82] and who argued that 'sculpture is an art because it partakes of our plastic sense of ourselves, that is the materials of the sculptor and his final product occupy a physical space in the same way we do.'[83]

Merleau-Ponty concludes his essay *Eye and Mind* with an intriguing evocation of the world that might come into view were one immersed in that intensified awareness of materiality and temporality elicited by visual art. In such a world, one would never finally emerge from the density and opacity of physical existence to enter some arena of transcendence over mere brute existence. If one takes this world of art as the reality one inhabits, and comes to the conclusion that any higher realm is an illusion, and that it is no longer credible to believe in a cumulative, dematerialising progress in processes of thinking, or in some evolution of human history towards an ever increasing refinement of mental capacity and control over things, where does this leave human reason? 'Is it the highest point of reason', Merleau-Ponty asks, 'simply to ascertain the slipping away [*glissement*] of the ground under our feet, pompously to call interrogation what is a state of continuous stupor, research a tramping round in circles?'[84]

The awareness of our grounding in the materiality of things seems to leave us no scope to move beyond such a bleak Beckett-like drama. But then he interjects: 'This disappointment is that of the false imaginary, which demands a positivity that exactly fills its emptiness.' To view his insistence on the material grounding of human existence as offering a counsel of despair, rather than to recognise this grounding as integral to being alive in the physical and temporal world we inhabit, is according to Merleau-Ponty the flip side of a modern positivist outlook. Positivism is that 'irrational' desire for a world that has no constitutive gaps or opacities, and can in theory be ever more fully understood and manipulated, where the human subject strives for a seamless and transparent apprehension of itself and the world around it. The world that Merleau-Ponty wishes to draw attention to, the world in which he felt visual art immerses one, was, by contrast, 'a zone . . . peopled by dense, open, torn beings.'[85]

This could work as a good description of the sense of self and world evoked in some of the more interesting sculpture or three-dimensional art of the past few decades. It seems to be the very antithesis of the utopia of flawlessly shaped figures and ideal plastic forms that previously dominated the sculptural imagination – I say seems because this utopian form was largely an empty formula, subtly subverted in actual engagements with the sculptural. Merleau-Ponty's world of 'dense, open, torn' beings, then, should not be seen as some hidden, archaic essence of human experience. On the contrary, it is a significant and characteristic aspect of contemporary cultural experience, no more or less real than this culture's sophisticated systems of capital flow and computerised networking. It is not an archaic residue rendered redundant by modernisation and the imperatives of modern capitalism any more than it is some universal ground of being, as Merleau-Ponty sometimes implies.

The vision he offers here as an antidote to narratives of positivistic progress is a 'deaf historicity, that advances in the labyrinth by detours, transgression, encroachment and sudden thrusts . . .'[86] It strikes a startlingly contemporary note. As the description of a temporality submerged within the blind contingencies of material existence, it is evocative of significant aspects of the fabric of life in a modern culture increasingly permeated by the anarchic yet rigidly systematised grids of electronic technology and monetary and bureaucratic organisation. More particularly, his vision has telling affinities with the aimless directedness and sudden seizures of intensity that characterise the responses elicited by much contemporary art.

7 The Performance of Viewing

The artists who came to prominence in the mid to late 1960s as Minimalist object makers working in three dimensions engaged in a highly self-conscious dialogue with the formalist paradigms that had dominated previous conceptions of the sculptural. This is evident both from the conception and staging of their work, and from their compulsion to reflect on and verbalise the larger imperatives guiding their practice. In the latter respect they were following the example set by David Smith, and certainly presented a persona very different from the traditional sculptor as a somewhat taciturn, non-intellectual and non-verbal kind of person.

Donald Judd was one of the more important art critics working in New York in the 1960s, and he valued his writing enough to anthologise it in a volume of *Complete Writings* that came out in 1975. His essay 'Specific Objects', published in *Art News* in 1965, was the first sustained attempt to analyse the new Minimalist interest in the object-like qualities of a work of art. [This 'report on three-dimensional art',[1] as Judd himself termed it, made the case for a form of work that moved beyond the confines of painting's two-dimensional format, but was not sculpture in the conventional sense either – in effect rendering redundant the distinctions between sculpture and painting that had previously defined and marginalised the sculptural object.] Robert Morris may not have been a professional art critic like Judd, but he was one of the new breed of artist-theorists, publishing a number of extended critical essays, most of which were collected, if rather later than Judd's, in a volume significantly titled *Continuous Project Altered Daily* (1993). His 'Notes on Sculpture', which initially appeared in two parts in *Artforum* in 1966, was, with Judd's 'Specific Objects', one of the earliest attempts to adumbrate the new aesthetic priorities of Minimalist three-dimensional work. It is particularly notable for putting the configuring of the viewer's interaction with a free-standing object on the agenda and directly challenging the traditional focus on the object as self-sufficient plastic form. Morris's was the most significant early apologia for Minimalist work to make a serious issue of the fact that the apprehension of a work in three dimensions is irreducible to conventional models of image or form perception.[2]

With Andre too the verbalising of his priorities as an artist was a significant activity in its own right, as one might expect of someone who initially made his mark as a concrete poet. Like Judd he cultivated a carefully crafted style of expression whose terseness and precision was itself Minimalist in tenor. Andre, however, published almost no extended expositions of his ideas. His preferred medium was the finely honed short statement, the gift for which he deployed to great effect in his carefully elaborated responses in published interviews. In the interchange with Phyllis Tuchman that appeared in *Artforum* in 1970, he gave a vivid account of how he saw himself reconfiguring the sculptural object and moving away from a conventional modernist preoccupation with form

or structure. The interview became an important medium for artists to present their ideas, and several such interviews have become classic texts in their own right. Some of the most widely quoted early formulations of a Minimalist aesthetic are to be found in the published version of a discussion organised by the critic Bruce Glaser with Frank Stella and Donald Judd, which Lucy Lippard edited and brought out in 1966 under the title 'Questions to Stella and Judd'.

The point here is not so much that these artists wrote well, but rather that their writing made them the leading theorists of a new understanding of sculpture, and it is to their writings as well as to their art that we must turn if we are to get a sense of what was at stake in this development.[3] They displayed an unusual self-consciousness regarding the formal and ideological parameters of the shift taking place in the staging and configuring of the sculptural object, and they played a key role in setting the agenda for future discussion of a reconstituted, partly anti-sculptural, sculptural practice. The medium for this theorising, as we have seen in Andre's case, was as much the verbal fragment as the discursive essay. Judd's finest articles could be said to be both. One such fragment by the artist Eva Hesse deserves to be singled out because it encapsulates so resonantly the radical aspirations that briefly made the move out into three dimensions, beyond the fixed confines of painting or sculpture, seem so compelling and urgent. It comes in a text she prepared for the exhibition of *Contingent* (fig. 143) in 1969:

> not painting, not sculpture. it's there though./I remember I wanted to get to non art, non connotive,/non anthropomorphic, non geometric, non, nothing,/everything, but of another kind, vision, sort./from a total other reference point. is it possible?
>
> . . .
>
> it's not the new, it is what is yet not known,/thought, seen, touched but really what is not./and that is.[4]

The Staging of Sculpture: Morris

Two artists stand out for making a feature of the staging of sculpture and for focusing attention on the phenomenology of sculptural viewing, Robert Morris and Richard Serra. Morris's complex engagement with these issues is worth exploring in depth, not only because his early writings directly address the aesthetics and viewing of sculpture, but also because later he played out in an at times tortured, at times oddly eloquent way certain political tensions inherent in the new awareness of the context and staging of three-dimensional work. Richard Serra is a rather different case, for it was primarily through his work rather than through his own commentary on it, or interest aroused by his self-presentation as an artist, as in Morris' case, that he has become a paradigmatic figure in post-war sculpture. However, he too had quite a way with words, and through the medium of published interviews conducted a self-conscious dialogue with himself and his audience about the significance of what he was doing.

Any account of the new focus on the situation and viewing of sculpture needs to reckon with Morris's 1966 'Notes on Sculpture'. The essay was instrumental in initiating a debate about the distinctive nature of the viewing that took place when a sculpture was

encountered in the public arena of a gallery. Morris brought into focus a potential tension between the public and the private dimensions of apprehending a work of sculpture, which at this point he negotiated by emphasising the public character of sculptural viewing, and by denying the legitimacy of any private communion with the object which modernist aesthetics seemed to privilege. But the tension, far from being resolved, became something of an open sore for him, infected by an ideological contamination of the entire arena of art in modern society. Moreover, while his critique of the idea of a private communion with a self-contained object would seem to cast him as a theorist who gave precedence to viewer response over the art work or the artist's creative act of making, he became more and more fixated on producing work that would at least momentarily be able to escape the mediations shaping public consumption of art. In the end, he seemed to fall back on the romantic avant-garde fantasy of a work that would be synonymous with his own private conception of it, and where no existential gap could open up 'between the studio preparation and the formal presentation'.[5]

'Notes on Sculpture' begins with the incontrovertible claim that there is very little critical writing that addresses the distinctive concerns of sculpture, even though it is the case that 'the concerns of sculpture have been for some time not only distinct from but hostile to those of painting'. The preoccupation with painting, particularly in its latest conceptualising by Greenberg and Fried, Morris explains, focuses attention on formal qualities relating to the nature and structure of the support and the tensions between depth and flatness, or between the ostensive or optical and the literal.[6] The imperative of recent modernist painting to evacuate the depictive to the point where the work becomes first and foremost an object is irrelevant to sculpture because a sculpture is of its very nature an object. So far so good. The problematic of sculpture within a dominant painterly aesthetic is set on the table and the starting point for a reconfiguring of the sculptural in its own terms is marked out. But Morris still finds himself trapped within a painterly perspective because he wants sculpture to be so completely other than painting. The defining concerns of sculpture are, as he puts it, 'qualities of scale, proportion, shape, mass', 'physical . . . qualities . . . made visible by the adjustment of an obdurate, literal mass' (figs 102, 103). Colour is inconsistent with 'the physical nature of sculpture' because it is 'essentially optical, immaterial, non-containable, non-tactile'.[7] Similarly, properties of 'surface' and 'material', or any emphasis on 'specific, sensuous material or impressively high finishes', distract from a clear apprehension of the sculptural qualities of shape, scale and mass.[8]

Here we have a replay of the standard modernist idea that painterly effects and visually interesting surfaces distract from plastic form, as well as a reprise of the traditional metaphysical distinction between primary and secondary sensory qualities, with the tactile and sculptural bound up with objective qualities of shape and form and space, and the optical and painterly involving subjectively perceived visual effects. However, this is not the whole story. The varying illumination of a work's surfaces by ambient light is seen by Morris as integral to a work of sculpture because this defines the viewer's apprehension of shape. As he puts it, 'Ultimately the consideration of the nature of sculptural surface is the consideration of light, the least physical element, but one that is as actual as the space itself.' For painting, lighting is a secondary issue, the only consideration being that certain optimal lighting conditions be met. With sculpture, where the viewer's

sense of shape and surface changes as a result of the changing incidence of light, the lighting is part of the physical fabric of the work. Morris thus hovers between a traditional notion of sculpture as the art of shape or plastic form, in which lighting simply functions to make visible the modelling of surface through shadowed gradations of light and shade, and an untraditional attentiveness to the effects of ambient light in defining what a sculpture is.

There are other ways too in which Morris's attempt to develop a systematically anti-painterly conception of sculpture moves beyond the confines of the inherited sculptural aesthetic in which his ideas are still deeply lodged. His conventional formal purism is fuelled by two imperatives that are new and relate to the larger reconfiguring of sculptural sensibility then taking place. Firstly, there is his Minimalist fascination with simple, unitary objects that focus attention as much on staging and viewer response as on inner structural form. Secondly, there is the heightened awareness of the physical kinaesthetic dimension to sculptural viewing which Morris brings to the fore.

Morris comes up with one of the more suggestive accounts of why sculptors at that time were driven to limit themselves to simple, no-nonsense, regular geometric shapes. The imperative, as he sees it, is to get away from an artistic construct whose impact depends upon the relation between its parts and the various sensations these parts generate, and to create an object (fig. 116) whose immediate impact effectively precludes the viewer from making any clear distinctions between different aspects of it – distinctions of the kind still to the fore in even the most reductively simple painting where one's sense of the surface as literal support, and of what is on the surface, can never quite coincide. 'Could a work exist', he asks,

> that has only one property? Obviously not, since nothing exists that has only one property. A single, pure sensation cannot be transmissible precisely because one perceives simultaneously more than one property: if color, then also dimension; if flatness, then texture, etc. However, certain forms do exist that, if they do not negate the numerous sensations of color to texture, scale to mass, etc., do not present clearly separated parts for these kinds of relations to be established in terms of shapes. Such as the simpler forms that create strong gestalt sensations. Their parts are bound together in such a way that they offer a maximum resistance to perceptual separation.[9]

In a way, Morris is transferring to the sculptural object the idea of all-overness that had played such an important role in high modernist conceptions of painting. But he goes further than this, by describing a different kind of attentive viewing from that usually associated with looking closely at works of art, namely one in which no awareness of vividly defined parts or aspects separates out.

The use of the term *Gestalt* alerts one to a schematic formalism in Morris's analysis whose parameters become clearer later in the essay, precisely at the point where he offers his most astute insights into the dynamics of viewing sculpture. In this key passage, it becomes clear that for Morris a suppression of textural, surface and colouristic qualities is necessary because the more intimate absorptive viewing these invite distract from formal features, such as shape and situation, that define the distinctively sculptural responses to a work. Sculptural viewing is different from painterly viewing in that one stays at a distance from the work so one always keeps the basic shape or *Gestalt* clearly in view. In Morris's words:

102 Robert Morris, *Untitled (L-beams)*, as installed in the Leo Castelli Gallery, New York, in 1965, painted plywood, each 240 × 240 × 60 cm

The better new work takes relationships out of the work and makes them a function of space, light, and the viewer's field of vision. The object is but one of the terms in the newer aesthetic. It is in some way more reflexive because one's awareness of oneself existing in the same space as the work is stronger than in previous work, with its many internal relationships. One is more aware than before that he himself is establishing relationships as he apprehends the object from various positions and under varying conditions of light and spatial content. Every intimate relationship, or what have you, reduces the public, external quality of the object and tends to eliminate the viewer to the degree that these details pull him into an intimate reaction with the work and out of the space in which the object exists.[10]

Morris envisages a kind of work whose size is broadly speaking commensurate with that of the viewer – neither a small-scale sculptural 'object' nor a 'monument' – and that invites a continually shifting, relatively distant viewing from positions where the whole work and its immediate occupancy of space can be taken in at a glance (fig. 102). Interestingly, this is rather like the configuring of the relation between viewer and object that high modernist work of the period such as Caro's work invites.[11] Such a distancing of the viewer, so as to exclude those close, relatively intimate

apprehensions of the object in which one is no longer aware of the object's larger situation in space, has two overriding functions. It sets up a formal framing of the viewing experience in which the shifting spatial relationship between viewer and object can become a defining parameter of the work. 'This distance between object and subject', as Morris puts it, 'creates a more extended situation, for physical participation becomes necessary'. And secondly, it constitutes this relationship as operating in a 'non-personal or public mode.'[12]

'Physical participation' reveals something about how Morris came to this conception of sculptural viewing. The viewer is conceived as a performer, at the same time that the viewer/performer who really matters for Morris is not so much a member of the public as the artist himself. Morris began his career as a dancer, and a number of his early Minimalist objects were props incorporated in performance pieces such as *Site*, a collaboration with Carolee Schneeman dating from 1965.[13] Fried was quite right to detect a note of almost flagrant theatricality in Morris's early work. It sometimes presents itself as existing in an indeterminate position between stage prop on one hand and autonomous art work on the other. Morris's first significant theoretical intervention, excluded from his collected writings, was 'Notes on Dance', published a year before his 'Notes on Sculpture' in the *Tulane Drama Review*. There he traces the performative inspiration for his new notion of sculptural viewing as a process acted out in space and time:

> The objects I used [in performances] had no interest for me but were means for dealing with specific problems . . . by the use of objects which could be manipulated I found a situation which did not dominate my actions nor subvert my performance. In fact the decision to employ objects came out of considerations of specific problems involving space and time. For me, the focus of a set of specific problems involving time, space, alternate forms of a unit etc., provided the necessary structure.[14]

A keen sense of staging and a certain disregard for the subtler sensuous qualities of surface and finish are pervasive in Morris's early painted plywood and fibreglass pieces. Indeed, *Two Columns* dating from 1961 was first presented as a performance prop. A six-foot high and one-foot square plywood box painted a neutral grey was made to stand vertically for a period of time and then toppled onto its side to become a horizontal floor piece – the no-nonsense phenomenological implications of which Morris nicely encapsulated in his dictum 'A beam on its end is not the same as a beam on its side.'[15] The famous installation he created in the Green Gallery in New York in 1964 (fig. 103), at least in the carefully staged photograph of it circulated in the art press, transforms the gallery space into a set on which a viewer/performer is being invited to carry out his or her routine. The painted plywood L-beams (fig. 102), propped in different positions to show the situation-dependent nature of their character as objects, have been so brilliantly posed in the photograph by Rudolph Burckhardt that later actual reconstructions seem by contrast rather lacking in substance and presence.

But this staginess is only one, if very striking, aspect of Morris's activities as a Minimalist object maker. Several of the works he produced in the late 1960s, such as the wire mesh *Untitled* of 1967 (fig. 105), are as dense and intriguing as objects as any Minimalist art being produced at the time. Moreover, Morris made it quite clear in his 'Notes on Sculpture' that the new kinds of sculptural object he had in mind were

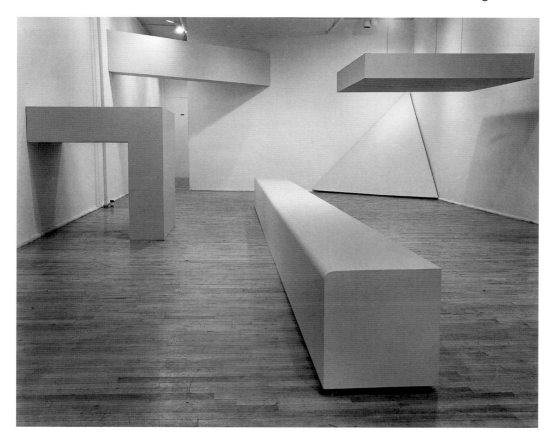

103 Installation of Robert Morris's work at the Green Gallery, New York, December 1964 – January 1965, painted plywood

different from props that might be used in performance pieces, and were certainly no mere triggers for the playing out of a viewer's response. His aim was to create a more broadly based sculpture. As he put it, 'the situation is now more complex and expanded'. If 'it is now not possible to separate these decisions, which are relevant to the object as a thing in itself, from those decisions external to its physical presence' and if 'what is to be had from the work is [not] to be located within the specific object', this does not mean that 'the object itself has . . . become less important. It has merely become less *self*-important.' Crucially, he then emphasised that 'by taking its place as a term among others the object does not fade off into some bland, neutral, generalized or otherwise retiring shape.'[16]

It would be misleading to see this concern with the situating of the object and its interaction with the viewer as marking a straightforward shift from a conception based on the artist and art object to one based on viewer response. Morris is symptomatic in this regard because he, more than any other major figure of the period associated with Minimalism, made an issue of abandoning the modernist privileging of the object. His concern with the impact a work had on the viewer sharing its space, however, did not mean that he was downplaying the artist's role. At a very basic level, viewing is always

an issue for an artist because realising a work inevitably involves some kind of give and take between facing up to, testing out and viewing it and the process of conceiving and fabricating it, or directing its fabrication. When Morris became preoccupied with how his work might relate to a person viewing it, this was not a matter of his calculatedly thinking what his audience would make of the work and adjusting it to match these imagined expectations – of theatricality in its most negative sense. He was primarily thinking of his own involvement with the work and reflecting on the kinds of kinaesthetic viewing it invited as he was in the process of realising it. To put it another way, what he described as the public, extended and expansive mode of viewing invited by his sculpture was something he as an artist got a charge from as he set up his work and tried it out. By contrast, when a sculptor of an earlier generation such as David Smith talked about physical expansiveness, he was referring exclusively to the gestural acts of assembling and physical making.[17]

That Morris was focused on his own interaction with his work as viewer and performer emerges clearly in an interview conducted by David Sylvester in 1967. Here Morris consistently refuses to take up Sylvester's leads to reflect on how a viewer coming to his work as a relative outsider might respond to it. At one point, for example, Sylvester asks the very question invited by Morris's own ideas in 'Notes on Sculpture' as to whether he is 'concerned with the relation between the spectator and the object rather than with the object itself as a self-sufficient entity, which I think, say, Brancusi was.' Morris hesitates to see the situation defined so explicitly in terms of audience response, and tries to bring the discussion back to the kind of object involved and to what he feels about it. He replies: 'Well I can only say that I think that the work is less introverted than something like Brancusi. It seems more open and extroverted, in some way makes one more aware maybe of oneself.'[18] Then, when Sylvester goes on to talk about the presence his sculptures have, and the kind of attentiveness they demand, Morris again firmly shifts things away from the critic's or viewer's perspective to the viewing experience of the artist:

> They don't have to demand my attention always. That's a kind of relation I had not thought about much until this point, but it's one which I have because I'm around the pieces a lot. I find that I like that situation with the work. I don't have to attend to it, and yet it's there.

The only psychic inflection of viewing that has any meaning for Morris is that felt by someone so drawn into the ambit of the work that the experience involved is in effect the same as the artist's, is a sort of insider's handling of the work rather than an outsider's view onto or confrontation with it. This in effect forecloses on the theatrics of staging. Sylvester makes Morris articulate his ideas on something that the latter clearly thinks is peripheral when he asks about the psychodynamic between viewer and work Morris is aiming for. Morris explains, in terms showing a nice modernist distancing from the easier melodramas of viewer response, that 'I don't want to be specially dramatic. I don't want it [the work] to have a kind of boring passivity either. Generally it's a term that I would prefer not to have to deal with.'[19]

What emerges from the tension between Sylvester's viewer-orientated perspective, and the artist-orientated one he cleverly teases out from Morris, is that Morris's sense of

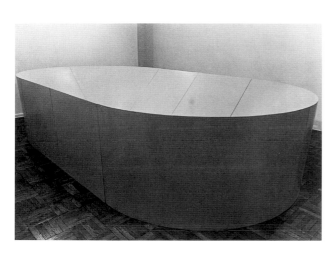

104 a and b Robert Morris, *Untitled*, 1967, installed in the Leo Castelli Gallery, New York, in 1967, fibreglass, eight units, four 122 × 153 × 153, four 122 × 122 × 122 cm, Solomon R. Guggenheim Museum, New York

himself as an artist is quite a traditional one. He clearly envisages his work in terms that are not overtly public in the way that some comments in 'Notes on Sculpture' might imply. What really concerns him is the engagement to be had with the work in the relatively private confines of his studio. A public mode of engagement in this context is one in which the artist's or viewer's experience is acted out more in externalised physical actions than in intimate, inward-directed communion with the work.

It is striking that, when Sylvester prompted Morris to reflect on how the sense he had of a sculpture when working on it in his studio might shift when he saw it displayed in a public arena where he could get more distant from it, this almost seemed to occur to Morris for the first time. They were discussing one of Morris's recent fibreglass floor pieces assembled from modularised segments, a simple oval construct about four feet high with the inner walls sloping down to the floor to form an empty interior space (figs 104a, 104b). Sylvester got Morris to reflect on an intriguing disparity the latter only noticed once he set the work out in the Castelli Gallery and was able to stand back from it for the first time. Seeing it at a distance, from where he was able to take it in at a glance, he noticed how the curved outer wall largely obscured the empty space in the middle, while by contrast, when seeing it close to while working on it in his studio, he had always been able to look down over the wall and get a clear sense of its interior layout. Now he found he kept

walking around it as though I can never convince myself of what that shape really is, until I get up close and see the floor . . . So that I think that the experience of the outside being away from it is very different from going up close and looking down into the piece, and this is something new for me. I hadn't thought about that before.[20]

Here Morris gives a particularly engaging account of how one can become engrossed by the evident disparities that emerge in a sculpture's appearance as one's viewpoint shifts. The variations that intrigue Morris, however, do not include those qualitatively different perceptions that occur when surfaces, textures and vivid modulations of light and colour momentarily loom into view and obliterate any sense one might have of the work's overall shape or form. For Morris, the operative disparities are conventional formal ones between different apperceptions of overall shape. Here, as ever, he is fixated on shape envisaged as a geometric construct grounding the apprehension of a work – so much so that he said of the fibreglass work he and Sylvester were discussing that he 'found in photographing that the only photograph I wanted to take really was one from almost directly above. That seemed to me the only one that read most clearly as shape.'[21]

From Public to Private

Morris's account in 'Notes on Sculpture' of the disparity between the invariant shape of a work and the variable aspects it presents as one looks at it is clearly indebted to phenomenological analysis. Indeed, it relates directly to the standard phenomenological thought experiment about how a simple cube is apprehended by way of the perspectivally variable shapes it presents within different horizons of viewing – a scenario that his own early work explicitly staged. When Morris later cast aspersions on the fashion for phenomenology, he was effectively criticising his own early fascination with the processes of visual apprehension that an attentive looking at simply shaped objects brought into focus. Such interest in the phenomenology of viewing had become equated in his mind with the rotten baggage of modern formalism he was now determined to leave behind once and for all. And in a way he was right, if unintentionally, about the formalistic character of his own earlier reading of phenomenology. His model of viewing invoked notions of shape or *Gestalt* in ways that had much more in common with standard modernist paradigms than with the larger critical imperatives of phenomenological thinking. If Morris read Merleau-Ponty at all closely, which he may well have done, his would have been a narrowly focused misreading, framed by the high modernist formalism dominating the New York art world at the time. Indeed, Morris's moving on to a categorically anti-form, anti-object and anti-Minimalist position can in part be understood as a reaction against the fairly conventional formal assumptions shaping his novel preoccupations with sculptural viewing.

The formalist nature of Morris's perspective on viewing becomes particularly evident once one considers it in relation to Merleau-Ponty's thinking on the subject. For one thing, we have seen how Merleau-Ponty categorically refused the standard distinction between optical appearances and tactile form which was central to the Greenbergian for-

malism that still dominated many aspects of Morris's analysis of sculpture. Moreover, the notion of *Gestalt* to which Morris appeals is clearly at odds with Merleau-Ponty's more critical understanding of *Gestalt* as something shaping our visual apprehension of things which is so imbricated in this process that it could never be envisioned as a geometric structure or model.[22] When Morris invokes the idea of *Gestalt* in his 'Notes on Sculpture', it is conceived as the invariant underlying shape of an object that one holds in mind as one experiences the various partial perspectival aspects it presents. Such a separation of underlying structure from immediate visual appearances is a feature of formalist, not phenomenological, thinking.

Finally, there is the very different understanding of the whole thing one intuits from the flux of partial views an object presents. Morris inclines to the conventional modernist idea that one's sense of an object's totality is defined in terms of its overall shape. For Merleau-Ponty, by contrast, when an object impinges on one's awareness, some sense of it as a whole thing, including vague intimations of features that are mostly invisible, such as its other side, or the space in the middle of Morris's fibreglass work (fig. 104), is lodged in the immediate appearance it presents from the very outset and continues to be immanent, while always slightly changing, in the flux of different aspects that emerge subsequently. The thing one sees is at its most basic an immediate sense of something being there, of something differentiating itself from the ground of one's awareness.[23] The nature of this thing is no more essentially a shape than it is a modulation of colour or of light and shade or of texture and substance.

The model of visual apprehension that Morris evokes at the end of his 'Notes on Sculpture', when he refers to what seems to be a phenomenological notion of *Gestalt*, is conceived very differently. He is describing, quite evocatively, a particular kind of viewing invited by the visually neutral and simply configured Minimalist work he was producing at the time. What fascinated him, as he put it succinctly in his commentary on his early performance pieces in 'Notes on Dance', was 'the coexistence of the static and the mobile.'[24] He went on to explain how

> While the work must be autonomous in the sense of being a self-contained unit for the formation of the gestalt [the overall three-dimensional geometric shape], the indivisible and undissolvable whole, the major aesthetic terms are not in but dependent upon this autonomous object and exist as unfixed variables that find their specific definition in the particular space and light and physical viewpoint of the spectator. Only one aspect of the work is immediate: the apprehension of the gestalt. The experience of the work necessarily exists in time.[25]

This declaration helps to explain two things. Firstly, it clarifies Morris's distinctive kinaesthetic, or one should say kinetic, conception of sculpture, in which the work produces a particularly focused awareness of the distinction between some fixed image one has of its overall shape and the spectacle of continually shifting formal configurations it offers as one circumambulates it. This effect will usually be occluded in conventional sculpture because the complexity of form makes it impossible for the viewer to hold onto a fixed, clearly articulated image of the overall shape. The passage also draws attention to the limits of the general model of viewing Morris is invoking. His is a very simple *Gestalt* theory of vision, in which we are understood to perceive the world by organising its

complex forms in terms of simple geometric forms, such as cones, cubes and cylinders – the popular version of *Gestalt* psychology that was common currency then among theorists of modern art, and whose positivism was one of Merleau-Ponty's *bêtes noires*. Taken as a general theory of viewing, Morris's analysis offers a very narrow notion of what goes on when one looks at a work of sculpture. Seen in context, however, it makes an interesting point about the distinctive viewing elicited by Minimalist objects that artificially focus attention on the variations of appearance that can come into play as one moves round what might at first seem to be a reductively simple three-dimensional object.

In everyday experience, outside a gallery context where one's awareness of viewing is abnormally heightened, disparities in the apprehension of shape as one looks at something from different angles do not normally strike one, either because the shape is fairly complex and one's sense of it is anyway constantly being modified as one takes a closer look, or because the shape one has in mind for practical purposes is very basic and all-embracing and thus will not usually have to be refined in the light of odd unforeseen aspects that come into view. Were Morris's fibreglass piece (fig. 104) to loom up as one was driving down a road, one would hardly take the trouble to adjust one's sense of it as a broad, four-foot high elliptical obstacle after noticing the space in the centre. Seeing it in a gallery, the disparity between the initial view and one's later mapping of the shape becomes much more striking. Such work also highlights how, whatever one knows of the actual shape of something, if the visual clues offered from a particular angle run counter to this knowledge, one will persist in finding the actual shape counter-intuitive.[26] One becomes both vaguely fascinated and faintly disturbed by a disjunctiveness in one's apperception of things that is usually overlooked.

In his 'Notes on Sculpture' Morris emerges as a theorist who is anti-formalist in his out-and-out critique of the modernist notion of the art object as autonomous internally articulated shape, but who is also formalist in a traditional modernist sense when he defines the structuring of the viewer's experience of the work as an interplay between its given structure and its variable appearances, including 'the varying context of space and light in which it exists.'[27] As this opening up of the object occurs, in Morris's view, so its situation in relation to the viewer becomes part of its spatial configuring and 'the sensuous object, resplendent with compressed internal relations, has had to be rejected,'[28] along with the 'intimate mode' of viewing this kind of object invited by virtue of its being 'essentially closed, spaceless, compressed, and exclusive'.[29] The issue here is clearly not just an aesthetic one, for there is an ideological dimension to Morris's rejection of the closed form and exclusive intimacy of the modernist object.

The new work, as he put it in an essay published a year later in 1967, is characterised by a look and feel of 'openness, extendibility, accessibility, publicness, repeatability, equanimity, directness, and immediacy'. It is formed by 'clear decision rather than groping craft', has 'a few social implications, none of which are negative' and will not appeal to those who want an art of 'exclusive specialness' to reassure them in their 'superior perception'.[30] This idea of liberating both the work itself and one's viewing of it from the constraints imposed by a traditional cult of the art object is clearly politically loaded, and the crisis that marked Morris's subsequent progress as he systematically negated and overturned his earlier commitments and became an increasingly defensive anti-form and

anti-art recluse, was also politically charged in ways that are illuminating as to the situation of a radical art practice in the aftermath of Minimalism.

* * *

Before exploring this later turn, we need to consider certain underlying preoccupations in Morris's earlier work and writing that almost openly contradict his apparently libertarian promotion of a more open and expansive conception of art. As we have seen, he was no naive anti-formalist. The work he had in mind that would emerge from a negation of the 'compressed' order of the modernist object was itself constrained by formal imperatives. Such critical self-awareness is part of the strength of Morris's theorising and of the work he was producing at the time. He talked of 'a new limit and a new freedom for sculpture'.[31] If his own work shows signs of being open and extended, it could equally well be described as closed and controlled. The repetition and looping it suggests are free and casual and also emphatically circumscribed. Such dichotomies are explicitly played out in his performance pieces, such as *Waterman Switch*, as well as in the viewing invited by his Minimalist objects of the period. Indeed, the persistent suggestions of control and closure, of situations structured by dead ends and repetitions, are an integral feature of Morris's more compelling work.[32]

Take one of the visually denser of his early Minimalist objects – a wire mesh construction lying on the floor, about nine feet square and rising to a height of two and a half feet to form an enclosed empty cube at the centre (fig. 105). Drawn in close to the work in order to get a clear view of the enclosed space at the centre, one finds that the outer structure is just too wide to allow one to bend over and look right inside. It creates a barrier that seems relatively modest but still excludes one, an ambiguity shared by the industrial mesh that is both open screening and rigid barrier. There is accessibility and also blocking, an openness and a fenced-in confinement and exclusion. The work invites a continuously repeated pattern of engagement from the viewer – moving in closer, peeping over and stepping back. This viewing is structured and somewhat purposive, yet in the end completely aimless, pleasurably intriguing at the same time as mildly frustrating. The thing we see keeps shifting register, at one moment transparently self-evident, at another obdurately resistant, opening up and then closing in on itself, echoing the endlessly repeating circuits of our pattern of viewing it.

Then there are the felt pieces shown at the Castelli Gallery, also in 1967. One of the more elaborate of these (fig. 13) might at first seem to invert the formal imperatives of Morris's wire mesh object: it is abundant, shapeless anti-form as against rigid geometric structure. But if superficially it seems to offer a release from formal constraint, the viewer who engages closely with it is hardly projected into an exhilarating openness. One's viewing again insistently terminates in dead ends, and keeps repeating itself in looped sequences. This pattern is implicit in the basic structuring of the piece, the soft yet dense and weighty folds of felt collapsing downwards from a few supports, down to where they twist and turn as they pile up on the floor. A circuit of viewing is invited that begins by echoing the way one might imagine the felt would have fallen into place as it was installed – first a tumbling downwards, then a spreading outwards and then a coming to a halt, that then prompts one to look up again to the supports on the wall from where the whole collapsing process can start again.

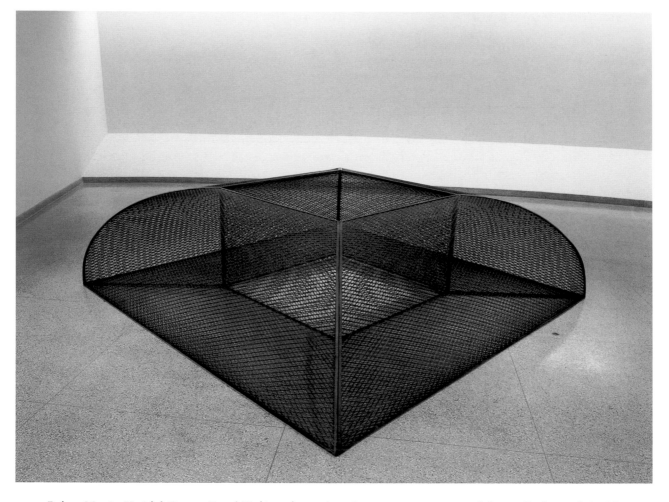

105 Robert Morris, *Untitled (Quarter-Round Mesh)*, 1967, steel grating, 79 × 277 × 277 cm, Solomon R. Guggenheim Museum, New York (Panza Collection)

Parallels are sometimes made between the loose randomness of Morris's felts and the drips of Jackson Pollock's painting (fig. 126),[33] but the analogy fails to do justice to the visual impact made by the wedges of optically inert absorptive industrial felt. A sense of awkward weighty collapse is important in Morris's felt, quite at odds with the dripped filigree of Pollock's painting. Looking closely at it, one is faced with stuff that blocks and almost imposes physically on one's viewing. By contrast with the smooth, clearly defined surfaces one usually finds in sculpture, here any optical effects of sheen and sparkle and reflection that might momentarily suggest a visual fluidity or dematerialisation are snuffed out. The slightly yielding yet utterly inert surface of the felt creates a visual and tactile deadness that blocks the possibility of creating any painterly illusion of depth or shifting optical effects. Yet the felt is flexible, and there is no end of twisting and turning and piling to attend to, an excess of surface modulations that one's view can go on tracing for ever. That the surfaces mostly have no underlying supporting structures allows one's

view a more expansive sense of ever shifting variation, but the absence of articulations also means that these surface variations never even momentarily lead one anywhere beyond them. One is trapped in a world of endlessly variegated yet endlessly undifferentiated sculptural surface, one that is unconstrainedly open yet densely and hermetically closed.

Entrapping the viewer in closed looping sequences of response was clearly something of an obsession with Morris. This is evident from the simple repeated cycles of action that structure his performance pieces, but is also made explicit in a film he devised to demonstrate the kinds of interaction between viewer and object he had in mind for some of the work featured in his Tate Gallery exhibition in London in 1971. In this show he was experimenting with sculptural objects that the audience would not just look at but could manipulate and engage with in a directly physical way. As he put it rather grandiloquently, 'the pieces . . . render physical and practical what was left to empathy and imagination in the earlier sculpture'.[34] The show was a success in that it attracted a lot of publicity, but a failure in that the audience did not act as Morris had anticipated. It had to be closed after a few days because a number of people, given the chance actually to climb on and push around objects in a gallery, went over the top – pieces were damaged, members of the public suffered minor injuries.

The short film he had made in connection with the show, called *Neo Classic*,[35] while being technically a modest affair, is quite complex in conception. It exemplifies how the interactive works are ideally to be handled. At the same time it is a kind of performance piece offered as spectacle to the viewer of the film. One extended sequence shows a female model manoeuvring a large wooden cylinder, rolling it back and forth slowly and steadily between two limits marked on the floor by a line of bags. Not only is the movement of the rolling cylinder strictly regulated, but Morris has obviously instructed the model to behave in such a way that her actions are very measured and controlled. The disjunction between the frenzied and anarchic activities of some of the exhibition going public, both excited and provoked by the unusual if still restricted possibilities for direct physical interaction being offered them by this highly contrived adult adventure playground, and Morris's ideal projection of a very measured and rigidly circumscribed manipulation of his objects, could not be more complete.

Another striking aspect of this film is the kind of spectacle the film itself offers the viewer. The camera's eye obsessively fixates on the model and her movements – the term fetishistic seems hardly adequate to describe this. Making it clear that the film is to be seen as a staged spectacle and not just as a presentation of how he imagined the gallery viewer might behave with the work, Morris had the female model perform her actions in the nude – thereby also invoking associations with the traditional motif of the model in the artist's studio. The camera lingers with undisguised pleasure on the leisurely movements of her naked body. As it pans in and out, it echoes the simple to and fro rhythm of her pushing the cylinder back and forth. It starts with a relatively distant view embracing her whole body from the back, then moves in to take a close look at her buttocks, lingers there for a few seconds, and melts back again. As the model advances slowly with measured pace away from the camera, the camera unerringly follows, keeping her in the centre of the picture. *Neo Classic* is a good title because this is just the kind of gazing implicit in the many classicising representations of the female nude in late eighteenth

and nineteenth-century art – though rarely so evidently controlled and framed by the artist's sexualised fascination with the model as in Morris's film.

This is worth highlighting because it is one of many instances of how the apparently empty forms of Minimalist art could be staged in a way that momentarily gave them a libidinal charge. The radical negation in the shaping of the object itself, denying not only figurative form but any quasi-figurative structure or presence, was complemented by an intensive focus on the viewer's engagement with the work, and with a felt sense of occupancy of space which in turn could become psychically loaded. What Morris does with the female body in this film, and in performance pieces such as *Site* and also with the naked male body in performance works such as *Waterman Switch*, is to enact for the viewer a sexualising of space and object relations by literally introducing a naked human presence. We shall see how in Judd's and Andre's case too, a sexual charge will sometimes erupt in the midst of a measured engagement with austerely formal configurations and placings of things. Morris is only distinctive for his easy-going unapologetically priapic cool, at least until he switched gear and found that there was more mileage to be had from a male feminist or masochistic castigation of masculine libido. When asked by Jack Burnham in an interview in 1975 about how he accounted for the sensuality of his apparently totally unsensual early large-scale plinths, cubes and beams, he replied candidly 'Their sensuality has to do with their shape, how they stand in space . . . I just think that there are certain shapes that one . . . gets [a] charge from.'[36]

* * *

Both as an artist and a theorist, Morris soon changed tack after publishing 'Notes on Sculpture'. He not only rethought his priorities, but he radically reconfigured his whole project in a quick succession of moves that in the end led him entirely to abandon his earlier concerns. First he came to reject the idea of a rigid sculptural object in the interests of something more informal; then went on to try to eradicate from his artistic project any lingering traces of modernist formalism; and finally was driven to cast a deep shadow of suspicion over the whole institution of art, while trying to keep a tenuous purchase on the value of individual art making that refused to have any truck with the public values and expectations of what he saw as an utterly poisoned artistic culture. Morris's initial turn away from Minimalist object making involved not so much a negation of as a moving on from his earlier position. Minimalist work, as he explained in an essay entitled 'Some Notes on the Phenomenology of Making' published in 1970, may have broken with the modernist focus on composing form and creating tightly ordered objects when it engaged in a more open, less aesthetically controlled fabrication of simple constructs, but it did not go far enough (fig. 103). The new anti-form work proceeded a stage further with its open processes of working directly with materials, involving hanging, leaning and dropping rather than constructing.[37] Such process art, characterised by a 'disengagement with enduring forms and orders of things', and driven by a continually evolving, ever more radical refusal to 'continue aestheticising the form by dealing with it as prescribed end',[38] had entirely abandoned rigid shapes and experimented with amorphous loose pilings of materials (fig. 13).

This imperative to move on is structured along standard avant-garde lines: once a form of artistic activity is fixed, it is in danger of becoming reified and subsumed within dominant values. There is then a need to undo the impending closures and move out beyond the boundaries it is in danger of establishing. The theoretical trajectory Morris traces from 'Notes on Sculpture' in 1966 to 'Some Notes on the Phenomenology of Making' in 1970 falls fairly readily into this pattern, at the same time that it closely tracks the mutations in Morris's own practice as an artist over the same period, from conceptual objects to Minimalist sculptures, to anti-*Gestalt* felts and to the gallery presentations of process work in 1969–70. The one unusual aspect of this trajectory is the speed with which it is traversed – though one might argue that in this respect it echoes the art historical parable about Braque's and Picasso's invention and successive transformations of Cubism around 1910. Moreover, the late 1960s and early 1970s were a time of rapid evolution in a number of artists' oeuvre. Think of the shifts in Nauman's work in the period round 1968, and in Eva Hesse's too. Morris is unusual only in the need he felt to shape the changes in his work into a systematic, self-justifying theoretical narrative.

His later moves were something different, more akin to a crisis than a progression, ending as they did in a bleak rejection of almost everything he had seemed to stand for when he embarked on his career in the mid-1960s.[39] Almost all the so-called Minimalists retrospectively expressed their distaste for the label, thereby simply echoing what many other modern artists had done when they protested that critics were seeking to pigeon-hole them in neatly packaged movements. But Morris's was a more driven, at times almost vehement, attack on what he came to see as the degraded nature of his own and his contemporaries' initiatives of the 1960s, particularly those in a Minimalist vein – work which by 1973 he was already characterising as hopelessly formalistic with its 'undisguised shape-type forming'.[40]

Before looking further into this crisis and its political ramifications, we need to pause for a moment to consider quite how radical the new position was that Morris mapped out for himself when he moved on from Minimalist sculpture. We find in it a strange double-take. At a formal level, there is a deconstructive progression from simple geometric forms to more informal, unstructured anti-form work. [But equally, there is a retreat from a frank engagement with the staging of art that eventually led to a kind of solipsism, as he searched for a practice that would abolish any mediation between viewer and artist and would thus insulate itself from the corrupting commodification of art in the modern world.] If a consistent negation of the compressed modernist object persists in Morris's analysis, this negation eventually issues in a traditional, almost romantic fetishising of process over product. But the aspect of the crisis in Morris's theorising and practice that particularly interests me concerns the shift from an open public ethic to a protective private or individualistic one.

The process art which Morris was championing in his 'Phenomenology of Making' essay would, he claimed, reduce or abolish the 'existential gap between the studio preparation and the formal presentation'. The idea in itself is quite a suggestive one, and could be seen to inform some of the more interesting process work being produced at the time. But its consequences were driven home by Morris in such a way as to feed a growing fantasy of his that he could make work that would entirely escape the tensions and

mediations inherent in presenting his creations to a public of some kind. Morris now sought a situation for his work where the taming effects of the public arenas for the presentation of art would be completely abolished, and where there would be no aesthetic or ideological framing of the viewer's access to this work. His new pieces were to be apprehended as identical with his performance of them, so there was as he saw it no artificial separation between ends and means. Any framing or insulation of the work would take place inside the viewer's head, and would not be imposed from the outside, the viewer Morris had in mind occupying the same psychic space as the artist through a total identification with the artist's activity of making.[41]

Morris took his conception of process art to the point where he came close to advocating the late Romantic idea that the essence of art lay in some unmediated transfer between the inner sprit of the artist's creative act and the inner imaginative world of the viewer. Indeed, he makes it quite clear in his 'Phenomenology of Making' that he is only concerned with 'the artist's role playing' and not at all with either the 'social function' or 'the general semiotic function of the art . . . Psychological and social structuring of the artist's role I will merely assume as the contextual ground upon which this investigation is built.'[42] There was a similar Romantic refusal of mediation between artist or art work and audience underlying much radically anti-form and performance work in the period. In an early article on happenings published in 1961, for example Allan Kaprow saw the dissolution of the art work in immediate participation in performance as holding up the promise of an art that exists entirely as a 'state of mind' in which the 'artist may achieve a beautiful privacy'.[43]

This excluding of the public arena of a viewer's encounter with a work become increasingly insistent and programmatic in Morris's later writing, as for example in the essay called 'Aligned with Nazca' he published in 1975, where he set out the case for an ideal art which 'can never become "other", which can never become objects for our external examination', and which involves one in examining, testing, shaping 'the interior spaces of the self'. 'Deeply sceptical of experiences beyond the reach of the body', he continued, 'the more formal aspect of the [exemplary] work in question provides a place in which the perceiving self might take measure of certain aspects of its own physical existence.'[44] In a much later article called 'Professional Rules', published in 1997, Morris went a stage further in privileging the artist's private inner psychic spaces, 'a shaded and sheltered space housing questions that never heal', over the 'space of the gallery' where 'the frame of the statement surrounds even the fragment'.[45]

Morris's attempt to insulate his creative processes as best he could from public contamination obviously involved him in repressing his inevitable, if in some ways unwilling, participation in the public display and circulation of his work. His increasing refusal to countenance any disparity between his personal involvement with it and how it might strike someone encountering it in the outside world, far from preserving him from the pressures exerted by the post-modern marketplace, however, seems to have left him more exposed to their unconscious effects. Rather than becoming more puzzling or intractable, his later work has often been increasingly theatrical and consumable, and in conception certainly not out of tune with art world fashion.

In a statement published in 1997 in connection with an exhibition of his recent felts, he could talk eloquently about the experience of being inside the making of the work,

of 'groping with coils of a hundred pounds of felt, the body tangled in its whorls and loops, sweating and cursing . . . [trying] to find something in the chaos of felt falling all around me'.[46] But to look at the perfectly symmetrical, cleanly cut and neatly designed felts on display, some with the requisite suggestions of embodied and ensexed vaginal imagery, it would be hard to imagine a greater disparity between what it feels like to look at a work and Morris's evocation of the process of making it. The phenomenology of making is largely a matter of indifference unless it has an impact in some significant way on the phenomenology of viewing – an impact that can be direct or indirect, paradoxical or even perplexing. Such impacting necessarily involves some recognition, however tacit, that the encounter between viewer and object is mediated to a degree and played out in a public context of some kind, not just in a private psychic space – a reality that Morris at one point seemed to embrace but later found increasingly depressing to countenance.

* * *

The change in Morris's position dramatised in his critical and theoretical commentaries, as we now look back on it, seems more like a rupture than a development, more a defensive response to a crisis than a shift of gear in a continuously unfolding project, or a considered adaptation to changing times. The break from the confident avant-gardism of the later 1960s to the depressed negations which take over in his later writing, and which were already emerging in an essay published in 1973 called 'Some Splashes in the Ebb Tide', are striking if nothing else:

> Perhaps art deserves no more support than it can manipulate for itself. If its discourse now sloshes back and forth, causing a kind of tired flood in the support systems that come to look more and more like old MGM lots, one might expect art to sink below the surface, to reappear or not appear elsewhere. Or perhaps it won't sink, but will continue to float around, soggy, bloated, and malodorous.[47]

[The negations in Morris's later theorising and self-justification are so insistent that it is tempting to talk of a compulsion that approaches the pathological, as long as it is understood that this refers to the persona implicit in Morris's writing about art, not necessarily the man himself.]But even if the writerly person who announces himself in the texts is a fiction that a light-hearted real Morris constructed, the question still remains as to the compulsion that fed the creation of this fictional construct and also made the construct such a success among critical theorists of art. However one looks at it, the shift in his writing is symptomatic of a real disturbance affecting the projection of self, or myth of selfhood, within American artistic culture at the time, something that made it seem necessary to abandon the image of the artist as confident public performer, and to invoke instead that of the artist as recluse who had to retreat from the public arena to preserve some measure of personal integrity.

In Morris's case, what had once been a strong identification with an expansive American-style avant-garde project, based on a confident assertion of the new, seems to have turned into an aggressive distancing from, and then a sometimes bitter attack on, this whole mythology, as if it had seriously let him down. His later position was more

overtly political, a shift that was no doubt part of the sharp politicisation of American culture in the late 1960s and early 1970s. Morris was one of many intellectuals caught up in the wave of anti-government protest that reached a peak with the opposition to American military intervention in Vietnam.[48] One of Morris's few overtly political works, the installation *Hearing* which he made in 1972, exudes a quasi-Foucauldian exposure of the dark dynamics of power and repression inherent in the workings public institutions, a mode of critique that became a pervasive feature of radical post-1968 political culture. It was as if Morris had come to see American public life as irredeemably corrupting and menacing.[49]

At the same time, in the late 1960s and early 1970s, Morris, like several of his Minimalist contemporaries, was propelled dramatically from small-scale success to high-profile public recognition. Public exposure in the form of major one-man exhibitions in established museums came very fast – first at the Whitney Museum in New York in 1970, followed soon by the major show at the Tate Gallery in London in 1971. In both these exhibitions, however, Morris responded by refusing the conventions of the one-man retrospective and instead devised entirely new large-scale works that took over most or all of the gallery space, in both cases with ambiguous success. The Whitney show was closed three weeks early. While Morris himself had tried to call it off just before its opening on political grounds, protesting against official complicity in the shooting of four students during an anti-Vietnam demonstration at Kent State University, other more mundane factors too played a role. His massive process piece, which made the gallery into a building site, with workers using a pulley and a fork-lift truck to assemble and then collapse a massive structure of concrete blocks, metal pipes and pieces of timber, seemed not to have been as sustainable in the longer term as he had imagined.[50] It was a gesture that magnificently defied the established expectations of gallery viewing but also, for better or worse, took little account of the circumstances of a public staging in the way that his earlier performance and installation pieces had done so consummately. It was as if he had in mind something where the real physical process of making would instantaneously and without mediation become a spectacular public event.

The Tate Gallery exhibition gained something of a mythological status after much of it had to be closed because, as we have seen, the interactive sculpture provoked too uncontrollable a response from the public. At a stroke, Morris sought to break with the hands-off rituals governing the viewing of work in a gallery and offer an opportunity for new kinds of sculptural experience, where members of the audience involved themselves physically with the work, literally becoming actors in a performance that they would stage partly on their own initiative. The ambitions were nothing if not grandiloquent, as Morris made clear in a flier in the catalogue:

> These pieces . . . represent an art that goes beyond the making, selling, collecting and looking at kind of art, and proposes a new role for the artist in relation to society.[51]

Both exhibitions were symptomatic of an unwillingness on Morris's part to take into account the contingencies of an audience's interaction with the work he devised and to consider the disparities that inevitably occur between the imagined projection of a work and an actual encounter with it. At one level, then, they were romantic public fantasies. At another, both shows were risky but hugely ambitious experiments by an artist com-

mitted to reconfiguring the function of art and creating a radically new kind of public work, involving particularly in the Tate Gallery an unprecedented level of audience participation. But Morris could not with a single gesture overcome the dichotomy between private and public domains of experience structuring the public viewing of art in his chosen arenas of performance. That he himself had not abolished the individualising dimension of art, and dissolved it in a purely public conception of things, is clearly evident in the way that the artist hero remained a significant presence in his own conception of this new public sculpture.

To conclude, I also want to insist that the crisis, or whatever it was, which subsequently made Morris turn so violently against the public dimensions of staging and viewing sculpture and retreat into the private spaces of the artist's and viewer's mind, would not have taken the form it did, could not have been articulated with such intensity or have found such a wide audience, unless it played out something very real in the larger situation of art at the time. His was a particularly dramatic case of the American art world's giving up the ideal, or myth, of a radical, uncompromisingly individualist, and at the same time public and democratic art, an ideal that had fuelled the ambitions of earlier artists such as David Smith, even as its public aspect became increasingly unviable with the political closures and conservatism of the Cold War period.

With the upsurge of oppositional politics in the 1960s, a radical individualism combined with a democratically orientated anti-establishment politics again became a real possibility, though the conjuncture between the political and the artistic was rather different this time, more demonstratively libertarian and allied with an activist public stance often directed against the art market and established institutions of art. Morris was very much at the centre of this development, both in its earlier more easy-going anarchic phase and in its later more sharply politicised one. His trajectory thus followed a larger pattern of upsurge of libertarian innovation and activism, followed by retreat and disillusionment. It played out in rather melodramatic terms the rise, and subsequent collapse, in the belief generated at various points in the 1960s and early 1970s that a new, genuinely radical form of art could develop within the restructured public spaces opening up at the time that might resist, or even subvert, the reifying and consumerist tendencies of modern capitalism.

The vicissitudes of Morris's career also relate to tensions that became manifest between the public and private condition of modern sculpture and that he himself addressed in his early 'Notes on Sculpture'. There he had articulated the desire for a renovation of sculpture in which the image of the artist as heroic individual would combine, if necessarily a little ironically at times, with an entirely publicly orientated sculptural practice. When radical renovation on these terms began to look unworkable, Morris, as we have seen, responded by seeking to withdraw from the public arena. However, he was unable to fall back on the modernist image of a heroically isolated individual turning from a hostile environment to gain sustenance from his inner world, which had been so important for many artists of the Abstract Expressionist generation in their later years. This image was seriously at odds not only with the changed condition of the art world in the 1970s and 1980s, but also with the lingering force of Morris's earlier insistence on the need to move from a private to a more public form of sculptural practice. In such circumstances, a sado-masochistic stance was perhaps one of the few options available to

him, with the negativity of the drive to self-destruct providing at least some continuing sense of purpose. His being unable to sustain the illusion that he could protect his own artistic endeavour from being taken over by a bleakly corrupted art world coloured his position of retreat with an almost morbid defensiveness. This was not just an individual condition, but symptomatic of ructions then occurring at the tense and uneasy interface between the private and public dimensions of a sculpturally orientated practice.

The Siting of Sculpture: Serra

If Morris is the artist who both through his writing and work put the behavioural dimensions of sculptural viewing and the staging of the sculptural object on the agenda in the 1960s, in retrospect it is Serra's work that has come to embody for the contemporary art world the new situated, non-object-orientated conception of sculpture that Morris once promoted.[52] I say in retrospect because Serra is of a slightly later generation than Morris and only established the practice for which he has become so well known in the early 1970s. There are several reasons for the centrality of his work, not the least of which is his move into publicly sited sculpture, where situatedness became a more immediately pressing concern. One of his larger projects, the now destroyed *Tilted Arc* (figs 94, 95) in the Federal Plaza in New York, generated a particularly intense controversy, and momentarily made his abstract Minimalist vocabulary and its powerful rhetorical and psychic resonances a subject of widespread debate.[53] The controversy, which has become an important reference point for subsequent discussion of art placed in a public setting, if anything raised Serra's stock in the art world and progressively minded commissioning bodies, particularly in Europe, to the point where he has become almost as dominating a presence in the arena of public sculpture as Henry Moore once was. But there is another factor which has given his work a high profile in recent thinking about sculpture, and that is the persistence and consistency, and I might add intelligence and intensity of commitment, with which he has pursued a project of generating work that focuses attention not on the object itself but on its occupancy of space and on the viewer's bodily engagement with the spatial field it sets up. In sticking to these issues, he could not have been more different from Morris, who was always moving on and re-situating his practice and theoretical commitments.

Like Morris, though, Serra did not want to be associated with Minimalism. This attitude of mind seems to have originated in his early process art days in the late 1960s, when his practice was probably closer to Morris's than at any subsequent point in his career. He recalls how he and Robert Smithson, to whom he was very close at the time, came to the conclusion that the first generation of so-called Minimalists, including Andre and LeWitt and Flavin, had got locked into a closed system – had in other words become trapped within a new formalism.[54] He clearly wished to associate himself with a later generation of artists, such as Eva Hesse, Bruce Nauman and the composer Philip Glass, who could be seen to be taking a critical distance on the structurings proposed by the earlier Minimalists. Nevertheless, in retrospect, and increasingly so after successive waves of post-modern and late modernist fashion, Serra's unbending commitment to working with a set of simple basic forms and materials does make him

something of a Minimalist. That he refuses comparison with Judd and Andre, with whom, for viewers at least, he has certain clear affinities, almost goes without saying, given the competitiveness and generation consciousness of the contemporary art world. The pressure of having to move beyond and escape the limits of the work of one's immediate predecessors is pretty well taken for granted. Andre gave a nice political inflection to this when he commented that 'the besetting vice of the proletariat under capitalism is envy and all the artists I know, especially myself, must constantly overcome the surge of displeasure which accompanies the realization that another artist may have added a truly authentic and autonomous utterance to the stock of the imagined world.'[55]

Given Serra's distinctive commitment to site-specific practice, it is also hardly surprising that he came to criticise earlier Minimalist work for its narrow understanding of context. 'The Minimalist's notion of site specificity was always limited to the room, the prefect white cube', or the 'well-lighted white shoebox', as he put it. Moreover, 'Simultaneous to the rarefaction of the context the Minimalist object turned into a high-tech, mass-produced commodity.'[56] He has a point, particularly in the sense that the Minimalist commitment to grid-like structures and rectilinear forms was clearly partly conditioned by the unadorned rectangular spaces where the work was displayed. Yet a number of Serra's earlier works were specifically made for white-cube galleries. No more than Robert Smithson,[57] who shared his misgivings about the restrictive contextual framing of Minimalist work, did he abandon making work for standard gallery spaces.

The gallery context, as Serra exploits it, has two aspects. First, it is a very particular kind of interior space, shaped by certain formal imperatives, and in this respect limiting, but not more so than many other framing parameters within which any artist who has a public profile has to work. Secondly, a gallery space functions as a relatively neutral arena for the performance of three-dimensional work, like a theatre for a dramatist. The generic space is one that the viewing audience is attuned not to notice particularly, and it creates conditions where this audience can focus attention on the spatial and visual dynamic set up by the works it contains. Obviously, this relative neutrality ceases to operate once the work placed in a gallery is conceived as in some sense site-specific. On several occasions Serra disrupted the neutrality of the gallery space by making the viewer aware of it as a specific kind of site (figs 8, 9), but much of his interior work, like that of the earlier generation of Minimalists, simply stages itself within the given parameters of a standard empty modern space.

While both Serra and Morris retrospectively took pains to signal the distance they had travelled from Minimalism, they ended up in very different places. Morris embraced the post-modern turn and expanded outwards into a range of anti-formal practices, from earthworks to pure process pieces, to user-friendly adventure playground installations and to post-modern imagistic extravaganzas of death and destruction. He came to see Serra as representing the modernist baggage he had left behind. Serra, in his view, was an old-style pseudo-heroic object maker, still mired in the formulaic schema of Minimalism, the avatar of 'slumping iron', who clung to 'autonomous abstraction's desire for the whole, and ended in a bid for the transcendant and the heroic via phenomenological subjectivity'.[58] Serra was equally caustic in his antipathy to Morris's particular embrace of the

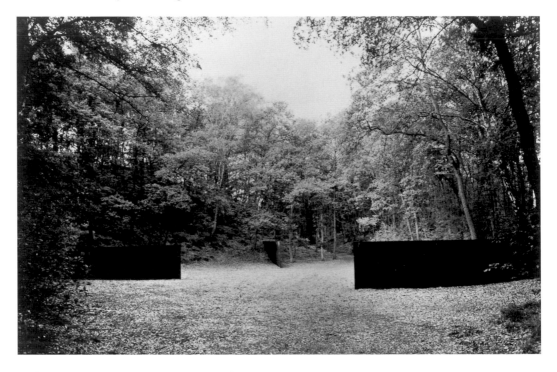

106 Richard Serra, *Spin-Out (For Bob Smithson)*, 1972–3, three plates, Cor-Ten steel, each plate 305 × 1219 × 4 cm, Rijksmuseum Kröller-Müller, Otterlo

post-modern, meanwhile evoking the rather apposite image of boyhood spats over who has the right to play in whose sandbox:

> The problem is that Morris plays in my sandbox and everybody else's. I call that plagiarism, other people call it mannerism or postmodernism. Those who play in others' sandboxes, or who play with the icons, form, or thematic, of history, labor under the assumption that history can be dispensed. The source and center of work no longer derives from the necessity of invention but from strategic game plans.[59]

Serra's career began in the late 1960s with a variety of conceptual and performance-orientated or process work. However, he soon settled into developing a sculpture based on a limited repertoire of elements, mostly rectilinear sheets, flat but sometimes curved, made of rigid, raw materials, such as steel and occasionally concrete. These are arranged in open configurations that require no welded or rivetted joins, and simply rest on or are anchored in the ground. The work makes a strong physical impact while at the same time it defies being conceived as a self-sufficient object. As its substance is made up of large dividers, whose opaque surfaces and hard edges reconfigure the ambient space, the viewer is presented with barriers and openings and directional axes rather than constructs that make sense independently of their siting (fig. 106). Where Serra did deploy solid objects (figs 8, 9), these are simple blocks set in spaces large enough for the blocks to function more as markers than as presences in their own right – in this sense they are very different from Tony Smith's *Die* (fig. 93).

Serra was pretty clear about what he was doing, and the comments he made in interviews are among the sharpest accounts there are of the formal priorities shaping his practice. The aim of his free-standing work, as he put it, was 'to define a space, to hold a space'.[60] It was a sculpture that sought to engage the viewer's body at an immediate physical level rather than to present an image of bodily shape with which the viewer could empathise:

> I want to make the volume of the space tangible, so that it is understood immediately, physically, by your body; not so that the sculpture is a body in relation to your body, but that the volume, through the placement of the sculptural elements, becomes manifest in a way that allows you to experience it as a whole.[61]

This involved a 'changed relationship of viewer to object' in which the viewer felt her or himself to be situated in the same space as the object, resulting in a new, more vivid sense of his or her bodily behaviour in the presence of the work. 'Changing the content of perception by having viewer and sculpture coexist in the same behavioral space', as he put it, 'implies movement, time, anticipation, etc.'[62]

<center>* * *</center>

Of all the Minimalist artists working in three dimensions, Serra was possibly the most concerned to identify aspects of past sculptural practice that resonated with his own preoccupations. He was a good, if austere, sculptural critic. His recorded comments on Brancusi, many generated in an interview with the Brancusi scholar Teja Bach, offer some intriguing insights into what it was about Brancusi's work that made it so relevant for Minimalist sculptors and object makers. The *Endless Column* (fig. 68) was a period icon, for obvious reasons,[63] but Serra was able to see affinities with other work that was not modular and did not look anything like what he and his contemporaries were producing, sculptures such as Brancusi's more elaborately shaped *Cock* and *Chimera*. Brancusi was particularly important for Serra because he had developed a distinctively sculptural definition of drawing as edge rather than line:

> What interested me about Brancusi was how he could suggest volume with a line along an edge; in short, the importance of drawing in his sculpture.
>
> . . .
>
> How he completes a volume on the edge is drawing, how he cuts a form is drawing. Drawing defines how one collects material through scale, placement, and edge.[64]

When faced with the perennial question about the significance of the bases in Brancusi's sculpture, he refused to take the standard Minimalist line that, for a contemporary sensibility, the bases were the really important part of the work:

> I never thought about Brancusi's works as being about placing artifices on top of bases. I always thought the entire structures were sculptures, and that they were not just configurations of elements on bases. The same kind of intention that went into the carving of one structure had to do with the discipline of the carving of the other.[65]

This assessment stands in marked contrast to an off-the-cuff comment made by Morris, which, though less attuned to the formal qualities of Brancusi's work as sculpture, is worth noting because it introduces a libidinal charge that often erupts in the Minimalist sculptural imaginary, and from which Serra carefully distanced himself:

> I was really fascinated with the bases [fig. 69]: they were stacked, permuted . . . all the sexual energy, all the implications of violence, were below a neutral axis, repressed in the base. What lay above these pedestals was absurd – obsessive, repressive, puritanical.[66]

Serra also made one rather unusual point about Brancusi's stacking of elements and his situating them in relation to the ground, which has ramifications for his own practice. He was describing how sometimes the elements were so precisely placed and balanced on top of one another that they no longer seemed to be held in position or weighed down. The result was a

> hovering quality of two discrete elements touching in a suspended state. This is obvious in some of Brancusi's best work, especially in his *Chimera*. I have always been interested in that. But that is something that one arrives at by doing. That has to come out of one's relationship to the material, or one's understanding of one's own body in relation to the ground.

However, Serra did simply echo the standard line taken by other artists of the period, like Morris and Andre, when he expressed his unease about the 'polished and utterly refined surfaces' in some of Brancusi's work, and argued that 'when one gets into materiality on that level of either surface or decoration' it is 'mere embellishment . . . any exaggerated emphasis on surface for the sake of itself is decadent.'[67] This attitude is obviously shaped by a preference for relatively neutral surfaces in his own work – he consistently favoured rough-and-ready opaque material finishes that precluded striking optical effects, and yet were just textured enough to make the work look (or feel) substantial and solid. At the same time, there is an echo of Morris's formalistic exclusion of texture and painterly surface from the domain of serious sculpture.

Among the more unexpected and intriguing of Serra's comments on the precedents for his sculptural preoccupations is a point he made about how a spatial dimension was activated much more effectively by certain figurative sculpture such as Giacometti's than by modernist experiments with holes and empty volumes. The grasp he had of Giacometti's work was quite at odds with the standard high modernist view that Giacometti's later figurative work (fig. 62) represented a regression from modernist object making to more traditional figuration. Serra was discussing how he was going to 'hold the space' of the large central sculpture hall – the Duveen Galleries – in the Tate in London with his piece *Weight and Measure* (figs 8, 9). This prompted him to remark that Giacometti's late attenuated figures and Degas's *Young Dancer* were among the very few works of modern sculpture that could sustain themselves in this way as interventions in space. For sculpture to do this, he explained,

> There must be enough tension within the field to hold the experience of presence in the place. You can say, why couldn't you do that with a sliver of plaster? Well, Giacometti did that. Also, I looked at Degas's dancer this morning and came to the conclusion that

the way in which his sculpture drinks the whole space from the room right into its grasp is pretty good. But very few figurative sculptors, with the exception of Giacometti, are able to do that. Punching holes through spaces never did it for me.[68]

It is indeed striking how a single small Giacometti figure can define its place and activate the space around it in a way that most other modernist sculpture fails to do, for all the self-conscious play upon abstract spatial elements or empty spaces piercing solid forms. The activation of space in Giacometti's later work is something that Judd, attuned as he was like Serra to this dimension of the sculptural, commented on too.[69]

<p style="text-align:center">* * *</p>

No sculptor has been more self-conscious than Serra about the formal problems of siting work. He made something of an ethic of not simply transposing work conceived in the studio and adapting it to an outdoor or public site, as so often happened with the corporate modernist public sculpture dotting the urban landscape. 'To take the work out of the studio and site-adjust it', he insisted, 'is conceptually different than building in a site, where scale relationships are determined by the nature and definition of the context.' And he added, 'Henry Moore's work is the most glaring example of . . . site-adjusted folly. An iron deer on the front lawn has more contextual significance.'[70]

At the same time, he was adamant that a genuinely site-specific work should not be seen as environmental sculpture. It should not simply fit in with or comment on its setting but needed to declare, to assert itself, to redefine its site, as his own *Tilted Arc* so notoriously did (figs 94, 95). If sited sculpture had to be realised very differently from more autonomous work produced for a gallery, it nevertheless needed to have its own powerfully stated autonomy within the context in which it was placed:

> I think that sculpture, if it has any potential at all, has the potential to create its own place and space, and to work in contradiction to the places and spaces where it is created. I am interested in work where the artist is a maker of an 'anti-environment' which takes its own place or makes its own situation, or divides or declares its own area.[71]

The notion of place being voiced here is not unlike Andre's, and its implications carry over into Serra's understanding of how work which he did for a gallery setting would have an impact on this relatively generic, unspecific kind of space. When he installed *Delineator* in the Pace Gallery in Los Angeles (fig. 107) in 1976, he described it as 'creating a definite space within the given space'.[72] The work consisted of two metal plates, each ten feet by twenty-six feet, one set flat on the floor and the other located on the ceiling directly above and at right angles to it. In this case the work was very clearly not only the metal plates but also the space compressed between them. Even so, it was not an installation in the sense of using the given space as a frame or container to set out an all-enveloping spectacle or create a total environment. Serra insisted: 'I didn't want to use the cube of the room as a container. I wanted to clearly define another kind of interior – structured space within the given space of the room.'[73] Generally speaking, he envisaged his interior pieces as taking two forms, either work like *Delineator* that made a separate space within the given space of the gallery (work which involved 'finding a

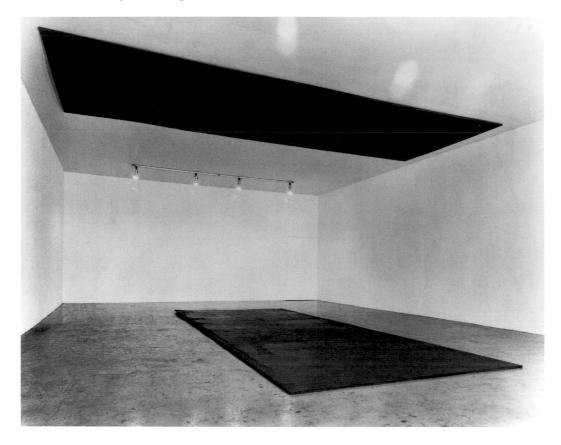

107 Richard Serra, *Delineator*, 1974–5, installed in the Ace Gallery, Los Angeles in 1975, two steel plates, each 305 × 792 × 2.5 cm

space within a space'), or site-specific work like *Circuit* (figs 99, 100) and his later *Weight and Measure* (figs 8, 9) that operated on one's sense of the whole interior space and reconfigured it (work which entailed 'structuring internal spaces').

Circuit and *Weight and Measure*, though, operate on the basis of two different, almost opposing tactics – the former literally invades and takes over the whole space of the exhibition area, while in the latter the vast central circulation area of the Tate Gallery, comprising two long high-roofed galleries facing one another across a domed central area framed by Ionic columns, dwarfed the two solid steel blocks set in the middle of the floor of the two galleries.[74] These blocks, though fairly massive, were on a human scale, unlike the surrounding architecture, both about nine feet wide and three and a half feet deep, with one five feet high so most people could easily look over it, and the other about six inches higher so that it just blocked the view of someone standing close by. The installation, partly through the emptiness it imposed, functioned to expose and draw one's attention to the gallery space and its architecture, usually ignored when one was looking at works of sculpture installed there or wandering through on the way to an exhibition, while at the same time it totally reconfigured one's sense of the space through the subtle interventions it made.

The two blocks were placed along the central axis, set opposite one another on either side of the central domed area, which then became an empty viewing space. While initially it looked as if two blocks of the same size had been set out in a symmetrical arrangement, on closer inspection a slight asymmetry began to assert itself. If one went to the very centre to get the measure of the whole installation, two contradictory alternatives presented themselves. Since the lower block was placed somewhat closer to the centre, the effects of perspectival diminution made it look exactly the same height as the other block. But the fact that it then looked wider than the larger block would prompt one to readjust one's sense of its scale and see it as equal in width but slightly lower than the other block. The shift to the latter perception was given a further prompt when one noticed disparities between the apparent height of the two blocks relative to the gallery visitors standing near them. It was only by taking the measure of the whole arena of the work that a clear mapping could establish itself, but this was continually subverted by the varying sense one kept having of the scale and presence of the two slightly differently sized blocks and by the recurring compulsion to visualise them as equal in size and symmetrically arranged.

Making one aware of how one's sense of a work could shift radically as one moved round and through it was a major preoccupation of Serra's 'phenonemenological' project as a sculptor. It was something he always insisted on, starting with the first extended commentary on his sculpture which he published in 1973 in an article occasioned by the outdoor piece *Shift*[75] – a work he later described as one in which 'the dialectic of walking and looking into the landscape establishes the sculptural experience'.[76] Like Morris, he saw himself as creating work that precluded definition as an autonomous object 'solely defined by its internal relationships.'[77] But his conception of how such work would be constituted by the relations it set up with the viewer was radically different from the formalist account proposed by Morris in his 'Notes on Sculpture'. Serra was much more phenomenological in envisaging the shifting partial views as the basis of any sense one had of the work as a whole, and in also insisting that the latter was not reducible to a fixed structure or *Gestalt*. With the work he had in mind, it would be impossible to 'ascribe the multiplicity of views to a *Gestalt* reading . . . [the work's] form remains ambiguous, indeterminable, unknowable as an entity', while still definitely being something.[78] It comes as no surprise to discover Serra commenting recently about how he was struck by the affinities with his project when he read Merleau-Ponty's *Phenomenology of Perception* in the late 1960s.[79]

He became particularly fascinated by a sculpture that precluded being seen as closed shape by virtue of its interior being opened up so a viewer literally went inside it and became physically enclosed within it. In his own sculpture he felt had made an important shift in this direction, away from more conventionally closed object-like creations:

> What bothered me about the *Props* [fig. 108], which were made of lead, was that you could walk all around them but you couldn't move into their physical space. I wanted to increase the scale to be able to walk into, through, and around them. I made *Strike* and then *Circuit* [fig. 99] for Documenta. And then I had the opportunity to build *Spin-Out* [fig. 106] at the Kröller-Müller . . .[80]

Serra was well aware that physically involving the viewer in this way in an interplay between exteriority and interiority involved not just formal or perceptual effects, but

108 Richard Serra, *One Ton Prop (House of Cards)*, 1969, photographed in Serra's studio by Peter Moore, lead antimony, four plates, each 122 × 122 cm, The Museum of Modern Art, New York

carried a certain psychological charge. When he was describing how he had moved from process pieces, where 'the building procedure, the pragmatic action – how you get the job done' defined the work, to work which intervened in the viewer's space and drew her or him into an interior, he himself made the point that 'as the pieces allowed entrance into their space, they became more psychological'.[81] But this psychological dimension was a muted one as he conceived it. It is striking how his work which allows the viewer to enter produces a much less psychologically charged sense of interiority than work such as Hesse's (fig. 147) or even Judd's (fig. 129), where the viewer feels drawn towards an interior space from which he or she is barred, and feels it to be strangely alluring and inviting yet separate. Serra's interior spaces are more neutrally architectonic, and have something of the outside about them, in the sense that they are not clearly defined as enclosed volumes, nor are their surfaces ever distinguished from exterior ones by differences of colour or texture. With Hesse and Judd there is a more charged sense of interiority that can echo one's own sense of bodily interiority in a way that Serra's interiors never do. Moreover, unlike Nauman say (fig. 162), Serra does not make architectonic enclosures that affect one as entrapping or empty or disconcertingly strange.

The psychological ramifications of Serra's work are ambiguous, being both muted and distanced and yet also at times very dramatic and insistent. The use of titles like *Strike*

and *Skullcracker Series* in his early work, the heavy, dark materials, often setting in train an incipient sense of physical threat – which in the case of the lead prop pieces is often dramatised by safety measures taken to keep viewers from getting too close to the seemingly precariously balanced massive sheets of lead leaning on one another or against a wall – positively invite psychologically charged responses. Such responses have been fuelled by public awareness of an incident involving a worker who was badly injured during the installation of one of Serra's works in the Castelli Gallery, and by the high-profile controversy surrounding *Tilted Arc* (figs 94, 95) and its supposedly invasive or threatening impact on its surroundings.[82] Andre was not alone in commenting, very much as an admirer of Serra's work, that it 'tends to go into the area of maximum threat, maximum physical extension'.[83] There is a lot in his work to feed the idea that it is aggressive and intrudes forcibly on the viewer's space. Unsurprisingly, when asked about his intentions in this respect, Serra has denied any interest in such a rhetoric of power play and domination – though it is important to remember that these denials are usually retrospective, and may not reflect the attitudes informing the more overtly aggressive gestures and titles of his earliest work.[84]

Let us take one instance from an interview conducted in 1989, just after the *Tilted Arc* incident. Serra was explaining how he wanted his public sculptures to 'deal head-on with their architectural sites' and to engage directly with 'the general condition of where people are', unlike work shut away in cultural institutions. When the interviewer raised the issue of 'confrontation', Serra interjected:

> I'm not interested in confrontation per se, and I'm not interested in obstructions per se. I'm interested in the particular relationships that I conceive to be sculptural in a given context and in pointing to whatever the manifestations of those sculptural attributes are.[85]

When the interviewer asked about the possible real physical threat posed by his assemblages of large, heavy metal plates that were not attached to one another in any way, he added: 'The sculpture when it's erected is not dangerous . . . I'm not interested in the sculpture toppling or in the sculpture being threatening or in the nature of menace. That's not my particular involvement with the work.'[86]

If Serra was making this point partly because of his sensitivity to the recent controversies surrounding *Tilted Arc* and the accident in the Castelli Warehouse, it also represented a consistent stance on his part. Rather like Morris, what he has to say on the dynamic of a viewer's physical engagement with his work is strictly formal. For Serra, a physical awareness of one's own body as viewer may be integral to experiencing a sculpture, but the body involved is one largely evacuated of everyday desires and compulsions. The following statement nicely encapsulates Serra's fairly formalistic understanding of the level at which a sculpture affects a viewer:

> I think in any work of art, whether one's dealing with volume, line, plane, mass, space, color, or balance, it's how one chooses to focus on either one of these aspects that gives the work a particular resonance and differentiates it from other people's work.[87]

This has obvious affinities with Morris's statement in his 'Phenomenology of Making' that the sculptural has to do with 'volume, mass, density, scale, weight'.[88]

Serra did not categorically deny any suggestions of a rhetorical element in his work: he limited himself to saying 'I am not interested in confrontation per se'. By putting it this way, he was not simply evading thinking about the psychodynamics of viewer response which his work set up, or repressing the inevitable complexities of a bodily interaction with things, particularly large, potentially dominating things like his sculptures. He was also making an important point about the situation that develops when a viewer becomes closely engaged by a work of sculpture and is immersed in the interactions created by looking at it intently. However dramatic the first facing up to a work might be, whatever sense of threat or monumental assertiveness it might generate in the initial few seconds of encounter, this inevitably wears off after a period of time. As a result of taking one's bearings from the ambient space the work creates, one begins to engage with it without always being affected by its physical presence. This does not mean that the initial affect entirely disappears. It becomes something in the nature of background noise, no longer quite held in one's consciousness, though of course it can easily erupt again if one suddenly reconnects with the work's more psychically imposing and psychically charged aspects (figs 95, 100).

A significant feature of work such as Serra's is the unstable fluctuations it can produce between a flagrantly psychologised response and a strictly formal one. This is inherent in its very conception. There is nothing either in the structure of the work itself or in the shaping of its relations with the viewer on which the viewer can peg a definite psychological response, partly because as viewer one is constantly renegotiating one's relation with the work, not only by physically moving round it, but by shifting between different modalities and focuses of attention. The formal qualities which Serra highlights do not exhaustively define the work, but they do pinpoint something that is always unequivocally there, dimensions of one's viewing experience that do not fluctuate wildly with shifts in one's inner emotional temper but which, however apparently divested of psychic charge, can at any moment become the bearers of powerfully driven bodily, psychic and ideological projections. Without a specific effect of scale, without a particular shaping of space, there would be no domination or threat – but equally the effect of scale, the shaping of space are not necessarily invested with threat, may indeed induce a certain calm and equanimity, which however would lack charge without the incipient suggestion of powerful intrusion on one's felt sense of ambient space.

* * *

There is one further point of contact and difference between Morris and Serra which ought to be mentioned because it has a bearing on how we understand the staging of Minimalist work, namely their attitudes to and exploitation of photography. One simple way of describing the conception of sculpture that emerged with Minimalism would be to see it as work that defied definition as self-contained form or image. Does this mean then that such sculpture is inherently unphotographable?[89] That is what both Morris and Serra seemed to be claiming when they addressed the issue. In 'The Present Tense of Space', an essay published in 1978, Morris developed an extended critique of the packaging and presentation of three-dimensional art through photographic imagery. According to him, photography reduced a three-dimensional art work to an immediately consumable motif,

and hence was totally inadequate for conveying anything of the felt sense of space and internal lived experience of time he saw as being of the essence of an authentic art – one which would of its very nature be resistant to commodification as object or image. But, as he put, 'there is probably no defence against the malevolent powers of the photograph to convert every visible aspect of the world into a static consumable image. If the work under discussion is opposed to photography, it doesn't escape it.' The blanket pessimism is tempered, however, by a flash of self-perception: 'How can I denounce photography and use it to illustrate this text with images I claim are irrelevant to the work proper?'[90] He was well aware that the medium through which much of a modern audience's encounter with sculpture took place was the photograph – nor was he blind to the need to exploit this.

The photographic presentation of sculpture was an issue Serra too had to address, particularly as several important works of his were sited in places that were relatively inaccessible to his mainstream public. As he commented in an interview in 1975, 'When a piece is placed in the Bronx, Harlem, Toronto, or Spoleto, the number of people who experience it are very few while the reportage of media and the photograph only rob pieces of their essentialness, which is a problem.'[91] On another occasion, he insisted on the disjunction between the situated experience of sculpture in space and time and the impoverished visual experience afforded by a photographic image: 'If you reduce sculpture to the flat plane of the photograph, you're passing on only a residue of your concerns. You're denying the temporal experience of the work.'[92]

Yet neither Morris's ideological denunciation of the photographic imaging of sculpture, nor Serra's more formal one, betoken an indifference to the photographic presentation of their work, quite the contrary. Both have taken considerable pains to make available fine, intelligently devised photos. A number of photographs of installations of Morris's work have become visual icons in their own right – particularly the famous photograph of his 1964 Green Gallery installation (fig. 103) and the Rudolph Burckhardt photograph of the two L-beams in different orientations (fig. 102), which served as a demonstration of the new situatedness exemplified by Morris's work in Krauss's *Passages in Modern Sculpture*. The catalogue of Morris's 1971 Tate Gallery exhibition, like the Henry Moore catalogue of a few years earlier on which David Sylvester also collaborated, is a veritable masterpiece of black-and-white photographic presentation.[93] It is clear that at some level Morris was acutely attuned to a photographic staging of sculpture, as was Serra. Serra made frequent use of the talents of the photographer Peter Moore, who produced several of the now classic images of Serra's early sculpture (fig. 108), and the 1986 catalogue of his one-man exhibition at the Museum of Modern Art in New York offers a dazzling array of fine-tuned yet dramatic black-and-white plates (figs 94, 95, 99, 100, 106–8).[94]

Something more than making the best of a bad job is going on here. A real, if vexed, conjuncture can be identified between photography and the imperatives of 1960s and 70s Minimalist sculpture, which we shall encounter again in the case of Andre. At a purely formal level, there are striking affinities between the conventions of late modernist, aesthetically self-conscious black-and-white photography and the monochrome and mostly rectilinear structures made by Morris and Serra and other Minimalists. But another more important factor is involved, which is closely related to the seeming

incompatibility between the photographic image and the phenomenological orientation of Serra's and Morris's work. We have already seen how important photographic reproduction was for Rodin and Brancusi, and how both took an active part in its devising that went well beyond the concern for effective visual packaging. The photograph functioned as a medium for recording a controlled staging of a work in an appropriate visual and spatial context which might be denied it in a real gallery setting.

A photograph is an image of something presented to the camera's eye and thus tends to blur the neat divide between reified image and lived physical experience of a work upon which both Morris and Serra in their different ways insist. Looking closely at a photograph, particularly of an object or an environment, one will not necessarily look at it just as a graphic image, but also as the representation of a visual and spatial field where the sculpture is placed, the field that once faced the camera and into which one can imaginatively project oneself. The photograph is an image of something but it is also a viewing of something, a viewing caught in the camera's eye. It may literally be static. Even so, the viewer looking at the photograph does not necessarily just fix on the whole image but also scans it, in effect moving round within the field that it evokes. Coming to the image of a sculpture with a predisposition to a temporal mode of viewing (fig. 106), which would involve moving around in the space where the work is situated – 'looking and walking', as Serra put it – one will also seek as best one can to read a photographic image of it in these terms, projecting in the mind's eye a trajectory through the space that the photograph represents.

8 Objects and Spaces

Specific Objects: Judd

Much of the cogency of Judd's best-known essay, 'Specific Objects', comes from its being both a statement of aesthetic principle and a broad critical assessment of the new forms of sculpture or three-dimensional art making an impact in the New York art world in the mid-1960s. Because he was trying to explain why he felt impelled to depart from accepted modernist understandings of the art object, the essay has a striking sense of urgency. But it does not deal directly with his own sculpture.[1] Rather, it develops its ideas by way of a perceptive analysis of a wide range of object-like work from the period, much of which does not now seem particularly in tune with Judd's priorities or even Minimalist. In spite of Judd's retrospective disclaimer that the essay was just 'a job of reporting', done on commission when he was 'earning a living as a writer', and was not intended as a 'manifesto',[2] it now reads as an ambitious piece – far broader in reach than Morris's 'Notes on Sculpture' and more closely attuned to the new developments that were putting object-making on the agenda than Fried's 'Art and Objecthood'.

The essay, published in 1965, came at an important moment in Judd's career when he was able to shift the main emphasis of his professional activities from writing art criticism to working and exhibiting as an artist. By now, he had an established record as an art critic, and he had got to the point the year before of being asked to write an extended survey of new developments in the New York art world, a brief he picked up again when he wrote 'Specific Objects'.[3] Meanwhile, he had begun to attract serious attention as an artist with the exhibition of his first box-like works at the Green Gallery in New York in 1963 (figs 109, 110). After that, public recognition came thick and fast. He was the first of the Minimalists to get a major one-man show at a public gallery in New York, at the Whitney in 1968, and soon after on the West Coast too, at Pasadena in 1971.

Judd's trajectory as a critic and artist put him in a good position to assess the larger imperatives of the new three-dimensional work. He was particularly attuned to the way in which this work simultaneously grew out of and defined itself in opposition to the dominant paradigms of high modernist painting. Like Serra and Hesse,[4] he started as a painter, and his writing is not only revealing about the continuing importance of the work of painters such as Jackson Pollock and Barnett Newman for American artists of his generation. He also offered one of the most eloquent accounts of what it meant to move from the familiar painterly norms of the flat canvas out into three dimensions. In an interview with John Coplans published in 1971, he recalled how:

> I was surprised when I made those first free-standing pieces, to have something set out in the middle of the room. It puzzled me. On the one hand, I didn't quite know what

109 Donald Judd, *Untitled 1963*, cadmium red light oil on wood, iron pipe, 49.4 × 114.3 × 77.5 cm, collection Philip Johnson

to make of it, and on the other, they suddenly seemed to have an enormous number of possibilities. It looked at that point from then on that I could do anything. Anyway I certainly didn't think I was making sculpture.[5]

The work he had began to make, with its dependence on colouristic and surface effects, may have gone against the traditional sculptural focus on pure form, but it was certainly out-and-out three-dimensional. Its occupancy of space, its precise situation in relation to its immediate environment and to the viewer, were crucial to its conception. In his writing, however, Judd did not offer any extended discussion of the new kinds of interaction with the viewer being activated by his and other three-dimensional work of the period, as Fried did, nor could he be said to offer a new phenomenology of sculptural viewing comparable to Morris's. Still, he was alert to larger issues of context and also to the problematic aspects of staging work for public consumption. If his occasional, usually brief comments on issues of context and situation were nothing like as subtle and incisive as his analysis of the visual and material qualities of the work that interested him,

110 Donald Judd, *Untitled 1963*, cadmium red light oil on wood, 49.4 × 114.3 × 77.5 cm, Donald Judd Estate, Marfa

he does voice anxieties relating to the public display and viewing of art similar to those we have seen played out so dramatically in Morris's case.

 Certainly, the basic abstract syntax Judd developed for staging and framing three-dimensional work has had a far-reaching impact on later twentieth-century sculptural practice.[6] His no-nonsense articulating of forms and spaces abolished any residual reference to the standing or reclining figure, by contrast with much previous modernist sculpture where the internal compositional structure still echoed aspects of figurative pose or form. His work also suggested procedures for setting out a convincing three-dimensional array in the relatively empty rectangular spaces of the modern gallery in which the scale was directly related to that of the viewer, without in any way representing a human figure. He, along with some of his Minimalist contemporaries, played a role for sculpture or

three-dimensional work analogous to that played for painting by the Abstract Expressionist generation of New York artists, whose paintings had offered a new working schema for a rigorously abstract, openly structured large-scale picture-making.

This makes Judd sound very formal, if not formalistic, which brings me to another key aspect both of his work and his critical writing – the combination of formal rigour with affective charge. This conjuncture, or should I say tension, is played out explicitly in his writing, particularly in 'Specific Objects', where strict formal analysis coexists with odd passages that are intensely sexual. His matter-of-fact reflections on his own work, however, refuse this juxtaposition of form and libidinal charge. Even so, the distinction is not entirely clear-cut. His critical commentary on contemporary art does include a lengthy analysis of work that he considered to be rigorously abstract and affectively reticent. When on occasion he reflected on the larger significance such art might have, he was in effect offering a basis for thinking productively about his own work's psychic and ideological resonances.

In his later, philosophically more speculative writing, such as the text of a lecture he gave at Yale in 1983 called 'Art and Architecture',[7] the bluff, very masculine, down-to-earth empiricism, often close in tenor to Stella's throwaway Minimalist comment – 'My painting is based on the fact that only what can be seen there *is* there . . . What you see is what you see'[8] – is complemented by intensive speculation on the existential significance of an art of unadorned visual facts and the resonantly charged interactions between self and world it sets up. The complex inflections of his plain-speaking thinking is nicely summed up in a comment he made in one of his heavier-handed diatribes on the state of contemporary art published in 1984:

> What is in front of you is what exists, and what is given. This fundamental rock in the road is what must be described and analyzed. The rock is a philosophical problem and a structure must be built to deal with it and beyond that a philosophical structure must be built to deal with the fact that there is more than one rock, even a lot.[9]

While the style of his thinking could not be more different from Merleau-Ponty's, there is still an affinity that goes beyond Judd's frequent use of the words 'existential' and 'phenomenon'. I am not talking about influence but a shared structure of thinking and sensibility that grew out of and sharply differentiated itself from a conventional modernist understanding of the relation of seeing to thinking and being. With both Judd and Merleau-Ponty there is a commitment to thinking hard about how material things manifest themselves as one looks closely at them, and about the larger temporal, spatial, situational and existential dimensions of such visual apperception.

* * *

If one reads Judd's 'Specific Objects' closely and does not stop at the general statement of formal principle with which it begins, it emerges as a rather strange and intriguing document, one that internalises the real complexities and ambiguities of the new three-dimensional object-making of the period. Affect, often of an overtly sexual and bodily kind, plays a key role in it. In this respect the essay departs significantly both from the

111 John Chamberlain, *Miss Lucy Pink*, 1962, painted chromium-plated steel, 119.5 × 106.5 × 99 cm, collection the artist

systematic formalism of the Greenbergian aesthetics which then dominated discussion of contemporary painting and from the fetishising of pure plastic form and shape common in discussions of modern sculpture. The insistent impurity of the essay raises another issue. Why this fascination with bodily affect, when it seems so at odds with Judd's own cool, radically non-biomorphic work as an artist at that time? The essay featured many slightly tacky, vaguely sexual and to our eyes rather dated sixties objects, of the kind promoted in period surveys like Udo Kultermann's *New Dimensions in Sculpture* published in 1967.

Both Judd's choice of the key artists he discusses most intensively and the terms in which he does so are rather out of tune with the straight matter-of-fact formalism that comes across in the well-known interview with Judd published in 1966, 'Questions to Stella and Judd'. The three artists whose work he singles out for detailed discussion are John Chamberlain, Lee Bontecou, and Claes Oldenburg, none of whom we would see as particularly Minimalist. Chamberlain's work is the most abstract, but the free assemblages of crumpled painted metal from cars and household appliances (fig. 111) are structurally closer to the Abstract Expressionist painterliness of Pollock than to the hard-edged abstraction with which Judd seems most closely associated. Moreover, Judd does more

than single out those formal qualities of Chamberlain's works that have a certain Mini-
malist coolness – the neutral glossy finish of the found pieces of industrially painted
metal, and the excess or redundancy of crumpled metal surfaces in relation to the overall
image or form. He also sees the images evoked by their shapes as important. This is partly
to establish a purely formal point about the new kind of unity created by the coincidence
of a simple image with a simple overall shape, where structurally diverse elements are
co-extensive rather than being arranged side by side in a unifying composition.[10]

What is most striking about Judd's analysis is the emphasis he places on the sexual or
bodily resonances that Chamberlain's work had for him – a work which from a present-
day perspective seems rather asexual and abstractly gestural. Judd was drawn to a dis-
tinctive emotive style that he described as 'simultaneously turbulent, passionate, cool and
hard.'[11] In the more extended discussion of Chamberlain's sculpture he had published a
couple of years before, he slid easily from a seemingly dispassionate description of the
literal physical aspects of the work to comments about the 'organised tumescent planes',
the 'involutions' of the metal, the 'expansion and contraction of parts', the 'fulsome'
forms, and the 'metal, enameled the colors of a display of flesh-colored fingernail polish'
(fig. 111).[12]

In Judd's analysis of Bontecou and Oldenburg, the psychosexual dynamic emerges with
much more 'blatancy', to use Judd's word.[13] He was fascinated by the powerful impact
made by Lee Bontecou's relief-like structures fabricated from strips of raw burlap
stretched over a shaped wire frame (fig. 112). Here again he commented on how a simple,
single strong image, with intensely sexual overtones, coincided with the singleness and
power of the work's formal aspects. As Judd put it,

> The image, all of the parts and the whole shape are coextensive. The parts are either
> part of the whole or part of the mound which forms the hole . . . The image is pri-
> marily a single emotive one . . . an image has never before been the whole work, been
> so large, been so explicit and aggressive. The abatised orifice is like a strange and dan-
> gerous object.[14]

This is reticent by comparison with the commentary on Bontecou Judd published in a
separate article in the same year. He there displays a responsiveness to the dynamic of
sexual fantasy, or one should say male sexual fantasy, activated by works of art that is
every bit as self-aware as anything he writes about their formal logic. I quote here from
the climactic passage:

> This threatening and possibly functioning object is at eye level. The image cannot be
> contemplated: it has to be dealt with as an object, at least viewed with puzzlement
> and wariness, as would any strange object, and at most seen with terror, as would be
> a beached mine or a well hidden in the grass. The image extends from something as
> social as war to something as private as sex, making one an aspect of the other. The
> objects are loricate; fragments of old tarpaulins are attached to the black rods of twisted
> wire. Black orificial washers are attached to some pieces; some have bandsaw blades
> within the mouth. This redoubt is a *mons Veneris*: 'The warhead will be mated at the
> firing position.' The image also extends from bellicosity, both martial and psycho-
> logical – aspects which do not equate – to invitation, erotic and psychological, and
> deathly as well.[15]

112 Lee Bontecou, *Untitled*, 1964, welded metal and canvas, 101 × 320 × 10 cm, whereabouts unknown

Here is one of the few instances in his criticism where Judd draws attention to the specific placing of a work. Though it is only a passing remark, he has touched on something significant that distinguishes work such as Bontecou's from traditional relief sculpture. He talks about how the work confronts the viewer at eye level, and sets up a powerful physical interaction rather than simply sitting back on the wall as an image or shape that is being held up to be viewed. This use of placement to break with the standard relation between viewer and image, and make the image as thing and presence impinge on and physically confront one, is something that other artists particularly attuned to the psychodynamics of viewing, such as Louise Bourgeois, have exploited to powerful effect (fig. 157).

There is also a strange sexual dynamic operating in Judd's response to Bontecou's persona as a female artist. He singles her out as an exemplar of the kind of strong, intensely focused individuality that one might expect someone with his gritty manly image as a writer to ascribe to a male artist. In effect, a female artist is being identified as embodying what seem to be very masculine qualities. Or are they so entirely masculine? To be thought of as peculiarly possessed of a raw intensity of purpose is a role that has been played by strong female characters in Western literature – Greek tragedy being the most obvious instance – even while it is starkly at odds with the traditional image of the female artist. In the following comments on Bontecou there are certain affinities with Stokes's earlier, but equally complex, highly wrought and slightly awkward, tribute to the power of Barbara Hepworth's artistry:

113 Claes Oldenburg, *Soft Switches*, 1964, vinyl filled with dacron and canvas, 119.4 × 119.4 × 9.1 cm, The Nelson Atkins Museum of Art, Kansas City, Missouri, Gift of the Chapin Family in memory of Susan Chapin Buckwalter

Bontecou's reliefs are an assertion of herself, of what she feels and knows. Their primitive, oppressive and unmitigated individuality excludes grand interpretations. The explicit power which displaces generalisations is a new and stronger form of individuality. Bontecou's work has an individuality equalled in the work of only a few artists.[16]

In the case of Oldenburg, Judd is also interested in how simple sensations of wholeness can be produced by work where a very basic shape coincides with a simple sexually charged image, though here, as with Chamberlain, a dead-pan 'cool' mitigates the effect. Judd makes the point that in Oldenburg's sculptures, the forms of very ordinary functional objects we use and handle are made to coincide with an 'emotive form . . . basic and biopsychological', as in his 'flaccid, flamingo switch draped from two points' (fig. 113), or in his giant hamburger's 'three fat layers with a small one on top' which are 'enough' to make 'the whole thing . . . a profound form' (fig. 114).[17] In sum, then, 'the sense of objects occurs with forms that are near some simple, basic, profound forms you feel.'[18]

Several of the works to which Judd refers are set flat on the wall, so the three-dimensionality that counts in Oldenburg's case is not necessarily the conventional free-standingness of a sculpture placed in the middle of a room. The situation is similar to that with Bontecou's reliefs. These wall pieces installed as objects can be just as three-dimensional in their impact on the viewer as floor pieces. It is not only that if they protrude to any extent, one can partly walk round them and see different profiles or aspects, but also that their spatial placement is crucial to the impact they make, as we shall see is also true with Judd's own work of this kind (fig. 123).

Judd considerably amplifies the sexual resonances of Oldenburg's work in an article on the artist written the following year, which remained unpublished until the first volume of Judd's collected writings came out in 1975. Here he tries to explain how the

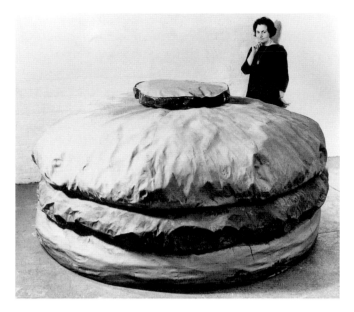

114 Claes Oldenburg, *Floor Burger*, 1962, canvas filled with foam and rubber, and cardboard boxes, painted with latex and liquitex, height 132, diameter 213 cm, Art Gallery of Ontario, Toronto, Purchase, 1967

evocation of nipples and breasts in the soft switches occurs by way of some simple immediate condensation of form that is quite different from figurative depiction. The object clearly is, as he put it, 'two switches or knobs, set side by side' formed of the 'same material', that 'bulges and sags the same throughout, and does not depict bodily forms', and yet

> The soft vermilion switch is sexual and also infantile. . . . The whole switch seems to be like breasts but doesn't resemble them . . . they aren't two breasts, but just two nipples . . . the whole switch is big and soft and the nipples are enormous – the main things.[19]

The sexual, he then goes on to explain, is one among several different kinds of affect that can be activated by the conjuncture of form and image in Oldenburg's work:

> A lot of the simple forms are sexual, such as the switches, the hamburger and the ice cream cone. These are senses of the body; some of the pieces are just that alone and aren't particularly sexual. Some of the pieces are shapes that have little to do with the body. They're shapes or movements of feelings.[20]

Prompted by having to negotiate the evident bodily resonances of Oldenburg's work, Judd offers an unusually forceful and fully articulated account of the anti-anthropomorphic imperative so strong in avant-garde and modernist circles, particularly in America, at the time. He makes the point that there is no direct correlation between the strong feelings elicited in the viewer by Oldenburg's work and the kinds of object the work represents. The evocative power of the work, and the identity of the useful

objects whose form they take over and inflate, do not correlate. By contrast, Judd explains, traditional anthropomorphism entails the belief that one's feelings about things say something significant about what these things are – some obvious examples of such anthropomorphic projection could include the sympathetic fallacy view of landscape, for example, or the classical theory that the harmonious feelings suggested by the beauty of an ideal figure bear testimony to a human capacity for an ideally harmonious subjectivity that is embodied in it. He sums up his position on the way Oldenburg's objects eschew traditional anthropomorphism as follows:

> It's pretty obvious that Oldenburg's work involves feelings about objects. His objects are objects as they're felt, not as they are. They're usually desirable objects, sometimes interesting or necessary ones. They're exaggerated, as interest is, gross and overblown, and simplified to what's most desirable about them or to what's most used. The grossness of the scale, simplicity and surface make it obvious that it's the interest in the object that is the main thing, not the object itself.[21]

Judd is trying to have it both ways. There is no denying the point that Oldenburg is playing around with feelings about objects and with the irrational sexual and bodily resonances that objects can evoke, and that his work also highlights the ludicrously illogical way in which the image of a perfectly ordinary functional object can elicit a sexual or other psychic charge. And yet there is a connection between what the viewer feels in response to a work by Oldenburg and what he or she knows about the real object it represents and how he or she imagines using it – biting into the excess of junk food evoked by the giant hamburger, for example, or feeling the disparity between the soft vermilion switches and the hardness of an actual wall switch that one would touch and push up or down. It is only because the connection is so blatant and connects so immediately to basic bodily activities and affects – ingesting things, handling things, prodding things – that it seems so different from the empathy informing traditional anthropomorphic projections of feeling onto objects.

There are signs that Judd is aware of the difficulties involved in holding onto a clear distinction between what he has in mind and anthropomorphism as it is commonly understood. He starts his essay on Oldenburg by saying that his work is so excessively or 'extremely anthropomorphic that it isn't anthropomorphic in the real sense of the word', and in 'Specific Objects' he describes Oldenburg's objects as 'grossly anthropomorphised objects'.[22] There is a disparity between the object and the feeling evoked, but also a substantive and literal connection between them, one whose crudity runs counter to conventional understandings of artistic expressiveness. Despite his very modernist attempt to separate a pure, immediately felt experience of form from feelings towards the object that the form represents, the details of his own analysis gainsay this. He almost admits as much when he makes the point in 'Specific Objects' that though 'three-dimensional work usually doesn't involve ordinary anthropomorphic imagery', 'if there is a reference it is single and explicit'.[23] The real issue Judd is raising is how in the new work, form, image and affect exist in a peculiarly direct and also inherently unstable relation to one another that is not mediated by formal subtleties, an instability exemplified in the unexpected and striking shifts from formal structure to vivid affect in Judd's art criticism from this period.

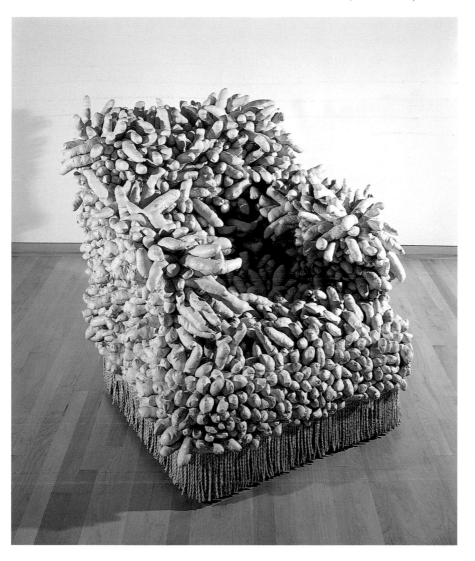

115 Yayoi Kusama, *Accumulation 1*, 1962, sewn stuffed fabric, paint, fringe on chair frame, 94 × 99.1 × 109.2 cm, Beatrice Perry Family Collection

In the case of all three artists featured in 'Specific Objects', Judd is promoting the idea of a specific object where simple image and striking formal qualities are brought into coincidence with one another in a process that is more like the uncontrolled psychic condensation in dream images than the process of integrating or juxtaposing different elements in traditional artistic composition. Hence his finishing the essay with the 'blatancy' and 'emotive form' of Oldenburg's 'basic and biopsychological' objects, with Bontecou's 'abatised orifices', and with the similarly 'intense, narrow and obsessive' work of another female artist, Yayoi Kusama, whose phallic 'boat and furniture' 'covered with white protuberances' (fig. 115) he singled out for mention. In this context Yves Klein's pure abstract blue object-paintings emerge as 'also narrow and intense'.[24]

All this seems to be at odds with the tenor of the earlier part of his essay, where Judd sets out a rigorously formal case for a kind of art that would break with the established aesthetic conventions of painting and sculpture. His idea of a new, more powerful, simple sense of wholeness, unmediated by conventional compositional processes where part is deliberately added to part to create an integrated whole, was defined in strictly formal terms by invoking new tendencies in American modernist painting also championed by Greenberg and Fried. He specifically cited the large-scale, rigorously abstract work of artists such as Newman, Pollock and Stella, where 'the elements inside the rectangle [of the canvas] are broad simple and correspond closely to the rectangle', 'the parts are few, so subordinate to the unity as not to be parts in an ordinary sense', and the 'painting is nearly an entity, one thing, and not the indefinable sum of a group of entities and references'.

But if this new painting was flat, all-over, largely denied pictorial space and eschewed conventional pictorial formats based on figures standing against a ground, Judd pointed out that there was still inevitably going to be some suggestion of depth, some degree of illusionistic figure–ground separation in any painting, unless there was a strict limitation to monochrome. For Judd, the logic of the situation favoured a move out from the confines of the canvas into three dimensions, thereby effectively abandoning, though he did not quite put it in these words, the by now rather stale, highly formalised concern with problems of flatness and depth, or with the tension between the actual shape and surface of the canvas and the depicted shape of anything delineated inside it, which were the stuff of high modernist art theory:

> Three dimensions are real space. That gets rid of the problem of illusionism and literal space, space in and around marks and colours . . . the several limits of painting are no longer present.[25]

The simple cogency of this argument, its challenge to high modernist picture theory, launched on the basis of its own formal logic, was partly what set Fried off and, more than anything else, may have made him envisage the new Minimalism as a serious threat. But it is still not the essence of what Judd has to say in his essay. Indeed, what looks most interesting in retrospect is the way that the objects which the essay goes on to discuss do not, to us at least, look like exemplars of the austerely abstract imperatives to which Judd theoretically seems to be committed.

This apparent disparity results in part from the nature of the work that was around when Judd was writing the essay, before Minimalism really got going, and also from the inevitably period-bound nature of his own taste. Judd may also have been fascinated by work whose overtly erotic overtones offered a counterpart to the much cooler, apparently disembodied style of his own practice as an artist. But the seeming disjuncture in his essay has much more cogency than this. A conscious strategy is at work which operates at two levels, one at that of Judd's conception of critical writing about art, with him distancing himself from the potentially arid formalism that might seem to be implied by his statements of general principle, and one at the level of a larger theoretical ambition to define the parameters of a new three-dimensional art in all their fullness.

In a passage in an essay on Pollock which he wrote in 1967, where Judd came as close as he ever did to explaining his views on art criticism, he insisted Greenberg-like on the

need to begin with 'the nature of the work', and, as he put it succinctly in a later interview, to keep to 'the pragmatic, empirical attitude of paying attention to . . . what is there'.[26] But, he hastened to add, 'this doesn't mean that the discussion should only be "formalistic" . . . Certainly the discussion should go beyond formal considerations to the qualities and attitudes involved in the work', even if it was very difficult to do this well in relation to 'specific elements in the work'.[27]

A proper critical analysis of significant three-dimensional art of the kind he attempted in 'Specific Objects', then, would on principle have to range widely and not only embrace a careful account of the specifically visual and formal aspects of the objects discussed, but should also deal with the basic feelings and attitudes informing the work, which of course the critic can only come to through the attitudes and feelings that they consistently provoke in him or her. Judd argued forcefully on occasions that a purely formal criticism was in the end no more illuminating than one that dealt in emotive responses. Real criticism was to be found somewhere in the mess in between the two. His comments on Fried's critical writing are revealing in this respect, if a little unfair in that Fried like Judd was quite capable of combining a carefully framed formal argument with flashes of intriguingly charged comment on the psychic and ideological resonances of a work – and given also that Judd's negativity must in part have been prompted by his taking umbrage over Fried's attack on him in 'Art and Objecthood':

> His pseudo-philosophical analysis is the equivalent of *Art News'* purple poetic prose of the late fifties. That prose was only emotional recreation and Fried's thinking is just formal analysis and both methods used exclusively are shit.[28]

The suggestive waywardness in Judd's criticism is not just something that strikes us in retrospect. Judd was dropped as a reviewer by *Art International* in 1965 because, as the editor wrote to him, though 'I like your writing when you . . . do a good square job of work; I don't like it when you talk off the cuff, it's too "informel" for my taste. Even garrulous at times – not because what you say isn't to the point or worth saying but simply, again, because of the shambling basic-Hemingway you elect to write.'[29] There is no doubt that Judd's deadpan writing style is often cultivated to the point where like Hemingway's it becomes stilted, even wilfully artificial. The very consistency of his literalism makes for loosely arrayed, disjointed prose structures quite unlike those of common speech – at times strikingly emphatic and charged and at others insistently flat and oddly inert.

The most significant factor in Judd's focus on work that elicits a powerful psychic charge has to do with a central formal concern of his 'Specific Objects' and its advocacy of a move from painting into three dimensions. For someone initially so imbued as Judd was with Greenbergian painterly conceptions of the formal integrity of the art work, how was the integrity of the three-dimensional object that moved outside these parameters to be guaranteed? In other words, how was one to create a compellingly whole object, detached from a pictorial frame and field and divested of the sense of evidently given unity this provided? At this stage, Judd seems to have felt a need to focus on work where the sense of wholeness would be amplified by a psychically charged image. He once commended Yayoi Kusama, whose blatantly sexualised objects (fig. 115) he had been drawn to for some time, for not, like so many other artists, downplaying 'those things'

she 'thought about most, the strongest and clearest attitudes, the psychological preoccupations', and instead dealing 'directly with her interests, developing them and making a clear and obvious form'.[30]

Such overtones are sometimes implicit in his general discussion of the formal imperatives guiding the new three-dimensional art in 'Specific Objects'. Take for example what he says about the new more intensely felt unity these created: 'the thing as a whole, its quality as a whole, is what is interesting. The main things are alone and are more intense, clear and powerful.'[31] Or consider how he envisages the move out from paintings to single objects existing in three dimensions as raising the level of psychic charge: 'A work can be as powerful as it can be thought to be. Actual space is intrinsically more powerful and specific than paint on a flat surface.'[32]

If these overtones are moderated in the statements Judd made in the interview 'Questions to Stella and Judd' published a year later in 1966, there is still a charged insistence on the idea of wholeness: 'Yes. The whole's it. The big problem is to maintain a sense of the whole thing . . . I just want it to exist as a whole thing'.[33] When Judd talks in these terms about the imperative to create simple whole objects, does he have in mind an absolutely pared down simple single form such as Tony Smith's *Die* (fig. 93)? If we think back to Judd's discussion of his three key object makers, this is clearly not the case. While he consistently lauds the absence of conventional compositional structure, his description of their work is at pains to highlight its different aspects or features as well as the sometimes apparently contradictory sensations these aspects evoke. The wholeness is a wholeness achieved through the striking conjuncture of several discrete and relatively autonomous features of the work, which are not brought into a calculated relation with one another but somehow are made to coexist convincingly. All-overness is a crucial issue, in that the aspects he responds to are ones diffused over the whole work, like the crumpled painted metal surfaces of Chamberlain's sculpture, or the simple image in Oldenburg's and Bontecou's work that encompasses the whole shape and does not separate out as a separate form. As he put it, 'In the new work the shape, image, color and surface are single and not partial and scattered', so 'there aren't any neutral or moderate areas or parts, any connections or transitional areas'.[34]

The favouring of the single simple thing that gets away from a fussing around with balancing and integrating discrete parts, and that has the affect of an indubitable powerful wholeness, is undeniably a distinctive feature of the artistic sensibility of the period, and one that is implicit in much so-called Minimalist work. While recent colour field and monochrome painting provided a certain precedent for such a conception of a whole object, post-war abstract sculpture offered little in this respect, based as it usually was on principles of collage or constructed composition. Indeed, Judd underlined the differences between his notion of a three-dimensional art and recent work by modernist sculptors such as David Smith[35] and Mark di Suvero,[36] and to a lesser degree Caro – whose early abstract work he had commended for being 'between ordinary sculpture and something new without sculpture's structure and qualities'.[37] Modernist sculpture, with its balanced constructions of metal beams and plates and wood planks and struts, was if anything more dependent for its formal syntax on a composed relation between parts than traditional sculpture. As Judd put it, this 'sculpture is made part by part, by addition, composed. The main parts remain fairly discrete.' While Judd looked to painting

for alternative models, Serra would turn to architecture as a basis for envisioning a three-dimensional art freed of modern sculpture's 'part-relation-to-whole' and 'steel collage pictorially and compositionally together'.[38]

'Specific Objects' is caught up in something of a compromise, at least if seen in relation to the purely abstract direction Judd's own work was taking at the time. The specific object exists in a region somewhere between the simple undivided three-dimensional form and the single powerfully charged, representational image, as if the compelling wholeness of form needed a boost from the psychic resonance of the image. This strategy partly compensates for an absence of any discussion of how a three-dimensional object might establish itself as a compelling physical presence and affect the viewer through its situation and its reconfiguring of its immediate environment. At this point Judd seems to assume that this mostly occurs by way of confronting the viewer with the image of some single powerfully affecting thing.

What Judd has to say on the situation of the object in this context is limited to one casually formulated point: 'obviously, anything in three dimensions can be any shape, regular or irregular, and can have any relation to the wall, floor, ceiling, room, rooms or exterior or none at all.'[39] Just to have remarked on this shows some consciousness on his part about how the positioning of a sculptural object might be part of its formal logic. But the comment reads as incidental to the main story he tells, the story of various kinds of simple, powerfully affecting whole things. Where his sensitivity to a three-dimensional work's occupancy of space emerges most clearly in his criticism from the period is, rather unsurprisingly, in his comments on Morris, an artist for whom he then had a very high regard. Morris is about the only artist whom Judd characterises in truly Minimalist terms, whose objects as he put it express the 'flat, unevaluating' anti-hierarchical view that 'everything is equal, just existing, and the values and interests they have are only adventitious.' Judd then goes on to comment that such 'Minimalism' in itself is not enough. One needs 'more to think about and look at' than these 'simple' and 'obdurate' 'facts of existence'. The work by Morris he finds most intriguing is enlivened by its dramatic intervention in space, work such as *Slab* (fig. 116), a simple eight-foot square and one-foot high grey-painted plywood object raised just above the floor. 'The space below it', he explains, 'its expanse . . . and this position flat on the floor are more interesting than the vaguely sculptural and monumental upright positions of the other . . . pieces.'[40]

Judd expands on this point in his commentary on Morris's installation in the Green Gallery in 1964 (fig. 103), where he indicates, as in his comments on Chamberlain, that the cool that interests him – and

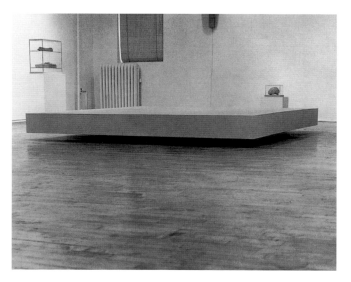

116 Robert Morris, *Slab*, 1962, painted plywood, 30 × 244 × 244 cm, Solomon R. Guggenheim Museum, New York

he specifically calls Morris's work cool – is one offset by some other specific quality, something a bit sexy or powerful:

> Morris's pieces are minimal visually, but they're powerful spatially . . . *The Cloud* occupies the space above and below it, an enormous column. The triangle fills a corner of the room, blocking it. The angle encloses the space within it, next to the wall. The occupancy of space, the access to or denial of it, is very specific.[41]

There is one point in 'Specific Objects' where Judd suggests that the more interesting contemporary object-making does not just involve work based on very simple, striking whole-looking forms. Trying to sum up the main tendencies evident in the work he has been surveying, he comments that 'the most obvious difference within this diverse work is between that which is something of an object, a single thing, and that which is open and extended, more or less environmental'.[42] By opening up the conception of a specific object so that it is not defined entirely in terms of a single shape looming before the viewer, a little like a traditional figurative sculpture, and by thinking of more extended structures that might have an equally compelling but very different kind of impact, he is directing attention to some of the different ways in which three-dimensional work might situate itself in its environment and relate spatially to the viewer.

'A Single Thing . . . Open and Extended'

This is the point to consider Judd's practice as an artist, as well as his own acute reflections on his own practice that he, like many of his contemporaries, developed in interviews, most fully in the long interview with John Coplans published in the catalogue of his one man show at the Pasadena Art Museum in 1971. The point he made in 'Specific Objects' about there being two main types of new three-dimensional art, either 'something of an object, a single thing', or work that was 'open and extended', nicely encapsulates a basic distinction in his own work between single-unit pieces (fig. 109) and those composed of repeated units spaced out along a line, either vertically or horizontally (figs 122, 123). It is more fruitful, however, to think of this distinction as one that operates internally to both kinds of work Judd was producing at the time. Any of the works posits a certain tension between the articulation of a clearly defined whole and a certain openness and extension in relation to the space immediately round it. While he did make several closed-in box-like works when he first moved into three dimensions, very soon even the single-unit pieces were given transparent or open ends or sides (fig. 101) or open tops, so that they were visibly not completely closed off from their surroundings. And even the very early wooden boxes were not entirely closed, nor were they exactly simple unitary *Gestalts*, as Morris would put it (fig. 110). Judd himself was adamant on this point in his interview with Coplans, insisting 'I didn't want to make just lumps. I didn't want to make just a red box. That seemed too easy and pointless.' To do so would simply have meant echoing in three dimensions the formal dead-end of monochrome painting.[43]

Seen in relation to work such as Tony Smith's *Die* (fig. 93) or Morris's *Slab* (fig. 116), Judd's early red-painted boxes almost seem a little elaborate, showing that there is some

logic to Judd's strong objections to the minimal or reductive tag against which he was already protesting in the statement he published in the catalogue of the 'Primary Structure' exhibition held at the Jewish Museum in 1966, an exhibition that helped to define public awareness of the new Minimalist three-dimensional work. There he insisted that 'new work is just as complex and developed as old work. Its color and structure and its quality aren't more simple than before'.[44] Indeed, none of the hollow, red-painted plywood boxes he exhibited in 1963 are just cuboid shapes. In all cases the top is cut into in some way. In one (fig. 110), an open semi-cylindrical groove running just off centre for the length of the box exposes an interior space punctuated by vertical slats separated by gaps which grow progressively wider from one end to the other. In another (fig. 109), a similar cut or indentation forms a hollow in which rests a cylindrical iron pipe open at both ends. With both these works, not only does a strictly rectilinear shape coexist with another quite different rounded shape, but a tension is set up between the sheer upper surface of the box and the cut or indentation made into it, which in turn activates an awareness of how the hard, flat outer surfaces surround an interior volume.

The outer facets of the boxes have a visual density in their own right because of the intense cadmium red hue and the slight reflectivity of their painted surfaces. This makes the variations in optical value of the different facets resulting from their different orientation to the incident light much more vivid than the purely tonal variations of the visually comparatively dead surfaces of Morris's plywood constructions from this period. Colour was clearly very important for Judd, both as a phenomenon in its own right and as means of activating a more intense sense of shape. When asked about his use of 'cadmium red light' paint, he explained that this was a colour whose 'quality' he really liked and one 'that really makes an object sharp and defines its contours and angles', adding 'at the same time as I was interested in developing plain surfaces, I was also interested in developing colours in a strong way'.[45] He naturally took issue with Morris's idea that sculpture required an absence of colour. Even Morris's grey was a colour of a particular kind, he pointed out: 'I consider everything to be color, including grey, so that business of grey not being a color that Morris talks about is nonsense.'[46]

Judd soon abandoned painted wood and used more expensive materials with smoother, harder and more reflective surfaces. These included metals that were simultaneously matt and slightly reflective, such as galvanized iron, anodized aluminium and stainless steel or, occasionally, shiny and highly reflective, such as polished brass, as well as translucent, tinted perspex. This shift was a highly self-conscious one that relates to a consistent preoccupation on his part with sharply defined surface and volume, and with colour and the play of light on surface. Rather than using a material whose surface would have to be coloured for it to achieve definition, in the way that paint was used to activate the indefinite canvas support of a painting, Judd sought materials that already had the surface qualities he wanted, even if he would sometimes still use paint (fig. 127) or a covering of tinted perspex to create colour contrasts (fig. 117). When he did use plywood again, starting in the early 1970s (fig. 119), the sheets were much thicker and unpainted. At this point, he was deliberately exploiting the matt, slightly dead texture of the wood and the less shell-like feel of its surfaces with a view to focusing attention on some larger architectonic or purely spatial effect.

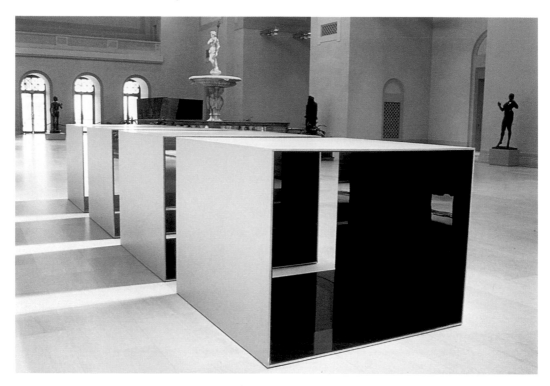

117 (*above*) Donald Judd, *Untitled 1969*, anodized aluminium, interiors lined with blue plexiglass, four units, each 122 × 152.4 × 152.4 at 30.4 cm intervals, St Louis Art Museum

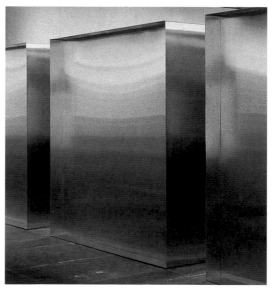

118 (*right*) Donald Judd, *Untitled 1968*, stainless steel, eight units, each 122 × 122 × 122 at 30.5 cm intervals, collection of Kimiko and John Powers, detail

119 (*facing page*) Donald Judd, *Untitled 1973*, plywood, seven units (no back), each 195.6 × 195.6 × 195.6 at 10.2 cm intervals, Museum, Wiesbaden

When asked about his earlier switch from painted plywood to metal, Judd explained:

the wood was a little bit absorbent the way canvas was. It wasn't hard enough a surface. It also had to be a thick surface, and I wanted a thinner, more shell-like surface, so that the volume inside would be clear. Half-inch plywood is pretty indefinite material.[47]

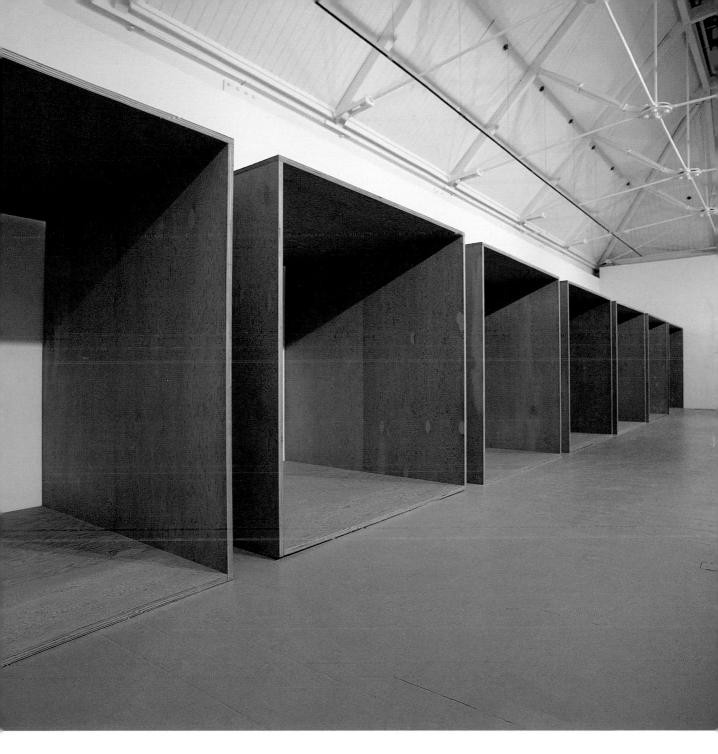

In his metal pieces, the viewer is usually prompted to envisage the outside of the sculpture as a shell enclosing a volume by an opening into the interior that makes some of the thin edges of the sheets of metal clearly visible (figs 128, 129). Where the metal units are entirely boxed in (figs 122, 123), there are always edges with exposed joins that allow one to gauge the thickness of the metal sheets, and one's perception of this is often enhanced by a recessing of the top or side (fig. 118).[48] This conception of sculpture as

being a shell enclosing a volume is something Judd very much responded to in Chamberlain's painted crumpled metal sculptures: 'Chamberlain's use of volume was important for me', he explained.[49] His description of Chamberlain's *Miss Lucy Pink* (fig. 111) gives a vivid indication of what was at stake, formally at least, in his rethinking of sculpture so that it would no longer be some optically inert plastic shape:

> The metal surrounds space like the eggshell of a sucked egg, instead of defining it with a line, core or plane. The hard, sweet, pastel enamels are the colors of surfaces, not solids.[50]

Some of what Judd says here might put one in mind of David Smith's late *Cubi* (fig. 79), works that deal in volumes and optically activated surfaces or skins in ways that must have been suggestive for Judd. Smith was also one of the few sculptors of an older generation who, like Judd, took colour seriously. This suggests that one may need to qualify the comments Judd makes, from his essay 'Specific Objects' onwards, about the structural difference between his approach to sculpture and Smith's. Indeed, in his 1973 interview with Coplans, where he repeats his characterisation of Smith's work as the epitome of 'part-by-part play', he admits that Smith did after all offer an alternative to 'standard vertical gestural sculpture', and adds 'I like David Smith's work mostly.'[51] In a review of Smith's late *Cubi* written in 1964, the year before 'Specific Objects', Judd begins by characterising Smith's sculpture as 'some of the best in the world' and analyses works such as *Cubi XIX* in terms indicating that they clearly echo his own interest in a new kind of simple disjunctive wholeness.[52] One might see the situation as Andre characterised it when he said that it was the very cogency of David Smith's achievement that prompted younger artists to look in other directions.[53]

There is one further feature of Judd's early wooden boxes (figs 109, 110) that needs to be highlighted since it distinguishes them in no uncertain terms from either simple Minimalist shapes or traditional sculptures in the round. They are not cubes but rectilinear forms with a clearly defined directional axis that makes it impossible to envisage them as all-round ideal forms, like a traditional sculptural figure. This is accentuated by their being so low-lying. They are just under twenty inches high and so in no way loom before one as clearly defined shapes cutting into space. They are if anything quite awkward to look at, neither lying flat out on the floor, nor rising up vertically to meet one's look, and offering no nicely focused overview. As Judd put it, on one of those few occasions where he referred explicitly to a work's situating of the viewer, 'there are no front or sides – it depends on the viewing position of the observer.'[54]

When all is said and done, though, there remains in Judd's case a fetishising of the box-like shape, which was a distinctive feature of Minimalism extending from art to interior design and architecture, and which could range in tenor from an obsession with aesthetic coolness to a libidinally more obviously charged fascination with biggish simple empty shapes with voluminous interiors. This obsession with the box also relates to Judd's initial involvement with a Greenberg-style modernist painting. The basic format of the box served as the three-dimensional equivalent of the rectangular canvas support in painting, and hence as a constitutive formal parameter of his work. We should also bear in mind Serra's point about the white box interiors into which the Minimalist boxes were designed to fit, the art work neatly echoing the more neutral forms of its container.

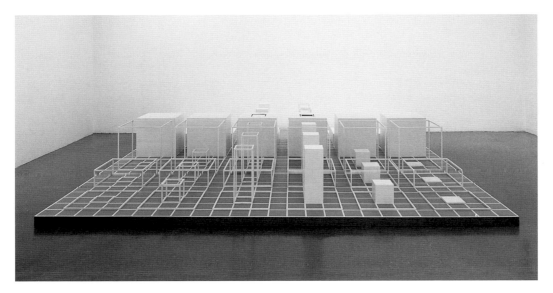

120 Sol LeWitt, *Serial Project No. 1 (ABCD)*, 1966–7, baked enamel on aluminium, 51 × 399 × 399 cm, The Museum of Modern Art, New York. Gift of Agnes Gund and purchase (by exchange)

At the same time, the box also functioned as such a serviceable shape for Minimalist artists like Judd because there was nothing very special about it. Being so basic, it could hardly be seen as defining the essence of a work. Sol LeWitt published a rather intriguing statement about the cube in 1966 which echoes Judd's concerns, if for a moment we take him to be referring to any simple rectilinear box-like form and not just a perfectly symmetrical cube:

> The most interesting characteristic of the cube is that it is relatively uninteresting. Compared to any other three-dimensional form, the cube lacks any aggressive force, implies no motion, and is least emotive. Therefore it is the best form to use as a basic unit for any more elaborate functions, the grammatical device from which any work may proceed. Because it is standard and universally recognised, no intention is required of the viewer. It is immediately understood that the cube represents the cube, a geometric figure that is incontestably itself.[55]

Whereas LeWitt used undifferentiated cubes as basic neutral units, like a line or square in drawing, from which he could generate any variety of invented structures (fig. 120), Judd's use of uniform box shapes was a little different, more phenomenological than conceptual. He deployed these structures as neutral overall shapes that would allow him to focus on other aspects of the work's appearance, the sense of scale, the occupancy of space, the activation of one's sense of edge and surface, and of interiority and exteriority. As we have seen, in phenomenological discussions of perception, the cube was often invoked because its simplicity allowed one to focus on the process of apprehending it, rather than on the shape itself.[56] It is somewhat in this spirit that Judd takes the box or cuboid shape as a basis for creating three-dimensional objects that elicit from a viewer an intensified awareness of his or her immediate perceptual engagement with the things and spaces he

or she is looking at. This of course would not work in practice were not other more local factors in play, particularly the art world's obsession with simple regular geometric shapes that made their deployment seem natural as a basis for exposing the ambiguous fascinations of viewing.

* * *

The empty box shape also has certain formal features that suited Judd's purposes particularly well, in that it is a simple structure with a clearly delimited boundary but without a precisely defined core or centre. The place it occupies is exactly defined – an effect enhanced in most of Judd's work because the interior is open to the supporting ground, whether floor or wall – but its centre is diffused over the whole volume it encloses. This ambiguity echoes something of the viewer's internalised sense of being situated in a particular area but not in one precise spot. Moreover, because of the slightly asymmetrical rectangular space occupied by the work, and the emphatic alternation of flat surface and sharp corner it presents as one moves round it, one's viewing of it cannot quite be structured as a continuous circling round a fixed centre.

The slight decentring and skewing becomes much more marked with a series of identical boxes set out in a line (fig. 118). Looking closely at such work, one's viewing is caught up in a successive displacement from unit to unit that actively forestalls seizing on the work as a firmly centred whole. In one of his very earliest full-scale works in this vein, Judd sought to mitigate the effect with a thin blue connecting beam running the length of the series (fig. 121), but he never used this compositional device again, perhaps because it drew attention to the disconnection it was trying to bridge. What is more, one's movements around a multi-unit work are much more radically skewed off-centre than with a single box. The decentring effect of the extension along one axis is amplified in cases where the boxes are open at both ends and a vista can be had along the length of the interior that simultaneously draws the units together as a long tunnel and dispels one's sense of the work as a closed shape with clearly bounded ends (fig. 117).

Judd's works, particularly those composed of a series of separate units, both offer the viewer a very simple clearly defined overall structure and block a conventional sculptural apprehension of this shape as an integrated whole, whether in terms of some inner core anchoring the whole structure, or of some fully present dense and clearly centred shape. Insomuch as the work operates as a whole, this is located in feeling that something is there that both encloses a space and opens out to the space immediately around it and manifests itself, not in the form of a single plastic shape or structure but of a variety of vividly particular sensations and aspects, some of which momentarily may seem disparate. This interplay between a sense of bounded, clearly situated wholeness on one hand, and of openness and dispersal on the other, echoes and is sustained by the similarly inflected, internalised sense of occupancy of space activated by engaging closely with the work.

If there is almost nothing in Judd's 'Specific Objects' essay to indicate how situation might play a role in his understanding of the specificity of a three-dimensional object, this becomes clearer if one considers how he envisaged his own work. The oeuvre cata-

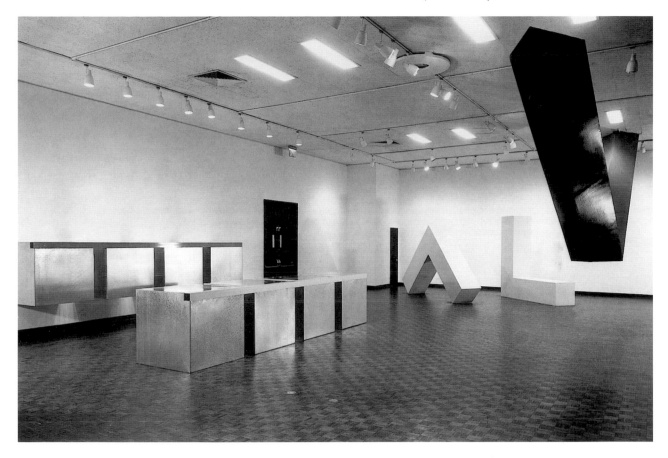

121 Donald Judd, *Untitled 1966* (on wall), and *Untitled 1966* (on floor), installed at the 'Primary Structures' exhibition in the Jewish Museum, New York in 1966 (with Robert Morris's *L-Beam*s in right background), each work comprising four galvanized iron units (101.6 square and separated by 25.4 cm spaces) with blue lacquered aluminium connecting strip inset, overall 101.6 × 482.6 × 101.6 cm (wall version in Norton Simon Museum, Pasadena, floor version destroyed)

logue accompanying his major retrospective held at the National Gallery of Canada in 1975 makes explicit how he sees specificity operating in a number of different registers, including not only materials, colour, scale, number and shape of units, but also placing or situation. A work becomes a different work if any one of these parameters is changed. Thus a series of four galvanised metal boxes are one work when their 'specific situation' is on the floor and another when they are cantilevered off the wall (fig. 121). To make this point, Judd exhibited two such works alongside each other at the 1966 'Primary Structures' exhibition, where Morris also offered up his more theatrical demonstration of situatedness with two differently orientated L-beams (fig. 102).

The difference between the pieces cantilevered off a wall and those set on an empty area of floor should not be confused with the traditional formal distinction between relief sculpture, even work in high relief, and free-standing sculpture. The closest parallel is architectonic, between say a sarcophagus set some way up a wall and one resting in the middle of the floor, give or take the fact that rarely are these simple shapes set against

the wall or on the floor without the mediation of mouldings or brackets or a plinth. In relief sculpture, by contrast, the protruding shapes emerge from a ground that frames and contains them, so the basic formal parameters are the same as those in painting. Judd, no doubt aware of the tendency to assimilate the viewing of three-dimensional work to the more familiar viewing of painting, felt he had to spell out how his stacks (fig. 122) and other works attached to the wall (fig. 123) were not to be seen in painterly relief-like terms:

> It is like a form cantilevered off the wall, as against a painting that clings to the wall. One is aware of the weight of the pieces thrust forward and the fact that they're being cantilevered off the wall.[57]

The constructional technique of cantilevering also means that the joining of the units to the wall is clearly distinguished from the way that paintings are hung against a wall or reliefs are embedded within it. The mechanics of the system of attachment Judd used are always carefully hidden from view so the units almost seem suspended rather than held in place, abutting the wall rather in the way that floor units simply rest on the ground. At the same time, however, one's awareness of gravitational pull means that a tension enters into one's perception of their placement, one that intensifies the feeling that they loom out at one and that counteracts any tendency there might be to see them recede as flat shapes.

The stacks (fig. 122) were conceived so that they could be situated very specifically in relation to the space where they were set, running in a continuous, evenly spaced series from floor to ceiling, though in practice they are often shown in galleries where a gap will open up between the top unit and the ceiling (fig. 128). The precise location of the horizontal rows of units (figs 123, 129) in relation to the floor was also crucial. This was carefully spelled out by Judd in another of his rare comments about how he envisaged his work being placed in relation to the viewer:

> The height of the boxes from the ground is . . . critical. The viewer is meant to see a little of the tops of the boxes, but the ceiling height doesn't matter. They should be hung at either sixty-two or sixty-three inches. The choice of that height is meant to avoid flattening the boxes when they are on the wall. If the viewer can see a little of the top plane it's going to keep them three-dimensional.[58]

Judd certainly has a point. His wall-hung pieces impinge just as insistently on one's sense of space as the floor pieces. Moreover, if they cannot be viewed all round, they demand to be seen from the full semi-circular array of positions still open to one.[59] This is most evidently the case with the series of units that have open ends (fig. 129), where one is clearly encouraged to try looking at the work from the side to get a clearer view into the interior. Just as with the free-standing floor units, there is a decided shift in one's apperception of the work as one moves from one position to another. Seen centrally, head-on as it were, and at a certain distance, such work can look fairly dispersed (fig. 123) because the gaps between the units are clearly visible. By contrast, the sharp diagonal view to be had standing close to the work at one end creates a strong sensation of it as a single thing. From here its overall depth stands out clearly and the gaps between the units look a little

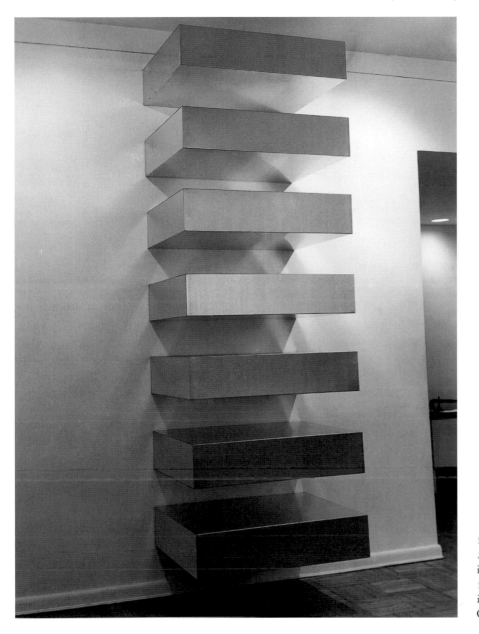

122 Donald Judd, *Untitled 1966 (stack)*, galvanized iron, ten units, each 23 × 101.6 × 78.7 at 23 cm intervals, Locksley/Shea Gallery, Minneapolis

like slightly darkened or tinted vertical bands connecting the wider unshadowed front surfaces.

* * *

When Judd stated in 'Specific Objects', 'it isn't necessary for a work to have a lot of things to look at, to compare, to analyze one by one, to contemplate. The thing as a whole, its quality as a whole is what is interesting',[60] this has to be read in a particular way.

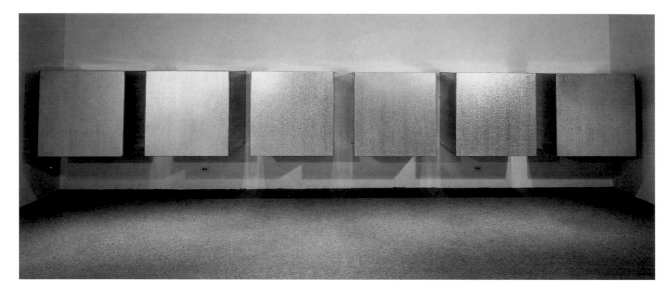

123 Donald Judd, *Untitled 1966*, galvanized iron, six units, each 120 × 120 × 120 at 30 cm intervals, as shown at the Dwan Gallery, New York, 1967, Donald Judd Estate, Marfa

Otherwise it will simply belie his own practice, especially the multi-unit works, as well as contradict what he says elsewhere about the 'new work' being 'just as complex and developed as the old work'.[61] At issue is precisely what he means by whole and how he conceives the disposition and constitution of those things or parts one might look at one by one. For a start, the whole is not the encompassing or structuring form of the work. It is rather the unspecifiable sense of wholeness one has when looking at it closely and becoming aware of its visual and spatial specificity. What is misleading is the implication that the work should offer no distinct parts or aspects that seize one's attention, and that one should only have a sense of it as an undifferentiated oneness. Judd's real point in arguing against part by part distinctions, even if it is lost in his momentary fixation on 'the thing as a whole',[62] is that a work's more striking aspects should not separate out as distinct forms balanced against one another within a larger compositional format. Rather they should be distinct and yet also dispersed in some way over the whole of the work.

Hence, in work composed of several separate units, like his early series of closed galvanised metal boxes, each forty inches square and separated by ten inch gaps (fig. 123), all the units have to be exactly equivalent. They also have to be repeated more than twice to avoid any suggestion of compositional balancing and give one a sense of a shape echoed over the whole extent of the work. If one focuses on any single aspect of it, the sheen on the outer faces of the galvanised metal units, for example, or the sharp edges separating the visually more activated outer surfaces from the shadowed and matt-looking side surfaces, or the empty gaps between the sheer expanses of the units' outer faces (fig. 124), these seem dispersed everywhere because of the basic repetitive array the work establishes. Here an even sharper interplay is set up between a sense of closed single wholeness and dispersed extension than with the single-unit pieces. But where is the significance,

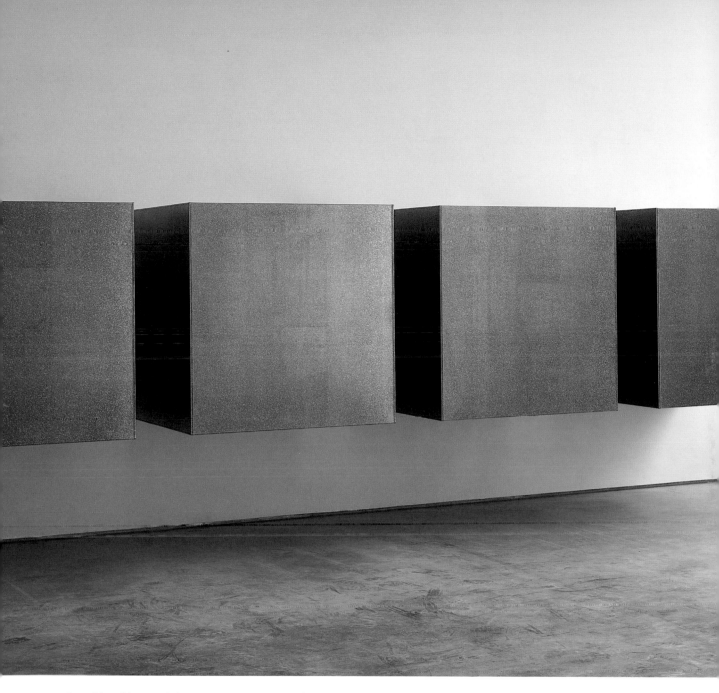

124 Donald Judd, *Untitled 1988*, galvanized iron, four units, each 101.5 × 101.5 × 101.5 at 25 cm intervals, Lisson Gallery, London

where is the charge in all this? Why is it not just another empty formal play, like the late Cubist compositions that Judd was trying to get away from? This is something I shall be addressing in the next section.

* * *

Space, Time and Situation

There is an intriguing passage in a late essay by Judd called 'Abstract Expressionism' in which he explained how the painting he particularly admired, the work of Jackson Pollock and Barnett Newman, provoked a powerful response that was quite different from the 'immediate emotions you feel when looking at the world' – by these he no doubt had in mind, not just conventional poeticised emotions such as gloom or regret or elation, but also other immediate, less nameable affects. He went on: 'The thought and emotion of their work is of the more complex kind, undefinable by name, underlying, durable, and concerned with space, time and existence.'[63] This take on Newman and Pollock is straightforwardly modernist, and in many respects directly echoes Greenberg's outlook. Judd was insisting that the most profound art, the art that engaged the viewer at the deepest level of which visual art was capable, was a radically abstract art that had no truck with representational content or conventional expressive feeling. But unlike Greenberg, Judd did believe that something could be said about the larger significance or content of such art.

He was explicit on this when he came to try to sum up what he felt the larger significance of his own work might be – work he clearly saw as continuing within the parameters opened up by Newman and Pollock:

> My work has the appearance it has, wrongly called 'objective' and 'impersonal', because my first and largest interest is in my relation to the natural world, all of it, all the way out. The interest includes my existence, a keen interest, that is created by the existing things. Art emulates this creation or definition by also creating, on a small scale, space and time.[64]

Nothing if not grandiose, but interestingly also specific in its phenomenological insistence that art has to do with the relation between self and physical world. Art's imbrication in one's sense of existing as a physical entity also had for Judd a latent social dimension, as he made clear when he commented that 'art is certainly about the existence of whoever is doing it and by implication about the existence of other people. And, of course, the existence and the circumstances a person exists in.'[65] Within this framing, the significant social – and also potentially political – content of art did not have to do with a social truth or attitude it expressed or represented but with the fact that it was of its very nature rooted in social existence. Art, in other words, did not articulate existential truths but functioned by being embedded in the network of relations between self and world and self and other that constitute our being alive.

Time and space, understood in these existential terms, were not objectively given entities but, according to Judd, needed to be activated in the process of establishing oneself as being there at a particular place and time. 'Space doesn't exist; time doesn't exist either', as he put it. 'So you have to make them exist. We know space and time, because things occur in them, are in it or happen in it. They are made by positions, events.' Judd's mind-set regarding this matter could be located somewhere between an eighteenth-century Humean empiricism and a twentieth-century existential phenomenology, though the rhetoric, the succinct concreteness of his formulations, puts his style of thinking more in the former category. What is particularly interesting, though, is that

125 Barnett Newman, *Vir Heroicus Sublimis*, 1950–1, oil on canvas, 243 × 542 cm, The Museum of Modern Art, New York. Gift of Mr. and Mrs. Ben Heller

he then goes on to give a larger conceptual framing to an idea widely current among his contemporaries, that a three-dimensional work of art is not an autonomous resplendent thing but has the conditional autonomy of something intervening in and activating the relatively neutral space surrounding it. As he put it, 'When you make a work of art, you are making space or further architecture . . . We have space in this room, but it is a weak nondescript, neutral space.'[66]

Judd's fullest account of how a work of art might activate a heightened sense of being situated in space and time comes in his discussion of Barnett Newman (fig. 125). Here he singles out several statements made by Newman, feeling that they 'explain much about his work' and also that of other Abstract Expressionists whom Judd admired, including the following:

> 'One thing that I am involved in about painting is that the painting should give a man a sense of place, that he knows that he's there, so he's aware of himself . . . that the on-looker in front of my painting knows that he's there . . .'[67]

Interestingly, Newman envisaged the sculpture of Judd and that of several of his contemporaries in exactly these terms, explaining how 'some do make something where if you stand in front of it you know that you're there'.[68] It is clear that Newman's work was a particularly important point of departure for the new three-dimensional art of the 1960s. Serra indicated how and why this was the case: 'In Newman content is inseparable from your sense of space and time. Without your experience there is no content in a Newman painting.'[69] Morris too felt deeply drawn to Newman's work and commented

on its 'real sense of immediacy, the greatest sense of immediacy of any painting that I have experienced.'[70]

For Judd, the sense of situation produced by Newman's work was not that of a 'single whole thing' located firmly in one place but was more 'open and extended'. In Newman's painting, he explained, 'the areas are very broad and are not tightly delimited by either the stripes or the edges of the canvas'. Particularly striking was 'Newman's openness and freedom', qualities that the 'closed somewhat naturalistic form' of earlier painting did not have.[71] According to Judd, the sense of '"place", "here", "moment", "now"' that his paintings asserted was an expansive one, though also one that involved an emphatic, almost heroic self-affirmation – I must admit I have cut out a certain amount of melo-dramatic heroics from the statements by Newman that Judd quotes. But if this accent is prevalent throughout Judd's commentary on art, he is also intrigued by other styles of being that works of art can posit, and it is probably most fruitful to see his own art as operating somewhere between heroic gesture and a down-beat matter-of-factness. I quote from some comments occasioned by an early exhibition of Morris's early grey plywood objects:

> these facts of existence are as simple as they are obdurate . . . Things that exist exist, and everything is on their side. They're here, which is pretty puzzling . . .[72]

The paintings of Newman, and of Pollock, were also exemplary for Judd because they apparently differed categorically from earlier European abstract painting by defining a new conception of pictorial wholeness. This insistence on a restructured sense of whole-ness, shared by a number of Minimalist artists working in three dimensions at the time, now seems one of Judd's more narrowly formalist obsessions.[73] However, already in the 1966 interview 'Questions to Stella and Judd', he was putting a larger philosophical gloss on it. He made the point, often repeated in his later writing, that traditional pictorial composition related to a rationalist, one might say Cartesian, world view that was no longer credible. An art based on compositional structures, where discrete parts were care-fully added together to create an integrated whole, was, as he explained, 'based on systems built beforehand, *a priori* systems; they express a certain type of thinking and logic that is pretty much discredited now as a way of finding out what the world's like' by 'both philosophers and scientists'.[74]

Judd's views are firmly in line with much philosophical thinking in the period that set up Cartesian rationalism as something of an aunt sally, epitomising an overly schematic and subject-centred understanding of consciousness and perception. His ideas also have affinities with the phenomenological critiques of rationalistic models of coher-ence implicit in traditional understandings of viewing and one-point perspective that were developed, for example, by Merleau-Ponty. But this does not get us very far in under-standing precisely what was at issue in the non-compositional sense of wholeness that Judd insisted on, in contrast with later post-modern or post-structuralist deconstructors of rationalist paradigms. His notion of the art work as a thing whose wholeness impresses itself on one immediately and forcefully carries overtones of powerful, in some ways macho, intensity, but this, as we have already seen, is not by any means all that is involved.

We need to begin with one of Judd's clearest early statements about how a viewer experiences a work of art: 'The wholeness of a piece is primary, is experienced first

and directly', he wrote. 'It is not something understood by the contemplation of parts.'[75] But what is this immediately felt sense of unity? In a lecture he gave in 1983, he explained how, in his view, a work of art had unity in the same way that a person had unity, as a basic fact of his or her existence rather than as an effect of his or her rational self-awareness:

> A person ordinarily lives in a chaos of a great diversity of ideas and assumptions, but does function after all as one in a natural way. A person is not a model of rationality, or even of irrationality, but lives, which is a very different matter. . . . Most people have some philosophical ideas. Almost none live by one of the grand systems, only by their fossil fragments. Neither is art at the present based on a grand system. The unity in art is the same kind of natural unity and is made similarly in the realization that knowledge is very uncertain and fragmentary. But as one lives with some assertion, art can be made with a corresponding assertion and confidence. There's no other way.[76]

The last comment makes it clear that the unity or wholeness of the art work was not some given entity. It had to be constituted or asserted – 'one lives with some assertion . . . There's no other way.' Its unity was not to be compared to the vague unfocused unity of a whole person's life but to the condensed unity manifest in a single declarative action. As Judd put it, art 'must be as decisive as acts in life, hopefully more so'. So while 'Art is made as one lives', 'the assertions of art depend on more organization and attention than is usual in living . . . so that it be clear and strong'. The 'clear and strong' gives a distinctive local, rather masculine, accent to the idea of wholeness and unity, which is amplified in a comment in Judd's essay on Malevich where he conjures up an even more specific sense of male Minimalist cool: 'With and since Malevich the several aspects of the best art have been single, like unblended Scotch. Free.'[77]

At this point we should remind ourselves that Judd is talking about unity constituted in the artist's act of making the work. In his view, 'embodiment is the central effort in art, the way it gets made, very much something out of nothing. Everything happens together and exists together . . .'[78] But equally, this unity has to be understood as constituted in the viewer's encounter with the work. There is a necessary reflexivity between what Judd says about making and what we are to understand about apprehending a work, given that the declarative force of the making can only operate if there is an internalised other to whom the artist imagines addressing her or his work, however unconsciously.

* * *

To focus on the preoccupation with wholeness and unity is a little misleading, partly because it is manifestly at odds with the logic of Judd's own practice. It also does not tally with some of his theoetical pronouncements. In the essay 'Jackson Pollock' he published in 1967, which offers a much more fully developed account of the formal priorities of the new art as he saw them than his 'Specific Objects' essay of two years before, the really significant novelty of Pollock's work is seen as lying, not just in 'the large scale, wholeness and simplicity which have become common to almost all good

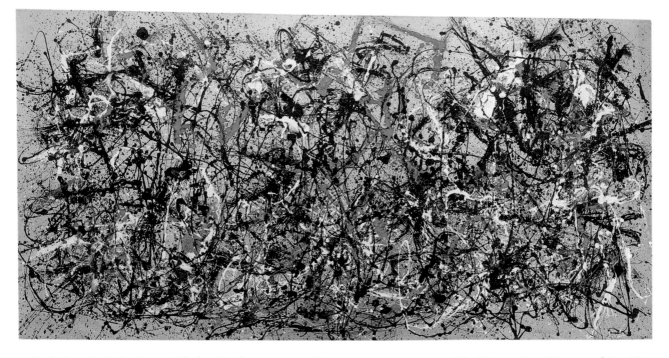

126 Jackson Pollock, *Autumn Rhythm: Number 30*, 1950, oil on canvas, 270 × 540 cm, The Metropolitan Museum of Art, New York, George A. Hearn Fund, 1957, (57. 92)

work', but also in 'a different idea of the disparity between parts or aspects and . . . a different idea of sensation.' Pollock, he explained, departed from the traditional conception of pictorial wholeness in which 'disparity is increased as much as possible within the limits of a given quality, wholeness or generality' and where the parts, for all their particularity, are subordinated to some 'general or main quality', and 'there's a gradation or evening out of parts and aspects.' By contrast, 'the elements and aspects of Pollock's painting are polarized rather than amalgamated . . . Everything is fairly independent and specific.'[79]

The essay then identifies what Judd saw to be some of the specific, immediate and undiluted qualities found in Pollock's work: the effect of dripped paint, the materiality of certain particularly striking colours, the distinctive kind of space the work forms and odd fascinating configurations, like the right angle high in the upper right-hand corner of *Autumn Rhythm* (fig. 126). Such configurations may seem suspiciously like parts of a traditional composition. What Judd had in mind, however, were configurations that stand out and float free and are not anchored in a larger overall configuration, and whose distinctive formation is independent of any shaping elsewhere in the canvas.[80] The really important point, though, is the conclusion he reached. This is stated most unequivocally in an assessment of Abstract Expressionism which he prepared in 1983 where he said of Pollock's work:

The sensation of dripped paint, the configurations made by it and the whole of any painting are further apart in quality than is usual. A fragment of a Pollock would have

much less of the quality of the whole than any part of a DeKooning . . . The greater the polarity of the elements in a work, the greater the work's comprehension of space, time and existence.[81]

Two points are particularly worth noticing. Firstly, Judd is indicating something of general significance, that the sense one has of the more vivid parts or aspects of a work is often not integrated within one's apprehension of its whole form or structure. If a compelling intuition of the wholeness of the work emerges as one experiences the flux of various and at times sharply distinct part-views or aspects, this intuition can be all the stronger if it sustains itself through – and is amplified by – the experience of a part or aspect that affects one so intensely that it momentarily completely holds one's attention. If something about the work's form or structure does come sharply into focus, then this is not the essence, the organising principle of the work, but rather one striking aspect of it. Judd is effectively challenging the parameters of, and suggesting an alternative to, a conventional formal analysis based on the idea that a work is defined by a determining compositional structure or overall shaping of plastic form – whether this structure or shaping is defined as integrative or in more modernist terms as some complex union of dissonant or conflicting parts.

Secondly, there is an important point that relates to the temporal rhythm of viewing implicit in Judd's insistence on the discreteness or specificity of the different aspects of a work. He might be seeming to advocate a return to a Humean understanding of the separateness and integrity of certain basic sensations, and there is no doubt an element of such eighteenth-century empiricism in his style of thinking. But he is making an important point about the particular kind of viewing invited by his own work and the abstract painting to which he felt such affinity. It is a kind of viewing that is continually shifting from one strongly felt aspect of the work to another, bringing with it a heightened awareness that the apprehension of the work is not entirely instantaneous but takes place over a period of time, a period enlivened by an intensified focusing of looking that does not occur in everyday perceptual encounters with things.

His detailed analysis of Newman's paintings can at first reading seem to be a rather bare, deadpan description of what is there before one's eyes, but it is also structured as a finely tuned account of the temporal experience one has in concentrating on different features. In the case of *Vir Heroicus Sublimis* (fig. 125), he briefly specifies the colour and width and spacing of each vertical strip, and the colouring of the areas or fields to either side of them, and then makes the point: 'these stripes are described in sequence but of course are seen at once, and with the areas.'[82] The preceding description taken together with this statement are true to one's apprehension of the work as something that is seen both in a succession of differently focused apperceptions and as one thing. Judd then makes a point about the distinctive dynamic of viewing necessitated by the fact that Newman's paintings are very large in scale as well as being gallery works that one is invited to see from close to, 'not fifty feet back reducing them to pictures.'[83]

While in a traditionally composed picture, it is usually impossible fully to hold onto the overall composition as one stands close to a stretch of canvas, in the case of Newman's work, losing sight of the overall form does not matter in the same way. The painting is primarily to be experienced by moving along it, either literally or shifting the focus of one's gaze, honing in first on this stripe and its immediate context, then the next one,

and perhaps lingering for a moment on the field of colour in between.[84] The sense of the whole work is generated in the interplay between these momentarily stabilised partial aspects and one's moving across the whole expanse of the canvas, whose scope one senses at any point without actually having it in sight. In an unpretentious way, Judd's description echoes this movement, pointing also to a richness and subtlety of immediate sensations of shifting colour values, of expansive surfaces and narrow punctuating vertical accents, and of differently coloured areas coming into phase with one another and falling out again, always being pulled back or forward flat to the canvas whenever they start configuring too definite a sense of depth.

* * *

With Judd's own work, the shifts occasioned by changes in viewing position and changing focus of attention are more insistent, partly because of its three-dimensionality but also because the surfaces are often opened up to allow a view into their interior. In some of his later work, an extremely plain exterior contrasts strikingly with an interior endowed with bright colouring and a structural complexity that is entirely hidden from certain points of view. The disparity between views onto the outside and ones that open into the interior can be such as to make one feel that one is looking at quite different works. A large steel open-topped box that rests on the ground (fig. 127), for example, whose three-foot high sides block out most of the interior when one stands back from it, looks to be an entirely plain, simple rust-brown structure as one first approaches. Closer to, however, its aspect is completely transformed as one is able to look over the sides into the lower parts of the interior and catch sight of the brilliant yellow colouring of the base and the structure of metal slats cutting into the space just above it.

127 Donald Judd, *Untitled 1989*, corten steel and yellow painted aluminium, 100 × 200 × 100 cm, Courtesy Lisson Gallery, London

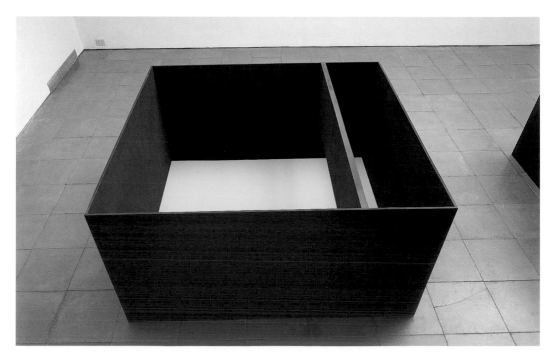

Judd often colours the interior surfaces of his works, thereby giving a more vivid, at times quite affectively loaded, inflection to the distinction between interior and exterior, and also making one more aware of the variations in what one can see of the interior from different positions. The inside of his metal containers is sometimes painted, but most often a difference of texture and reflectivity as well as hue is introduced, either by lining the interiors with a very thin layer of coloured perspex (fig. 117) or by placing a sheet of coloured perspex over the open ends so that they tint the light falling inside (fig. 129). Judd himself, when asked about those stacks in which the metal units had coloured transparent perspex upper and lower surfaces (fig. 128), made the point that the contrast between the coloured surfaces and the surfaces of relatively neutral hue made the perception of the work noticeably dependent 'on the viewing position of the observer.'[85] Even for a static viewer, position-dependent variations open up as one notices how different the units look depending on the angle from which one sees them. The units close to eye level, where the plain metal exterior edges dominate, have only small hints of colour, while those above and below take on an increasing richness of colour as the tinted perspex tops or bottoms comprise an ever larger portion of the overall view one has. These stacks also accentuate the double effect of dispersal and simple oneness that is such a strong feature of Judd's work. One can see the work either as a stack of separate shelves or as a coloured column of air running through the stacked units from top to bottom.

This rigorous, formalised play with situatedness is itself modernist in tenor, for all the emphasis on the positioning of the viewer in relation to the work. Indeed, in Judd's case, the modernist imperative to undo the massiveness of sculpture achieves a

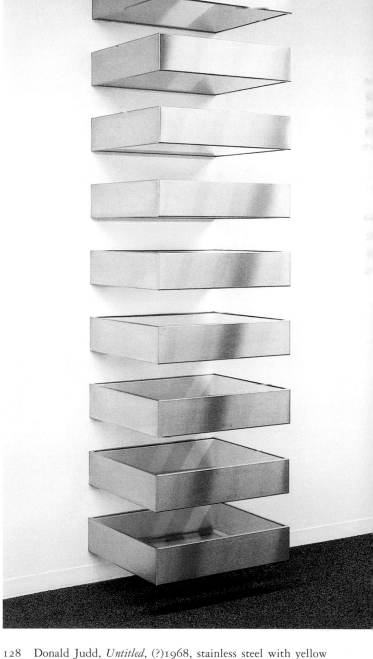

128 Donald Judd, *Untitled*, (?)1968, stainless steel with yellow plexiglass, ten units, each 15.5 × 68.5 × 61 at 15.5 cm intervals, Hiroshima Museum of Contemporary Art

particular consistency and clarity. There are no lumps, no solid plastic forms. Instead, one is made most intensely aware of volumes, of enclosures and openings, of the blocking out and division of space. The structural partitions are so devised that one's attention is focused on the surfaces they define – their texture, colour and reflective or absorptive qualities – and one is hardly aware of their massiveness or substance, as one is, for example, in the case of Serra's work. The metal, perspex and plywood sheets seem more suspended in place than solidly supported. Judd's comment, 'I dislike sculptural bulk, weight and massiveness', is entirely apt.[86] Yet the works are substantial. They are not to be apprehended as pure optical forms, in the way that Fried envisaged Caro's work for example. The shaping and occupancy of space, the sense of interiority and exteriority, of openness and enclosure, are palpably and sharply defined, are specific and unavoidably there.

The aspect of Judd's generally cool and insistently unexpressive, unanthropomorphic work that stands out as most evidently inviting a psychically charged response, in addition to the declarative emphasis with which it intervenes in the surrounding space, is its resonant evocation of interior space or volume. This effect is particularly marked in works where the interior surfaces are suffused with the rich reflectivity and liquid texturing of tinted perspex (fig. 117). A contrast is set up between the optically activated yet empty interior spaces, distinguished by a soft, coloured glow and a subtle play of shadows, and the sheer flat expanses of the exterior planes, whether opaque metal, which partly absorbs and partly reflects the incident light, or translucent perspex (fig. 129), which allows light through but also has a slightly reflective sheen.

Characteristically, when Judd was asked about his opening the interiors of his boxes so that one could see inside, he insisted that 'It's fairly logical to open it up so the interior can be viewed. It makes it less mysterious, less ambiguous.'[87] And yet the effect is not all demystification and formal clarity. Judd also saw this opening of the interior volume as having a certain charge, as he indicated when he pointed out how 'none of the boxes has a bottom . . . This opens the box up. The whole scheme has to do with defined ends and open body; this has been a sort of steady idea.'[88] The key phrase 'defined ends and open body' suggests a particular body image. It evokes a volume-defining and specifically positioned shape that, while being clearly circumscribed ('defined ends') also opens out to the spaces around it ('open body'). The optical effect of the sheen of shiny metal and translucent perspex surfaces enhances the sensation of boundaries that are emphatically defined yet not inert and impermeable (fig. 129). For a viewer caught up in a close perceptual engagement with such work, it will resonate with an analogous sense of his or her own body's occupancy of space – a sense of being, not an inert solid mass weighed down on the ground, but an arena of interiority extending outwards into its immediate surroundings while also being sharply delimited and clearly located in one place. There is a vividly physical sense of being there in which substance and weight do not strongly impinge on one's awareness, as they do in different ways with the more realist work of Serra, Hesse and Andre.

Judd's work might just be envisaged as a categorically modernist analogue of the ideal classical nude of earlier figurative sculpture, particularly if one thinks of Greek figures (fig. 34) with their poised positioning and their precise and clearly defined surfaces suggesting a certain lightness and openness, a free and easy interchange with the space imme-

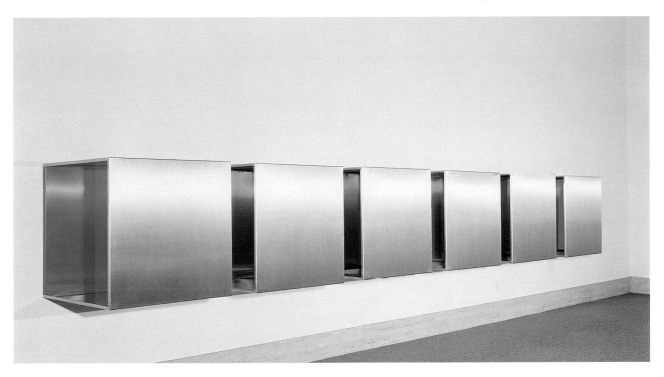

129 Donald Judd, *Untitled 1968*, stainless steel top, sides and back and amber plexiglass ends, six units, each unit 86.4 × 86.4 × 86.4 at 20.3 cm intervals, first exhibited in 1968 (steel surfaces damaged by welding, refabricated for exhibition in New York 1969–70), Milwaukee Art Museum, Partial Gift of Dr. and Mrs. Anthony Krausen

diately around them. In such sculpture, as with Judd's, the surfaces strike one more as an activated boundary between interior and exterior than an unyielding outer face of an inert solid lump. Depending on the disposition of the viewer, the forms of the finer classical Greek nudes can become charged with a certain affect, a certain sexiness, that is usually attributed to the representation of tactile bodily forms. Yet the source of the sexiness is not entirely to be located in the object viewed. It can also emanate from the internalised body image induced in the viewer by being in the presence of the work.

What sharply separates the conception of Judd's work from that of a Greek nude is the categorical erasure of any direct representation of desirable forms or body images in the work itself. This imperative can be read in a number of ways. At its most banal it is a standard modernist negation of representation in the interests of a pure abstraction. What interests me, however, is what this imperative means in relation to the viewer's perceptual engagement with a sculptural object – how a situation has been reached where it is felt that any intensified bodily or libidinal charge will be blocked if these qualities are seen to be objectified in the work.

The mode of viewing that a work by Judd invites might be described phenomenologically as one in which the viewing subject immerses her or himself in the objective world, setting up a symbiosis that can no longer be assimilated to the standard model in which a viewer looks out at an object located apart from her or him. Within the

parameters of this standard model, an art object will only come alive if it is projected anthropomorphically as the embodiment of a living presence, or as a subjective feeling or state of mind. With work such as Judd's, a presence emerges that is not locatable in the viewed object itself but in some indeterminate region embracing the viewer's interiorised awareness and the object with which he or she is engaging. While an ideal nude is in part apprehended in this way, it also invites one to envisage it as a figure endowed with qualities and a presence independent of one's process of apprehending it – as does, in a less insistent way, an abstract modernist sculpture designed to be seen as an autonomous object with its own inner logic. That in Judd's scheme of things a subjective resonance or significance can only be sustained with work where the viewer is precluded from projecting its form as the image or objectified visual model of the subjectivity it intimates, as so much earlier sculpture had been assumed to do, is one of the many things about his project that is historically specific and ideological, relating as it does to newly sceptical understandings of subjectivity, agency and rationality that were gaining currency in the post-war late capitalist world which he inhabited.

Judd once made a point that superficially seems to be at odds with his own art: 'Certainly, form and content, whatever, are made of generalizations, but they are also made of particulars, obdurate and intimate.'[89] 'Obdurate and intimate' would not be my chosen characterisation of Judd's art, though this might be applicable to his writing. But it is still the case that any charged or affective response to his work is going to have an ineradicable tang of particularity, one that no doubt will vary wildly from viewer to viewer. I have been suggesting that some indefinable sexualised intensity, maybe even sexiness, is intimated by the visual and spatial qualities of Judd's work. The latter would include the luminous interiority of the coloured and lightly shadowed volumes enclosed by hard, flat but optically textured and reflective metal surfaces, and the finely tuned divisions of space and precise definitions of inner and outer surface and placement, combined with a suggestion of openness and expansiveness (fig. 129). To this could be added a sense of looming presence that impinges on one physically but never quite becomes dominating or engulfing (fig. 124), as well as the interplay of polished neutrality and lively intensity in the play of light reflected on and absorbed by the sheer surfaces (fig. 101).

These are my specific, some might say very male-biased responses. Other viewers have identified in Judd's work suggestions of dandyish anxiety and lack, or even violence.[90] All these reactions only make any sense if a work by Judd is also seen for what it evidently is – an object, potentially empty, alien and indifferent. It would not be true to the condition of art, particularly of sculpture, in our time if this ambiguity were not so plainly and squarely manifest in it. The work is intriguing because its very physical constitution makes the instabilities in the close bodily-invested engagement with things invited by later twentieth-century art so vivid. Faced with its immaculate structures, whose look both anticipates and echoes commercial Minimalist design, just as the forms of Brancusi's sculptures prefigure chique Art Deco, viewer responses can veer between a sense of rigid alienation and of vivid immediacy, of uncompromising blankness and of sparely, subtly and openly articulated significance. In other words, viewer interactions with Judd's work play out the divergent imperatives in the aesthetics of modern sculpture that I have associated with Adorno on one hand and Merleau-Ponty on the other. The French philosopher's intensified focus on the

immediate phenomenology of viewing has come to the fore in a context where there has also emerged a sharpened awareness of the reifications inherent in the definition and apprehension of art objects in the modern world. It is now time to turn to an issue that relates to the latter point, and to consider Judd's concern with the situating of his work and with its ideological inflection by the public arenas of display that affect, or infect, its viewing.

<p style="text-align:center">* * *</p>

While the siting and installation of his work was a central concern of Judd's, indeed became something of an obsession in his later years, as we shall see, he did not consider himself as creating site-specific work.[91] Rather, he envisaged his work as shaping, or making an intervention in, a local environment defined in generic rather than specific terms, whether this be some indefinite open area of floor or wall (figs 118, 122), or a part of a room into which the work fits and which it articulates (fig. 119).[92] Whether work of the latter kind approaches the status of environmental work is an open issue, and was left open by Judd when he explained how he came to it:

> I got a little tired of big pieces which sit there in an indefinite space, so I wanted to do something that deals more with the space of the room. I don't know about being environmental – it is just a piece that does something with the space of the room.[93]

Outdoor pieces, where environmental considerations inevitably come into play, and where the space is no longer generic in the way that the spaces in a gallery are, were not Judd's forte, at least not until he experimented with large-scale outdoor displays in the empty fields of his estate at Marfa in Texas. When his pieces were set outdoors, the problem often was that they needed a perfectly flat artificial base and could not, like Serra's and Andre's outdoor work, be set directly on or in the ground. So they merely became displaced indoor pieces, many drowned out by the density of visual incident in their immediate surroundings.

What really mattered to Judd were the conditions of public display of sculpture or three-dimensional work in indoor gallery spaces. Most of his recorded commentary on the subject was straightforwardly negative and critical. He repeatedly criticised the insensitivity to the physical conditions of display shown by the installations in public museums and exhibitions, and became increasingly troubled by the ideologically loaded framing of his art when it went on public show. In a 'Complaint' published in 1973, he highlighted the failure to give work the space it needed if it was to be seen properly:

> Installation is seldom good. Almost always everything is crowded . . . In Geldzahler's show at the Metropolitan,[94] paintings were behind sculpture and sculpture in front of paintings as if the walls and the floor were not in the same room. There was no idea that the paintings and the sculpture were all equal and discrete works of art, that they couldn't overlap and that they required various kinds of space.[95]

What particularly taxed him about modern conditions of gallery display was the bad lighting, the main problem as he saw it being the use of spotlights and the disruptive effects of strong cast shadows these created. 'All my pieces', he explained, 'are meant to

be seen in even or natural light.'[96] This is an argument for conditions of display rather like those of a traditional sculpture gallery, where diffuse natural lighting creates subtle, softly modelled cast shadowing, rather than the sharp shadows that cut into a work with directed artificial light. When Judd said of the display of his own work that 'the shadows are unimportant, they are just a by-product',[97] he was referring to shadows in the latter sense. Shadowing was a different matter. Subtle variations of light and shade, as well as the muted play of reflected and absorbed light on differently orientated and textured surfaces, are an essential aspect of his work.

There is a certain irony in the fact that no recent sculptural work seems so made for the incident-free, relatively empty, modern gallery space as Judd's, yet no artist has been more obsessed than he by the actual inadequacies of display in such spaces. This is partly explained by the fact that his work is so easily badly installed, and suffers more than most sculpture from careless placing and lighting. But there is more at stake than this. Few artists of Judd's generation offered a more telling analysis of the larger problematics of the modern gallery space than this later complaint dating from 1984:

> Almost all art for 30 years now has been shown in white plasterboard galleries, vaguely derived from modern architecture. Again this is unconsidered convention, one which was not demanded by the artists. It's a particular appearance, not a fact of nature, and affects the work. This is art seen in a commercial situation, not as it should be seen. The lighting is always bad, created by spotlights so that the work will look precious, the saleable jewel. My guess is that this appearance began in the exhibitions of the Museum of Modern Art and was adopted by the galleries and spread by the later museums.[98]

So obsessed did he become with the belief that his work, and that of his contemporaries such as Chamberlain whom he collected and particularly prized, was being wrecked by the way it was being displayed[99] that in the 1970s he established what was effectively his own private museum at Marfa (fig. 130). Marfa in a way became his equivalent to Smith's Bolton Landing (fig. 85). In a statement published in 1977 justifying the Marfa initiative, he explained how in this context, the work would no longer be

> disembodied spatially, socially, temporally, as in most museums. The space surrounding my work is crucial to it: as much thought has gone into the installation as into the piece itself . . . My work and that of others is often exhibited badly . . . Somewhere there has to be a place where installation is well done and permanent.

Then he went on to make a more ideological point that echoes concerns also voiced by Morris:

> My work and that of my contemporaries that I acquired was not made to be property. It's simply art. I want the work I have to remain that way. It is not on the market, not for sale, not subject to the ignorance of the public, not open to perversion.[100]

This of course has to be qualified. He did make work that was sold, and the value of his work on the art market, bolstered by its high profile in public museums, financed the Marfa initiative – just as the value of Smith's work enabled him to produce ambitious sculpture that he did not need to sell but kept at Bolton Landing. To say this is

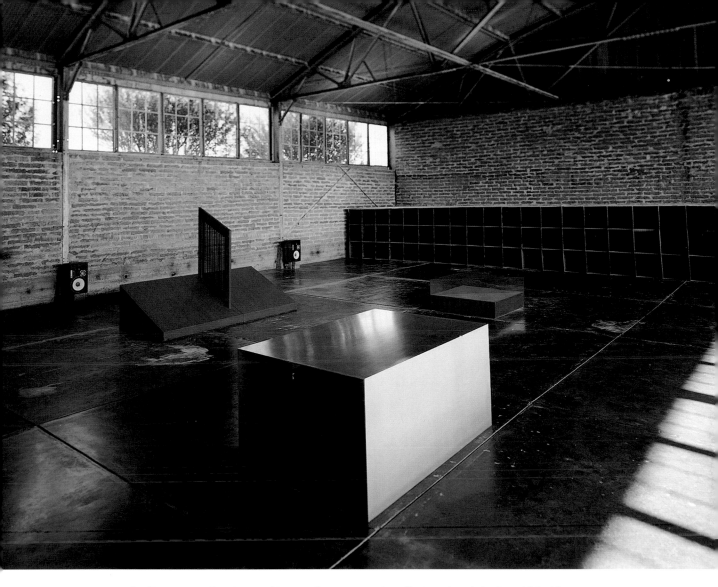

130 La Mansana de Chinati, Marfa, West Building with permanent installation of work by Donald Judd

not to deny that there was a genuine ideological anxiety fuelling Judd's ambitions to create a new kind of space for the display of his work. In a way, his concerns echo a long-standing sculptural problematic that sculpture devised in the private, controlled conditions of the artist's studio was difficult to situate in a public arena without making a travesty of the artist's conception. Judd did not quite have a studio in the conventional sense. After the early painted plywood pieces he rarely had work fabricated in-house but mostly had it done to his specifications outside. Still, like many earlier sculptors, he created spaces in his workplace – whether we call it office or studio – to display his work and work collected by him.[101]

The disused factory buildings and airforce sheds that Judd took over at Marfa are on a different scale from earlier sculptors' studios. Some were devised from the start as public gallery spaces to be administered by a foundation he established, while several of the originally private studio areas consist of large-scale displays of his own work which are in effect very fine museum-type installations (fig. 130). Judd had almost

complete control over how visitors would see the work shown there, but at a certain cost. Only the relatively committed make the pilgrimage to Marfa even now – it is quite a trek to this isolated town close to the border with Mexico, miles from any major urban centre or even regular public transport. The space he created is a hybrid space, ostensibly public, and given the trappings of a public institution through the special and complicated arrangements he made regarding his estate, and yet it bears the strong stamp, for good or ill, of a thoroughly private individual initiative. Judd was party to the traditional idea that the perfect conditions for viewing sculpture are those to be found in a studio-like space owned, occupied and controlled by the artist. There are parallels with Rodin and Brancusi, and with David Smith's installation of his work in the fields surrounding his studio at Bolton Landing. Judd's arrangements for a foundation to preserve his set-up after he died may in part have been prompted by the negative precedent occasioned by the dispersal of Smith's sculpture at Bolton Landing after the latter's unexpectedly early death.[102]

When Judd stated that 'the categories of public and private mean nothing to me',[103] he was not wishing to blur the conventional divide between public and private so much as denying the validity of commonly accepted notions of public statuary, notions he associated with the obsolete monumental and commemorative functions of traditional sculpture. To envisage his sculpture as designed for a private arena, existing in a category that was the polar opposite of the traditional idea of a public sculpture, would be equally inappropriate, conjuring up as it would associations of intimacy and preciousness. But if one can follow what Judd means when he laid claim to an arena for his art that was neither public nor private in these narrow senses, it is impossible to ignore the unequivocally individualist ideology framing his project.[104] The one arena of display that he thought would do real justice to his work was in his own private property where he could exert the control he felt was needed. So the tag 'private', in its flattened socio-economic sense, eventually has to stick, even if coloured politically by his suspicion of the available public spaces and arenas of art as inherently corrupting, as almost inevitably betraying the integrity of his work and his intentions.

I want to finish by returning to some general concerns Judd voiced over the situating and display of sculpture. In what comes close to a valedictory statement, published in 1993 shortly before his death, he showed a finely tuned awareness of how significant context is, how it colours a work, not only formally but ideologically, how it makes up part of its meaning and how this is something that any artist has to face up to – whatever form of work he or she is making. Marfa was one perhaps obsessive, perhaps eccentric way of seeking both to deal with and to evade the determining effects on art of the prevailing conditions under which it was being presented to the public. His comments show that he at least clearly knew what the larger stakes were:

> Any work, old or new, is harmed or helped by where it is placed. This can almost be considered objectively, that is spatially. Further, any work of art is harmed or helped, almost always harmed, by the meaning of the situation in which it is placed. There is no neutral space, since space is made, indifferently or intentionally, and since meaning is made, ignorantly or knowledgeably. This is the beginning of my concern for the surroundings of my work. These are the simplest circumstances which all art must confront. Even the smallest works of mine are affected.[105]

9 The Negated Presence of Sculpture

A Sculptural Imagination: Andre

Andre stands out from most of his Minimalist contemporaries by placing himself as a sculptor rather than as an artist who moved out into three dimensions from a practice inspired by recent modernist painting such as Jackson Pollock's and Barnett Newman's.[1] He insisted that he had 'always been drawn toward mass and weight and three-dimensional stuff' and, more candidly than many other sculptors and architects for whom 'representation, or portrayal' were at best peripheral to their thinking, he was quite pre-pared to admit 'I can't draw. I can't even doodle decently.'[2] Still, the conception of him as a sculptor in the grand tradition that has developed over recent years, fuelled by his statements – such as this from an interview in 1978, 'I may be absolutely mad, but I see my work in the line of Bernini, Brancusi, and then I would put my name at the end of that line'[3] – is a largely retrospective and deceptively monolithic construction.

He did, after all, start as a concrete poet, and his close involvement with the painting of Frank Stella when he was working in Stella's studio in the late 1950s played a forma-tive part in his career, as he himself was the first to admit.[4] The statement Andre wrote for Stella's contribution to the exhibition '16 Americans' at the Museum of Modern Art in New York in 1959–60 became one of the more widely quoted dicta of the new liter-alist Minimalism. Indeed, it is clear that Andre's conception of a sculpture of basic mate-rial facts developed out of his thinking about the implications of Stella's art – how, in his words, 'Frank Stella is not interested in expression or sensitivity' but 'in the necessi-ties of painting.'[5] Stella also played a role in a widely circulated story about how Andre moved from traditional carving to dealing directly with untreated blocks of wood. When Andre was working in his studio, Stella apparently once picked up an unfinished wooden sculpture (fig. 131), ran his hand over the uncarved back of the block and commented 'That's sculpture'. There in a nutshell, it seemed, was a whole new aesthetic. The untouched raw face of the saw-milled wood was itself the real sculpture. But that, it turns out, was Andre's perception of the situation, as Stella indicated some years later when the story was told in his presence. Stella claimed that he had simply been commenting that with sculpture, unlike painting, you had a back to deal with as well as a front – yet another instance where the constructions others put on what Stella was doing and saying in the crucial years of 1959–60 proved to be more radical than what he himself seems to have had in mind.[6]

Andre's work is sculptural, but not because it represents a return to traditional sculptural values. The unusually direct engagement with presence and solidity and materiality in his work is compelling because it involves a negation as well as a reactivation of the sculptural. In an interview conducted in 1968, Andre came up with

131 Carl Andre, *Last Ladder*
(1959, wood, height 214 cm, Tate
Gallery, London) in Frank Stella's
studio, photographed by Hollis
Frampton

a comment that struck a strong chord among his contemporaries, 'A thing is a hole in a thing it is not.'[7] Thought of in these terms, the presence of his sculpture also becomes an opening, or a tear, in the continuously given materiality of things. This is not some post-modern play on presence and absence, nor an existential hang-up on being and nothingness, but rather an acutely felt physical sense of presence coinciding with absence, something manifesting itself powerfully yet reticently through the evacuating of full-bodied shape and the flattening out of solid substance. Mel Bochner came as close as anyone to putting his finger on it when discussing the impact made by those most compelling of Andre's works, the metal carpets he produced in the late 1960s (figs 132, 133, 134):

> Although earlier pieces made of Styrofoam planks are large and space consuming[8] . . . recently Andre's work has tended to be more unassuming . . . the pieces . . . exist below the observer's eye-level. They are made to be 'looked down upon', impinging very slightly on common space. It is, however, just this persistent slightness that is essentially unavoidable and their bold matter-of-factness that makes them in a multiple sense *present*.[9]

One particularly striking thing about these early metal floor pieces is that they deprive the viewer of the features that usually give visibility to a free-standing sculpture's sub-

132 Carl Andre, *144 Steel Square* installed in the Karmeliterkloster, Frankfurt am Main in 1991, 144 units of hot-rolled steel each 1 × 30.5 × 30.5, overall 1 × 365.8 × 365.8 cm, Museum für Moderne Kunst, Frankfurt am Main

stance. No figure-like image or plastic shape looms up before one. These works have no face, not only because, like Judd's boxes, there is no privileged viewpoint from which they look particularly striking, but because literally nothing faces one as one looks straight ahead at them. This negating of a conventional frontal viewing forces one to engage with the work at a kinaesthetic as well as purely visual level. As Andre explained, his work offers 'no single point vistas or even several point vistas . . . Most of my works – certainly the successful ones, have been ones that are in a way causeways [fig. 135] – they cause you to make your way along them or around them or to move the spectator over them.'[10]

An Andre floor piece makes its impact as a thing one half feels and half sees, and which almost imperceptibly takes over an area of floor. One may be only dimly aware of it on

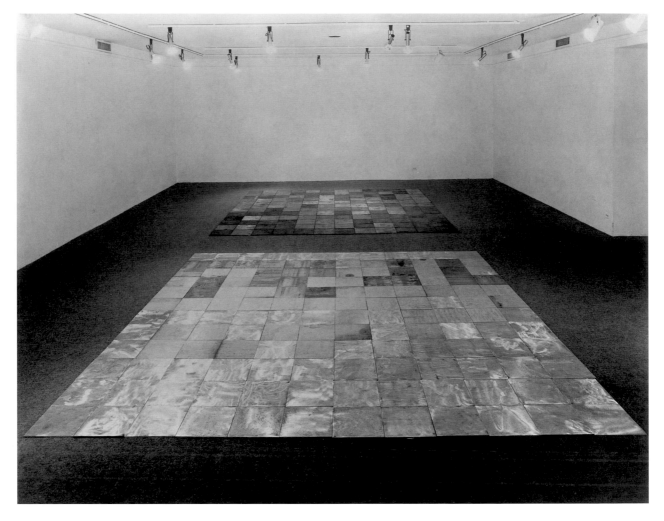

133 Carl Andre, *144 Magnesium Square* (Tate Gallery, London) in front and *144 Lead Square* (Museum of Modern Art, New York) behind, installed at the Dwan Gallery, New York, in 1969, both 144 units, each 1 × 30.5 × 30.5, overall 1 × 365.8 × 365.8 cm

first entering the space where it is displayed, and it can again slip from view as one comes close to it. Andre was drawn to the idea of a sculpture that required a certain attentiveness from the viewer to make its presence felt, as he explained when talking about his twelve by twelve-foot steel piece (fig. 132) in an interview with Phyllis Tuchman published in *Artforum* in 1970 – a document that functions as a carefully elaborated apologia for his new three-dimensional work rather like Judd's interview with John Coplans published the following year:[11]

Most people don't see it if they arrive in a room and are looking around. They can be standing in the middle of a sculpture and not see it at all – which is perfectly all right. I don't like works of art which are terribly conspicuous, I like works of art which are invisible if you're not looking for them.[12]

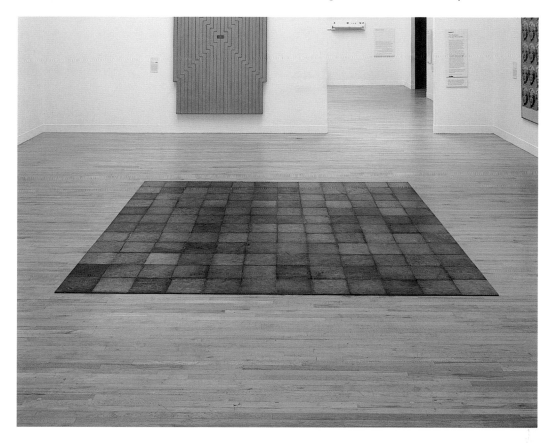

134 Carl Andre, *144 Magnesium Square*, 1969, 144 units, each 1 × 30.5 × 30.5, overall 1 × 365.8 × 365.8 cm, Tate Gallery, London

The work's mode of address as a kind of nothing looming in one's awareness, simultaneously negating and re-instating a powerful sculptural presence, suggests an intriguing combination of reticence and assertion. This rhetorical dimension of his work was characterised by Andre in a leaflet published in 1978 where he talked about wanting to make an art that would be the antithesis of something 'that dominates you, that is coming at you and is assailing you and is making an attack'. What he was after was works 'which sort of ambush you.'[13]

His metal floor pieces might be thought of as the empty bases of an absent sculpture that can only be filled with the viewer's own presence. To have another viewer stand in the middle of the work occupying the space, however, undoes the effect. The presence the work evokes needs to be partly internal, bound up with a sense of oneself being there as well as the sculpture. It is felt most strongly when one is slightly displaced and feels a hesitation to enter the space it claims, accentuated by the awareness that, however visually slight the three eighths of an inch vertical profile might be, the 144 plates constitute a substantial mass of metal. One also needs to be far enough away to take in the full expanse of the work and feel the effect of the plane it cuts into the inert, unarticulated environment around it.

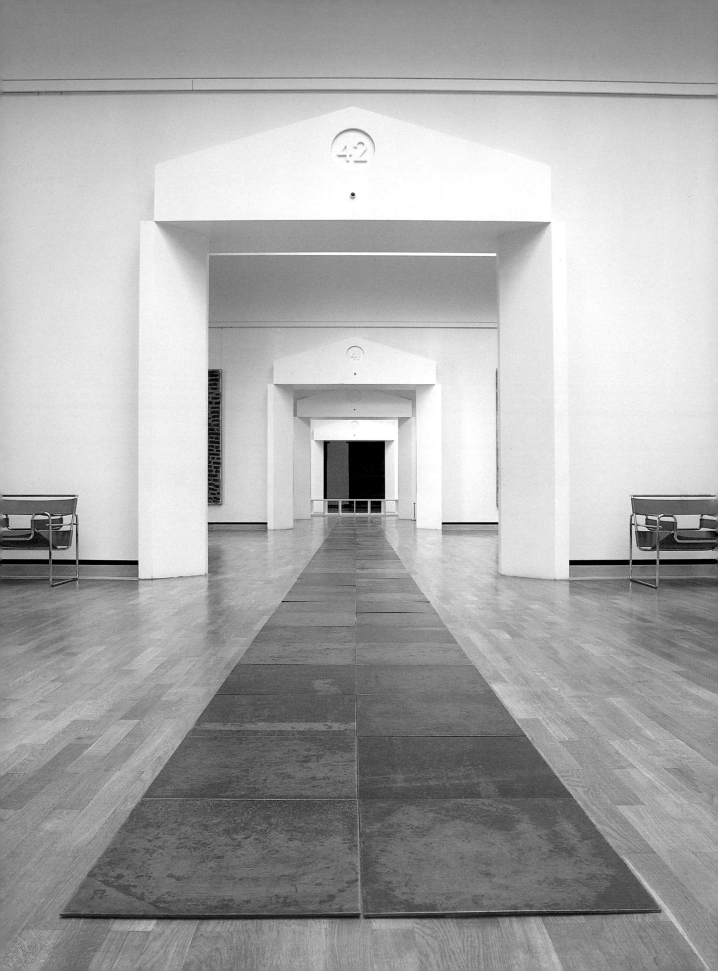

A lot of Minimalist sculpture involves a demarcating or enclosing of interior spaces. Andre emphatically set himself apart from his Minimalist contemporaries on this score, insisting that he was 'about the only one who never made any boxes. It has never been a concern of mine to create volumes.'[14] While much avant-garde twentieth-century sculpture seeks to get away from the solid masses and shapes of traditional monumental work, such sculpture almost always defines a space, often a clearly defined enclosure, whether with sheets of material, as in Minimalist work (fig. 117), or with beams and struts as in earlier constructed sculpture. In the case of Caro's sculpture (fig. 92), for example, the openness of structure might make the definition of the space it occupies somewhat ambiguous, but there is at least a spatial core that is effectively claimed as the interior of the sculpture. David Smith, and Giacometti in his later work, are rather unusual in their insistent flattening of form and almost complete negating of interior space. In most modernist and Minimalist work, there are usually edges cutting into space to create some demarcation of volume which can be more or less permeable or open. This is even true of Serra's work (fig. 100) with its vertical barriers blocking off areas around or in front of the viewer. Andre's floor pieces systematically deny any such visual articulation of volume. If the work does not lie entirely flush with the ground, the edges impinge too little on one's awareness to suggest a three-dimensional space or shape. At the same time, one knows that the work has a certain thickness and solidity. The closely pressed array of 144 plates (fig. 133) cuts into and asserts itself in the space before one in a way that no carpet would. If, when displayed in a gallery, these works are too low to bump into when one backs to see a painting, they have enough of an edge to make one stumble.

Andre described his work as a 'cut in space', activating the inert 'empty space' of the environment where it was placed.[15] While the idea of sculpture as an intervention in space was common currency in phenomenological understandings of sculpture prevalent at the time, and quite in tune with what Judd and also Serra were saying, for example,[16] the word 'cut' suggests something particular. It is evocative of the physical cutting into materials in sculpture and also creates a strongly physical sense of a cutting into and across the field of vision which is then echoed in the actual cut in depth produced by the sculpture's lying out on the floor.[17] The sculpture makes an impact partly because one feels the horizontal expanse it defines to be both at one with the broader area where it rests and clearly differentiated from it. The plates lie flat almost like a surface covering, but they also have a sharp definition of shape and a tensile strength that set them off from the relatively neutral ground supporting them, to the point where they can almost seem to galvanise into a self-activating metal expanse hovering in space.

Optical effects play an important part in this. What sets the metal plates off from the floor and gives them a clarity and vividness of definition is the variegated play of light on their smooth, dense, partly absorbent and party reflective surfaces (figs 136, 133). If one looks closely at the work, and if the gallery is lit properly, with some gentle directed light combining with diffuse ambient light to create subtly shifting reflections as one moves round, an effect of optical lift-off begins to occur. At the same time, the optical variegation is given density and substance by the fact that the work is not a single boring flat sheet but is broken up into close-fitting facets lying almost but not quite perfectly flush with one another. The sense of a single expanse of optically animated surface almost suspended in space is a complex one. It is activated by a tension between a more purely

135 Carl Andre, 2 × 50 *Altstadt Rectangle*, Düsseldorf 1967, 100 units of hot rolled steel each 0.5 × 50 × 50, overall 0.5 × 100 × 2500 cm, Staatsgalerie, Stuttgart

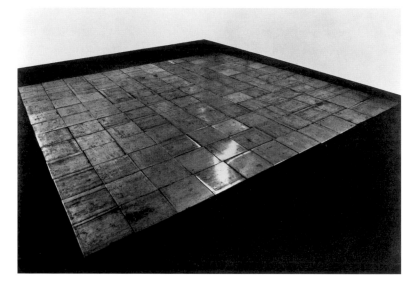

136 Carl Andre, *144 Zinc Square*, installed at the Dwan Gallery, New York, in 1967, 144 units of zinc each 1 × 30.5 × 30.5, overall 1 × 365.8 × 365.8 cm, Milwaukee Art Museum

visual apprehension of the work and an equally immediate awareness of it as an assemblage of heavy elements anchored in the flat, solidly supporting ground.

Photographs can easily annul these complexities. The unselective camera's eye, if it is to encompass the whole sculpture, cannot help but pick up visual incidents on the floor that catch one's eye in the way they would not were one actually there. To counter this, some early black-and-white photographs of Andre's sculpture accentuate the tonal contrast between floor and work to the point where the floor only registers as an empty black or grey field (fig. 136). But this undoes the work's visual and tactile complexities by indeed making it look like a free-floating optical plane. Andre's metal floor pieces present acute difficulties to a photographer, which go beyond the usual one that the camera can only freeze one view from the flux of continually shifting perceptions one has of a three-dimensional sculpture. Unlike the equally non-frontal and situation-specific work of Judd, Serra and Morris, Andre's metal floor pieces do not offer any strong vertical profiles that stand out from the background. If the photographer situates the work by including not only the floor but also some of the enclosing wall, the work is in danger of being dominated by the varied shapes and details of its surroundings (figs 132, 139); but if these distractions are cropped, very little sense is given of the interior space in which the work intervenes to define its presence (figs 133, 134).[18]

In many sculptures, a tension is set up between an inert lump of material and an enlivening modulation of its surface, which prompts one to see it more as volume than solid shape. With Andre's metal carpets, the squeezing out of enclosed volume resulting from the work being flush with the floor makes this tension into a rather starker opposition between pure vivid surface and dense materiality, with each term of the polarity much more separate and specific. The substance of the metal plates comprises more of what there is to see than is the case with the bronze or marble of traditional sculpture. At the same time, the surface cutting into depth is unanchored in any articulation of solid three-dimensional shape. Just as a Morris felt (fig. 13) can be imagined as a pure

137 Carl Andre, *The Way North, East, South, West*, Vancouver 1975, uncarved blocks of Western red cedar each 30.5 × 30.5 × 91.5, overall 91.5 × 152.5 × 152.5 cm, National Gallery of Art, Washington, D.C., Partial and Promised Gift of Agnes Gund and David Shapiro, 1992.83.1

modulation of surface from a sculpture with the stuffing knocked out of it, so Andre's metal floor pieces might be imagined as the surface of a bronze or metal sculpture that has either been melted down or beaten into a single flat sheet.

Not all Andre's sculptures are so flattened out. His work in wood, even after he had moved from his early cutting and constructing phase (fig. 131), presents a viewer with definite profiles and shapes, if only because the units are so much thicker and block-like than the metal plates, usually twelve inches square and three feet long, and extending much higher above the ground even when laid out sideways. Wood was the lightest material Andre used, apart from the styrofoam of some early pieces,[19] and was his material of choice for sculpture that offered more substantial or somewhat more complex shapes. By contrast with the metal plate works, *The Way North, East, South, West* (fig. 137), for example, almost begins to look like a conventional constructed sculpture, with a central up-ended block designating a pointing of the way in the abstract, a pure indexical sign as it were, surrounded by four equivalent blocks lying on the floor, marking out the directions of the compass, north, south, east and west.[20] His brick and stone pieces were less complex and more ground-hugging than this, but even the famous rectilinear brick *Equivalent* created in 1966 rises a comparatively visible five inches, the thickness of two bricks, above floor level (figs 140, 141).

These variations testify to Andre's programmatically different treatment of materials according to their basic properties of density and weight. The units of the densest, most tensile and also most reflective materials, the metals, are thin plates laid out flat on the ground, while those of less dense and more porous, more absorptive materials come in substantial and block-like units. The size of the units is roughly indexed to the mass of the material – brick being denser than wood comes in considerably smaller units, for example. In this way the units are very roughly equivalent in that they all come in sizes light enough to be handled and laid out easily by one person, but heavy enough to stay firmly in place without being fixed to the ground. The different qualities of the

materials also play a role in how the units are laid out. Metal plates, being especially dense and smooth, and evidently different in substance and surface texture from the floor where they are placed, can differentiate themselves from it even if they hardly rise above it. Works in brick or wood or stone, by contrast, where the materials are generically more akin in mass and substance to the stuff from which the interior architectural space is made, need to cut more of a profile that sets them off clearly from the floor.

Andre's distinctive obsession with the massiveness and substance of materials, which sets him apart from most of his Minimalist contemporaries, makes it only logical that he was one of the few to respond so directly to the sculptural qualities of David Smith's work (fig. 90). Of course, as Andre indicated, this was a complex affinity, involving as it did his ignoring all the so-called 'drawing . . . in space', and focusing on the material qualities of the pieces of metal from which a work was made. As he explained in the interview with Phyllis Tuchman in 1970, he was interested in how

> the individual units were solid. They weren't too big and they weren't empty [very like, one might say, Andre's metal plates]. I've always had a very primitive, infantile love of the solids and the mass, the thing that was the same all the way through. David Smith's sculptures seemed to have that quality. Of course, we read into the past what we need for the present and that's what I got from David Smith.[21]

If Andre's work in wood, brick and stone is more conventionally sculptural than the much flatter metal plate works, there is almost always still an insistently horizontal logic and closeness to the ground. The work has to be overseen rather than looked at like a conventional painting or sculpture, its horizontality contrasting with, rather than mirroring, the vertical placement of the viewer's body. This is a crucial feature of Andre's work, and might be conceived as echoing a general tendency in twentieth-century art towards a kind of debasement, an undoing of the idealising and elevating humanist posture embodied in traditional sculpture.[22] Such a symbolic reading of the horizonal floor-hugging quality of Andre's work, however, would not really take account of the complex dynamic of a viewer's encounter with it. The work is literally horizontal, but it is not just about horizontality. It makes its impact through the tension it generates between the flat expanse (fig. 134) or horizontal axis (fig. 5) it defines and the vertical axis of the viewer's body. The viewer is not simply prompted to think of her or himself falling flat and merging with the ground. The effect is less resolved than this, more in the nature of a tension between an enhanced sense of one's vertical stance and an enhanced awareness of the expanse of ground stretching out before one. Facing a conventional figure, there is a stable echoing of one's own verticality in that of the sculpture. Facing an Andre, where there is an absence of a mirroring vertical, one's verticality is partly destabilised, but at the same time one is made more acutely aware of it.

There is one further way in which Andre's work, particularly the metal floor pieces, both makes one more conscious of certain distinctively sculptural qualities and partly negates them. A sculpture encountered in a gallery space is literally closer, more immediately in one's space than a painted depiction – and yet it is separated from one by ever watchful if usually invisible 'do not touch' signs. Marble sculptures, particularly the exquisitely finished and eroticised white nudes of the traditional sculpture gallery

(fig. 14), seem designed precisely to activate a titillating frustration, evoking half felt, half seen sensations of a touching that can never be consummated. By contrast, one is allowed to make direct physical contact with Andre's metal floor pieces – indeed many museums have signs inviting one to walk on them. But this stepping on the work is not quite really touching it.[23] As a hand-out to the exhibition of his work in the Museum of Modern Art in Oxford in 1996 reminded one, 'Some of the sculptures in this exhibition can be walked on. However, none of them should be touched by hand.' Normally, touching and feeling things is done with the hands, not with the feet, let alone feet clad in boots or shoes. What is more, Andre's sculptures always keep one at a distance visually. One never gets closer than the gap separating the eyes from the feet, whereas most free-standing work allows one much nearer, at least to those parts that are more or less at eye level.

A close tactile engagement with the substance and mass of the units comprising Andre's work is only to be had by the artist setting them out, actually bending down and handling them. The viewer enters into this experience through imaginative identification, rather as, in the case of more traditional sculpture, the artist's carving or modelling or constructing is recreated in the mind's eye by way of traces this activity has left in the form and disposition of the work. It is the artist's laying out of the work that Andre evokes when he is talking about the direct tactile sense of substance and mass that fascinates him, skilfully presenting this as his internalised projection that the viewer can share directly:

> I do not visualise works and I do not draw works and the only sense I have running through my mind of the work is almost a physical lifting of it. I can almost feel the weight of it and something running through my mind either has the right weight or it doesn't.[24]

Andre made one very suggestive comment about the double take between a sense of immediate close contact with things and a sense of insistent distancing which his sculpture exposes more insistently than most. He began with a cliché about the direct physical engagement with the world that sculpture as the most primal visual art can offer, but did so in a slightly unusual manner by referring to infantile fantasies of oceanic oneness. Then, unlike most psychoanalytically inclined accounts of art, his commentary goes on to point out that this fantasy has its counterpart in an equally insistent and equally basic experience of alienation, the infant's feeling the obdurate indifference of the outside world to its inner impulses. For him, this too was central to the viewer's encounter with a work of sculpture:

> I think sculpture is a more primitive form than painting . . . there's something essentially infantile about the sculptural relation to matter. It has to do with the infant differentiating itself from the world . . . Of course, that's a disaster, because the infant wants to think of itself as continuous with the universe – the infantile omnipotence. It's a disaster when one realises one is discontinuous. There is the self, and all that is not the self. And sculpture has something to do with that fundamental feeling.[25]

<p style="text-align:center">* * *</p>

Place, Concept and Desire

In what is probably Andre's most widely quoted statement, made in his interview with Tuchman in 1970, he set out a schematic history of the structural negations played out in modern sculpture, culminating in the move in recent work away from the making of forms or structures to a kind of place making:

> In the days of form, people were interested in the Statue of Liberty because of the modelling of Bartholdi . . . Then people came to be interested . . . in Eiffel's cast iron interior structure . . . Now sculptors aren't even interested in Eiffel's structure any more. They're interested in Bedloe's Island [where the Statue of Liberty is sited] and what to do with that. So I think of Bedloe's Island as a place. I use place in a kind of aphorism that seems to work for me about shifting from form in sculpture to structure in sculpture to what I wound up with as place in sculpture.[26]

Place-making, as Andre conceived it, is not to be confused with the making of site-specific work. 'I don't', he emphasised, 'feel myself obsessed with the singularity of places', though he would sometimes use the name of the town where a work had first been set out as a tag to designate it. The important thing was not the specific place but 'generic classes of places which you work for and work toward.' Andre had in mind something similar to Judd's notion of sculpture as activating a space in some relatively neutral environment where it was placed. But place-making for him also involved an out-and-out negation of sculptural structure. Place-making was what was left of a sculpture once it was divested of plastic shape and of any structured, articulated relation between its constituent elements of the kind that in recent modernist sculpture had been effected by rivetting and welding elements together.[27] It might be thought of as an evacuated, destructured presence.

In the late 1960s and early 1970s, Andre's project was seen as an important point of departure by a number of artists such as Robert Smithson who were exploring practices that sought to abolish the art object as traditionally conceived, while at the same time he was considered to have stopped short of the more radical implications of what he was doing. In a discussion conducted in 1970 by Smithson and two other land art artists, Michael Heizer and Dennis Oppenheim, Oppenheim summed up these feelings when he pointed out that 'Andre at one point began to question very seriously the validity of the object. He began to talk about sculpture as place.'[28] The 'began to question' is an important caveat. As Smithson explained that same year, he and his contemporaries felt that in the final analysis Andre failed to get away from the fetishising of the object that had continued in 'Minimal art'. In an obvious dig at Judd, Smithson explained how he envisaged the radically anti-object and anti-Minimalist logic of his own recent art: 'My work has always been an attempt to get away from the specific object. My objects are constantly moving into another area. . . . They are things rather than definable presences.' While he sought a practice that 'breaks down the whole certainty which is the object,' Andre, he declared, was unwilling to this. As he put it, 'There is a cut-off point, probably around Andre; he is still involved in that certainty, laying out the thing – it gives the feeling that there is something definite there.'[29]

Smithson's point was that Andre in the end had not moved beyond the idea of a self-sufficient object displayed in a gallery, with the result that his work was still caught up

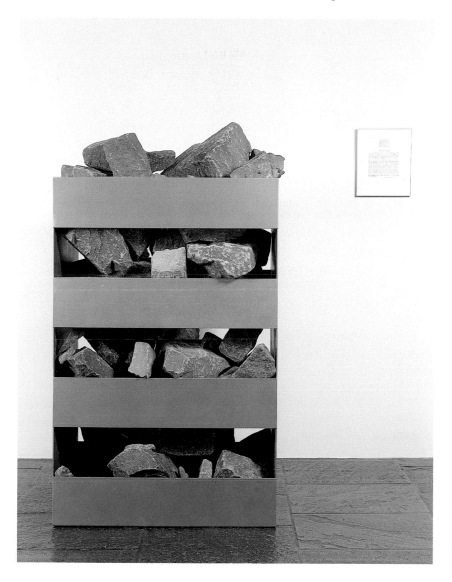

138 Robert Smithson, *Non-Site (Palisades, Edgewater, New Jersey)*, 1968, painted aluminium, enamel, stone, 142 × 91.5 × 66 cm, and typescript on paper, Whitney Museum of American Art, New York, Purchase, with funds from the Howard and Jean Lipman Foundation, Inc.

in the closures resulting from the contained interactions between viewer and work that took place within this environment.[30] Smithson, who was particularly close to Andre, was not arguing for a romantic abolition of all such framing, more for a destabilising of it. Unlike many other land artists, he was well aware that his art was inevitably involved in some kind of symbiosis between a display framed inside a gallery and a place or phenomenon in the outside world to which this display referred. The raw material from a site he would set out in a gallery was always artificially framed, usually in Minimalist-looking geometric containers (fig. 138). In retrospect, the difference with Andre that really matters is not so much whether Smithson more radically deconstructed the sculptural object, particularly as the documentary, conceptual features of his practice have now become established forms of gallery presentation. The difference lies in Smithson's

determination to get away from modernist self-referentiality without having recourse to conventional artistic representations of the phenomena outside the gallery which he was wanting to evoke. What is distinctive, and radically different from Andre, then, is the insistence on some concrete and potentially destabilising relation between a thing in the gallery and a thing in an environment outside. This symbiosis between the non-site of the gallery display and the substantive site conjured up through maps and other indexical signs, such as actual bits of material removed from the site, has the added complexity that the site exists for its audience only because of the existence of the non-site documents and indices. To put it another way, Smithson was interested in exploring the ambiguities and instabilities of everyday designations of place in a way that Andre patently was not.

For my present purposes, the differences I want to emphasise concern the different kinds of encounter between viewer and gallery display their work sets up. With Andre, the overriding emphasis is on the viewer's engagement with a physical phenomenon. Even in the case of his outdoor work, the emphasis is similarly, as it is with Serra, on the immediate physical and perceptual encounter one has with it, sometimes inflected by particularised references to this setting that are usually not present in Serra's more purely spatial involvement with place.[31] With Smithson, the real drama of encounter is played out in an imagined encounter between the self and an open outdoor site, which takes off from, and is ultimately defined by, the viewing and reading of Smithson's gallery presentation. An ostensibly unmediated, raw encounter is evoked through mediating references or indices or images. This does not annul the significance of the viewer's engagement with what is presented in the gallery, though it puts less pressure on this. Thus in the *Non-Site (Palisades, Edgewater, New Jersey)*,[32] a significant disjuncture opens up between the viewer's largely physical response to the rough lumps of rock caged awkwardly inside a rectangular container made of smooth slats of painted metal, and her or his more cerebral activity of reading the typed text and deciphering the map on a piece of paper pinned to a nearby wall. The presentation of the raw material itself introduces another level of complexity. The chunks of rock from the site are both immediately accessible and distanced, boxed up and partly blocked from view. Andre's point about the tension between oceanic oneness and insistent separation prompted by the encounter with a sculptural object would be apposite here.

Andre's place-making may not have engaged in a thoroughgoing deconstruction of the self-contained art object in the way that some radically site-specific or conceptual art work of the late 1960s and early 1970s did. But it did for a time sharply disrupt audience expectations regarding sculptural work. In a way, the ambiguous status of his work as sculpture, simultaneously negating and reaffirming, as we have seen, specifically sculptural values, may account for the peculiar persistence with which some of it so irritated large sectors of the art public in the 1970s once it achieved international currency and was being bought by modern art museums. Conceptual work may have attracted a certain amount of puzzled and angry commentary, but its impact was mitigated because it seemed to occupy its own niche and not to set itself up to rival traditional painting or sculpture. No conceptual work quite provoked the storm of controversy occasioned by the Tate Gallery's public showing in 1976 of its recently purchased *Equivalent VIII* (fig. 141) by Andre. His work got at people, perhaps because

it had pretensions to being as substantial as any sculpture by its sheer mass and size, yet seemed so flagrantly devoid of artistic form, structure or meaning. A stack of bricks was somehow more aggravating than a conceptual gesture or the casual display of a slighter object, like a snow shovel.[33]

Part of what made the brick *Equivalent* and the metal plate floor pieces both sculptural and anti-sculptural for a mainstream modern art sensibility was the use of heavy, solid, sculptural-seeming materials that had neither artistic nor natural associations, like Richard Long's stones, or any suggestions of patina, like the scrap wood and metal fashionable at the time.[34] Andre's materials were aggressively industrial and utilitarian: brick rather than clay, steel and zinc rather than bronze. The issue was not just the substance of the materials, but the form in which they occurred, not natural and unprocessed, like Smithson's, or finely finished, but semi-processed and ready for industrial fabrication. Morris used industrial felt, but almost always cut it up and arranged it so that it no longer looked to be a standardised industrial commodity.

Andre sharply differentiated his units of industrial material from the finished form of Pop Art's representations of consumer commodities:

My particles are all more or less standards of the economy, because I believe in using the materials of society in a form the society does not use them, whereas things like Pop Art use the forms of society, but using different materials to make these forms.[35]

The metals he used, such as aluminium, steel, iron, zinc, copper (fig. 139), magnesium, were he insisted what 'are called the construction metals. They are the common metals of everyday economic life',[36] though they were rather special too, in that they were all pure elements, not alloys. He thought of his work as echoing the 'conditions of industrial production' in that its elements were as he put it never 'hand-worked' but came 'from furnaces, rolling mills, cranes and cutting machines'. By limiting his handling of them to setting them out on the floor, he felt he was posing 'the question as to whether it is possible to make art that parallels the present organisation of production, technologically and economically'.[37]

It is important that this is posed as a question, and that he was not making some romantic claim to be embodying in his art a basic truth of modern industrial economy. He, no more than any artist, was able to get away completely from art making, nor did he particularly want to. At the same time his work and practice were definitely not preciously arty, and evidently bore testimony to a fascination with and pragmatic understanding of the stuff of heavy industrial production. The specific nature of this industrial reference, however, gave his work a less up to the minute contemporary look than the slick finishes of Pop work or the cool perfection of other Minimalist's units of fabrication – Flavin's fluorescent tubes or Judd's perspex and sheets of finished metal, for example. This is not just true of the bricks, which as solid masonry building blocks were at a far remove from the frame and cladding of modern construction methods, and at the time even out of fashion as a form of outside finishing, except in suburban domestic architecture. Significantly, the factory that made the special solid firebricks Andre had used in his initial installation of *Equivalent* (fig. 140) in 1966 had gone out of business when he remade the works in 1969, and he had to go to some lengths to find a suitable industrially made equivalent.[38]

139　Carl Andre, *36 Copper Square*, Krefeld 1968, thirty-six units, each 0.5 × 50 × 50, overall 0.5 × 300 × 300 cm, collection of Helga and Walther Lauffs in the Kaiser Wilhelm Museum, Krefeld

By the late 1960s, the kinds of industry and construction associated with the semi-processed materials Andre used were beginning to lose their position of dominance. A structural shift in developed Western economies had been occurring, away from heavy industry to light consumer industries, such as electronics. Particularly in America, the change to road transport was making the railways, the backbone of traditional heavy industry, increasingly obsolete. Andre often made a point of emphasising his credentials as someone who had first-hand experience of the world of modern industry by drawing attention to the period he spent working in the early 1960s on the Pennsylvania Railroad as a freight brakeman and freight conductor – shortly before the company ceased to exist. The blocks of timber and units of smelted metal he used could be seen as echoing the basic materials, the timber sleepers and steel rails, of the railway track. He himself talked about how 'all the industrial materials – coal, coke, iron ore, scrap materials' were 'raw materials that I was tremendously interested in', though he also made a more suggestive link between his carefully controlled manipulation of movable units in the shunting yards and the way he went about manipulating units of material in his art.[39]

In hindsight, the world of industrial processes evoked by Andre's work has more to do with the aging rust belt than the new world of consumer commodities and high technology industry. The materiality of his work, with its evocations of industrial grittiness, might now even have a slightly nostalgic patina. This only makes it logical that over more recent years he has not confined himself to the same rough-and-ready-looking materials, and has experimented with materials that might seem to have a more arty finish – variously coloured sandstones and limestones, and smoothly planed poplar planks rather than more rough-hewn blocks of cedar or fir. At the same time, standardised metal plates and bricks – even solid bricks done to unusual specifications – are hardly obsolete even now. Society continues to use these raw building blocks, however much such heavier materials have been partly replaced by lighter plastics. Andre's units of semi-processed industrial stuff, just like the raw rock and ore that fascinated Robert Smithson, are still integral to the material fabric of modern society.

The importance of the industrial references in Andre's self-presentation in the 1970s remind one of other sculptors like Richard Serra and David Smith, whose time spent working in a steel mill, or in a car and munitions factory, became an integral part of the persona they projected.[40] At that moment, one way of overcoming the portentous or arty image of the sculptor was to associate the making of sculpture with honest industrial work: both Serra and Andre did this without the romanticising of manly labour that sometimes comes to the fore in David Smith. The image had something exclusively masculine about it, as did indeed the whole heavy metal, post-war sculpture scene, with its implied workerist critique of bourgeois conceptions of sculpture as precious object. This is not to criticise that sculptural ethos but simply to underline its period flavour and its distance from the very different gendering of present-day sculptural practice. To be fair to Andre, it should be added that he was among the few male artists of his generation to go on record in the early 1970s voicing concern about the pervasive sexism, as well as racism, in American society at the time.[41]

The sexual politics involved in Andre's persona as an artist, however, have become painfully fraught as a result of the controversial circumstances surrounding the sudden

tragic death of his wife, the Cuban-American artist Ana Mendieta, in 1985, and the sub-
sequent court case. People's responses to the situation inevitably strongly coloured their
attitudes towards Andre and his work, particularly those who moved in the same New
York art circles as had he and Mendieta. I only mention this here because it would be
dishonest to blank out a factor which lingers in people's semi-consciousness and has had
long-term effects on the public uptake of Andre's work. In the short term, a repression
went into operation. To continue with a conventional critical analysis of his work momen-
tarily seemed either inappropriate or impossible. In the longer term, the result has been
a retrospective censoring of Andre's work from serious discussion of New York avant-
garde art of the 1960s and 1970s, as well as the occasional sensationalising reading of it
in psycho-biographical terms. It would be not just inappropriate but unethical to linger
here on details of his personal life when I have not done so elsewhere, particularly as I
have been seeking to establish connections between art and life that can be located in the
conception of the art work and in the viewer's encounter with it, and not by trying to
uncover in the art hidden, and inevitably highly individual and contingent, traces of the
personal circumstances of the artist's life. But pretending to the non-existence of an his-
torical reality that is out in the public sphere, still shaping the context in which Andre's
work is embedded, would in a different way be unethical too.

* * *

I have been focusing here on ways in which Andre's work both resisted and engaged tra-
ditional conceptions of the sculptural object. Commentators at the time usually discussed
his complex relation to traditional artistic values in more general terms that had to do
with the conceptualist negation of the art work as a self-sufficient object. We have already
seen how Andre, with his idea of place-making, was identified by younger artists such
as Smithson as pointing to, and then stopping short of, a radical deconstruction of the
art object. His own commentary seems to confirm this view – as early as the 1970 *Art-
forum* interview, he sought to repudiate any suggestion that he was a 'conceptual artist'.[42]
Yet the very fact that he felt he was being put in a position where he had to stake out
his distance from conceptualism gives evidence of affinities that nevertheless imposed
themselves, and that guaranteed him a fairly prominent profile in Lucy Lippard's
conceptualist anthology published in 1973, *The Dematerialization of the Art Object*.[43]
 Andre did not retreat into a rearguard defence of the traditional art object. Rather, his
attitude was based on the theoretically self-conscious, and also very contemporary, view
that a radical disjunction existed between idea and physical object, a view that he shared
with his more hard-headed conceptualist contemporaries. The force of his polemic against
idea art lay not in his somewhat superficial antagonism to the conceptualist art of the
period. It lay rather in his rejection of anything that suggested a naive conception of the
art work as a seamless mediation between idea and material entity, in which an object
somehow embodied and made fully manifest an idea that was its inner essence. He took
the view that ideas as mental and linguistic constructs and works of art as physical things
inhabited different realms. This not only echoed mainstream modernist principles but
was also an important tendency in contemporary philosophy. Both French structuralist
and Anglo-American analytic thinking insisted on a categorical distinction between

language, ideas and cultural constructs on one hand and things in the physical world on the other. Andre put his position as follows in an interview conducted in 1972:

> To me the work of art is not the embodiment of an idea; it doesn't spring from an idea; it has nothing to do with ideas. Ideas are abstractions of a different order than works of art. They are not only of a different order, but they exist in a different kind of space. Ideas by their very definition exist in zero space.[44]

If Andre had his own reasons to distance himself from what he identified as conceptualism in art, there is no denying that his more interesting work has an obviously conceptual aspect. The critic David Bourdon noticed one striking feature of this when he commented in a review written in 1966, when *Equivalent* (fig. 140) was first exhibited, on how Andre's works, unlike traditional sculptural objects, ceased to exist as physical entities the moment they were put away and were no longer displayed in a gallery:

> When an artist sees sculpture as place, there is no room for actual sculptures to accumulate. Andre's works come into existence only when necessary. When not in exhibition, the pieces are dismantled and cease to exist except as ideas.[45]

Of course, Bourdon was simplifying a bit, for the piles of metal plates or bricks do have a material existence of some kind when stored away. Andre's own take on this aspect of his work was to emphasize, not the conceptual tease, but something more pragmatic, explaining how he liked the way 'that my works lend themselves to installation, and I mean building and taking down very readily, so people can put them out when they want to and put them away when they want to.'[46]

This attitude ties in with Andre's particular insistence that a work was to a considerable extent created by the viewer in his or her encounter with it. Indeed, he reckoned on the defining role of viewer response in a way that almost no other of his Minimalist contemporaries did. Equally, his attitude has a conceptual bite to it lacking in the pseudo-romantic or pseudo-Zen notions current at the time that for example, every human being is an artist, or that the art work happens because the audience wants it to. As Andre put it, 'I make art works by doing art work, but I think the work itself is never truly completed until somebody comes along and does artwork himself with that artwork. In other words, the perceptive viewer or museum-goer who's got some kind of stimulus from the work is also doing artwork.'[47] For him, the art object existed as 'a locus of attention, a stimulus', not as a completely autonomous entity, fully present regardless of its situation and conditions of viewing.[48] Rather than being an entity that embodied an idea, the art object was seen by him as 'embodying some sort of transaction which is between . . . the reader, the recipient, the sender, the social situation, the art, whatever.'[49]

His notion that an art work was not guaranteed a secure autonomous existence extended to an insistence that it be conceived as subject to the depredations of time. He did not want his works to be thought of as sculptures with 'ideal surfaces that had to be maintained', but rather as designed to bear the marks of aging, however solid and substantial the materials, and whether or not they were kept inside or exposed to the elements.[50] He made this explicit in the preface to a catalogue from 1969 where he insisted that his work be seen as 'in constant state of change. I'm not interested in

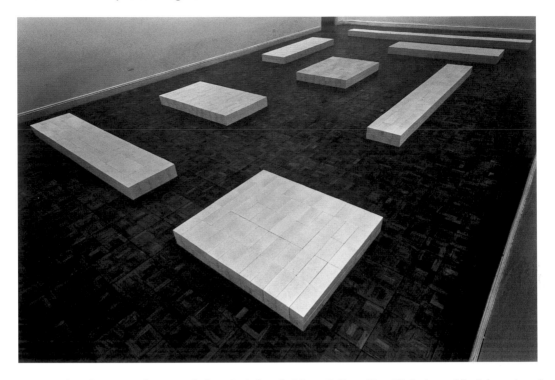

140 Carl Andre, *Equivalent*, installed at the Tibor de Nagy Gallery, New York, in 1966, eight units of variable dimensions made up of 120 firebricks, each brick 6.4 × 9.5 × 20.3 cm

reaching an ideal state with my works. As people walk on them, as the steel rusts, as the brick crumbles, as the materials weather, the work becomes its own record of everything that's happened to it.'[51]

Yet all within limits. For one thing, Andre did not want people touching his work with their bare hands, staining the slightly porous surfaces with fingerprints. If a sculpture deteriorated over time like any material thing, it could also be more lasting than most of the things one surrounded oneself with. He was well aware that part of the fascination traditionally exerted by sculpture was that it embodied a desire for some kind of permanence, and he clearly saw his work as playing upon this. Sculptures may in the end all crumble or rust way. But they were traditionally made of durable materials, such as stone, metal or baked clay, and designed to last longer than human beings. As such they had filled a very basic need. As he explained,

> I think the urge to sculpture is closely related to a sense of mortality. People began to sense that they physically and temporally passed through this world, and started setting up markers to indicate where they had been, almost like tracks, evidence of existence.[52]

This is not true of all societies – African cult statues or masks made of wood usually had to be remade more than once in a lifetime, and thereby enjoyed a rather different, con-

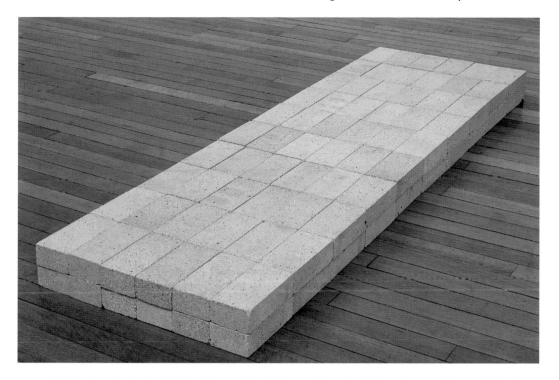

141 Carl Andre, *Equivalent VIII*, 1969, remake of destroyed version dating from 1966, 120 firebricks, 2 high, 6 header, 10 stretcher, each brick 6.4 × 11.4 × 22.9, overall 12.7 × 68.6 × 229 cm, Tate Gallery, London

ditional permanence. Andre's is a distinctively modern attitude. He both wanted his work visibly to submit 'to the conditions of the world' and not to be seen to buck the reality of temporal deterioration. But he was also drawn to the idea of producing something permanent enough to outlast him, even something that might still be there when 'I will have long been dead and persons who are not living will long have been dead.'[53]

Andre's relation to conceptualism involves not only certain general affinities between his rethinking of the sculptural object and the more thoroughgoing conceptualist deconstruction of the autonomous art work. Much of his work clearly has a conceptual element as part of its manifest content, and involves the viewer in actively negotiating between conceptual and physical or perceptual levels of response. This is most evident in his fascination with numbers. Envisaged in purely perceptual terms, *Lever* (fig. 5), for example, is an extended line of bricks. No one could immediately apprehend the fact that there are precisely 137 bricks there. It is only at a conceptual level that one can get a firm grip on this property of the work, and also be aware of the fact that, as a prime number, 137 is an indivisible entity. Such a double take between what is immediately seen and felt, and the more cerebral facts of the work defined by numbers and combinations of numbers is even more in evidence with a more complex work like *Equivalent* (figs 140, 141). The basic arrangement is determined by a simple mathematical system. Each of the eight units is equivalent because it is made up of 120 bricks laid out in a

rectangular pile two rows high. Looking closely at the whole array, there is a curious tease as one asks oneself whether one can actually see and feel the equivalence one knows exists between the different piles, for they look quite different, or whether one can ever take in visually the system one knows exists in the work's playing out of different multiples of sixty.[54]

The almost perversely extreme protest of Andre's against the 'grim misreading' of his work as '"art as idea" or "conceptual art"'[55] has a political edge to it that is worth highlighting, in that it establishes his distance from the easier, romantically inclined celebrations of the alternative nature of non-object-based practices, which the intellectually aware conceptualists, such as Art and Language, rejected as adamantly as he did.[56] It was almost commonplace for anyone with avant-garde pretensions in the late 1960s and early 1970s to lay claim to a practice that at least seemed to resist immediate appropriation as consumable commodity. A distinction needs to be drawn, however, between purely individualist, libertarian fantasies about alternative practices that could exist in a sphere apart from the art market and the established systems dominating the art world, and more hard-headed assessments of the operations of these systems and the scope there was for asserting some integrity of purpose and resistance to their more bankrupt values.

Andre rightly detected in the easier celebrations of the abolition of the art object a lack of critical awareness of how the capitalist art market operated. He made the point most fully in a joint contribution with the critic Jeremy Gilbert-Rolfe to *October* in 1976 under the title 'Commodity and Contradiction, or Contradiction as Commodity'. In this, he combined a pithy Marxist analysis with a narrowly polemical swipe against the Duchampian cast of what he saw as the conceptualist opposition or competition to his practice:

> It is the genius of the bourgeoisie to be able to buy anything. That is, by offering money the capitalist ruling class creates exchange value where none existed before . . . The most farcical claim of the conceptualizing inkpissers is that their works are somehow antibourgeois because they do away with objects.

By way of conclusion he added a sharp if bleak commentary on the socio-economic realities of the contemporary art world: 'We have always had the historical choice of either lying through or living through our contradictions. Now through the genius of the bourgeoisie we have the chance to market them.'[57]

On occasion Andre would even protest against naive celebrations of his own work as somehow refusing to accommodate itself to the conventional role of 'precious objects', pointing out that 'If they [the bourgeoisie] set out to make a commodity of you, there's absolutely no way you can prevent it.'[58] Of course some work is more easily commodifiable than others. In the contemporary art world, the insistence that a political, rather than an ethical or aesthetic, distinction can be made between art that is something of an object and art that has inscribed in it some refusal of this condition, no longer makes a great deal of sense. It did for a moment in the late 1960s and early 1970s, when both the art world and commodity markets in general were in a state of some disarray, and there was more scope for politicised interventions as new patterns of circulation, and new forms of monetarist control, had not yet settled in place. There is some realistic hard-

headed logic to the point Andre made in an interview in 1978, faced with the naive, populist, vaguely leftish romanticism of Peter Fuller, a critic soon to abandon all this for a new-right traditionalism, who was needling him about the cash value and commodity-like nature of his work: 'There's nothing wrong with precious objects. There are a lot of objects which I find precious. Other people do not find them precious. The question is whether their only legitimacy is that they are articles in trade.'[59]

* * *

For Andre, what made a modern work of art something other than a merely alien or meaningless object was its psychic rather than its conceptual resonances. This brought into play the dimension of desire, in which the physical and the mental were inextricably bound up with one another. Such at least seems to be the logic prompting his claim 'I am certainly no kind of conceptual artist because the physical existence of my work cannot be separated from the idea of it. That's why I said I had no art ideas, I only have art desires.'[60] Andre seems to be arguing that libidinal drive is more fundamental to the artist's making of – and the viewer's encounter with – art works than any epistemological or conceptual imperatives. As he comments elsewhere, 'art is sexy in its basic root. It is about an erotic relationship with the world.'[61] In making this point, he is suggesting that desire and the world of physical phenomena exist in the same realm in a way that ideas and material things do not. Such currents of thought are nicely condensed in the terse introductory comments to a catalogue of his work published in 1987: 'The entries in this catalogue are descriptions of works existing as real material conditions in the world. My works are not the embodiment of ideas or conceptions. My works are, in the words of William Blake, "The lineaments of Gratified Desire".'[62]

Andre seems to be implying here that there is a particular dynamic at work in a viewer's encounter with his sculpture, involving an unmediated, uncontrollable alternation between seeing it as plain material fact and as highly charged psychic fantasy. The latter certainly plays a prominent role in some of the readings Andre proposes of his own works. Take, for example, his comment on *Lever* (fig. 5) as glossed by the critic David Bourdon:

> 'All I'm doing,' says Andre, 'is putting Brancusi's *Endless Column* (fig. 68) on the ground instead of in the sky. Most sculpture is priapic with the male organ in the air. In my work, Priapus is on the floor. The engaged position is to run along the earth.'[63]

The sexual connotations are presented as simultaneously obvious and immediate and also somewhat far-fetched and ludicrous – but far-fetched only in so much as the psychosexual reading is based on seeing the work as an image, and interpreting the extended broken rigid form symbolically as a kind of phallus. Andre's point is a little different, and has to do with how the work is placed on the ground. Resting engaged there, not pushing upwards, it insinuates itself as an oddly stabilised phallic presence.

When commenting on the affective resonances of his work Andre usually emphasized ideas of serenity and calm, but he did so in ways that often introduce some powerful opposing term – whether passion, ferocity or threat. This is even suggested in the rhetoric

of his apparently straightforward insistence that 'In terms of desire I find my work at its best, passionately serene. I find there an ideal of serenity which I find absolutely impossible in my own life.'[64] Contradictory overtones are set up more pointedly in the conjoining of 'fierce' and 'calm' in a statement he made about the Japanese gardens that he, like Serra, so admired:

> I have a natural tendency toward calm or rest. Though I found in Kyoto and other places that this kind of calm has to be fierce calm, the calm of a kind of fierce attention, a fierce equilibrium.[65]

Something of this tension is also evident in the contrast Andre drew between the powerful suggestions of threat in Serra's work and the somewhat precarious calm or serenity he saw himself striving for.[66]

Once one takes note of the force of these psychic projections, some real affinities emerge between Andre's understanding of his work and Eva Hesse's response to it recorded in an interview conducted in 1969–70. If Hesse's commentary is very different in tenor from anything we find in Andre, it has a certain intensity and an openness to psychic fantasy that are not without parallel there. Hesse rightly stresses that her response would probably have been deeply antithetical to the spirit in which Andre conceived his work. Yet through the contiguities she sets up between her response and Andre's imagined denials, a complex affinity emerges which helps to illuminate the contradictory dynamics of encounter Andre's work invites, and in certain circumstances incites. Here is the relevant fragment of the interview between Nemser and Hesse:

> HESSE: . . . I feel very close to one Minimal artist who's really more of a romantic[67] and would probably not want to be called a Minimal artist and that is Carl Andre. I like some of the others very much too but let's say that I feel emotionally very connected to his work. It does something to my insides.
>
> NEMSER: What do Carl Andre's floors represent to you?
>
> HESSE: It was the concentration camp. It was those showers where they put on the gas.
>
> NEMSER: I wonder what would be Andre's reaction if you told him your response to his work?
>
> HESSE: I don't know, because we like each other maybe he'd understand, but it would be repellent to him that I would say such things about his art.[68]

Andre envisaged the material facts of sculpture as having a psychic charge because of the existential resonances of a viewer's engagement with these facts. Sculpture in his view was about one's basic physical interactions with the world. As he put it baldly, 'sculpture is a mediation between one's own consciousness and the inanimate world, which is after all what life and death are all about.'[69] This comment brings me back to the issue with which I began my analysis, the fluctuating sense of presence and of emptiness and absence that his work activates. This duality features in one of the few extended comments Andre published about how the notion of the minimal might apply to what he felt he was doing in his sculpture. Minimalism, as he saw it, was not to be located in the objective qualities of the work, but in the state of mind of the person closely involved with it. He was referring specifically to the artist, but what he said applies equally to a

viewer who becomes absorbed in looking at the work. The minimal state of mind, he explained, meant emptying out the 'dross' of things, 'the common exchange of everyday life'. The point was to 'really rid yourself of those securities and certainties and assumptions and get down to something which is closer and resembles some kind of blankness'.[70] The coupling here of 'something closer' with 'some kind of blankness' might be one way of describing the sense of presence emerging in insistent emptiness that is fundamental to Andre's work, and also to his fascination with and undoing of traditional ideas of the sculptural.

Borderlines, 'Nothing, Everything': Hesse

Eva Hesse's work represents one of the most radically inventive and complex engagements with sculpture and sculptural evocations of body image from the historical moment of Minimalism. In her case, we do not find the combination of powerful negation and reaffirmation of sculptural values enacted in Andre's work, partly because her point of departure was much more anchored in painting. Her work operates by defying the resonances of depth and weight, of a strongly posited occupancy of space, that emerge in a viewer's encounter with Andre's work and indeed with most of the Minimalist reconfigurings of the sculptural I have been discussing. At one level, my aim is to highlight the cogency of her refusal of the resonant 'being there' implicit in so much Minimalist sculpture of the period, a refusal which makes one aware that the complex dialectic such work sets up between presence and absence, or between a rigid and sometimes massive substantiality and the dissolution of this sculptural solidity in optical effects and surface modulations, has its own specific, maybe distinctively masculine, qualities.

There is also a more important issue to explore. The negations of sculptural weight and depth, and of expansively or forcefully posited occupancy of space, do not themselves account for the strange intensity of Hesse's work. The way it affects one has to do with a distinctive and potentially disconcerting suggestion of bodily presence. To understand the puzzling particularity of the impact it makes, we need to start on common ground, with the concerns Hesse's interventions in the sculptural share with other Minimalist work. To this end, we again have a substantial body of commentary by the artist on which to draw. The fragments of notes and annotations on which her earlier commentators, such as Lucy Lippard, have drawn, together with a published statement on *Contingent* (fig. 144), and especially the long interview conducted by Cindy Nemser in 1970, provide some of the most sharply focused and suggestive analysis we have of the paradoxes and obsessions played out in her art.[71]

Hesse is unusual in so explicitly thematising in certain works of hers that disjunction and interconnection between painting and sculpture which, as we have seen, has been integral to the more creative engagements with the sculptural in modern art, and in particular to the American Minimalists' developing a three-dimensional art that would connect strongly with the viewer – that would, to use Hesse's words, do something to the viewer's insides. A moving out from painting into three dimensions was dramatised intriguingly by Hesse in one of her major earlier three-dimensional works, *Hang-up*, dating from 1966 (fig. 142). This literally is a painting that has cancelled itself out to

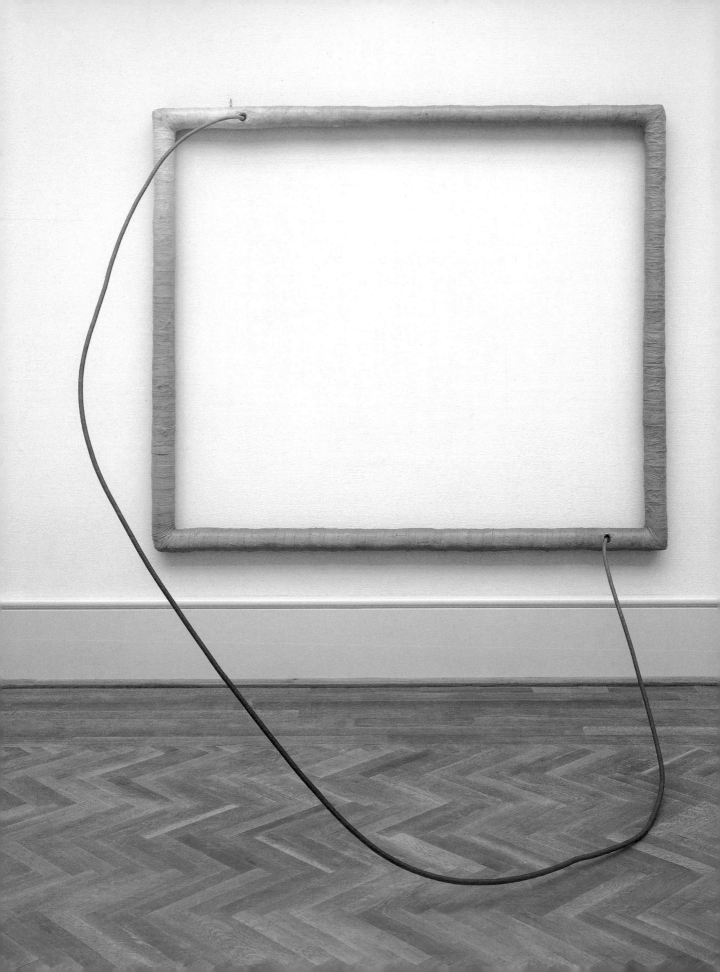

become a sculpture. The interior, the painterly field, has been evacuated, leaving behind not the blank of a monochrome but an empty expanse of wall. The literal substance of the painting has been absorbed by the frame bound with torn sheets of cloth, and painted in varying shades of grey liquitex. The utter emptiness of the interior field is further accentuated by a huge length of thick wire thrusting awkwardly out from and then back into the frame. The obsessively bound, and also subtly tinted, frame anchors this simultaneously limp and tensile assertion of three dimensionality, that droops and pushes out beyond the frame's limits, and extends out almost the same distance as the whole width of the work.[72]

A superficial look at an illustration might prompt one to see the wire as a drawing in space, but it evidently is not this when one faces the work directly. It sticks out too much, interferes too much with the empty space in front, which is usually cleared for viewing items hanging on the wall of a gallery. It also has body and substance. It is a fairly substantive half-inch thick rigid steel wire, and has been painstakingly bound with cord and painted in acrylic in graduated shades of grey, giving it a tactile density of surface. The absorbent roughness contrasts with the slightly shiny gleam of the liquitex on the bandaged frame. The wire's almost inconsequentially narrow surface, at least as seen from a distance, has in effect been worked over as thoroughly and completely as any traditional sculptural surface.

The format of the six-foot by seven-foot frame is roughly that of the large, ambitious Abstract Expressionist painting of artists such as Newman, and the work is a sort of joke on Newman's art. It is as if one of the precisely positioned vertical zips had got quite out of hand and become an unmanageable sculptural thing, while the rest of the painting had been reduced to wrapping round the framing support over which the painted canvas would originally have been stretched. *Hang-up* had a special place in Hesse's assessment of her own trajectory as an artist. She thought of it as 'the most ridiculous structure I have ever made and that is why it is really good. It is coming out of something and yet nothing.'[73]

The work fits well with her own assessment of the positioning of her practice in relation to painting and sculpture. When asked if she felt that she had 'broken with the tradition of sculpture', she replied 'No. I don't feel like I am doing traditional sculpture.' Asked then if her 'art is more like painting', the slightly less insistent response came, 'I don't even know that.' What she says echoes Judd's point about the paradoxical relation of the new three-dimensional work to the established categories of sculpture and painting.[74] In her case too, the negation of the sculptural is asserted more categorically than the negation of painting. As with her Minimalist contemporaries, the idea or the hope was to produce a three-dimensional thing that was not a predetermined kind of object. Echoing a point also advanced at the time by Robert Smithson, she maintained that 'a lot of my work could be called nothing or an object or any new word you want to call it.'[75]

Towards the end of her brief career, Hesse produced a rather different work, which also pointedly situated itself between painting and sculpture: *Contingent*, exhibited in 1969 (figs 143, 144). In her interview with Nemser, she herself described this as something 'which could be called a painting or a sculpture', and went further in her published statement on it, setting up an elusive interplay between negation and affirmation: 'not

142 Eva Hesse, *Hang-up*, 1966, acrylic on cloth over wood and steel wire, 182.9 × 213.4 × 198.1 cm, Art Institute of Chicago, Gift of Arthur Keating and Mr and Mrs Edward Morris, 1988, © Estate of Eva Hesse, courtesy Robert Miller Gallery, New York

143 Eva Hesse,
Contingent, 1968–9, early
photograph, fibreglass and
latex on cheesecloth, eight
units, varying in height
from 298.6 to 426.7,
width from 91.4 to
121.9 cm, now in the
National Gallery of
Australia, Canberra, ©
Estate of Eva Hesse,
courtesy Robert Miller
Gallery, New York

painting, not sculpture. it's there though.'[76] If the overturning of distinctions between painting and sculpture may be less immediately dramatic and conceptually striking than in *Hang-Up*, the resonances of *Contingent* are more dense and complex, particularly, and this is what concerns me here, in reference to the sculptural.

The work might initially be thought of as a three-dimensional painting. 'It is', as Hesse described it, 'really hung painting in another material than painting.'[77] Arranged in a line are eight slightly different abstract sheets, each roughly formatted Rothko-like in large rectangular fields. They are not painted on canvas, but the translucent fibreglass and latex surfaces create painterly variations of tone and modulations of hue as well as a certain optical glow, which can at times seem to dissolve the literal surface and create suggestions of a painterly field. Yet the positioning of the units emphatically blocks the perception of them as paintings. They are not displayed like paintings, flat against a wall, but hung out in a row, dangling free and marking out a three-dimensional space. Unlike a painting, but like a sculpture, each unit (and here we might think of Stella's comment)[78] has a back and a front that are equally visible.

As insistent as the blocking of a painterly viewing is the way the work also inverts expectations of a sculptural experience. It is not solidly grounded, as even the more spatial

144 Eva Hesse, *Contingent*

work by Serra and Judd is, and certainly does not hug the ground as the similarly surface-orientated floor pieces by Andre do. What we have instead is a series of relatively light surfaces suspended from the ceiling. This staging of the work also dissolves any sense of a self-supporting inner structure usually associated with free-standing sculpture. Instead of having an inner substance that holds itself up, Hesse's sculpture stretches and hangs. This is particularly evident in the less rigid sections made of latex on ripple cloth that form the central rectangle of each unit, pulled between the rigid fibreglass surfaces above and below.

Like much Minimalist art, the work is defined as much by the space around and within it as it is by its solid elements. But it does this rather differently – less sculpturally. Because the planes are thin sheets of light material, with slightly irregular and translucent, uneven surfaces, they do not convey the sense of cutting into or emphatically

dividing up or occupying space as do the sharply defined, geometric planes or dividers of most Minimalist work. If *Contingent* might seem 'open and extended', a little like Judd's series of open boxes (fig. 117), the sense of an open volume extending along a lateral axis is partly denied or dissipated, firstly because of the slightly irregular, contingent spacing of the elements, but more perhaps because there is no firm definition of the space between these. In Judd's work, the sequence of fairly broad, partly closed-in volumes, punctuated by much narrower blank intervals, gives resonance and dynamism to the lateral sweep. Even Sol LeWitt, an artist with whom Hesse had close affinities (fig. 120),[79] set up clear-cut geometric framings of space in his freely open structures that the slightly irregularly shaped, rippling sheets of moulded fibreglass and stretched skeins of slightly darker latex in Hesse's work defy.

And yet the layered accumulation of surfaces creates a kind of depth or density that the viewer cannot measure out, as one can, for example, the extended space of Judd's multi-unit works. Something very much is there, but in such a way as to deny one the sense of a clear sculptural occupancy of space to be had from the enclosed forms of traditional sculpture, or the open structures of modernist work, or the cuts into or divisions of space defined by Minimalist work. But neither can the substance of the work be located in its evocation of a painterly field, however painterly it is. The elements are too insistently separate, and too specific, to allow them to fuse together in the tinted glow of light emanating from their surfaces. It is as Hesse put it 'nothing, everything'. But if it is 'of another kind', what kind? Not enigmatic, nor quite 'absurd', to use one of Hesse's favourite words, because it also looks so self-evident and simple.

This is not the usual way to approach Hesse's work. I have been stressing the rigour, and I hope too the intensity and force, of her engagement with the ambiguities of the sculptural in order momentarily at least to exclude the emotionally loaded projections her work has invited because of the circumstances of her death from a brain tumour at the early age of thirty-three, just when she was producing some of her finest work (figs 143, 149). This work has been invested almost too easily with pathos,[80] a reading given added intensity by awareness of her precarious situation as a female artist having to make her way in a predominately male art world. But as her work comes to be seen as the embodiment of a doubly wounded subjectivity, wounded physically by disease and wounded psychically and ideologically by the often intangible pressures operating against a woman trying to sustain a serious professional role as an artist at that time, both Hesse and her work are in danger of becoming engulfed in myth. Hesse becomes, as Lippard suggested, another Sylvia Plath or Diane Arbus, supposedly a victim to the vulnerable feminine intensity that gives her work its charge and to which she can be seen to have sacrificed herself.[81]

My point is not to moderate over these various projections, nor to deny their validity, though I personally feel deeply uneasy about the tendency to dramatise her situation, going through the real tragedy of dying from a fatal cancer, as that of a victim suffering extremes of psychic and physical agony. There were too the moments of resistance, of getting on with living as best she could. A projection of what is known of the circumstances of her life into her art may at times be the vehicle for some illuminating and deeply invested responses to her work. I see my task as rather different, resisting an engulfing of the work by personal details of the life, or by suppositions about the artist's

frame of mind when producing this work. I am concerned with what happens in a viewer's encounter with Hesse's work, with the physical substance of what is actually there, and why and how it can be so resonant and compelling.[82]

She was something of a modernist in refusing any too straightforward symbolic or figurative reading of the motifs in her work.[83] The exchange with Nemser about Andre's sculpture is telling in this respect. Hesse talks about its affective power by invoking associations it stirred for her with the concentration camp, and then goes on to say that 'You can't combine art and life' in this way. Her outlook was more complex, however, than a standard modernist rejection of any expressively charged reference. If a work, even a radically abstract one, strongly engaged a viewer, it would have, in Hesse's understanding, an emotive power that was not an etiolated pure feeling but connected to concrete aspects of life in the world outside the gallery. Yet the impact the work made could not be tied down to the vivid images it might evoke of some actual or imagined real experience.

Hesse's take on the emotive power of the kind of work she herself made or responded to most intensely comes out in a comment that is characteristic of her ability to combine candour and sophisticated self-awareness:

> it's a contradiction in me . . . because I can't stand romanticism. I can't stand mushy novels, pretty pictures, pretty sculpture, decorations on wall, nice parallel lines – make me *sick*. Then I talk about soul and presence and guts in art. It's a contradiction.

While she refused romantic feeling, which she astutely associated with a tastefully formalised modernist abstraction, the 'soul and presence and guts' that engaged her was equally at odds with standard aesthetic categories of the sublime or the abject. It was the absurd that really fascinated her, as she emphasised on several occasions. The artists she identified as playing out a 'total image' of 'art and life', of 'artist' and 'person' operated in a cool, 'flip' mode – Claes Oldenburg and Andy Warhol. What she said on this is illuminating as to her distinctive commitment to realism – the 'realism' of a 'totally abstract' art. For she is, as I shall argue later, perhaps the most thoroughgoing realist among the Minimalist artists working in three dimensions:

> I absolutely do like Oldenburg very much. I respect his writings, his person, his energy, his art, his humor, the whole thing. He is one of the few people who work in realism that I really like – to me he is totally abstract – and the same with Andy Warhol.[84]

* * *

If we are to understand those features of Hesse's work that, as well as setting up a formal negation of conventional sculptural values, also activate a distinctive awareness of bodily presence and bodily contact with things, a good place to start is some of the early work that explicitly plays upon aspects of body image that have been central to traditional forms of figurative sculpture. The most ambitious of these is her modernist satire on the *Laocoon* (fig. 145), the celebrated antique statue of the naked Trojan priest heroically struggling against some huge serpents who are entwining him and about to kill him and his two sons (fig. 20).

145 Eva Hesse, *Laocoon*, 1966, early photograph, papier-mâché over plastic plumber's pipe, cloth-covered cord and acrylic on wire, 300 × 60 × 60 cm, Allen Memorial Art Museum, Oberlin College, Ohio, © Estate of Eva Hesse, courtesy Robert Miller Gallery, New York

The image of virile strength has been reduced to a spare, slightly awkward recti-linear frame made of plastic plumber's pipe covered in papier-mâché, painted a Morris-like light grey. This structure is partly smothered in drooping, twisting snake-like forms, also painted grey. The latter at first look a little limp, like ropes, but in fact hold their shape because of a substantive wire core that is wrapped in a softish, amorphous covering of cloth coated in papier-mâché and then bound in with a very thin wire. What gives the work its charge is not so much the jokey incisiveness of its undoing of heroic virility as its curiously ambiguous evocation of a body, of a physical presence that is clearly situated and structured and a little spare on the one hand, and also drooping and twisting and somewhat prolific and abundant on the other. An intriguing confusion between interiority and exteriority is also set up. The ropes could be things external to the suggested frame of the body, coursing over it like the snakes in the classical statue, yet they could equally well be twisting vital bits of its inside, the internal writhings as well as the source of pain.

The virile or phallic resonances of tradi-tional sculpture again have fun poked at them in *Several* (fig. 146). The cluster of several sausage-like or penis-like forms, each about the length of a human body, gives the phallic symbolism a physical excessiveness that undoes any pretensions to aura, an effect amplified by the limp clustering and dan-gling formation.[85] In preparatory drawings, *Contingent* too presented some immediately recognisable evocations of bodily form. The upper edge of the individual elements, instead of being approximately straight, are curved down at the sides to evoke the image of clothing draped over a body, or over a

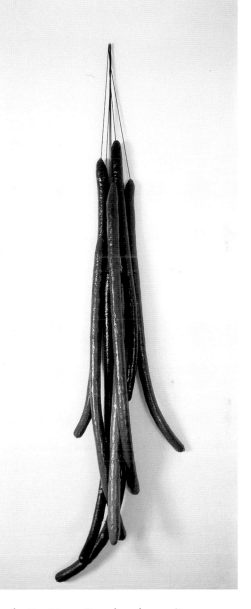

146 Eva Hesse, *Several*, 1965, acrylic on papier-mâché over rubber hose, 213.4 × 27.9 × 17.8 cm, Saatchi Collection, London, © Estate of Eva Hesse, courtesy Robert Miller Gallery, New York

hanger strongly suggestive of the shape of the absent body. In the final realising of *Contingent*, this evocation of biomorphic form was eradicated and attention focused instead on the particular look and feel of the suspended surfaces and their slightly irregular

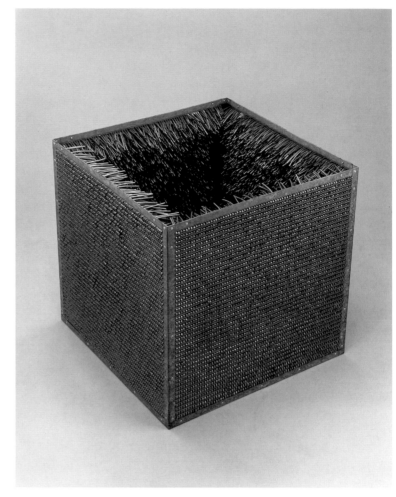

147 Eva Hesse, *Accession
II*, 1967, galvanized steel,
plastic tubing, 78 × 78 ×
78 cm, The Detroit
Institute of Art, Founders
Society Purchase, Friends
of Modern Art Fund and
Miscellaneous Gifts Fund,
© Estate of Eva Hesse,
courtesy Robert Miller
Gallery, New York

accumulation. But what precisely are these surfaces, surfaces that effectively make up the substance of the work?[86]

For one thing, they actively defy being seen in the way most surfaces are as either the outer face or inner face of something. Their thinness precludes one from envisaging the slight swellings and modulations of the more substantive fibreglass sections as a shaping of some interior volume. If such a sculpture of pure surface puts us in mind of Morris's evacuating of inner structure in his felts (fig. 13), the latter are still suggestive of a wrapping and enfolding, of an internally sustained twisting and turning that has a certain massiveness and depth, an illusion that is precluded by the distinctive formatting and placing of the surfaces in Hesse's work.

The suspended elements in *Contingent* are pure surfaces of contact, unanchored in a firm sculptural articulation of space, and so do not allow one to see them as having a distinct inner and outer face, or even a this side and a that side. Because of their organic-seeming irregularity, and the tactile variations created by the bending fibreglass and by the contrast between it and the softer, membrane-like skeins of latex, we can begin to

148 Eva Hesse, *Accession II*, detail of
interior

internalise them as suggesting a fluid sense of something both yielding to us and also
impinging on us, opening itself up to and resisting our half-felt, half-seen coming into
contact with it. This fluidity is enhanced by the slight softening and imprecision of the
optical definition of surface created by the translucent latex and the fibreglass resin – in
marked contrast to the sheer, precise flatness of Judd's sheets of perspex, for example.
There is here a suggestion of that felt contact with things which Merleau-Ponty talked
about so eloquently in *The Visible and the Invisible*, of surface as fluid tactile interface that
does not take shape as the outer boundary of an enclosed shape as do surfaces in our
everyday perceptions.

 The isolation of pure surface and the unfixing of a settled distinction between interior
and exterior in *Contingent* contrast with Hesse's intensification of sensations of insideness
and outsideness in her most deliberate evocation of mainstream Minimalist forms, *Acces-
sion II* (fig. 147), an open-topped metal box lined with small segments of flexible plastic
hose. In this work, a vividly felt differentiation is introduced between the inner and outer
surfaces. The outside is hard, dense and flat overall, the exposed inside (fig. 148) much

softer, more amorphous and organic-seeming. This sets in train a reversal of what is usually seen as the main face of a sculpture. The outer surfaces may define the basic form of the work and demarcate the space it occupies, and they are also what one first sees. Yet the inner surfaces are so much more tactile and intriguing, to the extent that almost the entire substance of the work seems to be located there. If one thinks of this distinction between inner and outer face in terms of the process of weaving suggested by the making of the work – each short segment of plastic hose is inserted into neighbouring pairs of holes in the perforated metal frame – the interior becomes a little like the visible surface of a thick pile carpet, the outside the carpet's usually hidden underside. The result is an inversion of conventional sculptural viewing, with the outer surfaces seeming to be mere support for the visually richer interior ones.[87]

Clearly, an awareness of how the work was made, which is apparent just from looking closely at it, plays an important role in amplifying and focusing the viewer's perceptual engagement with it. This is also true of *Contingent* (fig. 144), where the process is rather more complicated and indirect.[88] Here each dangling sheet is made up of an inner fibrous support, impregnated with a liquid that then goes hard and encases it. In the central areas, a rectangular piece of ripple cloth has been dipped into liquid latex and left to set between slightly uneven plastic sheets from which it has to be peeled away, the result being as Hesse described it, a 'clinging linear kind of thing'.[89] The rippling harder areas above and below are made from a core of flattened out glass fibre that has been stretched out on an irregularly shaped horizontal mould. Translucent liquid resin is poured over this, creating a firm but very slightly flexible sheet when it hardens.[90] In both cases, our awareness of process and material underlines the sense we have of the elements being layered and textured surfaces that are simultaneously fluid and firm, clearly shaped and irregularly modulated by contingent variation.

The significance of these effects is brought out in Hesse's published statement about *Contingent*, where she stresses the open nature of the working process that allows for variations of size and surface and placing within certain clearly defined limits, and removes the possibility of fine-tuned aesthetic adjustment and composition:

> irregular, edges, six to seven feet long.
> textures coarse, rough, changing.
> see through, non see through, consistent, inconsistent.
> enclosed tightly by glass like encasement just hanging there.
> then more, others. will they hang there in the same way? . . .
> today another step, on two sheets we put on the glass.
> one was cast – poured over hard, irregular, thick
> plastic; one with screening, crumpled, they will all be different.
> both the rubber sheets and the fiberglass.[91]

The process of making involved differs somewhat from the dominant practice of pre-programmed, non-hands-on fabrication in Minimalist work, but it differs much more from a traditional hand-crafting of sculpture. Hesse set up systematic procedures for fabricating her late work, which she increasingly had carried out by assistants. She also took an entirely pragmatic attitude to using pre-manufactured elements where this made most sense.[92] As she put it, it was a matter of using materials 'in the least pretentious and most

direct way'.[93] Hers was a process of making in between individually generated and mechanical fabrication, involving both the creation of newly invented material elements and the choosing of given prefabricated ones, and where some sort of gap opened up between conceiving and devising a procedure for making a work and the actual process of creating it. Hesse pointedly distanced herself from the fetishising of process, and her whole approach was antithetical to the idea that the work could somehow be identical with the process of making it.

Some disjunction between what a work is and how it is conceived on the one hand, and the material process of realising or fabricating it on the other, has always been part of the real condition of sculpture, where often quite complex and indirect procedures are required to fabricate objects or environments that will exist as relatively permanent things in three dimensions. The larger changes in approach to fabrication in later twentieth-century sculpture have functioned to create a much more sharply focused consciousness of this condition, making both artist and viewer more acutely aware of the tension and interplay between individually generated hands-on object-making on the one hand and some kind of de-individualised, mechanical making on the other. Along with this situation, there has developed a fascination with the relatively cheap, widely available new materials used in modern industry for the manufacture of consumer objects and interior finishings and decoration. With the Minimalists, such a fascination became more pragmatic, no longer so charged by a futuristic ideology of the modern and new.

Hesse, who tended to the hand-made end of the Minimalist involvement with modern technology, was very up-to-date in her experiments with new sculptural materials. Latex was then coming into its own as the easiest and most practical material for taking moulds, and fibreglass was replacing wood and metal in many contexts, such as small-boat building, because it could easily be made into different shapes and was lightweight as well as fairly sturdy. What is particularly germane to Hesse's reconceptualisng of sculpture is that both these materials, while not having the absolute rigidity of marble and bronze or steel, possess a light tensile strength which means that they can be used for making extensive forms that are no longer massive like traditional sculpture or modernist metal constructions.

There is another decidedly untraditional feature of both materials, particularly the kind of latex Hesse used, namely their impermanence.[94] The fibreglass resin in Hesse's work soon began to discolour, yellowing and losing its almost colourless semi-transparency, while the latex not only darkened much faster but also began seriously to deteriorate. The central areas of *Contingent*, for example, have lost much of their translucence and have also become quite stiff and fragile. Hesse herself was fully aware of the problem and made some telling comments about how the particular vulnerability of her materials to deterioration exposed a kind of paradox for the artist – how genuinely invested was an artist in the long-term physical survival of a work, after it had left her or his hands? Such survival was only a straightforward issue from the point of view of the market: the object needed to last to keep its value as a commodity. Hesse's unusual way of taking on board the fact of physical deterioration was something she shared with two of her contemporaries to whom she felt close, Robert Smithson and Carl Andre.

Latex, particularly after Hesse stopped using conventional moulds to cast it and began applying it directly to a wire mesh or textile support, was subject to almost immediate decay, and when challenged about this, her response was characteristically acute and at the same time ambiguous:

> . . . the rubber only lasts a short while. I am not sure where I stand on that. At this point I feel a little guilty when people want to buy it . . . Part of me feels that it's superfluous and if I need to use rubber that is more important. Life doesn't last; art doesn't last.[95]

It might be argued that Hesse's perspective on this issue was coloured by her acute awareness of her own mortality at the time once she had been diagnosed as having a brain tumour. Her comment, though, is compelling in its own terms, and her particular situation might just as easily have prompted her to take a very different view and become obsessed with ensuring a permanence for her work. Here she was voicing an ambivalence about whether works of art should be conceived as permanent objects, a view that was pervasive in avant-garde circles at the time. Implicit in this ambivalence was the sense that what mattered most was the vital moment of active engagement with a work, whether by artist or viewer, and that this was of its very nature impermanent. Such attitudes run through much of the art produced in the 1960s, including process, performance, Pop or land art. How important was it that a work should give one the illusion that it was going to be there almost for ever, once it had become a relic of concerns long dead, and why worry about making something permanent when its potential durability had nothing to do with the impact it now made?

Hesse's involvement with the issues of impermanence relates to that particular time in other ways too. The 1950s and 1960s saw widespread commercial exploitation of new materials, such as fibreglass, plastic and synthetic rubber, for finishings and surface coverings. The look associated with this was ultra-modern, yet the materials for the most part were rarely as lasting as more traditional ones, and often soon started to look tatty. This awkward coupling of an ethos of shiny ultra-modernity with the realities of almost instant aging was particularly evident in the case of materials used for finishings in architecture and interior design. It is also apparent in much three-dimensional or object art of the period, where some of the same materials were being used. In retrospect, the aging of this once glossy, surface newness is not usually very attractive – more a dulling and a wearing and peeling away messily at the edges than a process of acquiring patina. Hesse's work has aged better, and this is mainly because it was honestly conceived as peculiarly vulnerable to physical deterioration, not as something that should preserve as long as possible the look of the freshly manufactured commodity.[96]

* * *

Contingent focused a viewer's attention on an almost free-floating surface detached from an armature of shape or structure, or from a firm marking of place. Hesse's inversion of the sculptural took another equally striking form, which was most dramatically played out in the late untitled rope piece of 1970 (figs 149, 150). Here is something that is all connectives without any substantial body – rubberised ropes and strings, dangling from

a network of wires attached to the ceiling. There is one easy and I feel ultimately unconvincing way of envisaging the charge this work generates. It could be seen as the trace of a body of some kind, the congealed residues of twisting entrails and sinews, a strange sculptural rendering perhaps of Rembrandt's famous picture *The Slaughtered Ox*. These associations, however, say little about the work's physical make-up as a three-dimensional thing, and how and why it engages a viewer's attention in the long term. Talking about the work in this way would be rather like the sensationalising readings of *Contingent*'s surfaces as reminiscent of the dried skins of concentration camp victims from which the Nazis made lampshades.[97]

What happens once we attend closely to the work, to its curiously insubstantial substantiality, and to the way it emerges and defines itself in space while almost collapsing into disarray? In notes she recorded while making it, Hesse indicated something of the distinctive dynamic played out in the work's placing and arrangement. This 'rope piece', she wrote, was to be 'hung irregularly tying knots as connections really letting it go as it will', and was an attempt at 'non forms non shapes non planned' that could be 'floppy or stiff'.[98] Connection and knot are key words here. What happens when a work's substance is all pure connectives of varying thickness without any entities being joined together, whether shapes or surfaces? The pure winding and stretching and slightly congealed rubberised stringiness of the rope piece is in a way a radical counterpart to the pure surfaceness of *Contingent* as a denial or inversion of sculptural depth and volume.

If *Contingent* was about surfaces of contact, what physical immersion in things is suggested by the coils and knots, the tightly drawn connections and the limp collapsings and twistings of this interminable tangle of ropes and strings? If we think of the way such configurings might echo an awareness we have of our own body, we would probably be put in mind of our insides, of entrails or blood vessels or nerve fibres, just as *Contingent* might make us think of our skin. The visual images we have of our insides derived from anatomical illustrations, however, are rather different. Hesse's work is much more formless than these diagrammatic depictions, more akin to what we feel our insides to be, whether vaguely locatable twinges of sensation and pain, or some amorphous, flexible connectivity between one part of the body and another. Such sensations in a way echo the ever changing knotting and coming apart of the meandering, twisting and tightening ropes and strings in Hesse's work. Andre once made the comment about how he was 'the bones of the body of sculpture and perhaps Richard Serra is the muscle, but Eva Hesse is the brain and the nervous system extending' as he put it 'far into the future', but also we might say deep into our insides.[99] Such effects are enhanced for the viewer of the rope piece by the way the work is hung, allowing one to come in so close that one is right under and almost inside it.

At the same time, it is important to consider how the work impinges on our awareness as we stand back a little and take it in as a whole. Seen as an external apparition beginning to encroach on our space, what kind of a presence does it have? We might think of Hesse's work as the polar opposite of Judd's equally abstract, box-like structures, the astringent, 'realist' other to his expansive, yet clearly delimited 'classical' sense of 'being there'. The distinctive occupancy of space and complex interplay of internal and external resonances her work activates could also be elucidated by thinking of Merleau-

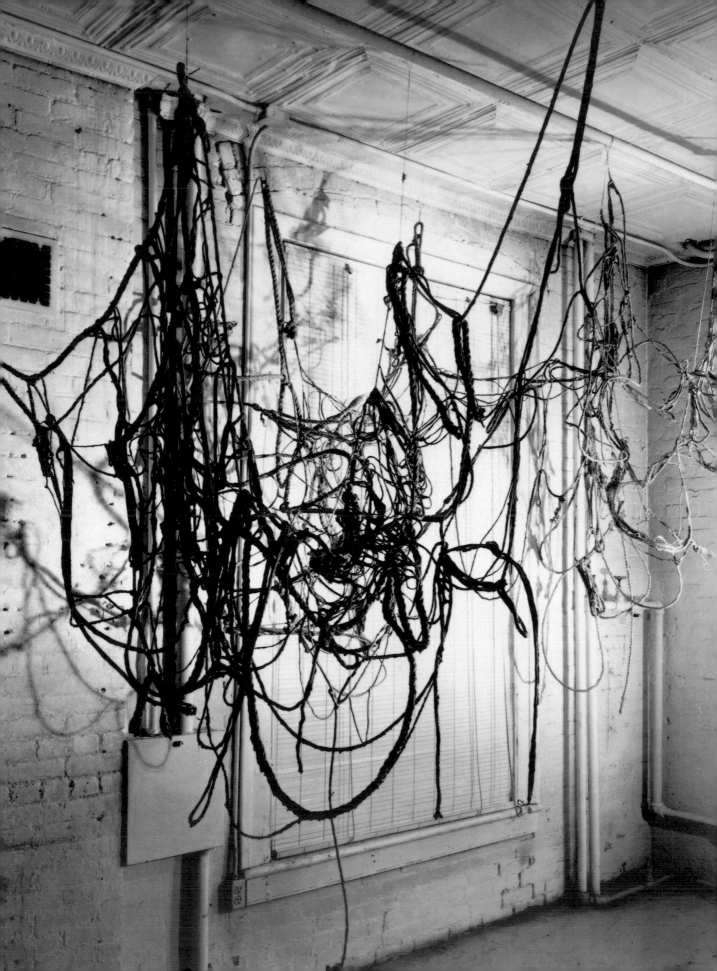

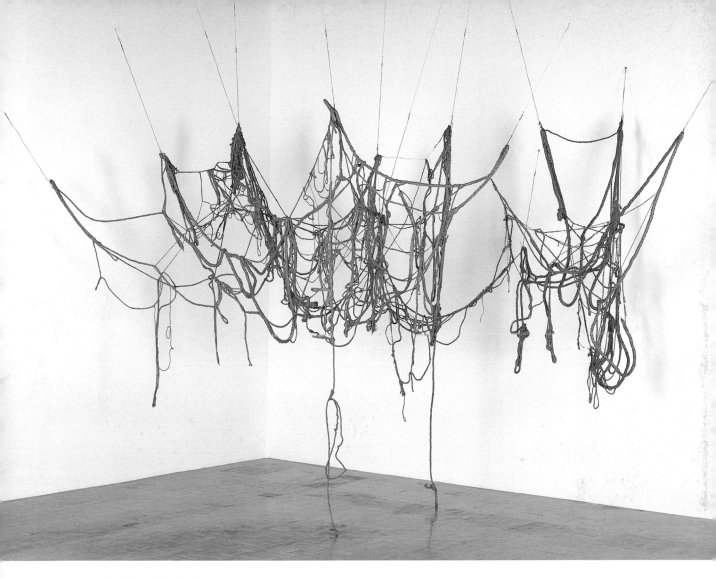

150 Eva Hesse, *Untitled*, 1970

Ponty's evocation of being immersed in the material fabric of things in *The Visible and the Invisible*. Here is a passage in which he talks about feeling some presence impinging powerfully yet elusively on our awareness, whose immediate reality lies in its not quite being definable as an objective entity separate from us:

> We never have before us pure individuals, indivisible glaciers of being, nor essences without place or date, not because such things exist elsewhere, beyond our grasp, but because we are [our] experiences, that is to say thoughts, which feel the weight behind them of the space, of the time, of the very Being that emerges in our thinking, and . . . which are situated in a time and a space that are a piling up, a proliferation, an encroachment, a promiscuity – a perpetual pregnancy, perpetual parturition, generativity and generality, brute essence and brute existence, the nodes and the knots of the same ontological vibration.[100]

149 Eva Hesse, *Untitled*, 1970, early photograph, latex over rope, string, wire, heights of three units 366, 320 and 228 cm, width and length variable, now in the Whitney Museum of American Art, New York, Purchase, with funds from Eli and Edythe L. Broad, the Mrs. Percy Uris Purchase Fund, and the Painting and Sculpture Committee, © Estate of Eva Hesse, courtesy Robert Miller Gallery, New York

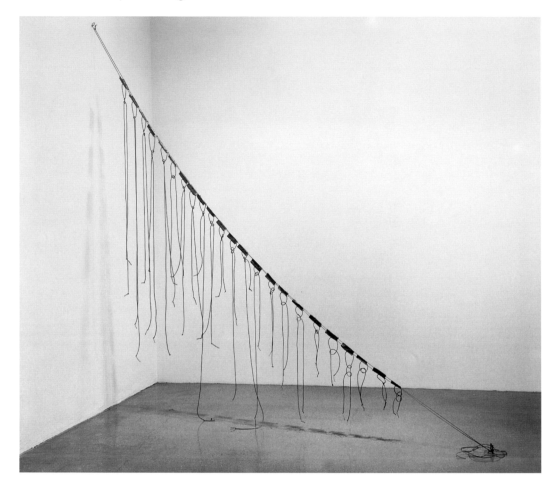

151 Eva Hesse, *Vinculum II*, 1969, latex on wire mesh, wire, staples, string, 297.2 × 293.4 × 6.3 cm, The Museum of Modern Art, New York. The Gilman Foundation Fund, © Estate of Eva Hesse, courtesy Robert Miller Gallery, New York

Such 'ontological vibration' puts one in mind of a rather terser comment Hesse made about plans for a future work just after she had finished *Laocoon*, her first major rope piece: 'Rope irregular . . . that does not come from a form, this is endless, totally encroaching and irrational. With its own rationale . . .'.[101]

The binding and connecting and dangling are enacted more much more sparingly and reticently in *Vinculum II* (fig. 151), a title Hesse chose because it evoked ideas of 'link, that which binds; bond, tie, connecting medium'.[102] Surfaces only exist in minimal patches – the sequence of rubberised segments of wire mesh stapled round the long connecting wires. The work stages a stark contrast between the two wires' taught connectiveness holding everything together and the loose drooping downwards of the twisting strings of rubber tubing. A pulling tight and emphatic ordering exists simultaneously with a casual dangling and mobility. As the wire mesh elements could in theory be made to slide along the wires and 'every connection is movable', the whole

work has, as Hesse put it, 'a fragile, tenuous quality except that it is very, very taught. It's attached from two angles so there's a lot of tension, yet the whole thing is flexible and moves'.[103]

Photographs can make this seem a relatively small piece, somewhat on the scale of Tatlin's Constructivist corner reliefs. But while it is very thin, it is more or less full body size in extent. Albeit operating in very different ways, it is like both *Contingent* and the 1970 rope piece in seeming slightly to echo one's presence as one focuses on it. What this presence might be, and how it is different from the sense of place and presence evoked by most Minimalist work, is suggested by Hesse's comment describing the arrangement of elements in *Contingent*:

> they are tight and formal but very ethereal. sensitive. fragile.
> see through mostly.
> . . . it's there though . . .[104]

* * *

The precariously insistent thereness of Hesse's work arises as much from its precise positioning in space relative to the viewer as from the internal arrangement and substance of its elements, and this is another respect in which Hesse is very much party to the Minimalist reconfiguring of sculpture. She herself made some astute comments about the kinds of space in which her work should be viewed, stressing that it was designed to be encountered in the enclosed, relatively small interiors of a gallery or studio, not in outdoor architectural or natural environments. By the late 1960s in New York, loft studio spaces and gallery spaces where new work was displayed were often generically very similar. Hesse's point was that her work needed to be seen somewhere that was not a grand public display area, like the traditional sculpture gallery, for example, or the new sculpture gardens springing up outside museums of modern art at the time.

She also stressed that her formal concerns went beyond the usual modernist focus on the internal form and materials of a work to encompass 'the size, the scale, the positioning or where it comes from in my room.' The way the work impinged on the viewer's awareness was an explicit concern of hers. This was not, she stressed, to be envisioned as some kind of dominating of the viewer or the viewer's environment. What mattered was the work's having a certain scale so that 'you have to walk in and around something and it covers or connects to the four walls and the ceiling and the floor. And some [of my work] can be very, very inconspicuous.'[105]

Like other Minimalists, but more insistently than any of them, she devised her work so that one's sense of it could not condense into a fixed structure or overarching form. She was intrigued by the shifting, informal juxtaposition of parts or aspects that could sometimes be varied through slightly different installations. Of *Contingent*, she explained in her published commentary: 'Each part in itself is a complete statement, together I am not certain how it will be.'[106] Early photographs of this work set up a viewpoint which conveys an optimal sense of optical unity between the spaced out separate units (fig. 143), just as the classic photograph of the 1970 rope piece

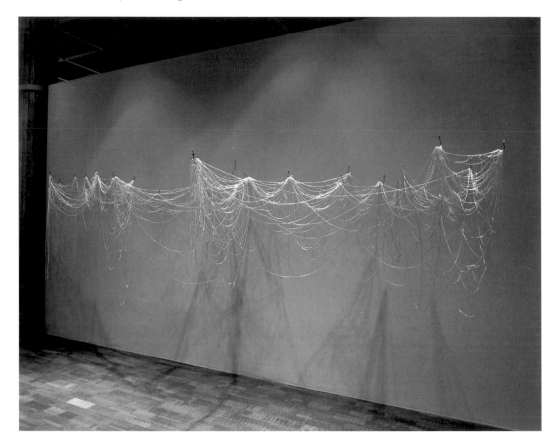

is devised so that the clusters of rope are drawn as closely together as possible (fig. 149). In reality, moving round these works creates a sensation of the parts moving together and then coming apart, of the work becoming closer and denser and then of opening out (figs 143, 144). In the case of *Contingent*, Hesse had the idea of this being played out through variations in its installation, with different spacings between the elements: 'try a continuous flowing one./try some random closely spaced. try some distant far spaced.' With the rope piece, the slight flexibility of the latex-covered rope allowed it to expand and contract somewhat so its installation could be a little denser (fig. 149) or a little more strung out (fig. 150), depending on how the supporting wires were placed in the ceiling; indeed, there was no definitive arrangement.[107]

In Hesse's case, the dissolution of a fixed plastic image is further intensified by a rather unusual alternation between a sense of order and chaos as one shifts from a distanced overview of the work to a closer look at some particular aspect of it. Usually, an overview conveys the maximum sense of order, and the various partial views introduce variability and even some chaos. When a work by Hesse is seen close to, the changing surface texture of fibreglass, latex and cord, the contingent variations in the hanging and twisting of string-like elements, will often intensify the sense of disorder. But the reverse can also occur. The 1970 rope piece looks most chaotic if one tries

152 (*facing page*) Eva Hesse, *Right After*, 1969, resin over glass fibre cord, 198 × 457 × 305 cm, Milwaukee Art Museum, Gifts of Friends of Art, © Estate of Eva Hesse, courtesy Robert Miller Gallery, New York

153 Eva Hesse, *Right After*, detail

to take in the whole tangle of ropes and strings. When a particular area becomes the focus of one's interest, individual elements that are much easier to get a grip on start standing out. One can begin to see how the ropes are hung or tied in place and the tangles glued together by skins of latex that have now gone slightly brittle. At times it is almost the case, as Hesse pointed out with reference to one of her earliest experiments with dangling string, that 'the further you get away from the structure the more chaotic it is',[108] an effect we have seen was also important for David Smith, with whose monstrous absurdities Hesse perhaps has closer affinities than any of her contemporaries, Minimalist or otherwise.

Ambient lighting as well as placement was for Hesse a crucially important aspect of her work. Like Judd and others among her contemporaries who were sensitive to the sculptural effects of lighting, Hesse was averse to dramatic directed light. She wanted a subtle, natural light to infuse her work. Because of the translucence of fibreglass, light would sometimes literally illuminate and give texture to the inside of elements of a work as well as modulate and reflect off the surfaces. Significantly, she became a little uneasy about the dramatically beautiful effect created by *Right After* (fig. 152), her first major string-like piece suspended from the ceiling, and predecessor of the rope piece I have been discussing. This work, she felt, 'left the ugly zone and went to the beauty zone. I didn't mean it to do that.'[109] The fairly uniform delicate glow of light

emanating from the gossamer-like threads meant that the piece could seem to dissolve in an optical glow, becoming a kind of painting in space. There was a danger that any sculptural sense of stringiness, of tension between opaque resistant stuff and free-floating openness, would be blanked out. Yet is it blanked out? Seen close to, the threads are not gossamer but hardened translucent resin encasing a thin dense cord of glass fibre (fig. 153).

Right After should not be seen just as a conventionally beautiful other to the literally weightier and potentially more disturbing rope piece, but as its counterpart, as if they were two aspects of some larger whole, one on the light and more delicate side, one on the dark and heavier side, and both in the end suffused by light and dark, with darkness emerging within transparency and light and hints of light gleaming from within darkness. Talking about the effect of natural light infusing the translucent fibreglass of her work, and why this should not be enhanced by extra lighting, Hesse made the point that 'Maybe dark does beautiful things to it.' *Contingent* (figs 143, 144), which so visibly comes alive through the modulations produced by changing effects of ambient light,[110] also has its darknesses, its opacities, its heavinesses – and, when one considers it carefully, even coarse resistant fibres impregnating its rippling surfaces, and awkward metal hooks gripping and holding these surfaces in position so they can seem to hover in the air. With a subdued light playing on its hardened surfaces, it can seem almost weightless, divested of solidity, and yet be substantially and insistently there. It could strike one, in Hesse's own words, as 'like a really big nothing', as something 'thought, seen, touched but really what is not', drawing us into some elusive yet real flickering between life and death.[111]

Conclusion

Arenas and Objects of Sculpture: Bourgeois

The story of sculpture I have been telling has a kind of ending, though not one that resolves the obsessions circulating round the sculptural object that have been the central theme of this book. Sculpture is neither finished nor has it completely shed the conventions that once gave it its special, uneasy status in relation to painting. Over recent years, a new form of three-dimensional art has brought to an end the subordination of sculpture to painting, and opened up a more theatricalised arena towards which modern sculpture may always half blindly have been striving. However, such work is not to be seen simply as visually striking installation, even if it is very different from sculpture as traditionally conceived. It exists in a space once occupied by the now discredited ideal of the autonomous sculptural object, whose residual imperatives are not without their continuing, if indirect effects.

Perhaps the most striking recent shift has been a regendering of the persona of the sculptor. This has been more dramatic than in painting or two-dimensional work because of the insistently masculine inflection of sculpture well into the 1960s and early 1970s. Nowadays, by contrast, sculpture is no longer thought of as particularly male. What is more, it makes little sense for critics to ask whether certain forms of sculpture or three-dimensional art should be seen as distinctively feminine or masculine, questions that dogged the careers of earlier female sculptors such as Barbara Hepworth. Perceptions of Louise Bourgeois's work have been less constrained by such considerations than that of other women of her generation, largely because of her late appearance as a high-profile artist. Coming to prominence in the wake of the major feminist interventions in the contemporary art world in the 1970s, she was able to assert her femininity unequivocally without having second thoughts about whether this would set limits on public valuations of her art. If anything, some of the more powerful recent work, which plays on the tension inherent in ambitious sculpture between a public and a more intimate or individual mode of address, has been by women artists, a situation, however, that has more to do with shifts in the gender politics of society at large than with anything specific to sculptural practice.

I shall finish by focusing on three radically different recent stagings of sculpture, instances of the different ways in which three-dimensional art is being realised in a contemporary context: one a sculpture of objects, one a sculpture of spaces and one a sculpture of figures. My key figure is Louise Bourgeois, whose oeuvre embraces a strikingly broad range of practices, starting with her existentially loaded, late Surrealist objects from the immediate post-war years and then, both spanning and evading the high modernist and Minimalist moments, through to the self-consciously dramatic staging of objects in her installation work of the 1980s and '90s. I also include Bruce Nauman, an

artist formed in the late 1960s, whose work activates psychically charged spaces without recourse to the tactile surfaces or resonantly present objects we associate with sculpture. At the opposite extreme, there is Georg Baselitz's wood sculpture. His work might seem to mark a return to conventional figuration but, no less than Nauman's, it draws the viewer into a destabilising drama in which a kind of condensation of presence alternates with a dispersal and displacement.

In all three instances, an encounter is elicited that foregrounds the psychic dimension of a viewer's engagement with the work. This marks a noticeable shift from Minimalist sculpture, where the formal articulations of viewing were paramount. Also in evidence is a particularly thoroughgoing negation of the serenity and repose associated with classical sculpture. The interaction between viewer and work, once it comes alive, almost seems to deny the viewer not only the residual reassurance associated with a momentary suggestion of resonant presence, but even the more fragile repose that might be allowed by an intensely absorbing blank. It is as if there were no mid-point between excitation and deadening emptiness, or as if, through the foregrounding of the unstable psychic dynamic of interactions with spaces and things, the viewer's response is almost completely taken over by unconscious processes of binding and dispersal. The most apparently solidly grounded object, the most emphatically articulated positing of a physical presence, seems to be evacuated of the potential to offer a stably anchored sense of being there.

While this is a tendency that particularly intrigues me because it deploys the formal conventions of sculpture to create the very antithesis of the serene plastic presence that previously haunted the history of Western sculpture, that is only part of the story. A viewer looking at this work does not actually regress to what psychoanalysts would call a paranoid-schizoid state or state of infantile omnipotence. Reflecting on her or his response to such work, a viewer can enjoy a certain stability, even if it is not quite what would be called serenity. The work gets at one but also, for moments, it leaves one be. What is more, this is only one, if prevalent, form of recent sculptural work. Other stagings of the interaction between viewer and object are not so evidently driven by a destabilising, regressive dynamic. An obsession with tactile sculptural surfaces and solid sculptural forms continues to operate in inventive and not entirely ironic ways, even if the idea of a clearly configured presence, and firmly centred shaping of things, no longer haunts the art world's imagination as it once used to.

A key figure in this respect is an artist of a younger generation than the three whom I have chosen to exemplify different present-day forms of three-dimensional art. I am thinking of Rachel Whiteread, whose intensely evocative work has obvious affinities with the emphatic no-nonsense formal declarativeness of earlier Minimalist sculpture.[1] Indeed, *Untitled (Orange Bath)* (fig. 154) could be seen as a kind of specific object. However, the structures of response it invites are in the end rather different, more in tune with the unsettled dynamic that characterises so much recent sculpture.

At first sight this looks to be a fairly straightforward, substantial sculptural block with an interesting bath-shaped indentation sunk into its upper face. But after continued viewing, it belies these settled appearances. While it might seem to be all about solid shapes and clearly defined surfaces, the orange resin from which it is made is slightly translucent, allowing light to penetrate the interior. The tinted inner luminosity is further varied by the slices cut into the interior of the block dividing it into sections.

154 Rachel Whiteread, *Untitled (Orange Bath)*, 1996, installed at Palacide Velázquez, Madrid, in 1997, resin, 80 × 207 × 110 cm, Saatchi Collection, London

Yet another level of visual complexity arises because the inside surfaces of the indentation are more substantially sculptural as a result of slight irregularities deriving from their genesis in the casting from an actual bath, while the outer surfaces are sliced smooth, lacking in tactile or visual density.

This is not just a subtly staged Minimalist block made more interesting by an interior cavity that is the trace of some object of common use. As soon as one ponders the process of casting that generated it, its apparent simplicity is subtly yet insistently undone. One's first instinct is to see the cavity as a replica of the interior of a bath, and the surrounding block as a cast of the cheap plywood frame in which such baths are often set, even if it is a little on the large size for practical purposes. However, as soon as one looks at the plug hole, it is clear that the interior surface is created from the impress made by the rougher outer surface of a bath, the part which one's body never touches and which is hidden from view. So one's interpretation goes into reverse. This is not the cast replica of a bath installed in a rectangular support. It is rather a cast of the negative space under the bath and inside the supporting frame. But this does not quite work either. When a bath is set inside a supporting structure, its upper edges have to curl over the top surface. Here they are sunk below it, as if the bath were suspended precariously in

155 Rachel Whiteread, *Ghost*, 1990, plaster on steel frame, 269 × 356 × 318 cm, Saatchi Collection, London

space, hovering just below a hole cut in the framing structure equal in size to its outer circumference, or as if the bath were simply pressed into a huge rectangular mould, settling into it as one might into a bath filled with warm water. Is this sleight of hand, getting rid of the awkward join between bath and support, or is Whiteread deliberately trying to forestall a consistent interpretation of the work as being the cast either of a solid object or of a negative space? There is a bit of both, I feel.

Certainly, a pragmatic choice has been made by her to go for a clean-cut form rid of awkward joins or bitty left-over gaps. But there is also a wilful conceptual double bind that makes the work very different from the equally Minimalist-looking piece *Ghost* (fig. 155), which established Whiteread's reputation as a sculptor of negative spaces. *Ghost*, as the opaque but hollow cast of the interior of a typical room in a Victorian terraced house, creates a slightly disconcerting reversal, in that one is looking from the outside at wall surfaces one normally sees from the inside. At least, however, there is a consistent positing of negative space as solid thing that one is denied in the case of the simpler seeming bath. Moreover, the surfaces, even if seen in reverse, are ones that are normally exposed, unlike the underside of the bath.

The slight frustration one feels in trying to make sense of *Orange Bath*, while it helps to activate one's response – guaranteeing that the work does not just sit there

as a stolid sculptural lump – also blocks the sense of resonantly configured and intriguingly textured presence that at times it seems to promise.[2] The only way to deactivate this low-level irritation, to be left in peace as it were, is to suppress the impulse to interpret the surfaces and volumes at a spatial, sculptural level and to view the work a little like a painting. In this case the encasing orange block ceases to suggest discrepancies of solid thing and empty space, and becomes instead a voluminous framing support for the impress and indexical image of the underside of a bath. However, because the work so looks and feels like a real bath, one can never entirely cease trying out incompatible realist projections of solidity and volume and of inner and outer surface. This sets in motion a restless positioning of the viewer not so unlike that produced in the more highly charged confrontations between viewer and work I shall be discussing from now on.

* * *

In the case of Louise Bourgeois's sculpture, the psychic resonances of the viewer's interaction with the object or array of objects become absolutely central. She is the sculptor *par excellence* of dramas of confrontation, dramas articulated in the structuring of her work and also explicit in her verbal representations of it, as in the now much quoted statement, first published in 1992:

> Several years ago I called a sculpture *One and Others*. This might be the title of many since then: the relation of one person to his surroundings is a continuing preoccupation. It can be casual or close, simple or involved, subtle or blunt. It can be painful or pleasant. Most of all it can be real or imaginary.[3]

Her focus on the encounter between viewer and work positions Bourgeois much closer to artists of the Minimalist generation than to the modernist or late Surrealist sculptors who like her came to maturity in the immediate post-war years. But she reverses the Minimalist terms of engagement between viewer and work. In Minimalist sculpture, the psychic resonances, however powerful, are implicit, and the formal structuring within which these are played out are to the fore. By contrast, there is in her case no lingering unease that the integrity of a work might be compromised by the use of striking body images, or by creating a situation where a powerful psychic or affective charge takes over a viewer's response.[4] Her use of blatantly sexualised motifs, and her repeated claims that her artistic project is driven by deep-seated personal obsessions and traumas, function as provocations to ensure that the viewer envisages an encounter with her work as psychodrama from the very outset. At the same time she has as firm a grip on the formal logic of the viewer's interaction with her work as any Minimalist sculptor.

Her understanding of the inherently unstable interplay between the psychic and the formal is suggested succinctly in two slogans that feature in her *Cell I* (fig. 158) dating from 1991: 'pain is the ransom of formalism', and 'art is the guarantee of sanity'. The investment we have in art, she suggests, is caught up in a fundamental – generative – double bind. An arid obsession with artistic form will only come alive if activated by psychic pain, and yet the deadening and distancing effects of form function to make the extremes of psychic pain bearable. When she offers a reading of her sculpture in terms

156 Louise Bourgeois, *Nature Study (Velvet Eyes)*, 1984, grey marble and steel, 66 × 84 × 68.5, on steel base, height 11.4 cm, Michael and Joan Salke collection. Courtesy Cheim and Read, New York

of some archetypal childhood trauma, as she often does, the story she tells should be interpreted as an allegory of the viewer's engagement with it rather than as a direct explanation of the work's meaning.[5] The structure of the story matters more than its manifest content. It is important to remember too that her readiness to offer accounts of the psychological origins of her art is qualified by some resolutely modernist negations of the idea that art expresses the artist's intentions or inner world.[6]

Two distinctive forms of interaction are brought into focus by Bourgeois's work, firstly interaction as a one-to-one confrontation[7] and secondly interaction conceived as the relation between some entity and its surrounding environment, often envisaged by her psychoanalytically as a family scenario. Judd characterised the new three-dimensional work as being either 'something of an object, one single thing', or 'open and extended, more or less environmental'.[8] A significant body of Bourgeois's work, particularly the earlier work, is clearly constituted as 'one single thing', an isolated object pointedly confronting the viewer. Whether the more environmental multi-object works, such as the cells, are to be seen as 'open and extended' is another matter to which I shall return a little later.

Her single objects such as the grey marble and steel *Nature Study (Velvet Eyes)* of 1984 (fig. 156) and the latex-covered plaster *Fillette* (fig. 157) of 1968, might seem to have strong affinities with Surrealist objects. But their larger scale, their simple wholeness of shape and their staging directly in the viewer's space make them very different.[9] *Nature Study (Velvet Eyes)* is set almost directly on the floor on a minimal steel base, and it is implacably there, blocking and obstructing one's passage, as well as projecting a strong fixed gaze out into the surrounding space. *Fillette* hangs at eye level, impinging on one in another way – its up-frontness as a large thing suspended directly before one echoing its up-frontness in photographic representations. The flagrant display of a phallic shape was deliberately designed to provoke, and did so very effectively, as Bourgeois herself found when she looked back on it some fourteen years after she made it: 'I am sorry to get so excited but I still react to it'.[10]

The drama of confrontation is amplified in Bourgeois's retelling of the traditional story of the sculptor's confrontation with her or his hard recalcitrant materials. Thus she says of stone carving:

How are you going to . . . make the stone say what you want when it is there to say 'no' to everything. It forbids you. You want a hole, it refuses to make a hole. It is a constant source of refusal. You have to win the shape. It is a fight to the finish at every

157 Louise Bourgeois, *Fillette*, 1968, latex over plastic, 59.6 × 26.6 × 19.5 cm, The Museum of Modern Art, New York, photograph published in 'Child Abuse', *Artforum*, 1982. Courtesy Cheim and Read, New York

moment . . . the thing that had to be said was so difficult and so painful that you have to hack it out of yourself and so you hack it out of the material, a very, very hard material.[11]

Bourgeois might at first seem to be talking about a confrontation that aims at subjugation – as in Sartre's Existentialist dramas of confrontation between self and other, a favourite author of hers who supplied the title of one of her earliest installation pieces, *No Exit*. The central thrust of the drama she is evoking does not have to do with subjugation as such, however, but with resistance. As she put it, 'the resistance that must be overcome in stone is a stimulation'.[12] It is as if the subject is drawn into a situation where it can only anchor and define itself by way of the resistance it encounters in impinging on and being impinged upon by an object looming before it – that is, by feeling the pressure exerted on it by some outside thing. Moreover, Bourgeois's talk of the struggle to dominate hard resistant materials is almost always given a dialectical twist – the aggressive hacking alternating with or giving way to processes that by contrast seem almost reparative, such as polishing, assemblage or a more flexible engagement with soft and pliable materials.[13]

How a viewer might relate to a work like *Fillette* in very different ways is teasingly suggested by Bourgeois in the classic photograph of her by Mapplethorpe from 1982 where she is shown holding the sculpture under her arm, as if either possessive or nonchalantly disrespectful of it. This may be stretching the point, but there is nothing in principle to stop one from imagining this 'very very strong thing' as also, in her own words, 'an extremely delicate thing that needs to be protected.'[14] Such a give and take between the thing as stiff and hard, crudely speaking phallic, and as somewhat soft and vulnerable, evocative of a tenderness of touch rather than a rigid thrusting confrontation, is already set in train by the title, 'little girl', and also by the physical constitution of the work: a softish flexible layer of latex covers the hard, rigid crumbly plaster. The slippage between a phallic and a feminised erotic image might recall Brancusi's *Princess X* (fig. 65). But there is a difference. *Fillette*'s form may momentarily mutate into the stylised neck and breasts of a female figure, but it remains first and foremost a monstrous penis, strung up on a hook like a piece of meat in an old-fashioned butcher's shop. In contrast too with the Brancusi, it does not have a reassuringly smooth surface: the latex in certain areas coagulates in awkward lumps, in places even peels away from its solid core, as if its skin might stick to one rather than glide under one's touch. And dangling, it is denied the suggestions of a rising upwards or collapsing inwards that give an inner animation to the Brancusi.

In Bourgeois's later work composed of assemblages of objects, the structuring of the viewer's response becomes very different and more complex. However, something still remains of a sculptural one-to-one confrontation, of the dynamic immediacy and instability, and the sense of obdurate otherness this induces. The tensions between the object-like and the environmental in her later work are brought out in a particularly complex and dense statement Bourgeois made about the kinds of interaction elicited by one rather unusual multi-part work of hers. The work in question, *Twosome*, dating from 1991, is composed of two cylindrical steel cells, a larger one about six feet in diameter and illuminated inside, and a slightly smaller one that slides along a track inside and out of the larger one. It is perhaps the relentless pumping of sexual intercourse, though the

158 Louise Bourgeois, *Cell I*, 1991 (exterior view), mixed media, 211 × 174.5 × 244 cm, collection the artist. Courtesy Cheim and Read, New York

moving bit might also be a little child trying to take refuge inside mother. Bourgeois begins by explaining how

> a twosome is a closed world. Two people constitute an environment, one person alone is an object. An object doesn't relate to anything unless you make it relate, it has a solitary, poor and pathetic quality. As soon as you get concerned with the other person it becomes an environment, which involves not only you, who are contained, but also the container. It is very important to me that people be able to go around the piece. Then they become part of the environment – although in some ways it is not an environment but the relation of two cells. Installation is really a form between sculpture and theatre, and this bothers me.[15]

For Bourgeois, the single sculptural object remains sadly lacking unless it is activated by some kind of interaction, in the case of this work the interaction of one object imping-ing on another, creating a dynamic that then echoes out to include the viewer. *Twosome*, she suggests, is the environment or arena encompassing the two cells as well as the viewer who has been drawn into their ambit. Yet it is also just the two cells interacting with one another – and this ambiguity bothers her. There is an irreducible tension between the sculpture as object and the sculpture as staged situation which her work cannot resolve – and in the end is the more intriguing and powerful for not doing so. Even the cells (fig. 158) present themselves simultaneously as a single thing in an empty space and as arenas that partly open up to encompass the viewer. Moreover, just as the two compo-nent units of *Twosome*, as Bourgeois put it, are 'next to each other' yet also 'completely isolated from each other',[16] so the viewer shares the same space as the work while being excluded by it.

Some such complexity had been set up by Bourgeois's much earlier installations of figurative wood sculptures in the Peridot Gallery in New York in 1949 and 1950 (fig. 159). These installations were both informal arrays of separate free-standing entities and scenarios that could include the viewer. Looking back on these shows from the pespec-tive of the late 1970s, Bourgeois remarked:

> The figures are presences which needed the room, the six sides of the cube. The privi-leged space has certain characteristics. It is closed and exactly defined and belongs to

159 Installation of Louise Bourgeois's work at the Peridot Gallery, New York, in 1949

the artist in the way the stage belongs to the performer for a certain number of minutes. The spectator is no longer merely a viewer if he is able to move from the stage of viewing to the stage of collaborating.[17]

The situation created by this complex staging of viewer and work had in her view a definite psychic and social dynamic. As she put it, 'My work grows from the duel between the isolated individual and the shared awareness of the group.'[18] It is important to hold onto the word duel here: we are not talking about a harmonious interchange binding individuals in a stable grouping, any more than about a firm compositional structure integrating the disparate elements of the display in a stably composed whole.

Whatever self awareness Bourgeois had at the time about the staging of these early wood sculptures, the exhibitions easily separated out into their individual components – sculptures conceived as autonomous entities that were and are still usually displayed as such. It was only in the late 1980s that she began to exhibit works that could no longer be seen as single objects and were unequivocally assemblages of objects situated in a spatial arena. The series of cells she began working on then were among the more prominent of the new wave of object-based installations. Unlike the installation work of her contemporaries such as Beuys (fig. 1) and of the younger generation of artists coming to prominence then like Robert Gober, and unlike her own earlier display in the Peridot Gallery, these cells did not take over an entire gallery space. Instead, they were closed shapes defining interior arenas isolated from the gallery area (figs 158, 160).[19]

From a distance, the cells present themselves as big, slightly awkward sculptures resting on the floor, fairly massive, yet not quite sculptural objects in the traditional sense because their outer shells have openings or are partly permeable, allowing one, indeed inviting one, to look inside to their visually more dense and resonant interiors (fig. 161). Yet, if the visual interest is mostly located on their inside, the outer aspect immediately confronting one still has a certain sculptural presence. One sees a substantive container rather than a mere frame. It prevents one from physically entering the interior but at the same time one's view can penetrate to the inside through apertures or gaps or glassed in or screened walls. Hence the use of doors and windows and fence-like mesh to define the outer boundary of the cells.

The interiors have obvious psychic resonances, usually associated with specific domestic spaces, often the bedrooms or dining rooms where memories of childhood family scenarios would be played out. The effect is both one of protective enclosure and isolating entrapment. Bourgeois has pointed out how in *Cell (Glass Spheres and Hands)* (fig. 161), the glass spheres are staged so 'they're enclosed; you do not get at them. They are sealed off without the possibility of communication and yet they are together.'[20] The uneasy, alienating interplay being suggested between the 'isolated individual' and the 'shared awareness of the group', as she put it, may remind one of the distinctive staging of the self in post-war Existentialist writing such as Sartre's, but it has other resonances that operate with continuing force today, neither so exclusively masculine nor purely feminine either.

The isolation of the more striking objects within the cells, their being contiguous rather than integrated with one another, might put one in mind of the Minimalist rejection of conventional composition. Even so, the arrangement has nothing of the fixed, grid-like placement of equivalent units in Minimalist work. Moreover, as one looks

160 Louise Bourgeois, *Cell (You Better Grow Up)*, 1993 (exterior view), steel, glass, marble, ceramic and wood, 211 × 208 × 212 cm, Galerie Karsten Greve, Cologne

through certain openings, a picture-like image will momentarily present itself. Such picturesquely composed scenarios are only glimpsed, however, and soon dispersed and fragmented as one moves round to get other views. In the end, what one feels is a vague contiguity of several discrete objects within an interior space more than a structured spatial arrangement or composition. The overall effect is a little like those vague memories of being in a situation surrounded or confronted by significant objects and presences. Sometimes there is a body-like object with which to identify, such as the two marble hands in *Cell (Glass Spheres and Hands)*. While these might suggest feelings of vulnerability, of being called to account or crowded out by the complacently blank glass spheres round them, the clasping might equally well be imagined as possessed of an authority that was commanding the others' attention.

This instability within what is an ostensibly closed and stable arrangement of things is so insistent because of the distinctive dynamic of viewing the work invites. Photographs are deceptive in that they seem to offer a definitive overview of the interior, when in fact

one has a number of partial and never entirely satisfying glimpses into the inside, some-times through small, restricted openings and sometimes screened by wire mesh or unclear glass (figs 158, 166). One always feels a little blocked and never actually finds a position where the interior is fully and comfortably laid out before one. The instabilities are further accentuated by the way one's eyes are kept on the move by the array of intriguing objects and fixtures dispersed in the interior spaces. With their dense materiality and richly pati-nated surfaces – whether hard glinting glass, solid marble, rusting steel, worn and roughly textured wood or fabric from cast-off clothes – these objects function visually as sharply defined condensations of weight and substance. At the same time, they are usually too compact to offer an expansive surface on which one's gaze can linger, and invite instead a more glancing and momentary looking, one that is sometimes literally kept in motion by tilted mirrors. The effect is enhanced by the combination of relatively low-level ambient light and directed spot-lighting, which makes the shape and substance of the objects stand out all the more, accentuating the disjunctions between their vivid materi-ality and the emptinesses that open up around them.

The viewer's positioning is inherently unstable, both isolated within the work and yet outside it and peering inside. As Bourgeois put it, 'each *Cell* deals with the pleasure of the voyeur, the thrill of looking and being looked at. The *Cells* either attract or repulse

161 Louise Bourgeois, *Cell (Glass Spheres and Hands)*, 1990–3, glass, marble, wood, metal and fabric, 218 × 211 × 218 cm, National Gallery of Victoria, Melbourne, Australia. Leslie Moira Henderson Bequest, 1994

each other. There is this urge to integrate, merge, or disintegrate.'[21] In another context, talking about the interior space created by an earlier work, *Articulated Lair* (1986), which the viewer could actually enter and take up a position on a seat in the centre, she stressed the double take between its being 'a protected place you can enter to take refuge', and one where one was vulnerable to, while potentially being free to flee from, 'the invading, frightening visitor'.[22] Like the close viewing of any work of art, this psychodrama is structured as something intimate that is also publicly exposed, but much more insistently and confrontationally than usual. The conjuncture between private and public in her art, and in her self-presentation as artist, clearly fascinated Bourgeois. Once, for example, when an interviewer voiced concern that she would be laying herself open in what was becoming a 'private conversation', she interjected 'I don't mind. Whether something is private or public makes no difference to me. I wish I could make my private *more* public and by doing so lose it.'[23]

Confronted by a cell such as *Glass Spheres and Hands*, the viewer feels drawn into, yet also partly excluded from, the richly resonant and unsettling drama it stages. The incessant fixations the array of objects engenders, and the oddly unstable sense of intimate exposure played out in their presentation, momentarily distracts one from the residues of one's own everyday psychic and social disturbances, and then incites these to re-emerge with unpredictable intensity. Few works of three-dimensional art so actively belie the traditional sculpted memorial's injunction, 'may she [or he] rest in peace'.

* * *

A similarly emphatic negation of inherited sculptural values could also be seen to operate in Nauman's work, though there is in his case an added edginess, and the alienation and confrontation are more insistent. I am thinking in particular, not of Nauman's object-like works, most of which I find pretty unremarkable, but of those that draw the viewer into highly charged spaces using video images and voiced utterances.[24] Several of these works, like Bourgeois's cells, are set up as partially closed-off interior spaces within the more open arena of the gallery. But there the similarity ends. The outer form of Nauman's corridor pieces, for example, is not at all visually or sculpturally significant. Indeed, they are often installed in such a way that one cannot see the outside, and one simply enters into a space that leads off the more open space of a gallery. The interior surfaces are quite different too, having none of the sculptural substance of the textured and patinated materials of Bourgeois's cells. The walls and ceilings of the corridors are flat, dead and inert, painted uniform white to guarantee minimal visual incident as well as maximum illumination from the naked artificial lighting. With a Nauman interior, one has no sense of the weight or density of the walls, but just feels the spatial pressure they exert, confining one and forcing one to follow a certain trajectory.

Entering the work momentarily creates a sense of withdrawing from the gallery area shared by other viewers, but one is soon made to feel more vulnerable than ever to exposure to their view. This arrangement effectively destabilises a viewer's positioning and also makes her or him feel uncomfortable about it. Nauman himself put this rather well when he explained how he was after

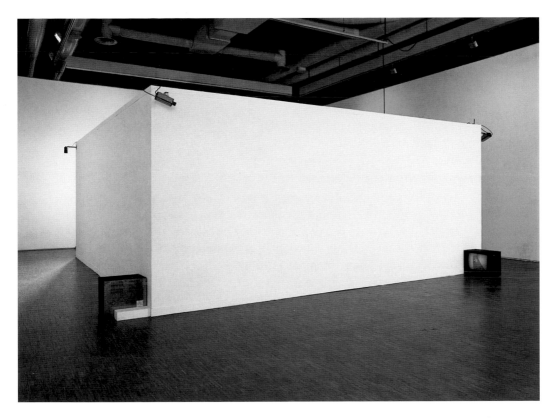

162 Bruce Nauman, *Going around the Corner Piece*, 1970, four panels each 305 × 610 cm forming the inner boundary of the circuit, four video cameras, four monitors, black-and-white and silent, Musée National d'Art Moderne, Paris

an art that puts you on an edge; it forces you into a heightened awareness of yourself and the situation. Often without you knowing what it is you are confronting and/or experiencing. All you know is that you're being pushed into a place that you're not used to and that there's an anxiety involved in that.[25]

And more specifically about the corridor pieces, he made the point:

When you are alone, you accept the space by filling it with your presence; as soon as someone else comes into view, you withdraw and protect yourself. The other poses a threat, you don't want to deal with it . . . What I want to do is use the investigative polarities that exist in the tension between the public and the private space and use it to create an edge.[26]

A corridor is not something to look at, or stand inside, but to be walked along – in the case of the closed corridor pieces, down into the far end and then back again, and with works like *Going around the Corner* (fig. 162), moving round and round, along the four sides of the square circuit which the work traces. These are looking and walking sculptures, like Richard Serra's, but without the substantive sheets of steel and strong articulations of space to provide a stable anchoring. In *Going around the Corner*, the

compulsion to keep moving is given an added impetus by the television monitors placed at the ends of each of the four sections. These echo back an image of the space one is in, but in a counter-intuitive way. The camera connected to a monitor surveys, not the space where one is located, but the one just behind. Moving round a corner, an image of one's back leaving the previous section flashes by on the monitor at the far end, but the moment one moves towards it, the image disappears, leaving the screen blank, though from time to time, other visitors, hidden from view, unexpectedly come up on it. Even after working out the logic of the arrangement, it is impossible fully to synchronise this with one's immediate perceptual take on the situation. There is an irrepressible compulsion to expect a direct mirroring of one's image in the monitor facing one. The effect of slight confusion and displacement is akin to that produced by the images glimpsed in the surveillance monitors now increasingly common in public spaces.

There is a rather different, if equally restive and edgy, interpolation of the viewer in Nauman's video installations. These draw one into what could still be called a sculptural mode of viewing because, unlike the more pure image-like effect of films projected on a screen in a darkened space, or of videos screened on monitors banked against a wall, the positioning of the monitors and the spaces they surround and activate are absolutely integral to the work. *Anthro/Socio* (fig. 163), for example, has quite a complex spatial structure. On three of the four walls of a large darkened room is projected a larger than life-size, close-cropped image of the head of a shaven-headed man, facing straight out and chanting incessantly. One of these images is inverted, slightly skewing one's orientation as addressed by the three looming, talking heads. The central area of the room becomes an activated space that they look into and surround.

Added to this is another spatial structure. Pairs of monitors, set one on top of the other, and showing the same talking head both the right way up and inverted, are set some distance out from each of the walls carrying the larger projected images, aligned to face in the same direction as these but a little to one side. The banked monitors establish three separate axes within the space activated by the looming images on the outer walls, the two facing pairs being somewhat displaced from one another, and the third perpendicular to these. Sound is used to create further patternings. Each pair of monitors emits a chant, voiced by the heads on the screens, one 'Feed me, eat me anthropology', the other 'Help me, hurt me sociology', and the third, as it were mediating between the other two, 'Feed me, help me, eat me, hurt me'. The chants, slow and measured but slightly hysterical, keep going on and on, creating random interchanges and interferences between the three screenings. The bare-faced projection of these peremptory addresses to systems of knowledge oscillates wildly between desperate appeal and defensive, confrontational agression, which may or may not be a totally ludicrous way of characterising what these human sciences mean to most of us.

One's situation as viewer and listener within all this is configured rather awkwardly. For one thing, it is impossible ever to find a position from which satisfactorily to view or hear the whole work. It is not just that one can never properly attend to more than one set of chanted utterances at a time. The images and voices are positioned so that they both include one and exclude one. The centre of the room is no place to stand, though at first it seems the obvious one, because one's body will inevitably get in the way of one of the screen images being emitted from projectors placed on the floor there. If one takes

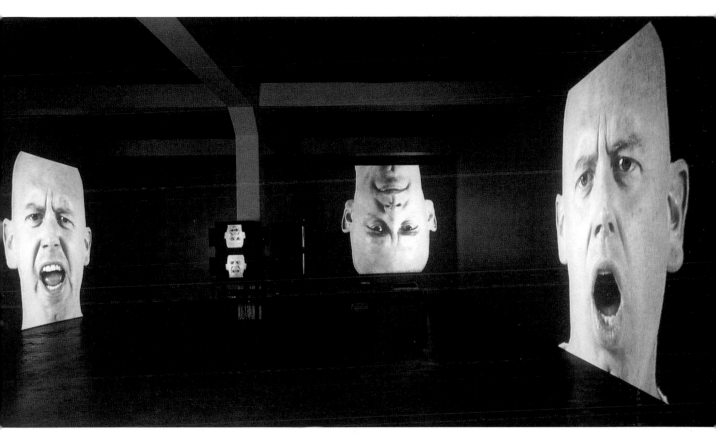

163 Bruce Nauman, *Anthro/Socio (Rinde Facing Camera)*, 1991, three video projectors, six monitors with stereo speakers, six video disc players, six video discs, one amplifier, two loud speakers (colour, sound), Ydessa Hendeles Foundation, Toronto

up a position backed against a wall, there is a feeling of being pushed to the edges, particularly if it is a wall where one has to keep out of the way of the image projected on it. Standing against the one entirely blank wall a little away from the central arena does not do much to resolve matters either. From here the images on the side walls are seen in steep perspective, and one feels frustratingly distanced from the voices, only one or two of the most insistent ones being properly audible. Wherever one stands, there is no settling down, no getting away from a feeling of being pointedly addressed and marginalised.

How one is interpolated by the work, psychically and spatially, is defined both by the look of the talking heads and by their utterances. Their peremptory appeals are addressed simultaneously aggressively and imploringly into the space in front of them. They command the viewer's or listener's attention, yet at the same time their invocations are launched into a void. With their incessantly demanding talking, they are so trapped inside their solipsistic psychodramas that there is no space for a response from the person they might be addressing. This perhaps is one peculiarly tense and edgy definition of the ambiguous autonomy of presence commonly associated with a sculpture – something that

addresses itself to a generalised viewer out there but also remains hermetically enclosed in its own world.

The visual and auditory looping into which the work draws the viewer is a distinctive feature of contemporary film and video work designed for presentation in a gallery. As we have seen, there is something about this that echoes the pattern of viewing invited by almost any free-standing sculptural object.[27] At the same time, it is a specific device that came to be exploited self-consciously in much time-based Minimalist work, from Warhol's films to the music of composers such as Steve Reich and Philip Glass. When it holds one's attention, the slightly irregular repetitiveness can immerse one in a vaguely pleasurable state of somewhat mesmerised distraction, but it can also function as a focusing device, the simple recurrences sensitising one to the slightest variations between different sequences, and to the way the sequences come in and out of synchronisation with one another. The device also has a psychic logic, which nowadays we explain perhaps too easily as a Freudian compulsion to repeat – a crazed compulsion, a childish compulsion, a gratuitous compulsion, which in some inexplicable way seems strangely satisfying.

The significance of this work by Nauman lies less in the images and utterances to which it could be reduced as a pure video piece than in its staging, and in the almost physical reverberations it sets up inside the viewer or listener. Entering the arena filled by the intense cross-play of sounds and visuals, one is held there for a time, half focusing on one face and sound and then another, half floating adrift amid the punctuating utterances and looks. Then, at some arbitrary moment, one has to disconnect and walk out. The timing and positioning and scaling of the elements in the work, their mutual affinities and repulsions, are as fine-tuned and as immaculately configured as any Brancusi sculpture. At the same time the work has a loud in-your-face quality that blocks the possibility of release into contemplative repose. This is an art of unrelenting excitation, where the blanks or empty spaces are little more than intervals of exhaustion or aggressive withdrawal. If stalled, the psychodrama of ceaseless projection and introjection would seem to issue not so much in peaceful repose as in aimless anxiety. And yet the work can produce curiously pleasurable sensations of bemused oblivion emerging out of incessant stimulation.

To turn from this complex interlocking of visual, spatial and auditory presentations to Baselitz's large chain-saw-hewn wooden figures might at first seem a lapse back into a very traditional and uncontemporary notion of the sculptural. But to assume this is to fall prey to a narrow formalism, that seeks to pin down the parameters within which any reasonably compelling contemporary art has to operate. Here I want to suggest how even such apparently figurative work can be caught up in distinctively contemporary stagings and rhetorics of address. In the end, Baselitz's eight-foot high *Untitled* of 1982/3 (fig. 164) is as involved in these as any work by Bourgeois or Nauman. A simply shaped object with built-in base planted directly on the ground, it confronts the viewer in a very physical way, and in this respect is different in kind from classicising figure sculpture as well as from the modernist work with which it might seem to have the closest affinities, the smaller neo-primitive figures in wood by Expressionist artists such as Kirchner. Seen in relation to works by Baselitz, the latter seem altogether lacking in any intensity of engagement with the viewer, and their arbitrarily shaped distortions and evocations of

164 Georg Baselitz, *Untitled*, 1982/3, limewood with blue and black oil paint, 250 × 73 × 59 cm, Tate Gallery, London

165 Georg Baselitz's studio in Derneburg, 1983

the human figure have none of the no-nonsense, almost found-object, quality of Baselitz's systematically blocked out, simple shapes.

Indeed, Judd's notion of a specific object might do quite well for Baselitz's work.[28] His sculpture is very much 'one single thing', a simple vertically situated object articulating one single emphatic gesture. It has none of the internal rhythms and integrated balancing and contrasting of parts found in most figurative work. Baselitz as much as Judd rejected a part-by-part construction: 'I do not want to construct anything', he insisted.[29] And the more striking aspects of his work, rather than being bound together by modulations of line and shape, are distinct, separate — specific as Judd would have said. 'Discordance' is a word that Baselitz often used to describe his way of working. The cross-cutting slashes made by the saw in the wood do not integrate themselves into the larger shaping of the figure's form, and they run against the grain of the wood rather than following it. His comment about the relation between the surface marking of a skin tattoo and the shape of the body beneath encapsulates this well: 'One . . . deforms the body by an opposing articulation'.[30] The dabs of colour do not model the surface either, but stand

out as independent splashes of paint, the forms they suggest almost floating free of the roughly hewn wooden block.[31] The result is to foreground a disjunction already implicit in the viewing of earlier sculpture, that between the apprehension of overall shape and the varying sensations produced by looking closely at its more intensely activated aspects. The difference with the Baselitz figure is that the disjunction strikes the viewer unavoidably from the outset, whereas even with Rodin, for example, the disparity between the clearly articulated shape of the whole and the ever shifting modulations and irregularities of surface seems more blurred.

Also of note is the gesture defined by the figure's pose, the way it posits itself to the viewer. How important this is for Baselitz can be gauged from the studio photographs he circulated of his sculpture, in which he placed himself in the picture and invited one to correlate the stance of the sculpted figure with his own self-presentation to camera (fig. 165). Amplifying on the way any large free-standing object directly confronts a viewer, the gesture of *Untitled* is emphatic, singular, up front and immediately affective, but simplified to the point where it has none of the nuances that would give it a specific content.[32] It is probably this direct rhetoric of engagement between viewer and work that Baselitz had in mind when he commented that 'sculpture is more primitive, more brutal and does not have that reserve which painting can have'.[33] The gesture sets up a clear signal, but the signal could equally well be one of refusal as summons. Even the more apparently unambiguous gestures of hailing someone in other figures by him can be interpreted in very different ways: the figure might be greeting you, stopping you short or desperately trying to get your attention.[34]

The gesture of address gives a quasi-linguistic cast to the sculpture's self-presentation, as if it were emitting a basic utterance. However, just as the figure's gesture lacks the internal complexity needed to convey a definite message, so its emphatic outward directedness has none of the nuances required for it to seem to be addressing anyone in particular. The indefinite interpolation of the implied addressee is accentuated by the figure's being slightly raised up off the floor, so it seems to look out over one as one approaches it. In a way, the effect of entering into the presence of the Baselitz figure is not unlike what happens when one enters into the arena defined by the talking heads in the video piece by Nauman. The mode of address impinges on one in such a way as to demand one's attention, and yet it also pushes one away and ignores one. The energetic outward-directedness seems too blind and indiscriminate to suggest recognition of another presence.

With most earlier figure sculpture, the pose is usually more inward-looking, and the implied interaction between viewer and work is that between two relatively self-contained entities, neither directly impinging on nor confronting one another. A close viewing, as we have seen, often functions to destabilise this nicely poised interplay between viewing subject and viewed object. But something very different is going on when, as with Baselitz's sculpture and Nauman's staged talking heads, this destabilising takes over from the very first moment of encounter, when the thing that initially intrudes on one's awareness emits an injunction resonant with splitting and self-displacement and seems to deny an integrating self-centring.

* * *

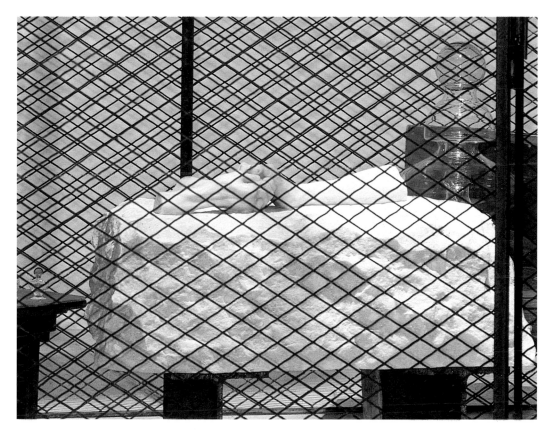

166 Louise Bourgeois, *Cell (You Better Grow Up)*, 1993, detail

A central preoccupation of this book has been the larger condition of modern sculpture over quite a long period of time, a condition I have explored by way of the structuring of a viewer's encounter with a largish object in a gallery setting. This condition is defined by historically specific, socio-cultural practices of viewing and also by the distinctive nature of a viewer's interaction with a work presented as a free-standing presence rather than as pictorial image or depiction. Within this larger condition, there are radical differences, differences that became particularly acute in the second half of the twentieth century.

I want to end by bringing out two factors which, if implicit in many earlier sculptures, are given a distinctive edge by the recent work I have just been analysing. First, there is the positing of presence as something unstable, more like an utterance than a thing, and activated in the contingencies of a viewer's encounter with a work rather than being anchored in its form. This denies the viewer that stabilised self-awareness occasioned by apprehending a sculpture as a substantial autonomous other. Secondly, there is a dramatising of psychic splitting and dispersal, as opposed to wholeness and condensation, and a refusal of the integrative structuring associated either with an ideal sculptural figure or a pure plastic form.

The modernist negation of the integrative centring implicit in the classical nude and the more recent negation of the modernist idea of autonomous form can in part be seen as shifts towards a more intensive engagement with the material conditions of encounter between viewer and work. But it is a shift registered more clearly in paradigmatic conceptions of the sculptural than in the actual practices of making and viewing sculpture. A sculpture entirely severed from the contingencies of viewing could not exist. One way then of describing recent changes in conceptions of sculpture would be to say that the sculptural has ceased to serve as an imaginative haven from the more deconstructive modern projections of the self, or from the destabilising engagements with things in the real world that these entail.

But equally, the demise of a myth of pure plastic form, and of the ideal of some self-sustaining rather than disintegrative engagement between viewing subject and viewed object, signals the demise of a very modern aspiration. What now no longer seems quite tenable is the expectation, implicit within earlier modernist aesthetics, that out of the negation of traditional aesthetic and ethical ideals, out of this facing up to the real emptiness and fragmentation of the fabric of modern culture, there might perhaps emerge a new, resonantly self-sustaining art that would project a radically different order of things. Ideals of this kind never have a definable moment of disappearance. I would hazard, however, that the post-war projects of artists like David Smith and Alberto Giacometti mark a kind of turning point when serious sculpture began to be severed from any connection with visions of a reconfigured world. Sculpture then became increasingly caught up in a bleaker, more insistently critical process of self-reflection, both at the level of questioning what a sculpture is or is not as a kind of object, and at the more rhetorical level of how the viewer is being interpolated by it.[35]

So let us look back for a moment at the phenomenological turn in post-war sculpture, and at the dissolution of the last residues of the idea that a sculptural object could represent an ideal configuring of things. The reality of this turn is not just to be seen as the concomitant of the supposed death of the centred bourgeois subject – if this subject ever actually existed or if, for that matter, it has entirely disappeared. The idea of an autonomous sculptural object would only have been credible if it successfully posited a collective image that mediated between the individual viewer's desires and the system of public values shaping artistic culture. Its evident unreality in present circumstances is symptomatic of a significant difference between the fabric of the culture we now inhabit and the fabric of the culture that still in a way fetishised this myth and the idea of a possibly integrative order it implied, finding in it an interpolation of the self that was in some way satisfying and credible – rather than empty and alien or merely irrelevant.

The three-dimensional art of the past few decades has tended to highlight forms of self-projection that are in tune with the more asocial, fragmenting and confrontational tendencies in contemporary society, perhaps as a way of both recognising and trying to live with these.[36] Also, in the provisional form of its staging, it has affinities with the instabilities of those phenomena that momentarily take shape as the collective realities of the modern world. If there is in all this an imperative that has some residual critical bite to it, it lies in the conviction that inherited images of order and integration, or of ideal autonomy, have too little residual reality or credibility to feature with much conviction, even in the relatively sheltered arena of the art world.

Yet it is also the case that within the scenarios of psychic instability and splitting, of emptiness and provocation,[37] dramatised so vividly in recent three-dimensional art, there can emerge modes of self-positing, or of being there, that have a sustained and even sustaining presence, and with which certain positive – if inarticulable – identifications are possible. Visual art, no less than other aspects of present-day culture, is subject to the restless and directionless dynamic of binding and dispersal fundamental to the operations of a now politically hegemonic capitalism. Therein lies much of its reality, which it has to confront and internalise and not evade in order to be of any substance. However, this cannot be the only reality evoked in those odd encounters with work that prove to be intensely compelling. The powerful effect certain work has on us may also bear witness to glimmerings of a collective reality that is not subsumed within the endless circulation of capital.

Notes

Preface

1 On the *paragone* debate as it developed in Renaissance Italy, see C. J. Farago, *Leonardo da Vinci's Paragone: A Critical Interpretation with a New Edition of the Text in the Codex Urbinas* (Leiden, 1992), and L. Mendelsohn, *Paragoni: Due Lezzioni and Cinquecento Art Theory* (Ann Arbor, 1982). In the sixteenth century, debate over the relative status of sculpture and painting acquired considerable theoretical sophistication, bringing into play issues such as whether a sculpture's being a real three-dimensional object rather than an artfully contrived painterly depiction was a limitation or enabled it better to render the substance and truth of things. While this obviously involved serious consideration of how a viewer apprehended a sculpture, the emphasis was still on the capacities required of the artist conceiving and creating a work.

2 James Hall's discussion of modern attitudes to sculpture in his recent *The World as Sculpture: The Changing Status of Sculpture from the Renaissance to the Present Day* (London, 1999) also highlights the radical shift in conceptions of sculpture that took place in the later twentieth century and similarly draws attention to the problematic status of sculture before this time when it was marginalised by a predominately painterly aesthetic. He however posits a clear-cut distinction between the painterly and the truly sculptural that I am questioning here.

3 There is a well-chosen anthology of key twentieth-century texts in *Qu'est-ce que la sculpture moderne?* (Centre Georges Pompidou, Paris, 1986).

4 Since the 1960s, European museums and arts institutions, mostly publicly funded, have provided a number of American artists with crucially important opportunities to display and create new work – Bruce Nauman, Richard Serra and Carl Andre being obvious cases in point – in a way, reversing the role played earlier by private American patronage for European modernism.

5 Significantly, Hans Haacke, who set himself apart from most artists in the USA involved in the Minimalist and conceptualist tendencies of the late 1960s and early 1970s by consistently producing work with an explicit political message, came from Germany, as did the most prominent, avowedly Marxist critical commentator on the post-war art scene working in the USA, Benjamin Buchloh.

6 A. E. Elsen, *Origins of Modern Sculpture: Pioneers and Premises* (London, 1974) and H. Read, *The Art of Sculpture* (London, 1956). By contrast, I feel that Elsen has some valuable insights to offer into modern sculptural aesthetics in his studies of Rodin, particularly his *In Rodin's Studio: A Photographic Record of Sculpture in the Making* (London, 1980). On Read, see Chapter 4, pp. 146–8. Rudolf Wittkower's writing on Bernini and Baroque sculpture, *Art and Architecture in Italy 1600–1750* (Middlesex, 1973), pp. 143–72, was an important stimulus for my general thinking about sculpture, but I found my ideas on sculpture of later periods increasingly at odds with what he says on the subject in his otherwise very fine study, *Sculpture: Processes and Principles* (London, 1977).

7 W. Tucker, *The Language of Sculpture* (London, 1974); R. E. Krauss, *Passages in Modern Sculpture* (New York, 1977, and Cambridge, Mass., and London, 1981).

8 H. Honour, 'Canova's Studio Practice – I: The Early Years', 'II: 1792–1822', *Burlington Magazine*, March and April 1972, pp. 146–59, 214–29. My thinking about the viewing and staging of sculpture, and about the new attentiveness to sculptural effects evident in the eighteenth-century art world, owes much to Malcolm Baker – see M. Baker and D. Bindman, *Roubiliac and the Eighteenth Century Monument: Sculpture as Theatre* (New Haven and London, 1996) and Baker's recent *Figured in Marble: The Making and Viewing of Eighteenth-Century Sculpture* (London, 2000).

9 M. Baxandall, *The Limewood Sculptors of Renaissance Germany* (New Haven and London,

1980). His later *Shadows and Enlightenment* (London and New Haven, 1995) analyses shadowing and the optical effects of light falling on surfaces in ways that are as important for understanding sculpture as the painting he focuses on there. On the implications of Baxandall's ideas for the study of sculpture, see the articles by A. Potts and M. Baker in A. Rifkin (ed.), *About Michael Baxandall* (Oxford, 1999).

10 Some recent work such as Louise Bourgeois's, however, is specifically devised to be viewed under such conditions. See Conclusion, p. 369.

Introduction

1 Quoted in L. Lippard, 'As Painting is to Sculpture: A Changing Ratio', in M. Tuchman (ed.), *American Sculpture of the Sixties* (Los Angeles, 1967), p. 31. The irony is that Reinhardt's paintings looked very good installed with three-dimensional Minimalist work in the exhibition 'Ten' held at the Dwan Gallery in New York 1966–67: see Y.-A. Bois, 'The Limits of Almost', *Ad Reinhardt* (Museum of Contemporary Art, Los Angeles, 1991), p. 13.

2 From 'The New Sculpture' (1952), G. McCoy (ed.), *David Smith* (New York and London, 1973), pp. 82–3.

3 Michael Podro's discussion of the complexities of response set in train by painterly depiction, as well as his attentiveness to the rhetorical subtleties of a viewer's engagement with the presences evoked in a painting, in *Depiction* (New Haven and London, 1999), were crucially important for my thinking about the distinctive nature of a viewer's encounters with three-dimensional work.

4 See F. Haskell and N. Penny, *Taste and the Antique* (New Haven and London, 1981), pp. 62–73. On sculpture galleries and the display of sculpture in the eighteenth and early nineteenth centuries, see the articles by G. Leinz, J. Kenworthy-Browne and A. Potts in K. Vierneisel and G. Leinz (eds), *Glyptothek München 1830–1980* (Munich, 1980), and also the catalogue entries, pp. 600–21.

5 See Chapter 9, pp. 322–4.

6 see P. O. Kristeller, 'The Modern System of the Arts' (1951–2), *Renaissance Thought*, vol. II: *Papers in Humanism and the Arts* (New York, 1965), pp. 163–227. On Lessing's distinction between literature and the visual arts, see E. H. Gombrich, 'The Diversity of the Arts: The Place of the *Laokoon* in the Life and Work of G. E. Lessing', *Tributes* (London, 1984), and W. J. T. Mitchell, 'Space and Time: Lessing's *Laokoon* and the Politics of Genre', *Iconology: Image, Text, Ideology* (Chicago and London, 1986), pp. 94–115.

7 See Chapter 1, pp. 28ff. Hegel's *Vorlesungen Über die Ästhetik*, given as lectures in Berlin in the 1820s and first published in 1835, contains an extensive discussion of the distinctive formal logic of sculpture (part three, section two).

8 W. Pater, *The Renaissance: Studies in Art and Poetry* (Berkeley, Los Angeles and London, 1980; first edition 1873), ed. D. Hill, p. 170.

9 Pater, *The Renaissance*, pp. 50–1.

10 See Chapter 3, pp. 103–6.

11 See ibid., pp. 111–12.

12 R. Krauss, 'Sculpture in the Expanded Field' (1978), *The Originality of the Avant-Garde and Other Modernist Myths* (Cambridge, Mass., and London, 1988), pp. 276–90.

13 The critical ambiguities of the shift from a non-situated to a situated sculpture enacted by Minimalist work have been analysed in some detail by Hal Foster, 'The Crux of Minimalism' (1986), *The Return of the Real* (Cambridge, Mass. and London), pp. 34–68. For a more general discussion of the move to installation, see O. Bätschmann, *The Artist in the Modern World: A Conflict between Market and Self-Expression* (Cologne and Berlin, 1997), pp. 229–40.

14 See e.g. Thomas McEvilley's recent celebration of the expanded post-modern practice of sculpture in *Sculpture in the Age of Doubt* (New York, 1999).

15 Recent publications that offer a particularly fruitful examination of the phenomenology of a viewer's engagement with painting include Michael Podro, *Depiction* (1999), Briony Fer, *On Abstract Art* (New Haven and London, 1997), Michael Fried, *Manet's Modernism or, The Face of Painting* (Chicago and London, 1996), and Yve-Alain Bois, *Painting as Model* (Cambridge, Mass., and London, 1990). Tim Clark's *Farewell to an Idea: Episodes from a History of Modernism* (New Haven and London, 1999) presents a particularly passionately engaged enquiry into how and why we should continue to take the close critical viewing of painting seriously.

16 See e.g. B. Buchloh, 'Michael Asher and the Conclusion of Modernist Sculpture', *Museum*

Studies, vol. x, 1983, pp. 276–95; 'Construire (l'histoire de) la sculpture', in *Qu'est-ce que la sculpture moderne* (Centre Georges Pompidou, Paris, 1986), pp. 254–74; 'Publicity and the Poverty of Experience', in *White Cube/Black Box* (Vienna, 1996), pp. 163–73; and T. Crow, *Modern Art in the Common Culture* (New Haven and London, 1996), pp. 131–50, 182–94.

17 The idea that Rodin's work marks the beginnings of a truly modern sculpture, more so even than Degas's wax sketches, is enshrined in William Tucker's *The Language of Sculpture* (London, 1974) and Rosalind Krauss's *Passages in Modern Sculpture* (Cambridge, Mass., and London, 1981; first published 1977), as well as in earlier standard texts on twentieth-century sculpture such as Robert Goldwater's *What is Modern Sculpture* (1969) and Giedion Welcker's *Modern Plastic Art: Elements of Reality, Volume and Disintegration* (1937). On the early formation of this paradigm, see Chapter 2, pp. 72ff, and A. Wagner, 'Rodin's Reputation' in L. Hunt (ed.), *Eroticism and the Body Politic* (Baltimore and London, 1991).

18 See Tucker, *Language of Sculpture*, pp. 108–9. Some highly prized antique torsos, most notably the *Belvedere Torso*, had been displayed unrestored since the Renaissance. The modern idea that a fine antique fragment should remain incomplete and not be adulterated by modern additions only began to take hold in the early nineteenth century, at the point when early classical Greek sculpture, such as the Parthenon marbles Lord Elgin shipped to Britain – see J. Rothenberg, *'Descensus ad Terram': The Acquisition and Reception of the Elgin Marbles* (New York and London, 1977), pp. 185–204 – and the *Venus de Milo* – see Haskell and Penny, *Taste and the Antique*, pp. 320–30 – was being acquired for Western European collections. While initially seriously considered for restoration, and sometimes actually restored, such works were increasingly valued as fragments that had their own distinctive integrity.

19 See Chapter 3, pp. 134, 136–9.

20 P. Tuchman, 'An Interview with Carl Andre', *Artforum*, June 1970, p. 55.

21 R. Serra, *Writings Interviews* (Chicago and London, 1994), pp. 48, 172.

22 M. Fried, 'Art and Objecthood' (1967), *Art and Objecthood: Essays and Reviews* (Chicago and London, 1998), pp. 166–7.

23 On this development, see P. Schimmel (ed.), *Out of Actions: Between Performance and the Object*

1949–1979 (Los Angeles and London, 1997), esp. pp. 227–328, K. Stiles, 'Uncorrupted Joy: International Art Actions'.

24 This was a point made by early nineteenth-century critics of Canova: see Chapter 1, pp. 43–4, 50–1.

25 The precariousness of this combination of ideal classical form with blatant eroticism is evident in some of the more uneasy critical responses to the work of James Pradier, the most prominent classical sculptor working in France in the early to mid-nineteenth century: see J. de Caso and others, *Statues de Chair: Sculptures de James Pradier 1790–1852* (Geneva, 1985), pp. 33, 39, 126–7, 143, 151.

26 On this shift, see P. Curtis, *Sculpture 1900–1945* (Oxford, 1999), pp. 108–9. The modernist conception of the studio as an ideal arena for intimate viewing is evoked particularly well in Tucker, *Language*, p. 313. See A. Chave, *Constantin Brancusi* (New Haven and London, 1993), pp. 273–84, on the privileging of the studio associated with Brancusi.

27 On the installation of art in the new white-cube gallery spaces, see B. O'Doherty, *Inside the White Cube: The Ideology of the Gallery Space* (Santa Monica and San Francisco, 1986; initially published as a series of articles in *Artforum* in 1976), who offers a critique of this development; and C. Grunenberg, 'The Modern Art Museum' in E. Barker (ed.), *Contemporary Cultures of Display* (New Haven and London, 1999), pp. 26–49. On the early formation of this mode of display in the 1930s, see M. A. Staniszewski, *The Power of Display: A History of Installation at the Museum of Modern Art* (Cambridge, Mass., and London, 1998), pp. 62–6.

28 See H. Zerner, 'Malraux and the Power of Photography', in G. Johnson (ed.), *Sculpture and Photography: Envisioning the Third Dimension* (Cambridge, 1998), pp. 116–30.

29 Morris's career provides a particularly dramatic example of the persistence of this tension: see Chapter 7, pp. 252–6.

30 See e.g. David Bourdon's comments on Carl Andre's early brick sculptures quoted in Chapter 9, p. 329.

31 Chris Dercon, 'Keeping it Apart: A Conversation with Bruce Nauman', *Parkett 10*, September 1986, p. 55.

32 Hal Foster underlines how, with recent installation work such as Robert Gober's, the viewer has 'an experience usually deemed private' in a 'space usually deemed public', in

P. Schimmel (ed.), *Robert Gober* (Los Angeles and Zurich, 1997), p. 63.

Chapter 1

1 One of the few treatises specifically devoted to sculpture in the period, it was published as the second volume of M.-F. Dandré-Bardon's *Traîté de Peinture suivi d'un Essai sur la Sculpture* (Paris, 1765).

2 E.-M. Falconet's *Réflexions sur la Sculpture* was first published as a separate treatise in 1761. References here are to the text in Falconet's *Traduction des XXXIV, XXXV et XXXXVI Livres de Pline l'Ancien, avec des notes par Etienne Falconet* (Paris, 1773), vol. II. All translations mine unless otherwise noted.

3 At this point, it was simply taken for granted by art theorists that sculpture had to be monochrome. There was also a growing consensus that sculpture should avoid elaborate painterly, or what we should call Baroque, drapery effects. These views were instated in the single most influential text on art theory of the early to mid-eighteenth century, Roger de Piles, *Cours de Peinture par Principes* (Paris, 1708), pp. 189–91. See J. Dobai, *Die Kunstliteratur des Klassizismus und der Romantik in England* (Bern, 1974–75), vol. II, pp. 1029–320, for a survey of sculptural theory throughout Europe in the eighteenth century. On the argument over sculptural polychromy in the nineteenth century, based on the new distinction between sculpture and painting initiated in the late Enlightenment, and prompted by a growing realisation that classical Greek sculpture would have been coloured, see K. Tür, *Farbe und Naturalismus in der Skulptur des 19. und 20. Jahrhunderts* (Mainz, 1994), pp. 95–142, and also A. Blühm (ed.), *The Colour of Sculpture 1840–1910* (Amsterdam, 1996).

4 Falconet, *Traduction*, p. 236.

5 Ibid., pp. 237, 343. See also p. 345.

6 Ibid., p. 347.

7 Falconet, *Observations sur la Statue de Marc-Aurèle, et sur d'autres objets relatifs aux beaux-arts* (Amsterdam, 1771), p. 21.

8 Falconet, *Traduction*, pp. 345, 350–1, 366.

9 J. Reynolds, *Discourses on Art*, ed. R. R. Wark (New Haven and London, 1975), pp. 182ff.

10 Falconet, *Traduction*, pp. 352–3.

11 Reynolds, *Discourses*, pp. 180–1.

12 Ibid., p. 182.

13 Ibid., pp. 187, 176.

14 Ibid., p. 177. On Reynolds's formalism, see J. Barrell, *The Political Theory of Painting from Reynolds to Hazlitt* (New Haven and London, 1986), pp. 82ff.

15 D. Diderot, *Oeuvres Complètes*, ed. J. Asséjat and M. Tourneux (Paris, 1875–77), vol. X, pp. 418–19. For illustrations of the so-called *Dying Gladiator* and the *Borghese Warrior*, see F. Haskell and N. Penny, *Taste and the Antique* (New Haven and London, 1981), pp. 223, 225.

16 Diderot, *Oeuvres*, vol. XIII, pp. 41–2.

17 M. H. Spielman, *British Sculpture and Sculptors of To-Day* (London and New York, 1901), p. 4.

18 J. G. Herder, 'Plastik', *Sämmtliche Werke*, ed. B. Suphan (Berlin, 1877–1913), vol. VIII, p. 14.

19 See M. Podro, 'Herder's *Plastik*', in J. B. Onians (ed.), *Sight and Insight: Essays on Art and Culture in Honour of E. H. Gombrich at 85* (London, 1994), pp. 341–53.

20 Herder, 'Plastik', pp. 10–13.

21 Ibid., pp. 6–7, 15–17. This distinction became pervasive enough for Kant to draw on it in his *Critique of Judgement* (Oxford, 1952), p. 196.

22 Herder, 'Plastik', p. 15.

23 Ibid., pp. 12–13.

24 Ibid., p. 76. See also p. 74.

25 For Herder, the classic formulation of this idea of clearly contoured shape would have been Winckelmann's, *Geschichte der Kunst des Alterthums* (Dresden, 1764), pp. 152–3, 163–4, though this too has its ambiguities, the bounding contour also being an ever shifting line of beauty, a little like Hogarth's; see A. Potts, *Flesh and the Ideal: Winckelmann and the Origins of Art History* (New Haven and London, 1994), pp. 170–3.

26 Herder, 'Plastik', p. 76.

27 Ibid., pp. 17, 85.

28 Ibid., pp. 26, 61.

29 Ibid., p. 23.

30 See B. Schweizer, *J. G. Herders 'Plastik' und die Entstehung der neueren Kunstwissenschaft* (Leipzig, 1948), p. 28.

31 See G. E. Grimm, '"Die schöne Philosophie": Johann Gottfried Herders Kunstwahrnehmung im Lichte seines Romaufenthalts' in C. Wiedemann, *Rom-Paris-London: Erfahrung und Selbsterfahrung deutscher Schriftsteller und Künstler in den fremden Metropolen* (Stuttgart, 1988), p. 232.

32 Herder, 'Plastik', pp. 17, 60.

33 Ibid., p. 35.

34 Ibid., p. 25. Elsewhere (p. 67) Herder suggests that a felt apprehension of things avoids the fetishising of the body that occurs through sight.

35 Ibid., p. 68.

36 Ibid., p. 40, compare pp. 3, 10–12.

37 Ibid., p. 39. There was one well known case of an Italian seventeenth-century sculptor, Francesco Gonelli, who gained a considerable reputation for work he produced after he went blind: J. Hall, *The World as Sculpture: The Changing Status of Sculpture from the Renaissance to the Present Day* (London, 1999), pp. 85–9.

38 Pliny had voiced the view that statues of the gods were 'but earth and stones and wood and cunning art', *The Elder Pliny's Chapters on the History of Art*, trans. K. Jex-Blake and E. Sellers (Chicago, 1968), p. 227 (*Natural History*, XXXVII, 8). On the role played by the story of Pygmalion in eighteenth-century conceptions of the visual arts as a way of imagining the viewer's engagement with a work, see O. Bätschmann, 'Pygmalion als Betrachter: Die Rezeption von Plastik und Malerei in der zweiten Hälfte des 18. Jahrhunderts', in W. Kemp (ed.), *Der Betrachter im Bild* (Cologne, 1985), pp. 183–224.

39 How this is played out in painting is discussed suggestively in M. Podro, *Depiction* (New Haven and London, 1999), pp. 6ff, 152ff.

40 J.-J. Rousseau, *Oeuvres Complètes*, vol. II (Paris, 1961), pp. 1224–31. On this 'Scène Lyrique', see P. de Man, *Allegories of Reading: Figural Language in Rousseau, Nietzsche, Rilke, and Proust* (New Haven and London, 1979), pp. 175ff.

41 This echoing effect is vividly evoked in Winckelmann's famous description of the *Apollo Belvedere*, *Geschichte der Kunst des Alterthums* (Dresden, 1764), p. 393.

42 Plato, *The Symposium*, 190–3, in *The Dialogues of Plato*, trans. B. Jowett (London, 1970), vol. II, pp. 203–6.

43 [F. Hemsterhuis], *Lettre sur les Désirs* (Paris, 1770), p. 11.

44 [F. Hemsterhuis], *Lettre sur la Sculpture à Monsieur Théodor de Smeth* (Amsterdam, 1769), pp. 9–10.

45 Ibid., p. 11.

46 Ibid., pp. 22–3.

47 Ibid., p. 21.

48 Ibid., p. 24.

49 Ibid., pp. 10, 24.

50 Even before the opening of the Museo Pio-Clementino in Rome as a designated public museum in the late 1770s, the famous sculptures in the Vatican Belvedere were accessible to interested visitors, as were the better-known antiques statues in other collections in Rome. Many were widely reproduced in casts and copies; see Haskell and Penny, *Taste and the Antique*, pp. 31ff, 62ff, 79ff.

51 In these galleries, the sculptures were usually given elaborate ornamented settings – framed niches or pedestals – so decorative effect was still a major consideration. See Introduction, n. 4.

52 Examples include the *Three Graces* commissioned by the sixth Duke of Bedford for his sculpture gallery at Woburn Abbey, the *Paris* commissioned by King Ludwig I of Bavaria and displayed in the Glyptothek, the public gallery of antique sculpture he built in Munich, and the *Perseus*, *Creugas* and *Damoxenes* placed in the Vatican Belvedere.

53 On the 'boudoir' Giovani Battista Sommariva created for a statue of the *Magdalen* by Canova he owned, see F. Haskell, *Past and Present in Art and Taste* (New Haven and London, 1987), p. 55–6. For Stendhal, Canova was an exemplary modern artist, celebrated as an antidote to the classicism of David and his school: 'Des beaux-arts et du caractère français' (1828) in *H. B. Stendhal: Du romantisme dans les arts*, ed. J. Starzynski (Paris, 1966), pp. 168–71.

54 On the increasingly self-conscious close viewing of sculpture and awareness of processes of making that were clearly in evidence by the mid-eighteenth century, as well as the concomitant commissioning of large-scale autonomous works for an indoor setting, see M. Baker, 'Addressing Sculpture' in *Figured in Marble: The Making and Viewing of Eighteenth-century Sculpture* (London, 2000).

55 The elaborate fake-marbled wooden couch Canova designed as a base for his statue of *Paolina Borghese* (Borghese Gallery, Rome), showing her as a reclining Venus, gives a good indication of how he wished to have his gallery statues raised above the floor. Statues with a metal handle or handles inserted into the marble stand to facilitate rotating the work on the base where it was displayed include the *Three Graces* (fig. 46) and the recumbent *Cupid and Psyche* (fig. 49).

56 Winckelmann offered the most thoroughgoing critique of the theatrical stance of modern 'Baroque' sculpture as compared with the natural calm of antique work, *Geschichte der Kunst des Alterthums* (Dresden, 1764), p. 171.

57 This was picked up in Countess Albrizzi's contemporary commentary on the work. See the entry on *Venus Italica* in L. Cicognara, *The Works of Antonio Canova in Sculpture and Modelling with descriptions from the Italian of the Countess Albrizzi* . . . (Boston, 1876; first published in Italian in 1821–24), vol. 1.

58 On the viewing of sculpture by artificial light in the period, see J. Whiteley, 'Light and Shade in French Neo-classicism', *Burlington Magazine*, December 1975, pp. 772–3. While most reproductions of Canova's statues were simple outline engravings, a luxury set of prints executed under the sculptor's supervision towards the end of his career are shaded so as to suggest the tonal subtleties crucial to the impact made by his work in marble; see M. Baker, 'Canova's *Three Graces* and changing attitudes to sculpture', *Figured in Marble*, ch. 13.

59 H. Honour, 'Canova's Studio Practice', *Burlington Magazine*, 1972, pp. 150ff, 214ff.

60 L. Cicognara, *The Works of Antonio Canova* (Boston, 1876), vol. 1, p. 15. The particular significance of subtleties of surface texture and detail in Canova's work has been registered in a number of recent publications on the sculptor by the unusual number of fine illustrations of close-up details, as in F. Licht, *Canova*, with photographs by David Finn (New York, 1983), G. Pavanello and G. Romanelli (eds), *Canova* (Venice and New York, 1992) and H. Honour (ed.), *The Three Graces* (Edinburgh, 1995).

61 Letter written in 1813, quoted in Pavanello and Romanelli, *Canova*, cat. no. 93.

62 Quoted in G. C. Argan, *Antonio Canova* (Rome, 1968–69), p. 120. The word *lima* used in the Italian can mean either rasp or file. Compare the comments on Canova's painterly subtleties of finish quoted in Pavanello and Romanelli, *Canova*, p. 242.

63 See his comments on Canova's *Paris* in a letter of 1813, quoted in Argan, *Canova*, p. 140.

64 Quoted in G. Hubert, *Les Sculpteurs Italiens en France sous la Révolution, l'Empire et la Restauration 1790–1830* (Paris, 1964), p. 45. The version of *Hebe* shown at the Paris Salon was slightly different from the one illustrated here, its feet anchored in a cloud rather than supported by a thin trunk: see G. Pavanello, *L'opera completa del Canova* (Milan, 1976), no. 100. The painter David advised the young French sculptor David d'Angers to take careful note of Canova, 'the seductive worker in marble', when he was in Rome, but to be careful not to imitate his 'false and affected manner, designed to lead a young man astray' (quoted in Honour, 'Canova's Studio Practice', p. 159).

65 Hubert, *Sculpteurs Italiens*, p. 54. One of the leading writers on sculpture in Victorian Britain, Richard Westmacott junior, in his *The Schools of Sculpture Ancient and Modern* (Edinburgh, 1864), pp. 177–8, 326, both singled out the Canova-like 'prominence given to exquisite manipulation' and the 'sensuous element' in later classical Greek sculpture as having diverted it from 'its higher purpose' and led to its decline, and was directly critical of Canova for sacrificing 'force and style' to 'the fascination of highly-wrought execution and the elaboration of surface.'

66 On Winckelmann's characterisation of the *Laocoon*, see Potts, *Flesh and the Ideal*, p. 136ff.

67 Cicognara, *Canova*, vol. 1, entry on *Hercules and Lichas*.

68 See Pavanello, *Canova* (1976), no. 112. The *modello* is in the Museo Correr, Venice.

69 See L. Hunt, 'The Imagery of Radicalism', *Politics, Culture and Class in the French Revolution* (Berkeley, Los Angeles and London, 1984), pp. 115–42.

70 On Canova's response to the French invasion of Italy, see Argan, *Canova*, pp. 122–3.

71 See C. M. Johns, *Antonio Canova and the Politics of Patronage in Revolutionary Europe* (Berkeley, Los Angeles and London, 1998), pp. 124–9.

72 C. F. Fernow, *Über den Bildhauer Canova und dessen Werke* (Zurich, 1806), pp. 138–9. For an illustration of *Hercules* as originally installed in the Palazzo Torlonia, see Pavanello, *Canova* (1976), p. 107.

73 See Chapter 4, pp. 170–3.

74 See Hubert, *Sculpteurs Italiens*, p. 44.

75 Something of this is suggested in a contemporary account of the statue by Countess Albrizzi, in Cicognara, *Canova*, vol. 1, entry on *Three Graces*. That contemporaries were struck by the unusual intertwining of figures and by the ever-shifting flow of contour and variegated surfaces presented from different points of view is indicated by other critical contemporary comments on the work, as well as by the sumptuous shaded, rather than the more usual outline engravings of the group published by the Duke of Bedford, who commissioned the second version illustrated here. See H. Honour, 'Canova's Three Graces', in *The Three Graces*, pp. 44–5.

76 For a fuller discussion of these complexities, see M. Baker, 'Canova's *Three Graces'.*

77 Fernow, *Canova*, pp. 89–90. The exceptional way the complex disposition of the figures in three dimensions actively frustrates any definition of a clearly resolved principal view links this work to mid-eighteenth century experiments in ambitious free-standing sculpture. See Katie Scott's analysis of how Edmé Bourchardon's *Cupid carving a Bow from Hercules' Club* (1750) involves the viewer in a 'restless turning about the figure in search of a perpetually deferred satisfaction: the moment of fully preceived, fully grasped comprehension', in 'Under the Sign of Venus: The Making and Meaning of Bourchardon's *L'Amour* in the Age of the French Rococo', in C. Arscott and K. Scott (eds), *Manifestations of Venus* (Manchester, 2000).

78 Fernow, *Canova*, p. 91.

79 See Pavanello, *Canova* (1976), no. 121. On the *Apollo Belvedere*, see Potts, *Flesh and the Ideal*, pp. 118ff.

80 Fernow, *Canova*, pp. 198–203. Misgivings over a supposedly excessive refinement of marble carving had been expressed earlier over work such as Bouchardon's *Cupid*: see Scott, 'Under the Sign of Venus'.

81 See for example Albrizzi's commentary on the *Perseus* in Cicognara, *Canova*, vol. I.

82 Exhibited in Rome in 1803, the plaster model attracted considerable attention, prompting Thomas Hope to commission a version in marble that was finally completed in 1828. Both the model and the marble are now in the Thorwaldsen Museum, Copenhagen, the latter illustrated in *Berthel Thorwaldsen* (Museen der Stadt Köln, 1977), p. 18.

83 Fernow, *Canova*, pp. 153, 154–5.

84 For a fuller discussion, see A. Potts, 'The Impossible Ideal: Romantic Conceptions of the Parthenon Sculpture in Early Nineteenth-century Britain and Germany' in A. Hemingway and W. Vaughan (eds), *Art in Bourgeois Society, 1790–1850* (Cambridge, 1998), pp. 101–22.

85 A number of versions in marble were made of this popular work, as well as of the *Ganymede*, *Thorwaldsen* (1977), pp. 180, 182.

Chapter 2

1 A. Rodin, *Art: Conversations with Paul Gsell*, trans. J. de Caso and P. B. Sanders (Berkeley, Los Angeles and London, 1984; first published in French in 1911), p. 99.

2 On the situation of sculpture at the Paris Salon in the early to mid-nineteenth century, see J. de Caso and others, *Statues de Chair: James Pradier 1790–1852* (Geneva, 1985), esp. p. 85, and P. Fusco and H. W. Janson (eds), *The Romantics to Rodin: French Nineteenth-Century Sculpture from North American Collections* (Los Angeles County Museum of Arts, 1980), p. 209. Sculpture's awkward status during the nineteenth century in France is discussed in A. M. Wagner, *Jean-Baptiste Carpeaux* (New Haven and London, 1986), pp. 5–28, and in Britain in R. Jenkyns, *Dignity and Decadence: Victorian Art and the Classical Inheritance* (London, 1991), pp. 97–114.

3 *Art-Union Monthly*, vol. VI, 1844, p. 170. On the display of sculpture at the Royal Academy exhibitions, See A. Yarrington, 'Art in the Dark: sculptors at the Royal Academy' in D. Solkin (ed.), *'The Rage for Exhibitions': The Royal Academy at Somerset House* (New Haven and London, forthcoming).

4 C. Baudelaire, *Oeuvres Complètes* (Paris, 1961), p. 943 (1846 Salon). Baudelaire's commentary on sculpture, together with Herder's and Rilke's, were discussed briefly in my article 'Male Phantasy and Modern Sculpture', *Oxford Art Journal*, 1992, vol. 15, no. 2, pp. 38–47.

5 Baudelaire, *Oeuvres*, pp. 943–4.

6 Ibid., pp. 944–5.

7 C. A. Böttiger, *Über die Dresdner Antiken-Galerie: Ein Vortrag gehalten im Vorsale derselben den 31 August 1814* (Dresden, 1814), p. 9. See also his lecture given in 1807, 'Über Museum und Antikensammlungen', published in *Kleine Schriften archäologischen und antiquarischen Inhalts*, vol. II (Dresden and Leipzig, 1838), pp. 3–24.

8 Baudelaire, *Oeuvres*, pp. 1086–8.

9 The first edition was published under the somewhat misleading title *Studies in the History of the Renaissance*, in 1873.

10 For a fuller discussion of the complexities of Pater's conception of Greek sculpture, see A. Potts, 'Walter Pater's Unsettling of the Apollonian Ideal' in M. Biddiss and M. Wyke (eds), *The Uses and Abuses of Antiquity* (Bern, 1999), pp. 107–26.

11 W. Pater, *The Renaissance: Studies in Art and Poetry*, ed. D. Hill (Berkeley, Los Angeles and London, 1980), p. 170.

12 Ibid., p. 169.

13 Ibid., p. 174.

14 Ibid., p. 176.

15 Ibid., pp. 186–7. On scientific theories of visual perception informing such conceptions

of a modern sensibility as caught up in a flux of unanchored sensations, see J. Crary, *Techniques of the Observer: Vision and Modernity in the Nineteenth Century* (Cambridge, Mass., and London, 1998), pp. 97ff.

16 See also Pater, *Renaissance*, p. 166.

17 Ibid., p. 174.

18 Ibid., pp. 50–1.

19 Ibid., pp. 51–2.

20 See Chapter 4, pp. 168ff.

21 Pater, *Renaissance*, p. 50.

22 Ibid., pp. 52–3. On Pater's interpretation of Michelangelo, see also A. Potts, ' "So strange a personality expressed in prophesies of art so pungent" – Symonds, Pater and Michelangelo' in J. Pemble (ed.), *John Addington Symonds: The Private and the Public Face of Victorian Culture* (London, 2000).

23 Pater, *Renaissance*, pp. 52–3.

24 Pater was criticised by Symonds on this point: see Potts, 'Symonds, Pater and Michelangelo', pp. 112–13. On the Victorians' fascination with Michelangelo's sculpture, see L. Østermark-Johansen, *Sweetness and Strength: The Reception of Michelangelo in late Victorian Britain* (Aldershot, 1998).

25 See Introduction, n. 18.

26 N. Hawthorne, *The Marble Faun* (London, 1990), pp. 380–1.

27 Pater, *Renaissance*, pp. 75–6.

28 On critical responses to Rodin, see A. M. Wagner, 'Rodin's Reputation' in L. Hunt (ed.), *Eroticism and the Body Politic* (Baltimore and London, 1990), pp. 191–242.

29 See for example the French critic writing in 1873 quoted in R. Butler (ed.), *Rodin in Perspective* (Englewood Cliffs, N.J., 1980), p. 18.

30 On the controversy over Rodin's *Balzac*, see J. Butler, *Rodin: The Shape of Genius* (New Haven and London, 1993), pp. 290–4, 299–305, 316–29; over Carpeaux's *Dance*, see Wagner, *Carpeaux*, pp. 209–56; over Alfred Gilbert's *Eros*, or more properly, *Shaftesbury Memorial*, see *The Survey of London*, vol. XXXI, *The Palace of St. James Westminster, Part Two, North of Piccadilly* (London, 1963), pp. 101–10, and R. Dorment, *Alfred Gilbert* (New Haven and London, 1985), pp. 108–15.

31 For images of the new displays in the Palais de l'Industrie in the 1860s and 1870s, see Wagner, *Carpeaux*, pp. 195, 261, who also reproduces a print showing the old arrangement on the ground floor of the Louvre in the 1840s (p. 18). In the 1898 Salon, the sculpture garden, installed in the Galerie des Machines, newly built for the 1889 Exposition Universelle, where Rodin showed his *Balzac* and enlarged marble *Kiss*, was particularly spectacular: see Butler, *Rodin* (1993), pp. 316–18, and A. E. Elsen (ed.), *Rodin Rediscovered* (Washington, D.C., 1981), p. 85.

32 See for example S. Beattie, *The New Sculpture* (New Haven and London, 1983), esp. ch. 6.

33 M. H. Spielman, *British Sculpture and Sculptors of To-Day* (London, Paris, New York and Melbourne, 1901), p. 1.

34 Ibid. On Carpeaux's 'modernity', see Wagner, *Carpeaux*, pp. 4–5.

35 Spielman, *British Sculpture*, pp. 3–4.

36 G. Simmel, *Vom Wesen der Moderne: Essays zur Philosophie und Ästhetik* (Hamburg, 1990), pp. 265–71.

37 Ibid., pp. 272–3.

38 Ibid., pp. 273–4.

39 G. Simmel, 'Über die dritte Dimension in der Kunst' (1906), *Aufsätze und Abhandlungen 1901–1908*, vol. II (Frankfurt am Main, 1993), pp. 9–14.

40 G. Simmel, 'Rodin mit einer Vorbemerkung über Meunier' (1911), in *Philosophische Kultur: Gesammelte Essays* (Berlin, 1983), p. 142.

41 Ibid., p. 148.

42 Ibid., p. 145.

43 Ibid., pp. 145–6.

44 Ibid., p. 152.

45 Ibid., pp. 152–3.

46 R. M. Rilke, *Gesammelte Werke*, vol. IV, *Schriften in Prosa, Erster Teil* (Leipzig, 1930), pp. 304–6. For English translations of the two Rodin essays and other important essays and notes on the visual arts, see R. M. Rilke, *Rodin and Other Prose Pieces*, introduced by W. Tucker, trans. C. Craig Houston (London, Melbourne, New York, 1986). The analysis here is rather different from my earlier 'Dolls and Things: The Reification and Disintegration of Sculpture in Rodin and Rilke', in J. B. Onians (ed.), *Sight and Insight: Essays on Art and Culture in Honour of E. H. Gombrich at 85* (London, 1994), pp. 354–78.

47 He acted as Rodin's secretary from September 1905 to May 1906, between writing the first essay published in 1903 and the second in 1907: see Butler, *Rodin* (1993), pp. 372–8.

48 Rilke, *Prosa*, p. 306.

49 Ibid., pp. 309–10.

50 Ibid., pp. 308–9.

51 Ibid., pp. 376–8.

52 Ibid., p. 379.

53 Ibid., p. 377.

54 Rilke, *Rodin and Other Prose Pieces*, p. 121.

55 Ibid., p. 123; see also p. 121.

56 Ibid., p. 126.

57 Baudelaire, *Oeuvres*, p. 1087 (1859 Salon).

58 Critical studies of Rodin's sculpture that were important for the ideas developed here include L. Steinberg, 'Rodin', *Other Criteria, Confrontations with Twentieth-Century Art* (London, Oxford, and New York, 1972), pp. 322–403; R. Krauss, 'Narrative Time: The Question of the *Gates of Hell*', *Passages in Modern Sculpture* (Cambridge, Mass. and London, 1981), pp. 7–31, and A. E. Elsen, *In Rodin's Studio: A Photographic Record of Sculpture in the Making* (London, 1980), and Elsen, *Rodin Rediscovered*.

59 In both cases, the studio display proved so significant that the plaster models from the studio were installed after their deaths in specially designed museums, Canova's in his home town of Possagno, and Thorwaldsen's in Copenhagen, on which see O. Bätschmann, *The Artist in the Modern World: The Conflict between Market and Self-Expression* (Cologne and Berlin, 1997), pp. 83–91.

60 Rilke, *Prosa*, p. 406.

61 Ibid., p. 415.

62 Ibid., pp. 415–18.

63 See R. Smithson, 'Spiral Jetty' (1972), *Robert Smithson: The Collected Writings*, ed. J. Flam (Berkeley, Los Angeles and London, 1996), pp. 143–53 and frontispiece.

64 See for example Leiris's commentary on Giacometti's early objects, Chapter 3, pp. 118–19.

65 Rilke, *Rodin*, p. 126, and also *Prosa*, p. 277. Baudelaire's considerably less disturbed essay on dolls, 'Morale du Joujou', published in 1853, ends similarly with an evocation of their destruction, *Oeuvres*, p. 207.

66 Rilke, *Prosa*, p. 416.

67 Rilke, *Rodin*, p. 81.

68 Rilke, *Prosa*, pp. 361–2.

69 A statement by Brancusi on *Bird in Space*, quoted in a catalogue dating from 1933, reads: 'Plan for a bird which, when enlarged, will fill the vault of the sky', in P. Hulten and others, *Brancusi* (New York, 1987), p. 206. See also A. Chave, *Constantin Brancusi* (New Haven and London, 1993), pp. 251ff.

70 See the illustrations in Elsen, *Rodin's Studio*, pls 60–4 and p. 172; and Butler, *Rodin* (1993), p. 212.

71 A bronze cast of the statue of *Eve* is said to have been exhibited at the 1899 Salon with its base buried in the floor of the exhibition hall so it was standing directly in the viewer's space, but this seems to have been a unique experiment: Elsen, *Rodin's Studio*, p. 166.

72 Rilke, *Rodin*, pp. 73–4.

73 Ibid., p. 73.

74 Rilke, *Prosa*, p. 325.

75 Elsen, *Rodin's Studio*, p. 158.

76 Rilke, *Prosa*, p. 326.

77 Elsen, *Rodin's Studio*, p. 181. The quote comes from a magazine article published in 1907.

78 On the issue of 'facingness' in art of the period, see M. Fried, *Manet's Modernism or, The Face of Painting* (Chicago and London, 1996), pp. 256ff.

79 C. Lampert, *Rodin: Sculpture and Drawings* (London, 1986), p. 221. The contrast between the upright and prone placing is brought home vividly by the illustrations on pp. 122–3 (also pp. 236–40 for illustrations of the drawings). On the complex nature of the insistently sexualised rendering of the female figure in Rodin, see A. Wagner, 'Rodin's Reputation', pp. 218ff.

80 Pater, *Renaissance*, p. 76.

81 On Rodin's use of photography to stage his work, see H. Pinet, 'Montrer est la Question Vitale: Rodin and Photography', in G. Johnson (ed.), *Sculpture and Photography* (Cambridge, 1998), pp. 68–85; Elsen, *Rodin's Studio*, pp. 10–32. On the significance of surface in Rodin's sculpture, see Krauss, *Passages*, pp. 26–31.

82 The mechanical enlargements of his plaster models were carried out for Rodin by the technician Henri Lebossé. On this and other issues relating to the making of Rodin's work, see Elsen, *Rodin Rediscovered*, pp. 248–59, 127–50, and R. Krauss, *The Originality of the Avant-Garde and Other Modernist Myths* (Cambridge, Mass., and London, 1988), pp. 176–89.

83 Rilke, *Prosa*, pp. 385–6.

84 A. Rodin, *Art: Conversations with Paul Gsell* (Berkeley, Los Angeles and London, 1984), p. 75.

85 Rilke, *Prosa*, p. 388.

86 Ibid., p. 389.

87 Ibid., p. 391.

88 Ibid., pp. 376–7. See also Rilke, *Rodin*, p. 46.

89 Rilke, *Rodin*, pp. 388–9.

90 S. Freud, 'Beyond the Pleasure Principle', *On Metapsychology: The Theory of Psychoanalysis* (Pelican Freud Library, vol. XI, Harmondsworth, 1984), p. 311.

91 On the early modernist reaction against Rodin, see P. Curtis, *Sculpture 1900–1945* (Oxford, 1999), pp. 216–19.

92 Rodin, mindful of his public image, partici-
pated very reluctantly: Butler, *Rodin* (1993),
pp. 220–5.

93 Rodin, *Conversations*, p. 111.

Chapter 3

1 Following Carola Giedion Welcker's *Modern
Plastic Art*, first issued in 1937 and reissued
in 1956 with major additions updating it (Ch.
4), books appearing after the war discussing
the distinctiveness of modern sculpture
include W. R. Valentiner, *Origins of Modern
Sculpture* (1946), A. C. Ritchie, *Sculpture of the
Twentieth Century* (New York, 1952), H. Read,
The Art of Sculpture (1956, see Ch. 4, pp.
146–8, M. Seuphor, *The Sculpture of this
Century: Dictionary of Modern Sculpture* (1959
in Fr., 1960 in Eng.), and E. Trier, *Form and
Space: The Sculpture of the Twentieth Century*
(1960 in Ger., 1961 in Eng.). The symposium
'The New Sculpture' organised in 1952 by the
Museum of Modern Art in New York marks
a symbolic high point of this tendency, to
which Greenberg referred when he gave this
name to his widely read essay on modern
sculpture in his collection *Art and Culture*,
published in 1961.

2 The spectacle of such an accumulation of
slightly outmoded modern sculpture is
evoked well in J. Burnham, *Beyond Modern
Sculpture: The Effects of Science and Technology on
the Sculpture of this Century* (New York, 1968),
p. 178.

3 This painted wood sculpture dating from
1947–49 is illustrated in A. Causey, *Sculpture
since 1945* (Oxford, 1998), pp. 60, 70.

4 Picasso, for example, is central to Krauss's
account of modernist sculpture, *Passages in
Modern Sculpture* (Cambridge, Mass., and
London, 1981; first published 1977), pp.
47–53, and Matisse to Tucker's, *The Language
of Sculpture* (London, 1974), pp. 85–106.

5 This is made explicit in his reference to the
earlier publication: U. Boccioni, 'Manifeste
technique de la sculpture futuriste' (1912), in
Qu'est-ce que la sculpture moderne (Centre
Georges Pompidou, Paris, 1986), p. 339. For
an Eng. translation of the essay, see H. B.
Chipp, *Theories of Modern Art* (Berkeley, Los
Angeles and London, 1968), pp. 298–304.

6 Boccioni, 'Manifeste', p. 339.

7 Ibid., p. 342.

8 Ibid., p. 343.

9 Ibid., p. 342.

10 Ibid., p. 341.

11 Georges Vantongerloo's unusual out-and-out
geometric abstractions from the 1920s have
more affinities with the architectural experi-
ments of the De Stijl architects and designers
with whom he was associated than with any
sculptural tradition at the time. If sculpture
features prominently in László Moholy-
Nagy's influential early modernist analysis of
space and volume (first published in Eng. as
The New Vision: From Material to Architecture in
1930), it is presented there as a preparatory
mode of experimentation dealing in volume,
while a truly modern, open play of space that
completely overcomes the limits of the tradi-
tional bounded object is seen as being realised
in architecture: *The New Vision* (New York,
1947), pp. 60–4; this reprints Moholy-Nagy's
essay, based on his teaching at the Bauhaus,
first published in Ger. in 1928.

12 On Russian Constructivism as a critical inter-
vention in and refusal of mainstream modern
notions of sculpture, see B. Buchloh, 'Con-
struire (l'Histoire de) la sculpture', *Qu'est-ce
que la sculpture moderne?*, pp. 254–74. Buchloh
is illuminating on the side-lining of Russian
Constructivism in the new formalist histories
of modern sculpture of the immediate post-
war period.

13 For example, Gabo's *Linear Construction in
Space, No. 1* (1942–3), Guggenheim Museum,
New York, illustrated in Causey, *Sculpture since
1945*, p. 42.

14 The exceptional intensity of purpose gen-
erated among radical Russian artists in these
circumstances is explored in T. J. Clark, 'God
is Not Cast Down', in *Farewell to an Idea:
Episodes from a History of Modernism* (New
Haven and London, 1999), pp. 225–97. On
the conception of Tatlin's *Monument* as seen by
his Russian contemporaries, see L. Zhadova,
Tatlin (London, 1988), pp. 342ff, and on
Tatlin's design of that and *Letatlin*, J. Milner,
Vladimir Tatlin and the Russian Avant-Garde
(New Haven and London, 1983), pp. 151–62,
217–24.

15 Breton's fullest analysis of the object comes in
the essay 'Surrealist Situation of the Object/
Situation of the Surrealist Object', initially
delivered as a lecture in Prague in 1935: A.
Breton, *Manifestoes of Surrealism* (Ann Arbor,
1972), pp. 255–78. A second essay, 'Crisis of
the Object', was published in *Cahiers d'Art* in
1936 in connection with the Surrealist exhi-
bition of objects in that year: *Qu-est ce que la
sculpture moderne?*, pp. 366–8. *Mad Love* was

published in 1937 with photographs by Man Ray of some of the 'found objects' whose story is told in the text: A. Breton, *Mad Love (L'Amour fou)* (Lincoln and London, 1987), pp. 13–35.

16 See D. Ades, *Dada and Surrealism Reviewed* (London, 1978), p. 322.

17 Breton, *Manifestoes*, p. 260.

18 S. Freud, 'Instincts and Their Vicissitudes', *On Metapsychology: The Theory of Psychoanalysis* (Pelican Freud Library, vol. XI, Harmondsworth, 1984), p. 119.

19 Breton, *Manifestoes*, p. 257.

20 Ibid., p. 258.

21 M. Leiris, 'Alberto Giacometti', *Documents 4*, 1929, pp. 209–10.

22 The objects included *Tête qui Regarde* (1928), *Homme et Femme* (1929), *Femme Couchée qui Rêve* (1929) and *Homme* (1929), works that now exist in bronze casts; illustrated in T. Stoss and P. Elliott, *Alberto Giacometti 1901–1966* (Edinburgh, 1996), Nos 56, 63, 62, 64.

23 S. Dalí, 'The Object as Revealed in Surrealist Experiment', in L. Lippard (ed.), *Surrealists on Art* (Englewood Cliffs, N.J., 1970), pp. 94–5.

24 This is one of two small-scale *Disagreeable Objects* Giacometti made in wood in 1931, *Alberto Giacometti*, Nos 69, 70. Giacometti's comment comes from his 1947 'Letter to Pierre Matisse', reproduced with a translation in P. Selz (ed.), *Alberto Giacometti* (New York, 1965), p. 22.

25 Selz, *Giacometti*, p. 22.

26 A number of American critics, most notably Clement Greenberg, nevertheless conceived it in these terms: C. Greenberg, *The Collected Essays and Criticism* (Chicago and London, 1986–93), vol. II, p. 207 (review of 1948).

27 D. Judd, *Large-Scale Works* (New York, 1993), introduction. See also Serra's comments, Ch. 7, pp. 260–1.

28 Sclz, *Giacometti*, p. 20.

29 Quoted in A. Chave, *Constantin Brancusi* (New Haven and London, 1993), p. 218.

30 D. Sylvester, *Looking at Giacometti* (London, 1994), pp. 26ff, 43ff, and the interviews republished there, conducted with the artist in 1963 and 1964.

31 B. Buchloh, 'Publicity and the Poverty of Experience', in *White Cube/Black Box* (Vienna, 1996), p. 167.

32 Giacometti very much became the intellectuals' sculptor in the period, his admirers including not only Sartre but also Simone de Beauvoir and Jean Genet, whose 1958 essay *L'Atelier d'Alberto Giacometti* became something of a classic.

33 J.-P. Sartre, *Situations*, vol. III (Paris, 1949), p. 301.

34 See for example the essay by Kurt Badt, 'Wesen der Plastik', first given as a talk at the Warburg Institute in 1940, and subsequently published in slightly modified form in *Raumphantasien und Raumillusionnen: Wesen der Plastik* (Cologne, 1963). For Badt, as for most writers of the early and mid-century analysing distinctively modern structurings of space in the visual arts, the main point of reference was not sculpture but the painting of Cézanne and the Cubists.

35 References here are to A. Hildebrand, *The Problem of Form in Painting and Sculpture* (New York and London, 1907), a translation by M. Meyer and R. M. Ogden from the third German edition of Hildebrand's *Das Problem der Form in der bildenden Kunst* (Strassburg, 1893). See M. Podro, *The Critical Historians of Art* (New Haven and London, 1982), pp. 66ff, on Hildebrand's significance for the new critical and formal conceptions of art developing in the German-speaking world at the time.

36 See M. Iversen, *Riegl, Art History and Theory* (Cambridge, Mass., and London, 1993), pp. 55, 72, 77–8. See also Wilhelm Worringer's comments, based on Riegl's theories, on how the definition of haptic form is based on a planar shape that can easily be taken in as a whole, *Abstraction and Empathy* (London, 1953; trans. from 1908 Ger. edition), pp. 39–41, 89–91.

37 See esp. Hildebrand, *Form*, pp. 29–31, and Podro, *Critical Historians*, pp. 110–1. E. H. Gombrich's *Art and Illusion: A Study in the Psychology of Pictorial Representation* (London, 1959) marks the beginning of a major shift in art historical studies away from these formal models. On later nineteenth-century scientists' questioning of the assumption that the two-dimensional structurings of the visual field in pictorial representation play a central role in everyday depth perception, see G. Hatfield, *The Natural and the Normative: Theories of Spatial Perception from Kant to Helmholtz* (Cambridge, Mass., and London, 1990), pp. 173–8.

38 Hildebrand, *Form*, p. 82; see also p. 87.

39 Ibid., pp. 14, 44.

40 The classic case is B. Berenson, *The Italian Painters of the Renaissance* (London, 1952; first published 1894–1907), pp. 40–3, 199–200.

41 Hildebrand, *Form*, pp. 21–5.

42 Ibid., p. 33; see also pp. 36–8.
43 Ibid., pp. 95–6.
44 Ibid., pp. 125–6.
45 At several points, he displays an acute aware-
 ness of the different priorities that come into
 play when sculpture is placed in different
 spatial contexts; ibid., pp. 86, 96–7.
46 See Y.-A. Bois, 'Kahnweiler's Lesson', *Paint-
 ing as Model* (Cambridge, Mass., and London,
 1990), pp. 74–82, for a discussion of these
 critiques and a different view of Kahnweiler's
 and Einstein's apparent privileging of fully
 three-dimensional cubic form. Very similar
 criticisms of Hildebrand were being made in
 the more aesthetically inclined art historical
 literature of the period; see for example F.
 Landesberger, *Vom Wesen der Plastik* (Vienna,
 Leipzig and Munich, 1924), pp. 25–6, 42–4.
47 D. H. Kahnweiler, 'L'Essence de la Sculpture',
 Confessions esthétiques (Paris, 1963), pp. 88–91,
 trans. from an essay published in Ger. in
 1919.
48 Ibid., pp. 93–4.
49 Ibid., p. 99.
50 Ibid., pp. 99–101.
51 C. Einstein, 'Negerplastik ("La Sculpture
 Nègre")', in *Qu'est-ce que la sculpture moderne?*
 (1986), p. 347. The text is trans. from the
 second Ger. edition published in 1920.
52 ibid., pp. 347–8.
53 Ibid., p. 349.
54 Ibid., p. 350.
55 C. Einstein, *Die Kunst des 20. Jahrhunderts*
 (Berlin, 1931), p. 219.
56 Ibid., p. 221.
57 Ibid., pp. 225–6.
58 Tucker, *Language of Sculture*, pp. 41–58,
 100–16; Krauss, *Passages in Modeern Sculpture*,
 pp. 84–103. Both, in their very different
 ways, link Brancusi's conception of the object
 to Duchamp's ready-mades.
59 A. Breton, from an essay for the catalogue *Art
 of this Century* (New York, 1942), quoted
 in A. Temkin, 'Brancusi and his American
 Collectors', in F. Teja Bach, M. Rowell and
 A. Temkin, *Constantin Brancusi 1876–1957*
 (Philadelphia, Cambridge, Mass., and
 London, 1995), p. 66. Celebrations of Bran-
 cusi by more formalist critics include Alfred
 Barr, writing in *Cubism and Abstract Art*
 (1936): see Temkin, p. 65.
60 See Temkin, 'Brancusi', pp. 59–65. See also
 Chave, *Brancusi*, pp. 5–10.
61 C. Giedion-Welcker, *Modern Plastic Art:
 Elements of Reality, Volume and Disintegration*
 (Zurich, 1937), p. 12.
62 Einstein, *Kunst*, p. 226.
63 See P. Paret, 'Sculpture and its Negative: The
 Photographs of Constantin Brancusi', in
 G. Johnson (ed.), *Sculpture and Photography*
 (Cambridge, 1998), pp. 101–15, and *Brancusi
 Photographe* (Centre Georges Pompidou, Paris,
 1977). For a full analysis of Brancusi's staging
 and photographing of his work in his studio
 see J. M. Wood, *The Materials and Metaphors
 of the Sculptor's Studio: Brancusi, Picasso and
 Giacometti in the 1920s and 1930s* (PhD thesis,
 Courtauld Institute of Art, University of
 London, 1999), pp. 99–184.
64 Chave, *Brancusi*, pp. 87–8. On Brancusi's
 practical interest in photographic equipment
 and other modern mechanical devices, see P.
 Hulten and others, *Brancusi* (New York,
 1987), pp. 191, 194–5, 202.
65 See R. Krauss, 'Brancusi and the Myth of Ideal
 Form', *Artforum*, Jan. 1970, pp. 35–9.
66 The marble version that Pound would have
 known dates from 1920; he would also have
 known the very similar *Sculpture for the Blind*,
 1916.
67 E. Pound, 'Brancusi' (1921), *Literary Essays of
 Ezra Pound* (London, 1954), p. 442.
68 See Hulten, *Brancusi*, pp. 184–6, and L.
 Adams, 'What's in a Name/Brancusi v.
 United States', *Art on Trial/From Whistler to
 Rothko* (New York, 1976), pp. 35–58.
69 Pound, 'Brancusi', p. 443.
70 Ibid., p. 444.
71 Ibid. The bronze version of the *Beginning of the
 World* postdates Pound's essay, but by the
 early 1920s Brancusi had produced versions in
 polished bronze of several of his works,
 including *Mlle Pogany* and the ovoid proto-
 types of the *Sleeping Muse* he first made in
 marble in 1909–10.
72 For practical reasons, *Endless Column* needed to
 be embedded in a concrete base that was not
 quite flush with the ground. Brancusi's pho-
 tographs of the first exhibited version, which
 is just over six feet tall, show it in his studio
 raised on a rectangular stone block which
 effectively functions as a pedestal, *Constantin
 Brancusi* (1995), p. 162, photograph from
 1922; and he sometimes mounted later larger
 versions in the same way, p. 348, photograph
 dated 1925. Minimalists who expressed
 enthusiasm for this particular work as well as
 the 'raw' bases include Andre in *Artforum*,
 June 1970, p. 61, and Morris, quoted in M.
 Berger, *Labyrinths, Robert Morris, Minimalism
 and the 1960s* (New York, 1987). See F. Teja
 Bach, 'Brancusi et la Sculpture Americaine

des Années 60', in *Paris–New York* (Centre Georges Pompidou, Paris, 1977), pp. 638ff.

73 See the versions dating from 1912, 1919 and 1931, illustrated in *Constantin Brancusi* (1995), pp. 121–3, 176–7, 258–9.

74 See Chave, *Brancusi*, pp. 32, 36. The plaster of *Mlle Poganyi* in the 1913 Armory Show (for a photograph of its installation, see Temkin, 'Brancusi', p. 51) was from an earlier, more naturalistic version than the ones illustrated here (fig. 71). On press coverage of the controversy surrounding the *Bird in Space* legal case in 1927, see references in n. 68.

75 For the latter conception of Brancusi, see Chave, *Brancusi*, esp. chs 2 and 3, pp. 68–123.

76 W. C. Williams, 'Brancusi', *A Recognizable Image: William Carlos Williams on Art and Artists*, ed. B. Dijkstra (New York, 1978), pp. 246–54. The essay was occasioned by the major Brancusi retrospective in New York and Philadelphia in 1955.

77 On the scandal surrounding *Princess X* when it was entered for the 1920 Salon des Indépendants in Paris, see Hulten, *Brancusi*, pp. 130–4. When shown at the Society of Independent Artists in New York in 1917, it provoked no such controversy and was if anything admired. Chave's *Brancusi* (1993) is the first recent study to follow Williams's lead and offer a substantive analysis of the insistent, yet complexly sexualised resonances of sculptures such as *Princess X*, *Torso of a Young Man*, *Leda* and *Adam and Eve*.

78 Williams, 'Brancusi', pp. 252–3.

79 Ibid., p. 250.

80 David Smith in 1953 quoted in G. McCoy (ed.), *David Smith* (London, 1973), p. 110.

81 C. Giedion Welcker, *Constantin Brancusi* (New York, 1959), p. 21.

Chapter 4

1 C. Giedion-Welcker, *Modern Plastic Art: Elements of Reality, Volume and Disintegration* (Zurich, 1937), pp. 8, 11–12, 13ff.

2 Her ideas on the Constructivist disintegration of mass and bounded shape relate to those in Siegfried Giedion's *Space, Time and Architecture: The Growth of a New Tradition* (Cambridge, Mass., 1941; given as the Charles Eliot Norton Lectures 1938–39) and in László Moholy-Nagy's *The New Vision: From Material to Architecture* (New York, 1930), on whom see

Chapter 3, n. 11, and P. Curtis, *Sculpture 1900–1945* (Oxford, 1999), pp. 101, 137, 252.

3 C. Greenberg, *The Collected Essays and Criticism* (Chicago and London, 1986–93), vol. III, pp. 275–7 (1956–57).

4 H. Read, *The Art of Sculpture* (Princeton, 1969), pp. ix–x. This later edition differs in a few minor details from the first edition of 1956.

5 See S. Stein, 'Notes d'après l'enseignement de Matisse' (1908), *Qu'est-ce que la sculpture moderne?* (Centre Georges Pompidou, Pars, 1986), p. 334.

6 Read, *Sculpture*, pp. 70–1.

7 Ibid., pp. 75–6, 109–11, 63–4.

8 Ibid., pp. 67–8.

9 Ibid., pp. 97–8, 103, 109–11, 114–16.

10 C. Greenberg, *Collected Essays*, vol. IV, p. 58 (1958).

11 A. Stokes, *Stones of Rimini* (New York, 1969; reprint of 1934 edition), pp. 108ff.

12 His key example is a comparison between two reliefs, a characteristically carved one by Agostino di Duccio, and a characteristically modelled one by Donatello, when in fact both are carved marble reliefs, ibid., pp. 135ff. On the seemingly masculine sexual fantasies of creation in Stokes's analysis, see ibid., pp. 109–10, the articles by Wagner and Potts in D. Thistlewood (ed.), *Barbara Hepworth Reconsidered* (Liverpool, 1996) and L. Stonebridge, 'Stone Love: Adrian Stokes and the Inside Out', *The Destructive Element: British Psychoanalysis and Modernism* (London, 1998), pp. 114–15. Other features of Stokes's analysis in *Stones of Rimini*, however, bring into play more complex, less normative understandings of sexuality. See R. Read, 'The unpublished correspondence of Ezra Pound and Adrian Stokes: Modern Myth-making in Sculpture, Literature and Psychoanalysis', *Comparative Criticism 21*, 1999, pp. 79–127.

13 Stokes, *Stones*, p. 111.

14 Ibid., pp. 107–8.

15 Ibid., p. 164.

16 Ibid., p. 128.

17 A. Stokes, *The Critical Writings of Adrian Stokes* (London, 1978), vol. I, p. 312.

18 Ibid., p. 309. The article on Moore is titled 'Mr Henry Moore's Sculpture', that on Hepworth 'Miss Hepworth's Carving'. On Hepworth and carving, see P. Curtis, 'Barbara Hepworth and the Avant Garde of the 1920s' in *Barbara Hepworth: A Retrospective* (Liverpool, 1994), pp. 14–27.

19 Some of these were not just cast but built up in layers over an armature and then carved. Throughout his career Moore combined carving and modelling: the surfaces of many of his bronzes were created by carving a plaster model.

20 On these features of Hepworth's earlier work, see A. Wagner, 'Miss Hepworth's Stone Is a Mother', in *Hepworth Reconsidered*, pp. 52–74. Moore made similar incisions on some of his earlier work, but the effect is often almost repressed in published photographs (fig. 102).

21 Stokes, *Stones*, pp. 120–1.

22 Ibid., pp. 122, 144–5.

23 Ibid., p. 166.

24 The best-known of these is 'An Invitation in Art', 1965. My ideas on Stokes's post-war writings owe a lot to David Hulks, who is completing a PhD thesis on 'Adrian Stokes and the New Art Object' (University of Reading).

25 See esp. the essays 'The New Sculpture' (1949, rewritten in 1958) and 'Collage' (1959) Greenberg republished in *Art and Culture: Critical Essays* (Boston, 1961).

26 Stokes, *Critical Writings*, III, pp. 318–19.

27 The theory is spelled out most fully in the section 'Art' in Stokes's study 'Greek Culture and the Ego', published in 1958, *Critical Writings*, III, pp. 108ff. On this psychoanalytic turn in his aesthetic, see Stonebridge, 'Stone Love', pp. 131ff.

28 Compare A. Warburg, 'A Lecture on Snake Ritual', *Journal of the Warburg and Courtauld Institutes*, vol. II, 1938–9, pp. 291–2 (from a lecture given in 1923). For a particularly vivid evocation by Stokes of a regressive part-object experience of human presences, see *Critical Writings*, III, p. 305.

29 Ibid., pp. 321, 320, 322.

30 Ibid., p. 321.

31 Ibid., pp. 322–3. One work he cited in this connection was the sculpture of a massively enlarged thumb by the French artist César.

32 Stokes, *Critical Writings*, II, pp. 242–3.

33 J. Burnham, *Beyond Modern Sculpture*, p. 150, referring to the wooden *Hollow Form (Penwith)*, 1955–56, in the Museum of Modern Art, New York.

34 Quoted in *Barbara Hepworth: Carvings and Drawings*, introduced by H. Read (London, 1952), section 4, 1939–46.

35 This is not only true of the Greenbergian tradition of writing about post-war sculpture. The only post-war sculpture represented in the British sculptor Tucker's *Language of Sculpture* (1974) as being on a par with the work of pioneers such as Brancusi, Duchamp and Tatlin is David Smith's.

36 This paradigm was a little hesitant in Greenberg's first extended commentary on Smith's work dating from 1943, *Collected Essays*, vol. I, pp. 139–40, and became firmer in reviews he wrote in 1946 and 1947, vol. II, pp. 53–4, 140–2, and also vol. III, p. 167. Smith shared Greenberg's view of the formal lineage of his work: see G. McCoy, *David Smith* (New York and London, 1973), p. 82.

37 Greenberg, *Collected Essays*, vol. III, pp. 275–9.

38 Ibid., vol. IV, p. 192 (1964). His elaborate, yet formulaic celebration of Caro's breakthrough in the same year (pp. 205–6) is lacking the charge found in his writing on Smith, and also has little of the passion that animates Fried's contemporary apologias for Caro, from which Greenberg took his cue.

39 The essay first came out in *Arts Magazine* in 1958 under the different title 'Sculpture in our Time', a much reworked version of the essay called 'The New Sculpture' which Greenberg had published in 1949. See Chapter 5, n. 6.

40 On Smith's political affiliations in the period, see P. Wisotzki, 'Strategic Shifts: David Smith's China Medal Commission', *The Oxford Art Journal*, vol. 18, no. 2, 1994, pp. 63–77. That until the mid-1940s Smith's work was seen by contemporaries to have socio-political overtones is demonstrated by commentary such as the article 'David Smith and Social Surrealism' by Stanley Meltzoff in *Magazine of Art*, vol. 39, no. 3, March 1946, pp. 98–101 (my thanks to Andrew Hemingway for this reference). Krauss's analysis of Smith's work testifies to the continuing political, anti-consumerist resonances in his conception of sculpture even after this point: see R. Krauss, *Terminal Iron Works: The Sculpture of David Smith* (Cambridge, Mass., and London, 1971), pp. 72ff, the most important study on the sculptor, and also *Passages in Modern Sculpture* (Cambridge, Mass., and London, 1981; first published 1977), pp. 154–5, 158–61. McCoy's introduction in *David Smith* (1973) perhaps best catches the tenor of Smith's continuing political self-awareness.

41 See M. Leja, *Reframing Abstract Expressionism: Subjectivity and Painting in the 1940s* (New Haven and London, 1993).

42 McCoy, *David Smith*, p. 22.

43 Ibid., p. 168.

44 Ibid., pp. 168–9.
45 Ibid., pp. 41–3; compare the article on pp. 44–8. Smith is referring to the critic Irving Babbit's deeply conservative critique of the post-Romantic breakdown of traditional cultural values in such widely read publications as *Rousseau and Romanticism* (1919). His earlier publication, *The New Laocoon* (1910), no doubt provided an ironic point of reference for the title of Greenberg's seminal essay 'Towards a Newer Laocoon', 1940.
46 McCoy, *David Smith*, pp. 142–3, 145–6.
47 Ibid., p. 145.
48 See Smith's photograph in ibid., pl. 55, and those by Ugo Mulas in *David Smith 1909–1965* (Valencia and Madrid, 1996), pp. 41, 65, 127.
49 On Smith's photographs, see J. Pachner, 'Private Views/Public Images: David Smith's Photography' in G. Johnson (ed.), *Sculpture and Photography* (Cambridge, 1998), pp. 131–47, and R. E. Krauss and J. Pachner, *David Smith: Photographs 1931–1965* (New York, 1998).
50 Quoted in E. A. Carmichael Jr, *David Smith* (National Gallery of Art, Washington, D.C., 1982), p. 81. The statement was published in *Arts Magazine* in 1960. See also Smith's comment in an interview in 1964 in McCoy, *David Smith*, p. 167.
51 McCoy, *David Smith*, pp. 183–4 (1964).
52 F. O'Hara, 'David Smith: The Color of Steel', *Art News*, vol. 60, Dec. 1961, pp. 33–4.
53 McCoy, *David Smith*, pp. 82–3.
54 *Julio Gonzalez* (Tate Gallery, London, 1970), p. 7. Smith drew on a slightly different translation of these comments that were quoted in a letter by Gonzalez's daughter, McCoy, *David Smith*, p. 138.
55 In the later 1930s Gonzalez himself began to work on a larger, less object-like scale, and not just in his figurative *Montserrat*. Smith's departures from Gonzalez included exploiting the new technique of arc welding: photographs indicate he was already doing so by the mid-1930s, C. Gray (ed.), *David Smith by David Smith: Sculpture and Writings* (London, 1968), p. 10. Later studio photographs show that he continued to use oxyacetylene equipment until the end of his career, *David Smith* (Valencia and Madrid, 1996), pp. 18, 98, 252. On Gonzalez's pioneering use of oxyacetylene welding, see J. Winters, *Julio Gonzalez: Sculpture in Iron* (New York, 1948), p. 19, n. 33, and pp. 11–12. When Gonzalez took up welding, it was a relatively new technique

developed in the armaments industry during the First World War. For Smith, as well as for Gonzalez, working in factories was important in practical terms for learning the nuts and bolts of this new process. I am grateful to Sue Malvern for drawing my attention to these technical details.
56 Carmichael, *David Smith*, pp. 45–6.
57 Greenberg, *Collected Essays*, vol. IV, p. 191 (1964). See also O'Hara, 'David Smith', p. 69. For a somewhat different perspective on the complex disarticulations induced by a close viewing of Smith's sculpture, see Krauss, *Passages*, pp. 157ff.
58 McCoy, *David Smith*, p. 184.
59 Greenberg, *Collected Essays*, vol. IV, pp. 227–8 (1966).
60 McCoy, *David Smith*, p. 155.
61 *Art in America*, January–February 1966, p. 47. Krauss drew attention to the significance of this interchange in *Terminal Iron Works*, p. 93.
62 Such a perspective is implicit in Krauss's close analysis of Smith's sculpture: see references in n. 40 above.
63 McCoy, *David Smith*, p. 85. On the echoes of vulgarity in contemporary Abstract Expressionist painting, see T. J. Clark, *Farewell to an Idea: Episodes from a History of Modernism* (New Haven and London, 1999), pp. 375ff.
64 From the poem 'Sailing to Byzantium', *The Collected Poems of W. B. Yeats* (London, 1961), p. 217.

Chapter 5

1 On these initiatives, see T. Crow, *The Rise of the Sixties: American and European Art in the Era of Dissent 1955–69* (London, 1996), which offers a valuable corrective to the usual New York-based view of developments in American art in the period, R. J. Williams, *After Modern Sculpture: Art in the United States and Europe 1965–70* (Manchester, 2000), and J. Thompson, 'New Times, New Thoughts, New Sculpture', in M. Ryan (ed.), *Gravity and Grace: The Changing Conditions of Sculpture 1965–1975* (London, 1993). The survey by A. Causey, *Sculpture since 1945* (Oxford, 1998), has a useful bibliography. On the reconceptualising of sculpture in the Anglo-American art world in the 1960s, see C. Harrison, 'Sculpture's Recent Past', in T. A. Neff, *A Quiet Revolution: British Sculpture since 1965* (London, 1987), pp. 10–33.

2 These ideas are developed in M. Fried, *Absorption and Theatricality: Painting and Beholder in the Age of Diderot* (Berkeley, Los Angeles and London, 1980).

3 On literalism as an issue in the U.S. art world at the time, see P. Leider, 'Literalism and Abstraction: Frank Stella's Retrospective at the Modern', *Artforum*, June 1970, pp. 44–51. My thinking on the subject was sparked by an unpublished lecture by Fred Orton, 'Appearing Literal' (Camberwell College of Arts, London, 1987).

4 M. Fried, *Art and Objecthood: Essays and Reviews* (Chicago and London, 1998), pp. 30, 56, 59. The essay 'Art and Objecthood' is also reprinted in G. Battcock, *Minimal Art: A Critical Anthology* (New York, 1968; republished with an introduction by A. M. Wagner, Berkeley, Los Angeles and London, 1995).

5 On the affinities between Greenberg and early modernists and theorists of formalism going back to Hildebrand, see Y.-A. Bois, *Painting as Model* (Cambridge, Mass., and London, 1990), pp. 75, 284–5.

6 This later version was first published in *Arts Magazine* in 1958 under the title 'Sculpture in our Time'. Greenberg then presented it as a revised version of his earlier essay 'The New Sculpture' in *Art and Culture: Critical Essays* (Boston, 1961).

7 C. Greenberg, *The Collected Essays and Criticism* (Chicago and London, 1986–93), vol. II, p. 314.

8 Ibid., vol. II, p. 316.

9 Ibid., vol. II, pp. 318–19; L. Zhadova, *Tatlin* (London, 1988), p. 342, quoting Schklovski (1920).

10 Ibid., vol. IV, p. 256. Compare Tony Smith's comment about his interest in 'pneumatic structures' quoted by Fried in 'Art and Objecthood', *Art*, p. 156.

11 Greenberg, *Art and Culture*, p. 204. The wording is considerably revised from that in the original essay on David Smith published in 1956, *Essays*, vol. III, p. 276.

12 Ibid., vol. IV, p. 60.

13 Ibid., p. 191 (from an article on Smith published in 1964).

14 Ibid., pp. 205–8.

15 M. Fried, 'Shape as Form: Stella's New Painting', in H. Geldzahler, *New York Painting and Sculpture: 1940–1970* (New York, 1969), p. 424.

16 Fried, *Art*, p. 7.

17 See ibid., pp. 29, 182–3. This tension is highlighted by Caro himself in an interview published in *Artforum*, June 1972.

18 See esp. Fried, *Art*, pp. 190–1.

19 The structural tensions in Caro's work are highlighted by Krauss in *Passages in Modern Sculpture* (Cambridge, Mass., and London, 1981; first published 1977), pp. 186–91.

20 Fried, *Art*, p. 191. Caro also insisted on this in the interview in *Artforum*, June 1972.

21 From an interview in 1961, quoted by Fried, *Art*, p. 273.

22 Ibid., p. 64 (author's emphases, unless otherwise noted).

23 Ibid., p. 152.

24 Ibid., p. 153.

25 From 'Questions to Stella and Judd' (1966), in Battcock, *Minimal Art*, p. 158.

26 Fried, *Art*, p. 161.

27 Ibid., p. 161.

28 Ibid., p. 151.

29 See the extracts from Cavell's essay on *Lear* and his *The World Viewed: Reflections on the Ontology of Film* in S. Mulhall (ed.), *The Cavell Reader* (Oxford and New York, 1996), pp. 143–66.

30 Ibid., p. 149.

31 Fried, *Art*, pp. 50, 47.

32 Ibid., p. 168. Fried's staging of his responses to Minimalist work, and the sharp focus of his polemic against its insistent theatriciality, have functioned as a point of departure for some valuable recent analysis of the bodily and performative dimensions to a viewer's encounter with a work of art, as in A. Jones, 'Art History/Art Criticism: Performing Meaning' in A. Jones and A. Stephenson (eds), *Performing the Body/Performing the Text* (London, 1999).

33 Fried, *Art*, pp. 155, 163–4.

34 Ibid., p. 156.

35 Illustrated in *Carl Andre Sculptor 1996* (Stuttgart, 1996), p. 115.

36 Tony Smith's *Die* is represented as the key Minimalist work in Georges Didi Huberman's psychoanalytically based critical examination of American Minimalism, *Ce Que Nous Voyons, Ce Qui Nous Regarde* (Paris, 1992). As a corrective to this focus on the closed, opaque and reductively simple object, see D. Batchelor, *Minimalism* (London, 1997).

37 Fried, *Art*, p. 42.

38 On British press responses to *Equivalent VIII*, see *Carl Andre Sculptor 1996*, p. 256 and J. A. Walker, *Art and Outrage* (London, 1999), pp. 73–7. Anna Chave's critique appeared as 'Minimalism and the Rhetoric of Power', *Arts Magazine*, January 1990, pp. 44–63. On the

controversy surrounding Serra's *Tilted Arc*, see Ch. 7, n. 51.

39 Fried, *Art*, p. 153.

40 See Chapter 6, pp. 222–3.

41 Fried, *Art*, pp. 167–8.

42 See C. Harrison, 'The Suppression of the Beholder: Sculpture in the Later Sixties', in *Starlit Waters. British Sculpture: An International Art 1968–1988* (Tate Gallery, Liverpool, 1988), pp. 40–4.

43 Fried, *Art*, p. 167.

44 Fried in *Anthony Caro* (Arts Council, Hayward Gallery, London, 1969), p. 12.

45 Fried apparently read Lukács in a Fr. translation of 1960 before it appeared in Eng. in 1971: see *Art*, pp. 18, 55.

46 Ibid., p. 15.

47 T. W. Adorno, *Ästhetische Theorie*, ed. G. Adorno and R. Tiedemann (Frankfurt am Main, 1973; first published 1970), p. 262. There is now a good Eng. translation by R. Hullot-Kentor, *Aesthetic Theory* (Minneapolis, 1997). My translations were originally carried out with reference to the less accurate earlier translation by C. Lenhardt, 1984.

48 The discussion of Adorno developed here is indebted to M. Jay, *Adorno* (Cambridge, Mass., 1984) and J. M. Bernstein, *The Fate of Art: Aesthetic Alienation from Kant to Derrida and Adorno* (Cambridge, 1992).

49 Adorno, *Theorie*, pp. 152–3.

50 Ibid., p. 134.

51 Ibid., p. 146.

52 Ibid., pp. 144, 129.

53 Ibid., p. 262.

54 Ibid., p. 134.

55 Ibid., p. 154.

56 Ibid., p. 267.

57 See for example ibid., p. 154.

58 Ibid., p. 449.

59 Ibid., p. 160; see also pp. 221, 252–3, 278.

60 Ibid., p. 234.

61 Ibid., p. 253.

62 Ibid., p. 142.

63 Ibid., p. 151.

64 Ibid., p. 412.

65 Ibid., p. 449.

66 Ibid., p. 164.

67 Ibid., p. 158.

68 Ibid., p. 165.

Chapter 6

1 Wollheim's essay is reprinted in G. Battcock (ed.), *Minimal Art: A Critical Anthology* (New York, 1968 and Berkeley, Los Angeles and London, 1995), pp. 387–99. Wollheim later developed a more general analysis of the problematics of the art object in his book on aesthetics, *Art and its Objects* (Harmondsworth, 1968). The focus on the constitution of the object features in a number of the key essays on Minimal art anthologised by Battcock, such as Barbara Rose's 'ABC Art', first published in 1965.

2 Merleau-Ponty's 'Cézanne's Doubt' was made available in 1964 in the Eng. translation *Sense and Nonsense*, and 'Indirect Voices' in the same year in *Signs*, the Eng. edition of *Signes*. Translations of the three essays on art are collected in G. A. Johnson (ed.), *The Merleau-Ponty Aesthetics Reader: Philosophy and Painting* (Evanston, Ill., 1993). An important guide to Merleau-Ponty for English-speaking readers was the anthology edited by A. L. Fisher, *The Essential Writings of Merleau-Ponty* (New York, Chicago, San Franciso, and Atlanta, 1969).

3 R. Krauss, 'Richard Serra, A Translation', *The Originality of the Avant-Garde and Other Modernist Myths* (Cambridge, Mass., and London, 1985), pp. 261–4. R. Nasgaard, *Structures for Behaviour: New Sculptures by Robert Morris, David Rabinowitch, Richard Serra and George Trakas* (Art Gallery of Ontario, Toronto, 1978), p. 39, commented that 'for the new demands on the spectator's behaviour' made by the three-dimensional work of the 1960s, 'Merleau-Ponty provided lively descriptions which . . . were critical of earlier passive theories of perception, and . . . confirmed a shared ambition of contemporary art and philosophy to seek a return to . . . things . . . as we "live them".' There is a discussion of the significance of Merleau-Ponty's phenomenology for critical writing on the visual arts in S. Melville, 'Phenomenology and the Limits of Hermeneutics' in M. A. Cheetham and others (eds), *The Subjects of Art History* (Cambridge and New York, 1998), pp. 143–54.

4 D. Sylvester, 'The Residue of a Vision' (1965), *Looking at Giacometti* (London, 1994). Merleau-Ponty is cited on p. 43.

5 M. Fried, *Art and Objecthood: Essays and Reviews* (Chicago and London, 1998), pp. 275, 276, n. 9 (from an essay on Caro published in 1963).

6 See e.g. *Anthony Caro* (Hayward Gallery, London, 1969), p. 14.

7 Fried, *Art*, p. 28.

8 R. Krauss, *Passages in Modern Sculpture* (Cambridge, Mass., and London, 1981; first

published 1977), pp. 239–40. Almost contemporary with Krauss's essay on Judd is a fine analysis by Jack Burnham, *Beyond Modern Sculpture* (New York, 1968), pp. 175–81, of the shift effected by Minimalist work from a modernist 'model theory' conception of the object to one where the viewer and the phenomenology of encounter play a central role, which also invokes Merleau-Ponty.

9 Krauss, 'Allusion and Illusion in Donald Judd', *Artforum*, May 1968, pp. 25–6.

10 See esp. Krauss, *Passages*, p. 239, where Merleau-Ponty is quoted.

11 This turn to Wittgenstein is evident in Fried's tracking of his career (*Art*, p. 33), but was particularly marked among the more conceptually inclined artists and critics, such as the Art and Language group in Britain and Robert Smithson and Robert Morris in the USA.

12 M. Merleau-Ponty, *Signes* (Paris, 1960), p. 155.

13 On the complexities of positioning Merleau-Ponty's thinking in relation to the divisions in post-war French thought between phenomenology and structuralism, see J. Schmidt, *Maurice Merleau-Ponty: Between Phenomenology and Structuralism* (Basingstoke, 1985).

14 Merleau-Ponty has also been criticised, if sympathetically, for the unreflectively masculine orientation of his notion of embodied subjectivity by R. Butler, 'Sexual Ideology and Phenomenology: A Feminist Critique of Merleau-Ponty's *Phenomenology of Perception*' in J. Allen and I. M. Young, *The Thinking Muse: Feminism and Modern French Philosophy* (Bloomington, Ind., 1989, pp. 85–100.

15 M. Merleau-Ponty, *Phénoménologie de la Perception* (Paris, 1945), p. 455. On Merleau-Ponty's attempt to bring together Existentialist phenomenology and Marxism, see M. Poster, *Existential Marxism in Postwar France: From Sartre to Althusser* (Princeton, 1975), pp. 144–53.

16 Merleau-Ponty, *Perception*, p. 445.

17 On Merleau-Ponty's political trajectory, see S. Kruks, *The Political Philosophy of Merleau-Ponty* (Brighton, Sussex, and Atlantic Highlands, New Jersey, 1981). The influential anthology of Merleau-Ponty's writings, *The Primacy of Perception* published in 1964, however, did reissue the essay from *Humanisme et Terreur* attacking Koestler's conversion to anti-Communism.

18 The complexities of his political commitments in the late 1940s emerges very clearly in *Humanisme et Terreur: Essai sur le Problème Communiste* (Paris, 1947), p. 16.

19 J.-P. Sartre, *Situations*, IV (Paris, 1964), p. 284.

20 See esp. Merleau-Ponty, *Signes*, pp. 12–17.

21 Ibid., p. 32.

22 My discussion of Merleau-Ponty is much indebted to Brendan Prendeville's analysis, 'Merleau-Ponty, Realism and Painting: Psychophysical Space and the Space of Exchange', *Art History*, September 1999, pp. 364–88, and to discussions with Michael Podro. Amelia Jones's, in *Body Art/Performing the Subject* (Minneapolis, 1998), deployment of Merleau-Ponty when making her case for a critical understanding of the role played by the body in performance work was instrumental in encouraging me in the view that a phenomenological perspective could have important insights to offer in a present-day context. Also helpful for clarifying my ideas was J. Andrews, 'Merleau-Ponty and the Question of Painting' (PhD thesis, University of Essex, 1997).

23 See for example the chapter 'Le Sentir', Merleau-Ponty, *Perception*, pp. 240ff.

24 M. Merleau-Ponty, *L'Oeil et l'Esprit* (Paris, 1964), p. 27.

25 Merleau-Ponty, *Perception*, p. 316. Compare Freud's comment: 'A person's own body, and above all its surface, is a place from which both external and internal perceptions may spring. It is *seen* like any other object, but to the *touch* it yields two kinds of sensations, one of which may be equivalent to an internal perception', from 'The Ego and the Id', *On Metapsychology: The Theory of Psychoanalysis* (Pelican Freud Library, XI, Harmondsworth, 1984), p. 364.

26 At the time when Merleau-Ponty was writing *Perception*, the new initiatives were largely coming out of *Gestalt* psychology, on which his analysis drew heavily. The affinities between Merleau-Ponty's understanding of visual perception and J. J. Gibson's ecological approach, launched with *The Perception of the Visual World* (1950), are explored in E. S. Casey, '"The Element of Voluminousness": Depth and Place Re-examined', in M. C. Dillon (ed.), *Merleau-Ponty Vivant* (Albany, 1991), pp. 1–29. For a mapping of the ongoing differences between 'traditionalist' and 'ecological' understandings of visual perception, see V. Bruce and others, *Visual*

Perception: Physiology, Psychology, and Ecology (Hove, 1996), pp. 367ff.

27 M. Merleau-Ponty, *Le Visible et l'Invisible* , ed. C. Lefort (Paris, 1964), p. 254.

28 Merleau-Ponty, *Oeil*, pp. 9–10; J. J. Gibson, *The Ecological Approach to Visual Perception* (Boston, 1979).

29 See his discussion of *Gestalt* in *Le Visible*, pp. 248–9, and also *Perception*, p. 61.

30 See Merleau-Ponty, *Perception*, pp. 148, 156.

31 On Husserl and horizon, see M. C. Rawlinson, 'Perspectives and Horizons: Husserl on Seeing and the Truth', in D. M. Levin, *Sites of Vision: The Discursive Construction of Sight in the History of Philosophy* (Cambridge, Mass., and London, 1997), pp. 265–92, and H. Kuhn, 'The Concept of Horizon' in M. Faber (ed.), *Philosophical Essays in Memory of Edmund Husserl* (Cambridge, Mass., 1940), pp. 112ff.

32 On point-horizon, see esp. Merleau-Ponty, *Perception*, pp. 100–2.

33 Ibid., p. 333.

34 See esp. ibid., pp. 327ff, 421ff.

35 Ibid., p. 330.

36 Ibid., p. 333.

37 See esp. ibid., Part I, Chapter IV, 'La Synthèse du Corps Propre (The Synthesis of One's Own Body)'.

38 Merleau-Ponty, *Perception*, pp. 98ff.

39 Ibid., p. 98.

40 Ibid., p. 322.

41 Merleau-Ponty, *Le Visible*, p. 176.

42 Ibid., p. 195; see also p. 192.

43 For one of Merleau-Ponty's most explicit critiques of the traditional focus on subjectivity and consciousness, see *Le Visible*, p. 292. As early as 1947, after a talk he gave on his theories of perception to a group of philosophers, one discussant who sprang to his defence suggested that Merleau-Ponty should follow through the more radical consequences of his ideas and abandon 'subjectivity and the vocabulary of subjective idealism' entirely: Merleau-Ponty, *The Primacy of Perception*, ed. J. Edie (Evanston, 1964), pp. 41–2.

44 Merleau-Ponty, *Le Visible*, p. 254.

45 On this issue my account differs markedly from Martin Jay's analysis of Merleau-Ponty's later thinking. He sees it as symptomatic of a tendency to denigrate vision in post-war French culture: M. Jay, *Downcast Eyes: The Denigration of Vision in Twentieth-Century French Thought* (Berkeley and London, 1993), pp. 298–328.

46 Merleau-Ponty, *Le Visible*, pp. 243, 245, 246, 250.

47 See esp. the section 'L'Entrelacs – le chiasme' (the interlacing – the chiasmus) in ibid., pp. 172–204, and also pp. 277, 287.

48 Ibid., p. 287.

49 See for example Merleau-Ponty's critical comments on Sartre in ibid., p. 290–1.

50 Ibid., pp. 269–70. The point was already made, if in slightly different terms, in *Perception*, p. 193.

51 Lacan was explicit about the affinities between his model of vision and Merleau-Ponty's, and clearly owed much to Merleau-Ponty's ideas on the subject, e.g. the references to Merleau-Ponty scattered throughout the relevant sections of his *The Four Fundamental Concepts of Psycho-Analysis* (Harmondsworth, 1977), pp. 71–3, 79–82, 93, 97, 107, 110, 114, 119. Merleau-Ponty clearly envisaged the texture of the intersubjective world in fundamentally differently terms from Lacan – less as a threatening shit hole, than as something akin to the warm embrace of 'the flesh, the mother' (*Le Visible*, p. 321), which may be one reason why Simone de Beauvoir and Sartre sometimes saw him as a little bourgeois.

52 Merleau-Ponty, *Perception*, Part I, Chapter V, 'Le corps comme être sexué' (the body as sexual being). See also the very sympathetic discussion of Freud he published at the end of his career: 'Phenomenology and Psychoanalysis: Preface to Hesnard's *L'Oeuvre de Freud* (Paris, 1960)', *The Essential Writings of Merleau-Ponty* (1969), pp. 81–7.

53 Merleau-Ponty, *Le Visible*, p. 292.

54 His specific comments on sculpture are very few and far between: see Merleau-Ponty, *Oeil*, pp. 78ff (on Rodin), and the somewhat imperceptive and banal comment, p. 89: 'there are fragments of Rodin that are statues by Germaine Richier, *because they were (both) sculptors*'.

55 Crucial was the compendium of Cézanne's statements in Joachim Gasquet's *Cézanne* (1921), a quotation from which heads Merleau-Ponty's *L'Oeil et l'Esprit*, p. 7. Merleau-Ponty also specifically cited (p. 66) the then classic study on Cézanne's restructuring of pictorial representation, F. Novotny, *Cézanne und das Ende der wissenschaftlichen Perspektive* (1938).

56 A. Malraux, *Le Musée Imaginaire* (Geneva, 1947), the first of a three-volume series Malraux initially published under the title *Psychologie de l'Art*. The later version, republished as the first in the series renamed *Les Voix du Silence* (Paris, 1951), appeared just

after Merleau-Ponty finished writing his essay, *Signes*, p. 63.

57 Merleau-Ponty, *Signes*, p. 65. See also pp. 60–1.

58 See esp. ibid., pp. 70–1, 80–1; and also *Oeil*, pp. 22–4. The issue is not depiction as such. Michael Podro, *Depiction* (1998) develops a much richer model based on the symbiosis between the depictive and the material dimensions of painting. For a discussion of how Merleau-Ponty's failure to take into account the viewer's apprehension of the painting itself as material phenomenon might be negotiated by drawing on his own general analysis of touch and vision, see R. Shiff, 'Cézanne's Physicality: The Politics of Touch' in I. Gaskell and S. Kemal (eds), *The Language of Art History*, (Cambridge, 1991), esp. pp. 150ff.

59 Merleau-Ponty, *Oeil*, p. 24.

60 Ibid., p. 12.

61 Merleau-Ponty, *Signes*, p. 64.

62 Merleau-Ponty goes on to discuss how any perception, any action, is a kind of primordial expression, ibid., pp. 83–4; see also pp. 82–3, 85–7.

63 Merleau-Ponty, *Oeil*, p. 26.

64 Ibid., p. 27.

65 Merleau-Ponty, *Signes*, p. 24. See also *Le Visible*, p. 189.

66 See esp. *Le Visible*, pp. 184, 188–91, and *Signes*, pp. 24–7.

67 The special issue of *Les Temps Modernes* (No. 184, 1961) on Merleau-Ponty included a densely written, characteristically conflicted tribute to him by Jacques Lacan: 'Maurice Merleau-Ponty', pp. 245–54. See also the references in n. 51 above, particularly the exchange with Jacques-Alain Miller in Lacan, *Four Fundamental Concepts*, p. 119.

68 Merleau-Ponty, *Le Visible*, p. 168.

69 See esp. ibid., n. on p. 190.

70 See Merleau-Ponty, *Signes*, pp. 99–102.

71 Ibid., pp. 100–1.

72 Ibid., pp. 78–9.

73 See Merleau-Ponty, *Oeil*, pp. 25, 69.

74 Ibid., p. 65.

75 Ibid., p. 67; see also p. 77.

76 Ibid., pp. 16–17.

77 Ibid., pp. 66–7.

78 Merleau-Ponty, *Le Visible*, p. 254.

79 Merleau-Ponty, *Oeil*, p. 66; see also p. 69.

80 He limits himself to a brief comment (*Oeil*, p. 76) about how the holes in Moore's sculpture 'show peremptorily that [a certain constitutive emptiness] is what sustains the supposed positivity of things', though the scooping out of hollows in Hepworth's work would have served his point much better, as explored in Ch. 4 above.

81 Ibid., p. 81.

82 The statement was made by Andre at a symposium held in 1968, and is quoted in L. R. Lippard, *Six Years: The Dematerialisation of the Art Object from 1966 to 1972* (New York, 1973; republished Berkeley, Los Angeles and London, 1997), p. 40.

83 C. Andre and H. Frampton, *Twelve Dialogues 1962–1963* (Halifax, Nova Scotia, 1980), p. 50.

84 Merleau-Ponty, *Oeil*, p. 92.

85 Ibid., p. 91.

86 Ibid., p. 90.

Chapter 7

1 J. Coplans, *Don Judd* (Pasadena, 1971), p. 30. The distinctive way in which American artists of the 1960s working in three dimensions engaged in an intensive critical interrogation of their pactice is highlighted in A. Causey, *Sculpture since 1945* (Oxford, 1998), p. 272.

2 In Morris's collected writings, *Continuous Project Altered Daily: The Writings of Robert Morris* (Cambridge, Mass., and London, 1993), two later articles, 'Notes and Non Sequiturs' first published in 1967, and 'Beyond Objects' (1969), where he shifts markedly from his earlier concern with the encounter between viewer and object, were renamed as 'Notes on Sculpture' Parts 3 and 4. Morris's in my view well deserved status as a key figure in this rethinking of the viewer's encounter with a sculptural object owes a lot to Krauss's presentation of him in *Passages in Modern Sculpture* (Cambridge, Mass., and London, 1981; first publish 1977), pp. 266–7. The more general interest in Morris as the exponent of a theoretically self-aware reconceptualising of the art work was staked out in Annette Michelson's seminal interpretation, 'Robert Morris: An Aesthetics of Transgression' in *Robert Morris* (Corcoran Gallery of Art, Washington, D.C., 1969).

3 Robert Smithson, who was a key figure in this respect, analysed both Judd's and Andre's distinctive style as writers in 'A Museum of Language in the Vicinity of Art' (1968), *Robert Smithson: The Collected Writings* (Berkeley, Los Angeles and London, 1996), pp. 79–80. On

Smithson as a writer, see T. Martin, *Robert Smithson: Writings, Sculptures, Earthworks* (PhD dissertation, University of London, 1999).

4 L. R. Lippard, *Eva Hesse* (New York, 1976), p. 165.

5 Morris, *Continuous Project*, p. 91; from 'Some Notes on the Phenomenology of Making' (1970).

6 Morris's 'Notes on Sculpture' is reprinted in G. Battcock (ed.), *Minimal Art: A Critical Anthology* (New York, 1968; republished Berkeley, Los Angeles and London, 1995), pp. 222–3.

7 Ibid., p. 225.

8 Ibid., pp. 231–2.

9 Ibid., pp. 225–6; compare p. 228.

10 Ibid., pp. 232–3.

11 See Chapter 5, pp. 183–4.

12 Battcock, *Minimal Art*, pp. 230–1.

13 On Morris's involvement with dance and performance, see M. Berger, 'Wayward Landscapes' in *Robert Morris: The Mind Body Problem* (Guggenheim Museum, New York, 1994), pp. 22–6, and *Labyrinths: Robert Morris, Minimalism and the 1960s* (New York, 1968), pp. 26–8, 81–105.

14 *Tulane Drama Review*, Winter 1965, p. 180. I am grateful to Fred Orton for this reference.

15 Battcock, *Minimal Art*, p. 235. On *Two Columns*, see *Robert Morris* (1994), pp. 90–1.

16 Battcock, *Minimal Art*, pp. 234–5.

17 For David Smith's comment favouring large-scale gestural acts of making rather than what he disparagingly called 'knitting', see 'Memories to Myself' (1960), in G. McCoy (ed.), *David Smith* (New York and London, 1973), p. 149.

18 M. Compton and D. Sylvester, *Robert Morris* (Tate Gallery, London, 1971), p. 16.

19 Ibid., p. 19.

20 Ibid., p. 18.

21 Ibid., p. 18.

22 See Chapter 6, p. 215. Merleau-Ponty's fullest account of *Gestalt* is in *Le Visible et l'Invisible* (Paris, 1964), pp. 258–9.

23 See Chapter 6, pp. 218–19. Merleau-Ponty frequently evoked the viewing of the cube, *Phénoménologie de la Perception* (Paris, 1945), pp. 203–5, 264–5, 324–5, and *Le Visible*, pp. 184, 255–6).

24 *Tulane Drama Review*, Winter 1965, p. 183.

25 Battcock, *Minimal Art*, p. 234.

26 See Morris on this in *Robert Morris* (1971), p. 18.

27 Battcock, *Minimal Art*, p. 232.

28 Ibid., p. 234.

29 Ibid., p. 231.

30 Morris, 'Notes and Non Sequiturs' (1967), *Continuous Project*, p. 33.

31 Battcock, *Minimal Art*, p. 228.

32 On *Waterman Switch*, see *Robert Morris* (1994), pp. 178–9, and references in n. 13. Recent analysis of Morris, as exemplified in the range of critical assessments of him in the catalogue of the 1994 show cited here, tends to celebrate, as Morris's own self-presentation often does, a moving beyond the closures imposed by modernism to a new, if at times bleak, arena of conceptual freedom and self-awareness. I feel that it is precisely Morris's complex, if at times disavowed, responsiveness to certain insistent problematics and closures of modernist practice that makes him such a significant artist.

33 See for example R. E. Krauss, *The Optical Unconscious* (Cambridge, Mass., and London, 1993), pp. 293–4. In the photograph apparently recording the arrangement realised in Morris's studio in 1967, the work looks more irregular, but also more two-dimensional and 'painterly' (Morris, *Continuous Project*, fig. 4.1).

34 Unpaginated enclosure in *Robert Morris* (1971).

35 The film was shown at the exhibition of Robert Morris's felts held in the Henry Moore Institute, Leeds, in 1997, but not at the retrospective in the Guggenheim Museum in New York in 1994. The latter effectively excised from Morris's career the experimental one-man shows at the Tate Gallery and the Whitney Museum in 1970–1. On *Neo Classic*, see J. Bird, 'Minding the Body: Robert Morris's 1971 Tate Gallery Retrospective', in M. Newman and J. Bird (eds), *Rewriting Conceptual Art* (London, 1999), p. 88–9.

36 Quoted in M. Berger, *Labyrinths*, p. 58.

37 Morris, *Continuous Project*, p. 91.

38 Morris, 'Anti Form' (1968), ibid., p. 46. On the trajectory traced by Morris's anti-form turn, see R. J. Williams, *After Modern Sculpture* (Manchester, 2000), pp. 29 ff., 68 ff., 86 ff., 111 ff.

39 This included a disgusted disavowal that he would ever have been caught 'standing knee deep in Merleau-Ponty . . . Voguing around in the stink of Presence, or tossing anything into that rotting sack of Humanism,' Morris, ibid., p. 296, which might seem a little disingenuous in the light of the title he gave his essay 'Some Notes on the Phenomenology of Making: The Search for the Motivated', *Artforum*, April 1970.

40 Morris, *Continuous Project*, p. 130.

41 See esp. ibid., p. 91.

42 Ibdi., pp. 71–2.

43 A. Kaprow, 'Happenings in the New York Scene', *Art News*, Vol. 60, May 1961, pp. 59–62.

44 Morris, *Continuous Project*, p. 173.

45 R. Morris, 'Professional Rules', *Critical Inquiry*, Winter 1997, p. 299.

46 *Robert Morris: Recent Felts and Drawings*, unpaginated leaflet with statements by Morris published by the Henry Moore Institute, Leeds, 1997.

47 Morris, *Continuous Project*, p. 138.

48 For an account of Morris's political involvements in the period, see M. Berger, *Labyrinths*.

49 *Robert Morris* (1994), pp. 202–5. On the disillusionment with the civic and public sphere that took hold in the aftermath of the politicisation of the American art scene in the 1960s, see K. Stiles, 'Uncorrupted Joy: International Art Actions' in P. Schimmel (ed.), *Out of Actions: Between Performance and the Object 1949–1979* (Los Angeles and London, 1997), esp. pp. 228–9.

50 For illustrations, see *Robert Morris* (1971), pp. 114, 124–5. There is a dramatic contrast between the public aspect of this work and the private character of the somewhat similarly conceived process piece Morris personally acted out the year before in the Leo Castelli Warehouse, *Continuous Project Altered Daily*: Williams, *After Modern Sculpture*, pp. 73–76, 113–14.

51 *Robert Morris* (1971), unpaginated enclosure. On the Tate exhibition and its reception, see J. Bird, 'Minding the Body', *Rewriting Conceptual Art*, pp. 88–106, who also supplies important details about the Whitney show (p. 95).

52 See L. Rosenstock (ed.), *Richard Serra/ Sculpture* (Museum of Modern Art, New York, 1986), with articles by R. E. Krauss and D. Crimp; and Y.-A. Bois, 'A Picturesque Stroll around Clara-Clara', *October 29*, 1984, pp. 32–62.

53 D. Crimp, 'Serra's Public Sculpture: Redefining Site Specificity' in *Richard Serra* (1986), pp. 40–56, and C. Weyergraf and M. Buskirk (eds), *The Destruction of Tilted Arc: Documents* (Cambridge, Mass., 1991).

54 R. Serra, *Writings Interviews* (Chicago and London, 1994), p. 112, from an interview published in 1980.

55 From 'Answers to my Disorder', in C. Andre and G. Gilbert-Rolfe, 'Commodity and Contradiction, or, Contradiction as Commodity', *October 2*, Summer 1976, p. 102.

56 Serra, *Writings*, p. 278.

57 See Chapter 9, p. 324.

58 Morris, *Continuous Project*, pp. 243, 279 (comments dating from 1981 and 1989).

59 Serra, *Writings*, p. 153 (from an interview published in 1983). Serra did actually use sandboxes when devising the layout of a work.

60 Ibid., p. 144.

61 Ibid., pp. 273–4.

62 Ibid., p. 146. The interview with the architect Peter Eisenman in 1983 perhaps drew out the fullest theoretical self-justification Serra has offered of his work.

63 See for example Carl Andre's comments in *Artforum*, June 1970, p. 61.

64 Serra, *Writings*, pp. 158, 279.

65 Ibid., p. 30.

66 M. Berger, *Labyrinths*, p. 60. Morris had written a dissertation on Brancusi. Andre similarly privileged the 'earth-driving, entering pedestals that were of an entirely different nature' from the finely worked objects they supported, *Artforum*, June 1970, p. 61.

67 Serra, *Writings*, p. 32. On *Chimera* (Philadelphia Museum of Art), see F. Teja Bach and others, *Constantin Brancusi 1876–1957* (Philadelphia, Cambridge, Mass., and London, 1995), pp. 156–7.

68 Serra, *Writings*, p. 272 (1992). He is referring to Degas's life-size *Small Dancer of Fourteen Years*, of which there is a version in Tate Modern, London.

69 For Judd's comments on Giacometti, see Ch. 3, n. 27.

70 Serra, *Writings*, p. 171.

71 Ibid., p. 171.

72 Ibid., p. 40. On Andre's conception of place, see Chapter 9, pp. 322.

73 Ibid., p. 55. Serra makes the point specifically in relation to his drawings, but clearly is also referring to his practice as a sculptor at the time of the interview in 1977.

74 See *Richard Serra: Weight and Measure* (Düsseldorf and London, 1992).

75 Serra, *Writings*, pp. 12–3.

76 Ibid., p. 48.

77 Ibid., p. 12.

78 Ibid., p. 123.

79 *Richard Serra Torques Ellipses* (DIA Center for the Arts, New York, 1997), p. 45.

80 Serra, *Writings*, p. 160 (1983). For an earlier commentary, see p. 32 (1978).

81 Ibid., p. 46.

82 The accident in the Castelli Gallery became enough of a public issue that Serra was asked to comment on it, ibid., pp. 190–1. On the *Tilted Arc* controversy, see earlier, note 52.

83 Andre in P. Cummings (ed.), *Artists in Their Own Words* (New York, 1979), p. 186 (1972).

84 The most striking case is *Skullcracker Series*, dating from 1969, which consisted of precariously balanced piles of steel set up temporarily in the disused Kaiser Steel factory in California: *Richard Serra/Sculpture* (1986), p. 79.

85 Serra, *Writings*, p. 188.

86 Ibid., p. 191.

87 Ibid., p. 265 (1992).

88 Morris, *Continuous Project*, p. 89.

89 For a fuller discussion of these issues, see A. Potts, 'The Minimalist Object and the Photographic Image' in G. Johnson (ed.), *Sculpture and Photography: Envisioning the Third Dimension* (Cambridge, 1998), pp. 181–98.

90 Morris, *Continuous Project*, pp. 201–2.

91 Serra, *Writings*, p. 32.

92 Ibid., p. 129 (1980).

93 *Robert Morris* (1971), and D. Sylvester, *Henry Moore* (London, 1968).

94 *Richard Serra Sculpture* (New York, 1986).

Chapter 8

1 In a footnote Judd added when he republished the essay in his *Complete Writings 1959–1975* (Halifax and New York, 1975), p. 189, he claimed that the illustration of one of his own works (fig. 109) was inserted by the editor.

2 From an interview published in J. Coplans, *Don Judd* (Pasadena Art Museum, 1971), p. 30.

3 Judd, 'Local History' (1964), *Writings* (1975), pp. 148–55.

4 See Serra's comment, 'I started as a painter (1960) and spent a year using paint as a found object', *Writings Interviews* (Chicago and London, 1994), p. 113.

5 *Don Judd* (1971), p. 31. The pieces to which Judd is referring are the works made of red-painted plywood shown at the Green Gallery in 1963 (figs 109, 110).

6 See the commentary on the significance of a Minimalist syntax for recent tendencies in British sculpture in C. Harrison, 'Empathy and Irony: Richard Deacon's Sculpture', *Richard Deacon: Sculptures and Drawings 1985–1988* (Madrid, 1988), pp. 17–22.

7 D. Judd, *Complete Writings 1975–1986* (Eindhoven, 1987), pp. 25ff. A key text for Judd, it was reprinted as an introductory statement to the catalogue of an exhibition of his work held in Paris, *Donald Judd*, Galerie Maeght Lelong (Paris, 1987).

8 From 'Questions to Stella and Judd' (1966), in G. Battcock (ed.), *Minimal Art: A Critical Anthology* (New York, 1968; Berkeley, Los Angeles and London, 1995), p. 158.

9 Judd, *Writings* (1987), p. 75.

10 Judd, *Writings* (1975), pp. 183–4.

11 Ibid., p. 110.

12 Ibid., pp. 109–10.

13 Judd used the term with reference to Oldenburg, ibid., p. 189.

14 Ibid., p. 188.

15 Ibid., pp. 179–80.

16 Ibid. On Stokes and Hepworth, see the references in Chapter 4, n. 12.

17 Judd, *Writings* (1975), p. 189.

18 Ibid., p. 192. See also his commentary (p. 153) on Oldenburg the year before.

19 Ibid., p. 193, from an essay on Oldenburg written in 1966.

20 Ibid. This was echoed by Oldenburg's own comment about his work in an interview in 1969, 'I've expressed myself consistently in objects with reference to human beings rather than through human beings. The human beings in my work are more or less spectators', J. Siegel, *Artwords: Discourses on the 60s and 70s* (Ann Arbor, 1985; republished New York, 1992), p. 183.

21 Judd, *Writings* (1975), p. 192.

22 Ibid., pp. 191, 189.

23 Ibid., p. 188.

24 Ibid., pp. 188–9. On Kusama, see L. Hoptman and others, *Yayoi Kusama* (London, 2000).

25 Judd, *Writings* (1975), pp. 181–4.

26 *Donald Judd* (Kunstverein St. Gallen, 1990), p. 56.

27 Judd, *Writings* (1975), p. 195.

28 Ibid., p. 198.

29 Quoted in ibid., p. 171.

30 Ibid., p. 135.

31 Ibid., p. 187.

32 Ibid., p. 184.

33 Battcock, *Minimal Art*, p. 154.

34 Judd, *Writings* (1975), p. 187.

35 *Don Judd* (1971), p. 30.

36 Judd, *Writings* (1975), p. 183.

37 Ibid., p. 157.

38 Serra, *Writings*, p. 169 (1985).

39 Judd, *Writings* (1975), p. 184.

40 Ibid., p. 117 (1964).

41 Ibid., p. 165.

42 Ibid., p. 183.

43 *Don Judd* (1971), p. 30. The analyses of Judd's work that have been particularly important for the account offered here are J. Coplans, 'Don Judd', *Don Judd* (1971), pp. 11–17, and 'The New Sculpture and Technology', in M. Tuchman (ed.), *American Sculpture of the Sixties* (Los Angeles, 1967), pp. 21–3; B. Fer, 'Judd's Specific Objects', *On Abstract Art* (New Haven and London, 1997), pp. 131–51; and Y.-A. Bois, 'L'Inflexion' in *Donald Judd* (Galerie Lelong, Paris, 1991). For a full catalogue of Judd's earlier work, with important photographic documentation of its installation, see B. Smith (ed.), *Donald Judd* (National Gallery of Art, Ottawa, 1975), and for a well illustrated survey of selected works that extends later into his career, see B. Haskell, *Donald Judd* (Whitney Museum of Art, New York, 1988).

44 Judd, *Writings* (1975), p. 190.

45 *Don Judd* (1971), pp. 25, 30. On the importance of colour in Judd, see D. Batchelor, *Chromophobia* (London, 2000), ch. 5, and B. Fer, as cited in n. 43. Judd's preference for red echoes the paradigmatic status of red as a hue in phenomenological discussions of colour: see for example M. Merleau-Ponty, *Le Visible et l'Invisible* (Paris, 1964), pp. 174–5, and D. Hume, *A Treatise of Human Nature*, Book I, *Of the Understanding* (London, 1972; first published 1739), p. 47 (Part I, Section I).

46 *Don Judd* (1971), p. 36.

47 Ibid.

48 See Judd's comments, ibid., pp. 44, 36.

49 Ibid., p. 32.

50 Judd, *Writings* (1975), p. 109 (1963–64).

51 *Don Judd* (1971), pp. 39, 36.

52 Judd, *Writings* (1975), pp. 144–5.

53 P. Tuchman, 'An Interview with Carl Andre', *Artforum*, June 1970, p. 61.

54 *Don Judd* (1971), p. 36.

55 Quoted in *Sol LeWitt* (Museum of Modern Art, New York, 1978), p. 172. Compare Judd's more down to earth commentary, *Writings* (1975), p. 193 (1967).

56 See Chapter 7, n. 23.

57 *Don Judd* (1971), p. 25.

58 Ibid., p. 41.

59 Krauss drew attention to this in 'Allusion and Illusion in Donald Judd', *Artforum*, May 1966, pp. 25–6. Earlier sculpture designed to be set against a wall often invited a similar full semi-circle of viewing, such as Bernini's sculptures for the Villa Borghese: J. Kenseth, 'Bernini's Borghese Sculptures: Another View', *Art Bulletin*, January 1981, pp. 191–210.

60 Judd, *Writings* (1975), p. 187.

61 From a statement published in 1966, quoted earlier in this section, n. 44.

62 Unease about this cult of wholeness in Judd is highlighted in Y.-A. Bois's commentary cited in n. 43.

63 Judd, *Writings* (1987), p. 44. He adds, 'It's what Bergson called "la durée".' Something of Judd's phenomenological take on a lived, interiorised experience of time and space may have come from his reading of Bergson, then standard fare for anyone with a philosophical turn of mind interested in the aesthetics of modern art.

64 Judd, *Writings* (1987), p. 32.

65 'Back to Clarity: Interview with Donald Judd', in *Donald Judd* (Staatliche Kunsthalle, Baden-Baden, 1989), p. 92.

66 *Donald Judd* (1990), p. 55.

67 Judd, *Writings* (1987), pp. 41–2. Judd is quoting from an interview David Sylvester conducted with Newman in 1966, published in *The Listener* in 1972, and reprinted in J. P. O'Neill (ed.), *Barnett Newman: Selected Writings and Interviews* (Berkeley and Los Angeles, 1992), p. 257. While Newman's paintings excited Judd, he was much less sure about the sculptures: J. Siegel (ed.), *Artwords* (1992), p. 49.

68 *Barnett Newman: Selected Writings*, p. 289 (1967).

69 Serra, *Writings*, p. 280.

70 *Robert Morris* (London, 1971), p. 19.

71 Judd, *Writings* (1975), p. 202.

72 Ibid., p. 117.

73 See Serra, *Writings*, p. 169, and Andre, *Artforum*, June 1970, p. 57.

74 Battcock, *Minimal Art*, p. 151.

75 Judd, *Writings* (1975), p. 153 (1964).

76 Judd, *Writings* (1987), p. 29.

77 Judd, *Writings* (1975), p. 212. Compare the baseball metaphor Frank Stella used to explain what he meant by the 'quality of simplicity' in art: 'When Mantle hits the ball out of the park, everyone is sort of stunned for a minute because it's so simple': Battcock, *Minimal Art*, p. 164.

78 Judd, *Writings* (1987), p. 31.

79 Judd, *Writings* (1975), p. 195.

80 Ibid.

81 Judd, *Writings* (1987), p. 45.

82 Judd, *Writings* (1975), p. 201.

83 Judd, *Writings* (1987), p. 47.

84 On this see Y.-A. Bois, 'Perceiving Newman', *Painting as Model* (Cambridge, Mass., and London, 1990), pp. 187–213.

85 *Don Judd* (1971), p. 36.

86 Ibid., p. 37.

87 Ibid., p. 36.

88 Ibid., p. 41. Here he is referring to work with sides and tops that are closed, or mostly closed in (fig. 101), not the metal boxes with open tops and often coloured floor panels (fig. 127), or the boxes open at both ends that structurally require a floor element (fig. 117).

89 Judd, *Writings* (1987), p. 56 (from an article published in 1984).

90 See Fer's suggestive interpretation (cited in n. 43) of the formal and psychic ambiguities operating in Judd's work. A polished brass floor piece (*Untitled 1968*, Museum of Modern Art, New York) by Judd features in Chave's diagnosis of what she sees as the 'domineering, sometimes brutal rhetoric' of Minimalist art in her 'Minimalism and the Rhetoric of Power', *Art Magazine*, January 1990, p. 44.

91 See for example the statement Judd published in 1977, *Writings* (1987), p. 8.

92 This is spelt out most fully in the introduction Judd wrote late in the day to a catalogue published in 1993 *Donald Judd: Large-Scale Works* (Pace Gallery, New York). See also his comment in a 1989 interview published in *Donald Judd* (Staatliche Kunstalle, Baden-Baden, 1989), pp. 89–90.

93 *Don Judd* (1971), p. 44. He was referring specifically to two metal pieces from 1968 and 1970 which occupied whole walls of a room.

94 H. Geldzahler (ed.), *New York Painting and Sculpture: 1940–1970* (New York, 1970).

95 Judd, *Writings* (1975), p. 209, first published in *Arts Magazine*, March 1973.

96 *Don Judd* (1971), p. 41. Richard Serra, *Writings*, pp. 106, 176, made the same point about the need for his work to be displayed in diffuse natural light, not spot-lit artificial light.

97 *Don Judd* (1971), p. 41. On the importance of subtle effects of shadow for Judd's work, see A. Potts, 'Michael Baxandall and the Shadows in Plato's Cave', *Art History*, December 1998, pp. 531–45; also in A. Rifkin (ed.), *About Michael Baxandall* (Oxford, 1999), pp. 69–83.

98 Judd, *Writings* (1987), pp. 82–3 (1984).

99 On several occasion he was involved in heated controversies over the exhibiting and display of his work, and towards the end of his career became extremely reluctant to lend work to exhibitions. For his own commentary on this, see *Donald Judd* (1989) pp. 95–6, and Y.-A. Bois, 'L'Inflexion' in *Donald Judd* (1991).

100 Judd, *Writings* (1987), p. 9.

101 The display of work was already something over which he took special care in his studio in New York before moving to Marfa where he had much more space.

102 Witness Judd's comment in a statement on installation published in 1982: 'David Smith's sculpture should have been left in the field where he placed it. I never saw the work there and will never see so much together. And as he placed it, not as it was shown, for example, in the stupid recreation of the theater at Spoleto in the National Gallery', *Writings* (1987), pp. 222–3. On Smith and Bolton Landing, see Chapter 4, pp. 162–5.

103 Judd, *Writings* (1987), p. 8 (1977).

104 Judd's diatribes extend in an entirely conventional way to attacks on big government, taxation and the restrictions placed by public authorities on his freedom of action, particularly where his property was concerned.

105 *Donald Judd* (1993) p. 9.

Chapter 9

1 However, Andre too stressed that he responded intensely to Jackson Pollock's painting, as well as to that of Agnes Martin and Ad Reinhardt, in P. Cummings (ed.), *Artists in Their Own Words: Interviews by Paul Cummings* (New York, 1979), p. 189. At the very outset he, like almost anyone else, began with painting, if only because painting and drawing were what you first did when you took art classes, Cummings, pp. 175–6, 178–9. The interview with Cummings conducted in 1972, together with the interview with Phyllis Tuchman published in *Artforum* in June 1970, pp. 51–61; reprinted in *Carl Andre Sculptor 1996* (Stuttgart, 1996), are Andre's most fully elaborated statements about his art. The discussion of Andre offered here develops out of my article 'The Paradoxes of the Sculptural' in I. Cole (ed.), *Carl Andre and the Sculptural Imagination* (Oxford, 1996), pp. 54–65.

2 Cummings, *Artists*, p. 175.

3 'Carl Andre on his Sculpture', *Art Monthly*, no. 16, 1978, p. 8.

4 See for example Cummings, *Artists*, p. 184, and C. Andre and H. Frampton, *Twelve*

Dialogues 1962–1963 (Halifax, Nova Scotia, 1980), p. 37.

5 C. Andre, 'Preface to Stripe Painting (Frank Stella)' in D. C. Miller (ed.), *16 Americans* (Museum of Modern Art, New York, 1959).

6 The original story is recounted in Andre's 1972 interview with Cummings, *Artists*, p. 190. By then it had already featured in the introduction by Diane Waldman to the catalogue *Carl Andre* (Guggenheim Museum, New York, 1970), p. 5. This and the essay by Nicholas Serota in *Carl Andre* (Whitechapel Art Gallery, London, 1978) offer the fullest early overviews of Andre's work.

7 L. R. Lippard, *Six Years: The Dematerialization of the Art Object from 1966 to 1972* (New York, 1973; Berkeley, Los Angeles and London, 1997), p. 40, from an interview conducted in 1968. This 'motto' was used by Robert Smithson as the title for an article he published in the same year, *Robert Smithson: The Collected Writings* (Berkeley, Los Angeles and London, 1996), p. 40. Smithson did not misquote Andre, as I wrongly suggested in G. A. Johnson (ed.), *Sculpture and Photography: Envisioning the Third Dimension* (Cambridge, 1998), p. 198.

8 Bochner is referring to Andre's unusually elaborate styrofoam beam works, *Crib, Coin* and *Compound*, installed in the Tibor de Nagy Gallery, New York, in 1965 (*Carl Andre Sculptor 1996*, pp. 114–15). For Andre's own comments on these, see *Artforum*, June 1970, p. 61.

9 G. Battcock, *Minimal Art: A Critical Anthology* (New York, 1968; Berkeley, Los Angeles and London, 1995), p. 94. This is a revised version of an article Bochner first published in 1967.

10 *Artforum*, June 1970, p. 71. The comment also evokes a very American 1960s free-wheeling cult of the open road, something in the nature of a road movie sculpture, perhaps. On this resonance in Andre's work, see M. Pimlott, 'Carl Andre: More Like Roads than Buildings', in Cole, *Carl Andre*, pp. 44–53.

11 J. Coplans, *Don Judd* (Pasadena, 1971), pp. 19–44.

12 *Artforum*, June 1970, p. 57.

13 Quoted in *Minimalism* (Tate Gallery Liverpool, 1989), p. 10.

14 Cummings, *Artists*, p. 184. See also *Art Monthly*, no. 17, 1978, p. 10.

15 Andre talks about a 'cut in space' in a comment quoted in D. Bourdon, 'The Razed Sites of Carl Andre' (1966), Battcock,

Minimal Art, p. 104. He describes the environment in which a work intervenes as 'empty space' in *Twelve Dialogues*, p. 19; see also p. 23.

16 See Chapter 8, pp. 297, 307.

17 This is discussed in some detail in Briony Fer's perceptive analysis of Andre's early floor pieces to which my discussion here owes much, 'Carl Andre's Floorplates and the Fall of Sculpture', in Cole, *Carl Andre*, pp. 37–43.

18 For a fuller discussion of Andre and photography, see my 'The Minimalist Object and the Photographic Image' in Johnson, *Sculpture and Photography*, pp. 181–98 (also correction, n. 7).

19 See n. 8.

20 Like *Equivalent*, this work formed part of a series. There were four variants with a vertical block and another horizontal one pointing in one of four directions, six variants with a vertical and two horizontals, and four variants with a vertical and three horizontals: *Carl Andre Sculptor 1996*, pp. 121–3.

21 *Artforum*, June 1970, p. 61. Compare also his slightly later comment in Cummings, *Artists*, p. 192.

22 Krauss, in her later writing, has put a powerful case for the significance of this tendency in relation to Giacometti's sculpture of the early 1930s: *The Originality of the Avant-Garde and Other Modernist Myths* (Cambridge, Mass., and London, 1985), pp. 73–85; and to Pollock's painting of the 1940s and early 1950s: *The Optical Unconscious* (Cambridge, Mass., and London, 1993), pp. 275, 284–308. In drawing attention to such resonances in the response an Andre floor piece might provoke, Briony Fer (n. 17) is talking more about a general condition of viewing brought into focus by this kind of Minimalist art than the activation of a debasing stance. Her emphasis on effects of undercutting and double bind also point to dynamic tensions inherent in a viewer's encounter with Andre's early metal plate and brick sculptures, albeit in rather different terms from those presented here.

23 See *Artforum*, June 1970, p. 57.

24 Andre in J. Siegel (ed.), *Artwords: Discourse on the 60s and 70s* (Ann Arbor, 1985; New York, 1992), p. 135.

25 Cummings, *Artists*, p. 185 (1972).

26 *Artforum*, June 1970, p. 55.

27 One of the more radically unstructured works Andre made was called *Spill (Scatter Piece)*. Dating from 1966, it consists of a canvas bag containing 800 small plastic blocks that are

to be scattered over the floor: *Carl Andre Sculptor 1996*, pp. 138–9.

28 Smithson, *Writings*, p. 246.

29 Ibid., p. 240.

30 See esp. ibid., p. 236.

31 In Andre's *Stone Field Sculpture* (1977) in Hartford, Connecticut, the granite boulders set out in rows on a slightly awkward wedge of public lawn next to a cemetery echo one of the more prominent monuments in the cemetery, which consists of a large boulder with a plaque inserted in it. Rows of boulders like these marking the boundaries of lawns are also a common feature in the Connecticut countryside. For illustrations see *Carl Andre* (The Hague and Eindhoven, 1987), pp. 109, 111.

32 For commentary by Smithson on his non-sites, see Smithson, *Writings*, pp. 192–5, 204–5.

33 On this controversy, see references in Chapter 5, n. 38. Something similar happened in the case of Andre's *Stone Field Sculpture* installed a year later near the art gallery in Hartford, Connecticut: *Carl Andre Sculptor 1996*, p. 260.

34 For example, the work of Marc Di Suvero in the United States and Philip King in Britain.

35 *Carl Andre* (The Hague, Gemeentemuseum, 1969), quoting a statement made by Andre at a symposium in 1968.

36 Cummings, *Artists*, p. 187.

37 'Carl Andre on his Sculpture II', interview with P. Fuller, *Art Monthly*, no. 17, 1978, p. 5.

38 Only one of the original series survived, *Equivalent VII*. See Andre's account in *Art Monthly*, no. 17, 1978, p. 6.

39 Siegel, *Artwords*, pp. 134–5. See also Cummings, *Artists*, p. 191.

40 See for R. Serra, *Writings Interviews* (Cambridge, Mass., and London, 1994), pp. 78ff, and for Smith, G. McCoy (ed.), *David Smith* (New York and London, 1973), p. 173.

41 See Siegel, *Artwords*, p. 133. This was in connection with a discussion of the political stand taken by the Art Workers Guild against the museum establishment during the Vietnam War.

42 *Artforum*, June 1970, p. 60.

43 There are illustrations of two works by Andre and also some important commentary by him: L. Lippard, *Six Years*, pp. 40, 46–8, 155–9.

44 Cummings, *Artists*, p. 193. Compare his earlier comments to Hollis Frampton in *Twelve Dialogues*, p. 50.

45 David Bourdon, 'The Razed Sites of Carl Andre', in Battcock, *Minimal Art*, p. 107, first published in *Artforum* in October 1966.

46 Siegel, *Artwords*, p. 137.

47 Ibid., p. 130.

48 Cummings, *Artists*, p. 193.

49 Lippard, *Six Years*, p. 156, from a 1970 symposium.

50 *Artforum*, June 1970, p. 59. Some work deliberately highlights this, such as *Small Weathering Piece* (1971), where 36 plates of various metals are laid out in a 6 × 6 square and placed outside to weather: *Carl Andre* (1987), p. 55; and *Joint* (1968), a work comprising a line of 183 rectangular bales of hay set directly on the ground: Lippard, *Six Years*, p. 46.

51 *Carl Andre* (1969), p. 5.

52 *Art Monthly*, no. 17, 1978, p. 8.

53 *Artforum*, June 1970, p. 59.

54 The eight combinations exclude the two least block-like and most line-like multiples of 1 × 60 and 2 × 30, and the remaining four (3 × 20, 4 × 15, 5 × 12 and 6 × 10) are doubled by the different combinations allowed by the bricks running end-on or sideways along any given dimension. On *Equivalent*, see D. Batchelor, 'Equivalence is a Strange Word' in Cole, *Carl Andre*, pp. 16–21.

55 Cummings, *Artists*, p. 193.

56 The perspicacious analysis of conceptualist tendencies in later twentieth-century art in T. Crow, *Modern Art and the Common Culture* (New Haven and London, 1996), esp. pp. 82–4, 215–6, comments at several points on the easy illusions of escaping the operations of the art market fostered since the 1960s by formal strategies that seem to abolish or ironise the commodifiable art object.

57 C. Andre and J. Gilbert-Rolfe, 'Commodity and Contradiction, or Contradiction as Commodity', *October 2*, Summer 1976, pp. 101–2.

58 'Carl Andre on his sculpture', *Art Monthly*, no. 16, 1978, p. 10.

59 Ibid., pp. 10–11.

60 *Artforum*, June 1970, p. 60.

61 Cummings, *Artists*, p. 195.

62 *Carl Andre* (1987), p. 5. Earlier, Andre had insisted on the erotic charge of his work by publishing an explicitly sexualised poem as the introduction to a catalogue of his sculpture in wood, *Carl Andre Wood* (Van Abbemuseum, Eindhoven, 1978).

63 Battcock, *Minimal Art*, p. 104. The Andre quote, without the gloss by Bourdon, is

repeated in D. Waldman, *Carl Andre*, p. 19.

64 *Artforum*, June 1970, p. 56.

65 Cummings, *Artists*, p. 189.

66 Ibid., p. 186.

67 Smithson, *Writings*, p. 84, commented on the romantic character of Andre's materialism.

68 C. Nemser, *Art Talk: Conversations with 15 Women Artists* (New York, 1974; republished 1995), pp. 195, 179.

69 *Art Monthly*, no. 16, 1978, p. 8.

70 *Artforum*, June 1970, p. 59.

71 C. Nemser, *Art Talk* (1975), pp. 173–86. Excerpts had already appeared five years earlier in *Artforum* (May 1970). Even in the fuller version, the interview, like most published artists' interviews, is considerably edited down from the original typescript, posing problems of interpretation highlighted in A. M. Wagner, 'Another Hesse', *October* 69, 1994, pp. 57–8. Hesse's statement for the catalogue of the exhibition *Art in Process IV*, held at Finch College, New York, in 1969, is reproduced in L. R. Lippard, *Eva Hesse* (New York, 1976; republished 1992), p. 165. Part of the value of Lucy Lippard's very fine monograph on Hesse lies in its attentiveness to the evident seriousness and cogency of the artist's own understanding of her project.

72 In her interview with Cindy Nemser, Hesse recalls the outward thrust being even more excessive, with the wire reaching out ten or eleven feet, Nemser, *Art Talk*, p. 180.

73 Ibid., p. 180. Hesse seems to have wanted the title *Hang-up* to be taken literally, suggesting something hung or strung up, and in retrospect found it a 'dumb name' because of the overriding connotations of psychological hang-up.

74 See Chapter 8, pp. 270, 282, and also D. Judd, *Complete Writings 1959–1975* (1975), p. 183: 'The new work obviously resembles sculpture more than it does painting, but it is nearer painting.'

75 Nemser, *Art Talk*, pp. 194–5. Smithson was fascinated by Hesse's work, as he had been initially by Andre's. See Lippard, *Hesse*, pp. 84–5, and Smithson, *Writings* (1996), pp. 36–7 (article published in 1966).

76 Nemser, *Art Talk*, p. 195, Lippard, *Hesse*, p. 165. *Contingent*'s complex and destabilising positioning between painting and sculpture is discussed in R. Krauss, 'Eva Hesse: Contingent' (1979), *Bachelors* (Cambridge, Mass., and London, 1999), pp. 91–100.

77 Lippard, *Hesse*, p. 195.

78 See p. 311 and n. 6.

79 See Lippard, *Hesse*, pp. 196, 201.

80 See ibid., p. 180, on the circumstances leading to the 'tragic' packaging of Hesse's work.

81 See Wagner, 'Another Hesse', *October* 69, and the chapter of this name in *Three Artists Three Women* (Berkeley, Los Angeles, and London, 1996), pp. 191–282, for a finely argued critique of various posthumous projections of Hesse as victim. Wagner develops a compellingly complex interpretation of Hesse's work, arguing that personal circumstances, including her being a woman who was of German Jewish origin, clearly inform it in significant ways, but at the same time should not be seen simply to subsume her unusually intense commitment to the possibilities that were open to her as an artist.

82 My interpretation draws on Briony Fer's analysis of the interplay between rigorous formal logic and psychic and bodily affect that characterises the more painterly aspects of Hesse's work, 'Bordering on Blank: Eva Hesse and Minimalism', *Art History*, September 1994, pp. 424–9, and also *On Abstract Art* (New Haven and London, 1996), pp. 108–30. For a range of different critical, biographically orientated interpretations of Hesse, see *Eva Hesse: A Retrospective* (New Haven, Yale University Art Gallery, 1992). I also found valuable the analysis of Hesse by K. Tong, 'The Sur(real) Sublime: Bourgeois, Hesse and Contemporary Sculptural Practice' (PhD thesis, University of London, 1997), whose discussion of Bourgeois's project also helped to bring home to me its wider significance.

83 See for example her exchange with Nemser, *Art Talk*, pp. 181–2.

84 Ibid., pp. 195–6.

85 Hesse also played upon traditional figurative sculpture's erotically charged imaging of the female body with work from this period such as *Untitled (Not Yet)* that evokes the shape of drooping, rounded breasts: Lippard, *Hesse*, pp. 60–1; see also the studio photograph pp. 68–9.

86 The drawing is illustrated in ibid., p. 167, fig. 213.

87 When the work was first exhibited, some viewers took this imperative literally and clambered inside, thereby not only damaging the work but also breaking the spell cast by the lure of the interior: ibid., p. 103.

88 On this process, see ibid., p. 164, Nemser, *Art Talk*, pp. 192–4, and B. Barrette, *Eva Hesse Sculpture* (New York, 1989), p. 226, who offers valuable insights into Hesse's methods of fabrication.

89 Nemser, *Art Talk*, p. 192.

90 On Hesse's use of fibreglass and latex, see ibid., pp. 190, 192, 194, and Barrette, *Eva Hesse*, pp. 13–15. Hesse interestingly was slightly concerned about the way that the casting of the fibreglass elements meant that the process was to some extent indirect. For clarification on these matters of technique, I am grateful to Sue Malvern and Adrian Forty.

91 Lippard, *Hesse*, p. 165.

92 The metal box with its thousands of perforations for *Accession II*, for example, was made to her specifications by the New York company Arco Metals, and her earlier fibreglass works, such as *Repetition Nineteen III*, were made at Aegis Reinforced Plastics, the same firm that carried out Morris's and Robert Smithson's fibreglass works until the company went bust in 1968 and one of the owners came to work in Hesse's studio; Barrette, *Eva Hesse*, pp. 13, 172.

93 Nemser, *Art Talk*, p. 192.

94 On this see Barrette, *Eva Hesse*, pp. 14–5.

95 Nemser, *Art Talk*, p. 190. See Hesse's further comments pp. 191–2. For Andre on temporality, see earlier in this chapter, pp. 229–30. Taking on board the temporal instabilities of material phenomena was a central concern of Smithson's. See for example the commentary he published in 1968 on 'The Value of Time', *Writings*, pp. 111–3.

96 Koons's response to this has been apt. If standard consumer products are to continue to look pristine for any period of time, they have to be sealed inside protective casing, as with the vacuum cleaner pieces (1981–86) from his series 'The New': *The Jeff Koons Handbook* (London, 1992), pp. 48–9.

97 See A. Chave, 'A Girl Being a Sculpture', in *Eva Hesse: A Retrospective*, p. 113.

98 Lippard, *Hesse*, p. 172.

99 *Tate: The Art Magazine*, no. 9, summer 1996, p. 41. There is a suggestive interpretation of the formal dynamic of the rope piece as echoing a sense of the interconnecting but disarticulated insides of a body in R. Krauss, *The Optical Unconscious* (Cambridge, Mass., and London, 1993), pp. 314–19. A number of features of my interpretation gained considerably from discussions of the work with Briony Fer.

100 M. Merleau-Ponty, *Le Visible et l'Invisible* (Paris, 1964), pp. 154–5.

101 Quoted in Barrette, *Eva Hesse*, p. 234.

102 Lippard, *Hesse*, p. 148.

103 Nemser, *Art Talk*, p. 191.

104 Lippard, *Hesse*, p. 165.

105 Nemser, *Art Talk*, p. 187.

106 Lippard, *Hesse*, p. 165.

107 See ibid., p. 172, Barrette, *Eva Hesse*, p. 234.

108 Nemser, *Art Talk*, p. 181. She is referring to *Ennead* (1966).

109 Lippard, *Hesse*, p. 161.

110 Nemser, *Art Talk*, p. 188. Lippard's (*Hesse*, p. 164) description of *Contingent*, which is the best record we have of the work before the latex became more opaque and dark and the fibreglass began to lose its translucence.

111 Lippard, *Hesse*, p. 161.

Conclusion

1 On Whiteread, see J. Bird, 'Dulce Domum' in J. Lingwood (ed.), *Rachel Whiteread House* (London, 1995), pp. 112–25, and B. Fer, 'Treading Blindly, or the Excessive Presence of the Object', *Art History*, June 1997, pp. 268–88.

2 The blocking of a consistent sense of castings of negative and positive spaces is also a feature of *Water Tower* (fig. 163).

3 Louise Bourgeois, *Destruction of the Father, Reconstruction of the Father: Writings and Interviews 1923–1997* (London, 1998), p. 223. The sculpture *One and Others* (1955), now in the Whitney Museum of Art, New York, is made up of a number of small, variously painted, tapering wooden shapes mounted close together on a rectangular base (illustrated in Bourgeois, *Writings*, p. 104). For recent critical interpretations of Bourgeois, see M. Nixon (ed.), *Louise Bourgeois*, special issue of *Oxford Art Journal*, vol. 22, No. 2, 1999, which includes an earlier version of my analysis here.

4 For Serra's often expressed unease about comments made on the powerfully affective dimension of his work, see Ch. 7, p. 265. Even Hesse had misgivings that her work might be interpreted too readily in terms of body imagery: see Ch. 9, p. 341.

5 This is particularly apparent in the careful structuring of her statement on *The Sail* (1988), Bourgeois, *Writings*, pp. 168–9. The

case that there is much of the canny modernist in Bourgeois is put persuasively by Adrian Rifkin in 'Reading the Sexual for Something Else', in I. Cole (ed.), *Louise Bourgeois* (1996), pp. 31–6. Rosalind Krauss, *Bachelors* (Cambridge, Mass., and London, 1999), pp. 51–74, argues that her project is embedded in a sharp awareness of avant-garde artistic strategies. The complex staging of the psychic in Bourgeois's work has been addressed most fully in M. Nixon's important studies on the artist, 'Eating Words', *Oxford Art Journal*, vol. 22, no. 2, 1999, pp. 55–70, and 'Bad Enough Mother', *October 71*, winter 1995, pp. 71–92.

6 Bourgeois, *Writings*, pp. 128–8, 302, 364.

7 *Confrontation* was the title of a performance piece Bourgeois staged at the Hamilton Gallery, New York, in 1978.

8 D. Judd, *Complete Writings 1959–1975* (Halifax, Nova Scotia, 1975), p. 183.

9 Bourgeois pointedly distanced herself from the Surrealist object, *Writings*, p. 161.

10 Ibid., p. 134.

11 Ibid., p. 142.

12 Ibid., p. 184.

13 Ibid., pp. 142–3, 156, 195, 74. There is an intriguing parallel with Barbara Hepworth's statements about carving stone: see A. Potts, 'Carving and the Engendering of Sculpture: Adrian Stokes on Barbara Hepworth' in D. Thistlewood (ed.), *Barbara Hepworth Reconsidered* (Liverpool, 1996), p. 50.

14 Bourgeois, *Writings*, pp. 183, 129. A similar alternation occurs in her account of *Janus* (p. 224). The Mapplethorpe photograph is illustrated on p. 199.

15 Ibid., p. 210. *Twosome* is illustrated on, p. 209.

16 Ibid., p. 209. For a particularly illuminating analysis of the shifts in psychic dynamic that occurred when Bourgeois moved from object-like work to more theatrically staged installations, see Nixon, 'Eating Words', pp. 55–70.

17 Bourgeois, *Writings*, pp. 104–5. The commentary was published in 1976, and very slightly predates Rosalind Krauss's formulation of this shift in *Passages in Modern Sculpture* (1977), pp. 243ff. Compare also Bourgeois's later comments, *Writings*, pp. 352–3.

18 Bourgeois, *Writings*, p. 66. The comment was published in 1954.

19 On Bourgeois's move to a more installation-orientated kind of work in the late 1980s, see T. Sultan, 'Redefining the Terms of Engagement: The Art of Louise Bourgeois', in C. Kotik, T. Sultan and C. Leigh, *Louise Bourgeois: The Locus of Memory, Works 1982–1993* (New York, 1994), pp. 41–7.

20 Bourgeois, *Writings*, p. 237; see also p. 264.

21 Ibid., p. 205.

22 C. Meyer-Thoss, *Louise Bourgeois: Designing for Free Fall* (Zurich, 1992), p. 136. Only selections from the interviews and statements published by Meyer-Thoss are included in Bourgeois, *Writings*. *Articulated Lair*, completed in 1986, is illustrated in C. Kotik and others, *Louise Bourgeois* (1994), pp. 94–5.

23 Bourgeois, *Writings*, p. 151.

24 On this aspect of Nauman's practice, see *Bruce Nauman* (London, South Bank Centre, 1998), which republishes a number of his more important interviews. An earlier version of my discussion of Nauman appeared in *Burlington Magazine*, July 1998, pp. 448–50.

25 Nauman quoted in C. van Bruggen, *Bruce Nauman* (New York, 1988), p. 194. He was specifically referring to *Floating Room* (1973) and *Installation with Yellow Lights* (1971).

26 Ibid., p. 117, quoting from an interview conducted in 1979.

27 See Chapter 5, pp. 196–8.

28 Baselitz, as much as Judd, rejected any suggestions that an art object could be expressive or depictive. See 'Georg Baselitz: entretien avec Jean-Louis Froment et Jean-Marc Poinsot', in *Baselitz Sculptures* (Musée d'Art Contemporain de Bordeaux, 1983), pp. 13, 15–16.

29 Ibid., p. 20.

30 Ibid., p. 21. Baselitz himself was explicit that the saw marks were not to be seen as a form of sculptural modelling, but rather were independent drawn strokes (p. 22).

31 Ibid., pp. 18, 19, 22.

32 Baselitz himself considered bodily gesture as a central feature of his sculpture, ibid., pp. 18, 22.

33 Ibid., p. 17.

34 See for example *Untitled* 1989 (Scottish National Gallery of Modern Art), illustrated in D. Waldman, *Georg Baselitz* (Guggenheim Museum, New York, 1995), fig. 98. There is a conventional gendering at work in Baselitz's sculpture, with the often partial female figures, such as *Frau Paganismus* (1994) and *Weiblicher Torso* (1993), being simple presences that address the viewer only in so much as they present or expose their sexuality: see illustrations in Waldman, fig. 111 and fig. 108.

35 Such a shift is discussed in relation to the
 increasing improvishment of public space in
 B. Buchloh, 'Publicity and the Poverty of
 Experience' in *White Cube/Black Box* (Vienna,
 1996), pp. 163–73.

36 Characteristic in this respect is the statement
 by Jake Chapman of Jake and Dinos Chapman
 fame: 'We're interested in trying to produce
 intensely sadistic objects, to populate the
 world with objects that the world doesn't nec-
 essarily feel it deserves. Our work is intensely
 strategic, intensely non-human, intensely
 cold and intensely cruel. It's made in an
 intensely uncaring manner – uncaring about
 the views of the person who is being invited
 to look at it, and not caring to reflect the emo-
 tions or the human empathy of the people
 who made the thing', *The Observer Magazine*,
 28 March 1999, p. 16.

37 Nauman put his finger on this with his
 ironically titled installation *Room with my
 soul left out, room that does not care* (1984),
 illustrated in J. Simon (ed.), *Bruce Nauman*
 (Minneapolis, 1994), p. 48.

Photograph Credits

Archivi Alinari 23, 24, 28, 35; Peter Bellamy 158; courtesy Louise Bourgeois 159; Dan Budnik, courtesy Woodfin Camp and Associates 78; Balthasar Burkhard 165; Rudolph Burckhardt 13, 102, 103, 109, 118; Geoffrey Clements 93, 138, 150; Photograph © 1999, The Art Institute of Chicago, All Rights Reserved 142; Alan Finkelmann 156; Photographs by David Finn 22, 25, 26, 29; Getty Center, George Stone Collection 20, 21; Photo John Goldblatt 92; Niedersächisches Landesmuseum, Landesgalerie, Hanover 2; Courtesy the Donald Judd Estate 101, 110, 121, 122, 123, 130; Krefelder Kunstmuseum, Photo V. Döhne 139; Courtesy of the Anthony d'Offay Gallery, London, 1, 41, 98, 154, 155; Photo Dave Morgan, London, courtesy Lisson Gallery 6, 7; © Tate, London 2000 51, 62, 63, 77, 81, 82, 91, 134, 141, 164; Tate Gallery Archives, London 57; MMK/Robert Häusser 132, Archivio Ugo Mulas, Milan 85; Peter Moore 157; Courtesy Leo Castelli Gallery, New York 104, 112, 118; Courtesy Paula Cooper Gallery, New York 5, 131, 133, 137, 140; Photograph by David Heald © The Solomon R. Guggenheim Museum, New York 52, 105; Photograph © 2000 The Museum of Modern Art, New York 50, 53, 100, 120, 151; Museum of Modern Art, Oxford, photograph by Chris Moore 119; © Musée Rodin, Paris 3, 32, 37, 38, 40, 42; © Photo RMN 27, 43; I.C.C.D., Rome 19; Photo Stefan Erfurt, Wuppertal, Courtesy Richard Serra 8, 9; Photo Gordon Matta-Clark, Courtesy of Richard Serra 107; Courtesy Richard Serra 94, 95, 99; Télimage 60; V & A Picture Library 11, 12; © ND-Viollet 15; © Roger-Viollet 17, 47, 48; David Ward 45, 46; © 2000 Kunsthaus Zurich. All Rights Reserved 33.

Copyright Bylines

© ADAGP, Paris and DACS London 2000 4, 49, 61, 62, 63, 64, 65, 66, 67, 68, 69, 70, 71, 72, 73, 81, 82; © Carl Andre/VAGA, New York/DACS, London 2000 5, 96, 131, 132, 133, 134, 135, 136, 137, 139, 140, 141; © ARS, NY and DACS, London 2000 8, 9, 13, 93, 94, 95, 99, 100, 102, 103, 104, 105, 106, 107, 108, 111, 116, 120, 125, 126, 162, 163; © Louise Bourgeois/VAGA, New York/DACS, London 2000 156, 157, 158, 159, 160, 161, 166; © Alan Bowness, Hepworth Estate 75, 76, 77; © DACS 2000 1, 53, 54, 55, 56, 60, 97; © Estate of Donald Judd/VAGA, New York/DACS, London 2000 101, 109, 110, 117, 118, 119, 121, 122, 123, 124, 127, 128, 129, 130; © Estate of David Smith/VAGA, New York/DACS, London 2000 78, 79, 80, 83, 84, 85, 86, 87, 88, 89, 90, 91; © Estate of Robert Smithson/VAGA, New York/DACS, London 2000 138; © Man Ray Trust/ADAGP, Paris and DACS, London 2000 60; © Succession Marcel Duchamp/DACS 2000 57, 58, 59; © Succession Picasso/DACS 2000 50.

Index